BOOKS BY JAMES THOMAS FLEXNER

DOCTORS ON HORSEBACK
(*Dover reprint*)

AMERICA'S OLD MASTERS

WILLIAM HENRY WELCH
AND THE HEROIC AGE OF AMERICAN MEDICINE
with Simon Flexner

HISTORY OF AMERICAN PAINTING
Dover reprints

THE COLONIAL PERIOD
FIRST FLOWERS OF OUR WILDERNESS

1760-1835
THE LIGHT OF DISTANT SKIES

THAT WILDER IMAGE
THE NATIVE SCHOOL FROM THOMAS COLE
TO WINSLOW HOMER

STEAMBOATS COME TRUE

JOHN SINGLETON COPLEY

THE POCKET HISTORY OF AMERICAN PAINTING

THE TRAITOR AND THE SPY:
BENEDICT ARNOLD AND JOHN ANDRÉ

GILBERT STUART

MOHAWK BARONET:
SIR WILLIAM JOHNSON OF NEW YORK

THE WORLD OF WINSLOW HOMER
with the editors of Time

GEORGE WASHINGTON:
THE FORGE OF EXPERIENCE, 1732–1775

GEORGE WASHINGTON:
IN THE AMERICAN REVOLUTION, 1775–1783

GEORGE WASHINGTON:
AND THE NEW NATION, 1783–1793

NINETEENTH-CENTURY AMERICAN PAINTING

The biographies of Copley and Stuart were based
on the shorter accounts contained in *America's Old Masters*

HISTORY OF
AMERICAN PAINTING
VOLUME THREE

That Wilder Image
THE NATIVE SCHOOL FROM
THOMAS COLE TO WINSLOW HOMER

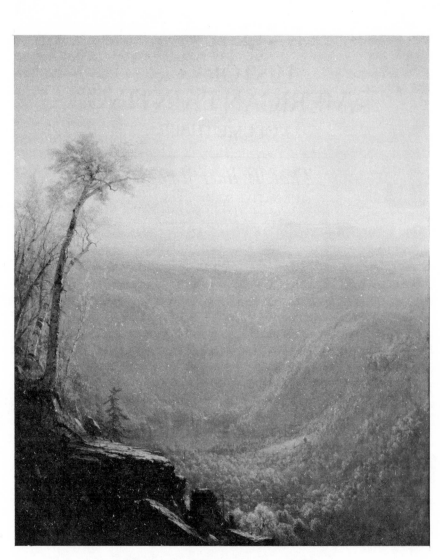

Sanford R. Gifford *Kauterskill Falls*

Oil on canvas; 1862; 48 × 39⅞; Metropolitan Museum, New York,
bequest of Maria De Witt Jesup, 1915.

HISTORY OF
AMERICAN PAINTING
VOLUME THREE

That Wilder Image
THE NATIVE SCHOOL FROM
THOMAS COLE TO WINSLOW HOMER

BY
JAMES THOMAS FLEXNER

DOVER PUBLICATIONS, INC.
NEW YORK

Published in Canada by General Publishing Company, Ltd., 30 Lesmill Road, Don Mills, Toronto, Ontario.

This Dover edition, first published in 1970, is an unabridged republication of the work originally published in 1962. The text has been repaginated and the illustrations have been rearranged and partially renumbered.

The sections on Mount and Blythe originally appeared in somewhat different form in *American Heritage.*

This edition is reprinted by special arrangement with Little, Brown and Company, publisher of the original edition.

International Standard Book Number: 0-486-25709-6
Library of Congress Catalog Card Number: 76-125911

Manufactured in the United States of America
Dover Publications, Inc.
31 East 2nd Street
Mineola, New York 11501

to Helen Hudson Flexner

To Cole, the Painter, Departing for Europe

by William Cullen Bryant

Thine eyes shall see the light of distant skies:
Yet, Cole! thy heart shall bear to Europe's strand
A living image of our own bright land,
Such as upon thy glorious canvas lies.
Lone lakes — savannahs where the bison roves —
Rocks rich with summer garlands — solemn streams —
Skies where the desert eagle wheels and screams —
Spring bloom and autumn blaze of boundless groves.

Fair scenes shall greet thee where thou goest — fair
But different — everywhere the trace of men.
Paths, homes, graves, ruins, from the lowest glen
To where life shrinks from the fierce Alpine air.
Gaze on them, till the tears shall dim thy sight,
But keep that earlier, wilder image bright.

FOREWORD

THE NATIVE SCHOOL

IN the mid-nineteenth century, painting was more popular in America than at any other time in our history. The interest was not inspired by the importation from abroad of already famous masters. The rage was for works of living American artists. A New York exhibition devoted exclusively to such pictures attracted from 1839 to 1851 an average annual attendance equal to 57½ per cent of the population of the city. From 1939 to 1951, the attendance at the Metropolitan Museum was only 16¼ per cent.

For two generations, ordinary American citizens bought paintings. Even leading collectors, at first almost unanimously and later to a considerable extent, did not buy foreign pictures. To be a painter was not then in the United States financially hazardous. Any artist capable of producing a good picture could sell it, and the abler painters became not only wealthy but generally recognized leaders of our national life.

Writing in 1905, the painter-critic Samuel Isham reported that aging artists who could remember the mid-nineteenth century "look back at it through the years as to an Eden, the like of which cannot occur again." Indeed, it has not occurred again. Despite the self-congratulations of our own contemporaries on what seems to them a phenomenal interest in American art, the *New York Times* reported during July 1961 that "the fundamental economic fact of an artist's life" in the United States is that he cannot make his living from art; "he must work at something else to survive."

Mid-century Americans loved their painting because it expressed effectively their communal experiences and ideals. The landscapist Asher B. Durand called for "an original school of art worthy to share the tribute of universal respect paid to our condition of political advancement." Democratic con-

ceptions, added the historian George Bancroft, pointed the way to "the sublimest success" since, by learning how to appeal to the common man, the artist would penetrate to the "universal sense of the beautiful . . . that lies deep in the human soul." In a statement that is hard to recognize as idealistic, now that modern criticism is so committed to the conception that art should exclusively serve a cultural elite, the genre painter William Sidney Mount summarized the attitude of the Native School: "Paint not for the few but the many."

To achieve their objectives, the painters turned for inspiration less to fine arts traditions abroad than vernacular traditions at home. Most had begun their professional careers in their teens as craftsmen: engravers, sign painters itinerant portraitists. Singly and in groups, by personal experimentation and mutual emulation, they refined crude popular styles into a manner that, at its best, achieved sophistication, subtlety, and power.

Some of the most effective exemplars of the Native School never went abroad. Those who did cross the ocean set out, even if quite young, not as raw students. They were practicing professionals, pleased with what they already possessed. They had no desire to be born again. They wished to use the esthetic riches of Europe as a means for refining an already established American manner. If, on their return to the United States, they found they had been lured into serious deviations, they usually regarded this as a handicap and labored, in the presence of American nature and art, to overcome it. At no other time has our painting been, for better or worse, so original, so far from European attitudes and forms.

When the Native School set out on its own way, it was reflecting broad historical forces. The War of 1812 had marked the end of American participation in transatlantic turmoils. Europe was wallowing in wars, tyrannies, and abortive revolutions that were fostering in art pessimism, violence, revolt, despair: a cold classicism or emphasis on those aspects of romantic thinking that denied ordinary experience. But the United States was looking westward, gleefully exploiting a vast, almost uninhabited continent. Political tyranny did not exist. Poverty was forced on no able white man. Dislocations seemed no more than growing pains; roughness — what Europeans called "vulgarity" — a proof of untamed force. Americans were enchanted with their world and their communal existence. Mount jotted in his journal, "I wrote with my finger on the bridge in the white frost, 'God is good.'" While the most-admired schools abroad were eschewing ordinary life, the Native School began its concentration on local landscape and genre. By the

time dominant European esthetic thinking had moved in the same direction, the Americans were deeply committed to going their own way.

Such were the artistic developments with which this book will deal. It will describe the most important and most long-lived effort yet made to grow American painting almost exclusively from native seed. The story begins in 1825, with the explosive emergence of the landscape painter Thomas Cole, and ends with the long career of Winslow Homer, who did not die till 1910. The next and almost opposite major tendency in American painting, that concern with foreign inspiration which became passionate on these shores about 1875, is here discussed only in relation to the continuing activities of the nationally oriented painters, for whom it created an increasingly inimical environment.

Hundreds of books have been written on the American literature of the mid-century, but this will be the first modern work to deal fully with the Native Painting School as a whole. Many of the most significant painters have never been accorded full-length studies. Their pictures commonly languish in museum cellars or, if exhibited, have been allowed to remain so obscured with dirt that they can hardly be seen. Although no aspect of our artistic activity promises more fascinating insights into the nature and the problems of American creativity, no important aspect of our culture has been less explored, is more misunderstood. For the twilight that has sunk over the Native School, its self-reliance is primarily to blame.

That the artists' aims and practice often differed from the European ones was hailed in their lifetimes as in itself a proof of their worth, but in more recent years their originality has caused them to be considered by definition worth= less. Our connoisseurs have, for the last several generations, refused to enter- tain the possibility that on any level except the crudest — what is today called "folk art" — painters in the United States could establish an effective but divergent esthetic of their own. Modern taste has demanded of sophisti- cated American painting that, while having a characteristic flavor, it should require for appreciation no shift in attitudes primarily developed through the study and almost exclusive acceptance of French schools.

Neither of these points of view, the mid-century or the modern, is pro- found. One is eagle-screaming, the other, eagle-blushing. The ultimate question concerning a work of art is not whether it is national or cosmopoli- tan, but whether it has beauty and power.

The object of this book is to give the Native School its day in a fair court. The jurymen do not need to be warned against esthetic chauvinism; that

seems, for the moment at least, fortunately dead. If, however, in the manner of most educated Americans, they look at all post-Renaissance art through French eyeglasses, the jurymen are invited to lay those glasses temporarily aside. For they are being asked to judge a school of nineteenth-century painting that was during the first half of its existence independent of French developments and in the second, while accepting some influence, paralleled rather than imitated activity in Paris. In the end, the American artists developed a semi-independent Native Impressionism.

To give one example of how French eyeglasses have distorted: Although the Hudson River School of landscapists was well under way before there appeared in France a similar movement devoted to rendering local landscape — that Barbizon School of which Corot was the most famous exemplar — the Americans have been derided for not seeing nature in exactly the same manner as the Frenchmen. Actually, the Hudson River artists demonstrated in their specific deviations a fundamental unity with the practice of great landscapists everywhere.

Landscape has always been local in origin, each artist laboring to express those aspects of nature he best knew and loved. Where Corot reveled in the mists and seclusion of small glades set like gems in a heavily populated region, where Constable emphasized heavy cultivation and the perpetual movement of light in England's volatile climate, where the seventeenth-century Dutch showed huge skies dominating their table-flat land, the Hudson River School painted at its most typical the clear, unshifting atmosphere of northeastern America, which makes visible details the European atmosphere would dull, mountains that swell under heavy foliage to dwarf the sky, light defining the land rather than gilding the air, not intimacy but size, not intensive cultivation but loneliness, and, above all, the gently lyrical communication with wild nature of contented men in a prospering nation. Who will say that they had no right to attempt this? Certainly their objectives were not unworthy of serious art. We must then limit our criticism to determining how well they achieved what they set out to do.

The Native School can be explained only secondarily through the influences of painters on painters, of pictures on pictures. The typical styles, even when they paralleled developments abroad, were more the result of inventions individually and collectively made in response to broad environmental forces. Thus, in our search for understanding, we must throw a wide net.

We shall examine the painters as people, born with peculiarities and talents. To define the society they experienced and their reactions to it is an

essential part of our labor. We shall attempt to determine why some artists refused to go abroad, and shall follow the others across the ocean, watching them choose which conceptions they will accept, which they will reject. We shall see what transatlantic ideas and pictures came to America and how they were received. Insights can be found in the resemblances and differences between the painting of the time and the other arts: literature, sculpture, architecture, music. What of the critics: were they sympathetic or hostile; were their voices listened to? Basic to our understanding are the writings in which the painters revealed their own attitudes toward the world and art. Above all, we shall study the pictures the artists left behind them.

Having determined, as best we are able, what the painters were striving for and why they were thus inspired, we shall make an effort not only to assess but to explain success or failure. In the end, we shall attempt to rank the Native School in relation to other nineteenth-century movements and the painting of all time. By then, the reader will be well prepared to form his own opinion; he will agree or disagree.

CONTENTS

FOREWORD: *The Native School* xi

1. Eagle Emergent: Thomas Cole Starts a Revolution 3

2. More Delightful than Eden: Art Turns to Life in America 19

3. The Trace of Men: Cole Mediates between European
 Tradition and American Inspiration 34

4. God in Nature: Durand and the Esthetic of the Hudson
 River School 52

5. Before They Bit the Dust: Painters of Indians 66

6. Artist Life: Merchant Amateurs, Artistic Lotteries, and
 Athletic Painters 87

7. Winds from Europe: Düsseldorf and Paris; England and Italy 103

8. Genre Expands: From Düsseldorf to the Missouri 122

9. The Grand and the Subtle: Frederick Church and
 John Kensett 135

10. Further Adventures of the High Style 149

11. The Decline of the Portrait 174

12. The Civil War Sweetens Genre 187

13. Popular Art: Panoramas, Prints, and "Folk Painters" 205

14. Thousands of Landscapes: High Tide on the Hudson River 220

15. Still Life: A Backwater 235

16. The Rocky Mountain School: Bierstadt and Others 241

17. Harbinger: William Morris Hunt 249

[xvii]

18. Native American Impressionism: Inness, Wyant, and Martin 258

19. Winslow Homer 273

CONCLUSION: *The Native School* 291

ACKNOWLEDGMENTS 309

SELECTED BIBLIOGRAPHIES 311

INDEX 331

ILLUSTRATIONS

	facing page
American School: *Meditation by the Sea*	229
Portrait of a Lady	217
Beard, James: *Out All Night*	197
Beard, William: *The Bears of Wall Street Celebrating a Drop in the Market*	200
Bierstadt, Albert: *Guerilla Scene*	245
The Rocky Mountains	244
Bingham, George Caleb: *Figure from Sketchbook*	132
Fur Traders Descending the Missouri	130
The Jolly Flatboatmen (Düsseldorf Version)	134
Landscape with Cattle	133
Stump Speaking	131
Blythe, David Gilmour: *Libby Prison*	190
Pittsburgh Horse Market	188
Sharpening the Axe	189
Bodmer, Karl: *Bison Dance of the Mandan Indians*	76
Figure later incorporated in Bison Dance of the Mandan Indians	77
Mato-Tope	76
Brown, John G.: *Nary a Red*	196
Casilear, John W.: *Landscape*	228
Catlin, George: *Konza Indians*	81
Mandan Medicine Man: Ma-To-He-Ha	77
Mandan O-Kee-Pa: The Bull Dance	78
Chambers, Thomas: *Looking North to Kingston*	215
Church, Frederick E.: *Cotopaxi*	141

[xix]

The Heart of the Andes (detail) 140

Interior of the Temple of Bacchus at Baalbec, Syria 144

Scene in the Catskills 135

Cole, Thomas: *The Course of Empire: Third Episode:*
Consummation of Empire 41

 Moses on the Mount 40

 Mountain Landscape with Waterfall 47

 The Ox-Bow 46

 Tree Trunk 8

 View near Ticonderoga 17

Cummings, E. L.: *The Magic Lake* 220

Deas, Charles: *The Death Struggle* 86

Delaroche, Paul: *Lady Jane Grey* 166

Doughty, Thomas: *View from Stacey Hill, Stoddard,*
New Hampshire 16

Durand, Asher B.: *Ariadne* 56

 J. W. Casilear 57

 Kindred Spirits 58

 Monument Mountain, Berkshires 59

Durrie, George H.: *Returning to the Farm* 214

Egan, John L.: *Terraced Mounds in a Snow Storm* 208

Elliott, Charles Loring: *Asher B. Durand* 177

Field, Erastus Salisbury: *Mrs. William Russell Montague* 216

Francis, John F.: *Still Life with Wine Bottles and Basket of Fruit* 239

Gifford, Sanford R.: *Kauterskill Falls* *frontispiece*

Gignoux, Régis: *Winter* 258

Gray, Henry Peters: *The Judgment of Paris* 155

Gude, Hans Friedrich: *Landscape — Norwegian Scenery* 106

Hardy, Jeremiah P.: *Mary Ann Hardy* 186

Heade, Martin Johnson: *Magnolia Grandiflora* 230

 Storm over Narragansett Bay 231

Healy, G. P. A.: *Miss Tyson* 184

Hicks, Thomas: *General George G. Meade* 185

Hill, Thomas: *Yosemite Valley* 246

Homer, Winslow: *Canoe in the Rapids* 288

 Country School 284

The Gulf Stream 289

The Life Line 285

Northeaster 290

Prisoners from the Front 279

The Sleighing Season — The Upset 273

The Walking Wounded 278

Hübner, Karl: *The Young Couple's First Quarrel* 107

Hunt, William Morris: *Flight of Night* 255

Judge Lemuel Shaw 254

Huntington, Daniel: *Mercy's Dream* 154

Inman, Henry: *Mrs. James Donaldson* 176

Inness, George: *The Coming Storm* 263

Delaware Water Gap 262

Indian Summer 266

The Old Mill 259

Johnson, Eastman: *The Family of Alfredrick Smith Hatch in Their Residence at Park Avenue and 37th Street, New York City* 187

The Maple Sugar Camp — Turning off 204

Old Kentucky Home 201

Kensett, John F.: *Chocorua, White Mountains* 145

Storm over Lake George 146

View from West Point 147

Lane, Fitz Hugh: *Owl's Head, Penobscot Bay, Maine* 234

Leutze, Emanuel: *Queen Elizabeth in the Tower* 159

Washington Crossing the Delaware 167

Martin, Homer: *Harp of the Winds* 272

Lake Sanford 269

Matteson, T. H.: *Distribution of the American Art-Union Prizes* 87

Miller, Alfred Jacob: *Camp along Green River* 79

Setting Traps for Beaver 80

Moran, Thomas: *Grand Canyon of the Yellowstone* 247

Mount, Shepard Alonzo: *Fish and Turtle* 235

Mount, William Sidney: *Eel-Spearing at Setauket* 33

The Power of Music 32

Page, William: *Cupid and Psyche* 158

John Quincy Adams 158

The Young Merchants 159

Palmer, Frances Bond: *The Mississippi in Time of Peace* 209

Peale, Mary Jane: *Still Life* 238

Quidor, John: *Ichabod Crane Pursued by the Headless Horseman* 22

 The Money Diggers 23

Ranney, William T.: *The Trapper's Last Shot* 125

Rimmer, William: *Evening: The Fall of Day* 172

 Flight and Pursuit 173

Spencer, Lily Martin: *Celebrating the Victory of Vicksburg* 191

Stearns, Junius Brutus: *The Marriage of Washington to Martha Custis* 205

Wallin, S.: *Gallery of the Art-Union* 97

Whittredge, Worthington: *Camp Meeting* 227

 Crossing the Platte 226

 The Crow's Nest 221

Woodville, Richard Caton: *The Sailor's Wedding* 124

Wyant, Alexander H.: *The Mohawk Valley* 267

 The Pool 268

HISTORY OF
AMERICAN PAINTING
VOLUME THREE

That Wilder Image
THE NATIVE SCHOOL FROM
THOMAS COLE TO WINSLOW HOMER

{ 1 }

EAGLE EMERGENT

Thomas Cole Starts a Revolution

GOVERNOR De Witt Clinton, balancing on the gunwale of a canal-boat, poured water into the Atlantic Ocean from a green and gold keg labeled "from Lake Erie." New York Harbor reflected a surrounding circle of frigates, barges bright with banners, and, most exciting to the American imagination, all the fiery spirits that frequented the Hudson River and the Bay. Where else in that November of 1825 could so many steamboats have gathered together as here, where eighteen years before practical mechanical navigation had been born?

"The elements," so poetized the official report, "seemed to repose as if to gaze on each other and participate in the beauty and grandeur" of what appeared "more a fairy scene than any in which mortals were engaged." Yet the elements were principals in a surrender as basic to America's future as Cornwallis's at Yorktown. At this opening of the Erie Canal, Distance was handing its sword to Public Works. The East was now linked to the West, and New York City crowned King of the United States.

The orator of the occasion could not help condescending to the Old World: "Did we live amidst the ruins which mark former greatness, were we always presented with scenes indicating present decay and foreboding constant deterioration, we might be as little inclined as others to look forward. But we delight in the promised sunshine of the future, and leave to those who are conscious that they have passed their grand climacteric to console themselves with the splendor of the past."*

*The spelling and punctuation in all quotations has been modernized.

However, the task of epitomizing in a design this New World triumph had been entrusted to no American-bred artist, but to a watercolorist who had been imported from Scotland to teach New York's polite young ladies drawing. Alexander Robertson (1772–1841) had dreamed up a canoe paddled by an Indian and so crammed with bales that the Western merchant is forced to extend his furry, hoofed leg overboard. It is Pan who is escorting to market the products of the new settlements! And he has found a customer. Up to the canoe, a fish-tailed Triton has pushed a cockleshell from which tridented Neptune leans to embrace the goat god in an ecstasy of good commercial relations.

The design was criticized by romantics, who argued that Scott's Lady of the Lake would have been a better symbol for the Western wilderness than old-fashioned, classical Pan, but the debate generated little enthusiasm on either side. Americans only used imported metaphors because they could think of nothing more apposite. They yearned, if still half unconsciously, for an art that would speak directly for their own enchanting continent.

New York's best-known painter was still a ramrod-backed old gentleman who insisted on being called by the title he had acquired during the Revolution. Colonel John Trumbull (1756–1843) had not painted with effect for forty years — but he could remember. Even as he had fought beside the founders of the United States, he had worked with the American artists of that excited generation who had, by expressing the ideas of the New World in the idiom of the Old, charted advanced directions in Western painting.

That since then he had lost his artistic way Trumbull could not, for all the fustian and snobbery with which he faced the world, in his secret mind deny. Why he had strayed he did not know, but this he was sure of: he had not strayed alone. It seemed to him that the great days of American painting were over. Benjamin West lay under a marble monument in Westminster Abbey; Copley had outlived his talent and died obscurely; Stuart was an old, angry, snuff-encrusted semialcoholic in Boston. And where were the new American talents?

Trumbull was now surrounded with artists who dreamed of Italy and hardly scratched their own soil, men who talked great pictures and painted commercial portraits, or talked so much they hardly painted at all. The times were mean, Trumbull felt. Ever since the godless Jefferson, with whom he had refused to dine, had brought in Jacobinism, the heart had gone out of American life. The Republic had seen its best days! So the old painter grumbled, and yet the patriot who had fought redcoats and dreamed empires could not help being moved by the opening of the Erie Canal.

[4]

At the very moment when the waters of the Great Lakes first moved down the Hudson, a New York frame maker put on display three Hudson River views by an unknown stripling named Thomas Cole. Happening on the canvases, Trumbull saw the American land depicted in all its native peculiarity with powerful realism and yet a lover's eye. As he gazed, the years seemed to fall from him, and he stood again, a young artist jocund in the springtime of the Republic.

Hurrying to the studio of William Dunlap (1766–1839), another veteran who had experienced the fertile years, Trumbull announced his discovery with one of those terrible statements that sometimes escape the lips of the very proud: "This young man," he said, "has done what all my life I attempted in vain to do."

Dunlap was amazed, but as he later wrote, "When I saw the pictures, I found them to exceed all that this praise had led me to expect." He had returned with Trumbull to the frame shop. Cole, who had been summoned, stood, Dunlap continued, "like a school boy in the presence of the trustees" before the two elderly painters, "neither of whom could produce a rival to the works he was offering for the paltry price of twenty-five dollars each."

Slight, basically pale but now as rosy as a girl with agitation, Cole, so it seemed to Dunlap, looked younger than his twenty-four years. His blue eyes strained with frustrated vivacity while he stuttered so desperately that he could hardly speak. But, under patient questioning, this shrinking young man told of hardships strongly conquered. "You surprise me!" Trumbull kept exclaiming. "You surprise me!"

Thomas Cole (1801–1848), who was to be the initiator of the Native School, did not reach America until he was seventeen. Born in the very cradle of the industrial revolution, England's textile center Bolton-le-Moors, he grew up under a smoky pall, then limited to a few counties, which was to spread until it strained sunlight wherever the world considered itself most civilized. His father, a handicraft manufacturer, went bankrupt when forced to convert to machines. As a boy, Thomas was apprenticed to a calico designer. The only son in a family too refined for the station to which it had descended, petted by his mother and four older sisters, he found his fellow apprentices rude and vulgar. He sought various escapes: country rambles, writing poetry, playing the flute — and then a book filled his mind with the vision of a great river called the Ohio, which flowed through romantic forests, singing songs forgotten by the mill-enslaved streams of Lancaster.

Since ancestors on both sides of the lad's family had lived in America, he felt that the wonders of that unspoiled land must be his natural heritage.

He had little difficulty persuading his father that fortune awaited them in the United States. And so the Coles sailed in 1818 to the nation about which Thomas later stated, "I would give my left hand to identify myself with this country by being able to say I was born here."

The Coles' first stop was Philadelphia. Thomas worked as a journeyman wood engraver, staying there after his father, whose effort to establish a dry goods store failed, had moved on to Steubenville, Ohio. It was the fall of 1819 when the young man walked the three hundred miles across the mountains. He found his family again optimistic. To bring culture to a community so new that the first paint was still unstained on the original clapboards, his sisters had initiated a "seminary for young ladies" and his father was planning to set up a wallpaper factory. Although Thomas worked on both ventures, teaching drawing and designing paper, both collapsed. But not before he had had a new awakening.

The man's name was Stein; he was said to have come from Virginia; he was a peddler with the most wonderful wares. The blank oblongs of canvas blossomed, as Cole watched him work, into colored effigies of people. Stein dug into his pack and lent the youngster an "English work on painting. . . . It was," so Cole remembered, "illustrated with engravings and treated of design, composition, color. This book was my constant companion night and day. . . . My ambition grew and in my imagination I pictured the glories of being a great painter."

With no further practical instruction than watching Stein paint, Cole sent out in February 1822 as one of those walkers who swung on their backs not tinkers' tools but canvases, raw paints, oil, and a heavy stone muller. His experiences were not untypical of the humble workmen today called "American folk artists." Almost drowning when he fell through the ice as he tried to cross a stream was his first professional hazard. His second was the discovery, after he had reached St. Clairsville, that a German named Des Combes had recently passed through the village, lapping up all visible portrait business. With great trepidation, as he tells us, Cole examined one of the rival's works. It was a double portrait of "a very large man and his little wife. The painter had complimented the fair: she was painted twice as large as her husband. I determined to compete with this German master."

Cole was helped by the new West's genuine hunger for art. His flute brought him the friendship of the most upholstered dowagers, the prettiest young ladies, and a saddler, who offered himself as a subject. "I remember I kept him sitting the whole of five days, from morn till night, and at last I

produced a thing called a likeness." The picture elicited from "an old man who had been in Philadelphia" the statement that "the handling [style with which the paint was applied] was excellent."

"What a compliment!..." Cole wrote years later. "I had something else to do than think of handling. Without knowledge, without training, it was a life and death struggle with me. But it pleased, wretched as it must have been. I painted the visage of a militia officer. This was my best likeness: I could hardly miss it. 'Twas all nose, and in the background a red battle. This tickled him, and I received a silver watch for my pains." From his first sitter he had received a saddle, which would come in very handy if he ever got a horse.

St. Clairsville was soon rocking with a debate as to who was the better painter, Des Combes or Cole. Seeming victory came when Cole was given a dollar — the only cash he received in the village — for improving a pair of portraits by his rival, his principal task being to push back the buck teeth of a shoemaker's wife which Des Combes had recorded too accurately. But when Cole prepared to move on after three months, he found that his rival had really triumphed. The German, who had demanded board and lodging as part of his fee, had been able to keep whatever produce he received towards the additional five dollars he asked for each picture; Cole's asking price of ten dollars had brought him only some goods which he was now forced to hand on to his tavern keeper, along with his dollar, to make up what was left of his bill after he had painted for the barroom a landscape and a drinking scene.

With depleted paint and canvases, worn clothes, and in his pocket not a penny, Cole walked the hundred miles to Zanesville, only to find Des Combes in residence. The German called, examined Cole's samples, nodded several times, and made an offer: "If you will say notink apout ma bigture, I will say notink apout yours." Cole took another look at his own work and shook hands on it.

Although Des Combes soon removed himself from competition by deciding he could make more money preaching, Cole, as he continued his wanderings, found it increasingly difficult to please his clients. He was being overwhelmed by a temperamental impediment that was to bother him throughout his career. When he tried to portray a fellow human being, he suffered such crippling embarrassment that he worked with "a heart full of anxiety" unless he could bore a sitter into minimizing personal contact by falling asleep. To regain joy in art, he painted as a present for a friend "a feudal scene —

moonlight, beacon fires blazing on distant hills, in the foreground men in armor." He was soon so heavily in debt that only charity kept him from prison.

Cole rejoined his family, who had drifted on to Pittsburgh, and he found them practically destitute. His impractical sire was for once enthusiastic about a practical idea: Thomas should give up art and enter some lucrative trade that would enable him to support his parents and sisters. While hesitating, Cole took the decisive step of his life. "I had painted some landscapes but had never drawn from nature." Now he took a notebook into the woods.

As Beauty's love transmuted the Beast of legend, Nature in an instant elevated the primitive dauber into an artist of power. His drawing of a tree trunk, dated May 20, 1823, could be mistaken for the work of a twentieth-century surrealist. Without deviating from extreme naturalism, the youth selected and terminated the gnarled shape into a powerful and self-contained abstract design. The eyes feel the forms as if a hand were passing over them. And the whole is given a disturbing impact by double images he certainly did not consciously intend. The tree trunk seems a monstrous cancer growing from eroded roots shaped like crouching animal haunches.

As the painters of the eastern seaboard dreamed of reaching Europe, Cole dreamed of the fabled art galleries of Philadelphia. With six dollars in his pocket, and a tablecloth over his shoulders in lieu of an overcoat, he recrossed the mountains. In a furnitureless and fireless Philadelphia room, the table-cloth served as a blanket while he slept on the floor. Although almost crippled by inflammatory rheumatism, he haunted the Pennsylvania Academy until the keeper admonished him, "Young man, this is no place to lounge in."

The acerbity in the keeper's voice was undoubtedly because the limping, ragged youth was reacting in a completely unsuitable manner. He had no interest in the casts after the Antique and he passed by the Academy's "Old Masters" with hardly a glance.* His single-minded purpose was to learn at once how to translate into paint the inspiration that had kindled his mind and firmed his hand when he first drew from local nature. Figure paintings seemed to him irrelevant. Nor did the old Italianate and Dutch landscapes — attributed to Claude Lorrain, Rubens, Ruysdael, etc. — hold him long.

*That those of the Academy's fancily attributed pictures which were not frankly copies were misattributed daubs was then only partially realized but, had it been acknowledged, would have no more justified Cole's conduct than a modern art student would be justified in refusing to examine admittedly imperfect color reproductions of acknowledged sources of taste.

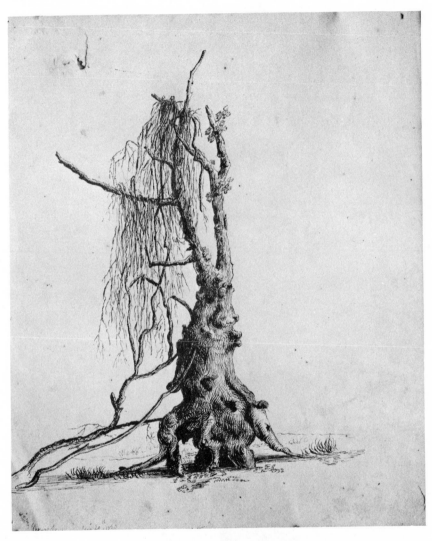

1 Thomas Cole *Tree Trunk*

Black ink on paper; 1823; 9¼ × 7¾; Edith Hill, Scottsdale, Arizona; photograph, Wadsworth Atheneum, Hartford, Connecticut.

Their techniques puzzled his innocent eye, and their images did not connote the wild forests and hills of America. "His heart sank and he felt his defi-ciency in art" primarily before pictures by two living Philadelphians of small and altogether local reputation: Thomas Birch (1779–1851) and Thomas Doughty (1793–1856).

If the keeper bothered to expound correct taste to the underfed ignoramus, he told him that it was his duty to imitate the Ancients and the Old Masters whether at first blush he admired them or not: better to doubt his own uneducated judgment than the sanctions of tradition. Furthermore, no serious artist could be bothered with landscape, which was internationally regarded as a secondary branch of art. If this were true even of renditions of culture-hallowed Italy, how much more so of the raw scenery of the United States. That common Americans asked for and bought views of their local world only made creating such views more common. The very pictures Cole was staring at proved the keeper's contentions. Who took Birch and Doughty seriously as fine artists? No one who mattered.

According to internationally accepted taste, there was only one road to artistic greatness, "historical painting." The "high style" called for painted tableaux in which figures, identified as persons famous in the past, acted out significant occasions. This taste, which had its roots in the humanism of the seventeenth and eighteenth centuries, still followed, in its most conservative and deep-rooted aspects, neoclassicism as it had been recodified in the 1760s by a German critic resident in Rome, Johann Joachim Winckelmann.

The object of painting, so the theory went, was the improvement of mankind. Accepting the basic conception of the enlightenment that man's intellectual and moral natures were the same, neoclassicism wished art to express primarily the reasoning faculty. Any direct appeal to the emotions was likely to mislead.

Neoclassicism regarded as no more than hindrances to understanding those local and specific phenomena on which science was to build a very different cosmology. Thus, the painter should "abstract" away all "accidents of nature" that obscured perfect form. The dross included everything contem-porary, since the present implied not permanence but fashion and change; everything national or regional, since such variations were inciters of anti-rational prejudice. The painters could only refer to their own environments through allegories that emphasized relationships with the immutable prin-ciples of the past.

To find a calm era of time-tested reason, neoclassicism urged painters to

spring backward over more recent history to the Ancients. The Greeks and more particularly the Romans should supply artists not only with stories to paint but also with fundamentals of technique. That the available classical models were almost exclusively in cold marble was viewed as an advantage. Neoclassicism distrusted color as unamenable to reason. Color should not go beyond giving verisimilitude to the fruits of the intellectual component of art, drawing. And it was better to draw from ancient statuary than from living people, since marble offered you a perfect model, flesh an imperfect one. Much was also to be learned from the Florentine School and especially from Raphael, who was considered the most intellectual and thus the greatest of painters. Other Old Masters should be studied selectively, the Venetians, for instance, being considered imperfect because of their reliance on color. Above all things, artists should eschew originality: their object was to bring into synthesis the best of the past.

Every other mode than the historical was downgraded as violating humanistic canons. Seeking heroes and villains on a grand scale, neoclassicism could not accept genre, which showed the local and the low: the provincial behavior of unelevated people. Still life was grossly material. Since portraiture, even of the great, depended for likeness on the particular rather than the universal, it was in theory unworthy, although it was much practiced. Living men felt a yearning no philosophical conceptions could undermine to have their features preserved for posterity.

Because nonhuman nature was fundamentally unamenable to human reason, landscape painting could be for neoclassicists never more than a secondary art. It was permissible at all only in so far as views could be made a source of ethical meditation. Thus the realistic scenes of the seventeenth-century Dutch were considered the misguided works of "little masters." But partial acceptance was accorded to "the Virgilian mode": pictures based on the inspiration of the seventeenth-century Frenchman Claude Lorrain which showed Italy's classic ground as it would be generalized through learned associations in the mind of a philosophic wanderer. Picturesque ruins, well-washed peasants recognizable as the descendants of the noble Romans, and vistas pruned towards intellectual beauty were combined, under sunset skies that symbolized time's sad and radiant afterglow, into Arcadian visions. Realism was so minor a component that the Italianate effects were achieved successfully enough by many a man who had read books and looked at pictures but never visited Italy. More a precursor of modern landscape painting than its inspiration, the Virgilian mode showed

nonetheless a yearning, even among the educated, for aspects of expression outside the neoclassical pale.

Although the ruling theory sternly outlawed obscurity, insisting that painted lessons should be stated clearly, neoclassicism could not appeal to the common man: the pictures were only intelligible to those familiar with ancient history and legend. The esthetic was, if not aristocratic in the old sense, antidemocratic. Its distrust of emotion was in essence a belief that man's natural instincts were evil and, indeed, dangerous unless controlled by "decorum."

Thus neoclassicism denied individualism, the basic conception of the new age that was gradually, painfully, but irrevocably overthrowing established institutions. Individualism fostered in opposition two artistic forms that reflected somewhat contradictory aspects of that ideal itself. The desire of the unusual man, be he in business or art, to achieve untrammeled the ultimate expression of his genius was reflected in "romantic idealism," imaginative pictures and glorifications of emotional extremes. On the other hand, the belief that ordinary men had a right to establish collectively what was best for all was establishing "romantic realism," that glorification of everyday experience that was to achieve its most typical disclosure in landscape and genre.

Although the three-sided international conflict between neoclassicism, romantic idealism, and romantic realism was to continue through Cole's lifetime and cause increasing strains in his career, it had become active well before he was born. Significantly, one of the first major revolts within the neoclassical ranks had been staged by the first American painters of importance to study and paint abroad. It was no coincidence that these artists had belonged to the generation that was at home fighting the American Revolution, which opened for the world a new era of accelerated national and democratic striving. Men thus nurtured could not believe that the lessons of the past alone were important, that the present was mean, and that artists should not search in their own breasts for personal inspiration.

This was the artistic surge that Trumbull remembered. Working in London, then an international artistic capital, Benjamin West, John Singleton Copley, and Trumbull himself had carried the high style of historical painting towards both romantic realism and romantic idealism, pointing directions which Europe was to follow for half a century. They portrayed great moments of contemporary history realistically, in modern costume. They explored unclassical extremes of emotion. Copley took seriously

tragedies in which the protagonist was not a hero at all, but an ordinary man. West in particular applied the high style to scenes from the Bible, and joined with other artists resident at London in conning from Shakespeare's pages alternates to ancient legends that opened the door wide to every kind of romantic subject from the comic to the grandly awful.

From the happy establishment of a republican United States through the early stages of the French Revolution an accelerated drift towards societies both democratic and sane seemed to be proving that the golden age, which classicists had claimed was in the past, was just around the corner, and that it would be reached not by imposing restraints but by sweeping them away. Artists could not resist celebrating the world through which they walked and their ordinary neighbors. Growing up in those optimistic years, two Englishmen, Constable and Turner, and a German, Caspar David Friedrich, dedicated themselves to lifting landscape painting to a great art. Around the Academy of Copenhagen, where Friedrich studied, there arose an impressive Danish landscape school. A Scot, David Wilkie, opened a vein of local genre that pointed far. into the future.

In this development, American painters played no major role. As long as the most skillful worked primarily abroad, they could not depict American life and land. Thus, while Constable was painting English fields, Washington Allston (1779–1843), the American landscape leader who was his almost exact contemporary, traveled around Europe working charmingly in the Virgilian mode. While Wilkie was painting the peasants of his native Scotland, Charles R. Leslie (1794–1859), who had been raised in Philadelphia, lived in London and found his genre in the pages of English writers. The American scene had been expressed in no important art when the European movement towards romantic realism was brought to a slow halt by political developments.

The terror in France had given renewed substance to every classical fear of unbridled emotion and the common man. Then came the Napoleonic Wars with their radical hopes that were finally stamped under by the Metternich System. As Cole stood in the Pennsylvania Academy, tyrannies were bracing themselves throughout Europe to withstand further nationalistic and democratic uprisings. Neoclassicism climbed back into the esthetic saddle. Historical painting became as before the only truly acceptable mode. Pictures were supposed to teach a moral lesson. Originality of technique was again frowned on; color was suspect; form should be conned more from ancient statues — or at least the Old Masters — than from living flesh.

In various European nations, it is true, official art accepted various drifts towards romantic idealism. Room was made beside classical subject matter for past events in the histories of the different regions, for sentiments urging Christian piety, for paintings from the Bible. A doubt that even reason could perfect man encouraged, particularly in France, a new morbidity and despair, a tendency to flee, under the disguising cloak of historical painting, into sensationalism and the pursuit of form for its own sake.

However, the accepted breaks in neoclassical rigor did not include any renewed approval for painting the contemporary, the ordinary, what was uncontrollable by the human will. Realistic landscape and genre were thrown back to their mean position at the bottom of the esthetic scale, and the Virgilian mode was reestablished as the least objectionable approach to inanimate nature. In Germany, Friedrich, who persevered in painting local landscape, was so snowed under that his work remained forgotten until the twentieth century. In France, romantic realism was a subterranean whisper: Delacroix and the other young lions of "the generation of 1830" were beginning to attack the ruling icy neoclassicism in the name of a romantic idealism as little concerned with existing French scenery and life.

England, the European country least hurt by the Napoleonic upheavals, remained a reservoir of coloristic techniques, into which Delacroix was dipping. But even in England, the surge towards romantic realism was impeded. The high style turned away from the contemporary, finding its most approved inspiration in the Bible. Wilkie receded from pure genre to genrelike historical painting. Constable and Turner matured as landscapists, it is true, but no brilliant young Englishmen followed in their footsteps, and they had to wait until they were old for general recognition.

Although the United States was hardly more than irritated by the environmental causes of European esthetic reaction, taste here had followed the conservative turn. Trumbull had been the first casualty. At the time of the French terror, he had feared that an ensanguined Jefferson would lead murderous mobs through the American streets. Abandoning, as an incitation to riot, his mission of painting the American Revolution, he had lost his way and drifted into artistic sterility.

The Jeffersonian triumph had, of course, proved peaceful and beneficent. Our part in the Napoleonic conflicts, the War of 1812, was more *opéra bouffe* than Armageddon. Yet the departure from contemporary reality, inspired abroad by disillusionment, was promulgated here by cultural embarrassment.

Even those national leaders who were glad to see the ballot box securely in the hands of classes that in Europe obeyed the bayonet, even the Jeffer-

sonian artistocrats, were afraid that the increasing influence of the common man would prove the death of art. And they were painfully conscious that they belonged to a new nation with no artistic traditions of its own. Eager to demonstrate to Europe that they were not artistic parvenus, they felt it their patriotic duty to "elevate" American taste by planting here the theories and practices most admired abroad. That neoclassicism had no fundamental connection with the pragmatic and blossoming society of the United States made it seem even more valuable as a refining influence.

The same attitude overwhelmed the most able and ambitious artists. Where the School of West had worked in England but expressed American conceptions, the younger painters (with the exception of Leslie) came home after the War of 1812, inspired by renewed loyalty to their own nation. But in their desire to bring culture to that nation, they repudiated the forward sweep of its society.

Allston had already moved with the backward swing of English development away from landscape to such historical paintings from the Bible as *Dead Man Revived by Touching the Bones of the Prophet Elisha.* The other two leading American painters of the generation before Cole's — Samuel F. B. Morse (1791–1872) and John Vanderlyn (1775–1852) — did not have to revert since they had from the start of their European studies surrendered to the reactionary high style. Morse had painted in London *The Dying Hercules;* Vanderlyn, in Paris *Marius Amid the Ruins of Carthage.* However, after their return to the United States, all three leaders lost their ability to complete pictures in the exalted manner they considered alone worthy. Allston was struggling near Boston with his *Belshazzar's Feast* in a nightmare of frustration which was ended only by his death. Resentfully earning his living from portraits, Morse was sinking into the despair that was soon to make him abandon art for invention. Vanderlyn complained that "only a humbug could paint in America."

That the high style, so powerful abroad, was refusing to root in a happy, prosperous, and democratic United States opened to Cole — although this he could not know — great opportunities. He could not be long penalized for the naïve stubbornness with which he ignored conventional advice. Not a fortress to be scaled, the American art world was a vacuum waiting to be filled.

However, Cole could receive no help towards realizing his ends from the work of his admired predecessors. In so far as they practiced landscape, Allston, Morse, and Vanderlyn all subscribed to the Virgilian esthetic:

Nature was made worthy only by association with historic man. It followed that American scenery, which bore less than any other the marks of cultivation, was of all nature the least paintable. When in Massachusetts Allston created a landscape, it was a memory of Italy, rendered in an unrealistic style that Cole was later to denounce. Less financially independent than Allston, Morse and Vanderlyn were lured into concocting some realistic American views, but they paid little attention to such potboilers, which they insisted were demeaning and which they refused to exhibit. Their landscapes had no discernible influence on Cole.

Birch and Doughty, the two artists whose work so impressed him at the Pennsylvania Academy, represented another international tradition, which had as long a history as neoclassicism, but which had operated semi-independently on a lower economic and artistic plane. This was the "vernacular mode," the type of popular expression which had displaced the rigid folk arts of peasant societies whenever and wherever feudal conceptions had been disrupted by the mercantile revolution. Since America had never truly known feudalism, the vernacular had existed on these shores from the early days of settlement.

Here as in Europe, the ruling genie of the mode was the printing press, which enabled pictures to be sold in quantities for small sums to people of modest means. To draw for engravers offered the best source of income, and the widely distributed results served as models for those vernacular artists who painted or drew solely for the cheap wall-decoration trade. Thus the demands of a mass audience, including people who preferred pictures because they read with difficulty, prevailed. The learned allusions of neoclassicism were discouraged, as was any philosophical concern with the universal. At its most typical, the vernacular served the desire of simple people to surround themselves with representations of the familiar. In every nation, the vernacular was dedicated long before any fine arts movement to romantic realism. It became in every nation, when the time was at last ripe, the subsoil from which realistic landscape and genre painting rose to enter the more sophisticated and expert practice of the fine arts. This development had already been exemplified in England, where landscape illustration had been expanded by brilliant topographical watercolorists to form the base on which Constable and Turner were building their world-shaking achievements. Cole was now preparing to use similar if less exciting sources.

From the seventeenth century onward, America's emerging cities had

been drawn and engraved. As the romantic groundswell emerged among the people, the practice was extended to include picturesque vistas. And gentlemen who would have shunned romantic realistic paintings that they had to take seriously, welcomed portraits of their estates or their favorite prospects as long as the pictures were so cheap that their purchase could not be construed as a cultural act.

Thomas Birch, the older of the two painters Cole was admiring, had inherited the business of supplying these demands from his father, William Birch (1755–1834), an English topographical engraver of medium ability who had brought him to Philadelphia at the age of fifteen in 1794. As a seascapist — a direction that did not interest Cole — Thomas had transcended the limitations of topographical art, but the landscapes he showed at the Pennsylvania Academy were no more than unusually expert examples of the unreconstructed vernacular mode.

The topographical artists reproduced specific, local prospects in a manner that appealed to naïve eyes and suited not too skillful hands. The fundamental objective was literal representation of the maximum amount of detail. Objects, animate and inanimate, were drawn each for its own sake and laid down side by side in designs that showed things in the background reduced in size but in no way blurred by the intervening depth of air. Color was applied in a corresponding naturalistic pattern independently to each form: skies blue, trees green, houses whatever color they naturally were, costumes as best suited the artist. The result could be charming, but it could not convey more than a hint of the continuity of nature, nor any unified emotional effect.

When topographical views were published, they were increasingly accompanied by passages of perfervid prose that were as ecstatic as the pictures were pedestrian. The artists too tried to pull poetry in from the outside. Unable to achieve an emotional synthesis of what they saw, they borrowed clichés from the ubiquitous Virgilian mode. Thus homely renditions of American reality were topped with golden, dreamy skies descended by diminishing inheritance from the Italian views of Claude.

In all the American arts, a desire to express the untamed beauty of the American world was struggling to escape the twin impediments of educated embarrassment and uneducated crudity. The breakthrough came almost simultaneously in painting and literature. Bryant's "Thanatopsis," published in 1817, irradiated neoclassical moralizing with a direct response to nature. A few years later, Washington Irving was publishing tales that,

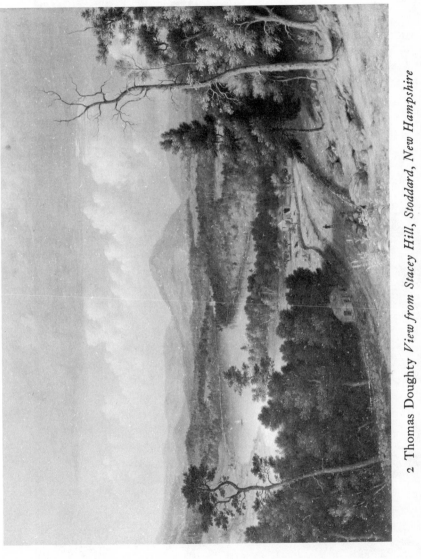

2 Thomas Doughty *View from Stacey Hill, Stoddard, New Hampshire*

Oil on canvas; 1830; 22¼ × 30¼; M. and M. Karolik Collection, Museum of Fine Arts, Boston.

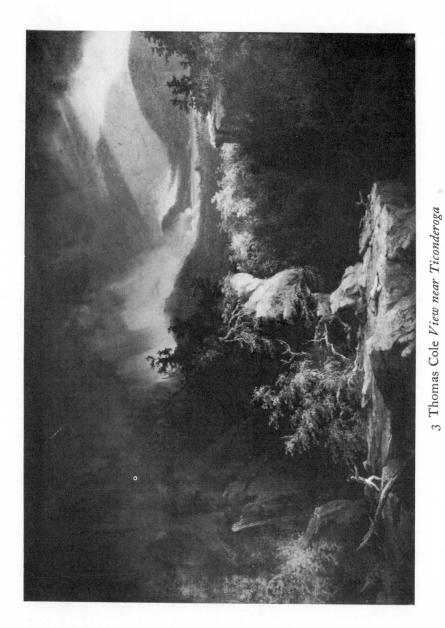

3 Thomas Cole *View near Ticonderoga*

Oil on canvas; 1826; 24 × 34½; Fort Ticonderoga Association, Ticonderoga, New York.

like "Rip Van Winkle," depended for much of their tone on lyrical descriptions of scenery of the Hudson River valley. And the wilderness entered world literature in all its baroque glory during 1823, the year Cole entered the Pennsylvania Academy, with the publication of Cooper's third novel, *The Pioneers*.

In painting, a major transitional step had been taken by the second of Cole's early inspirations, Thomas Doughty. The son of a Philadelphia shipwright, Doughty had been apprenticed to a leather currier. Having set up his own leather shop, he had added to his stock painters' colors, had started using them himself, and had found that his pictures sold. This left him unsure what profession he practiced, as directory entries show. In 1814, he called himself "leather currier"; in 1816 and 1817, "painter"; in 1818, "leather currier" again. It was 1820 when he settled on the appelation "landscape painter."

The Philadelphia portraitist Thomas Sully (1783–1872) was helping Doughty become the first landscapist to express, even partially, the poetry of American nature. As a pupil of Stuart and then the Englishman Sir Thomas Lawrence, Sully had evolved a coloristic style. He showed Doughty how to pull his landscapes together with light and shade, and inspired him to seek lyricism through clear, consistent color that touched the air as well as the land. This was much more effective than interpolating in the Virgilian manner hints of Claude, but Doughty lacked the creative force really to combine fact and mood. In his *View from Stacey Hill*, hard, over-insistent drawing breaks all over the canvas through the tenuous spell of hue. Such landscapes could be considered either unusually elevated examples of the old topographical manner or the first, incomplete statement of the style that was to characterize the Hudson River School.

As a result of his study of Birch and Doughty, Cole completed a landscape (now lost) which he showed at the Pennsylvania Academy. It attracted no attention. The artist needed to consolidate his new acquirements in the presence of his first inspiration, nature.

During the summer of 1825, Cole journeyed up the Hudson River, which was at the very point of being made, by the opening of the Erie Canal, into the resplendent main link of the American geographical chain. As he approached the Catskills, he saw, moving towards him, the physical manifestation of those dreams that had called him across the ocean from smoke-choked Lancaster. There was the broad, surging river; then strips of idyllic cultivation, "a varied country through which meanders the Catskill Creek,

a beautiful stream"; then, "at a pleasing distance," the mountains, clothed in glorious trees, "ever changing in color, light, and shadow." When he saw the Rhine, he was to rule it "infinitely" inferior to the Hudson "in natural magnificence and grandeur."

Having sketched until his hands and his eyes ached, Cole carried the drawing to New York City. In a tiny attic room, "perpetually fighting with a kind of twilight, . . . elbowed and pushed by mean partitions," he labored to put down on canvas nature as he had just seen it "in perfect beauty."

Cole was developing a landscape style that did not so much break with the vernacular tradition as transform it. To the old pallid shapes he brought violence of handling: leaves brushed in as by a giant, rocks ponderous, shaggy mountains swelling irresistibly from the pitching lowlands. His color was both strong and tender: greens, virginal or hoary, shading to gold in the sunlight; lakes agleam; skies sometimes gentle, sometimes blackly vaporous. Here was exuberance and power, a conviction of importance, an expression of beauty that had never before been brought to renditions of the American land.

Such were the pictures that caught Trumbull's eye. Their fame, so wrote the engraver-painter Asher B. Durand, "spread like wildfire." The poet Bryant was to remember "the delight expressed at the opportunity of contemplating pictures which carried the eye over scenes of wild grandeur particular to our country, over our aerial mountain tops with their mighty growth of forest never touched by the ax, along the banks of streams never deformed by culture, and into the depth of skies bright with the hues of our own climate, skies such as few but Cole could ever paint, and through the transparent abysses of which you might send an arrow out of sight."

MORE DELIGHTFUL THAN EDEN

Art Turns to Life in America

WHEN the fine artists of the previous American generation had ventured on genre — which was rarely — they adhered to a modification of neoclassicism connected with the Virgilian mode. Since Italian peasants were considered descendants of the noble Romans and their traditional costumes immune to changing fashion, they were partially excepted from the taboo on painting anything contemporary and unheroic. Allston imbued his nephew George W. Flagg (1816–1897) with this taste, as well as one for grisly historical pictures like *The Murder of the Princes in the Tower*. Flagg had natural gifts; from his uncle and from study in Italy he imbibed a romantic warmth of color that gave *The Savoyard Boy* a glow unknown to the Native School. However, after his return to America in 1836, Flagg soon receded to the portrait practice, which Cole described as "frequently the last anchor of the artists, which they cast out when all others have failed."

Even more than landscape painting, nineteenth-century realistic genre was to receive its theoretical backing from nationalism, that force which had helped inspire the American Revolution, which had been unchained in Europe by the Napoleonic Wars and rechained in many places by the Metternich System. Where classicism had wished to elevate all men according to universal standards, patriots wished to think of their fellow nationals as a unique order of man, separated by history and culture from all others. The word "folk," which had once merely connoted "vulgar," took on a mystical significance. To paint the national folk was a patriotic, and sometimes a radical, act.

However, the distance from peasants that were classical hangovers to one's own unwashed neighbors was commonly proving for critics and painters too great to be covered in a single leap. A stepping stone was supplied by the darling art of mercantile societies, literature. If you translated into paint the scenes from celebrated national writers — you could protect yourself from contemporaneousness by selecting dramas laid in the past — you were working not from commonplace reality but from texts as pure historical painters did. Reference to the written page helped you, as it helped them, by adding to what an unassisted visual image could portray those elaborate narrative overtones beloved by a reading public. Even as all educated men knew classical legends, they were familiar enough with standard literary works to understand if an artist summarized stories by delineating only climaxes. The resulting pictures resembled theatrical stills in which each actor was featured, costumed, posed, and given a facial expression that fitted not only the action portrayed but all that had gone before and what readers knew would subsequently occur.

Instead of following Wilkie into those directer renditions of contemporary local life which he himself had largely abandoned, English genre was concentrating on Shakespeare, Sterne, Fielding, Scott. And in the United States, Irving was supplying, in his tales of vanished New Amsterdam, ideal source material for literary genre. His scenes were neither rawly up-to-date nor so far in the past that they had to be treated with awe. They were a little exotic, yet Americans recognized in Irving's Dutch burghers close reference to themselves. Despite some reliance on German models, Irving had created, largely from his own imagination, an American folklore. It was robust, the fairies being hard drinkers and the devil adept with an ax. It laughed at constituted authority (royal governors were fools); it was optimistic (all you had to do to escape a shrewish wife was to drink deep and then sleep). Exuberance exploded into self-enchanted grotesquerie.

Many painters tried to recast this material into the accepted type of frozen tableau. Although the experimenters included Asher B. Durand, who was to pioneer brilliantly in other aspects of American artistic development, the result was always both stilted and dull. Given the best of sources, the type of theatrical and literary genre that was to have a long run in Europe refused to root here.

In genre as well as landscape, the new forms of the Native School were to be derived not from the fine artists who modified yet did not break with traditional critical canons. It was the vernacular practice that swayed.

One stream of influence flowed from the English caricaturists. Fathered by the moralistic satires of Hogarth, English comic drawing had moved during the Napoleonic upheavals into the violent lower-class protests of Rowlandson and Gillray, and then, with the post-Napoleonic reaction, had calmed a little into the still-raucous drawing room comedy of Cruikshank. Since all the Englishmen either engraved for themselves or drew for engravers, their work was well known in America, and on it American vernacular illustration had long been based. As a general rule, the results had been diminished imitations.

However John Quidor (1801–1881), our first exciting genre painter and Irving's one effective illustrator, possessed too strong a gift to walk in any other man's footsteps. He used English caricatures as he did Irving's texts, not as models to be exactly followed, but as liberating examples that encouraged him to express his own imaginings through distortions and explosions that carried him towards the wilder aspects of romantic sensibility.

Quidor had been born on the shores of the Hudson that were awaiting Irving's still-uncreated spooks. When he was ten, he was taken to New York City by his schoolmaster father. His apprenticeship to the successful portrait painter John Wesley Jarvis (1780–1840) ended in a lawsuit. He gestured towards portraiture and painted at least one sugar-and-water literary gloss. Then, in 1828, he exhibited *Ichabod Crane Pursued by the Headless Horseman.*

Through spidery evergreens, blasted tree hulks, and knuckled roots, a horseman in scarecrow attire gallops towards ghastly incandescence thrown in from outside the picture. The glare illuminates the rider's face, a hatchet-mask of terror, and the horse's head that is distorted with equal anguish: crocodile mouth agape and under his horn-like brow a bloated, rolling eyeball. But whatever waits unseen ahead can be no more terrible than what rides behind: a topless human trunk. The torso's hand dangles, against the flank of its black horse, the head that should be on its shoulders, an oversized booby face staring with idiotic amusement at poor Ichabod. Nothing is painted as it would show itself to the physical eye. Shape departs from reality to serve effect. Of color, there is hardly any: the dark brown of midnight foliage, the black of menace, the white of terror. This was, as contemporaries realized, only a" presumed illustration to Irving." It passed beyond that gentle satirist to greater raucousness and darker meanings.

Such pictures so pleased a facet of American taste that Quidor could have enjoyed worldly success had he been able to accept it. His wild images

attracted attention at the National Academy. However, Quidor picked a fight with that powerful organization of his fellow artists and virtually ceased exhibiting there. Although he accepted the pupils that knocked at his door, he could not be bothered to teach them. Authors were interested in having him illustrate their works, but he neither learned to engrave nor ever drew a design that was not too complicated for other engravers. In those days when an artist's painting room was also his showroom, Quidor allowed his to outrage all proprieties. Ancient dust blew across the filthy floor and shrouded his few dilapidated chairs and the long bench on which he slept off the hangovers he had accumulated on sprees that kept him unlocatable for weeks at a time. The hilarity in his studio was usually at the expense of the conventional great, Quidor's favorite story being of how his crony, the "gigantic" sculptor John I. H. Browere, had almost killed Jefferson by suffocation when taking a life mask.

Quidor made his living from one of the most rowdy aspects of city life. As a painter of engine panels, he gave the brawlers in the amateur fire companies exactly what they wanted, such spicy but esthetically unexciting examples of the sign painter's art as his celebrated rendition of a half-naked Indian maiden saying farewell to her lover. While this potboiler elicited cheers as it was pulled through the streets, he kept almost secret the visions into which he poured his talent.

What Quidor painted most often, the tale of Rip Van Winkle, he recast into a personal allegory. Young Rip, who in Irving's original was beloved of tavern and town, in Quidor's pictures stands to one side in a pose of exaggerated diffidence, staring wistfully at his fellow men engaged in conviviality. However, Rip returns from his long sleep in the mountains transformed into a giant. He is still alien and alone, but now ordinary mortals gather around him. As they question and mock him, he towers above them, and his cry of bewilderment comes like a bull's bellow from Gargantuan lungs. Although confused, he cannot be subdued; he could, like Samson, pull their world down around his tormentors' ears. Off by himself, watching with the old diffidence, is the young man Rip once was, his son, who is starting the whole saga over.

Quidor's two border haunters, the delicate stripling and the giant linked to inanimate nature, frequent many of his paintings. Thus in *The Wall Street Gate*, a scene of jubilation in old New Amsterdam, we see unobtrusively watching the procession from the background the figure of young Rip. And, as we examine the picture closely, hillocks in the foreground form themselves into a giant lying on his side and comfortably observing as he

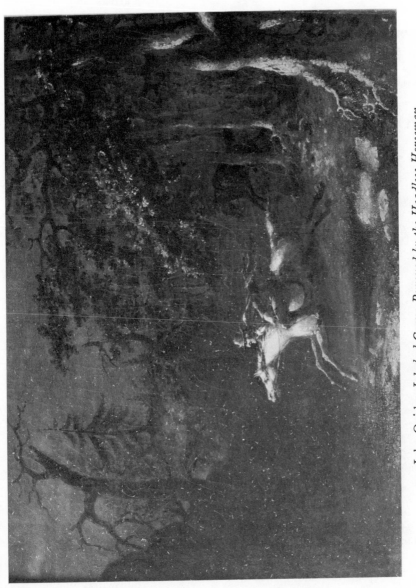

4 John Quidor *Ichabod Crane Pursued by the Headless Horseman*
Oil on canvas; 1828; 23¾ × 30; Yale University Art Gallery, New Haven, Connecticut.

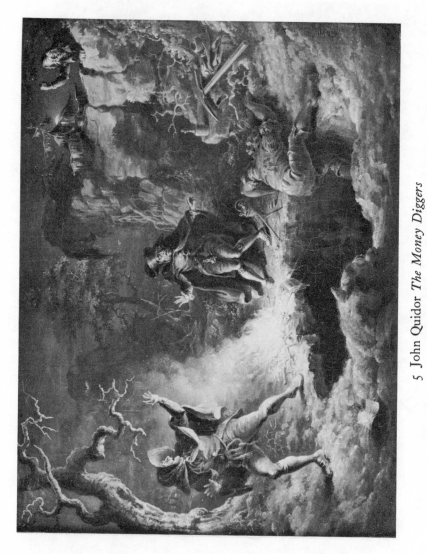

5 John Quidor *The Money Diggers*

Oil on canvas; 1832; 16¾ × 21½; Brooklyn Museum, Brooklyn, New York.

smokes his pipe. More staring brings out a gun beside him and then a huge dog — could it be Rip's Snyder? — who barks at the movement of the normal-sized people. Finally, another tremendous figure appears to complete a frieze across the whole front of the picture, this one sound asleep, perhaps Rip in another manifestation.

Raising our eyes again to the concourse of burghers parading through a superficially normal world, we realize that they are all touched with madness. The three boys in the foreground carry mischief beyond sanity, and the horse's eye belongs to a wizard.

Many of Quidor's pictures were dedicated to the delineation of fear. *The Money Diggers*, a scene from Irving's *Tales of a Traveller*, shows three searchers for pirate treasure interrupted by a neighbor's nightcapped head which seems to their excited imaginations "the grim visage of the drowned buccaneer grinning hideously." Quidor never showed terror as the gnawing at the vitals familiar to European art and which Allston had expressed in *Dead Man Revived*. The more frightened the painted figure, the more the viewer is supposed to laugh, as at a successful practical joke. The avaricious, the respectable, the pompous are humiliated but not seriously hurt. Thus the inflated warrior who, as he brandishes an immense sword, is thrown over backward by a thrust of Peter Stuyvesant's wooden leg, lands not on a rock — here Quidor exactly follows Irving — but is softly received by a squishy mat of cow droppings.

In his earlier works, Quidor applied the garish and permanent hues of the sign painter less to duplicate nature than to suggest emotion. Thus he conveyed the terror in the faces of his two money diggers by stroking one with pure red, yellow, blue-green, and black; and by making the other take its allover hue from green spectacles. Naïvely he anticipated that sophisticated movement, Expressionism, that lay generations in the future.

Although he must have continued to use for his fire engine panels, which had to withstand heat, water, and weather, the sound technique in which his easel pictures were at first painted, he increasingly sought to bring mystery to his personal visions by mixing his pigments with varnish to form transparent glazes, which he laid down one over another. This was a method for which American art offered him no precedents, and in evolving it he left sound chemistry behind. His later works have turned irrevocably brown. Yet enough color gleams through to show that he never used his glazes, as a sophisticated artist would, to tone local hues into a consistent chromatic whole. As before, he spotted color for echo and contrast. With no more

justification than that it suited the immediate passage he was painting, he would make the shadow on tan leggings blue. Faces were drawn in white lines against dark backgrounds, in black lines against light.

Until the last phase of his career, Quidor's pictures were electrified by an overpowering linear rhythm. Rich and poor, plagued and triumphant, governor and subject, even warring armies execute to some celestial beat the granddaddy of all Charlestons. They dance like men and women possessed. Other writers have their theories as to who invented jazz: I say John Quidor first belted it out in "spirit ditties of no tone."

His marvelously free line communicated movement in its smallest parts as well as its broadest sweeps. Every shape is instinct with weight, grotesque and extravagant; so minutely evolved that a few square inches of canvas contain all the elements of a complete picture. At best, the result has the crazy unity of some mad fretwork out of a high baroque frieze, but the convoluted parts disagree as often as they pull together. To be fully appreciated, Quidor's paintings must be studied in detail: there is no whole that is as impressive as the sum of its parts.

When, towards the end of his life, he found an obsessive new theme in pictures of his wild cast of characters sailing away into shadows, color drained away almost completely and, although he still drew details energetically, movement does not surge through his compositions as of old. In *Peter Stuyvesant's Journey up the Hudson River*, the background hills are stylized to contain in a static design the shapes of the square sails. A stationary arabesque, begun by a snag rising in the foreground, is continued on, up to the top of the mast, by the ship's pennant. Although the boat moves, it is held. Was this seeming inconsistency a failure in technique, or did Quidor feel reality dragging back escape into dream?

The sun sets behind tiny figures who from a high bluff wave farewell — but Stuyvesant's visionary crew are not sailing sadly. They fire at ducks that fly in a horizontal line overhead. Two birds have been hit and are falling while the oversized voyagers, who dwarf their boat, gesticulate with pleasure. A strange picture, so haunting that the mind works hard to supply deficiencies, to make it what it seems too full of crudities to be: a major masterpiece.

It is a further indication of how new tendencies were rising from the vernacular that Quidor was, among American painters, the first "romantic seer." None of his significant predecessors had painted primarily for their private enjoyment, none had so broken with craft methods that their colors were evanescent, none had believed that to achieve beauty it was only necessary to open the floodgates of genius and pour.

Despite his aggressive avoidance of the normal ladders to success, Quidor continued to have a reputation: a fellow painter remembered that he was considered during 1855 one of New York's leading figure artists.* His pictures had, indeed, recast Irving's tales in directions more suited than the originals to rising facets of American popular taste. Playing down gentlemanly urbanity, stressing Gargantuanism, glee, and irreverent vitality, Quidor caught in paint the mood of such comic whoppers as were being published about Davey Crockett. He anticipated the immortal horselaughs of the early Mark Twain.

As a painter, however, Quidor had no real followers. His only able pupil, Charles Loring Elliott, soon abandoned for portraiture efforts to imitate his deviltries. Among genre artists, Albertus D. O. Browere (1814–1877), the son of the Jefferson-endangering sculptor, was closest to his father's friend Browere imitated, though palely, some of Quidor's mannerisms, but increasingly applied them to incidents he distilled on his own from everyday life.

Quidor was, indeed, a transitional figure rather than the founder of the native genre school. He differed because he triggered his imagination not from life but from the printed page; because, even if his subject matter was antiheroic and his mood comic, there was in his art a strong strain of romantic idealism. He subordinated to personal vision the testimony of his physical eye. The mainstream of American genre was to be dedicated to the direct recording of unheightened reality. Its initiator was William Sidney Mount (1807–1868).

No artist was ever more than Mount the product and the interpreter of his birthplace. He had been born in rural Long Island and raised in two centers of conviviality: first his father's tavern at Setauket and then his grandfather's tavern nearby at Stony Brook. His boyhood was a round of delights broken every Seventh Day by enforced attendance at a Presbyterian church where "thoughts of eternal damnation and brimstone were to be raked over, which to my mind seemed strange when I could not discover anything in nature to bear the doctrine out." As a mature man, he wrote of his native Long Island, "It is a delightful locality. No wonder Adam and Eve, having visions of the future, was [sic] glad to get out of the garden of Eden."

The greatest human influence on Mount's childhood was his uncle Micah Hawkins, a "haggard and soulful-eyed" greengrocer who could discern no distinction between practical jokes and art. Hawkins's *The Saw Mill, or a Yankee Trick* was one of the first comic operas by an American successfully

*Although Quidor's name was forgotten with his death, whenever in later years one of his pictures surfaced, it was admired, even if strangely attributed. He was rediscovered as an artistic personality by John I. H. Baur in 1942.

produced; he published a book of satirical verse; he was an inventor of that international rage, blackface minstrelsy; and he pioneered modern merchandizing methods by secreting under the counter of his store a piano on which he played mood music that induced housewives to buy more pickles.

One of William Mount's three brothers became a musician and dancing master; the other two were, like him, artists. Henry Smith Mount (1802–1841) led off as a sign painter so adept at swinging handsome pictures out over the street that he was elected an associate member of the National Academy. Although apprenticed to a carriage maker, Shepard Alonzo Mount (1804–1868) taught himself to be a successful portraitist. When William's turn came, he was put in Henry's New York City shop to learn sign painting. This family initiation into craft so suited the budding master that, on being given an opportunity to work as an assistant to the celebrated portraitist Henry Inman, he quickly fled that semisophisticated studio. He was propelled back to the family circle, he explained, by "the desire to be entirely original."

However, Mount's first efforts were at historical painting. His melodramatic *Christ Raising the Daughter of Jairus* (1828) displays correct neoclassical costumes, but the twenty-one-year-old beginner failed to get completely off the ground. For the sickbed from which Jairus's daughter had just risen, Mount delineated such an ordinary four-poster as that in which he himself slept.

Two years later, Mount created *The Rustic Dance*, showing a bumpkin standing up with his girl in a bare room while a colored man fiddled and other couples watched or flirted. Exhibited at the National Academy five years after Cole had launched his realistic views of American scenery, the picture was praised and bought. Mount had found the vein from which he was never again to depart.

Returning to Stony Brook, he immersed himself increasingly in what was familiar, rural, his own, narrowing his life down to an exclusive love affair with one corner of the earth. As a lifelong bachelor living with married relations, he sashayed out to lead the local urchins — his long artistic hair bouncing on his shoulders — in dances down the street. Or in local parlors, he would bring tears to the eyes of maidens by rendering, using a door key instead of a bow, his own composition "Babes in the Wood," on a violin he had invented — "The Yankee Fiddle or Cradle of Harmony" — which he insisted was as mellow as ancient instruments, and better because it could be manufactured from fewer parts.

[26]

In his paintings, Mount hymned the masculine pleasures of his rural neighbors. Children were not cute darlings awaiting mother's caresses but bad boys playing when they should do their chores, and about to be whipped. In courtships, the men are ridiculous, entangled by simpering charmers in the strands of wool they clumsily hold up to be wound. The best dances are not in drawing rooms, but impromptus bursting out on barn floors to banjos or violins. He showed an old man telling endless tales by the stove of a country tavern, and young men sleeping luxuriously in the noontide shade between sessions of reaping. He sent fishermen out into the soft glow of delicious American springs.

"Lean upon the favorable side," he wrote. "It is the sign of a good heart." And, indeed, he could not accept unhappiness in his Eden. Fascinated always with the colored men, whose musical talent he so admired, he depicted the slaves of rural Long Island — who were not, in fact, badly treated — as inhabitants of a childlike Arcadia: a fortunate people relieved of the ambitions and responsibilities that toned down their owners. He never insulted them with such caricatures as were to become a stock in trade of Currier and Ives. Imbued with natural grace and dignity, they worked as little as they dared, and for the rest danced ecstatically in the sun.

Anxious, as he wrote, "to take all the comfort I can in this world, believing that I shall thereby be happy in the next," Mount grounded native genre on hedonism. He expressed his disdain for the provident when he stated that he never asked "any man where he eats and sleeps." He equated the "pious" with the "cold-blooded," and enjoyed shocking both with "a good, loud laugh." A devotee of that pseudoscientific effort to extend the telegraph into infinite, spiritualism, he was considered by the local minister "a religious pariah."

Patrons and dealers offered to send Mount to the art galleries of Europe; always, he refused to go. European books, he explained, were bad enough, as they attempted by dilating "on ideality and the grand style of art, etc., to divert the artist from the true study of natural objects." As long as painting avoided such educated conceptions, it had, he continued, the advantage over writing "by addressing itself to those who cannot read or write of any nation whatsoever." Mount's work did, indeed, transcend national boundaries. Mostly to satisfy international curiosity about American Negro life, ten of his paintings were engraved in Paris, with such success that his portrait by Elliott was also engraved there.

Mount was given an advantage over European genre painters by the fact

that in the United States no sharp break existed between high life and low life. Since the farmer in work clothes might well be the social and political leader of his community, he did not have to be portrayed with condescension. Were not overalls and shirt sleeves the court dress of the sovereign American voter, who was at least the equal of any European king? Nor did the rags of the hobo call for pity or political protest. Mount saw rags as happy symbols of personal liberty: no American citizen was forced to be poor if he were willing to conform.

Mount's Long Island was a microcosm of the well-settled United States. Less than 10 per cent of the population then lived in towns of over twenty-five hundred, and most of the city merchants who were his patrons had grown up on farms: they commissioned pictures "to call up early associations." Behind the American genre of that time lay the fact that both creators and consumers were birthright members of the world depicted. Thus the pictures were preserved from the besetting sin of nineteenth-century European rural genre: a lack of emotional involvement.

Overseas, artists peered into farmyards as outsiders in search of the sentimental and picturesque, and felt it necessary to supply patrons, who had never danced on barn floors except as incongruous visitors, with exterior props to help sympathy and understanding. In his most realistic country scenes, Mount's Scottish predecessor Wilkie had suffered from this dichotomy, which was to remain typical of European rural genre far into the nineteenth century. Even after fine artists had discarded literary sources, they invested peasants with what was supposed to be an appealing quaintness. And lest what they showed going on in this strange, lower-class world would not be comprehensible, they made their characters — often as in Wilkie's famous *Blind Man's Buff* a large cast doing the same thing over and over — exaggerate the action with too expressive poses and gestures borrowed from the theater rather than studied from actual life.

The host of overtones an unheightened rendition of local farm life communicated to Mount's public is revealed by what a newspaper paragrapher wrote concerning the listening Negro in *The Power of Music:* "A brown jug and ax standing near inform us that he has been to dinner after chopping all the morning, filled his jug with blackstrap or a mixture of vinegar, water, molasses, and ginger, . . . and was about to resume his labor for the afternoon when he was arrested by the notes of the violin. He has got his 'stent' for the day, but thinks he can listen a little longer, work all the harder, and get through before sunset."

Accumulations of such meanings made Mount's compositions seem to some of his contemporaries too broadly humorous. However, now that so many of his storytelling references fail to impinge on a public unfamiliar with the minutiae of nineteenth-century farm life, we feel no lack. That, on the contrary, we get heightened pleasure from being able to experience his pictures in more purely visual terms makes clear that, in comparison with the European artists of his generation, Mount was amazingly free of what we today disapprove of as "literary values."

"I launched forth on my sea of adventure," Mount wrote, "with the firm determination to avoid the style of any artist and to create a school of my own." For this, he felt his apprenticeship in a sign painter's shop had been the perfect preparation, since it gave him tools without dictating how he should use them. Unlike Quidor, he never forgot the value of craft, being "most careful" to use permanent colors.

For the rest, he went his own way as much as is possible for any ambitious artist who is not a fool. "I never speak highly of an Old Master," he commented, "unless I see a servant advancing with some choice wine and refreshments." His attitude towards the vanished great is revealed by his association with Rembrandt at spiritualist séances. He took down, he claimed, from that spirit's dictation, an essay on art which expressed exactly his own views. With such authority on his side, how could he go wrong?

If Mount studied prints after Wilkie, there is no direct indication of it. Grotesquerie being far outside his temperament, he got little from the English illustrators' tradition. His basic source was the same as Cole's: the vernacular landscape mode. Since purchasers of cheap pictures wanted as much of their world as possible crowded in, landscapes for the popular market usually included human figures pursuing ordinary tasks. Too subordinate in the whole effect to tell a literary story or require dramatization, each genre passage showed, as the *New England Magazine* pointed out in 1834, "some little incident that explains itself." Mount's earliest drawings were clearly based on genre elements in landscape prints.*

Mount's objective was to express "nature untrammeled by the formality of conventional rules of elegance," without "straining for effect," without "theatrical display," and "in such form as the happy but unstudied circumstance of the moment should offer." To this credo, which the much later

*The same evolution had led Alvan Fisher (1792–1863), a Boston ornamental painter turned incompetent portraitist, to switch again in about 1815, to "barnyard scenes and scenes belonging to rural life, winter pieces, portraits of animals, etc." Although he anticipated Mount by about fifteen years, Fisher, whose primary activity became drawing for engravers, never really lifted his art above the vernacular level.

Impressionists would have agreed to, he added what would have shocked them: the artist should labor to suppress "individual mannerism." Mount was one of the first to state the ideal of the Native School that most separated it from European practice. A picture, the American artists believed, should seem less the work of a human hand than an actual slice of nature.

Aiming at naturalism, Mount eschewed logically controlled studio lighting, thus taking a step that carried him far into the future of figure painting. For outdoor scenes, he posed his models, singly or in groups, under the sky. Indoors, he avoided the constant north light that correct artists desired, inventing such expedients as this: "Two south windows (in winter) and separated by a curtain to divide the lights: the artist by one window, the subject by the other."

However advanced in conception, Mount's methods caused him much difficulty. Light was perpetually changing, but his desire to paint solidly, his need to evolve his technique as he went along, kept him from working fast. Strain induced "quivering nerves and the pains of indigestion." Since he always had more orders for genre than he could fill, his friends were horrified that when he became upset, he did not finish up quickly as best he could, but laid the canvas aside to await the time when he was again "in the right spirit. . . . To paint understandingly, the mind must be clear." He would throw himself into "a fishing attitude" or, if in need of money, paint run-of-the-mill portraits on which he lavished little attention, but which sold well.

Mount's approach to his revolutionary subject matter was an amalgam of old and new conceptions. That his basic artistic weapon was draftsmanship accorded with neoclassicism. If he avoided the heroics of the history painters, he kept as far from the subjective exaggerations of Quidor. Mount muted rather than expanded motion, and expressed unpretentious natural poses with a gentleness, a precision, and a delicacy that varied little throughout his career. His very unclassical desire to catch "the unstudied circumstance of the moment" was very advanced, but did not carry him to the snapshot instantaneousness of the Impressionists. Selecting, in a manner of which Winckelmann would have approved, a point in the action that summarized it, he recorded such an image as a vivid memory would bring back of an incident actually seen.

That he naïvely made no use of the dimming qualities of atmosphere — distant ducks a quarter of an inch high can be distinguished from turkeys — did not belie the fact that his vision was always to some extent generalized. Here also he took a middle ground. He did not allow specific likenesses to

intrude on his broad effects, yet he gave his figures enough personal identity to keep them from being the symbolic types beloved of neoclassicism. Still-life objects have shape and position (he could effectively foreshorten a log of wood extending almost directly towards the spectator), but not the aggressive form and texture that would carry them over to *trompe l'oeil*.

Since he never discovered how to interpose distance between objects that overlap each other, Mount's compositions are most effective when his characters are silhouetted singly against deep backgrounds. That his figures have little weight or plastic position in space is his art's greatest flaw. It usually expanded to a major blemish on the rare occasions when he abandoned the small scale that tradition dictated for genre. (Only heroes were considered worthy of being depicted large.) Mount's one truly successful venture in life size was his half-length single figure of a Negro minstrel, *The Banjo Player*, which is unified by a big, easy, full-flowing, if not rounded, design.

Mount always employed the opaque pigments of craft tradition. He used them as a gifted sign painter would, thick in the figures and foreground, thinner in background trees, and thinnest in the sky. During his first decade he applied bright and gay hues naturalistically to each element in his picture, achieving balance rather than harmony. When he painted out of doors, he did not, in those early years, seek evanescent effects but limited himself to a glareless, even illumination that clarified figures and setting without implying any mood of sun, sky, or human protagonist.

However, as he continued to paint under the heavens, he experienced some of the emotions that were to underlie Impressionism. Experimenting with oil on small oblongs of canvas, he pitted his limited technical resources against the problem, then still unsolved in art, of conveying bright sunlight. In 1841, he shaded light green foliage to white in the glare and a luminous olive in the shadows. Two years later, he flecked a foreground splash of yellowish cream with vivid blue, and touched the surface of a brook with streaks of bright red. Even after he had secured Chevreul's book on the science of color that was to mean so much to the Impressionists, he failed to do more than grope for what was so far beyond his reach. Yet that he made the effort to achieve what accepted artistic theory said was impossible shows how unconventionally he followed the lead of his eyes.

Although Mount did not attempt to incorporate his more inconclusive experiments, his finished style altered. He painted an occasional pure landscape. And in his outdoor genre he expanded nature's role from verisimil-

itudinous setting to an important element in the evocation of mood. Needing to immerse his figures more effectively in their environment, he was forced to tone into a more general harmony his formerly obtrusive local colors. However, the sophisticated way of doing this through consistent chiaroscuro and the modifying effects of atmosphere still eluded him. For some temperamental reason, he could not accept the example of the Hudson River School landscapists. Despite his written insistence that painting should duplicate nature, he moved away from nature to develop a subjective color formula.

For his *Eel-Spearing at Setauket,* he silhouetted his protagonists inside an extensive view that interacts with their poses and expresses their emotions. Everything is immersed in the greenish-tannish tonality with which he had become obsessed. It modifies the costumes, takes over the boat, springs from the fields and foliage of the shore, and almost banishes blue from water and sky.

Modern critics, who like to see nature clearly altered by art, regard *Eel-Spearing* as Mount's masterpiece: the color is delightfully and lyrically modulated to communicate a gentle, springing joy. However, Mount's departure from naturalism was contrary not only to his conscious intentions but to the taste of his American contemporaries. A critic wrote typically that his renditions of landscape "lack everything. They might have been painted by a blind man — but his figures are the best ever attempted in the same line. ... It is downright infatuation that leads him to depart from a walk where he is without equal to wander away where he has more superiors than inferiors."

Painting slaves with complete conviction as happy men, Mount, when the Civil War approached, blamed the unrest on abolitionist fanatics. During the war he was a Copperhead, but on the whole, he preferred to hitch a fat horse to the portable studio he had designed for himself and dream down the rural lanes that, when you could forget gunfire to the southward, seemed as peaceful as they had ever been. He drew, on sheets of paper less than a foot square, miniature genre compositions — as many as nine to a sheet — sometimes grouping a half-dozen figures in hardly more square inches. But the urge to enlarge one of his drawings into a finished picture rarely came. Thus sterilely, he drifted through disillusioning times to his death in 1868.

Always technically somewhat naïve, preferring to any soul-searching or examination of meaning a lyrical rendition of the surface of things, Mount was in no way a profound artist. Yet he was delightfully original, and his work is capable of giving Americans continuous pleasure because he preserved

6 William Sidney Mount *The Power of Music*

Oil on canvas; 1847; 17 × 21; Century Association, New York; photograph, Metropolitan Museum, New York.

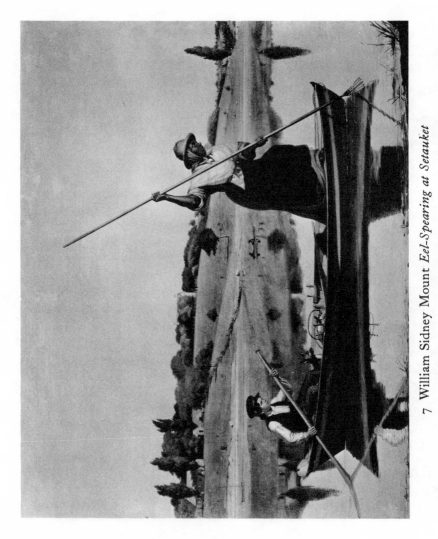

7 William Sidney Mount *Eel-Spearing at Setauket*

Oil on canvas; 1845; 29 × 36; New York State Historical Association, Cooperstown, New York.

so graciously an idyllic time in the development of our nation. He was one of those minor but authentic creators who are justifiably beloved in the lands of their origin, but would be as lost as a gifted child in that international pantheon where the greatest artists of all time endure the shifting glare of centuries.

{ 3 }

THE TRACE OF MEN

Cole Mediates between European Tradition
and American Inspiration

AS from a suddenly released balloon, Thomas Cole saw shrink beneath him the familiar paths of artisan endeavor. The horizon raced backwards; vistas opened and widened and merged into expanses ever more grand. "I have begun three or four pictures, and have thrown them aside in disgust," he wrote in 1826, the year after his triumphant debut. "I sometimes think I have lost the little talent I did possess." Yet he painted doggedly away, trying to reduce the contrast between his "weakness" and nature's beauty as manifested in his beloved Catskill Mountains.

At first he tried to give reality to the boyish dreams that had called him from the smoky pall of industrial Lancaster: he painted "the wild and great features of nature: mountainous forests that know not man." Great storms blew down rocky declivities where centuries of aerial turmoil had splintered some trees and deformed others; his brush moved with violence, leaving gobs of paint that made the surface of the picture as rough as the view depicted. There was power here that reminded the well-educated of Salvator Rosa, with whose style Cole was still unfamiliar; there was Byronic passion. Americans were impressed, but soon an undertone of complaint appeared. The nation's leading collector of "Old Master" canvases, the well-born, European-traveled Baltimore merchant Robert Gilmor, Jr. (1774–1848), admonished Cole that only human figures gave landscape "character and spirit." The critic of the *New York Mirror*, probably Cole's original admirer,

Dunlap, wrote that his "delight in the wild and rugged" gave his pictures "little to recommend them except the ability with which they were executed."

Although Americans had long been complimented by the way European romantics visualized their virgin forests as God's handiwork at its purest, this Rousseauean doctrine did not accord with local experience which taught that the wilderness endangered life and blocked progress. And from Cole the Byronic mood soon faded. In 1828, he jotted in his notebook: "Alone as I was on the shore of that dark, unrippled water, with towering precipices above and almost impervious around, where the voice of man was not heard nor the sound of the ax, there was an awfulness in the utter solitude that was almost painful. Man may seek such scenes and find pleasure in the discovery, but there is a mysterious fear comes over him and hurries him away. The sublime features of nature are too severe for a lone man to look upon and be happy."

Cole was balanced on the final, the continental, divide between aristocratic and democratic thinking. Down one slope, philosophy flowed backward to the tragedy in Eden (which Cole was to paint). Down the other, it flowed ahead to a confidently foreseen Utopia. The old conception saw nature infected with original sin. The new believed that whatever was natural was good.

Cole held both views simultaneously. Although his greatest pictures were hymns to nature's glory, he could not subscribe wholeheartedly to the pantheism that was to be the religious base of the American-born landscape painters who came after him. He felt in inanimate creation evil as well as love, and towards unelevated humans his reactions were equally mixed. On one hand, he spurned neoclassicism's exclusive concern with the educated, wishing his pictures, however complicated in technique, to be in result "on the level with the meanest capacity." However, when he was with his fellow men, he found all but the most refined disturbing. "Man," he wrote firmly, "is in need of a Redeemer." Out of these confusions came confused variety in his art.

On the issues of God's unbroken wilderness versus the inroads caused by civilization, Cole did, it is true, find a compromise well suited to American thinking. He denounced "the copper-hearted barbarians" who brought ugliness with them, but argued that "the great works necessary for the progress of commerce" could, "if man were not insensible to the beauties of nature," be achieved without destroying nature's charms. He came to believe that, although paintings of "pathless solitudes" inspired "religious

musings," to depict cultivation at its best "is still more important to man in his social capacity," since it showed him how to make his environment suitable to "refined and intellectual beings." Cole added that progress contributed by making the wilds "more accessible"; unless he were to balance in a treetop, he could not sketch untamed nature if he did not have a high clearing to stand in.

The question of how far and in what way nature, either wild or pastoral, should be edited by the artist became at the very start of Cole's career a subject of argument with his patron, Gilmor. The Baltimore collector put forward what could be called in vernacular terms the "portrait," or in later fine-art terms the "naturalistic" approach. He quoted an English writer on prints, William Gilpin, who had stated that, as an artist could select the exact spot from which he overlooked a view, he could alter foreground detail, but that the view itself should be painted just as God had made it. This, Gilmor added, was an especially fruitful doctrine for unskillful American artists, since exact natural effect and local reference went far by themselves to give crude work charm. As an example, he pointed out that when Doughty attempted to be imaginative, his pictures became valueless.

Although Cole had once been overawed by Doughty, he had no intention of also remaining a semivernacular artist. "If the imagination," he replied, "is shackled" to what the eye sees, "seldom will anything great be produced in painting or poetry." By utilizing accurate sketches made in many places, the artist could keep "the beautiful impress of nature" and also bring together "the most lovely parts" into "a whole that shall surpass in effect any picture painted from a single view. . . . If I am not misinformed," Cole wrote, "this had been the practice of the Old Masters."

Cole, as his later critical writings show, applied to landscape the neoclassical conception that "truth" was nature purified of "accident," the most perfect leaf being that "which had performed its various functions to the greatest perfection." But he extended the doctrine in romantic directions: artists should find perfect form not by the study of artistic precedents but on their own from a reexamination of nature; and furthermore, men and trees bent by the storms of the world were not, as neoclassicism insisted, accidents to be pruned from art. They served their own function. "Nature is not incongruous. I have generally found in the wildest situation the wildest and most picturesque trees."

To secure the elements of nature which he later combined into paintings in his studio, Cole inaugurated the Hudson River School method of rambling

endlessly through forests and mountains in search of new vistas, fine trees, hidden lakes, surprising falls of water. His notes were as verbal as they were pictorial: on forms recorded in black and white sketches, he marked color in words, and he preserved his emotional reactions in long and often brilliant diary essays. However, in the last analysis, memory was his principal implement. It was so vivid that, as he wrote, "I have never succeeded in painting scenes immediately on returning home from them. I must wait for time to throw a veil over the common details," leaving "the most essential parts."

That Cole was satisfied with making in the presence of nature uncolored drawings showed a primary concern with draftsmanship that harked back to neoclassicism. He was, indeed, one of the most plastic of landscape painters. It was useless of Gilmore, who collected sky-dominated views of Europe, to admonish the American that his mountainous horizons were too high; it was pointless for Cole himself to write, "Light is the great stimulant; it is the fire of life." He was a depicter not of light but of earth, not of air but of textures. His painted hills make the viewer's hand cup to imitate their shape; his nearer foliage could abrade the skin; the eye falls physically from treetop to clearing. Before the tranquil, velvet-covered ruggedness of his distant mountains, the view swells and recedes like a magically arrested ocean. Hills, knolls, wall-like forests, and free-standing trees; the weeds and flowers painted large in the foreground — all these pull upward to balance the downward tension of roads burrowing through the woods, dipping fields, sunken riverbeds, and deep-shadowed fissures. This movement weaves complicated designs, yet there is no laxness; every form is held firmly in its three-dimensional place. Thus Cole imposed order on the fundamental disorder of the newly settled American East, where the land pitched every whichway and man did not, as in Europe, further smooth an already supine prospect but, engaging in a fair fight with wild nature, hacked what holes he could in her verdure, and plowed around what he could not tame.

Cole's landscapes were crowded with details that delighted his admirers. Thus the Hartford collector Daniel Wadsworth praised his *Last of the Mohicans* (1827) as "without possibility of improvement. It is so finished in all its parts up to the very corners! Every tree, every bush, every rock, shrub and weed — nothing overlooked. . . . It is like a fine printed page, where every word is distinctly and clearly seen, and every word tells its meaning."

The welter in which Cole reveled buried linear perspective, with which, indeed, he had little concern. He stretched far the deep distances he loved

to paint by defining successions of horizontal planes, by patterning warm and cool colors, by contrasts, often as sharp as they were arbitrary, of brightness and shadow. Light, the dancing fairy of many landscapists, was Cole's drudge, his maid of all work. Her primary tasks were to indicate space and to throw the shadows needed to emphasize shape. To these neoclassical chores, Cole added a romantic one: by mingling gloom and brightness, in a manner more emotional than natural, light was to serve sentiment. "A beautiful sentiment," Cole wrote, "even if feebly expressed, is of far more worth than the most skillful display of execution without meaning."

No wonder poor, overworked Light lost her own identity. In many of Cole's pictures, she is off in so many directions that the imagination cannot fathom where outside the composition the sun is supposed to stand. And Cole's heavy reliance on the molding and receding properties of shadow forced him to darken his paintings far below nature. Luscious green where the sun smashed down on foliage would have blared like an irrelevant trumpet; Cole rediscovered for himself the Old Master's trick of making brownish foliage stand in artistic context for green. Eliminating the brighter hues of nature, he achieved a naturalistic consistency of tone, and considered lyrical color well lost in the cause of solidity.

Now that Cole had come down from pathless heights, he showed human figures wandering seemingly at random through wide vistas and painted so small that the eye often misses them at first glance. Their purpose was not that which Gilmor had conned from European practice to give "character and spirit to the scene." Cole's humans inhabit the American world on a basis of equality with all living things — trees, flowers, horses, deer — not masters of nature but one facet of her delightful abundance. Even when in *The Ox-Bow* he put in a prominent position an artist and his easel, the figure does not serve as the traditional Claudian symbol that we are seeing nature as experienced by the mind of man. The tiny artist is one with the dog that sniffs at his feet. Indeed, emphasis in this miniature genre passage is on nothing animate, but on the painter's furled umbrella which helps, as it sticks out from the cliff, to bind the two halves of the picture together.

Cole's compositions not only fail to focus on human protagonists; they fail to focus at all in what was then the invariable manner of sophisticated European art. In a hangover from the vernacular, there is no unified vanishing point: different parts of the same picture are drawn in different perspectives. It is impossible to command, while holding one's eyes in a constant position, all aspects of a Cole landscape. As if in the presence of an

actual prospect, we must look first here and then there, go close to see some things, back away to appreciate the full effect of others. According to every accepted esthetic rule, this is a solecism, yet it served Cole's purpose of communicating the diversity of a huge land which man had only started to tame.

As Cole's realistic renditions of the local landscape grew in strength and poetry, his reputation consolidated. Few would deny that the young man was the leading painter in the United States. However, acclaim did not bring Cole self-confidence, for his augmenting knowledge made him ever more conscious of contradictory drives.

He could write proudly, "The painter of American scenery has indeed privileges superior to any other: all nature here is new to art." Yet in other moods he wondered whether neoclassical theorists were not correct in regarding such newness as a crippling disadvantage. Was not the history of the world the history of man? Was not an artist who left to one side human experience, and the lessons it taught, paddling up a backwater? Such worries found fertile soil in the part of Cole's mind which doubted that the contemplation of nature was in itself a moral act. Was it not the artist's duty to speak more directly to the ethical sense than he could as a recorder, in however exalted a manner, of hills and fields?

From almost the start of his true career, Cole had tried to increase the importance of an occasional landscape by inserting an episode from American history, sometimes based on a Cooper novel. As long as the additions embellished his naturalistic views without dominating them, they fitted in with the portmanteau attitude of the vernacular taste, and, on the whole, pictures like his *Last of the Mohicans* pleased Cole's public. However, the artist himself was not long satisfied. His esthetic instincts reported that in such pictures were unhappy mixtures: the impact of nature was weakened, and his stories were inadequately told. He would have to develop alongside of his realistic manner an independent historical style. But the effort to do so presented him with a major problem that was to plague his entire career: how to make his human action effective and yet not break completely with the landscape mode, to which his talents so strongly called him.

Cole conned his first solution from prints by John Martin, a contemporary English historical painter and engraver. Martin had offended the connoisseurs but pleased the public when he had visualized scenes not only, as neoclassical thinking required, in terms of major actors, but also of anonymous crowds. Thus for his *Belshazzar's Feast* he dashed off a distant view of

tremendous architecture and showed in the central courtyard Babylonians by the hundreds fleeing the terror induced by the prophecy of doom. His landscape settings were equally effective and equally contrived. He made his characters focal points in constructions of seminaturalistic elements that symbolized their situations and emotions: caves, cliffs, poetic glades, swirling mists, and bright light erupting from darkness. Martin's expedients so suited the youthful Cole that his *Expulsion from Eden*, which is a free gloss of Martin's, is in its own right an effective high romantic imagining.

Now that he had a method which seemed to open to his brush a wide choice, Cole made lists of subjects that appealed to him. Almost every narrative theme based on his own imaginings — including all the most important — that he was to paint until the very end of his career can be found among the hundreds of ideas he jotted down in 1827 and 1828. For the moment, however, he made no effort to paint the allegories he had outlined. When he took time from his realistic vein, he followed Martin into the more traditional occupation of illustrating the Bible.

His *Moses on the Mount* shows vision streaming down on humanity from the fierce zenith. A burst of yellow in the left sky, brightened by contrast with cool blue shown on the right through a low hole in stormy clouds, establishes height and almost dazzles out the physical world beneath. Rays pitch downward, and, in following them, the eye is pulled dizzily past cliffs bathed in a sulfurous glow to the crag where Jehovah and Moses are illuminated against darkness, and then on, down and down, to a low and distant land where the children of Israel parade in tiny pomp around the golden calf.

Although such paintings abounded with eloquence, the public which hailed Cole as the initiator of an art that celebrated the American world were worried by his ambition to paint Biblical imaginings. Concern was heightened by the news that he was planning such an extended stay in Europe as the previous generation had considered the only correct approach to the art. When the painter prepared to sail, Bryant penned an admonitory sonnet urging him not to be overwhelmed by "the light of distant skies," by "the trace of men" ubiquitous in the Old World: Cole was to keep "that earlier, wilder image bright."*

Cole's anticipations, he himself wrote, "are not at all pleasing, for I am going to study the great works of art. I feel like one who is going to his first battle and knows neither his strength nor weakness." He tried to arm himself with a trip to Niagara Falls. He wished to impress the features of

*Bryant's sonnet is quoted in full at the opening of this volume.

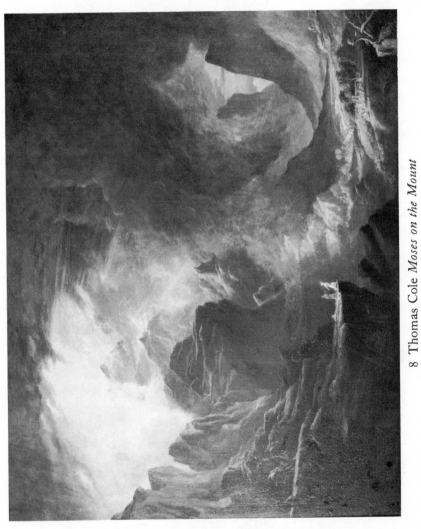

8 Thomas Cole *Moses on the Mount*

Oil on canvas; *c.* 1828; 46 × 59, Shelburne Museum, Shelburne, Vermont.

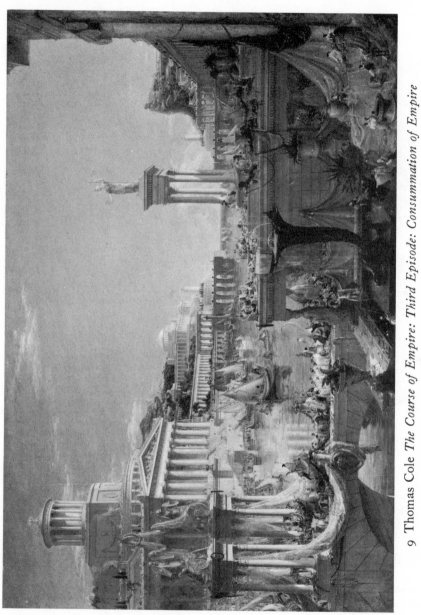

9 Thomas Cole *The Course of Empire: Third Episode: Consummation of Empire*

Oil on canvas; 1835–1836; 51 × 76; New-York Historical Society, New York.

"our wild scenery . . . so strongly on my mind that in the midst of the fine scenery of other countries their grand and beautiful peculiarities cannot be erased." Disturbed to find that Niagara's elemental energy did not inspire him — "it has a horrible appearance" — he could only, as he prepared to sail in June 1829, mutter like a magic charm some lines of his own composing:

> *Let not the ostentatious gaud of art*
> *That tempts the eye but touches not the heart*
> *Lure me from nature's purer love divine.*

Eleven years after he had left England, an obscure and impoverished emigrant, Cole returned at the age of twenty-eight the leading painter of a great nation. He settled in London, and set to work on pictures, both American views and Biblical reconstructions, which he confidently believed would dazzle his former homeland.* When they were "skied" — hung in the top tier — at the Royal Academy to leave the good places for what he considered "the vilest daubs, caricatures, and washy imitations," he reacted with charges of conspiracy against a stranger.

As Cole goes to call on Constable, the watching historian may well hold his breath, for the great Englishman's example is just then, through its influence on Delacroix, bringing to French painting the coloristic skills that had so long been extinguished there under the snows of neoclassicism. As a landscapist Cole has, it would seem, even more to learn. But he is unimpressed.

A call on Cole's old inspiration, Martin, was surely a disappointment, since that inspired engraver was as a painter almost incompetent. However, Turner had in his early oils brought true genius to conceptions similar to Martin's; he kept them closer to nature while infusing them with deeper poetry. Turner, Cole ruled, had been in this phase "one of the greatest landscape painters that ever lived." Yet Cole believed that in his later pictures, where form was obscured by light, Turner had changed into "the prince of evil spirits." He had made his landscapes into "jellies and confections" because of an "undue dislike of dullness and black. . . . Nature in her exquisite beauty abounds in darkness and dullness. Above all, she possesses solidity."

"I cannot but think," Cole wrote, "that I have done more than all the English painters. . . . The standard by which I form my judgment is beau-

*Not since Stuart had come to London from Rhode Island in 1779 as a self-enchanted primitive, had any other able artist tried to conquer a European capital with a homegrown American style. Stuart did not succeed and in the end accepted English sophistication. In the intervening half century, Americans had, on their first contact with Europe, invariably cast themselves as humble students.

tiful nature." He still saw that nature with American eyes. Although he made notations like "nothing can be a richer green than an English lawn," he wrote of the landscape painting which reproduced such colors: "My *natural* eye is disgusted with its gaud and ostentation." Himself dedicated to plasticity, he found English art lacked "the solid beauties of design and sentiment that convert an empty amusement of the eye into an elegant entertainment of the fancy." An explanation is inherent in the statement later made by the New York diarist Philip Hone that Cole's "landscapes are too solid, massy, and umbrageous to please the eye of an amateur accustomed to Italian skies and English park scenery, but I think every American is bound to prove the love of his country by admiring Cole."

As the Revolution of 1830 flamed and died in France, Cole waited in London, "painting unremittingly but with increasing gloom." When he finally reached Paris in 1831, he was outraged at the contemporary pictures he saw, primarily at the Salon: "The subjects which the French artists seem to delight in are either bloody or voluptuous. Death, murder, battles, Venuses, Psyches are portrayed in a cold, hard, often tawdry style of color and with an almost universal deficiency of chiaroscuro. The whole is artificial and theatrical." He did like the sentimentalities of Ary Scheffer, but found less than two weeks in Paris long enough.

In Italy, he stayed for a year and a half, working "like a madman" and looking around him. Although he was uninspired by classic statues, he was so overwhelmed by Raphael, whom he considered the greatest of painters, that he added to his worries the fear that portraying landscape in whatever form was unworthy of a great spirit. As a step towards more conventional history painting, he essayed drawing from the nude, but the diffidence in the presence of physical humanity that had blocked him as a portraitist now rose in an even more virulent form. His nude studies are, for all their surface propriety, as embarrassing to look at as Cole was himself embarrassed. Although he continued in depressed moments to bemoan the fact, which he blamed on lack of early training, he could not hope to switch from landscape to true figure art.

In his specialty, Cole did not, as he was to criticize Allston for doing,* adopt any traditional style. Instead, he deepened his own practice. Without abandoning his method of combining in a single picture objects seen from

*Cole wrote of Allston in 1843, "His taste was pure and elevated far above that of most of his contemporaries," but his admiration for the Old Masters "led him somewhat astray.... His pictures, beautiful as they are, always reminded me of some work or school of art."

various points of view, he learned to bring all, according to his own rules, into a more subtle equilibrium. Although his light did not lose its tendency to obey, in various sectors of a painting, special needs, he expunged the more glaring inconsistencies. His brushstrokes became even freer; his color took on richer harmonies.

Cole wrote that in "natural scenery" Europe could not equal "the wilderness places of America. . . . Although there is a peculiar softness and beauty in Italian skies, ours are far more gorgeous." Yet he was deeply moved by the "trace of men," against which Bryant had warned him.

After his return to the United States, Cole, who called Claude "the greatest of all landscape painters," was to paint many a Virgilian vision of Italy as a vanished Arcady. But while he was still abroad he painted the European land as realistically as he painted the American, and, in his more imaginative moods, reacted with as much depression as exaltation to the remains of times gone by. At crumbling, medieval Volterra, he stood at the edge of such a cliff as had seemed "indestructible" in America, and was amazed to feel that at any moment it might slide away beneath him. There among the ruins of past human greatness, the earth seemed "perishable as a cloud." Later that day, he visited dungeons in an ancient fortress: "the sense of human cruelty bore with crushing weight upon my heart." Thus was encouraged a typical direction of romantic thinking which his mind had already been exploring.

Before he had left the United States, Cole had outlined a series illustrating "the mutation of earthly things" in four paintings: (1) sunrise over a partially cultivated country — rude hamlets, peasants, peace and happiness; (2) a noble city, great temples, port crowded with shipping; (3) storm, battle, burning of city; (4) sunset with ruins. While in London, he had added to the plan of what he was to call *The Course of Empire* a fifth picture which was to show "the savage state," not in the American terms of Indians, but philosophically: bearded European hunters chasing deer before a mingling of clouds and rocks which implied that the natural elements of creation were first coming into order.

That Cole was in Italy when he decided to make *The Course of Empire* an immediate object of ambition was probably more than a coincidence, for he had excluded from his strictures on most contemporary European painting "a few German and English artists in Rome who paint with more soul." The specific artists to whom he referred have never been identified: perhaps some have been altogether forgotten. Yet it is safe to say that the mood of that international artistic center — where Joseph Anton Koch painted

[43]

crabbed symbolic landscapes in the name of neoclassicism; where the followers of the German Nazarenes and the precursors of the English Pre-Raphaelite Brotherhood dipped anemic brushes in moral purity; where sentimentality and storytelling were rife — gave Cole the final impetus towards putting in paint his own narrative imaginings.*

Although he had now turned his back forever on illustrating other men's writings, he still felt the need for a full text to guide his brush. His first step towards the final realization of *The Course of Empire* was to expand his earlier notes into an elaborate essay conveying both the content and the mood of each episode. This was to be his method for all his romantic idealistic pictures. For a painter, he had dangerous literary gifts.† He wrote voluminously, throughout his career, not only for his personal pleasure and to preserve impressions he might wish to paint, but also for publication. He contributed to magazines poetry, stories, essays, critical and travel pieces. Had he not constantly reminded himself that it was painting "on which my imagination wings itself," he might well have earned a solid if minor niche in the history of American literature. Sometimes his essays for pictures were more evocative than the pictures themselves. Such writings were, he explained, "spontaneous," while he found it hard labor to express the same ideas "by means strictly pictorial."

Cole spent "the better part of seven months" in Italy, painting what proved to be a preliminary version of *The Savage State;* he sent it to Gilmor in payment of a three-hundred-dollar debt and tried to persuade the Baltimore collector to commission the entire series. But Gilmor was displeased with the picture and urged him to stick to realistic views.

This was the situation when Cole was called home by a cholera epidemic in New York that seemed to menace his parents. Arriving in November 1832, he soon established his lifelong pattern of living and painting in the village of Catskill, making annual forays to New York City in search of

*The Nazarenes were a group of German artists who in the early nineteenth century occupied a deserted Franciscan monastery near Rome and produced pictures accurately described in the title of a book by the critic Wilhelm Heinrich Wackenroder: *Herzensergieszungen eines Kunstliebenden Klosterbruders* (*Heart-outpourings of an Art-loving Cloisterbrother*). The Nazarenes combined neoclassical generalizations, hard outlines, and cold color with an effort to catch the simple piety of such Italian painters who predated Raphael as Fra Angelico.

For a description of the English Pre-Raphaelites, see the note on page 113.

†Cole wrote during his second European trip (1841): "The Alps cannot be described. They are too beautiful to be compared with anything on earth. They seem of an ethereal tissue, like drapery composed of moonbeams and tossed by the breeze. They are like silver festoons suspended from the blue heavens. They are like the moon when six or seven days old and seen through a telescope. I mean in texture and color. They are more like snowdrifts than anything else."

business and artistic contacts.* He married a "sweet, madonna-looking" Catskill ingenue, who presented him with two children. She read aloud as he painted, and the maiden female relations who accumulated in their home watched admiringly. From this distaff environment, he would set out on wild rambles through storms or far into uninhabited mountains.

Roughly a year after Cole's return from Europe, he had confided to Luman Reed his passionate desire to paint *The Course of Empire*. That munificent collector (of whom more later) needed no further persuasion to commission the whole series.

Having completed with no particular difficulty a new *The Savage State* and a Virgilian *The Arcadian or Pastoral State*, Cole began on *The Consummation of Empire*, the huge central canvas, similar in conception to works by Martin and his followers,† that was to be the focus of the series. It was to show a classical city basking in "the fullness of prosperity."

For his naturalistic landscapes, Cole relied heavily on drawings of specific places. Had he belonged to the neoclassical generation, he would have sought for his historical compositions equally firm sources: John Vanderlyn, before he painted *Marius Amid the Ruins of Carthage*, had built in his studio an archeologically correct scale model of the ruins. However, when Cole had first started on his series in Italy, he had created among classical buildings a savage landscape. It was under savage mountains that he set to work on his classical city. To spark his imagination, "I want but little": a few chance engravings that gave "a hint or two." What actual models were offered him by his surroundings he avoided, asking Durand to send him into a country-side that teemed with horses a statuette of a rearing horse he could paint from. "The poetic mind," Cole explained, "clothes the dim and shadowy forces of the past with a drapery of its own."

The great, gaudy capital Cole intended to build from his own brain cells had to be presented as a happy image for contrast with the horror of its destruction in the next episode. Yet Cole hated cities: even New York filled him with "a presentiment of evil." And the problems of scale and perspective were vast. After a long summer of labor, he had "rubbed out enough for five pictures," but the composition was still confused. It was winter before he

*Only willing to travel by boat, Cole would not make the trip between Catskill and the city when the Hudson was frozen. Among the hazards of a stagecoach ride in winter was, as a letter to him reveals, the tendency of the postilions to inoculate their galloping horses against the cold by making them blind drunk.

†As Wolfgang Born has pointed out, several elements of the composition were based on a commercial panorama Cole had seen in London: *Pandemonium*, drawn from Milton's *Paradise Lost* by H. L. Schous.

dared carry the big canvas downstairs to examine it at a greater distance. Horrified, he wrote Reed that he would like to start over again. That ever-generous patron offered to finance the effort.

As Cole eyed the new big canvas on which he had redrawn the composition in chalk, he seemed about to replay the tragedy of Allston, who, under very similar circumstances, had almost halted his productive career to paint over and over the *Belshazzar's Feast* that was still unfinished when he died. But craftsman-trained Cole did not share Allston's gentlemanly disdain for practical considerations. He wrote Reed that, on second thought, he could not afford the time to start again. In less than three weeks he declared the original canvas finished, although "not satisfactorily." He had, he wrote, erred a little in perspective (the same error that had set Allston on his downward path) and "in the endeavor to make it rich," had introduced too many small objects.

We cannot doubt that, although these self-criticisms were valid, Cole was wise not to squander his talent on further repaintings. This is underscored by the use he made of the extra canvas. To Reed's suggestion that he paint another Virgilian vision like *The Pastoral State*, Cole answered that would take too long and imaginative compositions did not sell as readily as American views. Perhaps, something deep in his nature sought refreshment by a return to his realistic vein. In any case, he painted, from sketches made on the scene, *The Ox-Bow*, an actual Massachusetts prospect. Today this is considered one of his masterpieces, a much more solid work of art than the allegory on which he started again as soon as the landscape was finished.

The fourth episode was *The Destruction of Empire*. In the peaceful American countryside, where prosperity showered down with the sun and safe slumber with the moon, the gentle landscapist labored during four long months to conjure up the sadistic violence he had denounced in French art. "I have," he wrote Durand, "been engaged in burning and sacking a city, . . . and am well tired of such bloody work. . . . I *did* believe it was my best picture, but I took it downstairs and got rid of that notion." Indeed, no vision of doomed flight, sprawling corpses, and anguished pleading females was ever less appalling.

That such lack of conviction was characteristic of all Cole's efforts to paint horror and tragedy seems strange, since darkness often filled his brain: he was haunted by potent psychological demons. His portrait by Daniel Huntington shows a face in which the innocence of perpetual adolescence wars with disillusion beyond the experience of years — the face of a blue-eyed

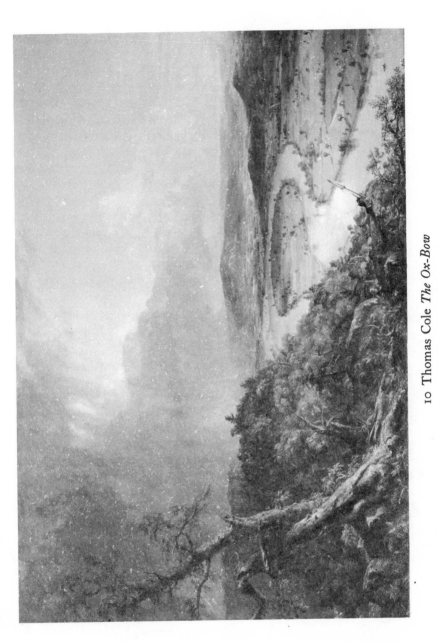

10 Thomas Cole *The Ox-Bow*

Oil on canvas; 1846; 51½ × 76; Metropolitan Museum, New York, gift of Russell Sage, 1908.

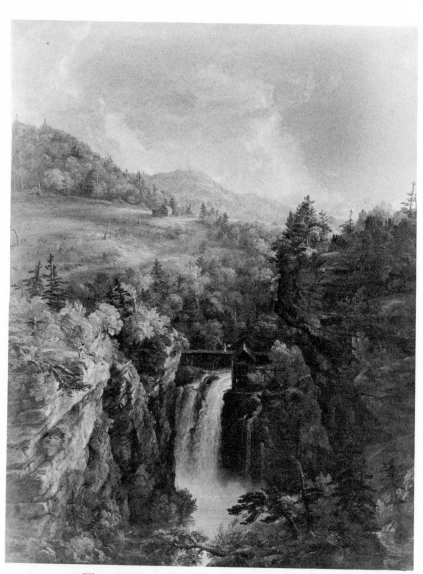

11 Thomas Cole *Mountain Landscape with Waterfall*
Oil on canvas; 1847; 51 × 39; Museum of Art, Rhode Island School of Design, Providence.

faun tensed with neurosis, a terrifying face. Had Cole worked in another environment, he might have been able to give his personal agonies expression. As it was, he never communicated powerfully any more grievous emotion than the melancholy of *Desolation*, the last episode in *The Course of Empire*.

This vision, which he painted fluently, shows the sun setting over ivy-softened ruins from which all human turmoil has receded. The mood, like that of his other landscapes featuring peasants who brood beside medieval as well as classic remains, extends the Virgilian point of view in more romantic directions. The past is reinvoked not because it was in itself noble but because the crumbling of so much splendor reveals the destructive force of time. Cole's reaction is not rebellion but a happy sadness: the release that comes with the end of striving, when all passion is spent.

The entire *Course of Empire* was dedicated to the vanity of human greatness. However, when the series was exhibited at New York in 1836, the public that flocked there — Cole cleared almost a thousand dollars from the showing — and the press refused to accept any such pessimistic interpretation. The pictures, it was insisted, by signalizing the inevitable doom of Old World tyrannies, happily revealed the superiority of democratic America. But even this patriotic gloss failed to keep general admiration alive after the first excitement passed. The *Course of Empire* did not prove popular enough to be engraved, and a chorus of critical voices demanded that Cole return to subject matter more basically American.

He angrily styled such advice as "the buzz of these dirt flies"; he refused to be "a mere leaf painter." In the romantic manner, he felt in himself all potentialities. As an inventor, he made a model of a steamboat that was supposed to roll over the resistant water like a carriage on huge air-filled cylinders (Mount, amusingly enough, had the same idea). Cole built a piano in which the ivories raised before lights transparent sheets of color: dreaming of symphonies in color, he worked out scales of hues analogous to those of sound.

Cole had blamed his troubles with the huge central panel in *The Course of Empire* on its being "the first architectural piece I ever painted." Now he took up the study of architecture so effectively that he played a major part in designing a huge, ungainly monument of the Greek Revival style: the Ohio State Capitol at Columbus. Although his plan to found an architectural firm with his nephew William H. Bayless came to nothing, he continued to erect structures with paint on canvas. His *Architect's Dream* symbolizes the ecclecticism then rife in that sister art by juxtaposing historically incor-

rect buildings in the Grecian, Egyptian, Gothic, and Moorish tastes.

The Voyage of Life (1839) was Cole's only other completed series comparable in scope with *The Course of Empire*. A voyager, adrift in an elaborately carved boat, is shown in separate pictures at four key points in his journey. For each episode, the landscape symbolizes his condition. In *Childhood*, the baby's guardian angel guides the vessel as it emerges into springtime from a flowery cave. *Youth* shows the protagonist himself at the helm: all his smiling summer and happiness glows in the air, a domed mirage. *Manhood* rocks dangerously through autumn tempests. Winter's more grievous storms would swamp the boat in *Old Age* did not the guardian angel return to rescue the now broken figure and carry him to "the Haven of Immortal Life."

Having got entangled in small forms when he tried to show humanity en masse, being unwilling to symbolize mankind with the neoclassicists through a king or hero, Cole took from Bunyan that semimedieval conception, Everyman. This forced him to ban all specific connotations from figures and nature. Such generalization was so alien to the wellsprings of his art that he painted the four large canvases with great speed. Although he did have a moment in which he considered trying to strengthen his unlocalized prospects with written sentiments painted as if carved on rocks and trees, he never got deeply enough into his subject to recognize its tremendous difficulties. The pictures were to be effective when eventually reduced into engravings, but the huge originals disappoint. The landscapes are not up to Cole's usual standard; the rocks are cardboard; the storms, fustian; the angel, a winged and togaed cliché; and Everyman has become that pointless character, Nobody.

But Cole was delighted with his handiwork. He was furious that, after Samuel Ward, the collector who had commissioned the series, had died, the heirs prevented him from exhibiting *The Voyage of Life*. He had hoped its triumph would finally persuade the public to accept him as an exalted painter, to demand no longer the naturalistic American views with which he was forced to support himself, his family, and the impecunious relations who continued to dip into his pocketbook. "Had fortune favored me a little more, . . . " he wrote, "I would have followed out the principles of beauty and sublimity in my work that have been cast aside because they were not marketable. . . . I am not the painter I would have been had taste been higher."

Although he would certainly have apportioned to it a smaller part of his energies, we may doubt that, had he been financially enabled, Cole would

have abandoned entirely the realistic vein that came so strongly from his brush. If one side of his nature rebelled against reality, there was also a side that rebelled against his more idealized compositions. Thus, when he was painting his Virgilian *A Dream of Arcadia*, Cole wrote Durand that the picture had started delightfully, but then "there came a classic fog, and I got lost and bewildered. I scraped my shins in scrambling up a high mountain, rubbed my nose against a marble temple, got half suffocated by the smoke of an altar where the priests were burning offal by way of sacrifice (queer tastes the god had, that's certain), . . . but worst of all are the inhabitants of the country. I found them *troublesome, very* — they have almost murdered me, alas!" When actually in Italy, he had written that the shepherds he was now trying to glorify "wear skins, and are no more civilized than Indians and somewhat more superstitious and ignorant." Yet, on completion, his *A Dream of Arcadia* was an altogether delightful evocation of the yearning which lurks in every breast for an older world, mellow in the sunglow of history.

The Virgilian mode, which he shared with Allston, was the most traditional aspect of Cole's practice, and he ranked with Allston as its leading American practitioner. It is Cole's architectural, his medieval, his moralizing landscapes, whether in one or several episodes, that were more up to date; they were America's best exemplars of types of romantic idealism considered very modern in much of Europe. Almost everywhere and always, such pictures were histrionic. The canvas is the artist's stage; the shudder or exaltation the viewer experiences is not in his own soul but outside; the picture is a spectacle to be admired. Cole's efforts run a wide gamut from the comparatively dull to the very exciting. Each was a conscious attempt to lift himself into a world beyond his own experience. Sometimes the wings of his imagination beat vainly; sometimes, catching the air, they lifted him high.

In this more down-to-earth branch of his art, there were no swings or variations, only a steady growth. He continued to show the American land as firm, crannied, tactile under a less important sky. All the diverse elements typical of local prospects seem, as before, to have been painted without premeditation, just as they fell from Nature's random hand, but each year the forces of weight, depth, shape, and light that pulled against each other from passage to passage resolved into a deeper equilibrium. Tiny details that still came out sharply to close scrutiny, increasingly vanished, when the viewer stepped backwards, altogether into the whole. As part of the consolidating process, brushstrokes became less rugged, surfaces more consistent.

Although he never reached the brighter aspects of nature, his color further escaped from brownness, finding subtler harmonies that included pearly grays, gray-blues, yellowish-greens, autumnal russets, and light ambers in addition to those touches of red he had long liked to spot in unlikely places.

In worsening health, discouraged by the continuing unfriendliness of his environment to his romantic idealistic pictures, Cole sailed to Europe in 1841. But instead of "renovating my artistic feeling," as he had hoped, a new sight of the Old Masters increased his sense of the unworthiness of his art. If only he had been born among great pictures! "I began too late in life — but I will do my best."

To do his best, he locked himself in a Roman studio away from all Old Masters and based on tracings of the first a second huge version of *The Voyage of Life*. The replay having been, despite praise from the Danish neoclassical sculptor Thorvaldsen, badly received in Rome, Cole returned after less than a year to the United States, where the series created, considering its size and the reputation of its author, an amazingly small stir.* Joining, after a lifetime of religious vagueness, the most traditional of American Protestant churches, the Anglican, Cole projected another series, this time in five parts and not only moralistic but specifically churchly. However, he was unable to carry *The Cross and the World* beyond the start.

As Cole's health continued to deteriorate, nightmarish depressions increasingly gripped his mind. His "best friends," he wrote, had turned on him. "I am forgotten by the great world, if I ever was known. What a dismal situation!" And yet the common American attitude towards his work was that expressed by the critic Charles Lanman, "Thomas Cole is unquestionably the most gifted landscape painter of the present age. In our opinion, none superior to him has ever existed."

The painter now found comfort only "in my family and my own dear Catskills." The wild America, which he had dimly envisioned during his smoke-palled childhood and which had first inspired his triumphant art, remained, when all exotic dreams failed, a joy and a never-ending inspiration. In the final years before his premature death at the age of forty-seven, Cole painted from earlier sketches such pictures as *Mountain Landscape with Waterfall* that carried to its greatest happy power his realistic landscape style.

Cole, the many-sided, the much-torn, played a major role in the development of American painting. At the base of his contribution lay real artistic power. And his inner conflicts served to lure all but the bedrock of conserva-

*This popular verdict was, as we shall see to be reversed, but not till after Cole died.

tive connoisseurs into sympathy with the Native School, which he had initiated. Cooper, while reacting with violence against Jacksonian democracy, could fly to the defense of *The Course of Empire* as "one of the noblest works that was ever wrought," and insist that it was attacked because "one easily gets in advance of the public mind in America by a residence among the great works of art in the Old World." But, having become Cole's champion, Cooper, like many another partisan of historical painting, had to look sympathetically at his naturalistic landscapes.

Cole was indeed, from the point of view of general acceptance, the perfect innovator, for he bestrode transition, one foot at the most advanced point that conservative taste could reach naturally, the other in the future. And younger artists, who were preparing to launch far beyond where he had gone, were reassured by the example of a compatriot who stood as so exalted a bridge between the past and innovation. Although Cole did not impress his attitudes or his methods on his followers, he enabled the conventionally slighted mode of landscape painting to achieve wider practice and admiration in the United States than it enjoyed at that time in any other major nation.

GOD IN NATURE

Durand and the Esthetic of the Hudson River School

U NTIL almost the end of Cole's brief career, he had stood alone as a significant American landscapist. The other artists who yearned to be more than topographical workmen were frustrated by their unwillingness or inability to break with the vernacular economic pattern of painting quickly to sell cheap. No shorthand methods having been developed to indicate native poetry, they sought "elevation" through heavy reliance on the old Virgilian clichés. Thus Doughty soon dissipated with his rapidly traveling brush those concentrations of personal awareness that had moved Cole, substituting the simpler task of assembling behind a sun-drenched mist soft forms American enough to connote his native land and Claudian enough to carry an implication of beauty even if painted with little attention. Such was also the landscape manner of Alvan Fisher. Although denounced by the *Literary World* as a "tea-tray style," this stir-about served to give its practitioners reputations until the Hudson River School really got under way. Then their pictures seemed by contrast so artificial that they had difficulty making their living.

In addition to the topographical Claudians, more pedestrian landscape illustrators, usually British-born and trained, worked around Cole. For a worthy colleague on the fine arts level he had to await the slow advance, through trades and modes, of a craftsman five years his senior, Asher B. Durand (1796–1886).

Durand's New Jersey childhood had combined artisan ingenuity with farming. His father was an impractical watchmaker turned "universal

[52]

mechanic"; a brother invented a machine that could worst a New England schoolmaster at grammar — but the family made its living from the soil. Too delicate for farmwork, the slight, blond lad rambled with soft joy through the pastures, woodlots, and orchards of a nature quite tamed, and, in his admiration for the makers' tickets that decorated the insides of watches, beat out a piece of copper, scratched on it with tools of his own devising, and, to the cheers of his benevolent elders, made a plate that would actually print.

Apprenticed to an engraver, Durand became so skillful that Trumbull, who had long been seeking a workman capable of reproducing his famous *Declaration of Independence*, entrusted the task to Durand, then twenty-four. The satisfactory completion after three years of such a tremendous plate as had never before been made in America placed the young engraver incontrovertibly at the head of his profession.

Durand himself published likenesses of the well-known based on portraits by leading American artists. Considerably smaller in size were the reproductions of subject paintings he made on commission for hard-bound annuals aimed primarily at young ladies and brought out during the Christmas season. These "gift books" — the idea was imported from England in 1824 — enjoyed great popularity until the increase in mass distribution made it economic for true periodicals, like *Godey's Lady's Book*, to achieve as elaborate a format. For the eight to twelve "embellishments" in the better volumes the editors sought pictures that not only expressed "domestic sentiment" but were "within the scope of the American imagination." This meant that they distributed widely, whenever they could get them to reproduce, native landscape or genre or the two mixed. Historical subjects — usually either Biblical or, like scenes from the Greek War of Independence, in the news — were also common, as were those pictures of languishing young women of which the popular taste of the time never tired.

Since no royalty system existed, paintings or drawings to be reproduced had to be either borrowed or bought. Borrowing was difficult, as the pictures spent months at the engravers. Although Doughty was glad to get twenty dollars for two drawings, buying from such leading artists as Mount and Cole was too expensive unless, like Edward L. Carey of the *Token*, the publisher was also a collector. Thus there was a continuous shortage of copy that sent both publishers and engravers scrounging, and often resulted in pirating European plates. Of 230 identified pictures in the twenty-five volumes which the *Token* and the *Atlantic Souvenir* published first separately and then in

combination, mostly between 1828 and 1843, 119 were after American artists, 83 after English, 20 after French, and the rest various. In all the annuals, the pictures were considered so important that, instead of seeking designs that illustrated texts, the publishers had stories or poems written to go with the engravings.

Cutting in hard metal, as Durand did, a tiny plate that when printed in black and white communicated the effect of a large and colored painting, was a task of interpretation comparable to a violinist's interpretation of a composer's score. The engravings were reviewed by art critics and sometimes ruled more effective than the original.

President Jackson, when he closed the Bank of the United States, unwittingly created what were to be the nation's major art schools. The resulting proliferation of local banks was of such value to engravers that they supported as lobbyists the granting of new state charters. Every bank issued its own currency, and counterfeiters made their contribution by punishing institutions that saved money on sleazy jobs easily duplicated. As the expansion of the economy further accelerated the demand, bank-note engraving became the road to painting most readily open to poor young men. Had you, in the 1840s, thrown a handful of pebbles into any major workshop, you would have hit two or three future painters.

Of the vivified bank-note art, Durand and his brother Cyrus were the fathers. Cyrus invented a mechanical lathe which ruled on the plates counterfeitproof lines, and Durand pioneered in changing from copper plates to engraving on steel plates that permitted a longer run. He developed an iconography for decorative vignettes that still flourishes on stock certificates. Sometimes he engraved miniature genre scenes or portraits, but more often he made amusing use of the convention, exemplified in the architecture of banks and public buildings, that the classical connotes solidity. Adding to this another convention — that nudity, which would be shocking if exposed by drooping crinolines, was pure and cultural if framed in togas — he opened a field for metaphor both refined and spicy. A semi-nude shown sitting by a gear represented industry; for agriculture, she held a sheaf of grain; and how could patriotism be better exemplified than by a girl, hospitably naked to the waist, proffering a flagon to the American eagle? When Durand was dead, what he had evolved for currency became the stock in trade of mural painters — but he never enlarged such conceits into paintings.

Towards rendering flesh effectively in black and white print, the supreme problem of engravers, Durand's usual models were of no use, for they were

the casts at the National Academy. He would not associate with any stranger so immoral as to strip before him, nor would he debauch his wife by asking her to pose. So he bought America's most famous painting of the nude, the *Ariadne* Vanderlyn had created a generation before in Paris, and set to work on an engraved version (*c.* 1835) that proved a more unified work of art than its inspiration.

Vanderlyn, taking over the typical fault of French neoclassicism, had failed to establish true esthetic connection between the firm body and the umbrageous landscape in which it reposed. Durand infused this dichotomy with imaginative meaning. The fair, naked form — printer's ink communicates soft resilience — is strongly drawn, yet weightless. On her bed of draperies, in her trancelike sleep, full-breasted Ariadne touches the earth but inhabits the air. The landscape that encloses her but through which she seems majestically to glide is both real and ghostlike. Gray leaf and bark glimmer against black, heightened in vision. As in Titian's paintings of Venus and the musician, the actual-seeming body is present only in dream. It is wildly improbable that Durand was thinking of Titian: he was unconsciously expressing his own feelings. It was thus shadowy and thus firm, thus haunting and unattainable and strange, that voluptuousness manifested itself to New Jersey's somewhat puritanical son. (When he finally moved completely into the warmer medium of paint, he abandoned the female nude.)

Durand had become the only American who can be ranked among major nineteenth-century engravers. However, his ambition had moved beyond the pursuit. He was trying to establish himself as a painter. Beginning in 1834, the patron Luman Reed offered and secured him the commissions that enabled him to abandon print making forever.

He first devoted his brush primarily to the subject matter he had most successfully engraved, figure pieces and portraits. His figure compositions, whether literary genre or genrelike history paintings, proved heavy and theatrical, more inspired by other pictures than by nature or personal vision. However, he became almost instantly an extremely powerful portraitist.

As an engraver of the well-known, Durand had depicted men; men remained his specialty. In painted life-size as in printed miniature, he stylized faces into sharply drawn curved and indented planes. He dwelt, when limning ex-President Madison, on the shrunken cheeks and the pouches under the eyes; he had no mercy on the dents and flushes of the septuage-

narian's face. From a pyramidlike body capped with the high collar then fashionable, he thrust with electrifying intensity the smooth, passionate, sensitive head of his young pupil, John W. Casilear.

In Durand's portraits color is low in key, yellowish on the faces. It adds variety to a basically black and white design. His labors with *Ariadne* had not enabled him to give painted flesh transparency, but the hardness contributes to the power of the shapes. Costume is enlivened by a few crisp details, which seem to crackle on the canvas. Composition is kept simple to serve the vitality of large linear designs. Without grace, entirely devoid of effects that did not grow from direct simplification of actuality, Durand's portraits convey with arresting immediacy individual character. This love of personality to the utter banishment of flattery was so suited to the realistic temper of the times that men flocked to be painted. However, portraiture was only one more step in Durand's evolution.

As a fellow member of Luman Reed's circle, he was drawn into close contact with Cole. In 1836, their shared grief at Reed's premature death propelled the two artists into a sudden intimacy that encouraged Durand to undertake what was to be his greatest field of endeavor.

Country-bred but trapped by his professional activities in New York City, Durand believed that "the vast range of beautiful creation should be my dwelling place." He had for years tried his hand at an occasional landscape. For material, he could usually go no farther than just across the Hudson to the meadows of Hoboken. On these brief holidays, he found that "the luxury of nature is so fascinating to my senses that I feel no disposition for anything but attempting to imitate her beauties, not by any actual view but by catching some lovely features." Wishing to record exactly the appearance of details — usually a clump of trees — he was, like Mount, impelled to take his oil paints out under the sky.

Impressive results were not at first forthcoming. His oil sketches were no more than dry renditions of his leafy models struck by an anonymous light before a backdrop of flat blue. When, in his studio he combined them into compositions, he used as cement the more realistic of the topographical clichés: decorative trees framing the view, obtrusive foreground detail, nests of genre activity in the second distance, contrasting planes going back in strips to a mountainous depth. Yet somehow in all the accumulation of smallness one feels a mind at work that is both large and sincere.

After Reed's death, Cole, suffering from deep depression, begged Durand to go with him on a sketching trip to lakes high in the Catskill Mountains:

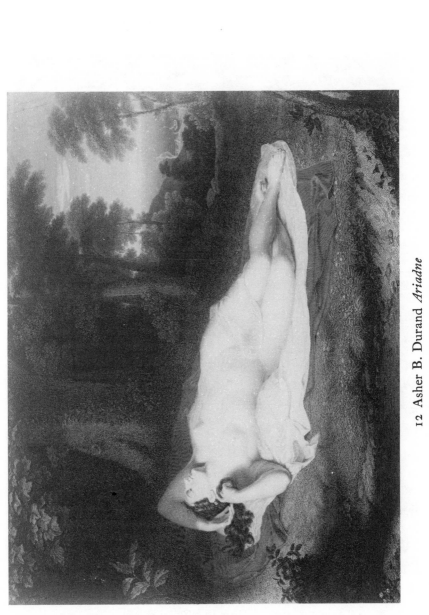

12 Asher B. Durand *Ariadne*

Engraving; 1835; 14³/₁₆ × 17¾; New York Public Library, New York.

13 Asher B. Durand *J. W. Casilear*

Oil on canvas; 30 × 24¾; New-York Historical Society, New York.

"You can have no conception of the kind of beauty, . . . lovely though wild."
A year passed before Durand could get away. Then he asked humbly what
oil colors he should bring. "I scarcely know," Cole replied, "what can be got
in bladders." But intrigued by this idea of actually painting out of doors, he
asked Durand to buy enough for both.

As it turned out, Cole found that making oil sketches overloaded his mind
with detail, and Durand was equally immune to Cole's heavy reliance on
memory. Unable to see nature the way his friend did, Durand continued his
independent efforts to pull towards greater naturalism the topographical
mode, sometimes, as in his *Sunday Morning* (1839), making an almost half-
way break between genre and view. Yet he still considered himself "a
trespasser" on Cole's grounds and wanted desperately to learn from the
only American who, so he wrote, could teach anyone to be a landscape
painter. As for the portraiture he had so recently mastered, he now consid-
ered it mere "fagging."

Having in relation to historical landscapes no strong convictions to inter-
fere, he tried to follow Cole in that direction. His two-part series, *The
Morning and Evening of Life*, mingled in the Colean manner humanity, time,
and architecture. The Arcadian shepherd is in the first episode a young man
beside a Greek temple; in the second, he is old, and the temple, of which a
few ruins remain, has been displaced by a Gothic church. The series has a
period charm, but critics damned it as an imitation of Cole, and Durand's
subconscious irritation at the whole mode may have inspired the dream
which he described in a humorous letter to that master. Cole, he wrote, had
showed him "what you introduced as a new kind of painting, which consisted
of a screen painted in part and the rest covered with actual leaves and
flowers, profusely interspersed with a variety of doll babies, and so much
attraction did it possess that I could hardly get a view in consequence of the
large number of ladies that were visiting you and expressing their admira-
tion."

In 1840, Durand sailed for Europe, taking with him three young engravers
and future painters: Kensett, Rossiter, and Casilear. During seven weeks
in London, he was impressed, as Cole had failed to be, by the "simple truth
and naturalness" of Constable's landscapes. Paris, where he stayed a fort-
night, excited him as if he were "on another planet." He found the Gothic
churches overwhelming. Although he considered the French historical
painters unchaste and corrupt, he could not help admiring their technical
achievements. Briefly in Brussels, he enjoyed Rubens's free and impulsive

manner that was so far from his own temperamental possibilities. Before the Renaissance masters in Italy, he felt, as Cole had, a sense of meanness in being a landscape painter, but he also felt a mounting fear, which Cole had never suffered, lest he be shaken off his feet and fail "to keep sufficient self-possession through all the sudden transitions and excitements." He was determined to call the Old Masters "trash," if they were so, but he was no longer sure which were trash. He was homesick, "bewildered, wretched, and desolate."

And then there was Claude, whose style called to him most strongly; he fought the hardest against Claude. Probably remembering Constable, he wrote that the Frenchman had "no knowledge of English effects, not even cloud shadows." Cole, so he wrote that friend, was "far above" Claude "in poetic conception" and just as true to nature. Claude was monotonous, for he attempted nothing but "a soft, unruffled day, no storm, not even a common shower." But yet when he looked at Claude's seaport scenes he became lost in their poetically wonderful renditions of atmosphere. Now that he had seen Constable and Claude, he was never again to show earth without air.

Having spent the winter in Rome, Durand returned to New York. His year abroad had, despite all resistance, reinoculated him with those romantic idealistic tendencies which he had halfheartedly adopted as a follower of Cole. Having been unable to carry his complicated oil equipment, he had made Colean pencil sketches. Now how he improvised around them semi-imaginary landscapes that, in emphasizing Europe's ancient civilizations, revealed how American was his eye. The foregrounds, which were always highly realistic, had an inescapable resemblance to his native countryside, while black-robed monks and castled cliffs in the middle distance carried no conviction whatsoever.

In a few years, "fancy" compositions vanished from Durand's output. This marked a major terminus. Romantic idealism and with it the Virgilian mode had died out as important directions in American landscape art. During the 1850s in his *Letters on Landscape Painting*, Durand expressed the typical Hudson River School attitude when he called views of nature just edged towards the high style "studied artificiality and imbecile attempts." They were suited to "the tourist and the historian" rather than the "true" landscapist. A landscape was "great in proportion as it declares the glory of God and not the works of man."

Durand's European experiences had been most beneficial in helping him to heighten and organize his realistic vision. After his return, he bound his

14 Asher B. Durand *Kindred Spirits*

Oil on canvas; 1849; 46 × 36; New York Public Library, New York.

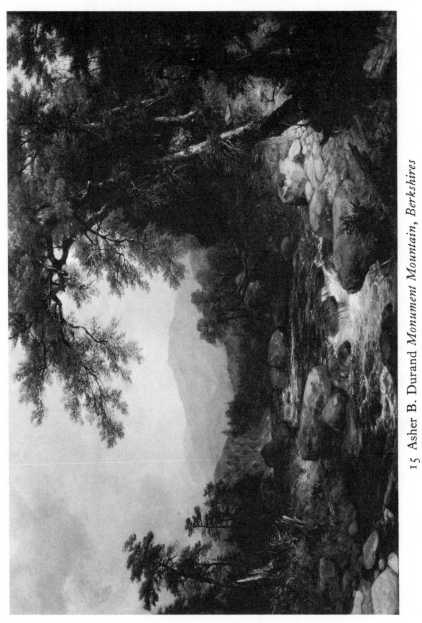

15 Asher B. Durand *Monument Mountain, Berkshires*

Oil on canvas; 28 × 42; Detroit Institute of Arts, Detroit.

forms more subtly together by tinting shadows with reflected lights. Now he saw that sunlight and shade, instead of dividing arbitrarily across the land, were part of over-all atmospheric effects that served to simplify detail and keep it from interfering too strongly with the larger view. Increasingly he subordinated genre elements as Cole had done in his later realistic landscape style. Figures, Durand wrote, should "work in union with the sentiment of inanimate nature, increasing its significance without supplanting it." Often no human beings inhabited his landscapes, and rarely now did he make them as conspicuous as they were in his *Kindred Spirits* where, to symbolize their shared love of American nature, he painted Cole and the poet Bryant standing in communion, side by side, on a cliff over a deep Catskill gorge.

The self-graduated engraver had been shaken by the rich color of men like Rubens and Constable, which he lacked the knowledge to duplicate. In his published *Letters*, he repeated self-defensively the neoclassical doctrine that "fascination" with color endangered those "higher qualities" achieved by accurate drawing. Yet the man who painted so passionately out of doors could not really believe this. He was faced with a dilemma.

Durand rejected the way out pointed by romantic landscapists he had seen in Rome — was one the German Karl Rottmann? — who sought "fine qualities of color without local meaning." To depart from direct and detailed reliance on nature into subjectively emotional hues could only, Durand was convinced, weaken. "There is no tint of color, nor phrase of light and dark, force or delicacy, gradation or contrast, or any charm that the most imaginative imagination ever employed . . . that is not seen in nature more beautiful and fitting than art has realized and ever can."

After Durand's return to the United States, Ruskin's writings fascinated him with the sky-painting of Turner. He collected engravings after Turner which he classified according to the words of Ruskin — but that was not much help.

Like Mount, Durand made his own open-air experiments, producing canvases rawly original in their bright splashes, but more startling than successful. Color, he mourned, was "a sort of humorous sprite or good demon, often whimsical and hard to control, . . . spoiling many a good picture as if with malicious intent."

In such typical paintings as *Monument Mountain*, Durand held his colors in place with what had been his basic tool as an engraver: black and white "values." Gray, he wrote, although never visible, was the most important hue to a landscape painter, since it modified local color, without dissipating

it, "according to distance." As the eye went back in the picture, the darks became lighter, the lights softer and weaker, until at last the mingling of light and dark resolved into comparative uniformity. Thus Durand achieved his silvery-gray tonality that is true to what the eye sees on a clear summer day after bright light has dulled its sensitivity to color.

Atmosphere, Durand stated, "carries us into a picture instead of allowing us to be detained in front of it." Since he communicated distance through modifications of light caused by variations in the depth and consistency of air, his method built into the structure of his paintings aerial effects. If this forced him to subordinate to his general scheme sharp variations of brightness and all evanescent effects — the angry flashes and the frivolities of the day — in losing intimacy he gained a sense of enveloping mood, a mellow grandeur.

For the formal compositions European landscapists employed, Durand had no use whatsoever. His effort was to make the scenery, although subtly unified, seem uncontrolled by human intelligence. Often he painted panoramic stretches from a high vantage point. His prospects of forest and field rising in ever increasing wildness to hills and then to the unbroken shagginess of mountains lack the tactile values with which Cole invested similar views. However, although the land is less firm, there is more sense of air. And the mood is quite different. Where Cole's feelings rushed onto canvas, Durand's express themselves through a Puritan reserve. His paintings convey a sense of worship, as grave as religion and as grateful as a happy heart. They were, a critic wrote, beloved of all Americans, "for they appeal to and satisfy the deepest emotion of the soul in their deep thoughtfulness, their quiet and serene beauty, and their sweet poetic suggestion."

Since Durand was particularly admired as a portraitist of trees, a patron would sometimes specify the species he wanted in his picture: black birch, pine, hemlock, beech, etc. According to the critic Henry T. Tuckerman, such sylvan views would suffer from "a paucity of objects" were not each tree "so characteristic" in "bark and foliage" that "the senses and mind are satisfied." Why should Durand pull in moldering castles when "every moldering stump beside a pool" enchanted "like an old friend"?

Tuckerman was referring particularly to the close-ups of nature which became an important part of Durand's practice during the early 1850s. Their intimacy gave them some resemblance in approach to the then emerging Barbizon School, but no European painter had ever experienced what Durand was seeking to express. Only where land and firewood existed in superabundance were forests left so utterly unedited: their fungus-shrouded dead moldering at the feet of the living while saplings rising from a prodi-

gality of seed fought with each other and the overhanging giants for the sun's filtered rays. To see at all, Durand had often to sight down streams which the birds he painted were using as passages through the silent riot of the forest.

Finding beauty, proof of God's abundance, in this dark, damp world, from which Cole would have shuddered, Durand scorned to smooth out the welter, crowded his canvas with lovingly studied detail. He painted individual leaves sharp in the foreground; he clearly outlined middle-distance sprays; he showed between low branches and underbrush glimpses of sky. The foliage that crowds the tops of his pictures filters the sunlight to a dappled gloom through which tree trunks, standing and fallen, glow in a multitude of dim colors that shade from the gray-white of fungus to the red of wet wood and the black of wet bark. Here is a heightening of vision, but the object is not, as in modern surrealism, to invoke the strange. Durand intensified the familiar.

To achieve composition in these cluttered canvases through a balance of forms would have weakened verisimilitude: Durand balanced stresses. His *In the Woods* features spaced horizontal logs that, pressing into and exaggerating the flatness of the clearing, help to create a downward pull that establishes equilibrium with the upward thrusting of the forest. Such pictures, although based somewhat on the practice of Cole, represent Durand's most extreme new departure in landscape art.

After Cole's death, Durand took over as the acknowledged leader of American painting. He was president of the National Academy from 1846 to 1861. Unlike Cole, he never engaged in conscious rivalry with the greatest masters. Trying each day merely to paint better than he had the day before, he led his younger colleagues in the evolution of the basic Hudson River School manner.

Although aimed at describing his own ideas and practice, *Letters on Landscape Painting*, which Durand published serially in the *Crayon* during 1855, is one of those rare documents that summarizes the spirit of a group and a generation. The conceptions expressed had been communally evolved in many a discussion at the National Academy and under the stars during sketching trips. They had backgrounds in European esthetic theory, and in the less formal aspects of American religious thought. They were so much in the air that many a landscapist glimpsed them before he got to New York City or Durand's *Letters* were published. They appeared in the writings of all critics who were sympathetic to the Native School.

Basic to this esthetic were optimism and a pantheistic reverence for

inanimate nature. Neither Durand nor any of his important followers — they were invariably American-born and raised — shared with the transplanted Englishman Cole any interior dichotomy between Old World teachings and American experience. They had always inhabited an abundant continent which because of its very newness showered prosperity and happiness on self-reliant man. Far from seeking with Cole the refining influences of humanistic and religious precedent, they avoided in their search for inspiration all traditional institutions, including churches. Typically, Durand celebrated the Sabbath by going out into the fields "the better to indulge in reflection unrestrained." Nature, he wrote, "in its wondrous structure and functions that minister to our well-being is fraught with high and holy meaning, only surpassed by the light of Revelation." The object of a painted landscape was to evoke "the same feelings and emotions which we experience in the presence of reality."

Against the classical conception that man was elevated by reason based on learning, aspects of international romanticism argued in an increasingly scientific age that man was primarily influenced by what he experienced. If debased by association with the bad, he was purified by association with the good. An inevitable corollary was that a painter who expounded on canvas landscapes that were instinct with divinity created a visual sermon which would elevate all who examined it. Although more philosophical writers than Durand argued out this doctrine more completely, its assumptions were inherent in his esthetic and did much to explain the wide popularity of the Hudson River School. Thus was overcome the fear that had so long worried American democrats that art was a useless luxury, a toy for the idle that could not be afforded by a nation that had its way to make. In a society that wished to merge the moral and the practical even the most pragmatic minds were drawn to pictures that brought to the people God's tangible word. A painting over the fireplace was as much a necessity as a Bible on the table.

Undisturbed by admixtures of older artistic doctrines, the Hudson River School applied their philosophical conceptions with a resolute completeness. Even as a theologian would be blasphemous if he rewrote Scripture, a painter should not distort the natural phenomena that were, as Durand put it, "types of divine attributes." The artist's concern was not self-expression but reverent interpretation. Whereas Cole had sought by means obviously painterly to carry the viewer away from nature into his own vision, Durand wrote that "freedom of execution" was what the artist should all his life

try to get rid of. He had no use for Cole's rugged brushstrokes that expressed the roughness of foliage by symbol more than actuality, for Cole's blasted tree with anthropomorphic connotations, for those of Cole's light effects that were emotional rather than accurate. Durand agreed with Mount that ability was shown by skill in subordinating means to results, so that the viewer would feel he was not looking at a picture but at nature's own face.

Although Durand admitted that distant objects like masses of foliage could not be exactly rendered, they should be summarized as realistically as possible. Foreground details should be reproduced with "minute portraiture," since this would lead to knowledge of "their subtler truths." Color, light, and atmosphere should be as accurately recorded as was possible for art.

Yet the Hudson River School esthetic did not seek what we would today call a photographic reproduction. Durand considered "servile" imitation "in every way unworthy." Although a painted landscape should be "true," the viewer should get more from it than from an unassisted ramble through nature. "The artist as a poet will have seen more than the mere matter of fact, but no more than is there and that another may see if it is pointed out to him."

This seeming paradox the Hudson River School resolved by insisting that the ideal was not opposed to the real but its perfection. The painter carried man closer to the divine by presenting exactly those aspects of nature that most elevated his own emotions, which were conceived of as being more sensitive than the emotions of persons not esthetically gifted yet in essence the same. Although Durand did not make the analogy, he urged such communication of "inner light" as a Quaker preacher engaged in when he rose in Meeting to share with his less pious fellows the words which God, operating within his own breast, had requested him to say.*

The esthetic inner light inspired not imaginative flights but ecstatic selection. As Durand put it, the artist was given "unbounded liberty" by his duty to "perceive" in "the infinite beauty and significance of nature . . . the time and place where she displays her chief perfections." Should that be found, "the artist will have no occasion to idealize the portrait." The difficulty was rather the other way: to catch the portrait at all, even in a

*The American painters thus found a solution, satisfactory to them and their compatriots, for a problem that according to the distinguished Austrian historian Fritz Novotny, bothered European art throughout the nineteenth century. Novotny points to "the failure, save in rare instances, to achieve a synthesis" between "closeness to nature and idealism."

diminished form, required all the labors of which the human hand and sensibility were capable.

In stating that the artist's method was "selection," Durand seemed to be returning to neoclassical principles. We can read old ideas into his statement that "when you have learned all the characteristics of an oak as an oak you will be prepared to apply these ... to the production of the ideal oak." But there was profound difference. Recognizing evil in creation as well as good, the neoclassicists used their reasoning power to "abstract" away what was evil and thus ugly. But Durand regarded what appeared to be evil as a superficial misconception and distortion of creation's underlying goodness. For him selection meant in effect intuitive synthesis which revealed all characteristic forms in the high and noble manifestations which he believed were inherent in whatever was real. Artistic progress was an ever deeper penetration into the infinite goodness of the divine. Ultimate beauty combined perfect details into "a perfect whole."

Such a search for ultimate values could have encouraged a retirement from personal observation into the gradual acceptance of established ideal forms. From this danger, which Durand defined as "the substituting of an easily expressed falsehood for a difficult truth," the Hudson River School tried to protect itself by refusing to accept any art, even a painter's own previous achievements, as an alternate inspiration to perpetual examination of nature.

Durand warned beginners that starting under the tuition of an experienced painter, although it might seem a saving of time, was in fact "pernicious." Even visiting exhibitions placed a young man "in danger of losing his individuality." Only after a painter had learned by himself "to imitate nature" could he "study the pictures of great artists with benefit. . . . Books and the casual intercourse with artists, accessible to every earnest student, will furnish you with all the necessary mechanism of the art."

The beginner should "go first to nature to learn to paint landscape," and in her presence he should (as Durand had originally done) "scrupulously accept *whatever* she presents." Only after he had become "in a degree familiar with her infinity" might a young artist venture "to choose or reject some portions of her wealth." However experienced he became, so Hudson River practice dictated, the painter should spend every summer walking under the sky, keeping his eye keen with new vistas, new beauties.*

*This unceasing wandering inspired the German-American critic Wolfgang Born to the witty conclusion that curiosity played the role in American art that tradition did in the European.

But in these walks, artists, Durand wrote, should not seek extremes. He spoke for the body of the Hudson River School when he attacked those important exceptions who, as he put it, "make long journeys in search of the picturesque in order to gain attention and win applause, when by the common roadside . . . nature has furnished elements of ideal beauty . . . more essentially beautiful . . . than any abortive display of the grand and striking features of nature." Young artists in particular should avoid "rare and extraordinary effects" when "simple and familiar passages . . . like the domestic virtues" strike more at the heart. Such pictures, "being appreciable by all, will be more certain of just and ample reward."

Although he stated that he did not wish to limit the universality of art with patriotism, Durand pointed out that depicting scenery "yet spared from the pollutions of civilization affords a guarantee of reputation of originality." If they remained "untrammeled, . . . free from academic and other restraints," Americans could "in accordance with the principles of self-government, . . . boldly originate a high and independent style based on our own resources."

Towards this end, Durand's own contributions were great. He produced strong paintings which combined with his writings and his personal influence to ground the landscape art of a young, exuberant, and rapidly expanding nation on a sound if limited technique, religious faith, lack of ostentation, and a deep sincerity.

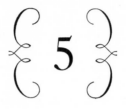

BEFORE THEY BIT THE DUST

Painters of Indians

ALTHOUGH white men and Indians had lived side by side on the North American continent for two and a half centuries, no profound pictures of the aboriginal life had resulted until the 1830s. In that single decade, three gifted artists — George Catlin (1796–1872), Karl Bodmer (1809–1893), and Alfred Jacob Miller (1810–1874) — were propelled independently of each other beyond the western frontier.

International curiosity about the appearance of the New World's exotic inhabitants had, of course, flourished since the earliest explorations. Under reigning esthetic theories, it could be satisfied only on the vernacular level. If scenes depicting unelevated white men were mean, how much meaner were paintings of men still in the Stone Age, with no recorded history and immune to classical restraints! When romanticism raised in opposition to such restraints the conception of "the Noble Savage," he was not thought of as a barbarian who would take your scalp. He was such a philosophical abstraction, imbued with benevolence and homely virtues, as Cole painted, in preference to his aboriginal neighbors, into the first episode of *The Voyage of Life.*

Americans had special reasons for not correlating the Indians with any ideal. Until after the French and Indian War, no colonial center could feel altogether immune from sack by France's red allies. The Revolution brought with it an upsurge of Indian "atrocities." And then the tribes fought back when settlers poured into the Mississippi Valley. The only good Indian was a dead Indian.

Down the generations, professional artists had done their best to keep away from the wilderness. Indian illustration developed here and abroad as a tradition largely independent of reality. Originally based on engravings after two sixteenth-century European explorer-artists, Jacques Le Moyne and John White, modified from imagination and travelers' rough sketches, this tradition showed the Indians as grotesque Europeans in feathers. Although the Iroquois had played an important role in white history from 1614 until after the Revolution, their culture survives in no adequate pictorial representations.

For such sign painters' art as Quidor's, use was made of the fact that if pretty girls were tinted brown, they could be displayed in the seminude. Another line of interest was heraldic. Seeking a non-European symbol for themselves, Americans often adopted the Indian, a line of thinking that discouraged depicting him for his own sake. Into this welter Cooper rode with his good Indian who was the English settler's friend and a natural philosopher, his bad Indian who obeyed French Papacy and his own savagery: conceptions that did not urge Cooper's illustrators towards validity.

It was in portraiture, the only mode in which serious painters could traditionally pursue the documentary, that the few effective Indian images had been made. Chiefs on missions to the white men were recorded in the centers of civilization. This activity was regularized in 1824 when the Secretary of War, who was in a position to know, prophesied that the Indians were, as a race, "about to become extinct." That their appearance might not vanish with them, he approved the commissioning, by the Indian Department, of a collection of portraits. Charles Bird King (1785–1862) was to paint Indian ambassadors at Washington, James Otto Lewis (1799–1858) at St. Louis.

A one-time student of West's, King was a conventional artist of the old school; Lewis was an incompetent primitive — yet each in his own way showed what a boon the gaud of Indian costume could be. King built color harmonies around red skin and glowing ornament; Lewis marked down wildly gleaming painted dolls. Both, like the Indian portraitists who had preceded them, suffered, as Lewis realized, from a lack of understanding. Having never seen the Indians in their native habitats, they could not imagine what went on behind the brows and eyes of these uneasy visitors in an alien environment.

As the 1830s approached, the active rivalry with the Indian that had for generations prejudiced white American vision temporarily abated. Settle-

ment, which had for half a century spread into the huge area between the Alleghenies and the Mississippi, was pausing to close its ranks. There was no warfare. West of the Mississippi, on the badlands and the plains, in the mountains, aboriginal culture was still intact. But it was manifest that the next sweep would roll the Indians under. There is an emotional appeal in a helpless enemy, and the hunter has a strange love for what he is about to destroy. Do not fishermen expatiate on the beauty of the trout whose death struggles they incite and supervise?

Natural history had long been a favorite field for American savants since they possessed unique material that was of interest everywhere: the variant plants and animals of a new continent. About 1807, Audubon had started combing the wilderness for birds. Although, here as in Europe, the scientific study of man had not yet emerged from theology, traditional philosophies, and disdain for primitive cultures, it was becoming increasingly clear that if Indian culture was not recorded at once, it would be lost to the world forever. As Catlin was to write, the animals would remain when the proud warrior existed only in memory.

When Lewis and Clark had sought a land route to the Pacific (1803–1806), they had collected flora and fauna but taken no artist to record what could not be carried home. However, when Major S. H. Long went across the Great Plains to the Rockies in 1819–1820, he employed Samuel Seymour (active c. 1796–c. 1825), an English illustrator then resident in Philadelphia. Seymour's images of plains and mountain, Indian council and Indian dance were no more than rudimentary, yet they attracted attention, as did the even more naïve watercolors produced in St. Louis by Swiss-born Peter Rindisbacher (1806–1834), who had been brought to the extreme frontier in 1821. The stage had been set for George Catlin.

Catlin's dark, hook-nosed face might have been an Indian's except for his incongruous blue eyes. Raised in Pennsylvania's Wyoming Valley among the survivors of the American Revolution's bloodiest Indian raid, he heard from early childhood tales of captivities in the wilderness. "My young imagination closely traced the savage to his deep retreats, and gazed upon him with dreadful horror, till pity pleaded and imagination worked a charm." Hating book learning, he played so realistically that he was one of "nature's wildest men" that he carried to his death a tomahawk scar accidentally carved in his cheek by a ten-year-old companion. But even deeper was the Indian sign on his heart.

Catlin's lawyer father sent him to Tappan Reeve's law school in elm-

quiet Litchfield, Connecticut. But the youth was unwilling to learn anything from anyone else. He set up as a determinedly self-taught painter.

Arranging naturalistic details in a pattern, Catlin started like any other naïve artist. However, while other ambitious beginners labored to escape from this practice into such naturalistic simulations of continuous reality as were then admired, Catlin stubbornly labored to deepen the schematic approach of the primitive. He further enlarged, simplified, and separated individual elements until they were transmuted into symbols. Thus, he attempted to express Niagara Falls by placing beside a brown column representing a cliff two irregular rectangles, the upper connoting sky, the lower falling water. The problem was too great to be solved by his unaided experimentation.

In portraiture, his method worked passably for miniatures, but foundered with every increase of scale. Neither his eye nor his imagination could extract from the faces and clothes of his fellow citizens any effective summations. Dunlap ruled Catlin's full-length of Governor Clinton, painted for New York's City Hall, "utterly incompetent." To achieve mass, Catlin had made the unfortunate statesman's body, in its wrap-around cloak, resemble a staved-in barrel. The face, from which all lines have been abstracted except those around the mouth, seems that of a pickerel about to snap at a minnow. To paint with such conviction so large and frightful a picture, and to get it accepted, took the hypnotic myopia of a genius or a madman. Catlin, indeed, reacted with rage to the refusal of his colleagues to hang his pictures in the best positions at the National Academy. Yet all his self-confidence did not bring him much portrait business.

Turning his hand to any task that would make a dollar, from drawing for lithographers to building a working model of Niagara Falls, Catlin seemed another eccentric on the borders of the fine arts — but already he had experienced the exterior vision that would enable him to close the fissure between his personal way of seeing and the naturalism that was welling everywhere in our art.

When at Philadelphia in about 1824 Catlin had seen a delegation of Far Western Indians who had "strutted about the city ... equipped," as he wrote, "in all their classic beauty with shield and helmet, tunic and manteau –tinted and tasseled off exactly for the painters' palette." Embellished face and picturesque costume presented endless designs for such a brush as his to work upon.

To this inspiration, Philadelphia had added another: the museum estab-

lished shortly after the Revolution by the painter Charles Willson Peale, where pictures were combined with specimens into displays of natural history. Catlin resolved to found, on a similar basis, an "Indian Gallery." He would journey to every tribe still extant in North America, collecting examples of their manufactures and weapons, "bringing home faithful portraits of their principal personages, . . . views of their villages, games, etc., and full notes on their character and history." Thus, he would "snatch from hasty oblivion . . . a truly lofty and noble race."

The scheme appealed to many sides of Catlin's wild nature. Not only would he find use once more for the rifle and fishing tackle that had been the delights of his childhood, but he would escape "the killing restraints of society where a painter must modestly sit and breathe away in agony the edge and soul of his inspiration waiting for the sluggish calls of the civil."

It was 1830 before Catlin earned enough from "the civil" to get away. That summer and probably the following one he spent in the territorial capital, St. Louis, painting the chiefs who came there. When in 1832 the American Fur Company sent its first steamboat up the Missouri, Catlin went along, mounting the river two thousand miles — the second thousand through country almost completely uncivilized — to Fort Union in what is now northwestern South Dakota. He stayed on when the steamboat returned, and finally drifted back to St. Louis in a tiny skiff, visiting the tribes on the banks.

The next year was given to completing pictures and exhibiting them in Pittsburgh, Cincinnati, and Louisville. Then, in 1834, he started out from Fort Gibson (Tulsa) across the southwestern plains to the Rockies. Taken sick, he was left behind with the Comanches in present-day southwestern Oklahoma. In 1835, he journeyed up the Mississippi to the head of navigation, Fort Snelling (St. Paul), and subsequently up the Des Moines River to the headquarters of the Saux and Foxes. The year 1836 saw him seeking the sources of the strange substance from which Indian peace pipes were made. He found it in what is now the southwestern corner of Minnesota. Scientists were to name the mineral "Catlinite."

These explorations, plus paintings of still-untrammeled Indians when they showed up in civilized places, were the basis of all Catlin's important work until the last phase of his career.

The Indians exceeded his expectations for "beauty and wildness," and each, he decided, was happier than "kings and emperors . . . in the simplicity of his native state." How Catlin would have scorned Thoreau's effort to

[70]

achieve, by building a cabin not too far from Emerson's kitchen, an approximation of what the Indians did naturally! Of course, Thoreau thought high philosophical thoughts, and the Indians did not, but Catlin believed that "the search for refined knowledge and pleasure" only caused pain.

Among the savages, Catlin found theoretical support for his congenital unwillingness to study in any accepted school. If, as Durand and others argued, Nature was the great teacher, did it not follow that she was at her greatest when completely uncivilized? As for Durand's idea that a workman already deeply versed in nature could gain method from studying art, Catlin would accept no such hedging. "The elegant polish of the polite world" created only "fleeting fashions" and "disguises." In wigwams, he felt "unceasing excitement of a higher order from the certainty I was drawing knowledge from the true source."

To his romantic insistence that "a state of primitive wildness and rudeness" created ideal beauty, Catlin linked neoclassical admiration for the perfect bodies of the ancients, and then threw in the Middle Ages for good measure. The Indians, he wrote, were "knights of the forest, whose lives are lives of chivalry and whose daily feats, with their naked limbs, must vie with the Grecian youths in the beautiful rivalry of the Olympic games."* He had found "the new and true school of the arts."

Still rarely visited except by fur traders who sought their favor, the Indians did not realize their extinction was at hand; they accorded white men their customary hospitality. They had, Catlin found, "feelings to meet feelings"; he quickly made friends. While official ethnology was still a correlation of chance writings by travelers and missionaries, Catlin joined in the Indians' games so that he could move on to ceremonies. "Their superstitions and mysteries," he recognized, were "the keys to Indian character." Although invited to sex and torture ceremonies so inconceivable even to scientists that his reports of them were branded as lies, he never doubted that the Indians were motivated by "thoughts, reasons, sympathies like our own." This identification, growing from shared emotion, endowed his paintings with depth. Expressing simultaneously familiarity and strangeness, they entice the viewer within the Indians' skins, communicate a sense of thinking thus and being thus feathered.

Catlin was a writer of awe-inspiring eloquence who deserves a high place in the histories of American literature, which usually fail to mention his

*West had foreshadowed this conception when, as a new arrival from America, he had in 1760 amazed Italian connoisseurs by crying out in the presence of the Apollo Belvedere, "My God, how like a Mohawk warrior!"

name. In this second skill he surpassed Cole, but, unlike the landscape painter, he did not confuse the two arts. Although his books add to vivid reportage moving attacks on civilization for destroying a savagery more noble, Catlin painted no editorials. He never depicted braves driven by brutes from the bones of their ancestors, or tried to appeal to white sympathies by painting his tribesmen sentimentally, as if they were distressed Europeans.

Catlin argued that most of the plains country — any smaller area would destroy free-roving savage life — should be made a "park" where the Indians would be undisturbed for the inspiration of future ages. But he had seen too much of land hunger to believe this was practical. He knew the beauty of the untamed tribes would vanish from the actual world. The only hope for its preservation was in his own hands. "I have flown to their rescue" so that "phoenixlike they may rise from 'the stain on the painter's palette.'" He pursued his mission with a grave sense of its importance. Although he sometimes told tall stories in his text, he painted with passionate accuracy. That he showed more than mere matter of fact, expressing emotion also, that he was too swept by inspiration to keep unscrambled the identifications of his subjects, has not kept modern ethnologists from accepting Catlin's pictures as scientific documents of primary importance. In his writings he was often a romantic idealist; in his paintings he was only a romantic realist.

When Catlin was painting beyond the frontier, Durand had not yet set for landscapists the fashion of working directly from nature. However, the depicter of Indians felt it would damage the authenticity of his images if he translated on-the-spot sketches into studio pictures. On his back he carried oil, pigments, and a tin case of rolled canvases.

His practice was greatly influenced by the need for speed. During eighty-six days in 1832, Catlin traveled some fifteen hundred miles, held ingratiating palavers with Indians and fur officials, hunted and took part in ceremonies, suffered bouts of sickness, and painted about 135 pictures: some 66 portraits, 44 genre scenes, and 25 landscapes.

Rapidity was further urged by the Indians' reactions to being painted. They would at first refuse — since the eyes in the portraits remained open, subjects feared they would never sleep again — but once long arguments overcame magical terrors, whole populations gathered around Catlin's easel. As in a barbershop with one chair, everyone clamored to be the next. Compatriots had to be taken in strict order of protocol. (Catlin had great difficulty painting a woman without outraging all unpainted males.) If

braves from two nations were present, rivalry expressed itself in "sidelong looks of deep-seated hatred and revenge." While tension mounted, Catlin felt impelled to finish each likeness as speedily as possible so that he could calm the other tribe by beckoning to one of them. But even his greatest efforts could not always forestall trouble. How could Catlin foresee that painting a brave in profile would touch off a murder when an enemy tribesman shouted that the picture proved the sitter was only half a man?

Having done faces, particularly the eyes and expression, as carefully as he dared, Catlin dashed in outlines of figures and dress with long strokes of sepia brown. Then he recorded in quick pencil drawings details of ornament he might wish later to include. Lacking time to make mixtures, he commonly used in their pure form the same dozen pigments — tawny brown, green, gray-blue, vermilion, etc. — he had brought with him. To save irreplaceable color, and so that the canvases would dry quickly for rerolling as he prepared to move on, he painted thinly. All his pictures had to be finished after his return to civilization. However, his theories urged him not to retouch the forms that had been completed on the spot, but rather to work around them in the same few pigments, with matching thin, quick strokes. His art remained improvisation, to which end his schematic style was well suited.

Audubon, who held, so Catlin wrote, "a rank between nature and art," had found birds' plumage well suited to the pattern-making in sharply contrasting bright colors of a semiprimitive technique. The plumage and body paint of Indians served Catlin equally well. Faces, torsos, and costumes were covered with designs, visually interesting and to Catlin humanly moving: these he laid side by side on canvas with simple power. Far from strengthening the sketchiness of the hands he had painted from life, he made it an effective aspect of composition. His lack of knowledge of anatomy did not prevent his full-length figures from standing powerfully upright (a feat at which even such skillful painters as Whistler sometimes failed). But his means depended on the surface image; thus the falling line of a feather headdress would contribute more to a springy stance than any underlying balance of weight on bone.

Depicting birds, Audubon profited from the small scale of his subjects that was perfectly attuned to episodic designing. Catlin's Indian portraits were the more consistently effective the smaller he made his figures. When he placed on the standard canvases that fitted into his carrying tube, not a full-length perhaps on horseback, but a bust likeness at life size, he found the

area of twenty-eight by twenty-three inches hard to fill. The powerful main forms are too often surrounded with lax places where the intensity fades.*

Uneven as they were forced to be by the circumstances under which they were painted, with all their crudities upon them, Catlin's Indian portraits were an esthetic achievement of great originality and power. Yet, since individual Indians had long been painted when they visited white settlements, the likenesses excited his contemporaries less than his landscapes and genre scenes.

Until Catlin recorded them, the badlands of Missouri had been invisible to all mankind except tribesmen and fur traders. Painting the bare hills as they receded from a chugging or a drifting boat, Catlin caught the shape of the land in tactile cones and dips. He applied the few colors he had brought along that were usable for landscapes to large areas, with little modulation except that heavy shading which contributed strongly to shape. The resulting images were marvelous and strange, like the surface of the moon. Sometimes Catlin would further emphasize the tossing of the land by including lines of buffalo curving with the hills. Or he would place in the foreground, where the rude swellings focused, a huge, shaggy, wounded, bleeding, dying, but still defiant bull. These were the first realistic buffalo known to art.

Catlin's genre scenes usually included hundreds of figures, each sketched quickly with a few strokes of the brush. To give the pictures what composition they had, he grouped his characters into crowds kept separate and balanced against each other. Drawn with an emphasis on motion that ignored anatomy, exotic in feature and costume, his protagonists are engaged in activities outside white experience. They sit in strange habitations, raise their dead on high platforms, endure ritual tortures, anxiously watch a medicine man dance. Because of strangeness, the effect is sensational, but Catlin's objective was not sensationalism. He played down that warlike ferocity which their white enemies liked to regard as the only important attribute of the tribes. Although he witnessed a skirmish between two nations, he did not paint it or any scene of Indian fighting.

The most convincing renditions of the Indians as bloodthirsty devils were created by the second of the three major depicters of Indians, Karl Bodmer.

*A book-sized color reproduction of one of Catlin's portraits can be more effective than the original, since the small scale pulls the composition together, while the few, bold colors are admirably attuned to printer's ink. Herein lies a principle which helps explain the current fad for "American Folk Art": paintings which achieve complicated effects through rich techniques lose strength when reduced to make illustrations, but naïve works usually gain. At a time when few people are — alas! — familiar with original American paintings, editors prefer to publish and praise the works that best dress up their pages.

Born during 1809 in Switzerland, Bodmer received his main artistic training in Paris, where romantic idealists like Delacroix were finding in Africa a violent exoticism that suited their dreams. This attitude Bodmer to some extent imbibed, although it was the scientific aspect of Europe's new concern with the non-European world that propelled him across the ocean. He had been retained as an illustrator by the German explorer and botanist Maximilian, Prince of Wied-Neuwied, who wished to follow his distinguished book on Brazil with one on the unexplored West.

Maximilian's party reached Boston in July 1832. They spent the winter with the philosophers who had colonized New Harmony, Indiana. In the spring of 1833, they went up the Missouri in the steamboat that had carried Catlin the year before. They continued in a keelboat farther north than Catlin had gone; and then returned downriver to spend the winter with the Mandans. In the spring of 1834, Bodmer returned to Europe, his American adventure over.

Bodmer's assignment had been to prepare accurate renderings for a mammoth atlas of engravings that would accompany Maximilian's text. As a draftsman, he exhibited all the skill of his French training. Whether completed on the spot or put together from sketches in Paris, his pictures have, as Bernard De Voto wrote, "the force and selectivity of medical art: . . . a clarity, emphasis, and separation of parts beyond the capacity of the camera lens."

Since the engravings were to be hand-tinted, Bodmer used watercolor. He applied washes freely when indicating sky or water, but for human or animal figures and foreground foliage, he carefully filled in drawn outlines. His color sense showed training and helped bring to his views of civilized scenery an informal charm. However, his sophisticated eye, bothered by the weird hues of the plains and badlands, fled from such unacceptable reality into formulas, often keyed to the salmon-pink skies beloved of European romantics. He found even more troublesome, when he delineated Indians, the bright patterns of paint, tattoo, and costume in which Catlin reveled. Trying to tone barbaric gaud into correct harmonies, Bodmer often sank into artificiality. His most effective likenesses of Indians are done in gradations of gray.

Bodmer's Indian masterpiece, *Bison Dance of the Mandan Indians*, exists only in engraved form, although elements can be found among his on-the-spot drawings. It is revealing to compare the print with Catlin's oil of the same subject. The American superprimitive lacked the control of depth

necessary to indicate space separating figures placed one behind the other in the same picture plane: he had either to string a few individuals across the foreground or to move his action back and treat crowds as masses. His Mandan *Bison Dance* is a panoramic view. But Bodmer used expert space construction and brilliant anatomical draftsmanship to carry us terrifyingly close to the half-naked dancers and communicate a ferocity entirely outside Catlin's range.

Both artists made portraits of the same Mandan medicine man (called *Mah-to-he-ha* by Catlin, *Mato-tope* by Bodmer). Bodmer gives us a strongly convincing view of the outside of a savage-faced man in wild regalia: this is a superb illustration. But Catlin communicates in a moving design the essence of a human being. Beautiful rather than impressive, his picture opens the doors of imaginative understanding.

The third of the able artists who crossed the frontier in the 1830s was the son of a successful Baltimore grocer. Alfred Jacob Miller had studied portraiture with Sully and then gone to Paris with the conventional ambition of becoming a historical painter. Among other pictures, he copied Alexandre G. Decamps's *Arabs in Cairo.* However, he was less ambitious than happy-go-lucky, and thus, when he returned to America after two years, he followed the line of least resistance, which was to travel from well-established city to city as a portraitist. He would probably be remembered only as a provincial artist of unusual skill had not fate called on him disguised as a much-mustachioed Scot of military bearing.

Miller's visitor, William Drummond Stewart, was a psychological casualty of the Napoleonic Wars, who had tried to recapture lost excitement through writing Byronic novels and wandering the Indian country. Finally called home by succession to the family baronetcy, he hired Miller to accompany him on a last hunting trip and prepare painted souvenirs for his Scotch castle's walls.

And so in 1837, when twenty-seven years old, Miller found himself, without any planning of his own, on his life's one high adventure. He was so little of an outdoor man that as he accompanied a fur traders' caravan overland to the Rockies along the River Platte (the future Oregon Trail), he resented having to catch his own horse each morning — that entailed running "a considerable distance in moccasins." He did not share with Catlin any sense of mission; he was not held down with Bodmer by requirements for scientific accuracy. His task was to record, for future transcription into large oils, a miraculous holiday. The very strangeness of the experience to

[76]

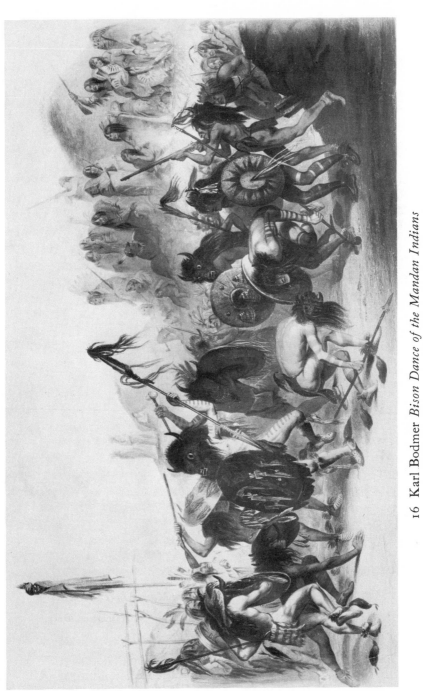

16 Karl Bodmer *Bison Dance of the Mandan Indians*

Engraved by Alexander Manceau; 13 × 17; New York Public Library, New York.

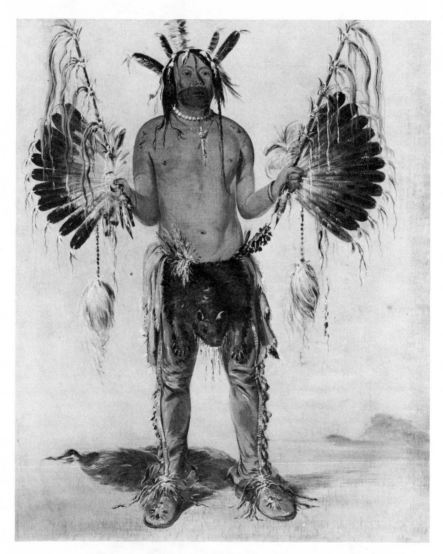

17 George Catlin *Mandan Medicine Man: Ma-To-He-Ha*

Oil on canvas; 1832; 28 × 23; Smithsonian Institution, Washington, D.C.

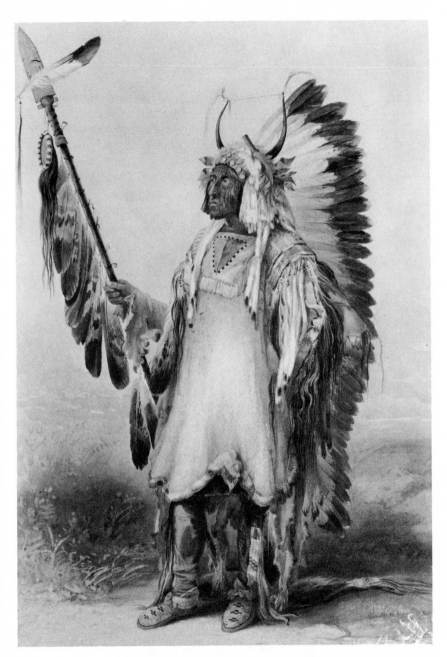

18 Karl Bodmer *Mato-Tope*

Watercolor on paper; 1833–1844; 22 × 17; Knoedler Galleries, New York.

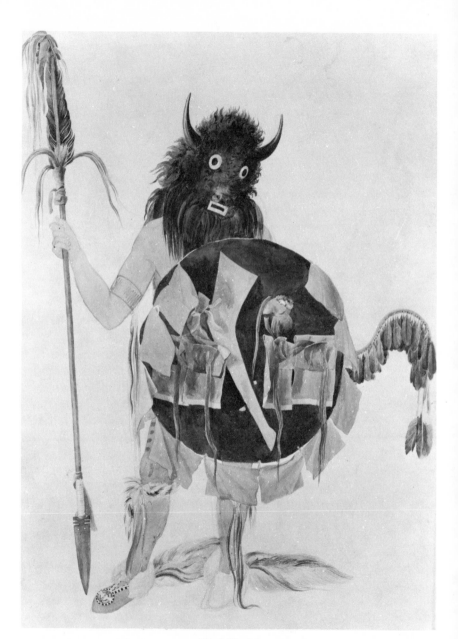

19 Karl Bodmer
Figure later incorporated in Bison Dance of the Mandans
Watercolor on paper; 22 × 17; Knoedler Galleries, New York.

one of his temperament increased his sense of wonder. He thought his way into nothing, and his art abandoned thinking. In wandering through a pristine world, he served only the lust of the eyes.

Happy vacations being not an uprooting and a replanting but a grafting of new experience on old, Miller mingled quite naturally with what he saw traditional conceptions and turns of mind. His squaws simper as if they inhabited Maryland parlors, and he only viewed their nudity from a polite distance. He played down the strangeness of Western landscape, creating sometimes Arcadian visions of Indians staring inland over glassy lakes to castled hills. Having studied Decamps, he drew ponies as Arabian chargers. But he took from French romantic idealism none of its brutality and tragedy, even painting *Running Fight — Sioux and Crows* without shedding a drop of blood. He depicted an innocent world of childish purity through which burly trappers moved as if they were gruff Teddy bears.

Like Bodmer, Miller sketched not in oil but in watercolor. However, since he created his effects, even in the rendition of figures, as much by direct application of his washes as by coloring in predrawn outlines, his practice was in advance of Bodmer's and, indeed, the usual watercolor technique of his generation. Here as abroad, despite outstanding exceptions like the work of Turner and sometimes of Delacroix, the medium was considered an adjunct to draftsmanship (it is still correctly called not "painting" but "drawing"). It was most commonly employed by illustrators to prepare, as Bodmer did, copy for engravers. However, Miller did not think of himself as an illustrator. He applied to watercolor the dislike of meticulous line drawing that had been deeply seated in one facet of American oil painting practice by the fact that so many of our artists had, as self-taught craftsmen, made their first essays at art directly with brush on canvas.*

Miller was undoubtedly further encouraged towards his unusual watercolor technique by his need, as the caravan advanced, to record rapidly and, above all, by his desire to express, with a minimum of hindrance, his instantaneous reactions to a world so new. He could afford to postpone achieving the completeness of image taste then demanded, since he did not regard his watercolors as ends in themselves. He would add the requisite thought and explanation when, after his return to civilization, he painted his large oils. For the moment, he was concerned with purely visual effects.

*When West had first reached Italy, the connoisseurs had been unable to understand how he could paint without knowing how to draw in line. Stuart had told his pupils, "Drawing outlines without the brush [is] like learning the notes without a fiddle."

As in oil technique, Miller colored his foreground forms heavily, and varied his surface textures by using, when he moved back in the picture, thinner pigment. He achieved brilliance less in the modern watercolor manner of letting the white paper gleam through transparent washes than by laying gemlike hues against opaque darks. Working too rapidly to mix colors or even select a wide variety, Miller employed a few tints in their pure state, keeping them separate and often touching up highlights with Chinese white. The stronger foreground colors reappear further back in patches equally bright but diminishing in size, becoming at last clearly visible only through a magnifying glass.

Thus, on small or medium-sized sheets of paper Miller indicated all the complication of a large oil painting. However surprising the means, the effect is realistic. Pure white in a moonlight scene conveys the impression of fire. Combinations of background streaks unrepresentational to minute scrutiny merge from the correct viewing position into men or horses. And, although we cannot identify the tiny dots of pigment in the deepest distances, we feel assured that they stand for something that was actually there.

Painting not only Indians but everything that met the eyes of an overland traveler — forts, fur traders, wagons, genre episodes, sportsmen and sporting life — Miller placed his men and their works in landscapes that have depth and atmosphere; the sun shines down hot, and mist brings a strange beauty to an old ruffian setting traps. More than Catlin, who did not paint out reality but summarized it, more than Bodmer, who cut into space with insistent lines, Miller carries us bodily into the vanished West. This is what we should have seen had our eyes been gifted and had we actually traveled there.

Torn and stained by the happenchances of horseback journeys and encampments in the wilds, the watercolors Miller created as he rode with fur traders along the Platte are so subtle, so personal a record that their impact is weakened when they are framed, glazed, and hung. Best to sit alone, as this writer was privileged to do, in a silent room with the pile before you, and turn them over slowly one by one, enjoying quiet companionship in his adventure with the gay, sensitive young man who was so unexpectedly carried to a savage Eden.

Miller never went West again after that one summer. The big oils he executed for Stewart were ponderous failures. He did some historical paintings — *Christ's Charge to Peter*, etc. — which posterity has not bothered to preserve. At his native Baltimore, he earned his living with gracious portraits in which his unusual abilities expressed themselves only through

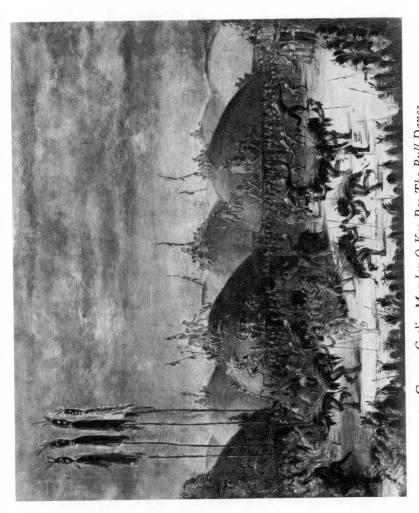

20 George Catlin *Mandan O-Kee-Pa: The Bull Dance*

Oil on canvas; 1832; 23 × 27¾; Smithsonian Institution, Washington, D.C.

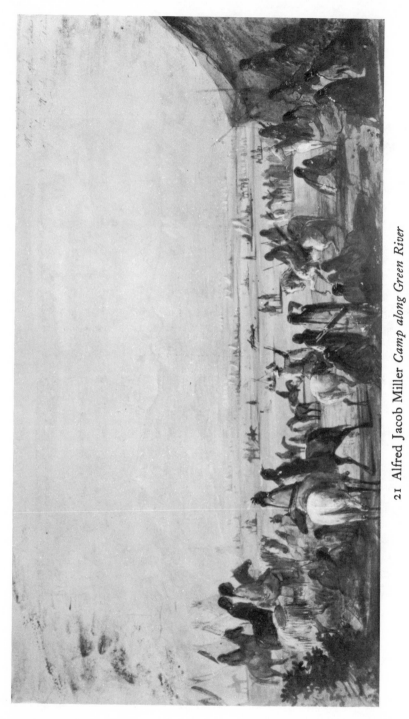

21 Alfred Jacob Miller *Camp along Green River*

Watercolor on paper; 1837; 5½ × 7⅞; Knoedler Galleries, New York.

an occasional brilliantly painted detail. He never sold his transfrontier sketches, which he used as the bases for new versions. The reworkings in oil are labored, and uninspired, but if he copied his watercolors in the same medium he was able to recapture much of the old lyricism. As the years passed, his pictures of the West, good and bad, vanished from sight, to be rediscovered in the twentieth century.

Indians had been for Bodmer an even more passing phase. His Western drawings disappeared into the archives of his employer — whence they have just been exhumed — and the huge atlas of prints was too rare and expensive to have much currency. Bodmer's American trip was considered to have preceded his true career. Settling at Barbizon as an etcher of animals, he became one of France's most successful illustrators. When, in 1850, an American publisher commissioned some more paintings of Indians, he paid an impecunious neighbor, the subsequently famous Jean François Millet, to ghost in for him the figures of grinning, horrible bugaboos menacing white virgins.

Of the three Indian masters, only Catlin continued to dedicate his life to the aborigines. He exhibited his "Indian Gallery" in the United States until 1839, then in England for six years, in France and Holland for three, and then briefly again in London. The "roughness and energy" of his subject matter and style caught the popular fancy. Thus the *Gazette des Beaux-Arts* wrote of his buffalo hunts, "*Une course diabolique! . . . Quel drame!*" And *The Times* of London was shocked into virtual treason to the British way of life: "The puny process of the fox chase sinks into insignificance when compared with . . . the grappling of a bear or the butting of a bison."

Catlin saw to it that his pictures were widely distributed in copies he himself made, in illustrations for his many successful books, in colored lithographs. Used as source material by illustrators everywhere, the prints had a profound effect on the vernacular image of the Indian.

However, Catlin was rarely taken seriously as a painter. Against the usual view, Charles Baudelaire thus protested in reviewing the Salon of 1846, where Catlin had exhibited two portraits of chiefs:

> The rumor went that he was a worthy man who could neither paint nor draw, and that if he had made some passable sketches, it was thanks to his courage and his patience. . . . It is today demonstrated that Mr. Catlin knows very well how to paint and draw. These two portraits would suffice to prove it to me, if my memory did not bring back many other pieces equally fine. His skies above all had struck me because of their transparency and their lightness.

Mr. Catlin has rendered in a superior manner the proud and free character and the noble expression of these good people; the construction of their heads is perfectly conceived. By their handsome attitudes and the unrestraint of their movements, these savages make antique culture understandable. As to the color, it has something of the mysterious that pleases me more than I can say. Red, the color of blood, the color of life, abounded until in that somber museum [Catlin's own] it was a drunkenness. As to the landscapes — wooded mountains, immense savannahs, deserted rivers — they were monotonously, eternally green. Red, that color so lightless, so thick, more difficult to penetrate than the eyes of a serpent; green, that calm and gay and smiling color of nature, I find them again singing their melodious opposition even on the faces of these two heroes. What is certain is that all their tattoos and colorings were made according to natural and harmonious scales. I believe that what led the public and the journalists to error in relation to Mr. Catlin was that he does not make the swaggering paintings to which our young people have so accustomed them that it is now the classic manner.

Catlin, who walked around in Indian costume, had started out in Europe as a great celebrity — an earlier Buffalo Bill — but his unassisted pictures did not serve to keep the public paying admission to the gallery on which his livelihood primarily depended. During his first stay in London, he invented the Wild West Show, hiring Cockneys to enact war dances, and then actual braves. As the years passed, increasingly sensational tableaux, which he staged to the damage of his reputation, failed to keep his venture afloat. He was forced to mortgage the pictures that he had hoped would be the resurrection and the life to the Indian tribes. Finally, in 1851, when he was in London, he could no longer keep his gallery open.

Catlin's last hope was that the United States government would buy the collection. Daniel Webster led the Northern senators in support of the purchase, but the Southern majority, who wanted Western land for the expansion of slavery, voted the bill down during 1852 as a move to hem them in by creating sympathy for the Indians who would be displaced. The collection was thereupon sold for debt to a boilermaker from Philadelphia who put it in his cellar. This seemed to Catlin the final catastrophe.*

After fourteen years as a showman, he was freed by failure to return his major energies to art. Still in Europe, he made albums of uncolored pencil drawings that recast his Indians in a new medium and a new mood. They

*The ways of providence are strange. The boilerworks did not burn, but the Smithsonian Institution, where the government would have placed Catlin's collection, did. Many paintings by his rivals—King, Seth Eastman, John Mix Stanley—were destroyed. After the Smithsonian had been rebuilt, it acquired Catlin's gallery.

22 Alfred Jacob Miller *Setting Traps for Beaver*
Watercolor on paper; 1837; 11 × 8; Knoedler Galleries, New York.

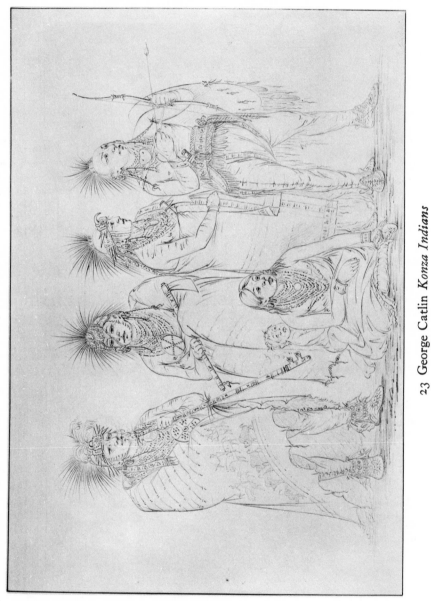

23 George Catlin *Konza Indians*

Pencil on paper; 1850; 13¼ × 19¾; New York Public Library, New York.

reveal that the man who had studied the unedited nature which he had considered "the true school of the arts" had not been tempted, during his twelve European years, by any artistic "fashions" from the Greeks to Delacroix. His new style was different from the old, but equally self-evolved. If the drawings show glints of resemblance to William Blake's marvelous designs, that is probably a coincidence, based on similarities of vision. The tribesmen Catlin drew in his discouragement five thousand miles from the prairies inhabited reality no more than Blake's prophets and angels.

Catlin grouped the Indians whose portraits he had so long ago painted, usually at full length, three to six on a page. Of their identities he preserved only the names: often several figures in one composition have the same face. All are noble of feature, composed and sad. Although they stand close and are linked by design, each is oblivious of the others. They stare with level-fronting eyes at some tragic vision that is to each his own but which they all share. They are sexless, the men indistinguishable from the women, and usually nothing is included to indicate surrounding reality. They inhabit, indeed, such a mathematical abstraction of space as no scientist had yet envisioned. Ranked two-deep along the picture plane, they have weight and depth, but the fundamental flatness of the paper is not violated.

Within the firm outlines of the major shapes, Catlin played a multitude of linear tunes. Undisturbed by color or texture — flesh, feather, face paint, and buckskin are rendered alike — he drew into figures six inches high every detail he had formerly included in large images. When happily achieved, the result is incredibly rich.

These exotic-faced dreams composed separately together personify a stoic nobility that transcends the world's troubles. But Catlin's renditions of ceremonies and hunts, where the world has interposed, where people are conscious of each other and acting in concert, express a bitterness, a revulsion, an all-embracing cruelty he had never felt when in actuality among the tribes. Demonic energy distorts motion, faces are grimacing masks, bodies are squat and horrible.

As the critic examines these remarkable drawings, he could drop a tear for the strange, ungoverned creature who created them. For beauty strikes upward again and again from the page, not only from bodies and faces, but from almost abstract background bits — a tattered tent flap, the barely indicated shape of a distant buffalo. Yet only a very few of these drawings are truly beautiful as a whole. Since a similar combination of wonder and ineptitude characterizes all of Catlin's work, his career exemplifies a dilemma

typical of American artistic creation although rarely so extremely manifested. Had this man of genius — for such he clearly was — been born in an environment where artistic sophistication would have come more naturally to him, could he have heightened his inspiration with knowledge? Or would he have just been silent?

Catlin, who had never felt comfortable in the United States except beyond the frontier, had not set foot in his homeland since he had departed in 1839. Certainly it appealed to him even less, now that his Indian paradise was being torn apart. However, after all his hopes seemed to have died, he heard a new wilderness call. In 1852, he sailed, hiding his identity under an assumed name, to South America. He was to wander for years, old and deaf, through the most inaccessible jungles and pampas — and briefly to still-wild spots on the western coast of North America — in search of gold, sport, and unspoiled Indian worlds to write about and paint.

His return from dream Indians to real aborigines did not rekindle the lyrical excitement of his youthful art. Nor did he revive his old techniques. To oil paintings on medium-sized oblongs of Bristol board, he adapted the conceptions of his later pencil drawings. For portraits, he balanced into a single composition some three to five small full-lengths. The South American Indians are squat, unlovely, usually static: they look straight ahead like waxworks without emotion.

Now wild nature gave Catlin more pleasure than wild man. He expressed high spirits primarily in pictures of such hunting scenes as those in which he himself engaged; and in his genre, he often kept Indian action subordinate to landscape. Men and animals are less commonly grouped than silhouetted singly against the background, often in long marching lines that weave, darker than their surroundings, through the immensity of pampas, under the luxuriance of rain forests, across rivers, against the sky. Contrast of form and position, often involving major distortion of naturalistic sizes, is used, with varying effectiveness, to enhance design and emphasis.

Although Catlin's color — predominantly light greens and blues — now tends to be unpleasantly thin and washy, it can rise to eloquence, as when the orange-red of torches flames against black. These pictures are not Catlin's most powerful works. Yet, if you stand for a while among them, they grapple you into his often crude and distorted vision until you believe that it is the street outside which is not real.

Catlin's lifetime of achievement is certainly one of the most amazing phenomena of American art. He credited the Indians he had known as a

young man on the plains. "Artists of the future," he wrote, "may look in vain for another race so picturesque, . . . and so well adapted to that talent which alone is able to throw a sparkling charm into marble or spread it on canvas."

Savage life and its wild habitat had, indeed, served as a springboard to throw high three very different painters. Each had in his own way labored to express as accurately as he could what he saw and felt. Except for Bodmer's concern with conventional color harmonies, no stylistic precedent had intervened between them and subject matter altogether new to art. Literature, still dwelling with the forest Indians of Eastern tradition, had hardly invaded the plains. Catlin, Miller, and to some extent Bodmer had seen with fresh eyes, recorded with excited hands.

They had no worthy successors. For this Catlin was himself to some extent responsible. His paintings and the engravings after them, his best-selling books in which he argued eloquently against white expansion and for .the nobility of the Indian, his increasingly flamboyant showmanship, and his eccentric personality became so associated in the national mind with the cause of the Western Indians that he stood between later artists and pristine experience. This was all the more the case because, although his images offered models too exciting to be ignored, his followers rarely shared the attitudes that had inspired the art they imitated. They could not build on Catlin's example; they could only distort and weaken.

Seth Eastman (1808–1875) may well have been consciously contradicting Catlin when he wrote in 1853 that the Indians could have no greatness or even happiness to lose under white blows, since the braves were ruled by "ungoverned passions," and the squaws by "superstition and degradation," while none were Christians.

An army officer graduated from West Point, Eastman had been intermittently stationed on the frontier before Catlin went West. His duty was not to love the Indians but to hold them in check. Although he sketched them sometimes as curiosities, when he practiced his avocation of painting, he preferred to do so in the East, where he could forget about "savages" and depict Hudson River scenes. Then, in 1841, he brought a scribbling bride to Fort Snelling. She launched at once into romances of Indian life — one is said to have inspired Longfellow's *Hiawatha* — and asked her husband for illustrations. This set him off. An occasional factual rendering has the immediacy of an unedited document, but the officer could not take aboriginal culture seriously. Like the authoress at his hearth, he preferred to visualize

[83]

the Indians in dramatic scenes expressive of civilized reactions or emotions. If he did undertake an unliterary subject like *Lacrosse Playing Among the Sioux Indians*, he felt an obligation for knowing art — had he not taught drawing at West Point? — that made him apply poses from the Old Masters and a heavy oil technique which exaggerated the ineptitude of his color, composition, and drawing.

When Catlin, that extreme individualist, refused to supply illustrations for the ambitious report on Indians which Congress commissioned and Henry R. Schoolcraft edited, Eastman was called to Washington. His plates mingled bored reportage with polite genre and historical reconstructions to produce Indian pictures which can only be described as loutish. Eastman was a mediocre artist whom the beauty and the grandeur of the tribes could not help, since he scorned their visual teachings.

To the frontier, Charles Deas (1818–1867) brought sick nerves. He was to spend the last eighteen years of his life in a lunatic asylum, from which he sent an occasional picture to the National Academy. They are all lost, but Tuckerman tells that one, "representing a black sea, over which a figure was suspended by a ring while from the waves a monster was springing, was so horrible that a sensitive artist fainted at the sight."

Before melancholia struck Deas down, this son of a distinguished Philadelphia family had tried unsuccessfully to enter West Point, had drawn at the Academy school, had painted in New York City comic genre, and then, inspired by Catlin's Indian Gallery, had gone west "to taste the wild excitement." Mostly at St. Louis he painted between 1840 and 1847 single figures envisioned as typical trappers or traders, and genre scenes of pioneer life, sometimes humorous, sometimes melodramatic. Widely disseminated in engravings, his frontier scenes enjoyed great popularity.

When Indians entered Deas's art, it was to incite terror. Thus *The Death Struggle* envisions a white man and a red suddenly electrified, as they grapple with each other, by the realization that their horses are carrying them both over a precipice to certain destruction below. For such a composition, which a French painter would have been taught how to render, Deas's artistic environment offered him no precedent. In the manner of those engraved vignettes, usually dedicated to very different subject matter, which were then becoming popular, he stylized and arranged naturalistic details to fill the picture space neatly. But then he strained against the neatness with garish colors, exaggerated gestures, and forms voluminously conceived if crudely executed. We feel passion struggling to escape from a straitjacket of technical littleness.

[84]

It was 1848 when a white man panned out of the South Platte some yellow dust. The gold rush, coupled with the discovery that beef could be cheaply fattened on the plains, changed the destruction of aboriginal culture from erosion to explosion. When the tribes objected, blood was shed. The landscapist Whittredge expressed what had become the typical attitude when, on a trip to the frontier in 1865–1866, he admired "the pluck" of a cattleman who, in retaliation for each stolen steer, killed an Indian.

Since they precluded sympathetic understanding, such conceptions were able to find their best expression in pictures painted abroad. The artist was Charles (Karl) Wimar (1828–1862). He had been brought from Germany to St. Louis at the age of fifteen, had cut his painting teeth on panoramas of the Mississippi, and had, after nine years in the West, recrossed the ocean to the Rhenish artistic center, Düsseldorf (1852). Studying under his fellow German-American Emanuel Leutze, he made copious use of engravings after Catlin to run up, in the medieval town, scenes of Indian atrocity and noble white self-defense. He showed Victorian virgins being abducted by evil savages,* and was one of the first to paint a covered wagon being attacked by a galloping circle of whooping braves.

Wimar returned to St. Louis in 1856. He took some trips to the Indian country, finding the camera, as soon as it had been invented, a welcome note-taking device. Before his early death, he somewhat anticipated the style that was soon to bring celebrity to another German-American who had worked beside him in Düsseldorf. As Bierstadt was to do, he combined the easy grandiosity of the commercial panoramist with the apparatus of German romantic painting. Wimar created views of the most splashy Western scenery, in which lurid light effects, often circling around pink, whip up a most unnaturalistic romantic glow. When he painted in the Indians, he found himself less inspired by his own sketches and photographs than by engravings after Catlin, which he "improved" with conventional picturesqueness, sentiment, savagery.

The menaced white girl had become the stock protagonist of anti-Indian editorials. Among her most fluent adherents was John Mix Stanley (1814–1872), an upstate New York wagon maker who became a sign painter in Detroit, then a portraitist. He was to wander the Indian country with a

*The girls, always identified as daughters of Daniel Boone, languish prayerfully under no worse treatment than the menacing frowns of their captors. Such Düsseldorf restraint was not for Jules Émile Saintin (1829–1894), a French artist who spent some years in New York City during the 1850s and exhibited at the Salon of 1864 his *Femme de Colon Enlevée par les Indiens Peaux Rouges*. Having to compete with Hercules killing his naked children and naked Sabines being carried off over the bodies of their dead husbands, he showed his *Femme de Colon* lying whitely naked across a horse's shoulders in front of a spear-waving *peau rouge*. Saintin soon gave up such tricks to make his reputation in Paris as a sentimental depicter of stylishly dressed young ladies.

camera in his hand, but with eyes that did not see and a heart that did not feel. The paintings he created in his studio are to modern eyes both comic and embarrassing, particularly his *Osage Scalp Dance*, in which the intended victims are two: not only the white-robed praying mother of convention, but an infant who has providentially lost his pants so that his bare bottom can elicit the tears of sentimental diaper changers. The one Indian who is trying to save the pair contrasts with his hideous, painted compatriots by having a washed face and white features.

Catlin's ubiquitous images were now serving the enemies of the cause he had espoused by making it unnecessary for depicters of Indians ever to have seen one. Savage scenes became profitable lines for Eastern illustrators and sporting artists. Thus Darley and Tait could, entirely unperturbed by experience, transmute engravings after Catlin's works into the most acceptable clichés.

Then, as successful warfare reduced the Indian menace in the Far West, a great lachrymose sob rose from the easels of the conventional genre painters. Endless canvases were dedicated to what the critic Sheldon called "the lonely, picturesque Indian, whom our forefathers dispossessed from his hunting ground and whom our philanthropists idealize and consecrate. He is a very nice person and very interesting." Often he was looking from a cliff westward to the setting sun, attended by his horse, his dog, and his family, more or less use being made, according to the intended market, of the seminudity of squaws. Lo, the poor Indian! Although the illustrator Frederic Remington (1861–1909) was to show him effectively as a conquered or almost conquered outcast, his untrammeled majesty had passed through its brief moment in American art.

24 Charles Deas *The Death Struggle*

Oil on Canvas; 1845; 30 × 25; Shelburne Museum, Shelburne, Vermont.

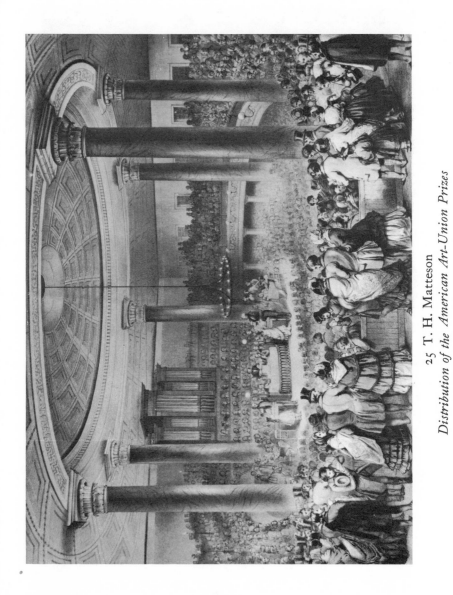

25 T. H. Matteson

Distribution of the American Art-Union Prizes

Drawn on stone by Davignon and published by Sarony and Major; 1847;

ARTIST LIFE

Merchant Amateurs, Artistic Lotteries, and
Athletic Painters

BEFORE the Erie Canal existed, the sloop *Shakespeare* tacked across
the Hudson's end-stopped waters. With the thrown ropes, a young
man sprang ashore. His small, square face was rough-hatcheted yet
ingenious, his black eyebrows so mobile that rising wrinkles marked his
forehead. Luman Reed (1787–1836) had the gift of making every exchange
of city goods for farmer's produce an act of friendship and profitable for
everyone.

Born in a hilly wilderness (now Columbia County, New York), Reed had
begun gainful employment as soon as he could swing an ax. He took a flyer
in lumber at Oswego, hired his Hudson River sloop, and at the age of twenty-
eight became a partner in a wholesale grocery house in New York City.
The opening of the Erie Canal cascaded him into wealth. Having built a
mansion that was one of the showplaces of the city, he turned his attention
to decorating its walls. His obvious recourse was to "Michael Paff, Esq." —
known to the painters as "Old Paff" — who advertised "genuine Old
Masters" that combined "the smallest expense with the greatest gratifica-
tion." Never at a loss when it came to expertise, Paff attributed a *Last
Supper* to Michelangelo by finding in the picture a line of stones equal in
number to the letters in "Buonarroti." He efficiently fixed Reed up with
such yellowed pictures dangling great names as it was common for Americans
to collect. Then Reed did something revolutionary. Although Gilmor, the
European-traveled connoisseur, fooled himself into believing many a glori-

ously attributed daub, the self-educated grocer applied to his collection the same personal judgment he used in evaluating peas. His conclusions were naïve — he decided that the whole cult for Old Masters was a fraud — but his behavior was intelligent: he dumped his fancily attributed lumber. His walls being again bare, he visited in 1834 the annual exhibition of the National Academy of Design.

This newly fledged organization was engaged in a war with the nation's oldest art institution, the American Academy of the Fine Arts. The latter, founded in 1803 by New York's hierarchical leading families, was dedicated to "elevating" the taste of the common man by imparting the esthetic theories and practices most correctly admired abroad. Although the connoisseur-managers accepted the work of local artists for their annual exhibitions, they preferred and more commonly purchased what they hoped were genuine Old Masters or at least "authentic" copies. For an art school that would "be a germ of those arts so highly cultivated in Europe but," so they wrote, "not yet planted here," they imported casts. They wished the new generation of painters to be grounded, in the neoclassical manner, on drawing from the Antique. The existing craft-trained generation they despised. Convinced not only of their cultural but also of their social superiority, they kept all professionals except the birthright gentleman Trumbull from their inner councils. It was this hauteur rather than any overt esthetic dispute that had incited the artists in New York City to revolt against the leadership of the connoisseurs and found their own organization, the National Academy. That had happened in 1825, the very year in which Cole had conspicuously raised, in the face of the old taste, the banner of local landscape.

Although Morse, who subscribed to neoclassicism, was for years its president; although instruction in its school remained conventionally based on casts, the National Academy was irresistibly drawn away from the old canons. Since the academicians, full and associate, had by rule to be professionals, connoisseur influence gave way to that of a membership mostly craft-trained. The exhibitions were open only to works by living artists not previously there shown: no casts, no Old Masters, no repeating war horses by elderly painters. In each show, almost all the pictures had been done during the previous twelve months by Americans — foreigners did not send — usually from the New York area.

Having no endowment and at first no donations to rely on, the artists supported their academy by small sums paid in by many people as gate

receipts to their exhibitions. This forced an appeal to popular taste. And the individual painters could no longer hope to sell to the old dispensation of connoisseurs, who, angry at their insubordination, wished them nothing but failure. The academy pioneered in using artificial light, at first six gas burners, so that businessmen tied to their counting houses by day could visit the exhibitions at night.

A revolution in the nature of patronage underlay the triumph of the Native School. Particularly during its rise to dominance, it found its primary market among men like Reed, who were neither gentlemen-born nor formally educated. Although, like the supplanted connoisseurs, they were of old American stock, their ancestors had been during the Revolution not generals or statesmen but at best militia captains. The typical collector had grown up on a farm, barefoot but well-fed, chore-ridden and mischief-prone, neither mooncalf nor clod: a boy whose homage to the beauty of a spring morning was a furrow plowed straight and true. He had found his Aladdin's lamp behind the counter of a country store. Summoning the genie of trade, he had been wafted to the national crossroads, New York. Far from being a manipulator of capital like later millionaires, he remained in close contact with the farmers and lesser dealers from whom he bought, with the regional storekeepers to whom he sold. He never lost touch with grassroots America.

Where older lines of commerce had carried merchants across the ocean, the new traders were drawn westward along the Erie Canal. They could practically never leave their businesses for long enough to make pleasure trips abroad. New York, the greatest metropolis they ever experienced, was the seedbed of their taste. Although "Old Paff" sat like a spider among his dusty wares, and an occasional entrepreneur appeared from Europe to offer at auctions "Titians" and "Correggios" by the dozen, the city lacked, as the Native School got under way, any truly effective imported pictures, any enterprising art dealers to scoop beginning collectors up. Since the American Academy quickly became moribund — it went out of existence in 1839 — the merchants commonly got their first view of persuasive art at the National Academy. Such neoclassical subjects as Vanderlyn's *Marius Amid the Ruins of Carthage* (1807) would have bored them: they had never heard of either Marius or Carthage. They admired with Reed pictures "derived from local life, history, and scenery."

Studying the three tiers of paintings on the walls, Reed selected among the artists with awe-inspiring perceptiveness. He decided to buy from Mount, Durand, and that brilliant flash-in-the-pan Flagg. Cole, after he

[89]

returned from his first European trip, became the fourth of Reed's favorites.

No dealers intervening, the purchase of a picture brought the patron into personal contact with the artist. As in Reed's case, personal friendships resulted. Where the old group of connoisseurs had condescended to the creators, the new collectors were humble. Reed considered it a privilege to be able to give "encouragement and support to better men than myself."

Merchants who had a taste for art were starved for wider horizons than their countinghouses, for more beauty than the haphazard city offered. Their ordinary business associates talked nothing but dollars and cents; the cultured society of the older families was socially above them and, in any case, seemed to them artificial; their cloistered women were absorbed in babies, clothes, and servants. Educated not by books but by experience, the merchants desired esthetic pleasures more tangible than those offered by the printed page. To such men it was a luxury almost beyond price to be able to stop, on their way uptown from work, at a painter's studio. They found there a free society in which professional men — authors, journalists, doctors, lawyers — joined.

Many of the painters could fascinate by telling European experiences — yet they comforted the untraveled merchants by preferring the United States. Artists, so a paragrapher wrote, "dressing themselves as they please and wearing their hair in such fashion as to each himself seems most comely ... are, generally speaking, the most stylish and picturesque portion of our population." However, they were far removed from what self-made traders considered the effeminate foppishness of the sons of the rich. Even if they wore frogged capes, the painters moved with energy and were expert with hammer, compass, and rifle. Artistic life was dominated by landscapists, hikers and climbers for whom painting was an athletic art.

A stockbroker, so the painter Whittredge remembered, hurried through his door to explain that he had made five hundred dollars with an unexpected hit and wanted to buy a picture before he went home, "otherwise my wife will spend it on a bonnet." It was a determining fact that artistic society was then exclusively male. Female patrons hardly existed. No woman was asked to wield her pencil at a sketch club or lend her charms to the fancy-dress parties the artists sometimes gave. Nor did the landscapists, many of whom were bachelors, take women along on their communal summer hegiras to wild scenery. They recalled the error that had been made when, unable to bear any longer the terrible cooking at a favorite Catskill hideaway, a group had imported wives and sisters. Although "new dishes were served

[90]

and the coffee improved," the ladies talked of the beautiful spot, the fashionable flocked, and the artists were dispossessed.

It was a gay, harmonious, and idealistic group that met in the studios. Outdoor men who kept themselves physically strong, they were characterized, as was their art, by "a health that reproves all morbidity." Their reminiscences reveal that the personal qualities the artists most valued in each other were benevolence and good-fellowship. If, as they believed, communion with nature ennobled, was it not required of them, as nature's high priests, to be noble? Working during the winters side by side in New York's few buildings that offered painting rooms, rambling side by side during the summers, they wished to be happy together. Eccentricity was supposed to indicate freedom from smallness and to further jollity. Visible rivalry and envy were barred. Rising as a team into admiration and prosperity, the members of the Native School praised each other. Except in depressions that were a common calamity, there was plenty of business for all, and all-were fired by a common aim: to create for the nation they loved what they intended to make a great school of art. What excitement for merchants to be able to take part in this patriotic adventure!

The painters and the patrons had an underlying source of congeniality in common backgrounds: the tone of both groups was set by farm boys come to the city to seek their fortunes. A picture of American scenery or country life seemed to all, as Durand put it, "an oasis in the desert." If adequately cajoled, a painter might listen to a merchant's memories of his childhood, and then, from similar memories of his own, conjure up on canvas what had seemed irrevocably vanished.

When buying art from painters, shrewd bargainers in wheat or beef joyously violated the rules of the marketplace, often paying an artist more than had been agreed on. Thus, three years after Durand had sold him a forest landscape, Reed's son-in-law, Jonathan Sturges, sent an additional two hundred dollars, explaining, "The trees have grown more than $200 worth since 1854." This kind of bounty was encouraged. However, when a wealthy patron broke the rules of the Sketch Club* by serving not a frugal but a grand repast, the organization was disbanded the next day, and a new one formed with all the old members except the delinquent. To keep

*The Sketch Club was organized in 1837 to include "artists, authors, men of science, and lovers of art." It met in rotation in member's houses. One group drew for an hour on a subject suggested by the host (who kept the drawings) while another group wrote a poem, each adding four lines to what the others had done. Such strenuosities being eventually abandoned by what was now known as the Old Sketch Club, the artists also frequented the New Sketch Club, where, as Cole wrote in 1844, "we really draw." The Century Association grew out of the Old Sketch Club.

unsullied their valuable independence from ordinary business considerations the artists refused, as a group, to exhibit at America's first world's fair, New York's Crystal Palace Exhibition of 1853, where their work would have been shown in connection with "grosser materials: *manufactures.*"

Reed's example helped to establish a continuing pattern. During less than three years as a collector — he died suddenly in 1836 — he bought from Cole five pictures in addition to *The Course of Empire;* from Durand, eleven; from Flagg, eleven; from Mount, all he could get, which was two. Far from trying, as Gilmor did, to tell the artists what and how to paint, he was eager to commission whatever it was their ambition to create. He elicited the help of his painter friends in decorating his private gallery, rushed to their sides when they were discouraged, employed members of their families, urged them to live well and opened his purse to them when their funds were low, persuaded his business associates to buy their art. Lesser collectors were to do the same, although on a smaller scale, being even willing, as time passed, to give money, no strings attached, to the National Academy.

That Cole's first departure for Europe had caused concern had been largely because he had already exhibited a tendency to stray from realistic American subject matter. Patrons commonly helped artists who wished to study in Europe by giving them money in advance for any original pictures* they wished to execute there. Thus Reed offered to send Mount abroad and did send Flagg. He lost his earlier skepticism and became, as he wrote, "now a believer in the Old Masters," as soon as he got possession of a truly fine picture (it still exists), *The Huntsman's Tent,* attributed to Jan Fyt: "I must say, I never knew what could be done in painting before." But he did not see why Americans could not do as well. "Compare your work to Titian's," he urged Flagg, "as if both were his, and then judge which is best." If Titian's were better, Flagg would have to hump himself. "You know my motto: 'With application comes everything.'"

As the open-sesame to patronage, membership in the National Academy was greatly desired. Although New York's artistic production was still so small that hanging committees had to beat the bushes to fill the annual shows, exhibition could damage if a painter could not prevent his picture from being hung in one of the upper tiers or in a bad light. The original founders of the organization kept so firm a hold on its councils that until after 1860 — a span of thirty-five years — no major officer was elected from outside their group. They opposed what Durand called "the hot-bed fermen-

*The older practice of commissioning copies of Old Masters persisted only in so far as the old taste lingered.

tation" of "juvenile artists" eager "to ripen before their time," but were hospitable to younger painters who appeared with true power. This writer has found no convincing evidence that before the esthetic conflicts of the 1870s, any artist who deserved election to the Academy and made himself available was long excluded.

Having themselves gathered from all over the United States, the members saw no contradiction in banning, as they did until 1862, from active membership in what they styled the National Academy artists outside the New York area. Philadelphia had its own organization, the Pennsylvania Academy of Fine Arts, and its specialized market as the headquarters for the publication of illustrated books and magazines. But even Philadelphia was a secondary art center. The economic results of the opening of the Erie Canal and the appearance in New York City of the Native School, had coincided to raise that center, which had formerly been artistically behind Philadelphia and Boston, with startling rapidity to be the capital of American painting. Despite important exceptions in individual cases, there was soon a solid base for the National Academy's contention that artists who made their careers in other communities were unambitious or incompetent men satisfied to remain "provincials." Only in New York could a painter improve his style by close contact with his most proficient colleagues. Only from New York could he command the top market, since residents elsewhere preferred to buy art not from their neighbors but during visits to the prestigious city.

The Academy exhibitions were theoretically open to pictures sent in from the hinterland, but no effective machinery was supplied to handle or sell them. And even for resident artists, the system had a major flaw. The shows lasted for only two spring months, and the Academy provided no method for catching transients during the rest of the year. Unless a collector was already half hooked, he could not be expected to respond to the advertisements the painters published stating that they would be at home to the public on certain days.

New York City was not yet ready to establish a permanent museum, as events after Reed's death showed. Realizing that if his numerous paintings were sold at auction, low prices might damage the ability of his friends to be well paid for their future work, his heirs established in 1844 the New York Gallery of Fine Arts, and subscribed most of the thirteen thousand dollars needed to buy the collection from the estate. The fifty trustees — mostly, as the deceased had been, grocers — were not rich enough to erect a building or continuously donate paintings. They secured from the city rent-free the

rotunda Vanderlyn had built to show panoramas. Expenses were to be paid from entrance fees, but, although the artists themselves gave a few more pictures, the collection remained too static and too small — less than a hundred objects — to bring the public back for a second or third view. Soon after the city took back the rotunda in 1848, the pictures were retired into storage.

In 1838, the Apollo Gallery, a sort of artists' cooperative that linked exhibition and sale, had opened on Broadway. Invitations having been sent to artists everywhere, forty-three New York painters were joined by twenty-four from Philadelphia, four each from Boston and Washington, three from Virginia, and a scattering from other places to make a total of ninety-six, more than twice the average representation at an Academy show. However, this was a time of financial depression: few pictures sold.

In despair, the Apollo Gallery took a step that was to have a crucial effect on the development of American art. In 1839, they turned to the "art union" method of selling that had been evolved in Germany and was spreading throughout Europe. For generations, vernacular artists, in America as elsewhere, had tapped light pockets by collecting small sums through lotteries in which the winners were awarded painted canvases. The art unions expanded this practice into centralized raffles that had some resemblance to the Irish sweepstakes of modern times. The American organization used national publicity to sell tickets in every state and territory. Then managers expended the receipts by purchasing outright a variety of pictures from many artists. These were the prizes that were assigned to the holders of lucky numbers at a reception and drawing held annually in New York City. For losers, the pill was sweetened by giving every subscriber a large engraving said to be worth the entire fee he had paid.

The Apollo Gallery became the Apollo Association and then, in 1844, the American Art-Union (which we shall henceforth call it in all its manifestations). Control was vested in a board of "merchant-amateurs" who served without pay as their contribution to the arts, and who, it was claimed, could select pictures more dispassionately than painters, since their personal interests were not involved. This was, of course, a return to the patron control that had been overthrown with the American Academy, but half the responsibilities of the board were what they had been specifically trained for — to merchandise — and the artists were reassured by the fact that the managers belonged not to the old class of patron but the new.

The avowed intention of the American Art-Union was that of the American

Academy, to foster art in the United States, but its approach was diametrically opposite. Where the old Academy had tried to root out what was native to make room for imported seed, the Union wished to encourage what grew naturally in our soil. Instead of spending the lion's part of its funds on foreign objects, the Union bought only the works of living American artists.

However, the new organization did not share the National Academy's primary concern with artists of established achievement resident in New York City. It wished to encourage, in addition to those painters who "readily command admirers and purchasers, . . . the immature efforts" of promising young men "cramped for want of technical skill." It invited and supplied means for the submission of pictures from all over the nation, and also of American artists resident in Europe, whose studies it helped finance by extensive purchases. It considered foreign workmen "naturalized" as soon as they set foot in the United States. "The task of The Art-Union," the managers wrote, is "not only to select but to create. . . . It has a school to build up, . . . a national school of art."

The Union utterly denied the canons of neoclassicism when it stated that seeking inspiration from the Antique or the Old Masters "defies the spirit of the age. . . . Modern artists have no hope but modern art." However, even the most renowned modern schools should not be accepted on faith; each should be carefully examined to see if it had merit. "There is no affection more contemptible than that which extols foreign productions above homemade simply because they are foreign. On the other hand, it is equally contemptible to shut our eyes upon the excellence of any importation from abroad for the same reason." If a native artist found his work inferior to some European picture, "the wise and manly course . . . is to acknowledge its superiority and then set to work immediately to equal or excel it." Equality was to be achieved not by imitation but by applying what the picture taught to the American artist's personal vision.

The Union's radicalism did not extend to disapproval of historical painting. It paid its highest prices for those large canvases containing full-length figures which of all productions took the painters the most time and for which only a few European-trained Americans possessed the requisite technique: $1500 for Gray's *The Wages of War*; $1200 for Huntington's *St. Mary and Other Holy Women at the Sepulchre*; and $1000 for Leutze's *The Attainder of Strafford*.

This strong encouragement of the high style reflected a desire to foster, with the more indigenous aspects of American painting, what would most impress international taste. It was also sound merchandising. The Union

was engaged in the mail-order selling, and it is much easier to write appealing descriptions of pictures basically literary than of landscapes or unliterary genre. The Union, indeed, made its greatest coup when in 1848 it secured and for the first time exposed to the public Cole's original version of *The Voyage of Life*. The opportunity to win, for a five-dollar chance, this moral allegory in four mammoth parts raised the Union's membership from 9666 to 16,475. It was in the following year that the three top-priced pictures just mentioned were bought.

The large engravings, suitable for framing, which the Union described annually in words and later distributed to all who subscribed, often reproduced historical paintings. This was especially true in the earlier years. And when the *Bulletin of the American Art-Union* was inaugurated in 1848 as America's first art magazine, the cuts were predominantly of such literary illustrations as came out best in small and cheap line engravings.

However, the vast majority of the 2841 original pictures by roughly two hundred artists which the Union placed on domestic walls in every corner of the nation were in the romantic realistic vein: landscape and genre. And the text of its publications preached devotion to "American scenery and American manners. . . . It is not only nature that we want in our works of art, but it is our own nature, something that will awaken our sympathies and strengthen the bond that ties us to home."

The Union came to hold brief shows in each region of the pictures won there, but its principal exhibitions were always held in New York City. Open annually from April to December, its New York galleries were kept excitingly in flux. Works were hung as soon as artists offered them for consideration, and, as the year advanced, the show was weeded of what the managers decided not to buy, while the pictures they did buy were given a double interest by the fact that they would certainly be among those the members might win when the lucky lottery numbers were determined. Since portraiture did not serve the Union's ends, since history was offered by only a few painters, usually resident in Europe or just returned from there, the overwhelming majority of the works exhibited by the Art-Union were, whether or not eventually purchased, local landscape and genre.

It had been the universal practice to charge admission for all public exhibitions: "Old Paff," for instance, demanded twenty-five cents for a view of his "Old Masters." But in 1842 the Union, "more wisely liberal" (as Bryant put it) than its sister organizations in Europe, abolished this barrier

between modest means and art. The Free Gallery became, so the *Knicker-bocker Magazine* reported, as basic to the city as

> the parks or the City Hall. . . . Its hall shows the progress of the hours as
> well as Trinity Clock. First come the noisy boys and girls on their way
> to school; then the staid merchants drop in as they go down to their
> counting houses; then appear the strangers from the country, who set
> off early after breakfast to see the lions; about noon the gentlemen in
> mustaches and yellow kids lounge about the seats, yawning in the faces
> of the fashionable ladies who alight from their carriages here on their road
> to Stewart's; in the afternoon, comes the returning throng from the
> offices and counting houses, while in the evening the working men . . . don
> their uneasy Sunday coats and come hither by hundreds, escorting
> their wives and children and all their female relations.

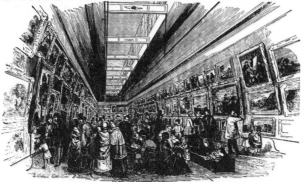

26 S. Wallin *Gallery of the Art-Union*

Woodcut; published in *American Art-Union Bulletin*, III (1849), 6; New York Public Library, New York.

The *Literary World* added that in the evening the red glass over the door drew "like a lurid extra-size planet" the human tides of Broadway in and up towards art. It was the Union Gallery that enjoyed, from 1839 to 1851, an average yearly attendance equal to 57½ per cent of New York City's population, as compared with the attendance from 1939 to 1951 at the Metropolitan Museum of 16¼ per cent. The actual figures were: 250,000 and 1,300,000.

By 1848, the American claimed it was the largest art-union in the world. Its success inspired regional imitations, which it welcomed as further support for American art. Founded at Cincinnati in 1847, the Western Art-Union lifted its membership to almost five thousand when it distributed Hiram Powers's sensational nude statue *The Greek Slave*. Promising beginnings

[97]

were made by the Philadelphia Art-Union (1848), Trenton's New Jersey Art-Union (1850), and Boston's New England Art-Union (1850).

The National Academy, which had at first welcomed the help of the merchant-amateurs, became increasingly worried by their methods and their success. Since the American Art-Union's mounting prosperity was caused not by an increase in the cost of chances but in the number of subscribers, it raised only slightly, between 1839 and 1851, the average payment per picture — from $85.70 to $104.40 — but doubled and redoubled the number it bought — from 36 to 395. That the Union, now rich, paid handsomely for only an occasional historical picture annoyed the leaders of the Native School, including some, like the Missourian Bingham, whose original reputations the Union had itself made. To their complaints that they were being insulted by being offered for their pictures less than they asked, the managers replied that the Union was educating private buyers who would handle the top market. Indeed, despite the seeming competition of the Free Gallery, paid attendance at the Academy exhibitions increased each year with the augmented interest in American art. However, the Academy attributed this growth to their own efforts.

Then there was the issue of quantity versus quality. Trying through careful selection of its membership and weighting of its shows to channel patronage to what it considered the best work, the Academy insisted that the Union was, by its emphasis on inexpensive pictures, encouraging incompetence and debasing American taste.

Painters were springing up under the Union's encouragement like shoots after a spring rain. The treasurer of the Academy, the miniaturist Thomas S. Cummings (1804–1894), had estimated in 1840 that "350 to 300 new works are the natural production of the year." A decade later, the Union was offered for purchase 1800 paintings. That this artistic population explosion included too many monotonies and trivialities both organizations agreed. However, to the Union's claim that the support of imperfection made growth to perfection possible, the Academy replied that the Union was fostering cheap labor to undersell the skilled. The Union's rebuttal was obvious: the Academy wished to limit all business to a clique.

The struggle for power between painter and patrons that had embattled the American and National Academies thus flared up anew. Not only was the Union management controlling a large part of the art market, but in the pride of their success, they were abandoning the humility which merchants like Reed had felt in relation to artists. They were accompanying refusals or shavings in price with lectures on how to improve. After such a session,

[98]

Mount wrote that dealing with merchants "lowers. the dignity of artists. . . . Who paints the pictures, the committee of the Art-Union or the artists?" Artists, the management replied to such strictures, were "conceited." If they "could only infuse as much spirit into their pictures as they put gall" into protests, "their fortunes would be made."

Having had in 1847 by far the best year in its history, the Academy felt strong enough to cut the Union down. The members decided to exclude from their own exhibitions any pictures that had been shown at the Free Gallery, which meant, in effect, all that had been offered to the Union. However, the mass of painters, forced to choose, chose the show that offered the best chance of sale. The Academy's walls became almost bare, and by 1849 its receipts had dropped so low that the organization was in danger of dissolution.

"The time and talents of every member," Durand cried out as president of the Academy, "are required to preserve the independence of the profession and keep it from being a humble follower of the Art-Union." The Academy threatened to establish its own art union, at which the Union threatened to organize the younger artists into an academy that would be less exclusive and would have schools rivaling Europe's.

At this point, the body of the merchant-amateurs intervened. They forced the retirement of the Union's aggressive management. Then they brought the Union to the rescue of the Academy, buying for two thousand dollars a group of pictures which the academicians had donated to their organization for the purpose.

Although sparring with the artists made the Union vulnerable by weakening its idealistic position, an extraneous issue pulled the organization down. In 1851, the directors made their mailing list available to the newly established abolition organ, the *New York Times*. Outraged at such support for the competitor he called a "nigger penny organ," James Gordon Bennett launched his *Herald* into an attack which accused the Union directors of sequestering subscribers' money for antislavery propaganda and to buy themselves "oyster and champagne suppers." When the directors sued for libel, Bennett wrote that he would give them "such a dose as will make them sick of the law for the rest of their journey in this mundane sphere." Sure enough, he had the suit thrown out on the grounds that the Union was an illegal lottery. In 1852, after additional litigation, the organization that did more than any other in all American history to further American art was ordered dissolved as a gambling hell.

For younger painters this was, as Eastman Johnson remembered, "a

misfortune"; studying in Holland, he was at a loss how to "dispose of my pictures at home." Although Cummings admitted that the sale of pictures dropped until the market had time to return "to its proper channels," the Academy welcomed the demise of the Art-Union. They may have been right. Control of their profession had been returned to the creators, and business was soon booming as never before. The Union had done its work so well that it was no longer needed.

Its tendency to place, in its merchandising efforts, emphasis on historical and literary art had an important influence on what can be called "the distaff vernacular," paintings made in finishing schools by young lady amateurs and engravings aimed primarily at refined Victorian females. But on the fine arts level the men called the tunes, and they proved significantly immune to all aspects of neoclassicism and romantic idealism. They took to their hearts the romantic realistic pictures which the Union had distributed so widely. As the management boasted, the Union had pursuaded the wide American public to "dare" esthetically "to love themselves."

Rooting deep in the hinterland the taste for native landscape and genre that had first arisen in New York City, the Union had, by operating from that city, encouraged artists and collectors everywhere to regard New York as the national artistic clearinghouse. However, the roads that had been opened were traveled both ways: the Union had strengthened the Native School with ideas and pictures brought in from the West. A critic in the *American Whig Review* considered the National Academy exhibitions "domestic and refined" as compared with the Union Free Gallery that was "bucolic and rustic."

In the great West, where books were rare and colleges almost nonexistent, where pragmatic considerations had been so important to pioneer survival and were now so important to creating prosperity, anti-intellectualism was rife — a disdain for book learning. One of the West's greatest itinerant evangelists, John Strange, orated, "Brush [thicket] college, more ancient though less pretentious than Harvard or Yale or Princeton: here I graduated and I love her still." Her curriculum contained, in addition to the Gospels, "the philosophy of nature, . . . trees, brooks, and stones, all of which are full of sermons and wisdom and speeches." Strange might have been paraphrasing Durand's *Letters on Landscape Painting*.

Herman Melville complained in 1851, "The country . . . is governed by sturdy backwoodsmen — noble fellows enough, but not at all literary, and care not a fig for any authors except those who write . . . the newspapers and

magazines." Visiting St. Louis a year later, Emerson doubted that there was among its ninety-five thousand inhabitants a single "thinking or even reading man." But at the very moment, St. Louis was the home of that important painter Bingham.

Uninterested in any esthetic theories except their own, appealing to a public that preferred pictures to words and was not philosophically minded, the painters were startlingly independent of critics outside their own ranks. Writers for newspapers and popular magazines, of course, responded copiously to the popular interest in the Native School. However, when they repeated ideas from books or dropped exalted names, it was only to exhibit erudition. In so far as the journalists had any consistent point of view, it followed the painters'.

As will be later demonstrated, the most intellectual contemporary theorists on art who wrote in the United States or were well known there — Emerson, James Jackson Jarves, Ruskin — supported esthetic theories inimical to the Native School. However, their books and essays, along with the erudite or holy effusions of bluestockings or scribbling divines, were primarily influential on a few variant artists and in those drawing rooms where American paintings were in any case least likely to hang. And even in the purlieus inhabited by usually hostile intellectuals, the Native School made inroads. Not only did they secure an occasional enthusiastic convert, but some perceptive individuals, whose theoretical objections remained strong, could not help admiring the best of the heretical landscapes, the plebeian genre. We shall see that this was the case both with Jarves and the young Henry James.*

Confusion was thrice confounded in the mid-century's most voluminous tome on American painting and sculpture, *Book of the Artists* (1867), by Henry T. Tuckerman (1813–1871). A literary man well known for his writings on European travel, Tuckerman stated in his Introduction that "the sudden prosperity of an imperfectly educated class" was valuing "the work of American artists, especially painters, . . . far beyond its actual market value if we take European prices as a standard." A "first-rate copy" of an Old Master or an original by one of the transatlantic painters then fashionable — he mentioned by name Landseer, Rosa Bonheur, and Achenbach (probably Andreas) — appeals "to the purses and the eyes of the judicious infinitely more." So Tuckerman wrote when he generalized, but when he moved on to discussing individual American painters and pictures, he

*"It is the kind of art," James complained (of Church's landscapes), "which seems perpetually skirting the edge of something worse than itself, like a woman with a taste for florid ornaments who should dress herself in a way to make people stare, and yet who should be really a very reputable person."

accepted almost all at their admirers' valuations. He reprinted potboilers he had himself written for *Godey's Lady's Book*, and quoted other periodical writers to make the body of his *Book of the Artists* a hodgepodge reflecting the broad public's joy in their Native School.

The period's two most influential writers on American painting were, not surprisingly under the circumstances, painters: Durand, whose *Letters on Landscape Painting* has already been discussed, and William Dunlap. Dunlap's reviews in the *New York Mirror* top all other such journalism. Chronicling with evocative enthusiasm the adventures and achievements of three generations, his book *The Rise and Progress of the Arts of Design in the United States* (1846) helped refute any lingering doubts that America was capable of producing art. As became an elderly man who had been a pupil of West, Dunlap had a predilection for the modernizations of the grand style made in the late eighteenth century by American painters resident in London, but he did not scorn the simpler painters who had worked closer to the vernacular manner at home, and he recognized in the contemporary Native School a new and exciting burst of creativity.

When they had refused to follow Quidor and especially Cole in romantic idealistic directions, the realistic landscapists and genre painters had left to one side the more intellectual, the speculative, the cosmopolitan, and the learned aspects of American thinking. If this narrowed their scope, it brought an invaluable boon. The painters escaped from the pressure that was damaging so much contemporary European art, the pressure to delineate on canvas what could better be expressed in words.

WINDS FROM EUROPE
Düsseldorf and Paris; England and Italy

IN 1849, when the National Academy and the American Art-Union were at the height of their controversy over whether painters or patrons should control the distribution of American art, two new artistic institutions opened their doors on New York City's Broadway. The Düsseldorf Gallery and the International Art-Union presaged revolutions that were, as the years passed, to make obsolete the issues concerning which their predecessors were skirmishing.

Both the newcomers promoted what Americans currently collected hardly at all: contemporary European art. And as an organ of the recently inaugurated American branch of a great Parisian firm, Goupil and Company, the International Art-Union was an effort to interpose between painter and patron such effective professional art dealers as had been previously unknown on these shores.

Of the two ventures, the Düsseldorf Gallery flourished most quickly. Its success in making the Düsseldorf School the most important non-English contemporary influence so far exerted on American painting has puzzled historians, who have regarded that school as the provincial expression of a small Rhenish center. Actually, it spoke for much of mercantile Northern Europe. The Düsseldorf Academy was an arm of the Prussian government; its director, Friedrich Wilhelm Schadow, had, with much of the faculty, been sent in from Berlin. Painters of many nationalities — Germans, Americans, Scandinavians, Belgians, Hollanders, and even Russians — made clamorous the studios in the sleepy Westphalian town.

While German official art still listened to the theorists and pursued the high style, Düsseldorf was a crucible of change. Although Schadow, a Catholic and a former Nazarene,* wanted to lead his academy along the correct path of religious historical painting, even his own pictures were not coming out right. His *Holy Families* seem depictions of bourgeois domesticity and his *Flights to Egypt* might be incidents in a burgomaster's picnic.

The second figure at the Academy, Karl Friedrich Lessing, had come with Schadow from Berlin, but was not a Catholic. In revolt against Nazarene conceptions, he painted Protestants being martyred and somber scenes from Germany's medieval past. Although their differences created religious and political tensions within the Academy, Schadow had to accept Lessing's art since, even when it contained strong landscape elements, it was historical painting. But Schadow saw to it that instruction in pure landscape was skimped,† and he actually expelled from the Academy that pioneer genre painter, Johann Peter Hasenclever.

However, Schadow's fundamental gifts were as a promoter. Having organized in 1829 an art union to sell Düsseldorf work, he found that to satisfy the middle-class European market he needed to distribute landscape and genre. Furthermore, the Prussian civil servants who ruled Düsseldorf, led by the poet and dramatist Karl Leberecht Immermann, initiated an amateur theater that sometimes convened in Schadow's own house. After a successful production of, say, a Shakespearean comedy, it seemed natural for the painters to preserve on canvas the most effective tableaux. The door to genre being thus opened, some daring artists painted it independently of written sources. And the drift towards landscape painting was encouraged by arrivals from Scandinavia. And so, although the less conventional activity was still largely outside the Academy, Düsseldorf became a center for that middle-class painting which Germans call Biedermeier.

When the upheavals of 1848 threatened Germany with civil war, John G. Boker bought and carried to the safety of New York City, where he was Prussian consul, a quantity of Düsseldorf pictures. The public gallery which he opened on Broadway charged admission and sold memberships in Schadow's art union. It was the first comprehensive exhibition of the Düsseldorf School outside Germany, and also the first such showing of any modern European school in the United States.

The Catholic-Nazarene side of the school, which was never to have any

*See footnote on page 44.
†Johann Wilhelm Schirmer, the primary instructor in landscape, represented a third party in the Academy disputes: the local Westphalian artists who resented the incursion from Berlin.

appeal in the United States, was played down in the Düsseldorf Gallery. The most ambitious picture in the high style was Lessing's huge *The Martyrdom of John Huss*, imported a year after the opening. It proved to be a superior exemplar of the rational historical illustration — to be read like a book rather than experienced through direct emotion — which West had pioneered in such pictures as his *Christ Healing the Sick*, that had since 1817 hung at the Pennsylvania Hospital. Huss's "agonies and ecstasies among the flames" are not shown but intellectually presaged by a stake in the background. The action is a three-fold static contrast between Huss on his knees in prayer, Catholic aristocrats and priests gloating evilly in plumes and fine vestments, and noble, weeping Protestants characterized by "the rude quaintness of peasants." Over this picture, great arguments raged in New York. To the charge that the innumerable meticulously painted details of pose and costume dribbled away all passion, defenders replied that the proponents of the Native School were jealous because their artists were not skillful enough to achieve that pictorial completeness which brought a "full moral impression."

Düsseldorf genre still leaned heavily on those theatrical tableaux illustrating Shakespeare and other literary sources which American painting had abandoned. More direct renditions of peasants reflected the artificiality of the Beidermeier manner that had been pioneered in the 1830s by the Austrian Ferdinand Waldmüller. Having, as a commentator wrote, "always moved in good society," the ruling painters and patrons of Düsseldorf possessed no firsthand knowledge of rural life. Mount's subtle effects that assumed familiarity with farming would have fallen flat. Thus, genre emphasized "the anecdotal element": usually sentimental, occasionally melodramatic depictions of nobly gesturing poor men being oppressed by monstrous aristocrats.

The old fear that too close contact with unexalted subject matter would make pictures mean lived on in the Biedermeier style. Far from attempting realistic depictions of actual peasants, Düsseldorf artists painted suitably costumed actors who struck poses conned from antique statues. Thus, Immermann explained, "the feeling for ideal form may be practiced simultaneously with the immediate vision of nature." Genre painters sought "the line of beauty," a tender, graceful swing of outline that was supposed to abstract away from boors their boorishness. Hübner's *The Young Couple's First Quarrel* was typical.

Among the landscapes shown at New York's Düsseldorf gallery, those by the Norwegian Hans Friedrich Gude were most powerful and also the closest

to Hudson River School practice. Gude's work was as realistic and detailed, more so indeed because he was a more skillful and determined draftsman. However, his mood was not the American happy lyricism: he painted the harsh scenery around the North Sea — cliffs, evergreens, rocky wastes impervious to the plow — as stern challenges to human fortitude. And instead of using values to draw the eye deep into the picture, he placed his greatest darks in the middle distance and then jumped to a dim background.

Such a sharp break — as in a theater where the stage ends suddenly as the backdrop takes over — was typical of Germanic romantic landscape painting. In the hands of less taciturn artists than the Norwegian-born Gude, it was used to seek *Stimmung* (mood) by startling contrasts between firm cool middle-distances and vistas dreamy against hot, often pink skies. The continuity of distance, which would interfere with such "poetry," was skimped or skillfully omitted. This practice, so different from the Hudson River reliance on a continuous gradation of values, was to become, especially in the work of Bierstadt, the major heresy among our mid-century landscapists.

The Düsseldorf landscapes which German critics today most admire were not shown in the New York gallery, for they were not the finished pictures commonly sent to exhibitions, but oil sketches made in the open air by artists like Schirmer and the brothers Achenbach. The spontaneity of these little canvases was lost when the artists painted in their studios their "important" pictures. Then a heavy touch banished lyricism. How ponderous were Düsseldorf's full orchestrations is nowhere more conspicuous than in the modifications — there were many in the New York gallery — of old Dutch styles. In waterfront scenes, the people dangerously overweight the wharves, and the boats, which are clearly made of lead, would certainly sink if the water were not molded from the same substance.

At the gallery, pictures of medieval Germany abounded, some in the *Marchen* style that substituted a cozy quaintness for the wild exuberance with which Quidor had reconstructed early New York; others dramatic renditions of old battles. There were none of those historical landscapes, for which Lessing was famous, that showed castles beetling down on romantic and often bloody action. Had there been, they would have reminded Americans of Cole's Gothic scenes — but with a major difference. Where to Cole the medieval was shuddery or gay playacting, to Lessing it was a national time of darkness or glory that reflected states of mind in contemporary Germany. His renditions were stronger and graver, less delightful and more moving.

[106]

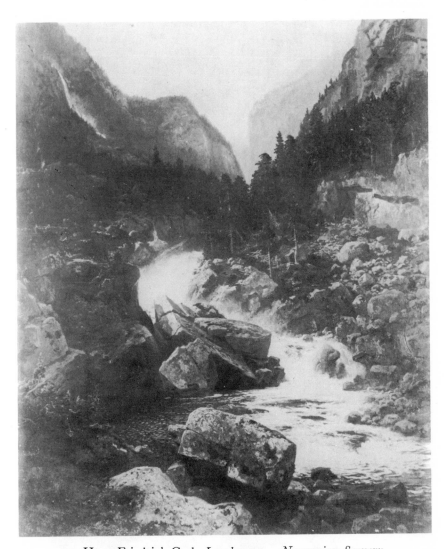

27 Hans Friedrich Gude *Landscape — Norwegian Scenery*

Photograph after the painting, published by Goupil & Co. in *Gems From the Düsseldorf Gallery*, New York (1863).

28 Karl Hübner *The Young Couple's First Quarrel*

Photograph after the painting, published by Goupil & Co. in *Gems From the Düsseldorf Gallery*, New York (1863).

In relation to the nude, Düsseldorf was as prudish as New York. Among its leading painters only Carl Sohn assayed such subject matter. He was represented in the Gallery by *Diana and her Nymphs Surprised at the Bath:* five young ladies whose bareness above the waist was clearly not the result of lascivious intentions since those who were not cringing modestly were indignantly turning the spying Actaeon into a stag. Other Düsseldorf ladies, as shown in *The Serenade* or the *Evening Song*, were in the mode of fancily costumed "ideal portraits" which Allston* had pioneered here almost a generation before, and which Sully had carried into depths of sentimentality that rivaled Düsseldorf's own. In America, such pictures were now only current as illustrations for ladies' publications.

Speaking for the patrons of the Native School, the *Bulletin of the American Art-Union* found in the Düsseldorf pictures little originality, a marring "display of the machinery of art," mechanical color that made the paintings look like decorations on snuffboxes, a want of "largeness" and "noble feeling," and too much dependence on other pictures rather than nature. However, so the *Bulletin* continued, no other foreign school offered as much to American painters. They could learn from Düsseldorf "the indispensable necessity of laborious" preparation, of "indefatigable and minute study of form." The "besetting sin" of American painters was hurry, beginning a picture before it was thought out and relying on inspiration to carry them through somehow. Düsseldorf showed how to make a picture as good at the finish as it had been at the start.

Undoubtedly, much of the Düsseldorf School's appeal to the Native movement was that so many of its artistic forms were for Americans old-fashioned, actually out of date. And this other purely middle class expression was, like our own painting, sane and moral: few imaginative flights, no glorifications of sex or violence, none of those esthetic niceties that the bourgeoisie considered toys for jaded aristocrats. While offering technical proficiencies, Düsseldorf presented nothing so exciting that it might lure our painters from their indigenous paths.

A favorite anecdote among the knowing was that a young lady thought the pictures "exquisite," but wondered "how Mr. Düsseldorf had found the time and patience to do them all so well." The general public was more impressed than the critics or the painters. The pictures were so completely worked out that the most torpid imagination could walk through them without any let. That they made the viewer accept the existence of a quaintly unreal world

*The elderly Allston now ranked German painting "very high, especially in purity of taste."

only increased the pleasure.* Thus the Düsseldorf Gallery had an amazing run on Broadway, from 1849 to 1862.

In 1857, the Gallery had been sold to Henry W. Derby, an auctioneer whose activities demonstrated how far down the American economic and cultural ladder a desire for art now penetrated. He had founded in 1854 the Cosmopolitan Art Association, an art union which evaded with legal fictions the antilottery decision that had killed off others. Although he considered it rewarding to tune the Cosmopolitan's sales pitch to the encouragement of American art, Derby was unwilling to pay the prices that even American beginners, if they were at all competent, could obtain. No creators' names were attached to most of the objects, sculptures as well as paintings, that he distributed. Most had been imported wholesale from Europe.

When in 1856 Derby began sending his members his own magazine, *Cosmopolitan Art Journal*, it proved to be aimed primarily at a female audience that relished attacks on the well-bred, the educated, and even the moderately well-to-do. Today, it would be impossible to interest so anti-intellectual and financially humble a public in a selling scheme geared to art. However, Derby prospered. To catch tourists visiting New York, he built in 1860 his grandly styled "Institute of Fine Arts," which sported a dome and an elaborate marble façade five stories high and dripping sculpture. Here the Düsseldorf Gallery lent respectability to the inferior art the Cosmopolitan distributed. However, as we shall see, a return to higher social status awaited the Germanic pictures.

When still a power, the American Art-Union, which had praised the then connoisseur-owned Düsseldorf Gallery, had attacked the International Art-Union as a selfish speculation of "mere picture dealers." Such base individuals, the merchant-amateurs contended, could only corrupt American taste since it was impossible for them to "love art irrespective of commercial value." The profit motive, so admirable in business exchanges, should be barred from the distribution of art. As for the suggestion that the managers of Goupil and Company could be experts, this was as ridiculous as if "a fish monger should claim superiority in knowledge" to a naturalist "because it is his profession to deal in fish." Thus the merchant-amateurs responded with alarm to a force that was to bring their richer successors obediently to heel.

The National Academy felt no qualms but welcomed Goupil as an ally

*The Düsseldorf type of painting is still used by dealers to get the unsophisticated rich started collecting art. When the clients graduate to what is more correct—and more expensive—the dealers buy the pictures back for resale to other beginners.

against connoisseur-domination. Although the International Art-Union distributed European art exclusively, the American painters felt too sure of their position to fear that they would be displaced in the home market. And they were glad to have their own esthetic horizons enlarged by good foreign canvases. When in 1856 the Academy petitioned — it proved vainly — for a duty on art imports, they asked that it be assessed not by value but by the square foot. This would bar "worthless trash," which lowered American taste — what the Cosmopolitan Art Association distributed — but not "works of excellence."

To Academy support Goupil responded by offering some native pictures in their shop; by sending some American paintings — as they did Mount's — abroad to be engraved for international distribution; by praising in the organ of their art union, the *International Art Journal*, the work of the academicians; and by promising to use part of the Union's earnings to give annually a scholarship for European study to an artist selected by the Academy.

Goupil sold privately what was probably the first important modern French work to reach these shores (1849), *Napoleon Crossing the Alps*, one of several versions by Paul Delaroche. Although their International Art-Union offered two minor studies by big names, Delaroche and Ary Scheffer, Goupil relied for popular appeal primarily on "exquisite and dazzling delineations of female beauty." Among the forty-three pictures in the International's first exhibition, twenty or twenty-one depicted girls, some seductively undressed to please the males, some wearing, for the female audience, the latest Parisian fashions.

Although the American Art-Union believed that foreign pictures "when really meritorious" should be extensively circulated and bought for a part of our annual expenditure on art, they threatened to have the International Art-Union's imports stopped at the border as obscene. "Faulty" in "moral tone," "sensual," not "spiritual," "extravagant in action and exaggerated in color," of all schools the French was best calculated to "stain the rising fountain of American art."*

When the International Art-Union sent its offerings touring to some forty places from Boston to Chicago to New Orleans, the sensation with the visiting crowds proved to be not the Delaroche or the Scheffer, not any young lady clothed or nude, but one of the few non-French works included.

*Before the reader gets too hot under the collar let him remember that the French themselves are now ashamed, although not for moral reasons, of the kind of art that their own connoisseurs then admired and to which American taste was being exposed.

It was *Children Leaving School* by Waldmüller, such a picture as might have been in the Düsseldorf Gallery.

The French government, as alive then as today to the interest of its artists, presented to the International Art-Union, for distribution the next year, at no extra cost, three paintings "to bear witness to the sympathy inspired by these efforts to extend to another country the popularity of the works of the school of France." When the legal striking down of the art unions forced the dissolution of the International along with the American, Goupil went on, if anything profited, for it was not their destiny to sell French art to the broad public. The American Art-Union had noted a trend that was to grow when they commented angrily, "Pretended connoisseurs suppose that to admire the same picture which pleases an uncultivated mechanic is necessarily a sort of admission of their own want of taste."

As the native economy swelled, plunged down the rapids of the Civil War, and then rushed on ever faster, it washed to the top of an ever-taller economic pyramid a new kind of rich man. He had little direct contact with the products of field and forests or with the plain citizens who produced them; he manipulated paper that symbolized national assets. Such capitalists followed at first the established fashion of collecting native paintings. But as their conspicuous wealth increasingly set them apart, they began to hanker for collections equally conspicuous and unusual.

The obvious beginning move was to the Düsseldorf School which combined a foreign cachet with technical proficiency and a comfortable backtracking of taste. Sensing the trend, Derby put the Düsseldorf Gallery up at auction in 1862. The pictures, so long the favorites of the simplest Americans, moved quite naturally to the parlors of the new rich.

However, in the late 1870s a writer employed by Goupil was able to exult, in describing the collection of John Wolfe, who had bought most heavily at the Düsseldorf auction, that the Germanic pictures had retreated from his parlor to his dining room or to resale. Now the Wolfe mansion featured "the more select names of Bonnat, Stevens, Lefebvre, Madrazo, Vollon, Munkácsy, Cabanel, and Breton." Düsseldorf's American day had ended.

The Baltimore railroad millionaire William T. Walters (1820–1894)* bought American art until he was forced to flee Maryland during the war because of his Southern sympathies. In Paris, he solidified a new taste that

*It was this man's son, Henry Walters (1848–1931), who was primarily responsible for the great collection at the Walters Art Gallery.

made him auction off most of his native pictures. He pointed with the greatest pride, after his return to Baltimore, to *The Duel after the Masquerade*, by Jean Léon Gérôme. It shows dawn in the Bois de Boulogne: fog, sleet, blood on the snow. Two jealous lovers have just fought. The victor, costumed as an Iroquois and assisted by a harlequin, walks off, so emotes Goupil's writer, "with the consciousness of guilt written on the lines of his back." "Pierrot" is dying: his agonies contort features covered with flour. Although his form droops "with the supine flexibility of a dead body, . . . his nerveless arm . . . still mechanically guides the rapier." Over him lean "the Duke de Guise," "a Doge of Venice," and a third man "muffled in a black domino. . . . There is," the writer continues, "the epitome of a hundred novels in this painting. . . . An appalling story of anguish and crime!"

The picture is, indeed, impressive if we accept the linear and literary taste in which it was conceived. No American could have painted it. For a Maryland entrepreneur in his own way daring, but not with the rapier or over love, it presented — as did the other romantic costume pieces that came in from France — a total release from the materialistic and Victorian world he normally inhabited. And after the bloodbath of the Civil War, the sense of danger and the imaginative escapes so long cultivated by French art had a new appeal.

While French influence on taste in the United States was as conspicuous as a red stroke on a green wall, English influence was at its strongest where it showed least. Not only our culture but our population had been, since the first settlement of British America, linked with the British Isles. The movement of men and ideas continued — yet no contemporary painter working in England and no contemporary English school had any really important effect on what were now the main channels of American art.

In so far as American workmen responded to specific rather than general British influences, they studied the artists of the previous generation. Engravings after Wilkie and the caricaturists helped get our genre school started. And the landscapists were commonly conscious of Constable and Turner, both born when the American Revolution was still being fought. Partly because what the artists accepted from Constable merged more smoothly with their native practice, his influence is less apparent than that of Turner, whose grandiloquencies appeared whenever the landscapists stepped away from the dominant realism towards romantic idealism.

No one was called "the American Constable," but James Hamilton (1819–1878) reveled in the title "the American Turner." Born in Ireland, he was

brought at the age of fifteen to Philadelphia, where he received craft training as a book and magazine illustrator. This involved depicting whatever an author described, whether one had ever seen it or not. Towards such an end, Turner's dramatic idioms were extremely valuable, as Hamilton realized when he spent two mature years in England (1854–1856). After his return, he achieved his most popular work: the plates for Elisha Kent Kane's *Arctic Explorations*. Immediacy was supplied by copying from rough sketches Kane had drawn on the spot; it was the Turnerian effects Hamilton added that made *Blackwood's Magazine* consider the illustrations "the products of a man who is a real poet in art, and [who] invests the whole work with a halo of romance mysterious as the effects of light in those northern regions."

As an easel painter, Hamilton usually sought what *Godey's Lady's Book* called "the grand and terrible." His *Foundering* is a confused rendering of a boat that seems to be crumbling away, a phosphorescent vision, into a gray sea. In his *Last Days of Pompeii* destruction rains from a wild sky on a city constructed from impasto and chromatic hints. That Hamilton had in his temperament other directions that might have been profitably developed is shown by his *Atlantic City Scene* (1870), which denies all bombast to present a simple, unheightened view of shore and ocean in delicate pastel shades that remind the viewer amazingly of Whistler.

The critic who had by far the most readers in mid-century America was the Englishman John Ruskin. This has induced historians to assume that Ruskin must have been highly influential on our painters. Actually, the Englishman's limited creative effect can be cited as the final proof of the divide which separated the intellectual reading community from the makers and purchasers of art.

In the copiously mushroomed cloud of Ruskin's writings there exist, it is true, passages which it could be assumed helped form the esthetic of the Native School, but the main directions of his thought ran contrary to that of the American painters. Where they, at their most typical and profound, wished to express God in nature, Ruskin was not in any deep sense a pantheist. He believed that at its highest art expressed "the Greatness of Man and of mind." Religion came in the back door as in this list of the attributes of great painters: "Kindliness and Holiness and Manliness and Thoughtfulness." Concerned with the glorification of humanity, he attacked artists who, as the Hudson River School wished to do, suppressed personal style to "trick the spectator into a belief of reality." He expatiated endlessly on "manipulation," on the handling of paint, insisting that the more surprising

the means by which a natural effect was achieved, the greater the esthetic impact. Like the Native School, he believed in the importance of subject matter, but he brought to his judgments on this score a delicacy and a snobbishness inimical to rough American democrats. He considered that Salvator Rosa, to whom Cole's admirers were happy to compare their hero, stood for "cruelty and horror and degradation and decrepitude of intellect"; and he attacked even his beloved Pre-Raphaelites* when the faces they painted revealed by "commonness of feature" that the protagonists — even villains — were not "gentlemen." That realism should be tempered with idealism Ruskin strongly believed, and he was deeply concerned — as the American painters were not — with both appreciation and imitation of Old Masters.

To the Hudson River School, Ruskin paid his compliments when he wrote, probably about pictures by Kensett, "I have just seen a number of landscapes by an American painter of some repute, and the ugliness of them is wonderful. I see that they are true studies, and that the ugliness of the country must be unfathomable."

Ruskin wrote that the English Pre-Raphaelites were "certainly the greatest men, taken as a class, whom modern Europe has produced in concernment with the arts." When in 1857 New York had its first Pre-Raphaelite exhibition, the reading public, as devotees of Ruskin, flocked with the determination to be impressed. However, they came away puzzled, a confusion which further importations did not dispel. A writer for the *Nation* stated in 1865 that among thousands of drawing-room references to the Pre-Raphaelites, he had only twice heard the word properly used.

Reacting to a style of decorative upper-class painting for which the United States had had no parallel, the Pre-Raphaelites had adopted a mannered angularity for which Americans could see no point. The English efforts to express mysticism, Toryism, and High-churchism through recourse to fifteenth-century Italian models had no greater local reference. Most Americans who were determined to admire concentrated their praises on that overemphasis of detail that was already the fault of the Hudson River School. Thus New York's Pre-Raphaelite journal the *New Path*, published by the "Society for the Advancement of Truth in Art," announced in its

*Founded in London during 1848, the "Pre-Raphaelite Brotherhood" mingled the medievalism and self-conscious piety of the German Nazarenes with an angularity all their own and a concern with English life that brought genre back into English fashion. The leading Pre-Raphaelites were Rossetti, Millais, Burne-Jones, Holman Hunt and Ford Madox Brown.

first issue (1863) that it was going to reform American painting, which it defined as worthless, but had nothing more startling to suggest than "loving study of God's work in nature, . . . selecting nothing, rejecting nothing, seeking only to express the greatest amount of fact." In its comments on specific native pictures, the *New Path* hardly strayed from well-traveled American critical roads. It was not uncommon to consider that extremely accurate Hudson River School painter Church a Pre-Raphaelite.

A dissident group accepted Ruskin's emphasis on literary values as the point of the British movement. However, American art had gone too far beyond that approach to return to it. Active concern with the Pre-Raphaelites soon faded except among extreme Anglophile groups, particularly in Boston, where intellectualism had blinded the "Brahmins" to visual impressions but compensated by giving them Ruskin as a seeing-eye dog.

Among the few American painters who wished to be considered Pre-Raphaelites, the leader was William James Stillman (1828–1901). He differed from his colleagues in being college-educated. Having studied briefly with Church, he fell under the spell of Ruskin, whom he met during a trip to Europe. To bring home the word, he founded in New York City America's first (1855) independent art magazine, the *Crayon*. However, he soon abandoned the publication to Asher Durand's son John,* who was less a disciple of Ruskin than of Taine. Stillman moved on to more congenial Boston, and he frequented Emerson's circle. Then he sailed to Europe, where he spent the rest of his life as a journalist. About 1860, Stillman abandoned landscape painting because he felt that his theoretical knowledge had outstripped his executive ability.

In the United States, true comprehension not only of Ruskin but of most European writers on art was impeded by a gleeful ignorance of the Old Masters. Even the staid *Knickerbocker Magazine* mocked as comic fops — "a pair of mustaches and lemon kid gloves" — American purchasers of traditional European art. Claims to have bought while abroad "that wonderful picture by a lucky chance" were regarded as proof that fools had succumbed to sharpers. This was not only recognition of a common contretemps, but also a desire to dismiss the Old Masters as opposed to progress.

Abroad, however, two expatriates were buying on a large scale and with an identical intention: to raise American culture by bringing home a gallery of authentic pictures exemplifying the historical development of Christian art.

*John Durand was to attribute to Ruskin's influence a rise jn American concern not with the English Pre-Raphaelites but with French art, based on Ruskin's lavish praise of the French genre painter Édouard Frère.

Based at that artistic crossroads, Paris, Thomas Jefferson Bryan (1803?–1870) acquired old Italian, Dutch, Flemish, and French pictures. In Florence, James Jackson Jarves (1818–1888) bought only Italian.*

For some twenty years Bryan scurried through French streets seeking "with infinite gusto" blackened paintings. "With admirable patience," he cleaned them himself. Usually, when the obscuring dirt was gone, Bryan was disappointed and discarded the result. But sometimes — oh, how he exulted! — he thought he recognized a master hand, perhaps Raphael, perhaps a lesser name. Then, as he wrote, he was "ready to establish and sustain his opinion in every possible manner."

Returning to America in 1852, Bryan wished to give his collection to a public institution in America's artistic center, New York City, but could find none to receive it. He crowded into a second-floor room above Broadway the more than two hundred pictures that then comprised the "Bryan Gallery of Christian Art." To protect his darlings from fire, he furnished an adjoining room for himself and practically never descended the stairs. "He could be found at almost any hour seated in an old-fashioned arm chair, in a picturesque *robe-de-chambre* and velvet cap, looking, with his snowy hair and florid complexion, like some old Venetian or Florentine, surrounded with pictorial heirlooms." His tranquillity was not often disturbed, for the public did not flock and the art students he invited to come and copy usually stayed away.

When in 1857 Peter Cooper founded Cooper Union as a cultural center for workingmen, Bryan lent his pictures towards the inauguration of a free museum. He enjoyed being able to walk the streets without anxiety, but on a rainy day he dropped in to see his collection and found Cooper pointing out the beauties of a "Rembrandt" with an umbrella. Cooper Union had to wait almost forty years to have a museum.

The ghost of the American Art-Union had supplied Bryan with an alternative. The inheritor of the Union's remaining assets, the New-York Historical Society spent them on a fireproof gallery that was opened in 1857. Art rolled in from all over the city. Bryan's pictures soon joined Assyrian reliefs, two mummified bulls, and the largely American collection of the New York Gallery of Fine Arts.

Member of a Philadelphia family that had accreted wealth down the generations, scorning trade in pictures or anything else, a courtly gentleman of the old school (he did not know that his valet was in fact a woman), Bryan

*Bryan's eclecticism extended to buying, when he was in America, pictures by America's Old Masters—West, Rembrandt Peale, etc.—something Jarves never did.

had recognized new times only in his desire to expand an "amateur's" collection into a public institution. Tuckerman derided him as ignorant of all modern achievements and of Ruskin: as a "dilettante," not "a philosopher of art."

By contrast with Bryan, Jarves seemed an inhabitant of the future. His family money was new and based on the mass distribution of cheap goods: his father manufactured Sandwich glass. Far from relaxing like an aristocrat, he bore on his superbly handsome face the angry stains of perpetual dissatisfaction: he helped inaugurate that continuing line of New Englanders who burn in exotic climes with tortured esthetic flames.

On the Sandwich Islands, Jarves edited a newspaper and became a potentate in the missionary-controlled government. He was thirty-three years old and on his first trip to Europe when he was struck with the revelation of art. Only three years after he had first looked meaningfully at a picture, he published his book *Art Hints* (1855) and brought back to Boston, as a dealer, a "Titian." After he had sold the "Titian," it proved a fake, and the book outraged every shade of artistic opinion. The intellectuals considered his generalizations clumsy steals from their own mentor, Ruskin, and he offended the supporters of the Native School by pontificating on an American art he had never bothered to examine. Having himself awakened to beauty abroad, he assumed that was the only way. Art would have to be "carried" to the United States by "students who will . . . go on their backs and knees . . . to read the soul-language of Europe." By thus jumping into the esthetic arena cocksure but half-cocked, Jarves made a disastrous impression on his countrymen that he was never to live down.

However, Jarves learned fast. There were many important pictures in the collection which, through Charles Eliot Norton, the Ruskin disciple and Harvard professor who was Boston's major esthetic figure, he offered (in 1859) to sell to the Athenaeum for fifteen thousand dollars, which he said was half what it had cost him. Boston was still hesitating when in 1860 — eight years after Bryan had come home — Jarves brought his collection to the United States. He showed it at Derby's Institute of Fine Arts, where the Old Masters hung as a pendant, considered less valuable, to the Düsseldorf Gallery.*

*Although we may discount Derby's public statements that he had bought the Düsseldorf pictures (which he said had originally cost $230,000 or $200,000) for $180,000, there is good reason to believe that when the Gallery was auctioned off in 1862, it brought about $45,000, more than twice what Jarves was eventually to get for his collection.

[116]

Soon storing his pictures, Jarves added to his collection on trips to Italy. He published several books to demonstrate historically that art and spiritual development advanced together. In *Art Idea* (1864), he devoted some chapters to American painting, which he now discussed on a basis of familiarity with what was being currently shown. Naturally, he preferred the pictures that most resembled European work. Opposed to "realists" who loved "facts," self-defined as an "idealist" who sought "the soul of the fact," he attacked the Hudson River School as "naked externalism," but welcomed the innovations of George Inness. Apart from his theories, he recognized quality when he saw it. We shall find many occasions to quote from *Art Idea*.

After Yale had opened America's first university art school (1864), Professor Lewis R. Packard wrote that the acquisition of the Jarves Collection "might keep out a host of modern pictures which wouldn't be worth the space they took up on the walls." Three years later, Yale lent Jarves twenty thousand dollars, keeping the collection as security. Since he spent the money on more pictures, he could not satisfy the note, which came due in 1871, and an auction was held. When the only bidder was Yale and the only bid the size of the debt, Jarves screamed of collusion. However, the *New York Tribune* explained that no one in America was capable of judging the true value of the pictures and that in "the small circle" that cared "there were the gravest and most reasonable doubts as to the trustworthiness" of Jarves himself.

That caldron of gossip, the American colony in Italy, had much to report. Not only did recognized authorities doubt the authenticity of Jarves's most grandly attributed pictures, but his private life was an open scandal. After bearing him two children, his wife had denied him further conjugal rights — "Mr. J. still professes to love me, but . . . since I have refused him (only one thing) I have seen no symptoms of it." However, she was soon dandling an infant daughter to whom Jarves had to give his name, although he complained loudly that she was the child of his "mortal enemies." When his wife died after twenty-three years of marriage, he broadcast that her current lover battered his way to the corpse and "pulled the tongue out of the mouth to kiss it." But Jarves's children revered their mother — "I can't imagine any woman having a more difficult task" — and agreed that their father desired indiscriminately the "tall or short, blonde or brunette." Furthermore, the compulsive collector starved his family and kept them in rags while he poured out money on more pictures. Jarves might write about the uplifting influence of his Old Masters as teachers of Christian ideals, but how were

American merchant-amateurs to believe a man who, as he lived among such pictures, seemed to deal in frauds, and certainly flouted all sexual and domestic virtues. Did not Jarves's behavior demonstrate what many a self-satisfied American suspected: that European influences were corrupt?*

Since the earliest pictures in the Jarves Collection (as in Bryan's) have proved the best, modern writers have assumed that Jarves (they pay no attention to Bryan) preferred the more primitive, semi-Byzantine masters. Actually, both men defended their purchases of such works only on the grounds of historical importance. Jarves wrote (and Bryan would have agreed) that paintings which predated the age of Raphael were significant primarily because of what had followed; both boasted most loudly of their pictures attributed to (in Jarves's words) "the most famous names." Works correctly attributable to those names had for centuries been in short supply: they were practically unobtainable even at prices far beyond those the Americans were willing to pay. In their need to crown their collections with what they considered the most admirable art at which all earlier pictures pointed, both men allowed eagerness to overcome judgment. The vast majority of the pictures that both Jarves and Bryan told the public were their blue chips were, as the public suspected, spurious.

The historical attitude towards painting which had risen in the eighteenth century had, before the appearance of either Jarves or Bryan, inspired books in many languages on the primitives, and also a few collectors — yet the vast reservoir of authentic early pictures had been hardly tapped. Offered a multitude to choose among, the Americans had been enabled to select on the basis of eye, of taste. Each did remarkably well. If Jarves seems to have bought more truly beautiful and important panels than Bryan, Bryan acquired his share, including a major masterpiece, a *Madonna* by the fourteenth-century Florentine Nerdo da Cione.† Both purchasers must have appreciated the virtues of the art they judged so effectively, yet their historical approach made it unnecessary for them to face up to the uncon-

*Although several artists connected with the Native School—Quidor, Blythe, Elliott—were severely damaged by drunkenness, which was then considered a venial sin, and many, probably including Winslow Homer, drank heavily, not a shred of evidence impugns any of them with sexual profligacy. They tended rather to ignore the ladies. However, revolts against the native esthetic were not uncommonly accompanied by sexual rebellion. Thus, as we shall see, Woodville abandoned his wife for another woman in Düsseldorf, and Page, "the American Titian," moved here and abroad through a sea of scandal.

†Deposited at a major university, the Jarves Collection has been studied thoroughly and publicized as the earliest important American collection of European art. The earlier Bryan Collection, despite the willingness of the New-York Historical Society to deposit it in a more suitable place, remains in that institution, which is now devoted exclusively to American art and history. Thus Bryan's pictures have been examined systematically only in part. An informed estimate, given this writer by Professor Julius Held, is that some forty or fifty of Bryan's acquisitions—which finally totaled 381—are of high quality.

ventionality of the taste they were displaying at a time when verisimilitude was demanded in painting. Neither tried to educate the American public to appreciate the stylized, two-dimensional images superimposed on flat gold backgrounds which are today recognized as the glories of their collections.

The Europeans who had found in the primitives esthetic inspiration had usually been, like the Nazarenes, neo-Catholics, or, like the Pre-Raphaelites, High-churchmen. In devotedly Low-Church America, the religious implications repelled as much as the unnaturalistic forms. Thus, in his memoirs of his childhood, Henry James scoffed at Bryan's "collection of worm-eaten diptyches and triptyches, of angular saints and seraphs, of black Madonnas and obscure *bambinos.*" Thus, when the Jarves Collection was opened, the undergraduate critic in the *Yale Daily News* denounced the martyrdoms — sometimes it was actually an undressed female who was tortured! — as being in bad taste. "One hour's study of Bierstadt's *Yosemite Valley,*" the critic concluded, "would, for me, be worth more than all this collection."

American taste at the time of the Civil War was summarized in the huge art exhibition held as part of New York's Sanitary Fair (1864). The object being to raise the largest possible sum for war relief, the managers certainly gathered from what pictures were locally available those that would have the greatest appeal. Old Masters were banned,* the only works of previous generations being a few American canvases with historical reference. The three pictures hung in places of special honor were all by artists considered American, although two, Leutze's *Washington Crossing the Delaware* and Bierstadt's *The Rocky Mountains,* had a Düsseldorf tinge. The third was Church's *The Heart of the Andes.* Not including the paintings donated, mostly by the artists, to be auctioned (these were almost exclusively native works), and six pictures whose origins I could not trace, the exhibition contained seventy-five American paintings to sixty-five from all foreign schools combined. There were thirty-four French works, many by the painters then most admired abroad but only one — a canvas by the Barbizon artist Rousseau — clearly outside the academic pale. Of the twenty German pictures, fourteen represented Düsseldorf. There were ten Belgian paintings and one by an English artist.

Twenty years before, there would have been many fewer foreign works, but since then the American art market had expanded so tremendously that there was more than enough business for all. During the war years, the prices

*The managers of a similar fair in Boston did not bother to answer Jarves's offer to lend his collection.

of native art skyrocketed, as the profiteers turned to the painters in their first gropings for status or because they regarded canvases signed with more celebrated American names as prudent hedges against inflation. Portraitists like Elliott set up their easels in the financial district, dashing off likenesses of speculators during moments of inactivity on the floors of the various exchanges. Auctions were crowded, and in the shortage of canvases by the well-established, the fevered bidding extended to the young and the relatively unknown.

After the war the financial boom swept on, and with it the demand for art. The many dealers who had appeared in the wake of Goupil* found it profitable to sell native as well as imported pictures. Cummings commented that, while the National Academy had once been the only place where artists could exhibit, now "if the work be of any size or merit, private enterprise is ready" not only to find a purchaser, but to "engrave and publish it, obtain subscribers, and return the artist a profit free of trouble."

During the hard times that had followed the demise of the American Art-Union, the Academy had found it politic to please wives by opening the 1852 exhibition with "a grand reception and evening dress party." Although "introducing art to fashionable ladies" was sneered at by die-hards, the idea caught on. Using their skills to create from cheap materials sumptuous decorations that railroad millionaires could not duplicate, the artists continued to stage fetes, sometimes in hired halls. The Artists' Studio Building† on Tenth Street contained a handsome exhibition gallery and housed "a considerable portion of the art talent of the city": it was the scene of famous parties. During the Civil War, "Artists' Receptions" were so wildly popular that rich men were driven by their women to make considerable sacrifices to get a ticket. But the moment had not yet come when the ladies were to take over the leadership of American taste. The most exclusive occasions, to which the inner circle of patrons alone were invited, were still only for men.

Although often uncongenial with the new rich, the painters had consolidated their position with conservative New York. The merchants who had come to their studios as beginners almost fresh from the farm, the authors and doctors and lawyers who had caroused with them in the old days were now gray leaders of society. When, at the depth of the war, the National Academy had needed a new building, the artists' business friends had cheer-

*Goupil itself still cuts a great swath in the American art market through its successor, M. Knoedler and Company.
†The Artists' Studio Building had been designed (1857) as a headquarters for the National Academy, which had, however, found the rent too steep and abandoned the structure to private occupancy.

fully subscribed the money needed to erect a Venetian palace on Broadway. The Old Sketch Club had during 1847 expanded into a major intellectual organization, the Century, where the painter members' pictures were lighted up at the monthly evening meetings and discussed "by members of all sorts." This, Whittredge wrote, was "a great advantage to me in my profession," since "an artist's works are not made to be criticized by artists alone."

Many a painter surveyed the street from the windows of the Union Club, where the movement to found the Metropolitan Museum was started. When in 1870 that institution finally filled the need for a permanent gallery in New York, there were among the trustees seven artists. Today, there is only one, the president of the National Academy serving ex officio, and his presence is dictated by the original charter.

8

GENRE EXPANDS
From Düsseldorf to the Missouri

ALTHOUGH humorous exaggeration stemming from the English car-
icaturists remained active on the vernacular level, the main line of
genre followed the indigenous realism of Mount. His most direct
disciple was Francis William Edmonds (1806–1863). A New York business-
man, Edmonds had at first considered it prudent to exhibit under an alias,
but by 1839 he discovered that his ability as a painter increased confidence
in his probity as a banker. His pictures, which exemplify everything in
Mount's approach except the inspiration which synthesizes, make doubly
clear how literal was that attitude. Still life — candle snuffers or piles of
vegetables — interested Edmonds as much as settings — cracks in a hearth
or paint peeling from a barn door — and settings as much as costumes, and
costumes as much as faces. Whatever he painted had to be completely
explained: thus we can study in detail the mechanism by which a wooden leg
is attached to a cripple's stump. Executed with considerable competence,
Edmonds's canvases are visual documents that lack the fire of art.

Mount was followed on a level closer to the vernacular by James Goodwyn
Clonney (1812–1867). Born in England or Scotland, at eighteen a lithog-
rapher in Philadelphia, Clonney graduated himself to painting miniature
portraits, moved to New York State, and, about 1841, made genre his
specialty. He enlivened clumsy shapes with a touch of caricature, and,
accepting the limitations of a semiprimitive technique, he simplified. His
What a Catch is dominated by an abstract form that comprises two boats,
four men, one sail, and the reversed reflection of these in still water. Color

is delightfully subtle: a distant knoll with tiny bright cows is a symphony of restrained sunshine, and the water is a very light gray touched up with yellow as well as blue.

Richard Caton Woodville (1825–1856) was the first of the genre painters to profit from foreign study. Unlike most others, he was not from simple stock. His father, a wellborn and wealthy Baltimore merchant, had sent him to the University of Maryland Medical School. However, instead of studying, he drew incisive caricatures and haunted Gilmor's collection, where, despite his proper education, he spent his time not before the historical paintings but before the Dutch genre scenes. This was certainly due in part to his own personal predilection for low life. His painting of "two vulgar habitués" in a barroom shocked his family but set everyone else laughing. After he had, at the age of twenty, married the daughter of a prominent doctor, his parents abandoned their opposition to his becoming a painter.

Being able to pay for his artistic education, he served no local apprenticeship to vernacular art. He sailed at once for Düsseldorf, where he became a private pupil of Carl Ferdinand Sohn, the genre painter most influential on the younger generation. Woodville painted at least one picture in his master's softened and sentimentalized version of the Dutch style exemplified by Vermeer. This expedition into the romantic past, which is summarized by its alternate titles, *The Cavalier's Return* and *Baby's First Step*, is impressive as a study of light coming through a single set of windows into a peopled room.

However, derivative subject matter did not really interest Woodville; his objective was to paint American scenes with the skills Europe afforded. He worked up sketches he had brought with him, and recrossed the ocean periodically to secure further material. More methodically than was to be common with his compatriots, he labored, "slow and patient," to acquire Düsseldorf techniques. Yet he had so little desire to impress the international community that he did not send his pictures to the local exhibitions. As soon as each was finished, he rushed it home. The American Art-Union praised and bought his works; engravers reproduced them.

When he had been five years in Düsseldorf, an exotic young lady, half German and half Russian, set up her easel beside him in Sohn's studio. Deserting his wife, Woodville eloped with the newcomer to Paris. In that city, he expressed himself as "quite captivated" with French color, although little seeped into his art.

The Sailor's Wedding exemplifies Woodville's mature style. We are shown

a bridal party — the groom jaunty, the bride coy, her drunken father weepy, her rusty mother sadly proud, the best man nervously courtly — streaming into the plebeian chamber of a crabby old Baltimore justice of the peace who has just sat down to his lunch and is wondering whether to marry them at once and get it over with, or to make them wait till he has finished eating. Minor characters are meticulously dramatized, and the decor is worked out in minute detail: the almanac pasted on the side of a bookcase and the mark where the paste slopped over, the old hair trunk, patterns on gown and apron, the embossed ornament on a spittoon.

This painting is an amalgam of Düsseldorf conceptions and skills with those pioneered by Mount. The Long Island painter could never have organized so much so effectively on so small a canvas: 18⅛ by 22 inches. The meticulously expert draftsmanship, the complicated but rational composition, the firm control of local color reveal how effectively Woodville had learned his lessons on the Rhine. He avoided the classic line of beauty Germanic painters valued, seeking in the manner of Mount naturalistic poses, yet echoes of German theatricality remain. Where Mount caught action at its most typical and then made no effort to heighten the impact, Woodville tried to "hit off" each of his characters by having his appearance epitomize his entire role in the little drama displayed. Since every actor is reacting to more than the immediate moment, that moment is fragmentized.

Woodville had turned to literary values to make up for lack of personal involvement. He could himself never have taken part, except as an observer, in the lower-class situation he portrayed. Even if his reaction was American humor rather than Germanic sentiment, he was no closer to his theme than the Düsseldorf painters were to Westphalian peasants.

That in Europe he painted American scenes shows how powerful the interest in national subject matter had become, since in his heart Woodville was trying to escape from what he knew. When for his *Old '76 and Young '48* (an incident contrasting the veterans of two wars) he showed his own world, even including portraits of his family, he did not produce his most emotional picture but his most artificial. He hid his feelings behind the whole pantheon of Düsseldorf crooked-fingerisms. Genre was not for Woodville a celebration of things he loved or an attack on things he hated. His best pictures expressed efforts to find things outside himself at which he could laugh.

What Woodville was fleeing we do not know, but we do know that he committed suicide in Paris at the age of thirty.

Very different from Woodville's and much more typical was the career of

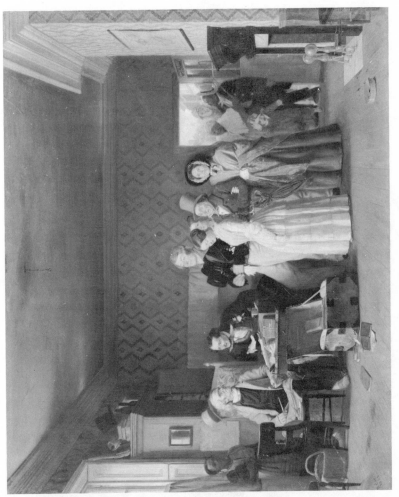

29 Richard Caton Woodville *The Sailor's Wedding*

Oil on canvas; 1852; 18⅛ × 22; Walters Art Gallery, Baltimore.

30 William T. Ranney *The Trapper's Last Shot*

Oil on canvas; 29 × 36; C. R. Smith, New York.

William T. Ranney (1813–1857). After his father, a Connecticut sea captain, had perished at sea, Ranney was apprenticed to a tinsmith. He hated the trade. He fled, whenever his master's back was turned, with his gun into the woods; and as soon as he could completely disentangle himself, he became a vernacular illustrator. The revolt of the Texans against Mexico promising excitement, he posted to the Southwest. Although he arrived after the fighting was over, he was "charmed with everything" he experienced on the frontier. He made notes on paper and in memory.

He soon returned to the East, but the studio he established across the Hudson from New York City was "so constructed as to receive animals. Guns, pistols, and cutlasses hung on the walls and these, with the curious saddles and primitive riding gear, might lead a visitor to imagine he has entered a pioneer's cabin." Despite his occasional efforts at historical illustration, Ranney became the first able American painter to specialize in sporting art.

Altogether self-taught, he remained an indifferent colorist, and when not moved by what he was painting, he damaged his effects with a histrionic bristle of gesture. Yet he could be a powerful if inaccurate draftsman, who used exaggeration to express emotion. His *The Trapper's Last Shot* is both restrained and dramatic. The danger the burly, buckskinned horseman prepares to fire at is outside the canvas — it was written down as Indians — but the urgency of the situation is conveyed by the man's electric pose and staring eye, which contrast with the calm mien of the horse, who does not understand. Reproduced by engravers, this became one of the most popular pictures of the time — deservedly, for it is an excellent illustration.

Among the genre painters of the first generation, only two achieved truly impressive stature. One was Mount; the other George Caleb Bingham (1811–1879).

Bingham had been born to affluence in the Virginia piedmont. However, his father, through endorsing a friend's note, lost the mill and the tobacco fields. The Binghams took flight, when Caleb was eight, to Franklin, Missouri, a city younger than the child, yet already the largest community west of St. Louis. In this mushrooming environment, the father rose to instant prominence and renewed prosperity. Then — Caleb was still only twelve — the father died. The Binghams refugeed again, this time to a farm near Franklin, where the boys worked in the fields like men and their mother's voice was ever loud in command.

Whenever he could, Caleb sneaked off to Arrow Rock, a bluff overlooking

the Missouri River. He stared downward hour after hour. Below was free-flowing freedom on which fortunate males drifted: fur trappers with strange mascots seeking jollity after hard labor in Indian-infested mountains; flatboatmen playing cards or dancing to banjos as the current carried them onward, outward, away, without effort and without sorrow. Here, even only in watching, was release for a lad whose life seemed to be rooted in flaws that created earthquakes. When Caleb finally went reluctantly home, his mother certainly scolded, for she could not know that these truant sessions were emotional experiences that would bring her son immortality. And he hung his head, for he did not know either. It would take him twenty years to find out.

At sixteen, Caleb was apprenticed to a cabinetmaker in nearby Columbia, Missouri. This led naturally to sign painting, and in 1823, when he was twenty-two, he became an itinerant portraitist up and down the rivers. Because he had learned to paint locally and by "unassisted application," his art was hailed in the new communities as a proof of "trans-Mississippian progress towards a state of intellectual and social refinement." The critic of the Columbia *Missouri Intelligencer* admitted himself "unacquainted" even with the work of Eastern American artists, but he could read and therefore pontificate that "of the three Italian Schools," Bingham "combined more of the Leontine and the Venetian than the Lombard." However, writers in more sophisticated St. Louis stated that Bingham had much to learn.

He must have imbibed his compositions from ancestral portraits settlers had carried over the mountains. As the youthful Stuart had done in his primitive phase some seventy years before, Bingham broke his backgrounds into differently shaded vertical oblongs that implied paneling; and he went further back for the convention of writing on the front of the picture the date and the sitter's age. He applied his color without much gradation to large areas, achieving clear and simple harmonies, even if the flesh is leathery and too bricky hot. His draftsmanship and linear design were, although harsh, extremely strong. The hardness of Mrs. John Sappington's forehead, the soft sag of her chin, and the pitching of the various planes of her face are brilliantly if naïvely expressed.

Had Bingham adhered to this style, he would today be considered among the most effective of "American folk artists." However, in 1838 he learned, during brief studies in Philadelphia and a visit to New York, how to carry his manner several steps closer to illusionism. As in his *Mrs. Shackleford* (1839), he kept the firm drawing and pattern-making of his earlier style, but light was no longer a hard, overall glare: it mottled face and background,

giving naturalistic unity to a picture colored with more subtlety and veri-similitude. Enchanted by what he had acquired in a few months over the mountains, Bingham concluded that to be an accomplished artist, he would have to leave Missouri. But for the moment he was held there by his second love, politics. Painting banners and making speeches, he helped carry the state for William Henry Harrison. That done, he set up as a portrait painter in Washington, D.C.

As he awaited famous sitters in his studio, "a small hut or shanty at the foot of capitol hill," Bingham also waited for true sophistication to lift his portrait style. Both hopes were vain. His only famous sitter, John Quincy Adams, was caught by chance, and disliked the outcome, while his portrait style lost the tense drawing and design of his earlier manner with little compensating gain. However, he was still convinced that to be an effective artist he would have to forget Missouri.

Bingham was called home by the presidential election of 1844. His oratory, even the banners — they were so large that it took four strong men to drag them down the street — that he painted glorifying Clay did not succeed in defeating Polk. This political setback was the springboard of Bingham's true artistic career. Not wishing to return to the national capital in control of a party he considered despicable, having no contacts elsewhere beyond the mountains, he found himself painting portraits in central Missouri. Yet he still yearned for fame in the East.

Wishing to send pictures to New York City — portraits of Missourians would not do — he remembered a strange fact he had learned on his visit to the metropolis six years before: Easterners were interested in the common-places of Western life. The Apollo Gallery had bought from him such a river scene (it is lost) as he had, when an unhappy boy, admired from Arrow Rock. And so he began depicting life on the Missouri for the Apollo Gallery's powerful successor, the American Art-Union. The directors bought all he offered, praised him in their publications, and distributed thousands of large engravings of *The Jolly Flatboatmen*. East and West, all over the United States, his art was suddenly hailed.

In his many river pictures, Bingham never showed anyone at work: driving a boat upstream or loading a cargo. Cards, music, dancing, fishing, yarning, sleeping are the occupations of his male protagonists, whom he never afflicted with a single woman to admonish them. The shores past which they glide or on which they relax are realistic but not particularized — certainly on the Missouri, but exactly where it is impossible to say.

Although Bingham felt an "inconvenient modesty" when asked to talk

about art, when he harangued election meetings he was buoyed up by unhesitating eloquence. His popularity grew until he could without madness dream of the Whig nomination for governor.

His decision to paint his political experiences was undoubtedly encouraged by celebrated pictures he had seen in Philadelphia, the work of John Lewis Krimmel (1789–1821). A German immigrant, Krimmel had created American genre before such subject matter was considered acceptable. He had had no immediate followers, although Mount was now his great admirer.

Bingham's first major political picture, *County Election* (1851), shows clear influences from two Krimmels that hung at the Pennsylvania Academy: *Election Day at the State House* and *Fourth of July in Center Square*. In Krimmel's *Election Day*, a line of buildings extending from the right front corner to the center background breaks at a sharp angle from a friezelike crowd stretched horizontally across the foreground. Bingham used a similar device, although his human frieze follows the slant of the buildings briefly before it cuts its horizontal across the composition. In the foreground area thus opened, Bingham put elements from Krimmel's *Fourth of July:* a table featuring liquid refreshment, then a shallow, half-empty space containing dogs, and then at the right a clump of figures farther back in the picture than the table it balances. Both artists made compositional use of high hats rising askew over grouped crowds. The two election pictures have a similar comic intent and irreverence of mood, but Bingham's Western characters misbehave much more boisterously, as became a more energetic artist and a more raucous place and time.

The Missourian's political paintings are, indeed, the most extreme artistic exemplars of America's pre-Civil War self-satisfied optimism. All the elements needed for devastating satire are portrayed — windbags and office-holding humbugs, wily or smug; voters idiotic or disreputable, usually drunken; liquor flowing at the polls — yet all is recorded with such admiration as a doting father lavishes on a spirited urchin come home filthy and with his pocket full of frogs. The very spirit of Jacksonian democracy may be recognized in a bewhiskered riverman, wearing a disreputable shirt and trousers and crowned with a stylishly wrecked hat, whose uncultivated face registers shrewd pleasure at the high jinks in which he is joined.

Bingham's genre technique, undoubtedly self-evolved, was different from Mount's, since he seems never to have painted directly from nature or from human models on canvases he intended to complete. That he did make sketches out of doors in pencil or oil written records tell. (All but some

meager pencil notations are lost.) For the rest, his methods were so entirely of the studio that he was able to execute his scenes of rural life, which were almost all laid in the open air, among the streets of St. Louis, or far from his Western cast of characters in Philadelphia and New York.

No compositional drawings remain, yet it is clear that his first step was to work out composition in great detail. He sought to achieve natural-seeming unity by arbitrary means. If, as in his river scenes, he included not more than eight people, he arranged their figures and accouterments into a pyramid or a half pyramid, often deep, usually with its base parallel to the bottom of the frame. This shape could stand almost free, could break sharply from the diagonal drawn by a receding shoreline, or could rise from the triangle into which exaggerated perspective transmuted the side of a flatboat.

To solve the grave compositional problems presented by his political scenes, in which he could crowd more than sixty persons on canvases no bigger than about four feet by five, Bingham grouped the figures into horizontal planes that sometimes rose into pyramids. Placed one behind the other, these strata are marked off by alternating bands of light and shade. In *County Election*, where there are seven such bands, chiaroscuro does not unify but tends to cut the picture into layers like a cake. Indeed, the only one of the crowd scenes really to hold together is *Stump Speaking*, in which, as in a fugue, Bingham contrasted his usual pyramids, planes, and bands of light with two other compositional devices: a circle drawn through the bands by figures picked out by white or off-white costumes; and in the very fore-ground a listener whose shadowed silhouette cuts a thin, expressive vertical from the bottom of the picture all the way up to the sky.

Having laid out his plan, Bingham drew each figure, one or at most two to a sheet of paper, in the pose and lighting that he intended eventually to paint. Parts of the body that would be hidden in the finished picture were often omitted from the drawing. He costumed friends to serve as models. Unconcerned by such incongruities, he drew rough boatmen from a sickly and intellectual law student. Sometimes he changed features to make them more suitable. However, he was not averse to topping with the recognizable face of the same model two differently clothed bodies that were to go into the same canvas.

Although, if he found the perfect subject to draw from, Bingham could catch feature and expression with delightful comic realism, faces were not basic to his characterizations. Back views could be as eloquent of emotion as front views. He placed his main reliance on posture and costume: on the

male body as one normally sees it expressing itself through past and present strains on its clothing. Drawing in pencil, erasing, revising, and then achieving permanence with strong black lines to which he added for powerful contrast gray to black washes, he became gifted at foreshortening and simplification, marvelously accomplished at showing the pull exerted on trousers by hands thrust in the pockets, or the set of shoulders as they strained the cloth encasing them. Although entirely devoid of conscious artistic style, these drawings translate nature into art with their own kind of virtuosity.

He applied them to his canvases soberly, sometimes making changes as the picture shaped up, but always following the forms with small, delicately pointed brushes that precluded a dashing manner. Every figure is delineated for its own sake, separate from the others and the landscape, yet rooted so powerfully in its position that the imagination cannot move it around. Shadows are inconsistent and break with an unnaturalistic sharpness from light. However, poses have a splendid naturalness. Although the full round is not indicated, a sense of weight is conveyed. Firmness is everywhere.

Bingham applied hues locally, hats, shirts, and trousers speaking their separate pieces like segments in a counterpane. As a result, his color sense finds its best expression the fewer the figures, the larger the forms. The simplest of his election pictures, *Canvassing for a Vote*, features only four men who sit in front of a tavern. For all the homeliness of its shapes, this picture is chromatically a burst of poetry: the blue distance is a real empyrean, and in the foreground soft sunlight turns bulging waistcoat and unpressed trousers into gentle gems.

In the fuss over Bingham as a delineator of Western life, his skills as a landscapist have been largely overlooked. Despite his trips to the East, he was, during his period of creativity, uninfluenced by the manner the Hudson River School had developed in the Catskills. His style was self-developed to express the fundamentally flat scenery around St. Louis. Distance was not the glory of the vistas he painted but the problem, since it went on and on undramatically to nowhere. There were similarities in his solutions, as there was in his subject matter, to old paintings of flat Holland. However, the new West offered much less richness of detail to vary the long spread of land that stretched to the low horizon. Since what few objects there were popped up here and there like jack-in-the-boxes, Bingham emphasized silhouettes against vastness, and balanced into three-dimensional designs, often deep, clumps of rocks and trees, freestanding men or animals. Or as in his *Fur*

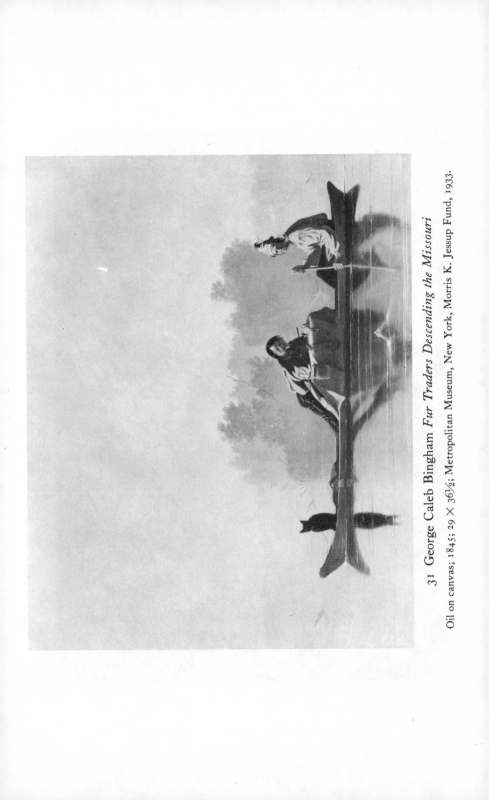

31 George Caleb Bingham *Fur Traders Descending the Missouri*

Oil on canvas; 1845; 29 × 36½; Metropolitan Museum, New York, Morris K. Jessup Fund, 1933.

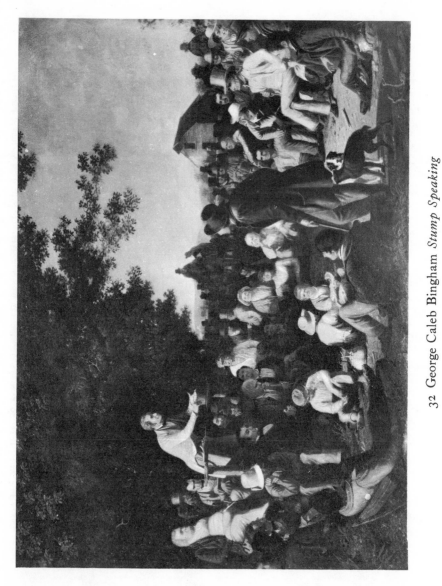

32 George Caleb Bingham *Stump Speaking*

Oil on canvas; 1854; 42½ × 58; Boatman's National Bank, St. Louis.

Traders Descending the Missouri, he would back his foreground action with a single landscape element shaped and placed for effect. Even when in *The Storm* he painted mountainous scenery for its own sake, he preserved his fundamental way of seeing. His cliffs seem less immemorial barriers than minor interruptions in horizontal immensity.

To keep his vistas intimate, Bingham cultivated a soft mist that closed in distances while yet implying with dim hints what was beyond. This choice of weather precluded the use of Hudson River School values or colors. Strained sunlight brought to Bingham's landscapes a typical smoky glow. In his *Landscape with Cattle* a middle-distance spray of tall trees separates two vistas into which the eye can penetrate through atmosphere to different depths, that on the right being narrow and quite shallow, while far back on the left there is the most delicate glimmer of pink light casting a romantic glow on a low hill. The foreground is mottled, containing much orange, and a bright ray coming in from the left centers the composition on a broad streak of spring green.

The lyricism Bingham's color achieved at its best reveals in him a vein of poetry entirely missing from the personality and the art of Mount. The Westerner had, indeed, a very different temperament from Long Island's little master: he had more power, more striving, and less control. Like the half men and half alligators who roared on the keelboats, he was easily discouraged and easily elated.

"I am getting quite conceited," Bingham confessed in 1853, "whispering to myself ... that I am the greatest among the disciples of the brush my country has ever produced." A year before, he had threatened to sue his original sponsor, the American Art-Union, over an article in its *Bulletin* which had stated that his work, "being so entirely undisciplined yet mannered," was inferior to Mount's.

Bingham was now painting primarily in Philadelphia or New York. Although he never tried to delineate its life or really put down roots there — he was not elected to the Pennsylvania or the National Academy — the East still appealed to him as the best place to work in. He repeated himself, doing second versions, less effective than the first, of two of his river compositions and one election scene.

The success of Leutze's *Washington Crossing the Delaware* made him yearn to create "some historical composition that would rival" it. He painted for the Art-Union's rival, Goupil, *The Emigration of Daniel Boone*. As originally executed (1851), it was an undramatic genre scene, showing a group of

[131]

pioneers advancing comfortably along a level trail. However, he repainted the canvas in 1852, adding mountains, beetling crags, storm clouds, and lurid, emotional lighting. For such delights, he had no talent. He also added artificiality.

Bingham had urged his political friends to get him the job of enlarging his *Emigration of Daniel Boone* for the Missouri State Capitol. However, the legislature preferred to order two mammoth, symbolical full-length portraits: Washington and Jefferson. These most grandiose commissions Bingham had ever been given sent him off to Paris. The Westerner had always felt sheepish in relation to the art of older American communities — only approval in New York had pursuaded him to paint his own world — and in 1856 he went abroad eager to make his art over.

To his desire for new inspirations the unrushing shadow of national tragedy was contributing. Long an antislavery politician, Bingham had written during 1854, the year that the Kansas-Nebraska Act promoted guerrilla warfare on Missouri's borders, "A storm is now brewing in the North which will sweep on with a fury which no human force can withstand." In the light cast ahead by the Civil War, his jolly flatboatmen seemed less significant to him, his county elections less delightful in their utter irresponsibility.

He hurried to the Louvre, but, on seeing how variously artists had portrayed nature he felt "like a juror bewildered by a mass of conflicting testimony." And Paris itself was so expensive, "such a wilderness to the stranger," that he posted on to Düsseldorf, where he was relieved to encounter "no dashing vehicles such as encumber the gay avenues of Paris, causing perpetual alarm to the humble pedestrian." And his artistic bewilderment seemed to disappear. The Düsseldorf School, he concluded, had disregarded the Old Masters to extract from nature "freshness, vigor, and truth."

How successfully Bingham now eradicated all the primitive elements of his style is shown by a new version of *The Jolly Flatboatmen*. He had exchanged his arbitrary, overcomplicated lighting for naturalistic chiaroscuro broadly handled to assist unity and emphasis. No longer separate shapes moored side by side, his figures are integral parts of a fluent compositional pattern. But, alas, Bingham had accepted with these improvements Düsseldorf's line of grace. His central dancer is a German actor self-consciously waving hat and handkerchief. Belief, immediacy, power, all have vanished.

After almost three years in Düsseldorf, Bingham returned to a United States on the verge of actual war. Although he had opposed "all compromises

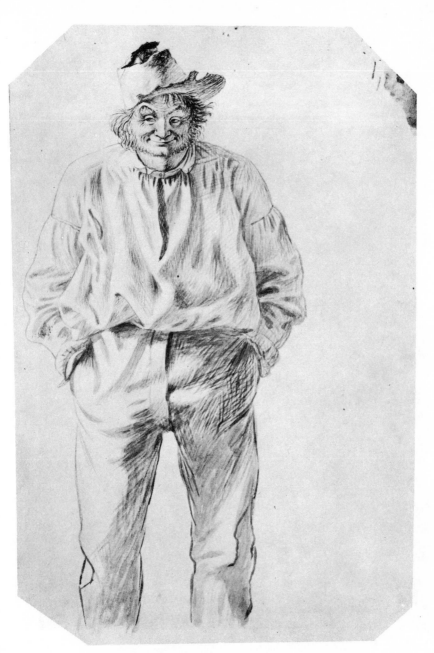

33 George Caleb Bingham *Figure from Sketchbook*

Ink and wash on paper; 10¼ × 7; Mercantile Library, St. Louis;
photograph from City Art Museum, St. Louis.

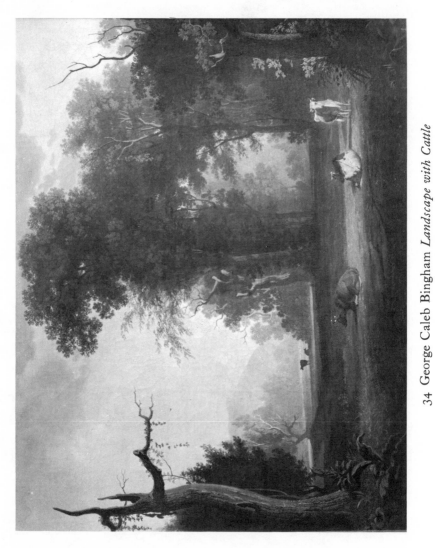

34 George Caleb Bingham *Landscape with Cattle*

Oil on canvas; 1846; 38 × 48; City Art Museum, St. Louis.

on the subject of slavery," the actual fighting filled him with horror. As Missouri State Treasurer, he tried to prevent a Union general from creating a defensive strip on the Kansas border by laying waste several Missouri counties. "If you persist, . . . I will make you infamous with brush and pen."

The earth was scorched according to order, and as soon as he could escape from his war duties, Bingham spent his major energies in first painting and then circulating his *Order No. 11*, a sermon against military suppression of civil rights. In the manner of the editorials against aristocratic savagery to peasants which Karl Hübner created at Düsseldorf, Bingham contrasted stony-faced villains with ladies fainting, pleading, weeping over a murdered husband.

When Bingham attempted in the post-bellum years an occasional genre picture in his old vein, he only demonstrated again that the inspiration had run out. He decided that full-lengths of political figures were "better adapted to my powers." His portraits of men who had died before his time were, he insisted, profounder likenesses than those artists he considered lesser — even Stuart — had painted from life, since he had deepened what he could ascertain about his sitters' actual appearances with what he knew of their characters and achievements. For these works he abandoned the sound technique of his genre. Most of the huge portraits have chipped from their canvases. However, photographs reveal that they were old-fashioned in composition — fat columns, looped curtains — and exaggeratedly windy in mood. To an occasional less elaborate portrait, especially that rendition of a pretty girl in sunlight which he called *The Palm Leaf Shade*, Bingham brought some of his old lyricism of color. Yet, when he died in 1879, he had not painted in his best vein for twenty-four years.

All of Bingham's most impressive pictures had been executed between 1845 and 1855. With the exception of an occasional pure landscape, all showed shirt-sleeved Missourians engaged in their ordinary amusements, from loafing to elections. And within this restricted realm, only a few activities had fired his fancy. Although not a prolific painter, he often executed the same compositions several times.

For Bingham to paint eloquently required a meeting of mood and subject so delicate that he was thirty-four before he discovered the balance. Even during his golden decade, he fled often from so exquisite an interior adjustment to the rough exterior tumble of politics. By the time he was forty-five his inspiration had faded. Of all our native-born painters, he was to surrender most grievously to Düsseldorf.

In his old age, Bingham was finally badgered into writing a lecture on art. He repeated Durand's theory that painters achieved beauty by imitating as exactly as possible the natural phenomena that most inspired in them "the esthetic sentiment." However, the man who had, while yearning for inspiration in esthetic centers, developed his most effective art virtually alone in the West, drew a corollary which Durand, as a member of a flourishing landscape school, had not drawn. "The ideal," Bingham wrote, was not a general principle many men could apply, but for each painter personal to himself. "Artists permit themselves to be absorbed only by what they love. As Nature presents herself to them in a thousand guises, they may worship her in few or many." Bingham had worshiped her in a very few. He had loved only the simple people and the landscape of Missouri. He had only painted with conviction when he gave full rein to that love.

35 George Caleb Bingham *The Jolly Flatboatmen* (Düsseldorf version)

Oil on canvas; 1857; 46¾ × 69; City Art Museum of St. Louis.

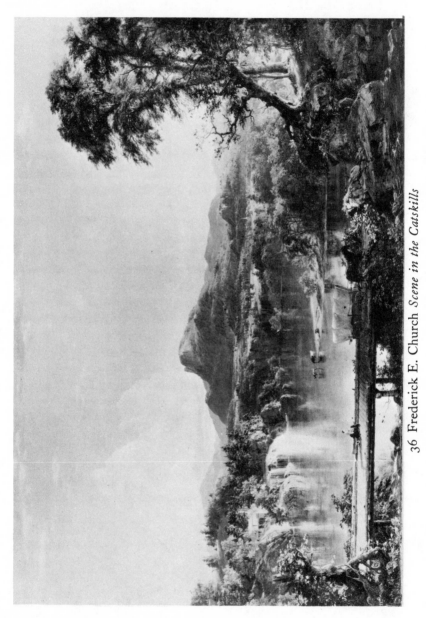

36 Frederick E. Church *Scene in the Catskills*

Oil on canvas; 1851; 40½ × 57½; G. W. V. Smith Art Museum, Springfield, Massachusetts.

THE GRAND AND THE SUBTLE
Frederick Church and John Kensett

D URING 1859, the American artists resident in Rome were break-fasting at the Café Greco, narrow and ornate and dark as the inside of a Renaissance ship, where the foreign artistic colony had time out of mind begun days dedicated to admiring the past. They were "happy and at peace" until someone showed them an excerpt from the *New York Herald*. Then their outcries startled the entire room. The aged Englishman John Gibson, "half asleep in a corner cogitating whether or not a little more color on his *Eve* would warm her up more to his satisfaction, suddenly waked up and wanted to know what the matter was. 'Plenty,' we replied. 'Look at this clipping!' "

It, Whittredge remembered, was three columns long and altogether devoted to describing the exhibition in New York of a single picture, *The Heart of the Andes*, by a young American who had never seen Europe. The painter, Frederick E. Church (1826–1900), was complimented on having "darkened his showroom and lighted his canvas with clusters of gas jets concealed behind reflectors of silver." Next, the article expatiated on "the rich tapestry hangings; the enormous palm leaves, all the way from the Andes, . . . suspended over the picture, with their long, slender leaves rising out of the darkness and kissing, as it were, the rich gold frame." But what really hurt were the editorial suggestions on how "to accommodate the crowds of people who came to see the picture, and who could not find even standing room. . . . The exhibition was yielding nearly $600 a day!"

[135]

As this intelligence was translated into all the tongues of the international art colony, disapproval sounded in all those tongues. The outrage thus expressed has continued down the years, ever shriller as "good taste" has increasingly ruled that popular appeal damns a work of art. Bracketed in the critical mind with the German-American sensationalist Bierstadt, Church is described as also the concocter of superficial excitements for torpid tastes. Hardly anyone bothers to exhibit his pictures any more. Yet when they were visible, they moved even those who disapproved of his objectives. Thus Henry James wrote (1875) that Church's *Valley of Santa Isabel* "leaves criticism speechless." James could not "quarrel with the very numerous persons who admire its brilliant feats." And Jarves ruled that "no one hereafter may be expected to excel Church in the brilliant qualities of his style."

The only son of a rich Hartford family, Church was independently wealthy. However, he refused the education of a gentleman: he wanted to do things with his hands. As long as a drawing master held him to copying European prints, "mechanical genius" seemed his bent. Then, just turned eighteen, he drew from nature. The effect was as explosive as it had been on Cole.

Sent at once to Catskill as Cole's pupil, Church attempted his master's method of making from nature pencil sketches on which colors were noted in words. However, in his most ecstatic moments, the young man found himself at a loss for anything to draw. He would write "the most beautiful sunset that was ever seen," and then cover his page with a scrabble of lines which he filled with numbers connoting colors.

After three years as a student living in Cole's house, Church set up for himself in New York (1848). Almost immediately his master died, and he made oil sketches towards a large picture to be called *Apotheosis to Thomas Cole*. A grotto, a distantly gleaming cross, trudging wayfarers — Cole's own furniture for such a subject — are murkily indicated, but Church's imagination only caught fire in a waterfall that is a plume of pink, yellow, light blue, and yellowish cream. The *Apotheosis* was never painted. Church did complete a few canvases with titles like *The Deluge* and *The Plague of Darkness*, but soon abandoned forever alternating with naturalistic landscapes finished pictures in Cole's more literary vein.

Church had made his debut at the National Academy in 1845, when only nineteen. This was less than ten years after Durand had begun working out the basic Hudson River School style, but the prodigy was thirty years Durand's junior. He was much more interested in painting light, a concern he shared with the Barbizon painters, who were emerging in France. However, since he was attracted by light in its most exalted manifestations, he

was closer to Turner, then at work on his most luminance-struck pictures. Like the composer Wagner, who had just enunciated his high romantic manner, Church was drawn to nature at her grandest and most extreme.

These transatlantic developments — except for Turner's work as far as it could be studied from engravings — were virtually unknown in the United States, and although he could well afford it, Church had no interest in visiting Europe. He built on existing American pictures according to the rules of Yankee ingenuity that made him, when he recorked a bottle of turpentine, "invariably turn the cork over . . . to see if it couldn't be put in that way and stop the flow better."

The twilight Church loved was not Corot's dusk, but the moment when the sky was midnight-blue shot with crimson. As a raying arc over distant gray mountains marked where the sun had just descended, the clash of color overhead found a thousand counterparts on the land. The dying light caught in high foliage that glowed against forests already dark. Headlands nudged their shadows into mist-dimmed reflections on still water of the glory beyond far hills. When Church responded to daylight, he sought the greatest possible refulgence. Sometimes he hung the sun in his picture space, its maximum radiance, being unpaintable, he obscured by cloud or mist. He liked to make light linger on falling water or, if nothing more dramatic offered, in the dust thrown up by wagon wheels.

However, Church did not let his interest in light carry him with Turner away from specific fact. His forms were firmly painted. In the foregrounds, stumps, rocks, and fallen trees. Further back, perhaps a house whose one lighted window exploded whitely in the gloaming; perhaps, a haywane and its pitchforked attendants glowing in a midafternoon glare. He wished to show solidity as it appeared when light was carnival.

Church was hardly twenty when it was clear that a titan had come to American art. Critics expatiated on his skies, although they pointed out, rightly, that his details were too insistent; he had not succeeded in bringing together light and shape, earth and air. Behind all was a Herculean grasp, a boldness that rolled problems under with the careless, muscle-swinging joy of pioneers chewing ragged clearings out of the wilderness.*

Church, like Cole, was separated from Durand and the main stream of the Hudson River School in not being a pantheist: no uplifting influence seemed to him to flow to man from nature's face. Thus he shared Cole's belief that nature in her ordinary aspects did not carry enough meaning, and preferred

*In his explosive career with its brilliant but confused results and premature end, Church had many resemblances to American painting's later prodigy George Bellows (1882-1925).

to a single view, however carefully selected, a composition combining perfect beauties found in various places. But where Cole had tried to add exterior values with historical, literary, and doctrinal associations, Church sought his deeper meanings in the regimen that was in his generation beginning to undermine religion, in science. He believed that knowledge of the physics of light, of the electrical laws of the atmosphere, of the biological principles according to which plants grew and the geological principles that had shaped the earth would enable the landscapist to achieve "organic unity." Not the romances beloved by Cole but scientific treatises occupied his leisure hours. This carried him back to a realism that paralleled Durand's. In the name of scientific accuracy, he sought to reproduce scenery with an exactitude from which all sense of paint, of a picture, had been refined away.

Church had adopted Durand's method of sketching in oil colors out of doors. However, his object was only secondarily the usual one of taking notes to be later worked up in his studio. That he hardly needed. As his pupil Stillman wrote, his ability to retain in memory "even the most transitory facts of nature passing before him must have been the maximum of which the human mind is capable." Church's sketches were experiments towards the solution of artistic problems. Although when asked what his methods were he replied "that he had never looked upon himself as having any," he was laboring to overcome his marring break between light and shape, to express both together in a unified image. He went at his task with a meticulousness that makes most of the sketches of his formative years in themselves dull, for he combined with his energy and intuition the passionate psychological need of the Connecticut Yankee for taking pains. His labors paid off so well that his finished paintings were increasingly both luminous and solid, the light integrally related to the land.

Church had explored no more widely for new natural beauties than was common for the Hudson River School when, in 1853, Cyrus W. Field (who was later to lay the Atlantic cable) planned a trip to South America in search of a vanished brother. His urging that Church accompany him was seconded by *Kosmos*, the recently published book of the famous naturalist, Baron Alexander von Humboldt. Humboldt, having enunciated theories about the relationship of landscape painting, nature, and science which Church might himself have written, prophesied that the art would flourish "with hitherto unknown brilliance" when able painters found "the true image of nature" where she was most varied and luxurious among the snow-covered Andes and in the primitive forests between the Orinoco and the Amazon. Church went with Field.

During a few months in Colombia and Ecuador, the painter penetrated six hundred miles up the Magdalena River and wandered on muleback in the Andes, making it his special business to call on volcanoes. This experience persuaded him to add sensational scenery to sensational light effects. Thus, it was only after his return that he depicted the wonder on his own doorstep, those Niagara Falls which Cole had found too overwhelming to paint.

Although Church's South American views were hits at the National Academy, *Niagara* was his first picture exhibited to crowds as a single attraction at a dealer's gallery (1857). Daringly, Church had showed hardly anything but water and sky: earthly majesty was conveyed by emphasis on light. The sinuous surface activity of the river's dark flow incited veins of glitter; white spray rose in pinpoints of radiance; the contrasting placidity of the air was an exhalation of gentler hues; and a rainbow across a grayish cloud burned as if lit from behind. Although the modern viewer feels a lack of formal tension to hold the long canvas — about eight feet by four — together, Church's *Niagara* is a monument to sober virtuosity.

His next major stunner, the result of a second South American trip was, that which had so disturbed the Café Greco. *The Heart of the Andes* was an effort to compress into a single large canvas all the wonders of the tropics. "Life is too short," wrote Church's friend, the novelist Theodore Winthrop, "for descriptive painting. We want . . . the essentials, the compact, capital, memorable facts."

To describe all these facts in his guide to this one picture, Winthrop needed thirty-four closely printed pages. What he tells us about the way that the geological formations stand for human situations calls to mind the landscape allegories in Cole's *Voyage of Life*. The distant, snow-capped dome is "an emblem of permanent and infinite peace." The plateaus on which Church summarized the temperate zone — "this central mass of struggling mountain, with the war of light and shade all over its tumultuous surface — represents vigor and perplexity." And Winthrop saw in the humid, tropical foreground valley "the groves and flowers of Arcady."

Religious interpretations were also made and, although not shared by Church, not by him discouraged. Thus Cole's biographer and his friend, the Anglican minister Louis L. Noble, saw the picture as expressing divine harmony resolving earthly confusion.

When we look at the picture today, obscured with grime as it hangs unloved on the walls of the Metropolitan Museum, we are puzzled by its ancient popularity: it seems a solid, unflamboyant chunk of overdetailed painting. But our impression changes if we employ the method of viewing

urged by the exhibitor on his audience: to look at the canvas, a bit at a time, through opera glasses (or the tin tubes he supplied). Now we are immersed in the picture, our eyes shielded from exterior objects which would by comparison make clear that this is a painting on which depth is an illusion and the objects portrayed are tiny in relation to their actual size. We can advance our focus along roads, up cliffs and watercourses, at the slow pace of a man moving through the actual landscape. And suddenly we are there, seeing tropical wonders with the heightened awareness of an artist's vision. We realize that every square inch is a masterpiece of almost *trompe l'oeil* realism on the miniature scale which despite the large canvas — ten feet by five and a half — was forced on Church by the amount of accurate detail he included. No photograph could give an equivalent sense of immediacy, for the lens sees differently from the human eye. It is safe to say with Jarves that illusionistic painting of nature in miniature has never been carried by any other artist to such perfection.

Put down your opera glasses and the picture's worst vice becomes again manifest: the mass of detail dissipates the allover impression. But further virtues also appear. Church has altogether abandoned *repoussoirs*, those prominent foreground objects against which distances can be measured which have been beloved of most landscape painters from Claude onward. Yet we do not doubt that the snowy dome is fifty miles away. Few artists have had such control of aerial perspective or of indicating distances through gradations of color. That color was considered very bright before the days of Impressionism — to Jarves it was "an Arabian Nights entertainment, a pyrotechnic display" — but it has none of the artificiality with which *Stimmungs Maler* tried to heighten their effects. Never was a work of art painted with a more sober and conscientious desire to duplicate visual truth.

Church largely abandoned ordinary easel pictures, preferring to concentrate his energies on tremendous distillations of visual experience like *The Heart of the Andes*. He worked on each with such intensity that the bronzed muscular man who entered his New York City studio in the fall emerged in springtime a pallid wraith. His willful refusal of European influences was, surprisingly, not accompanied by any preference for native subject matter. He left to Bierstadt the Rockies, which seemed designed for his art. In South America, which remained his favorite theme, he found the most dramatic of all his subjects: an enormous cloud of red smoke rising from the Ecuadorian volcano Cotopaxi contrasts with a bit of calm sky, while from behind it the setting sun throws a wild light into a mammoth lake and

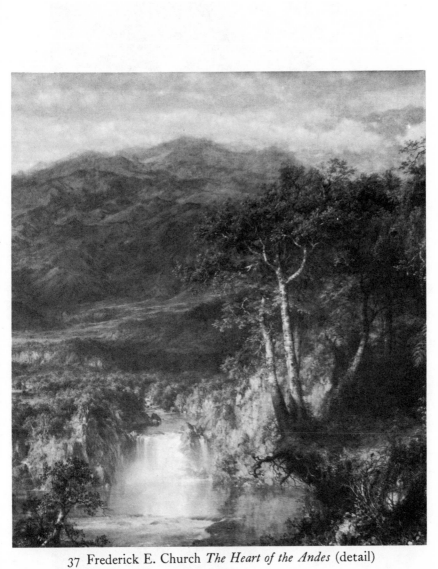

37 Frederick E. Church *The Heart of the Andes* (detail)

Oil on canvas; 1859; complete painting, 66⅛ × 119¼; Metropolitan Museum, New York, bequest of Mrs. David Dows, 1909.

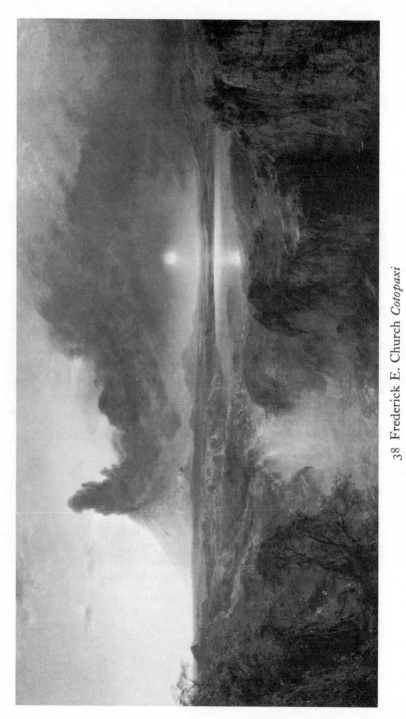

38 Frederick E. Church *Cotopaxi*

Oil on canvas; 1862; 48 × 85; John Astor, Miami Beach, Florida; photograph, Knoedler Galleries.

waterfall, over stern miles of rocky waste. He responded to the current interest in Arctic exploration by hunting icebergs off Labrador. The resulting major canvas is of awe-inspiring austerity: no pulse of life, but only glittering precipices of ice, ragged summits hoary with snow, desolate reaches of water faintly colored by a waning sunset. These stupendous scenes were rendered with a miniscule touch, monotonous in its very crispness and sparkle. The emotion was always objective, flowing not from man to nature but from nature to man.

For all the showmanship — borrowed, as we shall see, from the panoramists — with which they were displayed, the success of Church's reproductions of nature cannot be attributed to any facile popularizing in their execution. They gave serious expression to profound currents in the thinking of the time. Science was in the air, as was an interest, encouraged by improved transportation, in far places. Furthermore, scenery that realized, as Tuckerman put it, "the fondest imagination" of natural beauty resolved nagging doubts as to the coexistence of the real and the ideal. And the religious concluded that they were viewing hymns to the lovely variety of God's universe. Even the Civil War — the onrushing shadow, the actuality, and the disillusioning aftermath — helped, for Church's pictures offered both escapes into less menacing reality and a basis for patriotic self-confidence. The artist, Noble boasted, "has never seen a foreign gallery." To this Winthrop added that Church's pictures showed by their superiority how grievously "the effete schools of Europe" had been corrupted by the "rubbish" of the past. If in gathering from nature "the rules of composition for himself," Church had loaded on detail, that suited critics who believed that most American pictures suffered from slapdash carelessness. Was not every cranny of Church's canvases alive with "some positive recollection of nature"?

His dealers, Stevens and Williams, circulated his showpieces in Europe, *The Heart of the Andes*, for instance, traveling to London, Paris, Düsseldorf, Berlin, Vienna, Florence, Rome, Naples, Madrid, Lisbon, etc. Crowds came to see his renditions of exotic places, not because no other pictures of them existed — he had not been the first artist to penetrate anywhere — but because of his transcendent ability to fool the eye into accepting the actual physical presence of what was strange. Critics recognized that his methods were different from the European. In Paris, the pictures were admired for "force and accuracy" and "a manner of composition quite free from the considerations of the schools." In London, the Pre-Raphaelites were luke-

warm — Ruskin could praise only his skies — but other writers considered Church more "progressive" than all living English landscapists. He was said to be carrying on where Turner left off by combining with aerial and color effects like that master's "the most delicate and definite drawing, as well as a power of generalization which never becomes vague and careless."

Church was one of the most exuberant of mortals, given to practical jokes and possessed of a wild physical energy that made him, when lost in the jungle and precipitated by a crumbling bank into a stream, dance for a while "up and down with the warm water nearly up to his neck," before he resumed his search for the trail and safety. This vitality he poured out in small oils which he usually did not trouble to exhibit or sell: on paper or canvas, in sepia or color, tryouts for big pictures and experiments with strange light effects, and still an occasional Colean imagining. Hanging in profusion on the walls of the house he once inhabited, crammed in chests, piled on attic tables, these pictures are today known only to a very few persons. When they finally emerge into public knowledge, they will surprise even Church's admirers with their variety and power.

His smaller sketches are at Cooper Union, rarely exhibited but available for examination. Those he made in the presence of nature until he was almost forty were conscientious efforts to educate himself in styleless representation. But when in 1865 at Jamaica he revisited the tropics after an absence of twelve years, his exuberance finally rolled under his Yankee propensity for taking pains. Now he applied color in quick, thick swatches, seeking to express nature in a stylized shorthand. And instead of smoothing away the creamy texture of his pigment, he encouraged it to rise in ridges, to dribble along the edges of forms. However, when he returned to his studio he did not apply his new departures to his finished paintings.

In December 1867, at the age of forty-one, Church went at long last to Europe. Although he visited Bavaria, Switzerland, France, and England and spent a winter in Rome, he was most excited by the tours he took along the Mediterranean and the Aegean: to Egypt, the Holy Land, Lebanon, Syria, Turkey, Sicily, and Greece. He was in search not of new technique but of new subject matter — yet for him the two were inseparable.

The painter of wild nature turned to what he considered the essence of the Old World: "the trace of men." Catching in his sketches the intricate surface decorations on Arab walls presented no new problem, since he could apply the playfulness of the brush he had recently developed for tropical foliage. However, he had never been able to deal effectively with big shapes — a New England house or a South American hut — that could not be given

interest by miniscule elaboration. Classic architecture came to his rescue. Temples, columns, and pediments taught him to see beauty in the large, and once he had seen, his energetic and dexterous hand could catch in a single swoop the essence of three-dimensional form.

Church stayed in Europe less than two years. After his return to America, he summarized in large showpieces what he had seen and recorded. He still felt too conscientious to give rein in finished pictures to the arabesques that tripped from his sketching brush, but his new monumentality was enlarged into his *Parthenon*. Expunging small forms and intricate lights, he showed the broken pile standing out starkly before an evenly painted sky. On earth, sunlight and shade divide in a single diagonal: the ruined building is revealed by cold, unvaried luminance; anonymous shards of antiquity trouble the warmer shadow. Color is kept to a minimum: the sky, dark blue; the sunlit ruins, white shading to pink; the foreground, a mottled grayish brown. The powerful foreshortening of the fallen stonework, the spare vigor with which masses are shaped, the hypertranslucent light that seems motionless for eternity: all these make *The Parthenon* completely verisimilitudinous yet almost, despite a literalness that excludes subjective emotion, surrealist in intensity.

Others of Church's pictures reveal that he had found his European experience disturbing. In his *Aegean Sea*, billed as a compendium of Greek and Turkish civilization, earth is painted with a new largeness, but the surfaces are dull. And to express Greece's modern degradation, Church gave way to a symbol altogether literary: an open tomb. The best part of this picture is in his old style: a ruin-crowned island rendered with marvelous virtuosity, as seen through a haze that holds in its vapor two glowing rainbows.

Church seemed to be in the full tide of transition. Methods that he had not yet translated from his sketches to his paintings promised to overcome the monotonous brilliance of his touch, and he was now seeing in the large, although he had not yet discovered how to apply this vision to natural as well as man-made forms. True greatness was beckoning him when in 1877 — he was fifty-one — inflammatory rheumatism permanently crippled his right hand.

Doggedly, Church tried to educate his left, but with only rudimentary success. Living for another twenty-three years, he occupied himself in travel and in making ever more picturesque the villa Olana, which he had designed (with the help of the architect Calvert Vaux) in a Victorian-Persian style and had built on a high cliff overlooking the Hudson.

Church had won among his compatriots great fame, but his art was not

as influential, or as loved, as that of John Frederick Kensett (1816–1872), who, although ten years Church's senior, had appeared on the artistic scene at exactly the same time.

The son of an English engraver working obscurely in Connecticut, Kensett was at sixteen apprenticed to his father's trade. He subsequently found employment in one of those bank-note concerns that supported so many beginning artists. Like his fellows, he painted landscapes on his days off. In 1840, he sailed with Durand and two more young men — Casilear and Rossiter — for Europe. His avowed object was, like Casilear's, to improve himself as an engraver; he took along orders which would pay his way.

Although Kensett suffered from an uneasy desire to escape from engraving into landscape painting, he soon parted from Durand, who already had done just that. The youngster felt that in Europe it would be foolish to learn how to paint from an American. Better not to let "one lesson of wisdom" offered by the Old World "pass unheeded." However, none of the lessons seemed to apply to him. Having landed in England, he became so confused by what he saw that after moving on to Paris he hesitated for three weeks before he dared expose himself to the art in the Louvre. And when he made the plunge, the Louvre seemed to present no answers. Only after he had been called back to England and held there (1843–1845) by the hope of collecting a legacy, did he determine on a course. He would make a sharp break with his engraver's technique, forget about distances and black and white values. He adopted current English practices, descended from Constable, that showed depth only in little vistas under verdure, and crowded to the frames strokes of thick pigment intended to indicate the movement of light through foliage. Even after Kensett had moved on to Italy, he continued to consider this the right path, although he still sketched altogether differently, like an engraver.

It was probably with relief that he decided, when he returned home in 1847 after seven years abroad, that American scenery, being "entirely different" from the European, required for expression an entirely different technique. He was soon anchoring his compositions on those subtle gradations of gray that were the engraver's tool for indicating distances. This carried his practice close to Durand's.

However, Kensett did not, like Durand, use values primarily to push distances back; he wished the eye, comfortably at rest, to see position as a static pattern. He was thus enabled to devote his values, within a smaller range, to expressing minute gradations in the intensity of light as it pene-

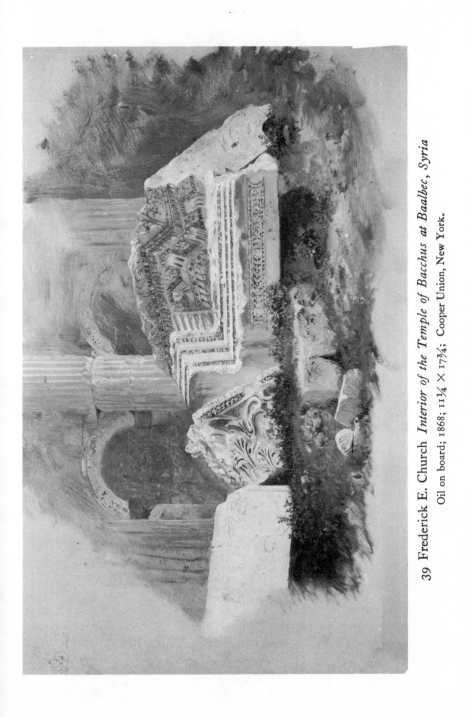

39 Frederick E. Church *Interior of the Temple of Bacchus at Baalbec, Syria*

Oil on board; 11¼ × 17¾; Cooper Union, New York.

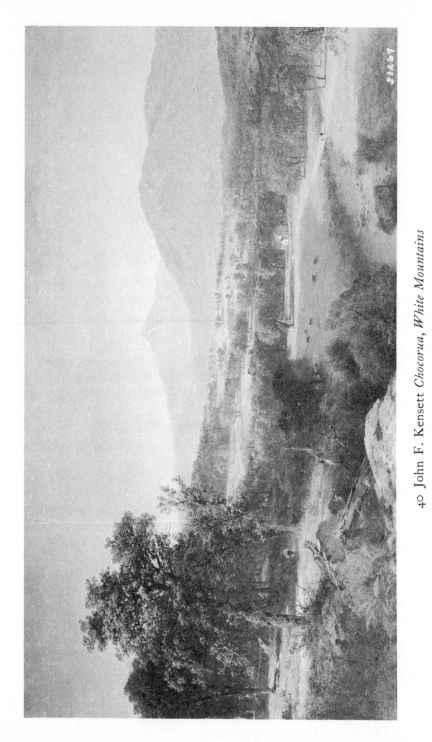

40 John F. Kensett *Chocorua, White Mountains*

Oil on canvas; c. 1867; Century Association, New York; photograph, Frick Art Reference Library.

trated through different consistencies and depth of air. He agreed with
Durand in drawing with an engraver's crispness, but his greater absorption
in atmospheric effects encouraged him to observe shape less closely. He put
his shadows and highlights more with a drawing master's facility than from
nature. This made his detailed foregrounds lack solidity and seem slightly
out of key with the beautifully realized distances and skies that were the
glory of his art. He showed his membership in the new generation by being
primarily a painter of light.

His light, however, was not Church's, strong, red, and burning. He had,
he wrote, "a most perfect abhorrence" for "a bright sky and a hot sun":
glare "almost totally unfits me for enjoyment." Loving a calm, medium
light in which the eye could enjoy an infinity of subtle variations, he became
famous for a prevailing silvery gray which reminded some critics of Corot's
contemporaneous work, although Kensett's gleam had less body and tem-
perament, shone more virginally.

Into his grays Kensett breathed warm hues often so gently that their effect
seems less on the eye than on the meditative imagination. Or sometimes, as
when he depicted autumn scenery, he would group subdued yellows, roses,
light greens, and salmon tans — not mixed but placed side by side, for he
respected the luminous quality of virgin pigment — that glow in contrast
with cooler passages to which they are tied by unobtrusive bright echoes.

More than Durand, Kensett loved nature in her wayside aspects. Al-
though he traveled to Colorado in 1866, he found the vast reaches of the
West unsuited to his art. Within the Eastern beat of the Hudson River
School, he did paint some panoramic views, but they were less typical than
canvases, often small, in which he envisioned the largeness of American
prospects not by looking down from an eminence but, more intimately,
standing below the mountains on level ground. A painter of clear light,
Kensett popularized, as new subject matter for the School, coast scenes in
which wide expanses of water catch and modify the luster of the sky.

Before he was sure of his method and his audience, Kensett had tried to
liven things up with conspicuous genre elements — he even descended to
stock-company Indians — but, as confidence came, he painted many unin-
habited pictures and, if he included humans, commonly reduced them to
unobtrusive notes — a distant sail, tiny pedestrians — that, without at-
tracting the eye, communicated that man is at home in God's world.

Like most Hudson River School painters, Kensett was a joyous pantheist.
More than any other, he saw nature entirely devoid of stress. Durand, for

instance, was capable of fury and bizarre revenge: he hounded a seducer to madness by engraving and circularizing the libertine's picture, accompanied with a warning to all womankind. Durand composed many a landscape in which forces warred into equilibrium, but Kensett contained all elaboration within large forms which he then balanced statistically like weights on a level scale. He was expert in the use of silhouette and the placing of masses. Thus, a coast scene will contrast a swoop of foreground beach with a protruding headland in the middle distance, the rest of the picture being a glistening medley of water and sky. Or when he looked from the ocean inland, water, cliff, and sky could form a simple succession of three bands across the entire canvas. Sometimes, the cliff is expunged and the bands reduced to two. If looked at through half-closed eyes that blur surface detail, his *View from West Point* could in its stark angularity — a bluff breaking vertically from the river under ragged horizontals of mountain and air — almost seem a twentieth-century abstraction.*

Where Durand specialized in depicting nature's mobiles, the trees, Kensett was celebrated for his renditions of immovable rocks. Never was his fundamental serenity more conspicuous than when he painted subjects that imply violence like *Storm over Lake George*. The foreground water is so shallow that the wind raises only ripples. Although high branches are blowing, the role of the trees in the composition is motionless. The dark clouds cast a refreshing, moisture-laden light, and already, in the farther distance, the sky is bright with the promise of returning peace. We are not menaced but comforted, for in her fierce contortions Nature is shown, even if momentarily angry, as a friend.

The consistency with which Kensett adhered to his mature manner once he had found it is explained by the inability of his contemporaries to discuss his work independently of his character, which also underwent no changes. "All his pictures," wrote the author George W. Curtis, "are biographical, for they all reveal the fidelity, the tenderness, and the sweet serenity of his nature. . . . He made sunshine that softened and harmonized all."

Kensett's stocky bulldog body was topped with a benign, gentle face, the beard both obtrusive and soft. Usually silent, never visibly firm, a bachelor seemingly immune to the world, he rose to worldly power. His universal generosity to young and old disarmed professional jealousy. Businessmen, enchanted to find in him "none of the irritability and oversensitiveness

*Kensett thus achieved, with more naturalism and sophistication, the type of simple landscape design which had defeated Catlin's symbolic and naïve early art.

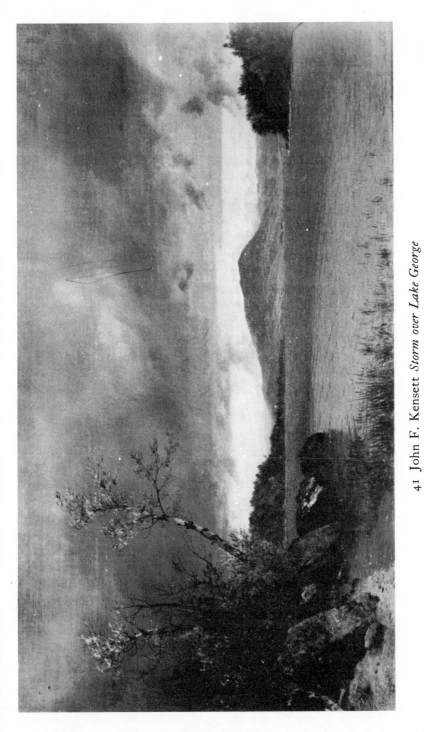

41 John F. Kensett *Storm over Lake George*

Oil on canvas; 13⅞ × 24⅛; Brooklyn Museum, Brooklyn, New York.

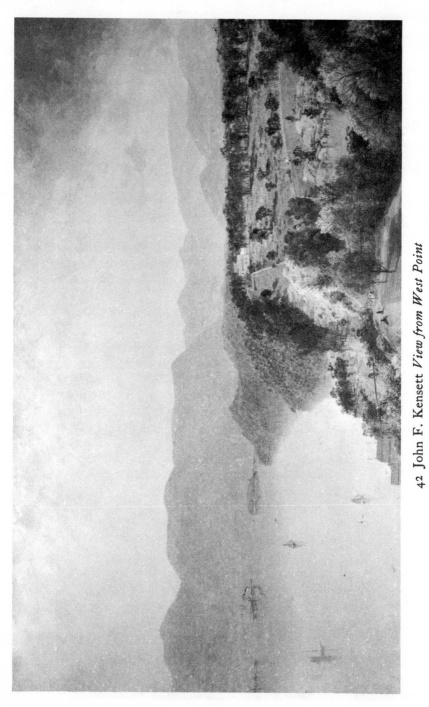

42 John F. Kensett *View from West Point*

Oil on canvas; 1863; 20 × 34; Robert L. Stuart Collection, New-York Historical Society, New York.

common to artists," elected him to their clubs, where he steered their interest to art. He headed artists' charities and played a major part in founding the Metropolitan Museum (which has recently "dumped" at auction a quantity of his works). He became the leader of the new generation of painters as Durand had been of the old.

Creating with the easy rapidity of a man without inner conflicts, willing to part with his outdoor oil sketches as well as his studio pictures (something hardly any of his contemporaries would do), Kensett had a tremendous output to sell, and it sold. "There is," a contemporary wrote, "hardly a parlor or a private gallery in our city [New York] that does not contain one or more pictures by his hand." He was America's most popular painter.

How was it possible, we may well ask ourselves, for such an artist to occupy so exalted a position among both painters and laymen? Are we not talking about the Hudson River School, which, we are told, specialized in vast, blatantly shouting pictures? And is this not the roaring mid-century, when the Civil War was fought, when the West was conquered, when tobacco juice splattered the land, when the new rich were building their flamboyant piles, when Whitman and Melville and Mark Twain exaggerated? How could an art so unobtrusive and subtle, so grounded on laconic understatement, catch the eye? Even today, when we pride ourselves on the exquisiteness of our appreciation, Kensett's pictures speak in such a low voice that we must strain to become attuned.

For his contemporaries, Kensett's was a reminiscent art, although it was not, like that of earlier landscape and genre painters, aimed at farm boys turned city merchants. His pictures reflected a more recent development that was being encouraged by the expansion of cities, the increase in size of business units (which made it possible for men to get away), the growth in wealth, and greater ease of transportation: summer vacations.

In search of permanent remembrances of relaxed days, urban dwellers went to Kensett's studio, where the walls were covered to the ceilings with oil sketches which the artist would sell or enlarge or combine. Each was so true to its locality that any yachtsman could tell whether the shore depicted was near Newport or Manchester, any mountain climber could recognize the Catskills, the Green or the White Mountains. This exactitude was not, like Mount's or Durand's, a farmer's truth, full of practical detail, but expressed those attributes of nature, more generalized and bland, that brought peace to city people who had found temporary respite from the strains of economic and, in the 1860s, physical war.

Kensett's landscapes were said to call back "the very countenance of a departed friend." Expressing "infinite peace and infinite sweetness," they rebuked with health all morbid thoughts. They were, indeed, "poems of our common lot, blessings in our daily path."

His art was unsuited to attracting crowds as Church's showpieces did, nor could it survive today when a painter must secure reputation through competitive display on impersonal walls. The pictures commonly hung over domestic fireplaces, whence they slowly shed their gentle charm, mature in tranquillity, until what seems to the modern museum-walker a seascape too empty to hold the eye became, as a critic then wrote, "pure light and water, a bridal of earth and sky."

{ 10 }

FURTHER ADVENTURES OF
THE HIGH STYLE

H ISTORY painting, still considered in Europe and by extreme American conservatives the only high style, demanded, as became its theoretical importance, big pictures, the human figures life-size and often intricately interrelated. Crudities that on the small canvases employed by genre painters hardly showed or could actually contribute to emotional effect, became on so large a scale devastating blemishes. Thus, more than any other branch, history painting was damaged by the American belief in untutored inspiration that encouraged neglect of formal training for artists.

Art schools for professionals were unconcerned with instruction in painting. Although some creators accepted pupils — Morse did for a while — the ubiquitous teaching of art as a polite accomplishment to young ladies gave the practice so bad a name that, as Cummings wrote, most serious painters eschewed "teaching or being looked on as teachers." Nor could future history painters hope to learn on their own, since in the entire United States almost no effective large figure paintings were available for study.

On the face of it, one would assume that acquiring draftsmanship would not also present serious problems, since the National Academy's school, like those in other cities, emphasized drawing from the antique. However, this reflection of the old neoclassical esthetic was allowed to continue only because no one cared enough about formal art education to sweep it away. The schools were, for all practical purposes, dead.

During the late 1850s, the National Academy's school was a pair of

"forlorn, desolate rooms" up two rickety flights in a loft building. The larger chamber contained "the usual casts: the Milo, Apollo Belvedere, Venus de Medici, etc.," placed under gas lights for which the students had fashioned paper shades. Around each statue was a semi-circle of chairs. On the coarse, whitewashed walls hung fragments of the human body cast from life in plaster, and some cheap lithographs of paintings from Paris or Düsseldorf. This was the "Antique School." Painting was forbidden. There was hardly any instruction in drawing, nor were any standards imposed beyond what the students thought of for themselves.

In the smaller room, the "Life School" met when there were enough applicants. Painting was permitted but not taught. The models were an old washerwoman, or her children, or an unemployed peddler. They posed clothed.

On one occasion, "a fair enthusiast" wrote that she had read of the difficulty the Academy had in securing models who would pose in the nude. She needed to contribute to the support of an invalid husband and "flattered herself that her figure was as perfect as that of the average woman." She offered to reveal that figure on condition that she be allowed to wear a mask, that she be spoken to only by the instructor, and that no student should leave the building until fifteen minutes after she had departed. All being agreed to, "she posed amidst the most respectful silence for several evenings, nude except for the mask, and her figure was declared as beautiful as that of the Venus de Milo." But one evening there came instead of the model an indignant letter saying that one of the students — "a tall, raw-boned Don Juan from Wisconsin" — had slipped out to accost her at the street door and ask to see her home. Drawing from the nude was indefinitely suspended.

"Women of no character" could undoubtedly have been found to pose — New York had its red-light district — but according to the ideas of the time, this would have served no useful purpose. The object was to learn how to depict a pure woman, God's greatest handiwork, rather than an impure one, the world's most debased inhabitant. That the bodies of the two were not in essence different was a conception untenable when God's grace was believed to manifest itself in visible nature.

If we are to understand mid-nineteenth-century figure painting, we must forget the more modern theory that only the vulgar see in an artistic nude anything but abstract esthetic values. In Victorian times, when women's bodies were invested with the most potent magic but were kept hidden even from husbands and other women, there flourished a compulsive fascination

with the female nude. So deep was the psychological need for representation, so great the release of staring if you could with good conscience, that society found ways to circumvent, but always with a sense of danger, its greatest taboo.

We have seen that a classic toga and taste saved in engraved designs the respectability of a partially clothed girl. Stripping off all vestments was the particular prerogative of sculpture, the classical art par excellence. Beginning during the 1830s, a new school of American sculptors, usually resident in Italy, represented ladies from antiquity naked, but in cold, white marble that, without dismaying intimacy, communicated what Victorians desired and feared. Hiram Powers was to achieve the greatest artistic sensation of the mid-century (1848 and thereafter) by sending through America to surging crowds his *Greek Slave*, in which he pioneered a further cauterizing device. The nude was shown chained. Whatever emotions moderns might feel this encouraged, in those days it was regarded as proof that she was not exhibiting herself willingly, as a bad woman would, but was forced to exposure by powers beyond her control. Thus she remained the purest of all creation, a good woman, whose image did not debase but elevate.* But even here the sense of danger reasserted itself. Although the main physical features were regarded as essential to such sculptured females, sensual details that gave too strongly the sense of a breathing body were, in what was called a classical manner, generalized away. This probably explains why *The Greek Slave* was in Paris "a dead failure."

Trapped in what the *Art Journal* called "the snare of color," painting made too realistic even the seminakedness of even the purest white woman — and the complete nude was, on tinted canvas, almost unforgivable. The typical members of the Native School, who were by no means in revolt against the society in which they lived, accepted this taboo of their own volition. They were repelled by the "licentiousness" of French art.

The anticlassical theory that character was shaped not by learning but by experience had, as we have seen, made Hudson River landscapes seem "leaves from a Gospel." The same reasoning dictated that pictures considered improper were worse than shocking. They were active magnets pulling the innocent to hell. The female nude was, indeed, considered much less dangerous for men, whose carnal emotions might be stimulated, than for women, whose spiritual purity was endangered. In those days men normally

*That no one thought the male body, virginal or not, elevated resulted in the male nude being almost completely banned.

frequented red-light districts, which were believed to soil their sex only slightly, like dirt that will wash off. There is no reason to doubt that the artists, so many of whom were bachelors, made use of this resource, but even in painting for their fellow males, they wanted no soil, no dirt at all, in their art.

Depicters of American life had no need to show the nude, since the nude never showed itself. Hawthorne argued in *The Marble Faun*, that in the United States clothes played exactly the same role as skin had among the ancients. It was, indeed, possible for a close observer to paint effectively — as Bingham did — a little figure in this cloth skin despite lack of concern with what went on underneath. But the historical artist, in addition to working life-size, had to paint someone in an exotic costume that was not a second skin molded by use to the body, but a passing disguise to which neither artist nor model had any experienced reaction. The painter saw nothing significant unless he knew the anatomy below more intimately than he could learn it from antique casts. Furthermore, traditional aspects of the historical mode depended on direct renditions of the nude.

The high style was so impeded in America that when the Boston Athenaeum offered in 1831 a premium for "the best historical or fancy cabinet picture," only one artist, Robert W. Weir (1803–1889), competed. And significantly, he did not send a large picture but nine small ones. They ranged from illustrations of Scott and the Bible through Greek, Roman, and old European subjects to an American Indian scene.

Son of a broken New York businessman, Weir had suffered great privations in his childhood, had escaped into the artisan practice of painting, had studied for two years in Italy (1825–1827), and after his return had used the skills he had acquired abroad primarily in making embellishments for gift books. Thus was exemplified a phenomenon that we shall meet again and again. Although historical painting was the high style, it was also, as other aspects of American art abandoned literary subject matter, the form best suited to humbler aspects of illustration. Thus it served on one hand the traditional taste of the best-educated connoisseurs, and on the other the naïve desires of simple people, who could only enjoy a picture if they could spell out from its surface a story. And the mode that traveled so easily into imaginary realms became the favorite of Victorian females, parlor-cloistered from mundane reality, whose dreams were not served by the aggressively masculine realism of the Native School.

This ambivalence was demonstrated again when in 1834 four huge murals

were ordered for the national Capitol. Passing for political reasons over Morse, Congress gave the commissions to Weir; the now superannuated Vanderlyn; William H. Powell (1823–1879), an Ohio portraitist with the right senatorial connections; and John Gadsby Chapman, who never saw any sharp distinction between easel painting and commercial illustration. Powell and Vanderlyn painted their canvases in France, Weir and Chapman at home, but all the pictures proved to be basically embellishments for the printed page that had lost, by being enlarged far beyond their possibilities, whatever validity they might have had in the small.

To lift historical painting to its proper stature, two wellborn New Yorkers, Daniel Huntington (1816–1906) and Henry Peters Gray (1819–1877), sailed together for Italy in 1839. Both accepted much neoclassical theory, although Huntington was more influenced by contemporary modifications, Gray more exclusively concerned with reactivating styles from the past.

Rome's dominant resident painter was the elderly German Johann Friedrich Overbeck, a Nazarene who had influenced a similar movement among the Italians, *Purismo*. From this Catholic practice, Huntington borrowed consciously childlike piety, gently dramatic draftsmanship, and superficially alluring soft color — but he applied them to Protestant ends. His *Mercy's Dream* illustrates *Pilgrim's Progress*. It shows a pretty ingénue leaning against a wooded bank in a deep trance, while over her head a low-flying angel holds a crown. Huntington explained his objectives in neoclassical terms. Expunging everything "trivial and accidental," avoiding "fixed costume" that would limit the action to one place and time, he sought "the generalized and abstract" rather than "the natural and imitative in which too literal resemblance amuses the eye." However, color and mood were sentimental, and the modern eye is amused to see that his generalizations and vaguely antique draperies do not keep Mercy from being manifestly a delicately nurtured Victorian beauty. Huntington's admirers agreed that much of the appeal of his moral homilies lay in the charm of his heroines. Painted by the artist in three large versions, engraved over and over, *Mercy's Dream* was one of the most popular pictures of its time.

Gray preached that it was as heinous for an artist to deny the authority of the Ancients and the Old Masters as it would be for a Christian to deny the authority of the Bible. Coloring forms copied from antique statues with unclassical hues conned from the Venetians, he created figures exemplifying human attributes which he arranged into allegorical compositions. In his *Wages of War* he spaced as if on a sculptured frieze a diaphanously clad

mother weeping over her almost-naked child; a wounded classic warrior lying on his elbow before a sarcophagus, bloody and holding a broken sword; and then another warrior being restrained from further carnage by his weeping wife. In this and in others of his paintings Gray was induced by his allegorical intention and also his admiration for Titian to employ, as Huntington did not, the seminude. However, the American Art-Union explained that "the nudity of a symbolic figure ... seems quite unobjectionable."

In 1849, the Art-Union paid its record price for Gray's *Wages of War*. In 1850, thirty-nine leading citizens staged at the Art-Union Gallery a large retrospective show — one hundred and thirty paintings — of Huntington's work, the greatest such honor till then given a living American artist. Gray and Huntington seemed about to revive the old historical taste, but at the very moment of triumph, inspiration faded from them. And the attention paid their pictures brought, in addition to praise, charges of conservatism and insipidness. The two painters shifted their major attention from the high style to society portraiture.

More durable was the concern with historical painting of William Page (1811-1885), who enunciated the old ideas with twists that pointed towards the future. His esthetic household was crowded with incongruous figures. He claimed, when like Gray he put antique statues on canvas with Titianesque colors, that he had married Faust and Helen. Paul Bunyan was also there and Swedenborg; Boston Brahmins and wayward little beauties; the spirits of science and of prophecy; the angel of megalomania and the devil of failure. Page was American painting's first full-fledged romantic seer and also her first experimental artist.

His father had been a drifter, a Connecticut farm boy who became successively a mail carrier, printer, shopkeeper, Hudson River navigator, and then plane maker in Albany, where the future painter was born. Taken to New York City at the age of nine, the child when eleven won a premium for drawing from the American Academy. He was soon, as an apprentice, painting signs and banners. He studied with Morse and at the National Academy, where he displayed "talents of uncommon strength." And then he decided he did not want to be a painter after all — he would be a Presbyterian minister. However, a year or two's study at the Andover Academy convinced him that he could not accept the Christian faith. He deserted to Albany, where he painted likenesses "with great ardor and success." He delineated *The Anger of Achilles* and dreamed of Europe, but just as he was about to pack his trunk, he met the most delightful young girl, the daughter

43 Daniel Huntington *Mercy's Dream*

Oil on canvas; 1850; 90¼ × 67; Corcoran Gallery of Art, Washington, D.C.

44 Henry Peters Gray *The Judgment of Paris*

Oil on canvas; 1861; 50⅞ × 41; Corcoran Gallery of Art, Washington, D.C.

of an Irish actor. Marrying Lavinia Twibill before he was twenty-one, he settled in New York City as a portraitist. He attracted great attention (1835) with a picture of his pretty wife dandling her baby, and was elected an associate of the National Academy. However, in that headquarters of the Native School, he felt himself isolated "as far as intellectual sympathy was concerned."

Page expounded theories of art with an eloquence that would have made the Sirens abandon their reef and swim for him. Yet his colleagues were too pleased with their own practice to listen. He was frustrated until, during a vacation in 1840, he became intimate with James Russell Lowell, who introduced him to other Bostonians, "companions of the highest caliber, interested like himself in the profoundest questions of art, philosophy, and society." As he talked with his new friends, his wife became so bored that she found herself with child by a taciturn stranger. Page divorced her and married another beauty of even tenderer years, whom he took with him to Boston, where, after making many visits, he finally settled in 1843.

That was the year of Allston's death. The older artist-seer had been encouraged into the long sterility of his closing decades by the belief of his Boston admirers that he was too great a man to express himself in paint. Soon a local critic was writing that Page's pictures "remind one of what he had read of Titian. But the man is infinitely greater than his works." This attitude was a corollary of Transcendentalism.

"Painting," Emerson stated, "seems to be to the eye what dancing is to the limbs. When that has educated the frame to self-possession, to nimbleness, to grace, the steps of the dancing master are better forgotten." Once art had developed "the perception of beauty," then "away with your nonsense of oils and easels, of marble and chisels! Except to open your eyes to the mysteries of eternal art, they are hypocritical rubbish." Painting was, in effect, a ladder leading to the spiritual and moral sphere. After you had successfully clambered up, you had no intention of going down again. You kicked the ladder away.

However, didactic theorizing like Emerson's own was not equally expendable. "The art of writing," he pointed out, "is the highest of those permitted to man, as drawing directly from the soul." This was gospel in Boston. Thus, in the very act of arguing that the city should found a museum (1870), Charles C. Perkins, a wealthy art critic and amateur painter, stated, "I do not intend to suggest that a cultivation of the sense of the beautiful as revealed to us in art is equally important with that of developing our

faculties by the reading of great or good books. Such a proposition would be absurd." But art was "a pure well of culture," and "here in New England, thank God, men are always ready to promote culture!"

Boston's first public art gallery was an adjunct to a library. On the top floor of a wing of the Athenaeum, it had opened in 1827 with a loan exhibition of American and foreign works. By 1834 it had become so dedicated to spurious Old Masters that the local painters rebelled and held their own show. This seemed a replay, nine years later, of the movement that had in New York produced the National Academy, but the Boston professional artists were not strong or numerous enough to achieve anything permanent. Allston refused to cooperate, and Page had not yet arrived. Except for a few strays, only four painters were represented: the landscapists Doughty and Fisher, the portraitists Chester Harding (1792–1866) and Francis Alexander (1800–1880). They all relied, so Fisher wrote Durand, not so much "on our own merit" as on the hope that Boston would "encourage its native talents."

Boston had other interests. During the days of Copley, of Stuart, of the younger, creative Allston, the city had been the leader of American painting, but it was now absorbed in a literary and philosophical renaissance. In the fine arts, it was anticipating later national trends by preferring to what could be nurtured at home what grew abroad. The *Boston Evening Transcript* reported that during 1860, local connoisseurs had bought from local artists two pictures for between $150 and $100; and four in each of the following ranges: $99–$50, $49–$25, $24–0. No wonder the prosperous painters in New York considered Boston "a provincial town!"

Page received some portrait commissions but was primarily encouraged to theorize, to seek, as he put it, "the subterficial." New England intellectuals felt uneasy with the visual arts. Thus Hawthorne considered that he had advanced in taste when he realized that some of the pictures at the Athenaeum Gallery were more unpleasant than others, and Emerson wrote in Italy, "I have made a continual effort not to be pleased except by what ought to please me." To such uneasy appreciators, a painter who could like Page verbalize art in philosophical terms was a godsend.

Page wrote that only if art could be made to follow "laws as definite and immutable as those of science" would it be "worthy to be the study of such men as could adorn any liberal pursuit." However, he felt it necessary to believe that his search for such laws was enabling him to paint like Titian. That neither he nor most of those who agreed that he had succeeded had ever seen an authentic Titian seemed a minor difficulty, for generations of reading

books had made the names of the Old Masters counters in the national art jargon. Raphael stood for draftsmanship and intellectual values, Michelangelo for power, Correggio for sensuality and chiaroscuro, and Titian for color. By selecting Titian, Page was expressing his basic interest in color. But he intended no subservience. If it should develop that Titian had stupidly failed to follow Page's methods, Titian "might be doubted, no name being sufficient authority for what reason rejects."

Much of the formulation Page published in 1845 served to answer the contention that art was no more than a means to educate the eye to appreciation of divine handiwork. Page argued that art should do more than reflect nature. It should be a separate if parallel creation. As he explained it, "The more nearly the means used correspond with or are analogous to those used by nature in her effects, the nearer will be the impression made on the eye." Thus, veins should not be put in with blue pigment but rather by drawing a dark red line to stand for blood and then covering it, until it seemed blue, with glazes representing "the light color of the skin and the coating of the veins."

In painting flesh, Page first applied a white ground that would represent the actual physical thickness of the body by drawing in light and reflecting it out again. Over the white, he put the red of flesh and then transparent layer after layer, each with its anatomical counterpart, finishing with Naples yellow mixed with ultramarine, which was his "representative of light" reflecting from the skin. Using not drawing but color to create shape, he glazed down, primarily with Prussian blue, the forms that were to recede. To look into this complex, Page wrote, was like looking into "the unfathomable depth" which existed in "all works of nature, . . . leading us to see more and more by increasing effort, and yet hiding the end ever from our reach."

When, shortly before Allston's death, Page had outlined his theories to that predecessor seer, the older painter, who was concerned with soul, not science — and used, when it came to art, to doing the talking himself — had asked if putting light colors over a flesh-red would not "have the look of a white veil," Page replied, "Well, is not the skin in some degree a veil?" Allston tinged his perpetually saintly smile with disbelief. Six years later, Page still burned at the slight, stating that Allston's flesh tones were "foxy."

Page's method of building shape without lines and of bringing transparency to flesh resembled the practice of Stuart, who had not bothered with scientific or philosophical justifications. While admitting the connection, Page insisted that Stuart's achievements could not be compared with his own, since the

old portraitist had possessed "no system, or thorough knowledge of the principle, so as to make anything certain of it."

Although he believed that the brilliance where light struck most strongly was "unapproachable by art," Page wished to parallel, in his artistic formulations, the whole range of nature's colors. He reasoned that brown, being the result when the three primaries were mixed together, was "the universal hue" from which all others should spring. (Had he not read that Titian made flesh "a golden brown"?) From neutral brown you could move towards any of the primaries to a greater relative brightness, so he argued, than was available to artists who began by painting bright. It was, Page claimed, as if he had, without simplifying any of the notes, transposed a song into a lower key.

Page spoke as a citizen of his American times when he denounced the artist who, in the name of the ideal, tore natural form "from its proper relation" to make a "chaos of his own creation." True art, he agreed, was "imitation," but he did not mean by the word, as his colleagues did, the reproduction of appearances; he meant imitation of the processes by which nature achieved her effects. Thus, he anticipated the twentieth-century doctrine that the content of a picture was the way it was painted, that a picture was a living organism in its own right. This, of course, affected the image.

Making an object, Page wished it to be a firm one, and thus he sought a unity of color and effect revolutionary for his environment. Although in his portraits he achieved likenesses as unflatteringly realistic as those of any of his contemporaries (John Quincy Adams is an irascible, pinch-faced old Yankee with a red nose), his result was much more monumental. Instead of joining various semi-independent shapes into a lively image, Page painted the body and the head into which it tightened as a single jutting form which controlled starkly whatever other forms the picture contained. Color is not a harmonious patchwork of separate hues but an immersing pool of intermingling pigments. Being concerned with paint surface, he made unusual use of impasto, contrasting thick passages with thin. His ability to render texture should have won him especial acclaim as a portraitist, since most of his rivals gave the flesh he did so well a lacquerish sheen. However, as his means became more complicated, he took an impractical time to finish a likeness, sometimes three years. The taste of the period ruled his dark color scheme dingy, and, after a picture was delivered, it turned even darker.

Seeking neither to duplicate nature nor to violate it, Page, when he painted

45 William Page *John Quincy Adams*

Oil on canvas; 1838; 47 × 36; City of Boston; photograph, Museum of Fine Arts, Boston.

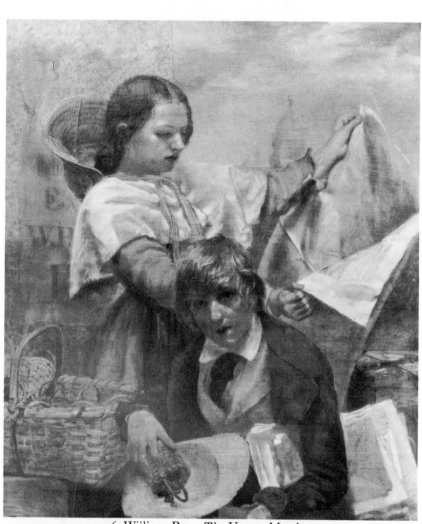

46 William Page *The Young Merchants*

Oil on canvas; 1842; 42 × 36; Pennsylvania Academy of the Fine Arts, Philadelphia.

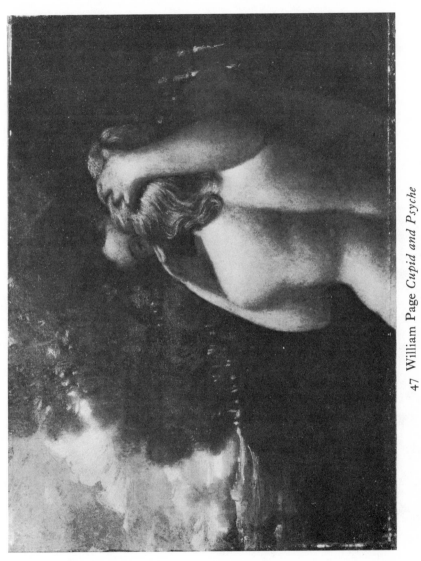

47 *William Page Cupid and Psyche*

Oil on canvas; 1843; 10⅞ × 14¾; Mr. and Mrs. Lawrence A. Fleischman, Detroit.

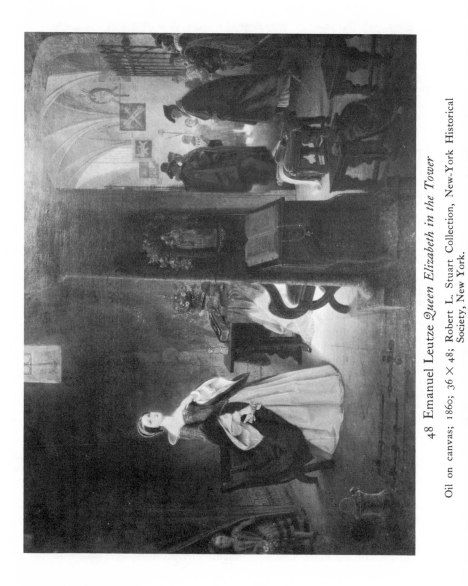

48 Emanuel Leutze *Queen Elizabeth in the Tower*

Oil on canvas; 1860; 36 × 48; Robert L. Stuart Collection, New-York Historical
Society, New York.

genre, achieved effects less like those of American than European realists. Although the two newsboys in *The Young Merchants* inhabit contemporary actuality, everything is arranged to serve design.

Naturally, Page's ambition was the high style. Of his many essays in the historical mode, most have vanished, but his *Cupid and Psyche* remains to testify that he was the most sensual painter of his American generation. (He tried, through announcing that it was based not on life but sculpture, to keep the National Academy from banning the canvas, but to no avail.) A deep landscape vista to the left serves by contrast to clamp together in their tight well of trees two naked figures engaged in the most passionate of kisses. We see only the woman's back cut off at the hip, and of the darker-fleshed man only an arm, which imprisons her head, and those bits of forehead and flank that are not hidden by contact with her blond skin. Yet this picture makes Gray's allegorical seminudes look like high-school boys' visions.

To be his chef-d'oeuvre, Page had sketched while still in New York *Jephthah's Daughter* as a scene of violent action. In Boston, the composition had changed (just as Allston's perpetually unfinished *Belshazzar's Feast* had done after he had moved to that city) in the direction of static meditation. Like *Belshazzar*, *Jephthah* was never completed. A New York friend commented that "the infernal influence of Boston" would make Page "drop his brush before long." However, Lowell warned Page that a return to New York would not be "at all conducive to your spiritual advancement." And, indeed, when Page was forced to return in 1847 by lack of business in Boston, he found New York more than ever uncongenial. In 1850 he secured enough commissions for copies after Titian to enable him to sail, at long last, for Italy.

Those who tremble for the result when the long-established "American Titian" came for the first time face to face with Titian's actual work underestimate the resilience of our seer. Page only saw what he wanted to see. Since he refused to believe that the old canvases had not always been so dark, the principal effect of the confrontation was to encourage him into even more murky complications of technique. He now felt justified in tinkering endlessly with his surfaces, altering in red or blue and then glazing with yellow. Thus he further infected his art with what might be called "seer's blight." He was prophetic of the next generation of exalted painters when, in his eagerness to express his feelings and his theories, he neglected those lowly considerations of craft which gave even a sign painter's work perma-

nence. No sooner did he declare his pictures perfect than, as he himself wrote, "some have turned red, some black, some spotted, some slid off the canvas, and all gone as if by spontaneous combustion." These mishaps had been caused because he was experimenting to find "a safe and permanent ground."

The greatest excitement of his Italian stay came when the sculptor Powers introduced him to Swedenborgianism, thus enabling him to find religious values in his previously altogether "scientific" esthetic system. From Swedenborg's doctrine that, since God expressed His will through function, physical structure was the reflection of active moral forces, Page concluded that his artistic structures that paralleled nature's were "soul manifestation."

Page's Italy was a garden suburb of Boston, since New Englanders found a special charm in a land where historical and literary associations mediated between the mind and the sensual beauty.* Although the New Yorker Weir had found ruins depressing, the Colosseum by moonlight to an educated New Englander was a reverie from Gibbon's tomes. Emerson spoke for his followers when he boasted that in the galleries of Italy he had first found himself really moved by the painter's art. The best English-speaking circles in Rome and Florence being dominated by Transcendentalists, Page enjoyed again conversation deep and high, especially as he now added to his intimates two English poets, Robert and Elizabeth Barrett Browning.

Page delighted writers, as he read aloud, by making their works seem better than even they themselves had believed. (After the painter had delivered Lowell's "The Washing of the Shroud," the poet could not resist jumping up and shouting, "It's a great poem!") And Page's pictures, Lowell noted, "never get so good a light as from the effulgence of his personal presence." His best reviews were written by young men who had looked at his pictures while he talked — and they were very good reviews. Thus, the Italian correspondent of the *London Art Journal* wrote that his portraits needed only the cracks of age to be mistaken for Titians, which made him "undoubtedly the best portrait painter of modern times." Robert Browning commented, "No such work has been achieved in our time," and the sculptor William Wetmore Story added, "I have met few, if any, persons who affected me so truly as men of genius."

*Cole's Italian views had sold particularly well in Boston. Many of the Massachusetts painters who did not, like Winslow Homer, emigrate to New York, found a refuge—which seemed less far from their home city—in Italy. Alexander, a disciple of both Stuart and Allston, painted portraits charming in color until he moved in 1853 permanently to Florence, where he changed his interest to buying and restoring old canvases for the Boston trade. During twenty years (c. 1839–1859) resident in Florence and Rome, Boston's favorite landscape painter, George Loring Brown (1814–1889), liked to be referred to as "Claude" Brown. He produced for tourists milk-and-water Italian views.

What of Page's young wife, whom a correspondent for the *Boston Daily Advertiser* called "certainly the handsomest woman I have ever seen"? After several years of writing pitiful letters bewailing her loneliness, she eloped with a count. When she was brought back by the police, Page begged her on his knees to stay with him, if only as a daughter. But she had had enough of that old black magic; she set out again. After tumultuous years involving several male protectors and a stint on the stage, she married Peter B. Sweeny, Boss Tweed's rich and crooked lawyer. Page never mentioned this crass association without expressing a philosopher's regret at how far she had fallen. What were her thoughts when, as diamonds sparkled in her ears and gross men crowded near to admire, memory brought back the condescending Transcendentalists and the husband Robert Browning called "that noble Page"?

Page horrified his admirers by becoming engaged even before he was divorced. Lowell objected that the seer should never get married, as he drank a woman's soul in one draught. However, his third wife was not, like the first two, a pretty ingénue. She was a dragonlike widow and newspaper woman who for the rest of his life warmed Page with the fire from her nostrils and forced her businessmen brothers to keep her genius financially afloat.

It was nice no longer to have his pictures attached for debt, but Page may sometimes have repined. Certain it is that he now gave his major energies to four versions of a full-length, life-size Venus scudding on a cockleshell. As he painted her naked flesh, he repeated over and over to give his brush rhythm Hood's poem "Bridge of Sighs," which mourned a beautiful young girl who had punished herself for her frailties — as neither of his pretty wives had had the judgment to do — by tossing herself into the river. Even his new wife thought the choice of poem rather strange.

Page's Venuses were a *succes de scandale*. His friends assumed that the versions refused by England's Royal Academy and France's Salon had been banned "on the grounds of decency." Certainly, the one presented by his friends to the Boston Athenaeum had to flee moral censure to the cellar. Another managed to tour the United States without being tarred and feathered, yet she stirred so much controversy that only the courageous dared visit her.

In defending his Venuses, Page again showed himself ahead of his time by sweeping aside the whole Victorian mystique of the nude. Far from trying to recast the goddess as a good woman, he dwelt with relish on the children she had had with a whole brigade of lovers. Venus, he wrote, was the

traditional embodiment of "health and nature." To consider her shocking was to prove yourself, "in the view of the educated and refined, . . . as either grossly ignorant or vulgarly and morbidly corrupt."

But even Page's greatest admirers did not agree. Venus, one contended, was obsolete, since the "ideal" she had stood for had been entombed forever "when the shadow of the cross fell across Olympus." And how, asked another, could Page's figures represent natural health, since their forms had been so clearly distorted by corsets? Three of the painted goddesses responded to such criticism by flaking from their canvases. The fourth, now in the possession of Page's descendants, simpers out over her heavy-membered form with a Victorian coyness quite frightening.

Page had worked out with a typical intermingling of the new and the old — by mathematical calculations based on a line from the Bible — the perfect proportions for the human body. After his return from Italy to the New York region in 1860, he applied his Swedenborgian ideas of "correspondences" between the spiritual and the physical to what he announced as a new type of history painting. From his knowledge of Shakespeare's character and achievements, he materialized the poet's portrait.* Then, abandoning all traditional conceptions, he painted the head of Christ. "There was never," wrote *Harper's Magazine*, "a picture more generally and universally condemned." On the basis of his belief that moral and physical power accompanied each other, Page gave Christ the features of a sensual bruiser. There were amusing resemblances between his *Christ* and his self-portraits.

As he continued to experiment and expound, Page often denounced his previous conclusions, but was always convinced that he had now found infallible answers. He believed that he had "done more for art than any man (or woman) since Titian. This is my private opinion of myself, and I care little how public it becomes."

Although he was made president of the National Academy for a brief term in 1871, in a vain effort to please the younger European-oriented artists who were about to form a rival organization, Page was considered by every shade of contemporary opinion a failure. Majestic perhaps, but still a failure. Since the triumphs of science had not yet created a cult for "experimental painting," his perpetual trying of something new was not considered in itself an esthetic achievement. That he had completed so few pictures and that these had usually fallen apart made the *Literary World* regret that he had

*Without the Swedenborgian overtones and perhaps independently of Page, Bingham, as we have seen, developed a similar conception of the historical portrait.

sacrificed all to his conception of progress. However, Tuckerman, noting that his portraits looked more Renaissance than modern, asked why he had thus denied "the progress so manifest in science and society." Esthetic theorists, like his fellow Italophile Jarves, could not accept his identification of physical with spiritual strength that banned the delicate and carried him "into repellent realism." However, the proponents of the Native School accused him of having fled American for Italian inspiration. As for the Boston Brahmins, they could not deify the artistic philosopher, for, unlike the cloistered Allston, he was often ridiculous and had shocked propriety with his wives and his Venuses.

To the examples supplied by Huntington and Gray as they relaxed from Italianate history painting onto the soft divan of portraiture, Page, "the American Titian," added the generation's most conspicuous artistic failure. No wonder the esthetic winds coming in from Italy seemed, as compared with the airs blowing from Düsseldorf, tainted with the scent of decaying bones.

That Boston, remaining faithful to the Italian taste as it receded elsewhere, was immune to Düsseldorf makes clear that there was little relationship between this new Germanic influence and the older flow into Transcendentalism of German philosophic thought. Expressing the middle-class approach called Biedermeier, Düsseldorf represented in Germany itself a later and different development.

American painting in the Düsseldorf manner was grounded on immigration. Emanuel Leutze (1816–1868), Wimar, and Bierstadt, the three most important practitioners, were all German-born. The bellwether was Leutze, who went to the Rhenish city nine years before the Düsseldorf Gallery opened in New York.

Leutze had been born in Würtemburg, the son of a radical combmaker. When he was nine, the family fled political persecution to America. Their Philadelphia household became so broken between two cultures that, on his travels as an itinerant portraitist to the southward, Leutze could not communicate by letter with his mother, since she could not read English and he could not write German. In 1840, the young artist attracted with *An Indian Contemplating the Setting Sun* the attention of the collector Edward L. Carey, who found him enough patronage to support a student trip to Düsseldorf.

Although he complained that he was going to "a strange country," Leutze was soon boasting to his sister, "I have adopted the characteristics of a German artist. Can you picture me in a long painter's robe with a pipe

reaching the floor, a little cap on my head, long hair, and a mustache?" His large historical pictures from the life of Columbus were an almost instantaneous sensation. The first was bought by Director Schadow himself for Düsseldorf's Art-Union. The second was distributed as a triumph of native art by the American Art-Union. Thus was established the double nationality which Leutze's reputation has never lost: German writers consider him a German, Americans, an American.

"For a beginner in the arts," Leutze wrote, there was no place like Düsseldorf. The Academy, it was true, prescribed a course so controlled and rigorous (you had to draw for two years and pass a series of examinations before you were allowed to paint) that it was repugnant to transatlantic individualism. Leutze never submitted to it. He was famous in the German city for slapdash inspiration, and thus he encouraged other American students not to acquire the skill for which critics at home most admired the Düsseldorf School: the ability of the artists to realize a picture to the ultimate detail.

Most of the Americans who made extended stays in Düsseldorf had not originally intended to do so. Traveling between artistic centers — London, Paris, Florence, Rome — they came, attracted in part by Leutze's success, to the Rhenish city and were held there less by the instruction — they wanted to preserve their originality — than by an environment delightful to painters.

The quaint old town, with its beer gardens and its haunted castle, seemed to Benjamin Champney of Massachusetts entirely inhabited by artists. John W. Ehninger of New York added that cheap rates and the economical habits of the Germans banished all care. According to Worthington Whittredge of Ohio, it was not the professors at the Academy but the whole international mass of artists who constituted the school. The talk was of pictures, the amusement was visiting other studios, and in the summers groups of jolly fellows set out with knapsacks for the mountains, where you had no difficulty finding the most paintable scenery or the cabins of the most picturesquely costumed peasants, for paths had been worn to them — as along American trout streams — by innumerable painters.

The American community lived under Leutze's wing. The privileged shared his studio. All profited (as a past generation had in London from the prestige of Benjamin West) from the position of the man who was in Düsseldorf "the most talked of artist of all."

Leutze's acclaim was based on his having brought Düsseldorf historical

painting more up to date by introducing conceptions that were spreading across Europe from the Paris studio of Delaroche. Great past events were not envisioned in the neoclassical manner as taking place on a grand stage removed from ordinary humanity, and the protagonists were seen not as abstract embodiments of human characteristics, but rather as particularized persons. Although correctly costumed for their epochs, old heroes and heroines were from a psychological point of view contemporaries with whom living viewers could identify themselves. They behaved in the glare of history as you or I might behave. Thus the high style was crossbred with genre.

Where Leutze got this manner is not clear. He never studied with Delaroche or spent much time in Paris. Yet Delaroche's work was widely available, if only in reproduction, and, in any case, the genre attitude towards historic events was typical of middle-class thinking everywhere. The note had been struck independently of Delaroche — and perhaps previously — in the early paintings of the Anglo-American Leslie. Parson Weems had added sentimental genre to Washington's biography by making up anecdotes like that of the cherry tree. And Emerson expressed the attitude when he stated, "All inquiry into antiquity is the desire to do away with the wild, savage, and preposterous There and Then, and to introduce in its place the Here and Now."

Leutze's approach to history differed from Delaroche's in exhibiting a Biedemeier *Gemütlichkeit*, which was more satisfactory to American taste than French violence. Both artists painted sixteenth-century English Protestant princesses, in peril from Catholic oppressors, as moonfaced nineteenth-century maidens — but there the resemblance ceased. In a vision horrific because so brilliantly realistic, Delaroche shows Lady Jane Grey, blindfolded and on her knees, her shapely mouth tensed in terror as her head is being guided to the fatal block, while a handsome headsman, ax in hand, anticipates with sober satisfaction his sadistic privilege. Leutze shows Queen Elizabeth standing in the Tower nervously alone and looking up to heaven, while menace is represented by nothing more grievous than wicked Papists conspiring darkly.

From his base in the genre approach to great moments in history, Leutze sometimes moved backward or forward in the evolution of the high style: backward, as in his *Washington Crossing the Delaware*, to a more aloof neoclassical heroism; forward to the practice of Delaroche's pupils, members of his own generation who often ruled recorded personalities and great events

unnecessary to history painting. Their pictures were distinguished from pure genre largely by the avoidance of common experience. Although ordinary subjects could be painted in the past (traffic on the ancient Appian Way) or in modern Africa (sinister sentinels before a sultan's palace), it was safer to make the separation from genre altogether clear with eroticism, exoticism, and violence: a seductive Christian girl about to be eaten by lions as Romans cheered; a Turk in a slave market pulling back a nude beauty's lips to assess her teeth; scenes like Gérôme's *Duel after the Masquerade*, which we have described as the celebrated purchase of the Baltimore railroad millionaire Walters.

As a German and an American, Leutze was barred from violence and eroticism, but exoticism he could use, and he had his own weapon: moralistic sentimentality. Thus, after his return to the United States, he painted, as an announced rebuttal to Gérôme's *Duel*, what he considered a more admirable rendition of the aftermath of a masquerade. Instead of contrasting gay costumes with a soulless winter dawn and murder over love, Leutze defined his dawn as Ash Wednesday and showed his revelers gliding in a Venetian gondola towards the Bridge of Sighs. From under the bridge comes a boat on which a dead body lies with its bloodless face full-front to the early light. A clown in the center of the masquerading group alone has seen the corpse. He is about to strike up "the bacchanalian chant," but his hand drops appalled from his cittern, while the rest of the revelers laugh at his gesture, not conscious that they too will confront in a moment the dreadful symbol of mortality. Thus Leutze recast the grisly gem of a rich man's collection into a moral homily suited to *Godey's Lady's Book*.

To his Biedermeier subject matter, Leutze applied the windy, exaggeratedly energetic draftsmanship with which the Munich Mural School* — he considered it "the best in the world" — emblazoned on walls the most grandiose possible subjects out of secular or religious history. Feeling, during three years in Italy, kinship with Michelangelo, he was further encouraged to consider himself a titan. He ate, drank, and shouted like an unrestrained giant,† and poured out art with all the vitality of an uncopious stream forced through a little aperture.

*Under the leadership of the former Nazarene Peter Cornelius, the Munich mural school carried neoclassicism to a hectic apogee. Religious and historical subject matter was executed in tremendous frescoes with cold color, insistent outlines, explosive movement and gesture.

†Unlike Stuart, Leutze did not keep his portrait sitters happy with brilliant conversation. "Leutze," so Hawthorne wrote, "when the sitting begins, gives me a first-rate cigar, and when he sees me getting tired brings out a bottle of splendid champagne."

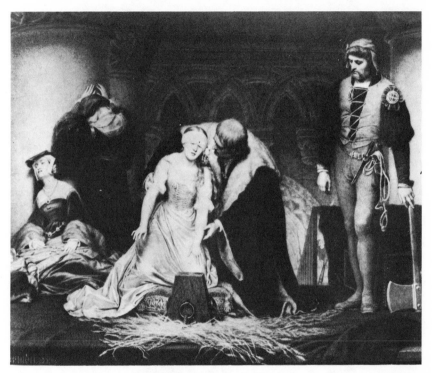

49 Paul Delaroche *Lady Jane Grey*

Photograph of the original, published by Goupil & Co.

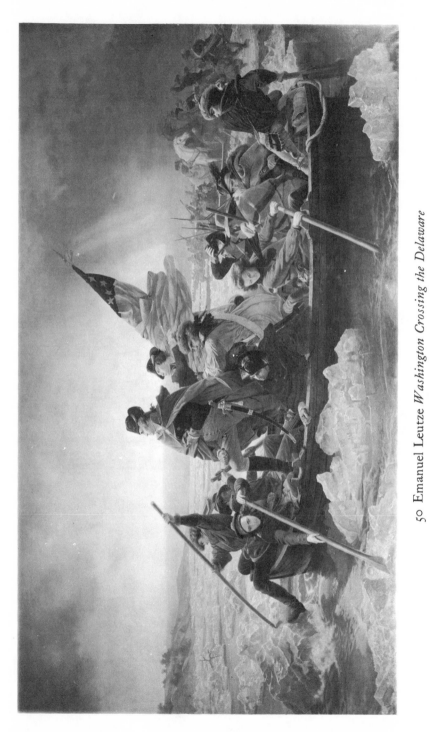

50 Emanuel Leutze *Washington Crossing the Delaware*

Oil on canvas; 1851; 149 × 255; Metropolitan Museum, New York, gift of John S. Kennedy, 1897.

From Munich more than Düsseldorf, Leutze conned a neoclassical coldness of color, which made Philadelphia's *Sartain's Magazine* state that he had been a better colorist before he studied abroad. His skill at composition came from both German centers.

Leutze accompanied his democratization — for such the genre approach was — of the historical style with political radicalism that further enhanced his influence with Düsseldorf's Protestant faction. During the troubles of 1848, he led in organizing the artists' club, *Der Malkasten* (the palette), that subsequently dominated Düsseldorf life, and he was a captain of the mob from the studios that had broken the town's ancient quiet with cries urging a united and democratic Germany. After the revolution failed, he determined to construct a great picture preaching to German nationalists resolution in despair.

"Since painting can be but partly narrative," Leutze wrote, his first step in preparing a picture was to determine "the clear thought"; his next was to find "some anecdote from history" to convey it. He needed an episode that symbolized the turning of the tide in a revolution that succeeded, and he decided to underline his message, in the neoclassical manner, with a celebrated protagonist. Unless he became feebly uncontemporary by going back to the days of individual combat, a turn in the tide of battle would not serve. He may well have remembered Delaroche's famous *Napoleon Crossing the Alps*, which showed amid snow and ice the hero, his mule, and his guide, the effect of the picture being the look on Napoleon's face. Fine! But Napoleon was too French for Germany, and mountains were too exclusively physical a barrier. He wanted an obstacle that would connote an epoch of fate. Perhaps he remembered Cole's use of a river in *The Voyage of Life*. In any case, he decided on a subject that combined his German radicalism with his American background: *Washington Crossing the Delaware*.

To a composition more elevated and austere than was usual for him, Leutze applied that hardy mixture of verisimilitude and artistic license (the "real" and the "ideal") which West had developed almost a century before. He procured a life mask of Washington and authentic Revolutionary costumes. Wishing to have only Americans pose for the figures, he kidnaped visitors to Düsseldorf before they even had a chance to register at their hotels. On the other hand, he committed for effect innumerable historical errors: showed an American flag before it had been adopted; cleared up the snow that would have obscured his image, but exaggerated the ice. In complete contradiction of traditional Düsseldorf meticulousness, Leutze

believed he could best achieve unity by doing large areas in extended bursts — even if he had to call on his friends to work beside him. Thus, he, Whittredge, and Andreas Achenbach filled the huge background of *Washington Crossing the Delaware* with sky in a single day; it was Achenbach who thought of and painted in an almost invisible star, the last to fade as morning came. This episode reveals how little Leutze cared about light. His life-sized figures were done with a similar dash. Whittredge had to stand for two hours motionless in Washington's cloak, while Leutze painted in a frenzy, juggling palette, cigar, brush, and maulstick from hand to hand, occasionally in an excess of energy breaking away to wrestle with his dog. "I was nearly dead," wrote Whittredge, "when the operation was over. They poured champagne down my throat and I lived through it."

Eastman Johnson, who like Whittredge shared the studio, tells how they kept Leutze in the mood by mounting near his easel a battery of three cannons "with the stars and stripes on one side and the white of Prussia on the other." Every visitor was given a salute: "The walls are fearfully scarred." Leutze had nearly finished when the studio caught fire. He surrendered the damaged canvas to his insurance company, but mended and completed it for them, so that it could be raffled off. Germany quickly absorbed ten thousand lots. This was the version of *Washington Crossing the Delaware* known in Europe. It was finally destroyed when the British bombed the Bremen *Kunsthalle* during World War II.

Leutze took about three months to paint the even larger version — 21′7″ by 12′5″ — which brought Mr. Goupil hurrying in person to Düsseldorf to purchase for six thousand dollars what he shrewdly realized would prove invaluable to his American branch. Exhibited across the United States, engraved at every size and price, this canvas rapidly became what it has remained: with the possible exception of Stuart's Athenaeum portrait of Washington, the nation's most popular picture. About a hundred thousand people a year make a special trip to the elaborate museum specially built on the banks of the Delaware to show this one huge canvas.

Washington Crossing the Delaware, which combined in one picture Leutze's experiences and ideals as both a German and an American, stands head and shoulders above the rest of his work. For once, dash did not go over the edge into slapdash. For once, flair sobered into feeling. The composition concentrates attention on Washington's expression — earnest, benign, careworn, resolute — as he stares at the distant, dangerous shore brightening with the dawn. Towards it he leads a surge of suffering humanity — men wan, weary, wounded, and inspired — as all together they hazard fate for an

ideal. Do not be blinded because the picture's popularity with the unwashed has made it to the passionately scrubbed a joke. Nor need the fact that its appeal has proved greatest for eight- to ten-year-olds damn it out of hand. To fire the mind of a child is the achievement not of a fool but of an artist. Like Longfellow's "Paul Revere's Ride," *Washington Crossing the Delaware* is, although not art on the highest level, impressive and eloquent.

The success of the picture brought Leutze back to the United States in 1851. Despite frequent trips to Germany, he made America his official home until his death seventeen years later. He took the necessary care to paint one more effective large picture, *Westward the Course of Empire Takes Its Way*, for the national Capitol at Washington, but in the rest of his output the faults of his style and attitude became increasingly manifest. Critics convicted him of carelessness, crudity, vulgarity, and exaggeration — but how could he be ignored? No other artist considered American could approach his facility in composing and realizing life-size figures, and there was in his canvases a barbaric yawp. As Tuckerman put it, "Whatever may be his deficiencies in artistic skill, . . . we are obliged to him for speaking out like a man and not mumbling."

Despite his celebrity, despite their true power (however misapplied), Leutze's historical paintings exerted no important influence on the main directions of American art. His impact was greatest in that twilight zone where the high style and the low, historical painting and popular sentimental illustration, engaged in their fecund miscegenation.

The strangest historical painter of the American mid-century, and possibly the one possessed of the greatest inborn genius, was in his lifetime known as many things — a doctor, an anatomist, a drawing master, a sculptor, a lecturer, and an eccentric — but few outside his family knew that he painted. Hawthorne liked to imagine men afflicted with family curses. William Rimmer (1816–1879) was such a man. He believed that his father and he were kings of France.

Raised in a family of English yeomen, Rimmer's father seems to have received an education above his presumptive station. He was sure that he was the Dauphin. He had not died in prison during the French Revolution as was supposed, but had been spirited away by Royalists who would eventually restore him to the throne. After Napoleon had been defeated, he waited hourly for the messengers who would kneel before him — but venal politicians crowned his "uncle" Louis XVIII. In despair, the elder Rimmer married an Irish servant girl and set up as a cobbler.

The future artist was brought from England to Nova Scotia at the age

of two. When the boy was ten, the family moved to a Boston slum. Believing that they needed to hide from Louis XVIII's assassins, conscious of awesome superiority to their simple neighbors, the Rimmers lived in utter isolation. When not cobbling, they moved behind locked doors in a glittering private world. The father made each of his seven children a silver flute. He shared with them experiments in raising silkworms, in metallurgy and electricity. He read to them out of old romances and urged them to act out the battles. Poverty tattered the furniture and kept the larder empty, yet, as William stepped into the street, he seemed to be descending to the sordid from what were, however disturbingly, heights.

At fourteen he carved in gypsum a small nude figure of his father, who was becoming ever more violent and strange, entitled *Despair*. Then he pitched in to help with the family support. Before he was twenty-one he had set type, made soap, fashioned India rubber, and worked at the lithographer's, where he got his only artistic training. His draftsmanship, his fellow apprentice Champney remembered, "was always full of energy but not suited for commercial purposes." Having married in 1840, Rimmer made a try at itinerant portraiture. However, reproducing plebeian features did not inspire him. Neither did executing religious pictures for a rural Catholic church: these were garish ineptitudes based on engravings. Forced to retreat to a cobbler's bench, he decided to become a physician. Having read medical books and dissected cadavers, he practiced as a self-taught doctor for several years before he secured a diploma by joining a medical society. The document proved in the long run useless, for "the King of France" had so repulsive a bedside manner that he was soon earning his living carving granite into architectural decorations.

His father had sent the family's last link to greatness — a signet ring bearing Bourbon lilies — to Queen Victoria. She had never responded, and the parent had sunk to death through alcoholic madness. To symbolize this tragedy, Rimmer made a statue: *Falling Gladiator* (1861). Although he used clay, he naïvely carved rather than modeled, and he got into many difficulties because he was ignorant of such rudimentary expedients as holding the mass together with an armature. However, he achieved an exciting work that shows the nude male body, covered with a net of muscles, tensed with the ultimate of exhaustion and strain. Worlds removed from the classic serenity of the American marble cutters practicing in Italy, *Falling Gladiator* attracted such attention in Boston that "everyone who cared a fig for art became interested in Dr. Rimmer." At the age of forty-five, the artist emerged from obscurity.

However, no one paid to have *Falling Gladiator* cast in bronze. Instead, Boston encouraged Rimmer to lecture. He taught "artistic anatomy." We have seen what a need there was in the United States for instruction in the appearance of the body, and Rimmer had brilliant insights to offer. But his pupils were almost exclusively polite young ladies. That amateurs and professionals could study together no one believed, and Rimmer made his choice by aggressively avoiding the company of professional artists — only William Morris Hunt was his friend, and even that relationship dissolved in a quarrel. Preferring, like Hunt, to teach pliable women, Rimmer discouraged the attendance of all males.

Yet he told his pupils, "Draw men not women. You will weaken your artistic power if you do otherwise." Perhaps because his art was so dedicated to expressing his father's tragedy, he differed from his entire generation by being primarily concerned with not the female but the male nude. However, his approach was basically symbolic, which explains how he was able to expound masculine anatomy to Victorian young ladies. When some overbold pupils petitioned to have a living man pose in "the entire nude," Rimmer was shocked. His grounds were both moral — from his own male figures he omitted the sexual organs — and artistic — he believed that to draw a specific body encouraged imitation of the imperfect. "In art we want the highest ideal generalizations, and our interest declines when individual peculiarities are given instead."

Although this was pure neoclassical doctrine, Rimmer's motivation may well have been a desire to avoid close contact with the reality that interfered with his very unclassical dreams. Rimmer was never able to make his peace with reality. In so far as they were not altogether ethereal, his visions always referred to Europe, but he rebuffed a lady who offered to pay his way to that continent. Called to New York City as director of Cooper Union's School of Design for Women, he refused to abide by its objective of teaching poor girls how to make a decent living at commercial art. He was dismissed. After his return to Boston and his own school, he engaged in quarrels, impractical inventions and business ventures that kept him in his conspicuous old age as poor and as isolated as he had been when a boy walking in ragged, head-high aristocracy through Boston's slums.

We are here concerned with Rimmer's continuing activity not as a sculptor but in the graphic arts. He worked publically as a draftsman and almost secretly as a historical painter. Since from his drawings the anatomical intent was never altogether absent, he kept muscle and sinew unnaturally clear under flesh. He had clearly got his sense of the nude less from the living

body than from antique casts, plates in anatomical texts, and dissections inspired by his medical studies.

However, he stated that "artistic anatomy" differed from "structural anatomy" by being concerned with "the form of the whole body as representative of a type of man or animal." In a passage that Page, who had preceded him in Boston, might have written, Rimmer added that "every element of artistic power" has "its laws . . . which are easily reduced to the limits of given formulas." Perhaps an early convert to the Darwinian theory, he began his instruction with the anatomy of the ape, whose skull, he stated, represented "the opposite extreme" from the "intellectual" classic head. He defined in terms of anatomy different human traits: "In New England, the English debased skull is of a very brutal character, and persons with such heads are found to be not at all amenable to civilization."

All this having been said and practiced, Rimmer exclaimed, "Science is to art what brickmaking is to architecture," and so he added to his technical drawings fantastic embellishments inspired by the heroic playacting in his father's house, and even more by that parent's tragic fate. Bare backs sprout wings, horsemen wearing armor pound at each other through earth-bound or starry lists, and ever and ever the good and the beautiful drop stricken through the air, as in Rimmer's lovely *Evening: Fall of Day*. Anatomical forms have become emotional designs. When the action is violent, muscle and sinew contort into angry lumps and swirls, while for scenes placid or piteous the body surface becomes lyrical.

Rimmer paid his compliments to the Hudson River School by stating that the gamut of art extended "from the most important events of history down to the merest copy of nature in a landscape." However, he did not recognize the conventional necessity of making history paintings large. His canvases were small and his compositional models primarily engravings. Finding no inspiration in the American world, he used in both his paintings and drawings sources ranging through Blake, Michelangelo, Allston, and the German romantics to the French academicians who were also concerned with gladiators and blood sports in the Colosseum. However, everything was caught up in the passion of his own obsessions. His historical paintings are so personal that their meaning remains obscure. If, as there is reason to believe, gladiators represented his father and lions worldly power, by what strange reversal did he show in his *In the Arena* the gladiator as a squat brute and the lions as helpless, cringing victims, one of whom had climbed up on a pillar in panic?

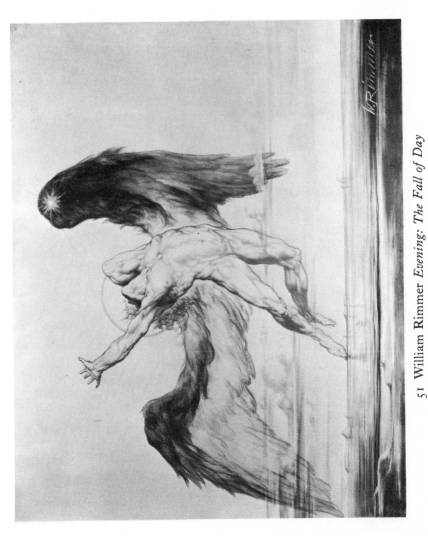

51　William Rimmer *Evening: The Fall of Day*

Oil on canvas; *c.* 1869; 40 × 50; Museum of Fine Arts, Boston.

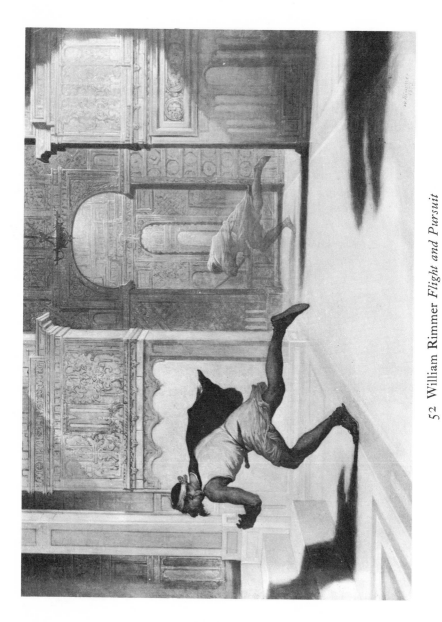

52 William Rimmer *Flight and Pursuit*

Oil on canvas; 1872; 18 × 26¼; Museum of Fine Arts, Boston.

Rimmer's color, often trite and dull, never rose above the adequate, nor was he usually able to carry his expert draftsmanship over into his oils: he distorted the human figure for effect in a manner too often crude. As a painter, Rimmer was almost an amateur. But always energy blows; always the viewer's imagination is stirred. And his *Flight and Pursuit*, in which his faults were fortunately minimized, is marvelously evocative.

A lightly clad, brown-skinned man runs along an Arabian hall with super-human vigor and intentness on an errand revealed by the dagger at his belt. Through a high archway we see, as in mutually reflecting mirrors, a succession of similar halls shrinking away into distance. Through the second hall a second figure runs almost on a level with the first, his body position almost a reflection, although instead of staring straight ahead he looks at the murderer. This apparition is somewhat transparent although tangible, shrouded from head to knee. Additional mystery is supplied by a black, double-headed shadow thrown in from outside by something ominous that follows the foreground runner.

Rimmer communicates that the two figures are aspects of the same man, that the one in the foreground realizes, although he does not look, that his double is there and that of all the dangers and terrors with which he is surrounded, this alter ego is the most deadly. Towards more exact understanding we can only quote Rimmer's variant title, *On the Horns of the Altar*. Do we see a man and his conscience, or what do we see? Here is a storytelling picture that, as it incites the imagination, tells no comprehensible story.

Flight and Pursuit, the work of an eccentric, an exception, and a semi-amateur, stands almost alone in mid-nineteenth-century American painting as an effective imaginative flight. Most of the other historical painters tried to give verisimilitude to literary subject matter or to reconstruct the past as it might actually have been. None had careers commensurate with their ambitions, for the American muse did not in those years truly smile on any painter who for long lifted his eyes from the world around him.

THE DECLINE OF THE PORTRAIT

WITH expanding prosperity and settlement, the demand for portraits swept the nation. While in aristocratic times, only the important individuals had considered their appearance worth preserving, hardly any nineteenth-century Americans would admit themselves so mean that they should not have their features preserved for their fortunate descendants. But artists had become equally equalitarian. Once they had been glad to celebrate greatness they acknowledged; now they considered it beneath their dignity and that of their art to serve the vanity of neighbors they regarded as their own equals or, indeed, inferiors. Thus, as the number of portraits increased, quality diminished. Individualism was, like Saturn, devouring its own child.

The desire of American painters to escape from the likeness trade was not new — Stuart had been the last of our major artists who valued the depiction of individual humans. However, our early nineteenth-century workmen had been trapped. Unable to acclimate the high style to the United States, scorning local landscape and genre, they had been forced to get through portraiture "salt for their porridge." The best-trained painters of the previous generation — Morse, Vanderlyn, Sully, and even Allston — had painted accomplished portraits, but none had brought to the mode that conviction that must underlie truly moving art.

When the old esthetic collapsed after 1825, the gleeful and remunerative pursuit of landscape and genre offered escapes. The demand for likeness came to serve the most ambitious painters primarily as a training ground (Cole, Catlin, Blythe), or a means of transition from graving tool to paintbrush (Durand).

When members of the Hudson River School had got fairly started, they almost never reverted to likenesses, for landscapists developed variant skills, enjoyed a steady market, and usually preserved till retirement or death their inspiration. But figure painters held portraiture in reserve, whether, like Mount, they created frank potboilers; like Page, drew no sharp distinction between the high style and the delineation of "a soul"; or, like Bingham, Miller, Huntington, and Gray, settled for easy affluence when their inspirations in other directions failed.

The best likenesses of the period were painted by men whose usual or final practice was in other modes, particularly the history painter Page and the landscapist Durand. Although the widespread demand summoned up all over the nation hundreds of portrait specialists, they were invariably artists of the second rank. Yet some became famous, and most made good livings. Their work is indicative of both social and esthetic attitudes.

When the Native School first emerged, Henry Inman (1801–1846) was rising rapidly to the position of America's leading portraitist. He had been born in the same year as Cole, but because he had started so young belonged in effect to the previous generation. At thirteen, he had been apprenticed in his native New York City to that successful likeness-maker John Wesley Jarvis, with whom he got on as well as his fellow apprentice Quidor got on badly. From Jarvis, Inman imbibed a rough-and-ready carelessness that passed for romantic inspiration and served to create elaborate likenesses with little labor. "What he saw," Bryant noted, "he saw at a glance, and transferred it to canvas with the same rapidity. . . . His work owes nothing to revision."

Inman improved on Jarvis by borrowing more effectively from the same sources. He made Stuart's transparent flesh tints histrionic with Sully's trick of juxtaposing the brightest lights and the darkest shades to create "climaxes." Also from Sully he got that gentility which the older artist had learned in England from Sir Thomas Lawrence. When Inman finally got abroad himself, he ruled Lawrence superior as an artist to Van Dyke, Rembrandt, and Titian.

Lawrence had brought the solidity of English portrait painting to a halt with a flashy art which reflected the social insecurity of a society that had cast loose from old aristocratic standards and was no longer sure how it should behave and look. Sully had imbued healthy American girls with a clinging romantic air and touched up American males with a refinement that in the early decades of the century they had found not unpleasing. As the

next in line, Inman complimented his society sitters by smoothing their personal peculiarities into a Victorian graciousness which he kept from being insipid by adding the vivacity of his own temperament.

Although no more than thirty when the landscape and genre storms broke, Inman, who was in chronic bad health, did not dare endanger by any major shift his tremendous income of eight to ten thousand dollars a year. He was tempted, but he did not take time from his portrait work really to look at nature — his outdoor scenes suffer from routine studio lighting — or to devote to landscape or genre more than an occasional afternoon. When the results did not excite and his efforts at history proved abortive, he blamed American taste for not enabling him, as he put it, "to follow my inclinations at all." Melancholy set in. "Give me a fortune," wrote the acknowledged leader of American portraiture, "and I would fish and shoot for the rest of my life without touching a brush."

Inman was never truly convinced that portraiture could be in itself an art. Although he occasionally followed Stuart into planning his color scheme to bring out flesh tints — his *Mrs. James Donaldson* is an exciting hymn to a brunette's warm tonality — he usually made his sitter's face no more than a cooperating part in color harmonies that spring equally powerfully from costume, upholstery, and background. Thus he produced an uneasy mixture of individual likeness and more generalized figure painting. When, at the age of forty-five, he knew he was dying, he said that if he could start over again, "each face should be a study in itself. No aim at a peculiar touch would betray me into a conventional style." He nominated to be his successor a young artist of a very different stamp, Charles Loring Elliott (1812–1868).

The son of an upstate New York architect-builder, Elliott had at the age of seventeen invaded the metropolis and studied with the eccentric, bibulous semigenius Quidor. Although he learned to illustrate Irving with considerable effect in his master's wild manner, his temperament shied from inspiration: even in Quidor's dusty madhouse, he exhibited "methodical habits, steady work, and great neatness." He turned to portraiture and soon disappeared back upstate. "I found more satisfaction in an honest way of doing things among old neighbors than can be found in towns." His true art school appeared near Utica on a client's wall, a portrait of Stuart's Irish period: *Dr. William Hartigan.* Having secured it in exchange for a portrait he painted of the owner, Elliott carried his Stuart with him everywhere for years.

53 Henry Inman *Mrs. James Donaldson*

Oil on canvas; *c.* 1830; 34 × 27; New-York Historical Society, New York.

54 Charles Loring Elliott *Asher B. Durand*

Oil on canvas; 1860; 27¹⁄₁₆ × 21⅞; Walters Art Gallery, Baltimore.

One of Stuart's very simplest portraits, *Dr. Hartigan* was an extreme reflection of the Revolutionary generation's fascination with individual personality that regarded as irrelevant all exterior embellishment indicative of social or economic rank. This approach to portraiture had, after the establishment of independence, weakened in the centers and been actively opposed by Sully and his followers. However, it had by no means vanished, since it expressed basic American beliefs. And now these beliefs were rising again to national prominence with the Jacksonian revolution. Elliott omitted from his portraits, in the manner of *Dr. Hartigan*, all details that would detract from an exclusive concentration on character. At his most typical he placed a head, topping a minimum of body, before a flat, unrepresentational background. He accepted the corollary that color had to be keyed to the flesh tones, and succeeded in giving faces a ruddy, springy transparency similar to Stuart's.* Elliott divined Stuart's method of building up heads in masses from a blurred to a sharp image, and followed it until the last stage, when he could not resist superimposing the hard drawing of feature and expression that the method was intended to avoid.

The ability to express texture that Elliott caught from Stuart suddenly brought him to the fore when in 1846 he exhibited at the National Academy a portrait of the author Thomas B. Thorpe, whose golden beard "seemed to possess the splendor of the setting sun." As every year thereafter beards become more fashionable, many portraitists were in the position of silent-movie actresses when the screen began to talk: how were they to paint the human English sheepdogs fate suddenly placed before them? But Elliott was expert at bristle shagginess, or such a limpid flow of soft hair as dominates his portrait of his fellow painter Durand.

Although his skill with whiskers first called Elliott to national attention, it could not by itself explain his acceptance, from about 1850 to his death in 1868, as America's leading portraitist. Nor can his success be explained in esthetic terms. Such ultrasimple compositions as he had borrowed from Stuart required, if they were to be beautiful, great subtlety of composition, of color, of touch, of taste. But Elliott just plopped heads down on the canvas; his color was crude and sometimes dissonant, his touch was heavy, and he scorned Stuart's eighteenth-century worldliness. He had never known, he wrote, an artist to be "materially benefited" by a trip to Europe.

*Elliott may have been helped by being, like Stuart, a heavy drinker. "Look at Elliott!..." exclaimed Mount's painter brother Shepard. "He has a red face and contrives to give that glow to all his pictures." The more correct read into Elliott's flesh tones a domestic connotation: they were such "rich" tints as "come out from faces around the fireside of home."

His artistic credo was "only let us have fair play." What he considered "fair play" seemed to James Jackson Jarves "savage realism and acerbity."

When Elliott could not express rough energy, he was at sea. He showed children as routine cherubs, and gave women waxy, conventionally symmetrical features drawn so strongly that they overcrowd the heads. Nor could he find any qualities to paint in sensitive males. He was at his best, as Tuckerman wrote, with "men of strong practical natures, who have battled with life and the elements, who have thought deeply, struggled manfully, or achieved success through firmness, shrewdness, and self-reliance; and whose faces bear the lines of this warfare and achievement." In his occasional full-lengths, the figures are not standing for their portrait, but on the move, as if they could not bear to waste a moment of time.

To his fellow citizens, Elliott's human images — no hesitation, no weakness, no shrinking of nerves, and great vitality — seemed to catch "the very best, the most natural and pleasing expression of his sitter. . . . All things undertaken are ennobled." He was considered typically American in painting humanity "on the sunny side of the hedge."

In his treatment of facial expression, Elliott did not, like Stuart, seek summation of character in a calm, classic image. Nor did he in the Lawrence-Sully-Inman manner try to catch the movement of feature that exemplified a salient trait. Elliott seems to have confronted his sitter with a Gorgon's head which froze forever the pose and expression of an energetic moment. Thus he reflected the greatest exterior interruption experienced by the development of art since a cave man scratched the first image on stone.

During 1839, Delaroche had stated, "Painting is dead from this day." Although this was of course an exaggeration, that the Frenchman L. J. M. Daguerre had taught a machine to reproduce nature in "chiaroscuro drawing" was to have a much greater influence on painting than most art critics are willing to admit. However, the effect was slow and in stages.

The daguerreotype, which was introduced into the United States by the fall of 1839, could achieve more brilliant contrasts and catch more microscopic detail than any subsequent photographic process. It was hailed as exhibiting "exquisite perfection [that] almost transcends the bounds of sober belief." For the moment, because of the long exposures required, it seemed most applicable to views. American painters generally agreed with Morse that the art of landscape painting "is to be wonderfully enriched by this discovery." Not only would exaggerated or slovenly effects be convicted by nature's own testimony, but, as Cole wrote, "the imagination will probably

rise to greater perfection," since the landscapist could, by filling his sketch-book with snapshots, enlarge "the mine from which to select materials for the structure and embodiment of his most beautiful and sublime concep-tions." However, when Cole sent in 1844 for a photograph of Albany that would enable him to carry out a commissioned view of that city, the reply was that the largest available plate measured three by two inches. And being exclusively black and white, photographic notes were of little use to Durand and his followers, who desired to record color as well as shape.

The daguerreotype entered its natural field, the portrait, when by 1841 the exposure time had been reduced from several minutes to fifteen or twenty seconds. Fourteen years later, the *New York Tribune* estimated that three million photographic likenesses were taken annually in the United States. Top artists and critics had foreseen without regret that such compe-tition would put out of business the lower order of painters — "the fewer," wrote the *Crayon*, "there are of artisans in the artist ranks," the better — but this did not prove the case. Miniature-painters were destroyed across the board, but portraitists in the large were hardly damaged. The normal size of a daguerreotype was 2¾ by 3¼ inches. Although plates existed as large as 15 by 17 inches, they were rare, and such a photograph, which would still be very small compared with the ordinary portrait and in black and white, cost fifty dollars. The better portraitists could ignore the competition of the photographers, and the artisans welcomed the invention as a help in produc-ing many cheap likenesses. Joseph Stock (1815–1855), one of the most avidly collected "American folk artists," painted over nine hundred por-traits in less than ten years; naturally he greeted as a brother the prolific box. Not only did he find copying its fruits a quick way to realize a head, but he established in partnership with a photographer a "Portrait and Daguerrian Gallery," where patrons could buy whichever best fitted their purses.

No sharp distinction was drawn between the esthetic objectives of the two arts. Morse, in the doldrums between his abandonment of painting and the success of his telegraph, was the most influential instructor in portrait photography; his pupils, like Mathew B. Brady (*c.* 1823–1896), had usually intended, before the new opportunity arose, to be painters. Daguerreotypes were, like painted miniatures, unique — one picture to one exposure — and they had for preservation to be framed under glass. Although small, they contained all the detail of a life-size portrait. They were considered the more successful the more they were lighted, composed, and organized like paint-ings. Only with the popularization during the Civil War of dimmer and

[179]

handier paper prints did photography begin to travel its own road towards snapshot informality.

Since the daguerreotypist's apparatus was not portable — it filled a wagon — photographing individuals in their own habitats was a practical impossibility. If background elaboration were desired, it had to be supplied in the photographer's studio, and focusing was easier if it took the form of a painted backdrop. Such scene-painters' embellishments were less common here than abroad. Thus, in awarding Brady a gold medal for technical achievements, the jury of the London Crystal Palace Exhibition (1851) complained that he had "neglected to avail himself of the resources of art," since "the portraits stand forward in bold relief upon a plain background," Brady was following the deep-seated American tradition, stemming from Stuart, of omitting what did not further individual likeness.

Influence also traveled the other way, from the photograph to the hand-made likeness. The prestige of machinery was high, and the prestige of portrait painting was so low in the minds of its practitioners that they had no strong esthetic convictions to leave behind.

Since painters could now justify, in the name of the scientific objectivity that the lens was supposed to represent, their lack of personal interest in their sitters, the camera encouraged the break between the artist's emotions and his subject matter, which was already the bane of portraiture. Most likenesses from the third quarter of the nineteenth century convince the eye but seem empty; they have the semblance but not the warmth of life.

The still camera is, of course, incapable of summarizing. Even if the exposure is long, the effect must be of an arrested moment. Like Elliott, portraitists were increasingly impelled, as film became more sensitive and the camera went more its own way, to record, in the snapshot manner, a random pose, which was interpreted as informality suited to democratic times.

Instantaneousness was to be the camera's gift also to Impressionism. However, the Impressionists' corollary that they should paint only what the eye can see at a glance was not anticipated by the likeness-makers. They did not wish to substitute the eye for the lens, but rather to imitate what the lens recorded. Was not such literalness in keeping with accepted theories on fidelity to nature? When an artist expanded a little plate to life size — as every portraitist from the seer Page to the downright Elliott did upon occasion — the increase in scale enabled him to put in without overcrowding everything that even a magnifying glass would bring out in the photograph. Thus was fostered a concern with detail apart from its esthetic significance,

and also a tendency to think out portraits not in color but basically in black and white.

On the matter of sincerity of image the camera created mutually opposite pressures. Within the limitations of its chemical brain, it was desperately sincere, for man had not yet taught it to lie. Critics insisted that this would reform "the morals of portrait painting," by making obvious where the artist flattered, but Morse was closer to the mark when he commented that the artist's ability to improve on nature was a powerful weapon against his mechanical rival. Even Elliott, when he enlarged a photograph of Cooper by Brady, brought to the tired, flabby, old man's face more youth and a rough nobility.

Elliott, whose energy, optimistic roughness, and avoidance of detail were not of the lens, was much less camera-motivated than George P. A. Healy (1813–1894). Significantly, Healy was to enjoy a glamorous international career presaging that of the later John Singer Sargent (1856–1925).

Healy had natural gifts which, had they been combined with esthetic direction, might have carried him as high in art as he climbed in society. The son of a bankrupt Irish sea captain, brought up on the wrong side of Boston, he developed a passionate desire to associate with the great. His first success was achieved when, as an appealing teen-age boy, he rang the doorbell of Boston's reigning society queen to announce shyly "that my ambition was to paint a beautiful woman." This contact, plus lively draftsmanship well adapted to naïve versions of female beauty, enabled him to earn in three years the cost of foreign study. He reached Paris in 1834.

From Baron Gros, Healy learned to silhouette, in the neoclassical manner, firmly drawn sitters against lighter backgrounds. However, when he painted the American minister to France, Lewis Cass, the New Englander's huge, monolithic head recalled the Copleys he had copied in Boston. He painted Cass powerfully in Copley's roughest style and then went to London, where he soon amassed "such an excellent English connection" that he decided to stay. Wishing "to please my aristocratic patrons," he adopted the manner of Lawrence. Back in France, however, Louis Philippe admired Cass's portrait and expressed willingness to be painted in the same manner. Hurrying across the Channel to bag his first king, Healy must have wondered what to do. His social instinct told him that, whatever the monarch thought he wanted, he would not be pleased to be depicted with Copley's burly realism. Gros's style would not seem fresh, and Lawrence's was too British. However, Daguerre had just (this was 1840) pointed a way out. The result-

ing portrait having delighted the monarch into becoming his patron, Healy established his headquarters in Paris.

With Louis Philippe, Healy worked out a system that was to establish his "connection" with the exalted. He would induce the head of one state to commission him, as a gesture of international good will, to paint the rulers of neighboring states. The French king even sent him to America to record presidents, living and dead.

Once he had met the important, Healy was able to charm. He summarized the method he used in Europe when he wrote about the Romanian court: "It was agreed that, in my character of an American republican, I might dispense with all ceremony." This role, played with discretion, enabled him to satisfy two opposite pulls that plagued nineteenth-century aristocrats. Needing to keep up their guard against levelers, they wanted to be surrounded with awe, but, on the other hand, they had been so infected with middle-class mores that they wished to escape from the old rigidity, appearing to the world and themselves as lovable human beings. Healy imbued their images with a transatlantic breeziness and energy they found flattering. And he conned from the photograph a verisimilitude satisfying but not revealing enough of personality to give democrats a handle or seem to the powerful themselves an invasion of their august privacy.

Read backwards, the formula worked as effectively in the United States, for Healy brought to American democrats an air of sophistication that never seemed sissified or stilted. He kept up his American connection, crossing the ocean thirty-four times. However, when in 1855 he decided to shift his base to the United States, he showed how ingrained was the native orientation of our art market. Although famous abroad both socially and artistically (he had won a gold medal in France that enabled him to show at the Salon without the intervention of the jury), he dared not settle in New York lest he be scorned as a foreigner. He built his home among the new rich of that infant colossus Chicago. Then he took to the railroad, following all over the nation "the unquiet spirit which all my life has turned my steps now here, now there." The spirit was the lust for business: in one six-month period he painted forty-six portraits, making forty thousand dollars. After twelve years of overwork in America, he moved to Rome and then back to Paris. He was seventy-nine when he returned to Chicago to die.

Healy's mature style was, although evolved in Paris, far from untypical of American post-Civil War portraiture. This was because his closest artistic

friend and mentor was Thomas Couture, who became the first* French painter-teacher to appeal powerfully to Americans. During the 1850s, Couture's studio superseded Düsseldorf for our artistic travelers as the main European stopping place. The Frenchman had, it is true, little to offer landscapists, but his methods were to be more influential on figure work — primarily portraiture and genre — than the Germanic school had ever been.

In Düsseldorf, the curriculum of the Academy — years of drawing before an artist was allowed to paint — was more painstaking than most Americans could bear. In so far as they had done more than work according to their own ideas in the agreeable environment, they had picked up outside the Academy what were admittedly a series of shortcuts. However, Couture offered a system that could be learned quickly in its entirety and prevented a painter from ever wondering what he should do next.

Couture scorned formal draftsmanship. To create figures he built up masses with underpaint and then added, in a prescribed sequence, layers of transparent shadows and solid lights. He finished with glazes. This method made impossible Düsseldorf's clutter of small detail. Seeking a broad effect, and through system an impression of spontaneity, he taught his pupils never to repaint, but rather, if the picture did not evolve according to plan, to scrap it and start over.

In French art, Couture was a transitional figure, a pupil of Delaroche and a master of Manet. Although he built up form with color, he insisted on firm outlines and silhouetted figures against background in the manner of Ingres. His color was warmer than the classicists' but cooler than the romantics'; he employed gray flesh tones that were supposed to "approach" Velásquez. He restated the sensational themes of French academic art but with a moralistic twist. Thus, his *Romans in the Decadence of the Empire* (1847), the picture that made his reputation, was regarded as an attack on the profligacy it displayed.

How well Couture was suited to mediation between American and French figure painting is revealed by Jarves's statement that his "esthetic perceptions were too nice to permit him to indulge in the common trait of making the nude simply unchaste." As a "genuine offspring of French feeling, tempering however its sensual bias . . . from an intellectual point of view," Couture practiced "allegory subdued by realistic treatment to the comprehension of everyone."

*Couture's master, Delaroche, who taught so much of Europe, had not had a single American-born pupil of even minor importance.

Americans did not follow Couture into painting nudes however chaste, or into allegory, but portraitists found his method excellently suited to photorealism, even if on the broadly painted core surface detail had to be added in a manner of which the master would not have approved. In applying such garnishments, Healy borrowed bits from many styles: a Copleyesque touch for this successful coal dealer, a dash of Lawrence for that princess. This gives his likenesses a superficial variety, but a second look inspires allover boredom, for his agreeably colored, expert work expresses no personality, not any sitter's nor the artist's. If a person's exterior appearance were lively, Healy could produce a lively image, but no inner qualities were excavated by his brush.

As Copley had done, Healy sometimes grouped portraits into historical paintings. His *Peacemakers*, an effort to memorialize the Civil War, showed Lincoln, Generals Grant and Sherman, and Admiral Porter discussing in the cabin of a riverboat the last, triumphant moves of the conflict. He had painted portraits of all the actors. Having secured from Sherman a written description of what had occurred, he completed in Rome a huge, full-length naturalistic scene. The four men are shown in conversation — but it might have been about horses or cigars. Healy could communicate nothing more than physical presence. He was, like most portraitists of his generation, a centaur of the modern art age, half man and half camera.

Despite his international social currency, Healy was much more successful with men than with women. When writing of the Queen of Romania, he thus described the female ideal he tried to paint: "No woman was ever more thoroughly a woman, more daintily refined, more genuinely warm-hearted, kind, compassionate; more enamored of all that is pure and noble." Since his camera eye could not find all this in actual female flesh, he had no resort but cliché. He gave all ladies tremendous eyes, alabaster complexions, and a look of soul that was no soul, for it was stamped on with a branding iron.

His was a universal dilemma. In those days, when men dressed like ravens, portraitists, you would think, would turn to brightly costumed ladies with relief. Instead, they felt social restraint. Critics continued to echo the verdict of the American Art-Union's *Bulletin* concerning "female portraiture: . . . really there is not an artist painting in America whose efforts in this line are much above mediocrity."

The social artificiality that destroyed "female portraiture" was at its most pervasive in the major centers. Where less sophistication reigned, the unretouched freshness of a young girl could be frankly appreciated, and a strong

55 G. P. A. Healy *Miss Tyson*

Oil on canvas; 1870; 13½ × 16; Knoedler Galleries, New York.

56 Thomas Hicks *General George G. Meade*
Oil on canvas; 1873; 51½ × 39½; Union League Club, New York;
photograph, Frick Art Reference Library, New York.

flavor of individual personality could be caught in that semi-primitive shorthand which has inadvertent resemblances to caricature. Thus some delightful likenesses of ladies were created by those rare portraitists who occupied a stable middle ground between the crude and the knowing.

Outstanding among such provincial painters was Jeremiah P. Hardy (1800–1887), who had been an engraver in Boston and who had studied with Morse in New York, but whose excessive modesty — on which friends commented — made him settle for an obscure career as painter-in-ordinary to his birthplace, the region around Bangor, Maine. His portrait of his sister, *Mary Ann Hardy*, has, if it lacks profundity, a troubled surface that reveals a strength and beauty of its own. Hardy was among the most engaging of the provincial painters.

When, after the mid-century, the refinement formerly reserved to women increasingly tinged the more sophisticated conception of the American male, the two retired history painters Huntington and Gray became so admired by New York's social leaders that the National Academy found it politic to elect each in succession its president. Gray gave to portraits of railroad magnates, corporation lawyers, and even soldiers a soft, a warm "Italianate echo difficult to define." Huntington increasingly endowed his male sitters with those Sunday-school virtues that had made his *Mercy's Dream* so popular with the ladies. In neither case, was this a basic departure from photorealism. It was rather what the photographers were learning to do with their retouching tools: a prettying-up, a smoothing-down.

In those earlier days when Elliott was still king of the portrait, Thomas Hicks (1823–1900) had brought into male likenesses elements of both genre and history painting. The nephew and pupil of the artisan painter of *Peaceable Kingdoms* Edward Hicks (1780–1849), Thomas emerged as an infant-prodigy portraitist before the invention of the camera. He never lost his early tendency to catch faces in extreme expressions, almost as in a caricature. Thus he gave to General George Meade, the victor at Gettysburg, a sinister ferocity, and mocked the physician Dr. Francis Upton Johnson by contrasting his lank, scarecrow face with the bland, rotund bust of Aesculapius beside which he mildly pondered.

Studying in the late 1840s with Couture, Hicks was one of the few American portraitists who found a use for that master's symbolic approach. He showed business and professional men at their desks, Meade standing before a military encampment, the Arctic explorer Elisha Kent Kane cramped in a cabin with instruments, utensils, and bunks on which sleep

dimly indicated companions. In such elephant-sized portraits, the romantically contorted faces top photorealistic bodies, a dichotomy which reveals that no more than his fellow portraitists did Hicks have any real strength of vision.

Hicks had no important followers. What can be called the habitat portrait had after the war a different development. Industrialism was making available even to the lower middle classes such a diversity of possessions as formerly had been the exclusive privilege of noblemen. That they were machine-made buoyed the economy and was part of the miracle. It increased their attractiveness. No wonder everyone weltered in the new profusion; no wonder the whatnot groaned under bric-a-brac; no wonder there was a demand for portraiture that included the family possessions.

This was a return to a portrait attitude that had flourished in the early days of the Republic, the previous period when Americans had been most proud of what they owned. Its earliest reappearance in the mainstream had been in children's portraits: hoops and hobbyhorses gave some life to the proper images demanded of Mama's darlings. Sometimes the mother was painted in. The extension to portraits that included men was slower and remained exceptional. However, the period produced a few pictures showing a whole family posed in the parlor, that room on which opulence had been lavished to create a domestic "corporate image." Eastman Johnson, whose achievements in genre we shall discuss, was the ablest artist to essay this mode. His *Family of Alfrederick Smith Hatch* groups at about a quarter life size two grandparents, two parents, and eleven children. As we look, we feel the artist's own boredom in the huge red "drapes" that, partly drawn across the windows, control the moodless light; in the curved, varnished, pinkish, and endless paneling; in the heterogeneous possessions; and, above all, in the fifteen sitters, whose faces, while certainly recognizable, exhibit no character whatsoever. Posing them as in a group photograph, Johnson has not tied his figures to the setting or together with any consistent emotional tension. Everything is sprawled out, the only concession to possible artistic unity being to blur a little the sharpness of the independent shapes, as if a filter had been placed over the lens. Such compendia can amuse the nostalgic or the sociological eye, but the esthetic eye prefers to be elsewhere.

As an art form, American portraiture was dead, awaiting possible resurrection.

57 Jeremiah P. Hardy *Mary Ann Hardy*

Oil on canvas; 1821; 18 × 14½; M. and M. Karolik Collection,
Museum of Fine Arts, Boston.

58 Eastman Johnson *The Family of Alfredrick Smith Hatch in Their Residence at Park Avenue and 37th Street, N. Y. York City*

{ 12 }

THE CIVIL WAR SWEETENS GENRE

ALTHOUGH born only four years after his fellow genre painter Bingham, David Gilmour Blythe (1815–1865) did not express Jacksonian democracy but responded to a later era of American life. His was a tortured temperament.

Blythe was born of immigrant parents — Irish and Scotch — near East Liverpool, Ohio, forty miles downriver from Pittsburgh, and was raised in a log cabin on a new clearing. He was apprenticed to a Pittsburgh woodcarver. After three years of whittling emblems and architectural decorations, he set up for himself, aged nineteen, as a carpenter. When wanderlust overcame him, he sailed down to New Orleans, but the river life that so fascinated Bingham was not exotic enough to soothe Blythe's hunger. He fled to New York and joined the Navy. For three dissatisfied years, he cruised local waters. Then he drifted through eastern Ohio and western Pennsylvania as a manufacturer of cheap, crude, and ordinary portraits.

Having inched down an endless vista of boardinghouses, Blythe found himself at last in Uniontown, Pennsylvania. He sat silent as the regulars roared over a local peddler who had fallen asleep on the road and awakened to realize that his horse had thrown him on top of the produce he had got in exchange for shoes: eggs, butter, and an outraged turkey gobbler. The next Sunday, the boarders saw on the parlor mantel a drawing of the scene. As laughter rocked through the village, Blythe, at the age of thirty-one, found friends and a place to call home.

Uniontown glowed with those high-spirited high jinks to which Mark Twain was to give immortal expression in literature. Blythe issued from his

studio, known as "the rat's nest," to mix liquor and jokes and art. He carved a huge statue of Lafayette for the courthouse dome, painted bad portraits to a buzz of admiration, wrote for the newspapers endless doggerel in which he attacked the next county as a "sow grown fat with buttermilk and meal." Or he would step from male conviviality to drawing rooms presided over by young ladies "all virgin purity," adorned, as he wrote in their albums, with flowers plucked in Eden. One of the loveliest became his wife. While "hope was lined with velvet," he drew genre only for ephemeral jokes.

His wife died; a panorama he painted failed because he could not stay sober; he fought with his friends and angrily severed connections with Uniontown. From the carefree exterior world of Mark Twain he walked through his own psyche to the horrors of Edgar Allan Poe. Here is a self-portrait:

> *Out from the cold, blank emptiness*
> *Of a drunkard's home, slowly and hushed as*
> *A gnome-shade vomited from the green pestilent*
> *Stomach of a sepulchre, comes forth a thing*
> *The suppliant tongue of charity might*
> *Hesitate to call a man,...*
> *His eyes like angry, ill-closed, half-healed*
> *Wounds, physicianless....*

From 1851 to 1856, Blythe wandered, no man knows exactly where, "half-demented," as he believed, "in trying to find some place . . . where man and man might dwell together in unity." But this was not what he really needed if his art were finally to flower. His eyes, attuned to darkness, blurred in a world of light, nor was he, despite the affinity he recognized in himself to Poe, a visionary who could give artistic substance to altogether mental monsters. He needed exterior horrors to paint, and he found them at last in the monstrous growing pains of industrialism.

Every time Blythe had visited Pittsburgh the air had been fouler, the sky darker by day and more lurid with strange flames by night, the street fuller of grand carriages and beggars, of foreign tongues and dark faces, bewildered, angry, and confused. In 1856, he settled there, and while he watched, the panic of 1857 slowed the dance of death into a ghastly pavan. As the mills shut down, the skies cleared and the pounding abated, but only to make sharper the small sight and the little sounds of individual anguish.

Through this turbulent world there walked, often unsteadily, the tall painter, whose unkempt red beard protruded from under a self-made buffalo-

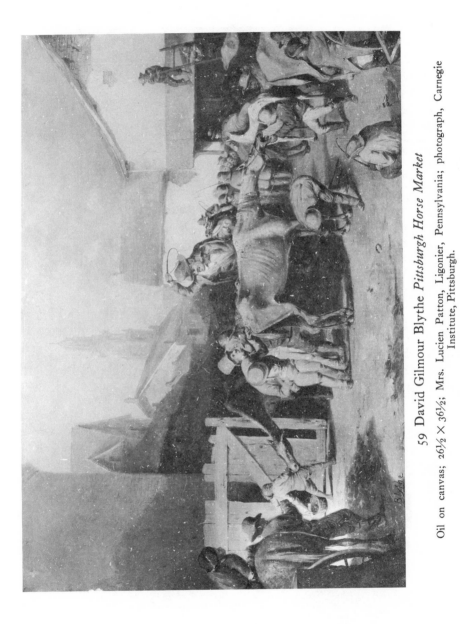

59 David Gilmour Blythe *Pittsburgh Horse Market*

Oil on canvas; 26½ × 36½; Mrs. Lucien Patton, Ligonier, Pennsylvania; photograph, Carnegie Institute, Pittsburgh.

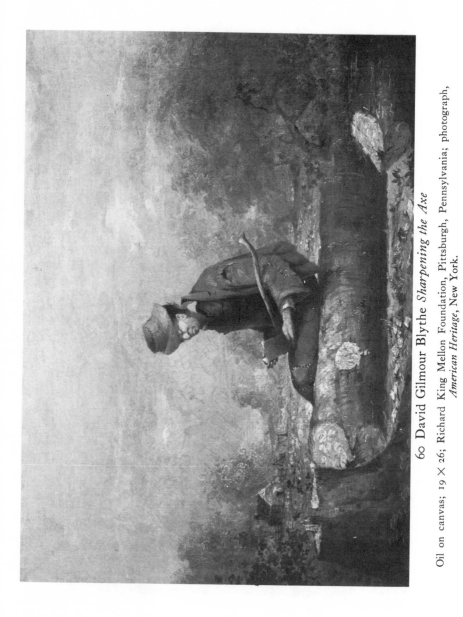

60 David Gilmour Blythe *Sharpening the Axe*

Oil on canvas; 19 × 26; Richard King Mellon Foundation, Pittsburgh, Pennsylvania; photograph, *American Heritage*, New York.

fur hat that half extinguished him like a candle snuffer; and on whose emaciated form a similarly fashioned suit flapped like an ill-fitting horse blanket. In churches he envisioned pompous hypocrisy. But in the haunts of thieves his heart warmed with pity. It was the pity of the surgeon — or the psychiatrist — who lays cankers bare.

Since Blythe could, when he wished, draw with considerable accuracy, it was not incompetence that produced his distortions of the human figure. He showed the run of humanity as squat and sluglike, wrapped in unlovely flesh, stupefied, like bloated leeches, with unhealthy blood. Then there were the oppressors, such men as the one who wields the whip in *Pittsburgh Horse Market*. With hardly any skin over the aggressive jutting of their grinning skulls, they are semiskeletons possessed by demonic energy. He painted trials in which the prosecutor is a lank, all-competent fiend, the judge and jury boobies, and the victim too deep in the degradation of the human lot to do more than stare stupidly and occupy his hands in the idiotic whittling of a stick.

For Blythe's horror was not, like Poe's, heroic. He painted no Byronic murderers flaming with the lurid glories of their vices, but rather anticipated the twentieth century by expressing the hopeless and dumb, compulsive suffering of Kafka. His concession to the genre style of his time was to couch his unhappy visions as humor. Occasionally he seems to have been genuinely amused, as in his series lampooning the crinolines that billowed around women's lower parts, but usually his comic action was of the order of the episode he included so often in his more crowded pictures that it is almost a trade mark: a little boy picking a prosperous pocket. Or he extracts bitter laughter from the plight of a ragged man standing in the doorway of a cobbler's shop barefooted and holding pleadingly towards the evilly grinning proprietor a shoe past mending.

During a productive period shorter even than Bingham's — eight or nine years — Blythe produced many more pictures on a much wider variety of themes. During the Civil War, he painted cartoons in support of Lincoln (probably an extension of those political allegories Bingham and others created as ephemeral political banners); a landscape showing Union soldiers passing through lyrical spring to Gettysburg and death (one is reminded of Siegfried Sassoon's World War I poem "And Everybody Sang"); and *Libby Prison*, a scene of horror which some art scholar will sooner or later — and wrongly — attribute to the influence of French romantics. Blythe's pessimistic approach inspired, indeed, many coincidental parallels with Gallic

practice. Although with more morbidity, he struck the note of only super-ficially comic urban protest which Daumier and Gavarni were contempo-raneously striking in Paris. His few country scenes point to the work of Millet, even if there was no mysticism in the American's approach, only brutal realism. No emotion except despair is expressed in Blythe's *Sharpen-ing the Axe*, which shows a ragged frontier boor engaged with depressed concentration on a joyless task.

Had Blythe gone to Paris, he would have found techniques ready-made for his vision, but he never sought artistic information outside the area where birth had dropped him. He knew the ubiquitous works of the English illustrators, and at least one Dutch painting: the *Interior of a Public House* by David Teniers the Younger, now in the Cleveland Museum. For the rest, Pittsburgh — then as artistically backward as was possible in the civilized world — was his Rome and alcohol his Raphael.

Encouraged to originality by innocence, Blythe would be classed as a "folk artist" had he not sought mature artistic effects. In the manner of all primitives and most alcoholics, his work varies greatly in quality. He depended, like Quidor, on flair that in a single picture both flashed and died. Thus in his *Pittsburgh Horse Market* the central group of human brute and underfed nag is magnificent, but the man looking down at the horse's rear has no head under his hat and his shoulders seem to be a feather bolster. As his *Libby Prison* reveals, Blythe understood better than Bingham the importance of keeping, even in heavily populated pictures, the light and shade patterns simple. However, his color was unfortunate. An unpleasant yellowish brown usually dominates the broken bits of hue he threw in almost at random like sparse bits of confetti.

Although historians of Pittsburgh have thought best to suppress Blythe's reports, they so suited his own rough times that when the pictures were exhibited in an art store window, laughing crowds blocked the streets. The pictures sold, and the dealer empowered Blythe to draw money when-ever he pleased. However, since everyone stood him drinks — he had become a community character — he had hardly any use for money; he drew only a few dollars at a time. Shortly after his fiftieth birthday, he was found dying, partly from the malnutrition that accompanies extreme alcoholism.

The changes in American life which Blythe recorded with such gleeful pain were, if extreme in Pittsburgh, by no means limited to that city. The Jacksonian era, "the era of good feelings," had faded. Not only did fratri-cidal war loom, but the old easy economy was increasingly torn apart. Men

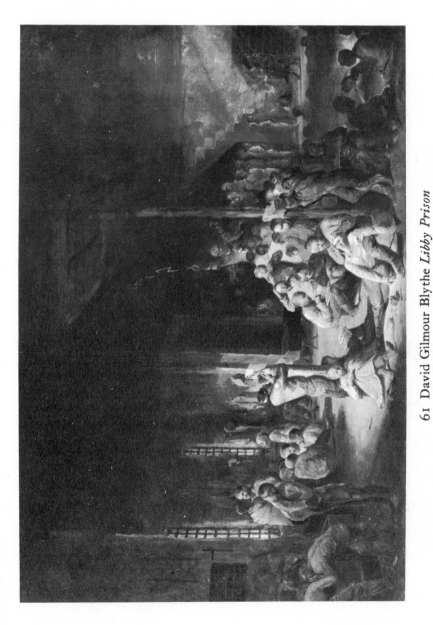

61 David Gilmour Blythe *Libby Prison*

Oil on canvas; 24 × 36; M. and M. Karolik Collection, Museum of Fine Arts, Boston.

62 Lily Martin Spencer *Celebrating the Victory of Vicksburg*

sucked into urban communities from abandoned Eastern farms, or from handwork shops or from Europe, served with bewilderment metal masters spouting steam. This rise of an unskilled labor force destroyed the trade unions that had been established by craftsmen. Manufactured goods, rushing around on rails, killed the crafts, abandoning more workers to the machines. Tightening over the land, the rails carried everywhere competition, strain, dog eat dog, the richer and the poorer, goods to keep up with the Joneses with, economic rivalry between areas once self-contained. This was a more basic development than the civil conflict it to some extent spawned: certainly, the Northern victory set the top spinning even faster.

The irresponsible gaiety of the older genre painters seemed no longer to reflect American life. As we have seen, Quidor responded to new times by painting his gay crew disappearing up a broad river into mist; Bingham retired into Düsseldorf artificiality and then the portrait; Mount amused himself by filling large pages with tiny drawings. Woodville, for whatever reason, had committed suicide, and Ranney was also dead.

American genre painters had not, like the landscapists who worked side by side, banded together into a true school: Mount's followers had been minor. Spread across the nation, the leading depicters of American life had developed their styles in semi-isolation. Hardly any had visited Europe during their creative years. More than the landscapists, they had feared sophistication. None had developed the subtleties of expression that came to characterize their contemporaries in the Hudson River School.

While American scenery preserved its basic character, the life the generation of Mount had painted became obsolete, as boring as yesterday's customs always seem. Collectors, now that rural existence had shifted from backbone to backwater, were no longer reconstructed farm boys not in need of explanations to help their understanding of country scenes. Nor did the vacationist's attitude towards nature, which was buoying up landscape, bring an equivalent new validity to bucolic genre. The reputations of Mount, Bingham, and the others disappeared. Jarves's statement, made in 1864, that the United States awaited "the dawn of a respectable genre school" would not have been contradicted by the Hudson River School's still-enthusiastic supporters.

Blythe would seem to have pointed the way to genre in keeping with the new times, but, although his art amused rough Pittsburgh, it was only as a sort of barroom prank. His reputation, always local, died with him, nor did any other artist strike, with consistency, similar notes of bitterness and protest. That, despite dislocations, industrialism was creating a happier

world for all men, that progress was operating in the United States as never before in history, remained a profound aspect of American faith. It was demanded of the new genre painters that they be as optimistic as the old.

The artists were thus presented with a grave problem, for they could not, like their predecessors, pour on canvas unedited lyricism. Did not every throw of the eye see flaw as well as hope; was not every glow of the mind tinged with fear, disgust, and doubt? How does a realist paint faith?

The most obvious answer was to adopt an approach from which earlier American genre had been amazingly free, although it had been the hallmark of Düsseldorf and had in England overwhelmed the humorous realism of Wilkie. This approach was sentimentality. For Americans to grasp it required no more than a change of emphasis from male to female taste.

The existence of so sharp a break between the two was a nineteenth-century development. In the eighteenth century, the basic economic unit had been the family: when merchants were away on voyages, lawyers on cases, statesmen at legislatures, their wives handled the business at home. The ladies learned bookkeeping at school; they faced the world beside their men in too exposed a position for chaperones, crinolines, prudery, or parlor prisons.

When, however, increases in distribution and in capital changed the basic business unit to the company, the ladies were displaced as junior partners and became, to the extent permitted by family income, symbols of conspicuous waste. In finishing schools, those seedbeds of amateur art, they learned to be decorative sprites, designed for nursery and drawing room. Barred from informing contact with the outside world, trained to deny all physical urges except motherhood, they were sentenced to goody-goody reveries, the artificiality of which custom insisted they should not recognize.

As their ladies retired into gentility, the men moved in opposite directions to become what European visitors considered barbarians. Unlike earlier American gentlemen, who had prided themselves on their French accents and their grace in the dance, the new generations felt that an energetic roughness — what Elliott painted — should characterize males who were not decadent Europeans, but were realizing the wild promise of a half-tamed continent. N. P. Willis thus summed up the situation: "While the boys in our country are educated over-practically, the girls are educated over-sentimentally."

It is significant that the most important European source of the sentimentality entering genre was England, where our artists did not study but whence our governesses and female literature came. However nationalistic

[192]

they may have been in regard to their own behavior, males accepted the land over which Victoria so primly ruled as the model for their women. Art aimed primarily at the ladies or produced by them had long showed a British tinge. Thus, the most successful specialists in "female portraiture" had been first Sully, who imitated Sir Thomas Lawrence, and then the immigrant Charles C. Ingham (1796–1863), who had learned in Dublin how to embed in an enamel-like finish handsome images of refinement. And America's only successful professional mid-century woman painter, Lily Martin Spencer (1822–1902), was intimately connected with polite English education.

Although both her parents were French, the former Angelique Martin had been born in England, where her father was serving out a twenty-year term as language teacher in the schools that spawned British gentility. When Lily was eight, the family came to America. In Marietta, Ohio, their efforts to refine the Buckeyes fell on relatively stony ground until she began in her early teens to paint. The stunner of the public exhibition which the community gave her, when she was nineteen, was a historical painting ten feet by twenty. It showed "a Gothic Hall in France, in the Middle Ages, in which the rout and revel of a nuptial banquet is represented as suddenly checked by the apparition of the ghost of the bride's former lover, in complete armor, who is dead in distant Palestine, a martyr of the Holy War, and who, in accordance with a vow on his departure, now returns to claim his faithless betrothed."

As an older woman, Lily Spencer regretted that she had never taken the time to learn to draw. Although her mature pictures are painted out in great detail, with a certain grace of composition and color, her draftsmanship never lost the amorphousness of childish expressionism: heads are too big for bodies, and the bodies, although agreeably in motion, have no bones.

Having married in Cincinnati the no-good husband she subsequently supported, Lily settled permanently in the New York area, where she produced six children and hundreds of paintings. She did not completely abandon her girlishly romantic vein, but her reputation was based on domestic genre. When depicting ordinary people, her mood was humorous: thus *Shake Hands* shows a grinning, not too pretty housewife, standing in a kitchen groaning with abundance and extending to the viewer a flour-covered hand. However, she brought to the children and the refined homes of the rich an almost nauseous glutinosity: *Celebrating the Victory at Vicksburg* features cute infants, some with chubby limbs emerging from nursery dishabille, parading in paper hats as one beats a spoon on a tin pan. Goupil used

her sentimentalities as its answer to those launched from Currier and Ives by another English finishing school product, Frances Palmer.

Children were a favorite subject of nineteenth-century genre, and nowhere so much as in America, where society had turned so passionately from the old to the new and was itself so much a child. The older generation had specialized in naughty boys, who were considered the more admirable because unedited by social restraints. Since even in Jacksonian times girls had to behave, they were largely excluded from the earlier pictures. However, in the 1850s misbehaving boys vanished from canvas, and little girls came in to behave decorously in the company of their now well-behaved brothers. Mischief could go no farther than such cutely wayward behavior as would make a mother exclaim, "Aren't they darlings!"

This approach achieved its most accomplished rendering in the work of Seymour Joseph Guy (1824–1910), who had arrived from England as a trained artist aged thirty. He painted pretty young ladies very much in the manner of Ingham, and brought to mother-love, usually lavished in opulent interiors on little girls, a verisimilitude of still-life detail and a warmth of coloring that has considerable charm. Attacking the Hudson River School's faithfulness to "external nature," he argued that true art should "discard the deformities." How he did this is symbolized by his pattable cats who would, if they met a witch, be embarrassed and not know what to say. But he did make use of a kind of spice which, although considered elevating by proper Victorians, seems shocking today: the transfer of sexual interest from nubile ladies to little girls, whose innocence was supposed to make their lusciously painted seminudity — on which critics expatiated — innocent.

That the Victorian point of view English artists brought with them could not be applied to all aspects of American life is revealed by Guy's hesitation to carry his brush downstairs from densely appointed nurseries to those overstuffed parlors which were in his homeland the main stage of domestic genre.* Gentility was more inbred in England, and industrialism had for a longer time been shedding the proliferation of possessions that induced an interior decorator to write, "Provided there is space to move about without knocking over the furniture, there is hardly likely to be too much in the room." One suspects that the American male, home from his day of economic plunging, could not, unless the drawing room was unfashionably bare, move about without knocking the furniture down.

*Also inapplicable here was the favorite dramatic theme of English genre: the domestic tragedies that resulted when a middle-class or rural wife, having succumbed to the mores of the aristocrats, was exposed as an adulteress. We had no bad baronets. For tears, we had to fall back on another English staple: a mother mourning her dead child, a child mourning its dead mother.

In any case, parlors appear in our post-Civil War painting primarily as settings for those static family portraits — each member rooted safely in one spot — already discussed. When later American genre finally made the plunge into drawing-room life, it usually excluded all males and showed languorous ladies expressing upper-class leisure by writing letters or just doing nothing. This was too great a break with masculine concerns to be, for the moment, a popular mode. However, we do find an occasional example, such as *New York Interior* (*c.* 1860) by the portraitist Alexander Lawrie (1828–1917), a picture which incidentally explains the prosperity of every kind of painter. The walls of the room where Lawrie's ladies so primly sit are almost invisible under two tiers of pictures. A long, thin canvas fills what would otherwise be a bare spot over the door.

The most successful genre formula was evolved on these shores by John G. Brown (1831–1913), who had arrived from England at the age of twenty, already a professional painter. His emergence into celebrity coincided with a revolution in the appearance of Northern cities caused by the influx of peoples used to living out of doors: immigrants from Italy and other warm lands, freed Negroes straggling up from the South. Streets that had been merely passages from place to place teemed with life. And that life, unlike the Yankee poor or new arrivals from northern nations, was enchanted to posture in a painter's studio with a drama that came naturally to it, and in rags it was glad to rearrange for effect. This opened to painters serving a society that was becoming ever more urban an obviously paintable theme: the picturesque street character. However, until Brown solved the problem, the social implications remained confused. Was humorous appreciation or sentimental pity for the immigrant poor enough to keep their tattered images from being an indictment of the wealthy, to whom the pictures were offered? And what of the many renditions of Negroes in stylish want? Did the happy smiles painted on their faces overcome the implication that abolition had not been as idealistic as it was supposed to seem?

Brown selected as his specialty the white boys who shined shoes on the streets, sold fruit or newspapers. With easy verisimilitude he made them such urchins as would tug at mothers' hearts: cherub-faced, appealingly unscrubbed, they were engaged with their pet dogs in tricks that were cute but never antisocial. For the ladies, they added to their other charms pathos, since they lacked the advantages which Mama showered on her own little ones. In addition, Brown's formula — he found it a half-dozen years before Horatio Alger's first "rags-to-riches" book (1867) — appealed to men, so strongly, indeed, that the pictures were hailed as almost holy documents of

the American way of life. For Brown's boys were independent businessmen in the newspaper or shoe line; they never allowed the cuteness women admired to get in the way of trade. Unlike Mount's children, who proved their spirit by shirking labor, Brown's would drop any amusement to make a nickel. They were hustlers who would go far.

Brown avoided all social criticism, in part by suppressing any peculiarity of feature that would indicate that the boys belonged to underprivileged minorities, in part by showing them as never sickly, never undernourished, never sad, always enjoying their American opportunity to rise. In so far as the viewer thought of them as actual representations of the city poor, they were a sop to the consciences of the rich and an encouragement to the immigrants themselves. In so far as they were thought of as symbols of typical American boyhood, they reminded the self-made of their own struggles and encouraged the self-botched to believe that if their children carefully tended paper routes, the family might pull out of the slough yet.

Brown disposed of his paintings from five hundred to seven hundred dollars apiece, often to collectors whose other prize possessions were all French works. Engravings after his pictures were best sellers at every price. He made an income that would in today's currency be several hundred thousand dollars a year. Despite the appearance of innumerable financially successful imitators, he got high prices for everything he did until his death in 1913, at the age of eighty-two.

Brown's formula reflected much of the American dream: faith in childhood and the future, belief in the melting pot and equality of opportunity. That his work and the work of his followers was slick and trivial was not due to any basic triviality of theme. It was due to venality of approach. He did not seek to cut deep, but distorted fact and cheapened idealism into painted slogans that would please his paymasters, that would sell. Like his descendants on today's Madison Avenue, he knew he was prostituting his talents but could not resist raking in the money; like them, he dreamed of going straight and blamed his degradation on a society that paid so handsomely for truth presented as a lie.

That social criticism, if it were to have the popular acceptance still desired by our leading painters, had to resort to strange devices is revealed by the practice of the brothers James Henry Beard (1812–1893) and William Holbrook Beard (1824–1900). They were raised as backwoodsmen near Painesville, Ohio, where they awoke in the night to hear wolves howling outside their log cabin.

[196]

63 John G. Brown *Nary a Red*

Oil on canvas; 1879; 13¼ × 10¼; G. W. V. Smith Art Gallery, Springfield, Massachusetts.

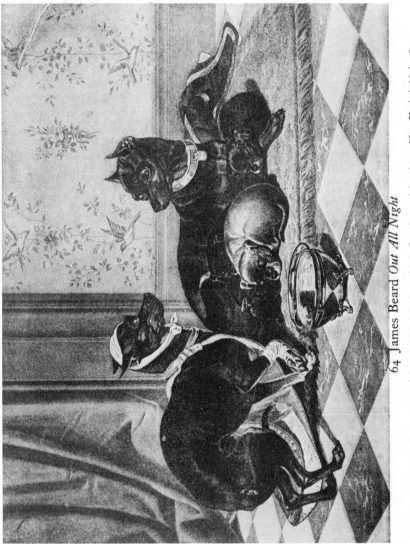

64 James Beard *Out All Night*

Photoengraving of mezzotint of the original; M. Knoedler & Co., *General Catalogue*, New York (1884), 28.

James dated back to the older days, being almost an exact contemporary of Bingham, but his initiation to art was symbolic of new times: he watched the carving of the figurehead of the first steamboat to ply Lake Erie. This experience set him going in his early teens as an itinerant portraitist. He doubled as a keelboatman and, from his labor on the river, imbibed a less enthusiastic view than Bingham had looking down from Eagle Rock. Although such pictures as *The Long Bill*, which showed a young man appalled in a general store by the accounting of all he had bought, were in the humorous, irresponsible mood of Mount, James Beard consciously set himself, in the 1840s, the task of depicting realistically the privations of the poor whites. His flatboatmen dance not in glee but to keep their spirits up, for their rags let in the cold and their laboriously built cabin is being undermined by the river. The American Art-Union hailed such compositions as another indication that "a new field of art is opening up in the great West" — Beard had settled at Cincinnati — and his depressing *North Carolina Immigrants* sold in New York for $750, then a phenomenal sum for a genre picture. The gay mood of those times could take some pessimism as a piquant sauce.

Beard never employed the powerful drawing and geometric construction of Bingham's art, preferring to rely on flair, on easily expressive draftsmanship, on a gift for color harmonies agreeable if not profound. Even a trip to Europe in 1858 did not remove from his style, which was indeed in no basic way altered, a touch of crudity which could, depending on how the cards fell, constitute a fault or contribute a caricaturist's power.

As the sentimental years closed in, James Beard did not, like Bingham, give up. A way out had been pointed when he had painted a child with a dog so successfully that all the mothers clamored for dogs in their infants' portraits. He became expert at painting them. And the best-selling engravings after the Englishman Landseer encouraged him to put dogs in human situations. Some of the pictures Beard now produced, like *The Widow*, which featured a Pekinese weeping over her husband's empty collar, rival Landseer's most noxious sentimentalities, but Beard also went further than the Englishman would have dreamed of going into using animal allegories to mock the polite conventions of the time.

Beard thus extended the convention that was enabling minstrel shows to sweep both America and Europe and make Queen Victoria laugh. The black on the performers' faces licensed them to overstep, even in the presence of ladies, Victorian decorum further than undisguised actors could. This convention also explained the popularity of Currier and Ives's *Darktown*

[197]

Comics, which were raucous satires on polite white behavior. Yet the mythical "darkies," since they remained human beings, might not mock moral shibboleths as James Beard made his animals do in his extremely popular *Out All Night*.

A sweet mother Pekinese, comfortable on a mat with her sleeping puppies around her, looks up with an expression of amazed innocence as her husband comes home swathed in bandages, his tail between his legs and sheepishness contorting his face. The overtones are all unsuitable and masculine: those blessed innocents, the children, snore like the fat little pigs they are; the virtuous wife, that Victorian ideal, is a self-righteous if elegant ninny; and the husband, bearing the scars of some high alcoholic chivalry, knows himself an asinine slave of convention to come home apologetically to such as they.

How far this mode could be carried was shown by James Beard's brother William, whose *Jealous Rabbit*, so Tuckerman tells us with relish, showed "two rabbits making love while a third stands on his hind legs and peers over a cabbage leaf with an expression of jealous surprise in his fixed and fierce eyes that is inimitable." Although the Pre-Raphaelite journal *New Path* objected "in the name of common decency," although ladies had to pretend to turn away, the Beards continued a triumphant course. To them was applied an adjective of praise which, with the rise of feminine taste, had appeared in the American critical lexicon: their art was "masculine."

William had studied under his much older brother, had operated in western Ohio as an itinerant portraitist, and had during the early 1850s wandered Europe for two years with so successful a determination to resist all influences that he was always considered self-taught. After a period in Buffalo, New York, he moved (1860) to New York City, soon outshining his brother, who stayed ten years longer in the West and who lacked his endless fertility of imagination.

To make acceptable such male jollity as Mount and Bingham had painted straight, William—his specialty was wild animals, while his brother's was domestic animals—introduced into iconography the American brown bear. That creature, he explained, had a great love of fun and a flexible nose which twisted to express humorous emotion. If we agree that bears are people, *Bears on a Bender* is a highly realistic stag party. A histrionic guest is telling an anecdote with too much flourish; a philosophical one sits back with a quiet smile of well-being; and the host is suitably active in pulling the cork from yet another bottle.

William Beard was one of the very few artists to express any emotional

reaction to the vein of violence which the Civil War had made so manifest in American life. His image of the swooning terror of an anthropomorphic huntsman's dog, caught and about to be eaten by Beard's beloved brown bears, is more horrifying than funny. His *Watchers*, so Tuckerman wrote, showed a wounded elk lying on the prairie, "a piteous expression on its face as if aware of the fate awaiting it." A group of young ravens are waiting eagerly, but a few "old beaks at this sort of business" doze "with their heads sunk low amidst their feathers, confident that the elk will die in good season for their evening repast. Perhaps there is an adage on crow life: . . . 'A watched elk never dies.' "

William did not work from animal models, preferring to see with his mind's eye his human beasts. As pliant as if made from rubber, they take expressive poses. He grouped them with the easy fluency of a born story-teller marshaling phrases. Color contributes but is never rich enough to trigger unliterary emotions. As a pure painter, William Beard leaves much to be desired, yet he had a force of imagination that jarred into praise the most sophisticated American critic. Finding in his work "fine wit" and "subtle meanings," Jarves hailed him as "an artist of genuine American stamp."

That stamp did not characterize the new generation of genre painters. The reason was not that, unlike their predecessors, they commonly studied abroad. Landscapists had long done so without defecting from its native flow the current of the Hudson River School. The explanation was the insecurity of the genre painters themselves. They sought European methods not to assist them in expressing what they themselves saw and felt, but rather as expedients that would second sentimentality in enabling them to achieve, while escaping from fact, the factual-seeming images American taste required.

Like their compatriots, the genre painters commonly congregated first in Düsseldorf and then in Couture's studio. From Düsseldorf they learned theatrical gestures and graceful "ideal" poses highly useful to painters now in no closer touch with American farm life than the Germans had long been with their own peasantry. Couture's influence was greater, so great that Jarves wrote in 1863 (when Barbizon influence was still rudimentary in American landscape) that "in some respects" painting in New York was "only an outgrowth of Paris."

Couture assisted his American pupils to escape from the embarrassments of direct vision by teaching them a system of figure painting that did not

grow from subject but would by itself bring verisimilitude to any subject matter. And his example encouraged genre painters towards the intellectual generalizations which he himself employed to create human symbols of virtues and vices. Thus John Whetten Ehninger (1827–1899) was enabled to paint in Paris a Yankee peddler who summed up the breed as the literary imagination conceived it. Couture's method allowed painters to create a village blacksmith who, like Longfellow's, had arms as "strong as iron bands" and wept to hear his daughter's voice singing in the choir. They could create a country belle who, like Lowell's, was "such a blessèd cretur, a dogrose blushin' to a brook ain't modester or sweeter." They could create a rural child suited to Whittier's lines, "Blessings on thee, little man, barefoot boy, with cheek of tan!" The pictures are often smoother technically than the work of Mount and Bingham, but oh my!

How painterly qualities could, if misapplied, be a hindrance was revealed in *Thoughts of Liberia,* by Edwin White (1817–1877), who had studied in Düsseldorf, Paris, Rome, and Florence. When official recognition of Liberia was being agitated, he decided to paint, as a highly salable comment, an old slave huddled in a squalid cabin dreaming of escape to the Negro republic. Having a fine eye for color, White made the peeling plaster walls that were supposed to signalize destitution a warm cream shading into tan. These hues harmonize delightfully with some old-rose rags hanging from the ceiling, and imbue the jewel-like brilliance a flame that is supposed to indicate cold by its tiny size within the huge, wrecked fireplace. The protagonist's dejection is completely out of key with this glowing fairyland. Breaking between chromatic fantasy and literary realism, the picture adds up to nothing. White is a forgotten artist.

Among the innumerable painters of American life who flourished during and after the Civil War, the acknowledged leader was a chameleonlike figure who worked in many styles. From the first, Eastman Johnson (1824–1906) had moved confusedly. The son of a well-to-do political leader in his native Maine, he had avoided advanced education. He had, like an artisan's son, set up while yet in his teens as a self-taught portraitist. Yet he lacked the naïve brashness that encouraged the humbly bred to twist at once the tails of art's most desperate catamounts. In Washington and Boston, where he was patronized by his family's correct friends, he limited himself to black-and-white drawings that imitated the effects of portrait engravings. He had been a professional for five years before he dared use color, and he had no sooner made this plunge than he posted for Düsseldorf. This was 1849.

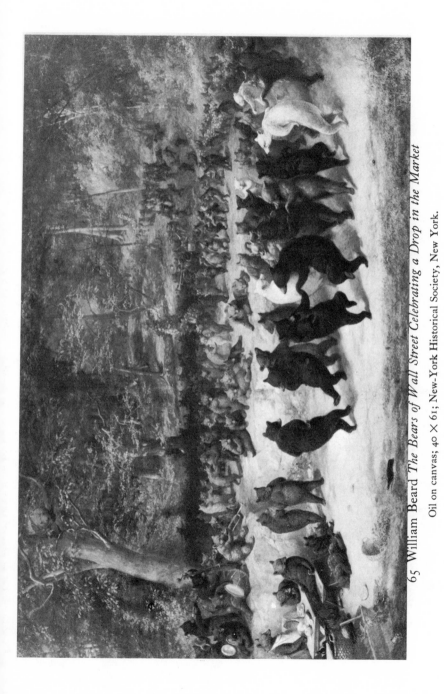

65 William Beard *The Bears of Wall Street Celebrating a Drop in the Market*

Oil on canvas; 40 × 61; New-York Historical Society, New York.

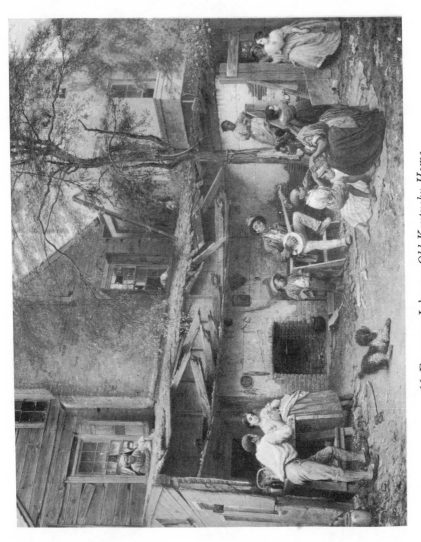

66 Eastman Johnson *Old Kentucky Home*

Oil on canvas, 1859. 26 X 45. Robert L. Stuart Collection, New-York Historical Society, New York.

Johnson was much less impressed than most Americans by Düsseldorf as an environment, much more by its artistic system. The town was, he wrote, "as humdrum as any of . . . our downeast villages. . . . They have an opera here, but I seldom go. The women are not handsome." But unwilling to accept the usual shortcuts, he matriculated at the Academy and worked there for two years as a student too humble to attempt a finished picture.

Johnson's next stop was The Hague, where he fell in love with Dutch art and stayed for three and a half years. This fascination with the most vital of early genre traditions was the first sign he gave of unusual possibilities, even if it eventuated in a Dutch drinking scene tricked up with Düsseldorf gestures, picturesque heads emerging from brown soup that were imitative of Rembrandt, and *The Savoyard Boy*, in which he mixed Dutch broadness with Düsseldorf fussiness and seasoned all with Victorian sugar.

He finally moved on to Paris. He would have stayed there forever, he later wrote, had his mother's illness not called him home. In two months, during which he officially studied with Couture, Johnson acquired enough Gallic gloss to enable Francophile American critics to compare him for the rest of his career with Édouard Frère, that leader of a bourgeois-Victorian genre movement in French painting who was praised by Ruskin for combining the color of Rembrandt, the depth of Wordsworth, the grace of Reynolds, and the holiness of Fra Angelico!

In 1855, Johnson returned to America possessed of better technical equipment than any other native genre painter. What to do with it? He sought picturesque subject matter among the Minnesota Indians, but he had expressed his fundamental turn of mind when he wrote, "Commonplaceness is the sum and substance of what one finds, go where one will." He found fame in the slave quarters behind his father's house in Washington. The painting (1859), which he called *Negro Life in the South*, but which was popularly rechristened *Old Kentucky Home*, became a national sensation and enabled him to reach "the American goal of a studio in New York."

How secondarily painting was caught up in the ardors that led to the Civil War is shown by the fact that in the years when *Uncle Tom's Cabin* was burning its way across the land, *Old Kentucky Home* was the most celebrated picture dealing with slavery. For Johnson had reported with such unemotional exactitude what the South considered right and the North wrong that the picture pleased all but extremists in both parties.

Johnson saw urban house slaves as well-fed and unmarked by brutality.

In the traditional genre manner, they are shown not at work but at happy play. However, the tension of the picture rises from the dissimilitude between their squalor and the luxurious life of their owners. The rotting roof of the Negroes' shed, sagging across most of the canvas, contrasts sharply with the trim, recently painted, four-square white man's house in the right background. Broken windows characterize one, are unthinkable in the other. The "anecdote" lies in the action of a beautifully gowned white girl stepping through a gate into the subworld of her family's raggedly if gaily clad possessions.

Old Kentucky Home is comparable with paintings of colored life by Mount. Both artists represented human action realistically and informally as it would appear at a moment of time. However, Mount's pictures have the permanence of moments selected by memory—they are what emotion engraved on the mind—while Johnson recorded an instant as a camera lens might if it were capable of all the subtleties of the artist's hand.

Where Mount limited his compositions to a single episode, Johnson combined many. Painting with a Düsseldorf completeness far out of his predecessor's scope, he recorded expertly the forms and textures of proliferated and tiny details: wrinkles in sleeves, moss on rotting wood. Unlike Mount's best compositions that hold together at a glance, *Old Kentucky Home* is at a glance as confused as such a slice of life—containing, in addition to an inanimate welter, thirteen persons, a dog, a cat, and a rooster—would actually be. Similarly, Mount's color, in which small variations are overlooked, is more unified than what Johnson achieved by marking down the correct hue of each detail. In verisimilitude, Johnson is the undisputed master: the eye moves through his canvas as it would through an actual scene. Yet there is less power. Although the banjo player is more exactly hit in pose and costume than Mount's colored musicians, you do not feel his nerves tightening to the music as Mount makes you feel.

Both artists took what an abolitionist would regard as a superficial approach to slavery. Certainly, neither told the whole story. Yet Mount loved his happy colored men, feeling in them a shared hedonism, while Johnson stayed firmly aloof.* As an illustration of American life, *Old Kentucky Home* is much more ambitious and complete than anything Mount undertook. However, it lacks Mount's charm.

*The utter matter-of-factness of Johnson's attitude is revealed by his statement that he told a European farm maiden "what an odd thing it seems to me to see such a pretty girl working in the field, and how nice and lazy she could live where I come from, where all the girls do nothing but grow fat and get married and have black slaves to wait upon them, which she could hardly believe, although she had heared America was a paradise."

Whenever Johnson made an effort to express emotion, he joined his contemporaries in the treacle-lake of sentimentality. The Civil War emblem that occupied the position of the unknown soldier in modern wars was the drummer boy, wounded but still cheerful, rallying his dispirited elders with his drum. Johnson made a particularly repulsive because particularly expert contribution to this mode, showing a bandaged pretty infant, jocund amid carriages, on a burly soldier's shoulder. His rendition of a damaged young hero, prone on a cot but happily dictating to a pretty girl his letter home, was esteemed, so Tuckerman quoted with approval, as a tribute to "the loving work so often done by noble women in camp or in hospital. . . . The picture describes the sunnier side of the soldier's life, but it may be the one we most love to remember."

Johnson traced drawings into his underpaint and colored meticulously within the lines. For interiors, he employed Rembrandtesque brown soup, which, deepening with shadow and thinning in light that usually entered the picture from a single source, brought local color and firm detail into over-all harmony. So far, his practice was altogether of the schools to which he had been exposed during his European studies.

For outdoor light he sought, particularly in the 1870s, more modern solutions. During summers in his native Maine, he made small experimental oils. Many of his new expedients resembled the current Impressionistic practices of Inness or Homer, and also the dashing style that young painters were bringing back from Munich. However, the synthesis is his own. Today these little sketches are the most admired of Johnson's works.

In them, his intention of making chiaroscuro studies dominated. With an energetic brush he showed groups, usually engaged in cranberry picking or boiling maple sugar, as areas or glints of light and shadow silhouetted against landscapes also indicated in terms of absorbed or reflected light. The individual figures are amorphous, often merging together into large compositional shapes. The color depends for effect on a generalized tone, almost always a shading of rich browns, into which other hues—reds, oranges, blues, whites—are worked. Although shape is never more than indicated, Johnson could, as in *The Maple Sugar Camp—Turning Off*, give on a canvas only ten inches by twenty-two a strong and harmonious impression of many people out under the sky.

Johnson hoped to combine what he regarded as incomplete records into fully realized and elaborate renditions of Maine rural life, but he waited to be paid and no commissions came. We need not be too sorry, for when he

did work up a brilliantly suggestive sketch (very reminiscent of Homer) into a large oil of children playing with an abandoned stagecoach, he translated luminous understatement into overstated cuteness and sentiment. He himself realized but could not prevent the loss of power. And in the end he gave up, turning in the 1880s from genre to portraiture of individuals or of groups in the relaxed, photo style we have already discussed.

The more you study Eastman Johnson, the more impatient you become. He had so many skills that you want to shake him from not putting all together into a masterpiece. But then you realize that he could not, for, like the other genre painters of his period, he lacked the most essential ingredient of all: something to express in which he profoundly believed. The Civil War may have been a holy crusade; industrialism and capitalism may have been building a more prosperous nation; but the painters of American life could hymn neither. Nor, with the startling exception of Homer, could they find any other human activity to hymn. They were not outraged enough for effective protest. In genre, triviality, or at best objective reporting, had taken over.

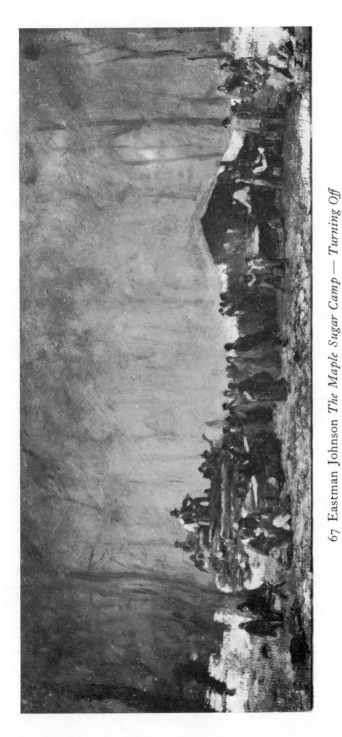

67 Eastman Johnson *The Maple Sugar Camp — Turning Off*

Oil on academy board; 1875; 10 × 22; Norman B. Woolworth, Winthrop, Maine; photograph, Kennedy Galleries, New York.

68 Junius Brutus Stearns *The Marriage of Washington to Martha Custis*

Oil on canvas; 1849; 40½ × 55; Virginia Museum of Fine Arts,

13

POPULAR ART

Panoramas, Prints, and "Folk Painters"

ATHLETICS not organized or publicized or suitable for women; cards, social dancing, extramarital kissing, theatrical comedy considered immoral; no automobiles; no phonographs, movies, radio, or television — in that benighted time matters today sneeringly relegated to "eggheads" served as popular amusements. They were so passionately enjoyed that in 1849 New York City suffered a major riot — barricades in the streets, twenty-six killed, thirty-six injured — touched off by rivalry between two Shakespearean tragedians. Among the greatest box-office successes were Jenny Lind singing Handel and Mendelssohn, Charles Dickens reading from his novels, Emerson expounding philosophy.

Before the motion picture with its endless possibilities of elaboration had killed off theatrical spectacles, the work of scenic designers was often billed over the actors and the plays. If the painters used their illusionistic skills to create shows altogether on their own, they gained advantages. Not only did they have a lower overhead than the true theater, but they could reach a wider audience. Puritans eschewed all playacting, while even in more libertarian circles many theaters were out of bounds for good women since "the third tier" was a traditional showcase for harlots.

The English actress Fanny Kemble was outraged to see in Boston "pictures of very high pretensions . . . exhibited like scenes in the theater by gaslight [and] advertised in colored posters all over the streets like theatrical exhibitions." Since the 1810s, paintings had traveled the nation on tour. The works of major artists usually only played big cities, and those of

[205]

sign painters rarely penetrated beyond the local areas, whose sensational events — murders, fires, shipwrecks — were exploited. The most extensive circuit was supplied by the second rank of historical painters, some even members of the National Academy, who painted for lease or sale to show-men. Thus was exemplified once more the alliance between the high style and popular illustration.

Thomas Pritchard Rossiter (1818–1871), who had accompanied Durand and Kensett on their hegira to Europe and studied for six years in Paris, Rome, and London, produced showpieces in all the accepted veins: *The Home of Washington after the War; The Last Days of Tasso; Joan of Arc in Prison; The Return of the Dove to the Ark,* etc. Also operating from New York City was Junius Brutus Stearns (1810–1885), who had studied in London and especially Paris. He was principally famous for his four-part series on Washington. As "soldier," the hero was depicted with Braddock, glorious in defeat; as "statesman," helping to ratify the Constitution; as "farmer," in the fields with his laborers; and as "citizen" — reader, can you guess? — getting married. This edifying work was lavishly engraved by Goupil in 1853.

Philadelphia, as the capital of book and magazine publishing, had its own group of popular history painters. The leader there was Peter F. Rothermel (1817–1895), who had spent two years in Rome. He concentrated first on the Spanish conquest of America and then on the Battle of Gettysburg.

Wherever they had studied, whatever American city they inhabited, the show painters mingled, in the manner of Delaroche and Leutze, historical reconstruction with genre* and contemporary sentiment. Their work was lax, genial, realistic, and adequate.

The craze for travel created a great demand for picture shows that re-called what many voyagers had seen, or opened to inspection exotic wonders. However, only a few landscapists, like Church and Bierstadt, were both able and willing to put enough detail in an easel picture to make crowds feel that they had got their money's worth. For lesser skills, the panorama supplied an answer.

In their then traditional form, panoramas required facilities — like the Rotunda which Vanderlyn had built in New York — that were economic, if at all, only in big cities. The pictures completely covered a specially built and lighted dome. Since the effect depended on making the spectator feel

*Pure genre could appeal if the pictures had enough relevance and content: thus Bingham's *County Election* toured successfully the regions where elections resembled the painting.

that he was standing in the center of an actual scene, foreground objects had to be painted as large as they would in fact appear at a distance of a few feet, while distances shrank away according to the rules of perspective. This necessary emphasis on what was closest dictated the representation of man-made huddles: cities or formal gardens such as Vanderlyn's *Versailles*. The static panorama offered little to the rising taste for wild nature, while being held to a single vantage point cramped Americans who loved to be on the move.

More suited to the mid-century was a new kind of panorama which grew out of the stage device that enabled a heroine both to flee the villain and to remain onstage: as she ran without advancing, the scenery rushed by behind her. Cashier the players, hire a lecturer to take their place, move close to the footlights the canvas strip that rolled by between drums hidden in the wings — and you had a device that could travel in a wagon and be set up in any hall, and that was eminently suited to pursuading the viewer that he was looking at distant scenery as he advanced in a carriage or a railroad car or a riverboat.

The moving panorama had been invented in Europe but proved most successful in depicting the vast reaches of America, particularly the banks of the Mississippi River, about which everyone had heard but which few had seen (even Westerners rarely penetrated above St. Louis). During the 1840s five Mississippi panoramas were painted in that city. John Banvard (1815–1891) claimed his roll of canvas was three miles in length;* this inspired his rival John Rawson Smith (1810–1864) to claim four miles; but the largest seems to have been that by Henry Lewis (1819–1904), which was actually twelve feet high and 3975 feet (about three quarters of a mile) long. That by Samuel B. Stockwell (1813–1854) was about half the size of Lewis's. They were all so big that careful painting was impossible. The fifth St. Louis panoramist, Leon Pomarede (*c.* 1807–1892), the one whom Wimar assisted, swung his brush over the canvas as if painting a door, calling out *"Comme ca!* Click, click! *Pouf-pouf!"* A few years later (1851), the popular concerns with the Mississippi and with science were wedded in what was advertised as "a magnificent scenic mirror covering 15,000 feet of canvas," which featured "aboriginal monuments:... Indian mounds." It had been run up by John J. Egan — probably an Irish immigrant — for "Prof. M. W. Dickeson, M.D." from that lecturer's drawings.

*When Banvard's panorama was shown in Boston, Longfellow took notes on which he based scenic descriptions in *Evangeline*.

The success of the Mississippi panoramas, which were as popular in Europe as America, encouraged depictions of the scenery along almost every river or road that was much traveled. Historical sequences were attempted, and Benjamin Russell (1804–1855) illustrated a whaling voyage. Among the innumerable panoramists only two, Blythe and Champney,* achieved anything in serious painting. That Blythe's effort was eventually cut up for stage scenery indicates the basic nature of the mammoth strips. They were painted as roughly as is commensurate with effect when viewed from a distance. Lack of true illusionistic skill and the need to hold attention with images that rolled steadily by encouraged painted bombast which accentuated the strange. Further piquancy was sought by pulling across the stage in front of the pictures physical props: miniature steamboats or, as Blythe did, a pond embellished with live ducks.

No type of barnstorming offered as large profits as the sale of engravings. After 1854, admission was rarely charged to the best publicized showings of the most important pictures. Doubling as publishers, the big dealers found it more profitable to familiarize the public with the paintings, while salesmen circulated with order blanks for reproductions. This was the situation with the work of Church, Bingham, Bierstadt, and others.

Engravings, more broadly distributable than original paintings and offered in a range of much cheaper prices, reflected by their sales the widest possible spread of American taste. In addition to the works of leading native landscape and genre painters, English pictures — especially Wilkie's *Harvest Festival* and Landseer's rendition of a rampant stag, *The Challenge* — did very well, as did a great variety of historical, illustrative, and literary concoctions. Long after Huntington had turned his main attention to portraits, feminine predilections kept in triumphant currency his religious allegories. And the ladies made Cole's *Voyage of Life* into the greatest smash hit of the mid-century print market.

Cole's series jumped, as we have seen, into national celebrity when the originals were purchased, publicized, and distributed by the American Art-Union in 1848. The lottery winner of the four-part prize sold it to the Reverend Gorham D. Abbott, whose Collegiate Institute for the Education of Young Ladies (alias the Spingler Institute) maintained in its "beautiful building" in New York City an art gallery, of which Cole's allegory became

*Champney, who painted the Rhine in Paris according to "the French method," tells us that he tacked strips of canvas to the floor. Then he and two assistants walked slowly backward in soft shoes, manipulating long-handled brushes. "It came very easy."

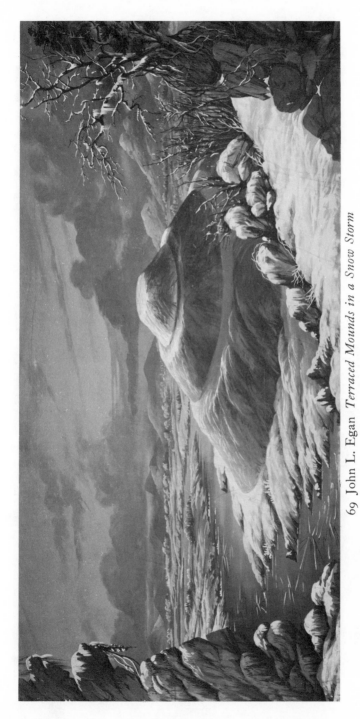

69 John L. Egan *Terraced Mounds in a Snow Storm*

Detail of a panorama; eight or nine feet high; City Art Museum, St. Louis; photograph, University Museum, Philadelphia.

70 Frances Bond Palmer *The Mississippi in Time of Peace*

Hand-colored lithograph on paper; published by Currier & Ives; 1865; 18 × 27¾;
New-York Historical Society, New York.

the star.* Among the prints of *The Voyage of Life* that flooded in every size from the presses, the most sumptuous were the four large engravings which the minister–school principal sponsored. "It is difficult to find," he stated in his sales pitch, "in the whole world of art a more interesting, appropriate, and valuable series of FAMILY PICTURES." So strongly, indeed, did Cole's moral allegory come to connote gentility that all four prints were commonly displayed in the parlors of the more refined brothels.

The sometime historical painter John Gadsby Chapman (1808–1889), who was to end his career in Italy creating agreeable views for American tourists, embellished Harper's *Illuminated Bible* (1843-1846) with fourteen hundred pictures which visualized the Old Testament in the portentous manner of Martin and the young Cole, the New Testament with more literal imaginings in a style stemming from the elderly Benjamin West. This volume topped the high tide of the use as book or magazine illustrations of easel paintings or pictures drawn in easel styles. Illustration became a separate specialty, a change that had been pioneered by the line drawings of Felix Octavius Carr Darley (1822–1888). A method of woodblock reproduction, inimical to all pictures not especially prepared for it, swept in during the late 1850s to help establish the modern situation: works by fine artists hardly ever found their way into books or magazines not specifically concerned with the fine arts.

Lithography, which had been introduced in the late 1820s, proved quicker and less expensive than the old meticulous techniques of engraving. It was used by the art publishers for their bargain-priced reproductions of easel paintings. However, its most successful exploiters, the firm of Nathaniel Currier that became Currier and Ives, anticipated the procedures of modern staff-written magazines by substituting for individual creation supervised cooperation.

A Currier and Ives print started with a rough sketch which had been bought from a free lance or run up by a staff artist. Hirelings then prepared a more finished picture that was criticized in the front office, redrawn, criticized again, and at last pulled together by the lithographer, who incorporated final commands made in writing by the proprietors and felt justified in signing the result with his own name. So far, planning had been exclusively in black and white. Now color schemes were tried out and modified, until at last the approved pattern was given to women who by

*The second feature was Stearns's four-part series on Washington.

[209]

hand covered the printed designs with transparent washes, the unskilled coloring the large forms, the supervisors flecking in details. Thus were produced the 90 per cent of the firm's output that cost from five cents to a dollar.

As house-written magazines feature an occasional signed article, Currier and Ives produced large lithographs, usually folios, that were credited to the original artist, and which were often based on paintings. Although the work of nonstaff members was bought, leading members of the Native School did not offer. This was probably because, even if the office machine ground less fine on such folios, the publisher's over-all style was imposed: at least one regular contributor (Tait) complained bitterly of changes made by both proprietor and lithographer.

Although Currier's folios were cruder, brighter, and cheaper than reproductions made by firms like Goupil, which worked for the top painters, they were, at their price of a dollar and a half to three dollars, the aristocrats of the Currier and Ives line. It is thus indicative of how the publishers judged taste that the folios invariably depicted contemporary America. Reflections of the "high style," Biblical, historical, and exotic subjects, were, with comics, sentimentals, ladies' heads, kittens, and puppies, reserved for the cheaper trade.

As had long been the case with popular illustration (even pictures made directly for that end by such fine artists as Doughty), Currier and Ives prints emphasized more aspects of the contemporary scene than did important easel painting: steamboats, railways, city traffic, industrial scenes. Yet, everything considered, the attitudes and interests of the firm followed surprisingly those of their artistic betters. Except in pictures of foreign celebrities or those aimed specifically at immigrants, the print-makers concerned themselves with the United States; they were, if anything, more resolutely optimistic and cheerful than the Native School; they too eschewed fantasy (except for realistic renderings of stage sets); and their sentimentality was of the variety sponsored by those English-born members of the National Academy Guy and Brown.

However, Currier and Ives crowded more into a picture than the National Academicians did. When they plagiarized Bingham's *Jolly Flatboatmen* for their *Bound Down the River*, they expanded his close-up of men dancing on a deck to include four steamboats, a wharf, and a settlement. The print which collectors have voted the "greatest" in the firm's output, *Central Park, Winter: The Skating Pond*, contains innumerable figures with little

more connection to each other than that they are all in one place and exemplify variations in the same sport. The work of English-born Charles Parsons (1821–1910), this picture is less in the American genre manner than that of the Englishman W. P. Frith, whose popular pictures, *Life at the Seaside, The Railway Station,* etc., are, if better composed, just such melangés.

Among the aberrations of the 1920s was the claim that Currier and Ives prints were the very most "American" of all our art. Actually, although the publishers were both natives, the vast majority of their creative staff were born and trained in Europe.* This was partly because lithography was best learned abroad, even more because Americans were then more individualistic than today. They did not want to be cogs in any publisher's machine, nor, as the market for native art boomed, were they forced to be.

The firm's sports headliner, Arthur Fitzwilliam Tait (1819–1905), was an Englishman, and their genre specialist, Louis Maurer (1832–1932,) was German. Both arrived in this country well trained, the former as a painter, the latter as a draftsman and lithographer. Tait had then and still has today a great reputation with the duck-blind and bird-dog set — perhaps squinting through sights in the dawn affects their eyes — but he was in his painted originals an artist of iron insensitivity whose bulky forms, often applied to a tall sportsman with gigantic shoulders, imply not strength and amplitude but dead weight. Although he was good at indicating textures — the feathers of a grouse, the steel of a gun — to compare his *Catching a Trout: We Have You Now, Sir* with Mount's *Eel-Spearing* is to feel for one illusory moment that Mount must have been the world's greatest painter.

Maurer, who did not take up painting until he was fifty, was a strong if uninspired draftsman. The firm's star humorist, New York-born Thomas Worth (1834–1917) had a free line and a ribald energy that shows best in his *Darktown Comics,* but he was a true hack who made careless sketches, leaving the finishing to redrawers and lithographers.

Of Currier's staff artists by far the most effective was Frances Bond Palmer (c. 1812–1876), an English gentlewoman who thus supported her children and alcoholic husband. Having first experienced America when she was about thirty, she saw its picturesqueness with an eye undulled by habit; having been taught to draw at a select English ladies' seminary, she understood refinement as no mere American woman could; she adored her work

*Of the seven artists the collector Harry T. Peters considered most important, four were English, one German, two American. Of the lithographers he names, not one was native-born. The young ladies who colored the prints were "mostly of German descent," and the free lances who submitted sketches were "of all nationalities."

that offered escape from a desperate family life; she had an innate gift for effective illustration; and, above all, she was an excellent cooperator who knew how to get the very best out of the Currier and Ives machine. Indeed her original watercolors are thin gruel beside such finished folios as her *Mississippi in the Time of Peace* (in which Bingham's *Jolly Flatboatmen* was again embedded).

As a group, the Currier and Ives prints accomplished efficiently their purpose of supplying boldly effective wall decorations that would hold the most sluggish eye. They have the excruciating timeliness of persuasive images that catch the moment without any universal undertones. Nostalgia for what they portray brings them great charm: without that nostalgia, there is little left in most of them but ink, bright washes, and paper.

The firm's primary role in the fine arts was to assist in driving the work of serious painters out of the cheap wall decoration market. Although the Native School was at the time so successful in other directions that the economic loss was hardly felt, the delayed economic and social effect was serious. Currier and Ives's methods contributed to the almost complete break between the vernacular and the fine arts, the people and the painters, that was to develop as the Native School faded into the past.

For many people, the words "Currier and Ives" connote at their most agreeable a microscopic part of the firm's output: ten prints out of between seven and eight thousand. Like *Home to Thanksgiving*, these are farm scenes after paintings by George Henry Durrie (1820–1863).

The son of a New Haven bookseller, Durrie was so absorbed in his Connecticut birthplace that when his picture *The Sleighing Party* was exhibited at the National Academy (1845), he did not make the half day's journey to see how it compared with the work of the national leaders and in his diary recorded thus vaguely what he was told: "Cole made some favorable observation concerning it." Since he noted more fully the comments on his art of local housewives, we need not be surprised that he did not submit again to the Academy for twelve years.

That New Haven was the seat of Yale University no one would know from Durrie's diary; that it was a provincial center was abundantly clear. Roaming like a terrier, he sniffed into churches to attend the weddings of strangers; he was endlessly gregarious; he was fascinated by domesticity and the minutiae of daily living. He produced portraits — he would only take a

[212]

likeness from a corpse* in hot weather if "application is made in due season" — coats of arms, "pantry pictures" (i.e., still lifes), signs, painted window shades, genre, landscapes, particularly the snow scenes, which were his and his public's favorites.

The Hudson River School was little concerned with winter, partly because the artists were then in New York City working up their summer's sketches, partly because the great snowfalls of those days closed the woods to artistic hikers and so added to the labors of the farm that happy winter scenes were envisioned as around the hearth, not out in the fields. Snowy landscapes were usually painted on the vernacular level and featured the sport of sleighing.

Durrie was not country-bred, yet his New Haven was a small market city, and many of his clients were farmers. For him the fields were both an escape and an intimate part of his existence. Thus he painted winter scenes in which the accouterments of labor connoted not frozen, aching muscles but fine meals. The chickens are clearly tremendous layers; the tools are arranged precisely in sheds; the logs being pulled by oxen on sledges have been cut and loaded — they will slip easily into a roaring fire; the cows have been milked; and the farmer stands on the porch welcoming guests to a hospitality all the more cheerful because of its contrast to the gleaming cold.

Durrie was a persuasive reporter. His object — verisimilitude — and his emotion — contentment — are conveyed with an immediacy usually reserved for greater art. He was surprisingly successful in combining into a unified impression means that vary from the childish to the knowing. He represented expertly objects as they are duskily seen in dark interiors by eyes peering in from sunlight; but his human figures, however well placed or gestured, are flat, as if cut from colored paper. Although the grayness of frozen mist often obscures most convincingly his deep vistas, all atmospheric effects come to a halt in his middle distances. From the line of farm buildings that back his detailed action ahead to the foreground, no air disturbs the uncompromising sharpness of his forms. Effective use is made of thick and thin paint textures to suggest the shagginess of trees partly covered with snow. However, his locally spotted colors are often garish

*Before the prevalence of the photograph made such last-minute resurrections unnecessary, portrait painters on every level of competence were called in to snatch the dead from visual oblivion. William Sidney Mount, for instance, usually charged double for a portrait "after death," and was particularly proud of his ability to bring "the loved one into your very presence with fine form and freshness of color, the eyes looking at you."

against the pinkish mauve which he loved to apply to raw wood, shadows on the snow, and some skies.

Durrie's cooperation with Currier and Ives took place at the very end of his life: six of the ten prints were issued posthumously. However, such publication was so little considered an accolade that as a painter he remained unknown outside New Haven until his canvases were exhumed in the 1920s.

Innumerable painters served, as Durrie did, provincial communities across the whole gamut from sign painting to easel pictures in a wide variety of modes. Those whose canvases sold to the best markets in the larger regional centers practiced approximations of the more sophisticated techniques of the Native School. A few, whom we have discussed or shall discuss, worked with an effect commensurate with Durrie's. However, the majority of the provincials were not knowing enough to excite with verisimilitudinous images, but too knowing to please the eye with naïvetés.

The more naïve examples of our vernacular tradition became a collector's fashion when in the 1930s the fad for Currier and Ives lost its freshness. The pictures have been described by two indicative appellations. They were "discovered" by adherents to the French modernistic admiration for primitive arts; they were called "American Primitives." However, as the Currier and Ives set got on the bandwagon, stronger nationalistic implications were desired. Inheriting the selling point of being considered "the most American" of our artistic expressions, the pictures were dubbed "American folk art."

To exalt their favorites, the supporters of the movement ignorantly damned the more knowing painters of the Native School as slavish imitators of European manners and assumed a sharp break in style and attitude between "Academicians" and "folk artists." However, no one who is in the least informed has ever succeeded in charting the supposedly wide gap. One would certainly have existed had the connoisseurs and foreign-trained painters of the early nineteenth century succeeded in establishing here, as the most admired style, a neoclassicism that denied American experience. However, since the Native School did not break with the vernacular base but evolved out of it, artistic practice was a solid pyramid rising from the work of the most naïve to that of the most knowing painters.

Although to be "self-taught" is considered the particular "virtue" of "American folk artists," our mid-century leaders, from Cole through Homer, were in essence self-taught. Even in the National Academy any other form of learning was frowned on as detrimental to individuality.

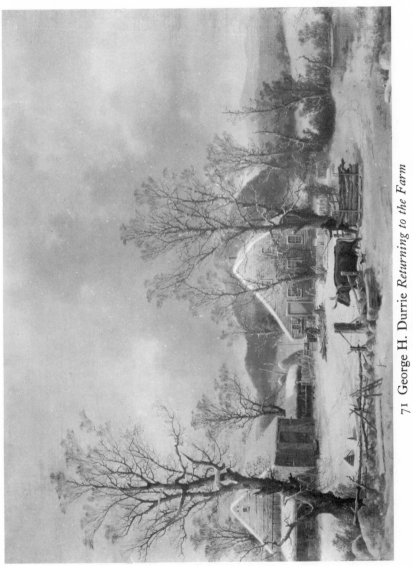

71 George H. Durrie *Returning to the Farm*

Oil on canvas; 1861; 25 × 36; Robert L. Stuart Collection, New-York Historical Society, New York.

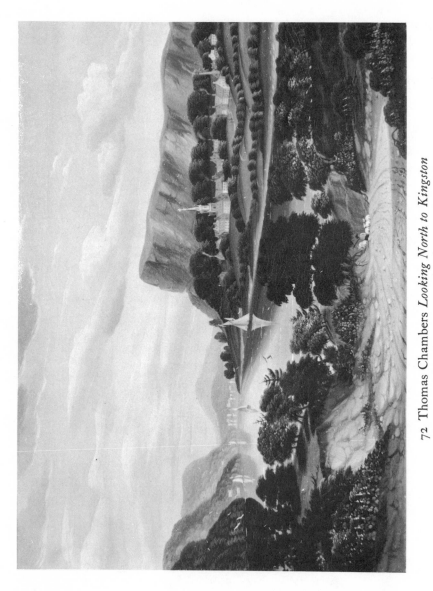

72 Thomas Chambers *Looking North to Kingston*

Oil on canvas; 22½ × 30; Smith College Art Museum, Northampton, Massachusetts.

Almost all beginners first practiced the naïve manner automatic to inexperienced hands. However, such renditions of forms as outlines to be episodically colored and juxtaposed into flat, noncontinuous designs had then no esthetic sanction. Among able and ambitious artists, only Catlin tried, in the manner of twentieth-century "modernists," to refine these automatic conventions into a mature means of expression.* Every other artist seriously interested in self-improvement moved towards a more naturalistic style. The *American Art-Union Bulletin* expressed the general attitude towards painters who remained in the "folk" ranks. Having admitted the existence in the United States of impediments to artistic knowledge from which Europe did not suffer, the writer continued: "But all these disadvantages, while they present reasons perhaps against the adoption of this profession, furnish no excuse for indolence in the prosecution of it. . . . We cannot afford to support here ignorant, stationary, or narrow-minded artists."

Huntington put the matter more sympathetically, when he wrote of his own early works, "In one respect, the first charcoal studies by a boy resemble the highest efforts of a great master: they aim at expression solely, striking at once at the main result, regardless of unimportant particulars. In the beginner, it arises from ignorance of the parts; in the master, from the power of subordinating them."

Since more ability to subordinate the parts was required at every increased level of income and taste, artisan painters who remained "folk artists" had to be satisfied with obscurity and such small fees that the pressure to work with speed had a major effect on their practice. Thus the muralist Rufus Porter (1792–1884) offered, when he knocked on doors from Virginia to Maine, to decorate walls for less than what wallpaper would cost. An endlessly ingenious Yankee who was to patent many inventions and abandon art to edit the *Scientific American*, Porter stamped on some foliage with a carved wine cork, beat on more with the end of a stiff brush, slopped paint through stencils to depict windowed farmhouses, thus completing the four sides of a parlor in less than five hours. Anything else requiring too much care, he applied himself wholeheartedly to the basic function of decoration, producing designs that have to modern eyes a most ingratiating wild charm.

Although Porter's murals were as far from visual naturalism as our abler nineteenth-century artisan painters ever remained, his attitude was basically naturalistic. Between his trees with their bending sprays of foliage, between his hills that mount into the walls away from us, observing his towns that

*Amusingly, Catlin has never been acclaimed as a "folk artist," perhaps because he became too expert, perhaps because he was already well known before the faddists tried to revolutionize American criticism.

cluster at points of emphasis, we seem to be out of doors in a world that, although stylized, is happy, smiling, beneficent to man. Porter's mood was that of the Hudson River School. And when he put on some conspicuous wall an imagined scene, it was usually from the Bible in the manner of Martin and Chapman and the early Cole.

Thomas Chambers (active in America c. 1832–c. 1866), an English-born workman so obscure that his movements between Eastern cities can sometimes only be traced in census records, did typical Hudson River School compositions in a style that gains from slapdash a gusty energy and boldness of design, but not without a corresponding loss of subtlety. Other artisan landscapists remained closer to the old topographical mode. They contrasted the horizontals drawn by roads and fences with the rectangular shapes of barns and houses to break their compositions into balanced static elements which, in the foreground, contain genre elements. Their mood was likely to be that of Durrie, although their skill was less.

Naïve painters had, unless they happened to work in the same communities, no way of seeing each other's work. Influences from the outside were primarily supplied by prints, from the most humble illustrations to fine arts reproductions, which disseminated the stylistic conceptions of the centers. That modifications by different individuals had a certain uniformity was due to independent reassertion of the innate tendencies of the uneducated eye and hand.

"Folk" portraiture followed, although with a time lag, the fashionable academic forms. Thus Erastus Salisbury Field (1805–1900), who served as resident artist in a succession of small Massachusetts towns, composed his likeness according to the attitude which Stuart had passed on to Elliott. He lavished his most careful efforts on heads which he managed to show with some naturalism in the partial round. Skimping bodies, as Stuart and Elliott did, he drew them flatly in a series of personal formulas, placing the same linear combinations of shoulders and costume under widely various heads. Such a dichotomy between the treatment of head and torso was so common among "folk artists" that their enthusiasts have believed that they painted during the winter hundreds of bodies to which, after the roads were open, they added specific heads. Actually, they followed the age-old practice of sophisticated artists, painting the heads first even if they later added the bodies in the seclusion of their workrooms.

Like other vernacular painters, Field found in women's furbelows amusements for his brush and eye well suited to his flat, episodic technique. This

73 Erastus Salisbury Field *Mrs. William Russell Montague*

Oil on canvas; 34¼ × 28; Pocumtuck Valley Historical Society, Deerfield, Massachusetts.

74 American School *Portrait of a Lady*

Pastel and watercolor on paper; c. 1830; 28¼ × 21¼;
New-York Historical Society, New York.

brought a decorativeness to naïve portraits of women that more sophisticated work lacked, but, as in Field's case, the effect was usually superficial, more effective in a photograph of the picture than in the original, where the tameness of the paint quality can be observed.

Local artists who painted anything their communities would buy, who embellished banners, signs, fire engines, and walls as well as canvas, were likely to work sometimes, as did popular illustrators, in the historical mode. However, they hardly ever leapt towards unusual imaginative forms, but rather continued aspects of neoclassicism and romantic idealism which were fading out of sophisticated American practice.

Field painted *Gardens of Eden* in the manner of the early Cole, and dramatic compositions based on illustrations in Sunday School tracts or in Bibles. His intended masterpiece, *Historical Monument of the American Republic*, (c. 1876), crowded to the edges of a tremendous canvas a gargantuan and impossible neoclassical building intended to symbolize, with the low reliefs painted upon it, the whole sweep of American history. When seen in all its crude actuality rather than shrunken into a neat-appearing photograph, this picture proves to have hardly any esthetic quality; it is one of the curiosities of our art.

On the rare occasions when vernacular artists attempted the macabre, they suffered from an unhappy dichotomy between the naïveté that allowed them to undertake such subjects and their continued subservience to the demands of the times for illusionistic realism. Thus when Charles Codman (1800–1842) of Maine, who had been an enlivener of clockfaces, undertook to show an ingénue frightened by a skeleton in a cave, he did not let himself go, but attempted to paint the incident — as in Allston's *Dead Man Revived* — the way it would actually have appeared to a spectator outside the frame. For this, his technique was utterly inadequate.

Under the general heading of "folk artists," the naïver artisans are currently grouped with amateurs who played a very different social and cultural role. These were almost exclusively women.* The seedbed of amateur painting was, even if graduates continued to practice it, the finishing school. Although an occasional lady later made pin money from her work, the basic objective was a polite accomplishment. Instruction was aimed at enabling every pupil, including those without skill or application, to achieve results

*While eighteenth-century gentlemen had not uncommonly painted for fun, this recreation had become obsolete with the sharper social division between the sexes. The males who now painted as amateurs—they were usually Bostonian disciples of Ruskin—were gravely demonstrating taste. If their work was not effective, it was also not naïve.

that would please parents and entrap suitors. This was the attitude in which the piano, dancing, and fine needlework were taught. Drawing masters often doubled as dancing masters: professional painters would have been subjected to the jeers of their colleagues had they thus demeaned their skills.

The finishing school curriculum was dedicated to "copying from examples." It is a rare amateur picture that does not have an engraved or lithographed source. That is, unless it was a still life executed through the stencils ("theorems") the teacher provided.

That the purpose was the embellishment of gentility determined the selection of prints to be copied. Many were the work of those English illustrators who were so expert at conveying refinement. Others represented the aspects of professional American creation best suited to correct feminine taste. No composition seems to have been used more often than *Youth*, the most idyllic of the episodes in Cole's *Voyage of Life*. The pretty female heads and the scenes of domestic felicity that Currier and Ives produced under Frances Palmer's supervision were often in the finishing school copying-racks.

Insofar as amateur work resembled that of the naïver artisans it was because both groups copied similar engravings with a similar stylistic innocence. But since there was much less pressure on the ladies to become proficient according to accepted esthetic standards, they made more wholehearted and gleeful use of the expressive possibilities of primitive distortion. Even if the emotions they could portray were rigidly limited by convention, they were at their best with imaginative subjects, which appealed to the surging romanticism of their young temperaments: Biblical and medieval scenes; elegantly costumed young ladies succoring beggars; exotic, virginal courtships; pictures that drop, in Hawthorne's phrase, "a maiden's sunshiny tear over imaginary woe."

Among the young ladies who drew with prim wildness there was undoubtedly more natural talent than among the artisan painters. With extremely rare exceptions, male professionals who had ability used it to climb at least some distance up the ladder of increasing knowledge. But even the most gifted women were held by social restraint in the naïve ranks.

This writer found in Plymouth, New Hampshire, a black and white crayon drawing that bears on the frame the legend "The Magic Lake," and written on the back: "Charles has not many pictures. If he cares for this it is his. Work done in 1864 by his mother, . . . E. L. Cummings." If Charles did not want it, he did not deserve such a mother.

[218]

The picture is based on a scene from a stage melodrama as reproduced in a Currier and Ives print that was often copied. Most of the amateur versions are routine. But in greatly enlarging her source, this young lady transmuted fustian into ecstatic terror. We look, under an unnatural bridge of weirdly convoluted cliff, down a deep vista where the moon sets huge over evilly tranquil water. Into the left middle-distance floats a mist that bears with it and half reveals rapt, winged cherubs and a dour Hecate who needs no wings. In the foreground, outside the arching cliff, on the marge of the glassy lake is a magic circle enclosing two figures. A black-robed wizardess waves her wand with the ease of habitude, her other hand pointing at the vision. Beside this calmly standing figure, a young girl kneels, her hands upraised in a wild gesture, her profile, silhouetted against the moonlight, a distorted image of grave, eager fear.

What other pictures did E. L. Cummings create? No one knows. The chances are that no other was as good as this one. Naïve artists, who are not in control of their medium, depend for their maximum effects on good luck, which does not often attend them. Thus the best examples of what is today called "folk art" are single works rather than exemplars of fruitful careers. Yet they can be very charming. *The Magic Lake*, which has hung over my desk as this book and others were written, has given me undiminished pleasure for fifteen years.

The delight we take in naïve art reflects nothing specific about the United States but rather a universal aspect of the human lot. A child chanting without premeditation throws off a poem that many a laborious adult versifier might envy. The quality is freshness, an instantaneous response like that of the eye to an isolated image, of the ear to a sweet, unexpected sound. Similarly, if the untrained hand, by skill or chance, catches something with effect, it records unhackneyedly. The result is almost never profound. However, in the presence of naïve art, the viewer — particularly if he is sophisticated — feels free to ignore his critical sense. This induces what is less a sensuous or an intellectual than an introspective joy. For we all miss the Eden from which the passing years and the fruit of the Tree of Knowledge have banished us all. If a picture can make us dream that we have won back that innocence, we respond with happy gratitude. But that gratitude is of different stuff than the appreciation of great art.

{ 14 }

THOUSANDS OF LANDSCAPES
High Tide on the Hudson River

IN the mid-century, the majority of the best-known American painters were landscapists, and so high was the prestige of this once despised mode that Whittredge was amazed to discover in Italy that the Western world's most-admired pictures were not landscapes.

The Civil War and the subsequent economic dislocations that drove the genre painters away from human reality strengthened the national concern with American nature. Hearts responded to the celebrated lines in the hymn "From Greenland's Icy Mountains": "Every prospect pleases and only man is vile." If man studied hard enough in God's outdoor temple, would he not be profited, would he not be shown a way out of human trouble? The painted landscapes seemed more than ever sources of "moral influence" which "stir the deep sea of human sensibility." And the conviction that American scenery was uniquely beautiful was an even more grateful foundation for national pride now that our social structure needed careful interpretation to be regarded as an emerging utopia.

Almost everyone agreed with Jarves that American landscape painting had reached "the dignity of a distinct school." It was, he added, "the thoroughly American branch of painting, based on the facts and tastes of the country." To brand the movement as provincial, a Europeanized critic in the *New York Tribune* had coined the phrase "Hudson River School," but the name achieved national currency as a compliment. The general opinion was that expressed by a critic describing the American pictures at the Paris Exposition of 1867: "Every nation thinks it can paint landscape better than

75 E. L. Cummings *The Magic Lake*

Monochromatic drawing on paper; 1864; 21¼ × 29¼; James Thomas Flexner, New York; photograph, Frick Art Reference Library, New York.

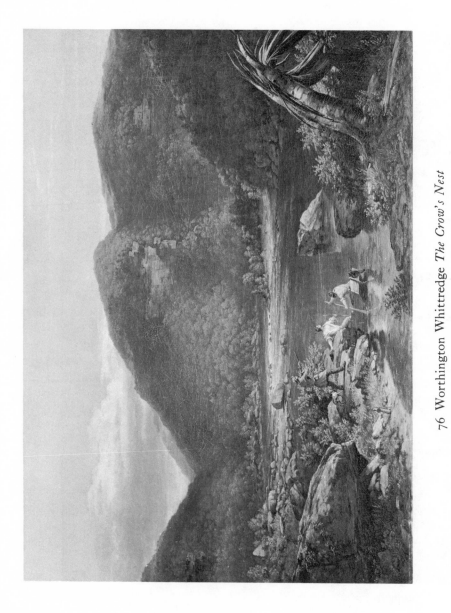

76 Worthington Whittredge *The Crow's Nest*

Oil on canvas; 1848; 39¾ × 56; Detroit Institute of Arts, Detroit.

its neighbor, but it is not every nation that goes about the task in a way peculiar to itself. No one is likely to mistake an American landscape for the landscape of any other country. It bears its nationality upon its face smilingly."

Even if the artists painted far afield, the title "Hudson River School" fitted, for the cradle of the style was the Catskill Mountains. Indefatigably exploring that complex of peaks and forests and inhabited valleys — those watercourses, first turbulent, then lazy, then mingling at last with the lake-like Hudson; the turning seasons there; the times of day; storm, mist, and sunlight — the landscapists established their way of seeing and their basic artistic idiom.

Some writers expanded the usual appellation to "the Hudson River and White Mountain School." Cole had tramped through Crawford Notch in 1828, when New Hampshire's mountain ranges were almost untouched wilderness. Artists continued to visit there, and in the 1850s a Boston group under the leadership of Benjamin Champney (1817–1907) met annually at North Conway with a New York group headed by Kensett. The Saco River, as it meandered through bucolic valleys under peaks, blossomed every summer with white umbrellas, each shading an artist at work. This shared activity established in New England a minor offshoot of the New York school, of which Champney was the most effective member.

As a boy in Boston, Champney had escaped from being a shoe clerk into a lithographer's establishment. After extended European rambles, he made Boston his headquarters until he moved permanently to North Conway, where his studio was a tourist attraction advertised in the local hotels. His paintings — the best are his oil sketches done directly from nature — are hardly powerful, but they spread gently colored lyrical charm when hung on domestic walls. To the historian, Champney has a second appeal: he wrote in his old age the autobiography often quoted in these pages.

The landscapists never shared the fear the early genre painters suffered that a blight might fall on their art if they went abroad: Church was exceptional in avoiding foreign studies. But on their return from European sojourns, they typically renewed their apprenticeships to the Catskills (or the White Mountains), laboring during rigorous experimental periods to assimilate their foreign acquisitions into the native manner that had been directly developed to express the American land.

It was [Whittredge wrote] the most crucial period of my life. It was

impossible for me to shut out from my eyes the works of the great land-
scape painters which I had so recently seen in Europe, while I knew
well enough that if I was to succeed I must produce something new and
which might claim to be inspired by my home surroundings. I was in
despair. . . . I hid myself for months in the recesses of the Catskills.
But how different was the scene before me from anything I had been
looking at for many years! The forest was a mass of decaying logs and
tangled brushwood, no peasants to pick up every vestige of fallen sticks
to burn in their miserable huts, no well-ordered forests, nothing but the
primitive woods with their solemn silence reigning everywhere.

Another problem for Americans returned from Europe was a difference
in light. The sculptor William Wetmore Story, fresh from Italy, complained
that at home "every leaf is intensely defined against the sky," and Henry
James, repelled by "a brilliance, a crudity which allows perfect liberty of
self-assertion to each individual object in landscape," quoted with approval
Story's conclusion that "the heart turns to stone." Story and James became
expatriates, but the hearts of the Hudson River painters leapt with joy as
they emphasized the clearness with which the American air reveals detail.
Church imposed this native characteristic on the humid tropics.

The world of the Hudson River painters was, at its most typical, not as
brightly colored as the European lands they had visited. As Story com-
plained, "earth never takes on the hue of heaven"; the clearer air did not
absorb so much sunlight. There was less cultivation to bring in the brown
of soil, the gold of grain, the polychromy of flowers. Nor was color heightened
by contrast with large areas of dark: where underbrush joined lower branches
to the ground, no pools of shadow gathered under trees. Even if the artists
exaggerated somewhat the hues of rotting, fungus-encrusted wood, the
American landscape was predominantly green, a monotone that encouraged
the School's use of an underlying monotint of gray.

There were, of course, autumn colors, such riots of red and yellow as
European scenery did not know. Even the loving Hudson River School
found the garishness hard to control, in their best pictures preferring to
autumn's full incandescence an occasional glowing passage enlivening
pervasive greens.

The American weather is more extreme than the European. We rarely
have days that, like a sampler, display all the vagaries of a temperate
climate. When the sun shines, it shines until Europeans fear they will be
blinded. Rain comes heavily from a leaden sky from which sunlight is
banished. Transitions are an extended movement of wind and cloud. Our

climate's volatile sprite, the thunderstorm, strikes like a foretaste of the Last Judgment and leaves behind giants of mist to elbow into clear blue. The painters were thus urged to think of weather not in the romantic manner as capricious, but classically as a fundamental display of character.

American scenery contained, of course, cultivated crannies, gardens, gracious and restricted vistas that might have been in Europe: these the School regarded as too untypical of their land to paint. Even in their smallest pictures, they never forgot that the continent was large. Their attitude was athletic, positive, devoid of self-pity or quaking nerves. When they looked at the dying day, they typically saw the splendor of the setting sun. To feel instead the romantic sadness of twilight was to move away from the core of the School.

Although centered on the Hudson River, the School attracted recruits from all over the nation. Worthington Whittredge (1820–1910) was born at Springfield, Ohio, in a log cabin which reverberated with hammering on his family's new frame farmhouse. He worked long in the fields and briefly in school, was apprenticed to a sign painter, failed as a commercial photographer, and abandoned itinerant portraiture when, aged twenty-three, he was enabled in Cincinnati to study some Hudson River School canvases.

Bingham's successful efforts in St. Louis to build a landscape style suited to flat, Middle Western scenery was to have no important seconders. Although Whittredge came to realize that "grandeur in a perpendicular line" was "altogether unsuited" to him, he now preferred, among the possibilities in Ohio, hilly scenes that resembled what the Hudson River School painted. His most powerful early picture, *The Crow's Nest*, features a wilderness. All the details of jutting rocks and mountain foliage are made to contribute to a sense of the tremendous current that endangers backwoodsmen about to launch a small boat.

Having secured from Ohioans support in the form of commissions to be painted abroad, Whittredge embarked in 1849 for Europe without pausing at the Atlantic seaboard. He found nothing to hold him in England and Belgium. He spent a winter in Paris looking vainly for some landscapist he considered worth studying with. Told that a group at Barbizon were "genuine kickers against all pre-existing art," he set off there.

The Barbizon School marked France's belated entry into the nineteenth-century flow towards naturalistic painting of local landscape. The movement had begun during the late 1830s, first with the work of Rousseau and then of Daubigny; Corot had come in during the 1840s. For long after Whittredge

visited them, on into the 1860s, the Barbizon artists were considered outcasts by correct French taste, since they did not try to improve nature in the interest of the ideal. The Count of Nieuwerkerke, the head of all official patronage during the Second Empire, exclaimed, "This is the painting of democrats, of those who don't change their linen, and who want to put themselves above men of the world. Their art displeases and disgusts me."

"I went to Barbizon," Whittredge remembered, "where I heard several young landscapists had congregated to set up a school by themselves. . . . They were represented as being very poor. . . . I liked the spirit of these young men but did not think much of their pictures."

This was to be, as the Barbizon painters became better and better known, the usual Hudson River School reaction. The Americans had their own longer-established style which saw larger vistas through clearer air. Jervis McEntree considered Corot "incomplete and slovenly. His landscapes are ghosts of landscapes," not "honest impressions of nature," but efforts to attract attention with something *"outré."* A critic asked typically how anyone could take seriously a picture in which "a swamp and tree" constituted "the total sum."

Paris, to which Whittredge returned, proving too expensive, he moved on to Düsseldorf. There he stayed, to the pleasure of his German-American patrons in Cincinnati, for four years. Primarily under the influence of Andreas Achenbach, he remade his style, painting pictures which, like *The Foot of the Matterhorn*, seem German works of the second rank. His formerly restrained color has become brassy, effect being sought by an unrelieved contrast between the icy-blue peak and a valley of warm straw color touched with purple and pink. His brush now moved freely, following the large forms but creating an unpleasant, ropy texture.

Whittredge crossed the Alps to Italy. During five years there, he sketched in the summers and, wintering in Rome, painted European views, which he sold to tourists or sent back to Ohio. He was worried that the Old Masters did not mean more to him, but contentedly bored with the work of the international colony of living painters. Concerning his Italian stay, he wrote, "I came away with the feeling that it had been of little use to me, unless possibly it might have improved my taste."

Although Whittredge's American connections were still all in Ohio, on his return to the United States (1859) he resolutely settled in New York City. He found a visit to the New-York Historical Society a greater revelation than all the European galleries had been. "Few masters of any age," he

decided, had surpassed Cole in "rugged brushwork." And "when I looked at Durand's truly American landscape, so delicate and refined, such a faithful — if in some parts sober — delineation of our own hills and valleys, I confess that tears came to my eyes." The thought of his own work, with which he had been happy abroad, now filled him with "despair." He concluded that "if I turned to nature I should find a friend," so "I hid myself for months in the recesses of the Catskills."

However, when he tried to paint a forest brook in the manner of Durand, he could not down his Düsseldorf coloring: a yellow sky, shining in reflection from foreground water and seconded by brick-red soil, wrestled unpleasantly with the cool green of the American forest. If only he had made "a flying visit" instead of engaging in "long foreign study!"

During 1865, Whittredge, Kensett, and Sanford R. Gifford joined a government tour of inspection to the Rocky Mountains. They rode for more than two thousand miles through the dramatic scenery that was making Bierstadt famous. However (as will be demonstrated in Chapter 16), Bierstadt and the other painters of the Rockies who followed his lead cannot be correctly classified in the Hudson River School. No true member of that school applied effectively to this strange, grander scenery the methods they had evolved in the Catskills and the White Mountains. Kensett and Gifford tried, but produced pictures so reminiscent of their own Eastern world that they did not add the Rockies to their permanent repertory. As for Whittredge, he was most moved by the plains, which seemed to merge all his experiences. The flatness appealed to his childhood memories of central Ohio; there were "scarcely any" of the "underbrush and debris" that had bothered him in the Catskills; "nothing could be more like an Arcadian landscape"; and yet there was an American freshness: "vastness and the appearance everywhere of innocent, primitive existence." Painting the plains, Whittredge was at long last able to bring into a single whole the warring elements of his style.

His *Crossing the River Platte* had resemblances in composition to Kensett's more panoramic Eastern views: the distant mountains served as walls to close the picture in, and despite the greater depth Whittredge painted, he also, by emphasizing horizontals and lengthening his composition in relation to height, indicated that space continued laterally. In marked contrast to Bierstadt's busy, melodramatic generalizations, Whittredge's picture breathed the hushed calm of Kensett's best work and was minutely faithful to local details of atmosphere and topography.

Into this Kensettian manner Whittredge assimilated European skills. Keeping to a minimum his formerly bruising pinks, he achieved lyrical color brighter because of less religious adherence to the Hudson River School spatial progression of black and white values. If, as a result, his distances are less continuous than Kensett's — bands of action succeed each other a little disjointedly like those in a stereopticon view — the chromatic richness compensates. Above all, he escaped from the sharp, miniscule draftsmanship that, in most Hudson River School canvases, made small forms show best to close scrutiny. Presenting to such scrutiny almost unrepresentational strokes of color, Whittredge's details merge into shape only when you step backwards. All parts of the picture are painted to be seen from a single vantage point.

Although Western scenery served as the catalyst in the formation of his mature style, Whittredge continued to be primarily concerned with Eastern landscape. He found particular pleasure, as Durand had, in recording forest interiors shaded under sunlight. But his results now depended less on clearly viewed details of form and broken light, more on broad naturalistic variations of tone.

Unlike the writers who were identified with the native aristocracy superseded in Jacksonian times, the Native School had been little concerned with the older aspects of American life. It was not a brooding patrician but the log-cabin-born Ohioan who first painted the eastern seaboard as long inhabited. To Whittredge one hundred and fifty years seemed a very long time. Over and over, he depicted such a weather-beaten gambrel-roofed farmhouse as Hawthorne might have peopled — but Whittredge's mood is not refined, ghost-haunted melancholy. His setting is wild: a pitted road, a superannuated stone wall, scraggly fields, and beyond, barren dunes receding to a gray ocean. Chickens, not witches, cackle; a healthy family, haying with cheerful strength, makes the old also new.

As on the eastern seaboard the forests fled up onto the mountains, and the population became increasingly unfamiliar with virgin wilds, the wilderness tended to recede into the backgrounds of Hudson River pictures or to vanish altogether from sight. Artists, like the brothers William (1823–1894) and James McDougal Hart (1828–1901), who painted pictures for quick sale at auction houses, found it economic to switch in mid-career from garnishing forests with deer to garnishing pastures with cows.

A charming bucolic note was struck by John W. Casilear (1811–1893). He had accompanied Durand, Kensett, and Rossiter on their hegira to

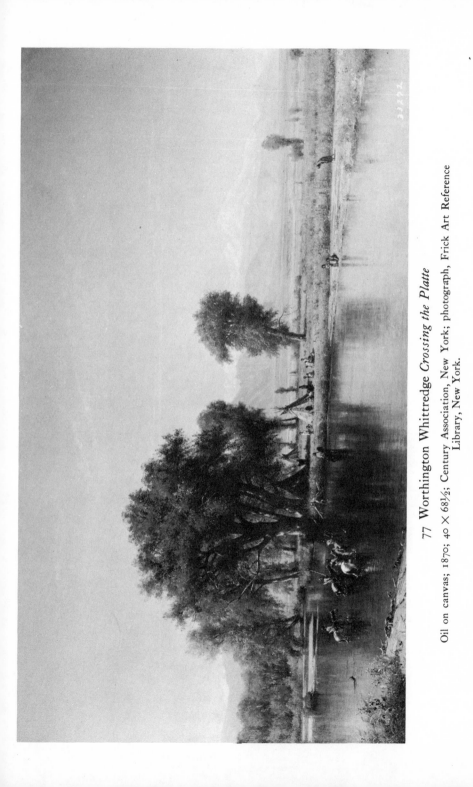

77 Worthington Whittredge *Crossing the Platte*

Oil on canvas; 1870; 40 × 68½; Century Association, New York; photograph, Frick Art Reference Library, New York.

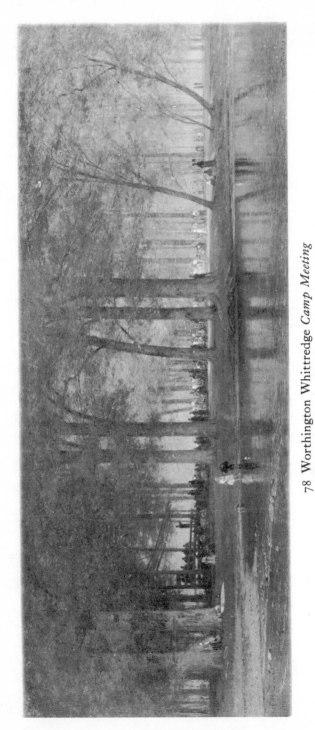

78 Worthington Whittredge *Camp Meeting*

Oil on canvas; 16 × 40¾; Metropolitan Museum, New York, Lazarus Fund, 1913.

Europe in 1840, but had been afraid to turn his main attention from his lucrative practice as an engraver until he had in middle age (c. 1857) laid by a competence. Usually keeping his canvases small, never succeeding mightily, failing only when he attempted a subject that, like Niagara Falls, required boldness, Casilear was at his best when he painted flat pasture land, lushly green with fertility, cut by still waters that reflected the clear blue of smiling skies. Admired for its "serenity" and "sweetness of tone," his art expressed with quiet dignity the relaxation which the fields bring to city dwellers sad in heart.

In the attics of old houses, one comes on the final proof of the tremendous popularity of the Hudson River mode, that "trash literature of the brush" with which, so Jarves tells us, incompetent artists successfully "deluged" the public. In these canvases, often large and complicated and expensively framed, natural forms were put down facilely according to formulas derived not from nature but from the work of the leading American landscape painters. Such copying pleased, since it called to mind better pictures widely admired.

Between the trash artists and the leaders there was, of course, every grade of achievement, and the demand for good pictures outrunning the supply, reputations spilled over to artists of the second rank like the Hart brothers and Jervis McEntree (1828–1891). Of the gifted painters only one used the wide public acceptance of the style as a cot to relax on. This was Jasper Francis Crospey (1823–1900). He had started out with power, but as the years passed, he shirked the Hudson River School duty of returning perpetually to nature for inspiration. Yet he remained too much a member of the school to seek through imagination subjective values. He painted literally the blurring images in his dimming mental mirror and tried to restore lost energy by making cacophonous use of autumn color.

Relaxation of naturalism could only weaken the Hudson River style. Supposing an artist went in the other direction, heightening sharpness of observation into the hypervisual, would he not slip over the edge into surrealism? The answer is yes — but the way was blocked. Surrealism must express obsessive personal emotion. However, it was basic to the Hudson River esthetic that the artist should, like an accurate and extremely sensitive instrument, reflect God's wonders without personal distortion. What we today call "magic realism" was not consciously sought. It could appear only as an undesired breakthrough of subliminal emotions.

Naturally, such breakthroughs appeared the more often the less artists

had technical control of their results. However, the same wobbly executive powers that opened the work of amateurs and cruder artisans to unconscious manifestations, almost always prevented strong esthetic realization. Usually, the surrealist elements are no more than potentially exciting bits embedded in compositions otherwise bland. When a picture is powerful in its entirety, it is an isolated example,* the result, one gathers, of happy happenchance. We know of no other work from the unidentified hand that painted *Meditation by the Sea*. This is a Kensettian beach scene gone wild, dominated by a small, misshapen figure who, as he stands with his arms folded in a Napoleonic pose, raises with his hypnotic stare the waves that the ocean, elsewhere calm, dashes at his feet.

Among skillful artists, only Martin Johnson Heade (1819–1904) was subject to surrealist explosions. His father, a prosperous Pennsylvania farmer, indulged him with two years in Italy when he was in his teens. This experience had so little effect that his first known picture, *Rocks in New England* (1855), differed from the Hudson River manner only through exaggeration of the normal mannerisms. Whatever interior seething it signaled, the overemphatic delineation of every detail served no esthetic or emotional end: it merely chopped up the composition. Heade's solution was not to follow further his personal bent but to try to tone himself down. That a trip to the radiant tropics was part of the process, shows both the perversity and pugnacity of his nature: he wanted to show that he could be restrained among the most flashing wonders.

In childhood he had been, as he wrote, "attacked" with an "all-absorbing craze" for those passionate darters, the hummingbirds. He loved to tame them to eat sugared water from his hand; he was to publish concerning them many a scientific article. In 1863 he went to Brazil to prepare illustrations for a book on South American hummingbirds. He never showed his subjects, as Audubon would have done, in flight. They are sitting for their portraits on sprays of orchids that dwarf them, the stems and leaves forming around them a decorative grill, through which we see a flattish backdrop, with which they are spatially unconnected, of softly painted tropical scenery. Charming pictures certainly, but more still-life compositions than views of flashing life. He took his portfolio to London to be lithographed, but when the first proofs were unsatisfactory, he jettisoned the project forever.

Despite the remonstrances of his closest artistic friend, Church, that he

*The only important exceptions to this statement are the canvases of Rimmer and of the coach painter Edward Hicks, who belonged to the generation preceding the Hudson River School. Both worked in the historical mode.

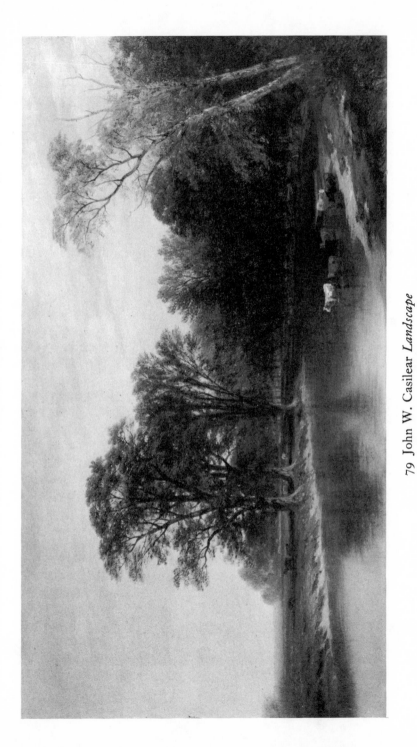

79 John W. Casilear *Landscape*

Oil on canvas; 14 × 25; New-York Historical Society, New York.

80 American School *Meditation by the Sea*

Oil on Canvas; 13½ × 19½; M. and M. Karolik Collection, Museum of Fine Arts, Boston.

"wrecked" his career by not establishing himself in New York City, Heade could not stay in one place. He wandered Central America, visited Puerto Rico, and set up studios in a dozen North American cities. Yet in his landscapes he struggled for the serenity of Kensett, whose concern with atmosphere and the times of day, whose long static compositions he shared, although with timidity and also a restlessness that made his sunsets sometimes garish, his foreground details often so strong that they broke his pictures in half. Over and over he painted similar compositions of salt marshes: a small foreground pool, haystacks, sometimes cows, more rarely human figures, low-lying hills, a cloud-shaded sky. These small pictures of flat, undramatic scenery were primarily studies of light. They found a ready sale in the household market, although Jarves considered them "wearisome" even if "flooded with a rich sunglow and a sense of summer warmth." Heade painted the tropics with so little of Church's splash that the *London Art Journal* ruled a view of Jamaica he exhibited in England as "dull," devoid of any appeal except "art merit." The critic, undoubtedly thinking of the difference between Heade and the Pre-Raphaelites, compl. mented the American on "simple breadth of treatment."

If such landscapes had been, with his hummingbirds and the formal stil lifes in which he silhouetted flowers for decorative effect, the sum of Heade': work, we would consider him, as his contemporaries did, an admirable second stringer. But sometimes his control broke. Significantly, this happened most often in what seemed the safest subject matter: his flower pieces. As the brilliant modern critic John I. H. Baur pointed out, Heade was "obsessed with the fleshy whiteness of magnolia blossoms startlingly arrayed on sumptuous red velvet like odalisques on a couch." To find an acceptable parallel for human sex, the Victorians often turned to the reproductive processes of inanimate nature. Often in Heade's flower pieces we feel a sexuality combined of fascination and repulsion. But the disturbing message is faint, only half expressed.

Heade's masterpieces are a few eerie seascapes. In *Storm over Narragansett Bay* unrestrained violence advances on bewitched calm.* The menace that rushes into the picture has not yet blacked out the entire sky; the lightening flash still strikes behind low bluffs across the bay. However, terror casts into the foreground hypernatural light, greenish but so much more than clear that it enlarges weeds, rocks, and sand. Still untouched by wind, the water

*The discovery in 1943 by Ernest Rosenfeld of Heade's *Storm over Narragansett Bay* was a dramatic event that rescued the painter from obscurity.

is a metallic mirror that brings the prophecy of storm to our very feet. Sails flap in the calm; the little pleasure boats are aimed at safety but remain motionless, held, it seems, by perilous adoration of the storm. A man and a boy have reached shore and have resolutely turned their backs on the lovely danger. They are in the position of walking, but they too will not escape. They do not move. They too are spellbound.

In the Hudson River manner, Heade's light effects — the soul of this picture — were achieved with values, but he abandoned subtle, naturalistic gradations for the most extreme black and white contrasts and he added colors to heighten mood. Like his colleagues, he shows nature as beautiful — but it is not beauty that comforts and purifies. It lures man to accept in ecstasy his own destruction.

Water had from the first appealed to the Hudson River School as an echo on earth of aerial effects. The first generation of painters had, however, made brooks, falls, and ponds compositional elements no stronger than the hills, meadows, and forests with which they were intermingled. As the second generation placed less emphasis on the shape of land and more on the glow of air, lakes moved into the foregrounds of mountain pictures. Thus James Augustus Suydam (1819–1865) established as the main motif of his *Study near North Conway* the angled push of cool water through warm brown fields. The smooth light-reflecting surface forced, lest it be overbalanced, simplification of the more involved shapes of earth. Suydam indicated variations in the fields with chromatic hints, and filled with only suggestive bands of warm and cool color the space between the middle-distance ending of the lake and the pale gray mountains which, softened by a haze, rise flatly to a pale sky. Such pictures, like the more light-struck works of Heade and Fitz Hugh Lane, have been grouped by Baur under the name of "luminism," and it has sometimes been falsely assumed that they represented a revolt against the canons of the Hudson River School. Actually Suydam, a wealthy merchant, worked in Kensett's studio. That Baur classed some of Kensett's work under luminism reveals that the movement was actually one aspect of the normal practice of the school Kensett led. It was, indeed, the growing concern with light effects where ocean met land that made the seashore, which had been ignored by the first generation of landscapists, such important subject matter for the second.

Among the "luminists," the one furthest from the Hudson River School was Fitz Hugh Lane (1804–1865); and he was so close that in all probability he would have been a full-fledged member of the School had he not been a

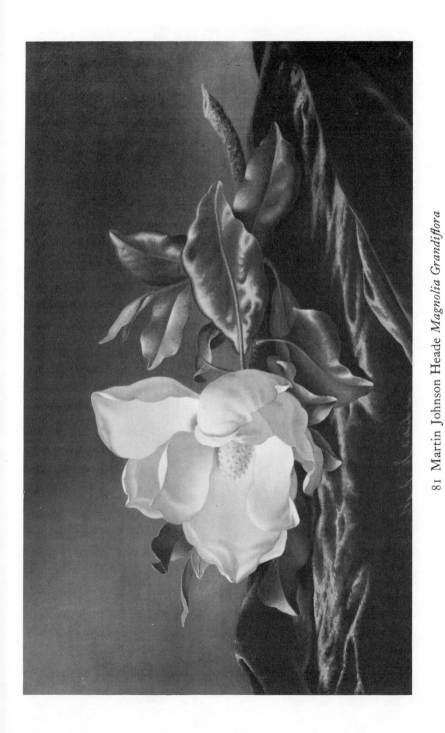

81 Martin Johnson Heade *Magnolia Grandiflora*

Oil on canvas; 15 × 24; M. and M. Karolik Collection, Museum of Fine Arts, Boston.

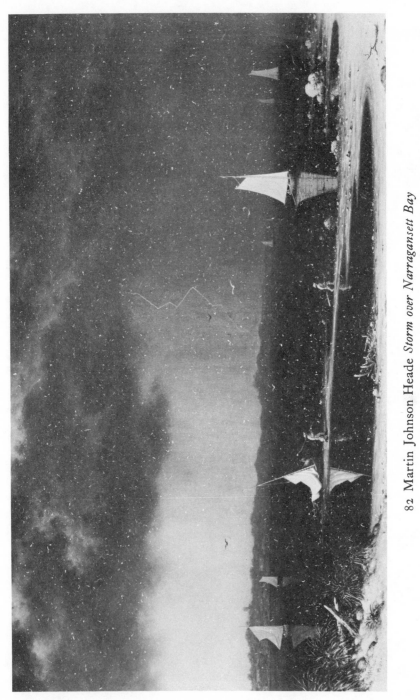

82 Martin Johnson Heade *Storm over Narragansett Bay*

Oil on canvas; 1868; owner Ernest Rosenfeld; photograph, Museum of Modern Art, New York.

cripple tied to a wheelchair. Thus, his professional beginnings were delayed — although in years a contemporary of Cole, in practice he was a contemporary of Kensett — and his career geographically curtailed. He exhibited only twice in New York City, where reputations were made and landscape painters developed their styles in happy unison. At twenty-six, he was still in his birthplace, Gloucester, Massachusetts, painting as an inspired primitive who imagined shipwrecks and rendered them in stylized, half-naturalistic swoops of line and color. Two years later, he went to Boston, where he worked in a lithographic shop beside Champney and Rimmer. Champney remembered that he was particularly admired as an accurate draftsman.

During 1849, Lane returned to Gloucester. In his continuing practice both as a lithographer and a painter he found harbor scenes particularly suited to his infirmity. Crutches would not carry him up hills, but when he sat on the waterfront, the scene shifted before him. The strength of his draftsmanship and the taste of a harbor audience for accurate ship portraiture joined to make his boats overinsistent. Under accurate rigging, dark hulls break into his renditions of ephemeral light as disturbingly tactile hunks. Land and the objects fastened to it being for an immobilized man completely static, he drew headlands, houses, and fences with a hardness that relied for its charm on the pattern-making of the craftsman-topographer. Like these humbler artists, he put in foregrounds more genre elements than belonged to the Hudson River style.

Lane's art would be unexciting were it not for his joy in the aspects of nature that shifted as he sat rooted: the traveling sun and blowing clouds, mists, and, on the water, glints, reflections, shadows. He expressed aerial effects with delicacy and elegance in his black and white lithographs. The color he added when he painted was not always an asset, particularly if it rose to a high key. But at his best, when he kept his skies dark to bring out the mingling of luminous tints in the water, he achieved true poetry.

Urged on by the strength of his feelings, Lane sometimes exaggerated contrasting values or the clearness of New England air. Yet, despite such intensities, he never broke with the fundamental objectivity of the dominant American landscape mood. As Baur writes, he seemed to have suspended conscious thought to permit the scene to impress itself with the purity of immediate perception. And like so many of his better-known colleagues, he preferred among nature's manifestations deep stillness and soothing calm. His mood was also ecstatic reverie on the real. That this artist, whose circumstances and market were so different, an isolated workman half naïve

[231]

though brilliantly gifted, deviated so little shows how basic the Hudson River manner was to American expression.

The style itself was evolving. By merging the small and the large chromatically in a single objective image, Whittredge pointed to the practice of Winslow Homer. And Sanford R. Gifford (1823–1880), whom many considered to be carrying into new times the romantic approach of Cole, was regarded by Jarves as a bridge between the "literal" Hudson River School and the "ideal" landscapes of Inness.

The son of a wealthy ironmaster, Gifford was raised in Hudson, New York, where he stared across the river at Cole's house as at a shrine. His father sent him to college, but in mid-curriculum, the young man abandoned more intellectual studies to follow his irresistible bent.

Gifford was already a member of the National Academy when he sailed for Europe in 1855. Although he felt in Cole's paintings emotions he wished to express, he was bored by the castles on the Rhine which Cole had wished could be transplanted to the Hudson. "No historical or literary association," he believed, "could help the landscape painter," who must "find something that was superior to man's work."

Asking himself, when deeply moved, "what causes all this beauty?" Gifford concluded that "the light giving properties of the sky," as carried to the earth by the atmosphere, imbued nature with sentiment, unity, and expression. He became so fascinated with "fleeting effects" that on walking tours he was willing to pause for only half a minute to sketch on sheets the size of a visiting card. If he took longer, might he not miss some greater beauty as it ripened and faded behind his back?

Among European pictures, Gifford was most impressed by the effects Turner achieved when looking into the early-morning or late-afternoon sun. But no more than his Hudson River School colleagues was he willing to accept the way Turner made light dissolve form. Even the Barbizon School seemed to him, in the usual American parlance, "slovenly." He considered Corot's finished landscapes scarcely more than sketches.

Gifford's efforts to make a single sky color dominate the American land carried him somewhat away from naturalism — he saw landscape, Jarves wrote, as if "through stained glass" — and forced him to seek light effects which, had they existed in nature at all, would have passed with great rapidity. But in the Hudson River School manner, he painted each vision as if it were a deeply established characteristic of the view.

In *Kauterskill Falls*, the theme is a reddish sunset glow which, as it enters

[232]

a deep central ravine, modulates into gray shadow. Mist clings to the earth, and wherever the mist controls, the paint surface is smooth. Where light hits unimpeded, impasto appears, even as tiny touches in the far distance. The foreground, which is as shaggy as an early Cole, is flooded with pink radiance that brightens cliffs and gives birches pink bark. Since it is autumn, no green breaks into a color harmony which, although startling, is restrained and simple. Foliage is either mist-gray or pink and gold. The far peaks are a smoothly painted flat boundary of gray; the sky is smooth pink and gold.

Although *Kauterskill Falls* looks at first glance, as so misty a scene actually would, shallow, the longer we stare, the more the cliffs push back, the more distant forms become visible. A long, narrow waterfall that drops through the middle distance becomes, although before unnoticed, the crux of the deep composition. And the pool below it sharpens until we feel the hard raggedness of the bluffs that crenelate its shores. Thus, as we stare, what seemed no more than a charming tour de force evokes (as Tuckerman phrased it) "the associations of a vast mountain range pensively glorified by the dying day."

Like Kensett, Gifford adhered for a lifetime to a style that was an inspired reflection of his own personality. He was "serene and placid," loving "nature in its most sunny phases." Yet he was restless too, a man who changed the usual painters' hobby of fishing into a passion, and sought far into Canada's northern lakes "the king of the waters, the finest fish that ever swam." His art, so the younger painter John F. Weir tells us, was an effort to find "the golden mean between extremes of hue and tone."

Gifford rarely consulted the notes he had taken in the presence of nature lest so doing would interfere with "the deeper values of memory." In his studio, he would lay aside all models and proliferate on canvases about ten inches by eight quick oil sketches until he hit an effect he wished to enlarge. Then he would get himself into top physical condition like an athlete training for a race. Finally, he would wait for sunrise behind the locked door of his studio and paint steadily until dusk — ten to twelve hours according to the season — not questioning what his inspiration urged. It was only after this Innesslike orgy that he applied the careful methods of the Hudson River School. He would meditate over the picture for months, making firm additions when he was altogether sure what he wanted to do. In the end, he varnished many times to create an atmospheric veil.

In 1868, Gifford returned to Europe for a two-year sketching trip that took him to Italy, Greece, Turkey, and Syria. Carrying only a knapsack,

he moved through the Old World as an anonymous hiker, an alien pair of eyes. After he returned home, he painted for an American audience what had seemed to him not "the dead, the ruined, the weak," but "the living, the perfect, the strong."

Gifford, Weir wrote, passed nature "through the alembic of a finely-organized sensibility" to avoid on one hand "superficial aspects that engage the common mind," and on the other, untruths "evolved from the vacuities of inner consciousness. . . . He knew well that the finest delicacies of nature are those associated with the most vigorous truths, — and [that] it is thus that sentiment is distinguished from sentimentality." Above all, "he steeped his brush in sunlight."

Remove from Gifford's style his fear of being too subjective, tone down but do not eliminate his emphasis on naturalistic detail, and you have the style of that greater painter Inness.

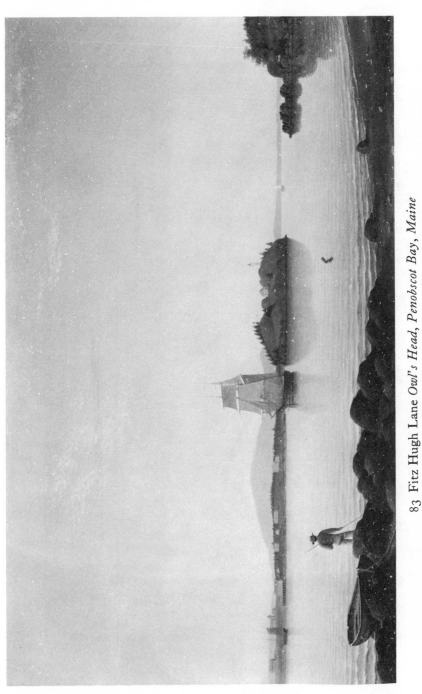

83 *Fitz Hugh Lane Owl's Head, Penobscot Bay, Maine*

Oil on canvas; 1862; 16 × 26; M. and M. Karolik Collection, Museum of Fine Arts, Boston.

84 Shepard Alonzo Mount *Fish and Turtle*

Oil on canvas; 1847; 10½ × 15½; Melville Collection, Suffolk Museum, Stony Brook, New York.

{ 15 }

STILL LIFE
A Backwater

IN his encyclopedic *Book of the Artists*, Tuckerman ignored the artistic possibilities of still life. Cummings's *Annals of the National Academy* grouped as equally unworthy appeals to popular taste panoramas and small paintings of fruit and flowers.

Although still-life passages played an important role in portrait and genre settings, and the plants in Hudson River School foregrounds were often meticulously depicted, to isolate such elements on canvas was considered a paltry occupation. Among artists admired today for their achievements in other modes, only the landscapist Heade paid enough attention to still life to develop for it a style.

To achieve a reputation as a still-life specialist was in the mid-century impossible. The closest approach was made by George Henry Hall (1825–1913), sometimes called "the celebrated art-fruitist," but equally well known for his slick illustrations of European life and landscape. Born in New Hampshire, trained in Düsseldorf and Paris, Hall added "art" to the "fruit" by making his still lifes tell a story. He combined objects to summarize an occasion — say Christmas in a European manor house — and reached for exterior mood through melodramatic lighting and windy brushwork.

Pure still life was impeded by esthetic theory. Although the subject matter of a picture was considered of first importance, that was only because of the emotional overtones conveyed. And natural or man-made objects were believed to lose value when separated from the larger whole that added clearer pantheistic or human significance. Since no distinction was made

between style or content — the one was only valued in so far as it expressed the other — it followed logically that subject matter considered mean could present no artistic problems worthy of accomplished professionals. To take still life seriously was to class yourself with lady amateurs who drew fruit on velvet and flowers in watercolor; with beginners who, far from art schools and professional models, tried to master form by painting things; with artisans who put tankards and high hats on tavern and haberdashery signs.

The most extensive exhibitor of still life at the National Academy was the one Mount brother — Henry Smith — who never escaped from the artisan ranks. His work reveals the limited ability that kept him from rising. A side of beef that would have clearly identified a butcher's shop fails to convince as an easel picture.

What happened on rising levels of practice is exemplified in the work of the other two Mounts. After he had become a successful if undistinguished portraitist, Shepard Alonzo wrote concerning a picture he had done of fish, "I sometimes think (and not without reason) that they are the only subjects I can paint really well." In his rendition of an angler's catch hanging in a cluster from a twig passed through the small, dead fishes' gills, he used chiaroscuro to shade some parts of the bodies as an effective dark background for the pearly, rough-textured scales that catch the light. This central grouping is impressive, but Shepard was at a loss for anything to do with the rest of his canvas. A dully painted form, identified as a turtle, looms from a pointless expanse of shadow. However much he enjoyed painting such pictures, Shepard did not try to base his reputation on them. Out of ninety-two canvases he exhibited at the Academy before 1860, only thirteen were still lifes.

The statistic for the celebrated Mount brother, William Sidney, was five still lifes out of one hundred and sixteen. His were quick oil sketches silhouetting a bouquet of flowers or a spray of small fruits against flat paint that served no pictorial purpose beyond enhancing the color scheme. To indicate that cherries were round he did no more than make highlights by touching each circle of red with one spot of silver paint. Although the result was bright and decorative, Mount could not regard his gay sketches as anything but an agreeable exuberance: the Native School saw little virtue in decoration apart from meaning.

It was to simpler taste that still life primarily appealed. When Durrie cheerfully classed his efforts as "pantry pictures," he indicated acceptance of the materialism of the times without any yearning for unmaterialistic emo-

tion. And on the humbler levels decoration was welcomed as an end in itself. Lady artists were not supposed to seek more meaningful effects, and vernacular workmen engaged in many an artistic activity that could have no object but ornament. They commonly in their own minds classed still life with these lesser aspects of their practice.

Only in Pennsylvania was there a continuous still-life tradition, and it was anchored in a single family. The portraitist Charles Willson Peale had set the stage in the eighteenth century by founding his museum of natural history, in which he used painting to provide settings for objects or to substitute for them. He taught his numerous relations to paint and employed them in his institution dedicated to science. Out of this double background came the basic concern of the Peale still-lifists with the presentation of things to direct contemplation under the best visual conditions.

The Peale manner, which Wolfgang Born called "botanic-decorative," reflected Dutch seventeenth-century practices as these were subsequently modified and made international by the rising interest in scientific natural history. (Charles Willson named a daughter Sibylla Miriam after Maria Sibylla Merian, a seventeenth-century German illustrator of botanical books.) The style was being practiced in France by the brothers Von Spaendonck, who had emigrated from Holland, one to work in the *Jardin des Plantes*, the other for the porcelain factory at Sévres.

The actual founders of the Pennsylvania School had been Charles Willson's brother and son: James (1749–1831) and Raphaelle Peale (1774–1825). Since neither went abroad, they were probably inspired by prints and chinaware. The manner they developed was carried on, throughout the period covered in this book, by their younger relations, principally James's four daughters, Maria (1787–1866), Anna Claypoole (1791–1878), Margaretta Angelica (1795–1882), and Sarah Miriam (1800–1885), and his niece, Mary Jane Peale (1827–1902). That these were all ladies, barred by their sex from high artistic endeavor, is not surprising, for the male founders of the school had not succeeded in bringing acclaim to the mode. James had been best known as a portraitist of the second rank, Raphaelle as a failure. The younger Peales, who exhibited regularly at the Pennsylvania Academy, attracted cheap sales and obscure followers, but little praise.

None of the ladies equaled James and particularly Raphaelle in power or illusionistic skill; some were a little crude, but all followed as best they could in the founders' footsteps. The typical composition was grounded on a table top which, filling the whole width of the canvas, cut in to meet at a

right angle a vertical plane of paint that, like a backing wall, kept the picture space finite and shallow. The horizontals of the frame established with the limits of the table a series of strong parallels. Contrasted with these and each other, carefully spaced in the limited depth, were the arcs made by the forward swelling of rounded objects. Probably because flowers were hardly susceptible to geometric treatment, the Peales made less use of them than did their European sources. Their favorite subject matter was fruit, extending from tiny raisins through peaches, pears, and apples to large wedges of sliced watermelon, in which the seeds picked out decorative designs. Small hard cakes were sometimes added. Stems supplied tentacles; leaves, thins to contrast with fats. Sometimes a bowl, plate, or glass helped in the organization of the various shapes into an irregular pyramid. Although forms usually overlapped, the individual identity of each was preserved. With brushstrokes, sometimes visible under a paint surface absolutely smooth, texture was indicated. Local colors were exactly reproduced, but orchestrated by arranging the objects with a casual-seeming care. Light was used in the foreground to throw the heavy shadows that emphasized form, and was often made to shine unnaturalistically in the opposite direction on the background so that bright passages might be shown against shadow and vice versa. Typically, the canvases were small, the number of objects few and ordinary, the total effect chaste and restrained, a statement of pleasure in simple things. Always the appeal of the pictures was largely decorative, and it became more exclusively so as the force of James and Raphaelle faded into the softer, less plastic styles of their female relations.

Many canvases in the Peale manner but signed with other names signal that Pennsylvania offered, in addition to a style to follow, a more concentrated — if unexalted — market for still life than existed elsewhere in the nation. This was undoubtedly because the German population had been accustomed, by the folk arts they had brought with them and were slowly abandoning, to paintings of fruit and flowers.

With the passage of time, painters in the unobtrusive Peale style had difficulty making themselves heard through the visual cacophony of Victorian decoration. To the call for more elaborate dining room pieces, the most opulent response was made by Saverin Roesen (?–1871), a German who may have begun his career as a porcelain painter in Cologne, and who came to America in about 1848. His lush conglomerations of flowers on marble slabs against romantic landscapes that could contain Old World temples were,

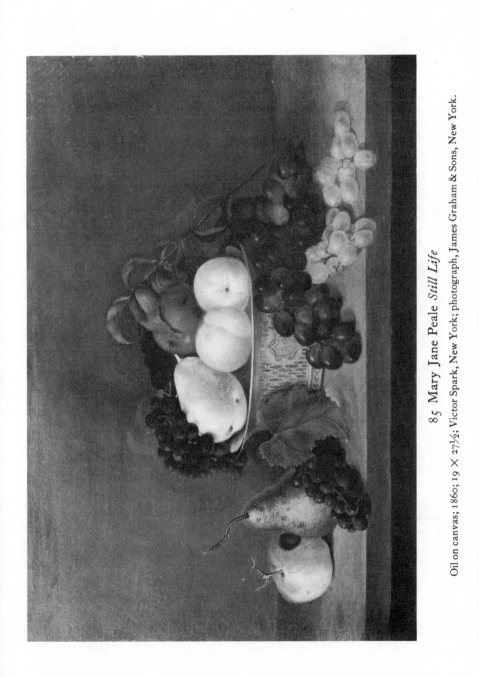

85 Mary Jane Peale *Still Life*

Oil on canvas; 1860; 19 × 27½; Victor Spark, New York; photograph, James Graham & Sons, New York.

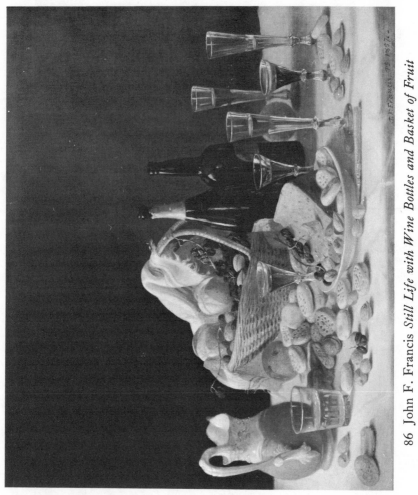

86 John F. Francis *Still Life with Wine Bottles and Basket of Fruit*

Oil on canvas; 1857; 25 × 30; M. and M. Karolik Collection, Museum of Fine Arts, Boston.

in the German manner, basically calligraphic; his success in the Pennsylvania hinterland was as considerable as his passionate intercourse with the bottle would allow. Today Roesen's large canvases seem in equal parts grand and ridiculous, decorative and vulgar.

John F. Francis (1808–1886) expressed the new elaboration in the older manner of the Peales. Born in Philadelphia of French Catholic parents, he worked throughout Pennsylvania, eventually making his headquarters first in Jeffersonville and then in Phoenixville. A general painter, he was proudest of his most conventional practice, portraits, a direction in which he had little more skill than the average provincial, although he produced a highly amusing small full-length of a fat politician in a silk vest posing as Cincinnatus in the company of a plow.

Francis's best still lifes preserve the table-top arrangement, the space firmly limited by an unrepresentational backdrop, and the objectivity of the Peales. Like them, he painted only dessert, but the number of objects is larger and his compositions correspondingly wider and deeper. While the Peales' shapes tend to overlap into a single complex mass, Francis spaces freestanding objects to play a visual tune in depth. Revealed in its entirety, the upward pull of tall, light, thin glasses establishes tension with the heavier squatness of opaque things. Francis relied less than the Peales on accurate local color, more on generalized values. Although his work lacks the exquisite verisimilitude, the restrained passion of Raphaelle, the greatest of the Peales, it has its own power and charm. Francis was the best American still-life painter of the mid-century.

None of the pictures so far discussed make the eye accept the actual physical presence of what was painted, since only depth at its very shallowest can be, without recognizable convention, simulated on a flat canvas. True *trompe l'oeil* was rarely attempted. When subject, technique, and moral intention were considered indivisible, to bamboozle the vision was ruled at best (as Ruskin put it) paltry jugglery, at worst (as Inness put it) fraud. The artists who attempted the mode were usually making practical jokes.

The Peales had used "deceptions" to tickle up the public in their museums. For Raphaelle, *trompe l'oeil* was a weapon in domestic warfare with his wife. Thus, when a careless puppy was driving the housekeeper to distraction, he painted on tin, to be placed on her best rug, a particularly repulsive mistake. Church, who carried meticulous illusion as far as was possible in landscape, carried it further only to amuse himself. When he executed one

[239]

of those compositions, beloved of *trompe l'oeil* artists, in which letters are fastened almost flatly to a board, it was to tease a man who had talked too glibly about realism in art.

Other workmen gave *trompe l'oeil* literary overtones by assembling objects to tell a story. Thus, the Washington cartographer Goldsborough Bruff (1804–1889) had the legible writing on the papers which seem to be stuck in a letter rack refer to various aspects of his career. Charles Bird King, whom we have met as a portraitist of Indians, crowded, for his *Vanity of an Artist's Dream*, a shallow cupboard with cheap food and the shards and impediments of art. He added, as if tacked to the outside wall, the notice of a sheriff's sale. Both Bruff and King felt it necessary to show that they were not really serious: the former included in his simulated papers a self-caricature, while King worded his sheriff's notice with sardonic humor. Not surprisingly, no mid-century example of *trompe l'oeil* passed beyond being a curiosity into the realm of art.

THE ROCKY MOUNTAIN SCHOOL
Bierstadt and Others

THE Hudson River School concentrated on depicting an area which, even if larger than many European nations, was, within the United States, restricted. They sought mountain scenery in New York State and northward among the Berkshires and the White Mountains, but they did not commonly follow the Appalachian range south even into Pennsylvania. For the seashore, they started in northeastern New Jersey, concentrated on Rhode Island, and only rarely went as far north as Mount Desert. Meadows were found mainly in New York and eastern New Jersey, sometimes in New England, eastern Pennsylvania, and Delaware.

The artists also painted the Old World, not only during their student years but also as a result of sketching trips made when they were mature and famous. They usually depicted places well known to history or legend, at first primarily in England, France, Germany, Switzerland, and Italy, later also in Greece, Turkey, and other more exotic Mediterranean lands. For culture and tradition not its own, the eastern seaboard has always looked more to Europe than to the American hinterland, and the Hudson River School was no exception.

It is more difficult to explain why those members of the Hudson River School who penetrated outside the usual Eastern beat for natural scenery only rarely and never consistently painted other parts of the United States. They preferred South America or even icebergs in far northern waters.

Unusual native phenomena, like the bayous of Louisiana,* were permitted to become the specialties of minor workmen, probably because they were not considered widely typical. Certainly, despite Bingham's triumph there, the Middle West did not appeal because-it was so flat. The California of the gold rush days was too rough to attract artists who could make their livings elsewhere. And there was little reason to travel from the eastern seaboard to find scenery which the artists could duplicate closer to home.

But what of the Rockies and the other great Far Western mountain ranges? Representations of those cliffed and precipiced regions appealed tremendously to the popular taste that had been nurtured on Eastern mountain views. Several leading Hudson River School artists made arduous trips to capture those higher and more extraordinary prospects. The results were never impressive or often repeated. Why did a style that could embrace the Andes and the Parthenon shrink away from these native wonders?

No reason is given in the writings of the time. One can only postulate that birthright American artists, who were happy to record foreign lands according to a manner developed for Hudson River scenery, felt a greater responsibility toward ~~nt nature within their own borders. Believing, as they did, that style gre./ from subject matter, they concluded that to depict the Rockies adequately, they would have to give them study as detailed as that they had given to the Catskills and the White Mountains. A tourist trip would not suffice, and they were New York artists. This explanation is supported by the fact that, at a time when every leading Hudson River School artist was American-born, every leading painter of the Far Western mountains was born abroad.

The founder of what I shall call the Rocky Mountain School was a German-American, Albert Bierstadt (1830–1902). Similarly, an English immigrant — Cole — had set the Hudson River School in motion, but the parallel goes no further. Cole developed his style in the region he was to paint. Bierstadt brought to the Rockies a manner developed in his trans-atlantic birthplace. Cole's followers, who evolved the true Hudson River idiom, were mostly birthright inhabitants of the area. The Rocky Mountain region was too newly opened to have any birthright artists.

Bierstadt was born near Düsseldorf, a cousin of the German genre leader Hasenclever, and was brought to New Bedford, Massachusetts, at the age of two. Showing at first more talent for business than art, he did not paint

*The bayous were exploited by Joseph Rusling Meeker (1827–?), a landscapist of mediocre powers who, after his training in New York City, wandered the Mississippi Valley, eventually settling in St. Louis.

in oils till he was twenty-one. When, a year or so later (1853), he returned to Düsseldorf, the sketches he brought with him were considered by Whittredge "absolutely bad." However, he showed remarkable determination and industry and was soon depicting in the most meaty Düsseldorf manner peasants frolicking against mixtures of architecture and landscape.

Back in America (1857), he took a postgraduate course from the White Mountains, recording the scenery not only in sketches but with a non-manual tool the Hudson River School usually avoided: the camera. The success of Church's *Niagara* as a popular showpiece did not escape him, and in 1858 he made, with a government expedition, his first trip to the Rockies. The gold rush was now ten years in the past and the transcontinental railroad eleven years in the future; the bloodiest wars with the Western Indians were just beginning; the Far West was in every mind, but no "real visual pictures" of it were available. When shown in 1863 Bierstadt's *The Rocky Mountains* set him up in competition with Church as America's most successful painter of showpieces.

Superficially the two artists had much in common: the large size of their major pictures, their method of exhibition, and concern with exotic rather than local scenery. However, the differences were much greater, and those differences are a measure of Bierstadt's departure from the Hudson River style. Where Church's big pictures are, because of their miniscule naturalism, the more effective the longer and more closely viewed, Bierstadt's are best from a distance and at first glance.

Bierstadt did not concern himself, in the Hudson River manner, with local subtleties of atmosphere, geology, or foliage. To his eyes, as he stated, the Rockies resembled the Bernese Alps, and indeed if no Indians or buffalo were included, many of his pictures might just as well have been painted in Switzerland. Far from seeking semiscientific exactitude, he commonly steepened declivities, sharpened peaks, and identified a mountain he had painted by whatever appellation would appeal to a potential buyer. Increasingly, he worked out and applied formulas for different kinds of trees, cliffs, clouds, etc. His objective was to exploit the most picturesque aspects of scenery for maximum effect.

Like Church, Bierstadt enjoyed dramatic light effects, but his were not studies from nature. They were worked out for maximum splash in his studio. Although what detail he included was drawn out with Düsseldorf (or Hudson River) thoroughness, he often arranged his light to cooperate with cloud and mist in blanking out large areas in the middle distance and

background, to give greater emphasis to a few sensational passages also studio-conceived: snowy summits glowing against suddenly unshrouded sky; dazzling, tastefully draped waterfalls. Genre elements, which the Hudson River School kept small and far back, Bierstadt brought boldly into the foreground: we see deer posing for their portraits or, as in *The Rocky Mountains*, a whole encampment of Indians who needed only a change of costume to be quaint Westphalian peasants.

Bierstadt's color was less observed than applied by rule: very lush green foregrounds, ice-blue water, blue and green mountains whitened in places by light rays and having no solidity, fleecy clouds shadowed above and glowing below. Far from advancing consistently into his backgrounds along the unbroken path of merging values so basic to the Hudson River manner, Bierstadt sought emotional effect with a sharp break between dreamy mountain heights and richer, more heavily painted foregrounds. This double organization, which expunged the middle distance, was, as we have seen, a common trick of German nineteenth-century landscapists.

The oil sketches Bierstadt made out of doors have a different flavor from the Hudson River School's. Each was done with great speed — he set fifteen minutes as his limit — the object being to improvise on a natural base stunning color effects. Looked at in rapid succession, the sketches seem exciting: they have vigor and clarity of hue; the eye is made to blink by an orange sunset springing from an otherwise cool canvas. But if you concentrate on a favorite for a minute or two, the effect diminishes like an overinflated balloon with a slow leak.

Wolfgang Born points out that Bierstadt typified the mentality of the Bismarckian era, which wavered between the old German love of the idyllic and a new spirit of aggression. Neither approach seems to have suited his temperament, for he was at his best in small, unobtrusive pictures which he did not take very seriously and which show him as an objective reporter. His *Guerilla Scene — Civil War* is moving precisely because it lacks striving for either poetry or power. The composition is simple, based on a sharp break between shadowed foreground and sunlit depth. Color is low and unforced, effective draftsmanship is not, as in his more elaborate works, obscured with froufrou. From the shadows soldiers shoot across a stone wall at fellow men grouped, tiny with distance, in the light. Death is indicated by no more than the miniscule galloping of a riderless horse. It is hard to believe that this painting made grisly by understatement is actually by the founder of the Rocky Mountain style.

The sources of that style are signaled by the fact that Bierstadt was to

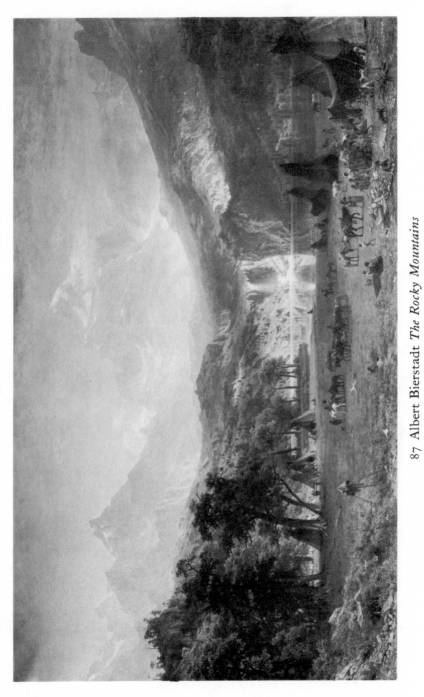

87 Albert Bierstadt *The Rocky Mountains*

Oil on canvas; 1863; 73½ × 120¾; Metropolitan Museum, New York, Rogers Fund, 1907.

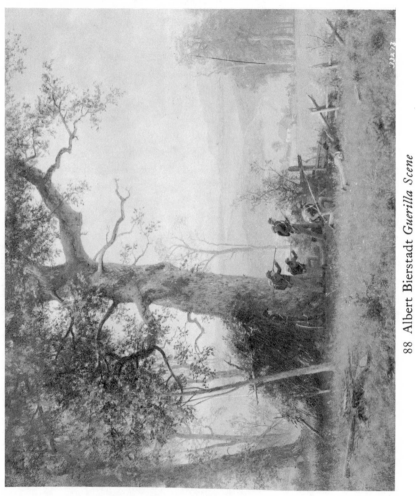

88 Albert Bierstadt *Guerilla Scene*

Oil on academy board; 15 × 18½; Century Association, New York; photograph, Frick Art
Reference Library, New York.

some extent anticipated by his fellow German-American Wimar, whose training combined apprenticeship to a Mississippi panoramist and formal study in Düsseldorf. Bierstadt's art was a cross between the slick, effectiveness of scene painting and the "*Stimmungs Malerei*," from which it got its approximation of serious art.

That Bierstadt cannot be correctly classified in the Hudson River School, that a separate Rocky Mountain School existed, is being for the first time argued in this volume. The painter's contemporaries did not feel it necessary to spell the matter out, the differences seemed to them so obvious. Jarves considered Bierstadt a Düsseldorf artist, as did Tuckerman, who added that "to this fact may be ascribed both his merits and defects."

As showpieces and when engraved, Bierstadt's large Western canvases were "a marvelous success" with crowds on both sides of the ocean. They moved expensively into the collections of American railroad magnates, English lords, Russian princes. He was enabled to build the bulkiest of the painters' castles that were appearing on the bluffs overlooking the Hudson. Named Malkasten, after the artists' club in Düsseldorf, it contained thirty-five rooms, the largest being his studio, fifty by seventy-five, and thirty-five feet high. There was plenty of the space for fourteen wapiti heads and other animal remains, the victims of his rifle.

Bierstadt received more praise from the sophisticated abroad than at home. American critics preferred Church because of his naturalism, but European writers familiar with the touring pictures of both artists usually chose Bierstadt because, as a London critic put it, he was clearly "not a mere copyist of nature." The resemblances between his style and scene painting, which were sometimes recognized, were generally forgiven on the assumption that such was the best way to represent such grandiloquent and uncouth scenery. Bierstadt's breast sparkled with medals awarded him by Austria, Prussia, Bavaria, Belgium, and France. However, the verdict of the Hudson River taste was that expressed by John F. Weir, who wrote that Bierstadt's "vast illustrations of scenery were carelessly and crudely executed." They represented, indeed, "a lapse into sensationalism and meretricious effects, and a loss of true artistic aim."

The other leading painters of the Rocky Mountain region did not share with Bierstadt particulars of technique as much as identities of attitude. All believed that the more unusual and stupendous the scenery, the more exaggerated should be the image.* Depicting even the most exotic South

*Despite lukewarm Eastern criticism, that doctrine rooted itself so firmly in the Far West that we find it expressed today in the candy-tinted reproductions of photographs in such magazines as *Arizona Highways*.

American volcano, Church was held to serious labor by his determination to have the canvas fool the eye into the belief that the body was actually there. But the Rocky Mountain artists could only too easily let the obvious excitement of their subjects lure them into lax exploitation. To this they were further encouraged by their conviction — which they took over from one facet of Hudson River taste — that an extensive view had to be put on a tremendous canvas. To paint carefully (as Church did) would have created only one huge picture a year, while in their heyday they could sell dozens.

Champney wrote that Thomas Hill (1829–1908) "can complete more pictures in a given time than anyone I ever met." This facility had proved on the whole a liability until Hill discovered the Far West. He had been brought from England to Massachusetts when he was twelve, was trained as a coach painter and self-graduated to portraiture, had gone to Paris as a figure painter and been redirected by his teachers to landscape, had failed to attract important attention with his depictions of the White Mountains, and then — oh, happy inspiration! — had adopted as his specialty the Yosemite Valley. He gave to large canvases a peculiar artiness, flaking on large brushstrokes borrowed from the Barbizon School and coloring everything dogmatically according to a formula of matched studio hues. Even if his pictures look as if they had been carved out of gelatine, they sold majestically — Senator Leland Stanford paid eleven thousand dollars for two — and he had in William Keith (1839–1911), who had also been brought to the United States from England as a boy, a disciple who stated, "I'd be satisfied if I could reach the power and success of Tom Hill."

The core of the Rocky Mountain School, like that of the Hudson River School, avoided frank subjectivity: when Bierstadt, Hill, or Keith departed from direct vision, it was with the avowed intention of communicating the essence of natural wonders. However, the Western school had in Thomas Moran (1837–1926) a heretic who repeated, if confusedly, some of the heresies of the Easterner Inness.

Moran was born in England, brought to the United States when he was seven, and trained as a wood engraver and illustrator in Philadelphia. When he revisited his birthplace at the age of twenty-five, he was vastly excited by the work of Turner. However, he was unwilling to seek out in Europe or conjure from his own imagination subjects that Turner might have executed. "I will," Moran explained, "paint as an American on an Ameri-

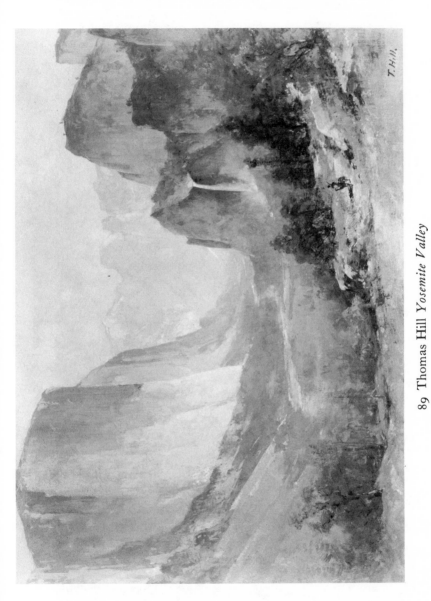

89 Thomas Hill *Yosemite Valley*

Oil on canvas; 18 × 24; Kennedy Galleries, New York.

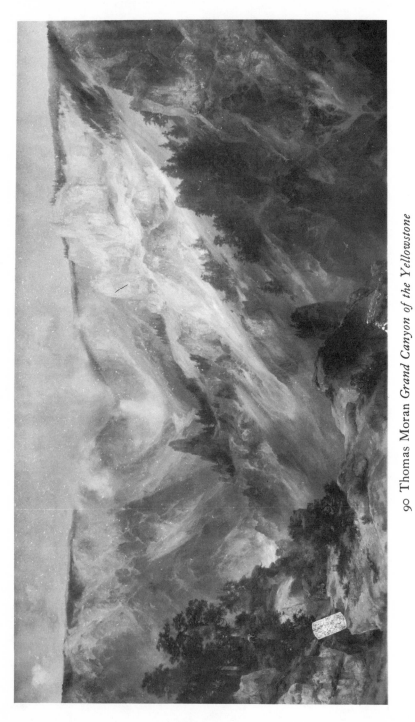

90 Thomas Moran *Grand Canyon of the Yellowstone*

Oil on canvas; 1893–1901; 96 × 185; Smithsonian Institution, Washington, D.C.

can basis." And so, on his return to the United States, he searched the eastern seaboard vainly for scenery to which, without taking too many liberties, he could apply Turneresque effects.

When in 1870 Moran was commissioned to illustrate in his Eastern workroom an account for *Scribner's Magazine* of the first scientific expedition to the Yellowstone Valley, he drew the Grand Canyon of the Yellowstone as only a few feet wide. The next year, he saw the Yellowstone firsthand and recognized that he had found at long last subject matter that whipped his brain to delightful heights. His huge *Grand Canyon of the Yellowstone* and the subsequent *Chasm of The Colorado* were bought by Congress for ten thousand dollars apiece and so fired legislative imaginations that they are considered responsible for our system of national parks. Grateful officials named a peak in the Tetons Mount Moran. And the pictures of Western scenery he turned out till his ninetieth year sold and sold, to appear subsequently on calendars in polychromatic waves.

Although Moran never relied with Turner on vague suggestion — "the tree drawing," pontificated the *New York Tribune*, "is most satisfactory" — he increasingly felt that "whatever arbitrary forms" grew out of his "intimacy with nature" became part of his style and were "legitimate in after work because my knowledge of the topic leads me to take liberties. In other words, he nourished formulas. The man," he explained, "must exhibit himself in his pictures."

Moran's studio procedure resembled what we shall describe as Inness's. He increasingly balanced on canvases forms and colors drawn from his imaginative memory. Like Inness, he was capable of impulsive switches. "I have known him," wrote a friend, "to change a carefully constructed snow-capped mountain range to a raging storm at sea, the formation of the mountains suddenly giving him the sense and feeling of white-crested waves." But where Inness erupted like a volcano, Moran pumped up his art with great energy from not too capacious a well. He was, indeed, most effective in that part of his practice that relied least on inspiration: the drawing that gave his panoramic views sweep and also depth, that made space drop into huge declivities. His color can seem less self-expression than self-indulgence: purple rocks, azure gorges, emerald leaves against ruby-streaked bark.

The modern critic Virgil Barker accuses Moran of having painted "demoralized" landscape in a "tantrum." This characterizes the painter's

usual output. At his occasional best (and his least brightly colored), he can communicate emotion, windy perhaps, overstrained certainly, but manifest. He was a gifted illustrator deformed by elephantiasis.

That the Rocky Mountain School has been regarded not only as part of the Hudson River School but often as its most typical manifestation shows how effective was the propaganda promulgated by the critics who, in the late 1870s and the 1880s, wished to tear down the old American taste to make room for a new, foreign-inspired movement: They found the slick, inflated styles of Bierstadt and his followers excellent clubs with which to belabor the less vulnerable Hudson River School. It is another demonstration of how little attention had been paid to our mid-century painting that the fallacy has for so long been allowed to stand.

The distinction made, it becomes clear that the Hudson River School did not, as is commonly stated, grow more gargantuan through the years and finally collapse under the dead weight of huge melodramatic canvases. The evolution was, as we have seen, the other way towards smaller, more intimate pictures, down from the mountains to the meadows and the seashore. It was the Rocky Mountain School that blew itself up like the frog in the fable.

{ 17 }

HARBINGER

William Morris Hunt

I N the early 1850s, the French painter Jean François Millet walked
through Fontainebleau in the peasant blouse and sabots he had worn
since childhood. He was followed by a wealthy New England blue-
blood trying to look at home in a similar costume. When a waiter at a
railroad restaurant actually mistook William Morris Hunt (1824–1879) for a
French tiller of the soil, the American was enchanted. Thus was presaged
an attitude that was eventually to overwhelm the Native School.

Hunt had been born in Vermont and raised by his widowed mother in
New Haven, where the whole family took art lessons from an Italian refugee.
During William's junior year at Harvard, the mother decided his health was
too delicate for him to continue. The family migrated to Europe.

This move was to be as momentous for American architecture as American
painting, for it was William's younger brother, Richard Morris Hunt, who,
after floundering through a variety of imported styles, finally (1881) built
for Mrs. William Kissam Vanderbilt a French Gothic château so impres-
sive that it actually forced Mrs. Astor to send her footman with a card.
This triumph was not lost on the firm of McKim, Mead, and White, and on
other fashionable architects, who joined with Hunt in making New York's
Fifth Avenue, Newport's waterfront, and the millionaires' row wherever
there were millionaires groan under vast piles of stone shaped in the late
French Gothic manner.

As Richard began his architectural studies, William resolved to be a
sculptor. Having worked for a while in Rome, he moved on to Düsseldorf,

where he found the systematic training irksome. He changed his main interest to painting, and in Paris became a more slavish walker in the flowery pathways of Couture than any other important American was willing to be. The French praised him by stating that his *Jewess* could be mistaken for the work of his master, but an essay in the high style, *The Prodigal Son*, was, when Hunt sent it to New York, damned as the worst picture at the National Academy "except for Miss So-and-so's flowers."

In Couture's studio, Hunt was known as "a gay dog." Art was for him no more than an agreeable cultural exercise until he saw at the Salon of 1850 Millet's *Sower*. Although Couture expressed correct French taste when he objected to painting "peasants so poor they have not even got a crease in their trousers," the American bought the picture, moved to Barbizon, and lived for two years beside Millet as his disciple. The peasant artist was pleased — particularly as Hunt continued to purchase pictures still unsaleable to Frenchmen — but refused to give away any information on how he painted. It was studying the canvases themselves that induced Hunt to modify Couture's system towards less use of glazes: as he put it, "solid painting, simple, full and round."

> When I came to know Millet [Hunt wrote] I took broader views of humanity, of the world, of life. His subjects were real people who had work to do. If he painted a haystack it suggested life, animal as well as vegetable, and the life of men. His fields were fields in which men and animals worked; where both laid down their lives; where the bones of the animals were ground up to nourish the soil, and the eternal wheel of existence went on. He was the greatest man in Europe.

No wonder Hunt emerged from his comfortable gentleman's house in a costume that seemed to link him with this anciently cultivated soil! What if Millet considered him a loafer and growled at his "facile, delicate way" of painting? Dressed as a French farmer, the American felt as never before an integral part of nature's plan.

Hunt had adopted from Millet a new stage in the nineteenth-century European attitude towards peasants. They had first been best painted in Italy as Virgilian descendants of ancient Romans; next, they had been picturesquely costumed examples of the quaint purity of various national folk. Millet painted them not at play but at work, as humbly heroic spokes in destiny's great wheel. This seemed shockingly realistic in his own time, although today Millet's figures seem sentimentally idealized.

When, after eleven years abroad, Hunt finally came home (1856), he did

not make the entire plunge. He settled at Newport, off the New England coast on that island which Henry James described as "the one right residence in all our country for those tainted, under whatever attenuations, with the quality and effect of detachment. The effect of detachment was the fact of the experience of Europe."

At Newport, Henry and William James, respectively seventeen and eighteen years old, studied with Hunt, the future novelist to gain culture, the future philosopher with a temporary intention of becoming an artist. John La Farge (1835–1910) was Hunt's one truly professional pupil. Having worked briefly under Couture, La Farge had been disappointed to find, on his return to New York, that not the painters there but the architects constituted a "link with Europe." Hunt's architect brother had forwarded La Farge to the studio where the extremely rich and correct Boston wife Hunt had married interrupted the morning's work "after a couple of hours or less" by bringing wine and "quaint" cakes after a Portuguese recipe.

"The master's house," Henry James wrote, represented "a more direct exclusion of sounds, false notes, and harsh reminders than I had ever known." But his comment on the master himself had a cutting edge: Hunt was, "superficially speaking, unsurpassable." And La Farge, although he had come to Hunt for European lore, criticized the teacher for repeating only a "recipe" conned from Millet.

Hunt was not encouraged to accept more male pupils. After he had made in 1862 the inevitable move to Boston, he established a class for polite young ladies, who were, he noted, more teachable than men. However, he complained that his female pupils did not understand the suffering and sacrifice needed to "do anything for art," and he felt ashamed that he was not carrying out the duty of "a true artist" to help young professionals surpass his own work. He diffidently encouraged a lady disciple to take down and publish his dicta. The resulting two volumes of *Talks* (1875 and 1893) were to have a considerable influence on the rising generations.

Hunt derided the Native School's emphasis on subject matter — "some find it [beauty] in a leg of mutton" — and opposed accurate reproduction of natural forms: "You must sacrifice as many details as possible. . . . Keep your masses flat, simple, and undisturbed, and spend your care on joining the edges. . . . It is the impression* of the thing you want."

*The pursuit of an artistic impression—i.e. to communicate more by synthesis than by description—is, of course, one major aspect of all artistic creation, and by no means the exclusive domain of the Impressionists, who sought to achieve certain specific impressions in certain specific ways.

The technique Hunt preached was Couture's modified by dilettantism and a Millet-inspired desire to achieve a broader, less specific, more poetic image. Where Couture had urged the achievement of a fresh effect by the application without revision of a prearranged, laborious plan, Hunt wrote that, since genius was love, pedantry began when an artist ceased to have fun. You preserved the vitality of a first sketch by never going beyond it. All of a picture but the final touching-up should be achieved in a single day, which in his own case meant an hour or two, since, "when weariness was half suspected," he would stop, lest his inspiration weaken. He contended that most pictures needed not more work but less: "I am striving to get what people call carelessness but I call nature."

"Color," Hunt stated, "is vulgar because it is in the direction of imitation. The less imitation, the more suggestion, and hence the more imagination and poetry." And, in any case, nature's color sense was bad: she put too much red in flesh, too much green in landscape. Flesh should be painted gray, as Couture did, with just a touch of red; foliage should be, as Millet made it, a brown that suggests green.

In portraiture, on which he concentrated after his return from Europe, Hunt sought, as he put it, not "scrutiny" but "perception." Everything depended on how successfully his impressions materialized during his first sitting, and this depended on his automatic rapport with the sitter. Admiring profoundly the benign, crotchety, blue-blooded Bostonian pundit Lemuel Shaw, who was Chief Justice of Massachusetts, Hunt found the subject for what became his strongest portrait, even if the image shared with the work of humble likeness-makers a marked dichotomy between the three-dimensional head and flattish body. Hunt's dislike for Charles Sumner burst out all over the abolitionist's likeness. The color is marred by an unpleasant break between the red and the gray in the flesh tones, and the features, although they reveal Sumner's fierce intransigence, give no hint of the conviction, the fire that made him an effective leader. Hunt was, in his own time, considered happiest at likenesses of ladies, to which he brought "the highest artistic tact." A lyrical response to the appeal of a young womanhood, *Miss Ida Mason* combines much sophistication of handling with a bothersome confusion in the rendering of the shoulders.

From portraits, Hunt gradually changed his emphasis to figures in genre attitudes. Lacking Milletlike peasants sowing immemorial bone-fertilized fields, he made up a pretty cast of characters. Thus a caped coachman leaning over to draw water for his horse inspired Hunt to paint a young girl,

[252]

vaguely European in costume, filling a jar at a decorative fountain. Her figure is graceful in line but has no depth; although there is no sense of outdoor light, the color is an agreeable harmony in browns: as a whole, the picture is a sweetly and delicately communicative vision.

To express "perfect ease and balance," he painted his only nude: a boy balancing over a pool on the vaguely indicated shoulders of another. The flesh tones and values are delightful, but again there is no sense of outdoors. Hunt admitted that the highly generalized figure "is a little feminine, but I did it from memory without a model, and was chiefly occupied with pose." When he enlarged his first sketch, he kept the fault to keep the spontaneity.

Not till middle age (1874) did Hunt discover that it was fun to paint in the actual presence of landscape. He would make a quick charcoal sketch, which he handed to his assistant, a former sign painter, who would start at once to reproduce it in oils. Having waited intently for the ripened moment, Hunt would seize the brushes and finish in one burst. The results, slight sketches in the Barbizon manner, suggest excellent pictures Hunt never painted.

His art was attacked in New York until he stopped sending there for fear he would be discouraged away from creativity, but in Boston he was the artistic god. He had the ability to talk pictures so admired by the Brahmins, while his impeccable breeding and his rich, inner-circle wife gave him license to amuse a society so staid that it bored itself. He was handsome — like an "Arabian sheik, . . . tall and willowy"; he was eccentric — he would balance a wineglass on his bald dome throughout a whole evening. He pioneered what was to be a great resource for younger European-inspired painters whose market was to be largely feminine: at his "famous receptions" he pleased the ladies by directing them in charades and *tableaux vivants*. Not for him, as for the Hudson River artists, a bare, functional studio: he threw over chairs richly colored draperies, displayed the Japanese decorations and prints that had begun their appeal to advanced taste. But all this implied no Bohemian relaxation of standards. When the singer Clara Doria was preparing for a party at the Hunts, she was forced to borrow clothes from her Boston hostess, since all the dresses she had brought from England were ruled too "low in the neck."

To be the artistic pet of rich and self-satisfied cultured elite had its obvious pleasures, but in some moods Hunt turned on his admirers with angry exasperation. He attacked the Brahmins for being concerned with lectures on art rather than pictures. After Boston's Museum of Fine Arts

had opened in 1876, he called it a mausoleum housing only what had been long dead. "Art, like jelly," he quipped, "has been more easily recognized when cold." Then he would admonish himself, "When I go about growling about Boston and her ideas of art it is because I am not painting. When I'm hard at work, I'm helping Boston to love art." But he found it easier to improve his neighbors by proselytizing taste. He joined with La Farge in promoting the new admiration for the Japanese and interested Boston collectors in the French artists that had been most radical in his young manhood (he felt that the Impressionists, when they appeared, went too far): Millet, Delacroix, Courbet, Corot, Daubigny, Rousseau, Troyon, Dupré.

Hunt admitted that in comparison with these masters he was only "a student," but added, "In judging a painter, his surroundings and his drawbacks ought to be considered. I might have painted if I had lived in an atmosphere of art, but in America everything resolves itself into the getting of money and selling a poor article instead of a good one."* Yet he insisted that he was not, as he recognized Allston had been, isolated from American life. Certainly he did not want to be. He longed to touch the beating heart of his land.

Architects were beginning to secure commissions for painters who shared their European orientation. In 1876, La Farge, home from further French studies, decorated Trinity Church in Boston. Two years later, Hunt was asked to paint a pair of huge murals for the dome of the New York State capitol that was building in Albany. He chose subjects he had first planned in Couture's studio. *The Flight of Night* showed the Persian goddess of the heavens, Anahita, who symbolized civilization and mind, dispelling the darkness, which represented barbarism and matter. *The Discoverer* featured Columbus, a "positive or masculine force," guided by "feminine sympathy" in the form of Faith, Hope, and kindred spirits.

Hunt had long theorized that when a picture was enlarged no additional detail was required: he would treat a canvas fifty feet long "as you would a small piece of paper." Now he prepared cartoons, measuring eight and a half by five and a half feet, over which he intended to paint after they had been thrown on the inside of the dome by a magic lantern that would expand them about five times. The sketches implied a result opposite in both strengths and weaknesses to the usual native style: tending towards

*Amusingly enough, the artists who blamed their troubles on American materialism were usually those most shielded from its influence by independent incomes.

[254]

91 William Morris Hunt *Judge Lemuel Shaw*

Oil on canvas; 77 × 49½; Essex Bar Association,
Salem, Massachusetts; photograph, Essex Institute, Salem.

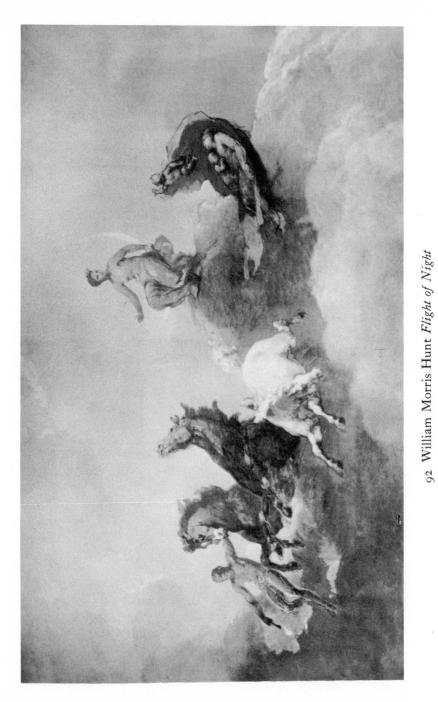

92 William Morris Hunt *Flight of Night*

Oil on canvas; 62 × 99; Pennsylvania Academy of the Fine Arts, Philadelphia.

vacuousness rather than too much detail; skimping the small to trap the large. More naturalism would have helped Hunt's seminude allegorical representations of femininity, which are hardly human and strangely androgynous, their often breastless torsos shaped and colored like pale carrots. Yet the figures have a strange charm and, judging from the cartoons, the total effect was to have an anemic grandeur.

When delays in raising the dome allowed him only two months to execute the murals before the Assembly convened, Hunt cursed ill-fortune, but fate was preparing for him the one truly ecstatic experience of his career. Construction had to go on around him as he painted. Although in the privacy of his Boston studio he had been bothered into days of sterility by the gnawing of a mouse, he found it "great fun to be one of a gang. There are," he explained, "ever so many workmen down below our scaffolding, working while we do. . . . Think of it, all these men and their families thinking and working, year after year, all for one end!" Laborers climbed to his high perch: "I tell you, I never felt so big in my life as when they asked if they could come again." The man who had tried to pretend he was a French peasant found himself, at long last, actually a part of communal labor. "Think of it! You never hear of Boston a hundred miles away! I am out of the world and I want to stay out of it."

Had he not stumbled on American subject matter comparable with what had inspired Millet to greatness? "That's the man I want for the center of a group of workmen in repose. . . . He's going up a ladder with a hod! . . . Do you see that old Irishman? . . . I'll put him where he will 'tell' for he has more character than the entire Congress. . . . Doesn't he handle his hoe with the dignity of a king?"

Although he was so nervous about how his murals would look when the scaffolding came down that his craftsman had to promise that he would, if Hunt were not pleased, paint everything out in a night, Hunt was pleased. So was a larger and more varied public than he had ever interested before. So were the architects, who said they would keep him employed further decorating the capitol for the rest of his life. He projected symbolical representations of New York State activities — commerce, education, etc. — and particularly tributes to the labor force that had erected the building. A bill was introduced appropriating $100,000.

Hunt had planned to go to Europe when the murals were completed. His doctor warned him to rest. But he could neither leave America nor stop. Having made with a new energy many easel pictures in his old manner, he

showed them in his Boston studio. What the *Art Journal* called "his crowd of enthusiastic friends" were as "lavish in their admiration" as ever — but he had tasted in Albany wider appreciation. He wanted, as the Hudson River School did, to touch the hearts of simple, unsophisticated Americans. When ordinary citizens were unimpressed or stayed away, he became irritable. He could hardly wait to prove himself by getting back to work in Albany.

To his great joy, the legislature passed the appropriation. When an economy-minded governor vetoed it, he sank into pathological melancholia. The bluestocking Boston poetess Celia Thaxter took him to her well-known cottage attached to the famous Appledore House on the Isle of Shoals and tried to soothe him into health. However, he visited the pool from which the local steamboat drew fresh water, and was found there "floating upon his face while the wind fluttered a fold of his long coat." Few believed the poetess's statement that it was an accident — the cane on which he leaned had broken — not suicide.*

Hunt was frost-killed, a flower that bloomed before its time. After him came more resolute Europophiles, painters who were often proud to have no contact with that they considered the crudities of American life. Whistler and La Farge inaugurated this new movement a few years before the outbreak of the Civil War. However, it was that conflict and its aggressive industrial aftermath that made flight from native inspiration the dominant artistic trend. Painters who had formed their attitudes and styles before the storm descended were, it is true, rarely caught up in the stampede. It was their juniors, for whom maturity and disillusionment were simultaneous, who commonly wished their art to be not an expression but an escape from matters American.

Almost all the members of the Native School had been professionals before they first experienced Europe. However, the younger men usually began their careers in the studios of European masters. And they repudiated, as part of the background they wished to overcome, existing American styles. It was probably because the tradition of the Hudson River School was so insistent that most of the young lions become primarily still-life and figure painters. They glorified technique over subject matter and accepted as gospel whatever manner of painting their teachers in Munich (which

*To complete the tragedy, Hunt's murals were so inexpertly applied, that they soon crumbled away from the capitol dome.

had succeeded Düsseldorf as the center for German studies) or Antwerp or Paris showed them.

The two most able of the cosmopolitan painters, Whistler and Cassatt, became permanent expatriates. But, from the mid-1870s onward, hundreds came home, some gifted, some not, each bearing a recipe which he believed would enable him to produce, for the first time in our national history, worthy art. As the young prophets gathered in New York City to express loud disdain of their elders, the National Academicians did not surrender their stronghold to that impetuous knocking. The returned travelers found themselves without a showplace — and also without a market. They were, of course, paralleling the desire of many rich collectors for pictures that did not reflect the ordinaries of American life, but such collectors preferred imported originals to homemade imitations. It was primarily purchasers still faithful to the Native School who desired pictures by Americans. Here was an outrageous state of affairs! The young lions established their own academy, the Society of American Artists (1877), and did everything they could to discredit their elders.

As time passed, the new movement captured American taste. Although the table set by our society for its own painters remained less opulent than it had been when the Native School ruled, what crumbs there were went increasingly to artists whose pictures would be acceptable — even if considered inferior — abroad. Now almost every American who considered himself cultured would agree with Hunt's dictum, "It is not absurd for a Frenchman to say anything against American art, but it is absurd for an American to say anything against French art."

However, it was during the transition to this point of view that the Native School had its greatest flowering.

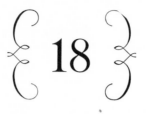

NATIVE AMERICAN IMPRESSIONISM

Inness, Wyant, and Martin

EXUBERANT health and tramps through the mountains were hallmarks of the Hudson River School. But after the Civil War, there rose to prominence a variant group. Its leader was an epileptic. Of his two main followers, one had such defective eyesight that he could not draw a vertical line and the other was so crippled that he had to walk sideways. These three men were, respectively: George Inness (1825–1894), Homer Martin (1836–1897), and Alexander H. Wyant (1836–1892).

Inness, whose art matured slowly, belonged to the high Hudson River School generation: he was a year older than Church. His father, a successful New York City merchant, retired to New Jersey, where the boy grew up among the verdant Hackensack and Passaic meadows. What he described as his "fearful nervous disease" resulted in his being dismissed from school as deficient. Having failed as a grocer and a mapmaker, he was at the age of nineteen put with the landscapist Régis Gignoux (1816–1882). Inness, who wished to be considered altogether self-taught, was to dismiss this contact as of no importance, but Frank Jewett Mather was probably correct when he wrote that it came close to ruining Inness's career.

Gignoux had arrived from his native France four years before, the only pupil of Delaroche in America. Since the Hudson River School practically never executed snow scenes, Gignoux made these his specialty, aided by the fact that he had brought from France a formula which he felt excused him from wading through drifts to study actual frozen landscapes. "He knew," Mather wrote, "the tree touch as exemplified by Hobbema, the cloud and

[258]

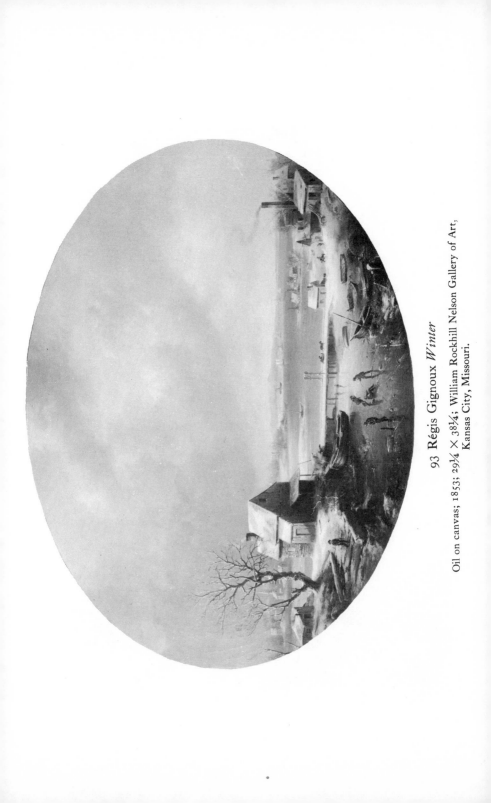

93 Régis Gignoux *Winter*

Oil on canvas; 1853; 29¼ × 38¼; William Rockhill Nelson Gallery of Art, Kansas City, Missouri.

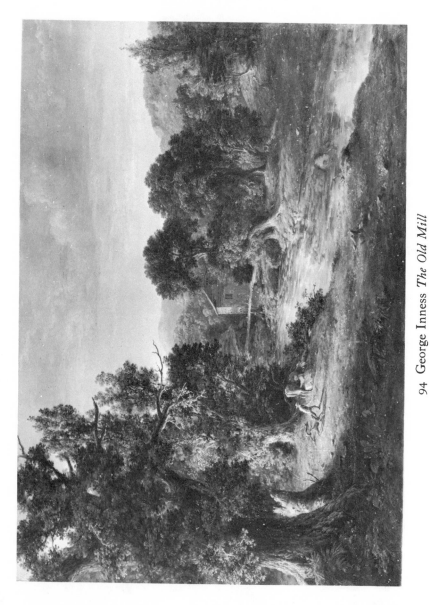

94 George Inness *The Old Mill*

Oil on canvas; 1849; 29⅞ × 42⅛; Art Institute, Chicago.

snow touches as worked out by Aart van der Neer." His unctuous use of paint — he could make even watercolor look as if it had been applied with a spoon — and quaint, vaguely Old World shapes gave his work a pastry cook's charm that was very popular. Thus, his huge *Niagara in Winter* rivaled as a showpiece Church's summer rendition of the falls. He also capitalized profitably on America's autumn coloring. *Harper's Weekly* (1864) ranked Gignoux with Cole, Durand, and Kensett, while Tuckerman considered his American views the best "by a foreign pencil." After his return to France in 1870, he enjoyed there, too, a profitable career.

Gignoux was not, as most writers on Inness have ignorantly assumed, an obscure foreigner easily ignored. It was certainly he — not, as had been further assumed, one of the self-reliant Hudson River painters — who told Inness "that I was a fool to try to set myself up against the rules laid down by my betters, and that if I did not paint trees brown in the foreground, I would certainly fail."

Inness realized that Gignoux's pictures lacked "the spirit of nature," but epilepsy "impaired my ability to bear the painstaking in my studies which I would have wished." To acquire the "grand" without "trifling detail and puny execution," he carried out into the fields engravings after Old Masters. Some of the same "qualities," as he wrote, spoke to him from the work of the Hudson River leaders: "There was a lofty striving in Cole, although he did not technically realize that for which he reached. There was in Durand a more intimate feeling for nature. 'If,' thought I, 'these two can only be combined! I will try.' "

When he tried to catch the Hudson River School's "elaboration of detail," he found that, "a part carefully finished, I could not sustain it throughout." He lost "the sense of space and distance," and also his subjective feeling for nature's "mystery." But if he gave way to his impulses and tried to paint "sentiments," he was "in a hobble" when he tried to make the pictures look "finished." So he modified Gignoux's formulas. If the result had, as "Achilles Bonbon" wrote in the *International Art-Union Bulletin*, "too much manner in it for nature," it also had charm. The American Art-Union bought Inness's work for good prices, and in 1850 an auctioneer financed a trip — his second — to Europe.

During more than a year in Italy, Inness responded to the classical sense of composition of Claude and Poussin. On the way home he passed through Paris, where that pioneer of the Barbizon School Théodore Rousseau "was just beginning to make a noise. A great many people were grouped about a

little picture of his which seemed to me rather metallic." His taste in French art was still Gignoux's. He named a daughter Rosa Bonheur Inness.

After two years at home, Inness returned to Paris in 1854. Living in the Latin Quarter he found himself immersed in the battle against the old guard fought by the Barbizon artists and the followers of Delacroix. "In a sort of stupor of intellectual amazement," as he said, he realized that the revolutionary movements contained the seeds of what he was seeking. Although he stayed less than a year, he brought back with him exciting memories of Delacroix's color, of the broad way the Barbizon School handled natural detail.

Twenty years later, painters who returned from Europe with similar acquisitions were convinced that they had found final answers. But Inness was one with the Hudson River School in believing that the first duty of a repatriated student was intensively to reexamine the American landscape. However, he did not, like his colleagues, go to the Catskills. He haunted scenes deep in his own experience, the cultivated valleys where a man with his infirmities might safely wander.

Inness's fellow painters annoyed him by refusing to admit that however he was painting at the moment was the only way to paint. He usually avoided the convivialities of the National Academy, to which he was elected as an associate in 1854, preferring the company of his wife, who was his mainstay; and in 1859 he willfully left the capital of the Native School, settling in Medfield, Massachusetts, whence he sold primarily to the Boston market. This lasted for five years. Then he returned to the New York area, making his permanent American base among the nearby New Jersey fields that had enchanted his boyhood. The Academy responded by electing him in 1868 a full member, although his style had in many particulars evolved away from theirs.

On his return from Paris, Inness had felt, as he wrote, free of the "fetters" that had formerly held down his self-expression, but freedom presented to his complex and impulsive nature so many possibilities that his style had swung like a weathercock between the pedestrian and the rawly emotional, the too regimented and the too confused. His experiments took on a hysterical violence when the outbreak of the Civil War overwhelmed his nerves. Yet his most successful pictures reveal a direction. He was merging Durand's example with a more coloristic manner that substituted for emphasis on the naturalism of accurately drawn detail the more generalized but still accurate naturalism of powerful hues. Color brought with it heightened emo-

tion and subjectivity. This was the style which Inness brought to true maturity after the Civil War was over.

His solutions were helped by a religious revelation. While his colleagues enjoyed exercise and good fellowship, he had sat in isolation reading theology, "the only thing except art that interests me." The pantheism of the Hudson River School was too impersonal to satisfy the semi-invalid who had to feed so much on himself and whose nerves so often overwhelmed the normal and the rational in irresistible surges. He had joined the Baptists and then the Methodists without finding a philosophical base for landscape art. Finally William Page, by introducing him to Swedenborgianism, enabled Inness to combine subjectivism with the philosophical base of the Hudson River School.

Durand would have agreed with Inness's statements that "the true purpose of a painter is to reproduce in other minds the impression which the scene made on him," and that "all things that we see will convey the sentiment of the highest art if we are in love with God and the desire of truth." But Durand would not have agreed that "the true use of art is first to cultivate the artist's own spiritual nature," since the "purity" of the artist's vision creates the "ideal." Where Durand emphasized familiarity with objective nature, Inness emphasized self-refinement.

However, there was no break in mood. While the Hudson River School sought to express the beneficence they found in Nature's God, Inness preached that the "unfolding of God's truth" within the individual was "the orderly centralizing of your spirit to a state of happiness." Since "man's unhappiness arises from disobedience to the monitions within him," to paint well was to paint joyfully.

Inness did not wish to discard Hudson River objectivism but rather to add to it what seemed its opposite. His subjective bias and nervous structure encouraged him towards imaginative release, but his desire to escape from the imperfections of the individual into oneness with God called him back to exterior nature. "I have always felt," he said, "that I have two opposing styles," one "impetuous and eager," the other "classical and elegant." If a painter could combine the two, "he would be the very god of art." For it was false to believe that "objective force is inconsistent with poetic representation." On the contrary, "local color" was necessary for the expression of emotion. "When John saw the vision of the Apocalypse, he *saw* it. He did not see emasculation or gaseous representation. He saw *things*, and those things represented an idea."

[261]

Inness's most celebrated pictures of the 1860s were panoramic views. To them, as to the smaller canvas he also painted, he brought a more lyrical color sense than his Hudson River School colleagues possessed. Having never been trained as an engraver, he had no temptation to base his pictures on an underlying scheme of gray. He preferred to use value contrasts for more direct coloristic and emotional effect. Where the Hudson River School usually found their brightest hues in the sky, he followed the Dutch and the Barbizon School in making his skies a middle tone. If less naturalistic, this contributed to the unity of canvases held together primarily by a chromatic scheme.

From the problem of how specific to make foreground detail, he escaped by having no objects protrude until the middle distance, where they could be particularized without elaboration. Beginning not with sharp drawings but with vague masses that he gradually refined, he expertly created outlines which implied the elements they contained. Inness, the *Boston Evening Transcript* exulted, "could get more varieties of foliage into a picture, so as to be distinguished even at a distance, than any other painter of our day."

In *Delaware Water Gap* the composition is both remarkable and verisimilitudinous. The vivid gray storm clouds that block like a wall the left middle distance open upwards towards the center over a huge arch lined by a rainbow. Under this iridescent portal, the valley stretches deep through mist. The glow of rainbow color in the air brings magic to the brightly reflecting foreground water, to cows motionless as if enchanted, to a floating raft, and even to a little train puffing inconspicuously along. This is what Gifford tried all his life to do, but much more subtle, much brighter.

Inness did not lack for sales. He was generally recognized as a leading landscape painter and particularly admired by those critics and collectors most impressed by European landscape art. (However American his work would have looked in France, it looked very French in America.) That the painter had difficulty supporting his large family was primarily due to his majestic financial incompetence and his tendency to throw prospective purchasers bodily out of his studio if they expressed opinions on art or haggled over price.

From 1870 to 1874, Inness lived abroad, first in Rome and then in Paris, drinking deeper of Claude and Poussin, of Delacroix and the Barbizon School. After his return, he produced, in addition to failures, marvelous pictures in a variety of modes. *The Barberini Pines* was a majestic mixture of Hudson River realism with Claudian formality. In his *Evening at Medfield* a shallow

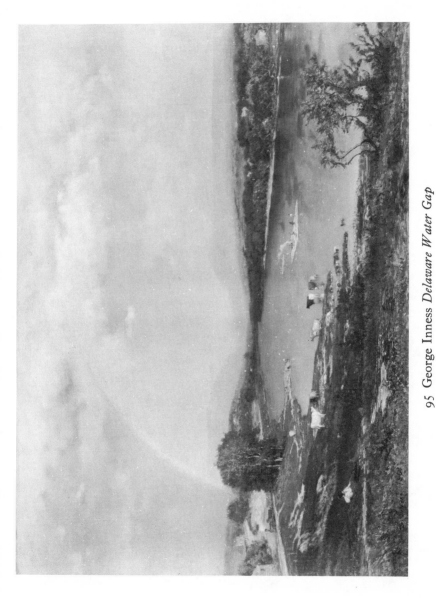

95 George Inness *Delaware Water Gap*

Oil on canvas; 1861; 36 × 50⅞; Metropolitan Museum, New York, Morris K. Jesup Fund, 1932.

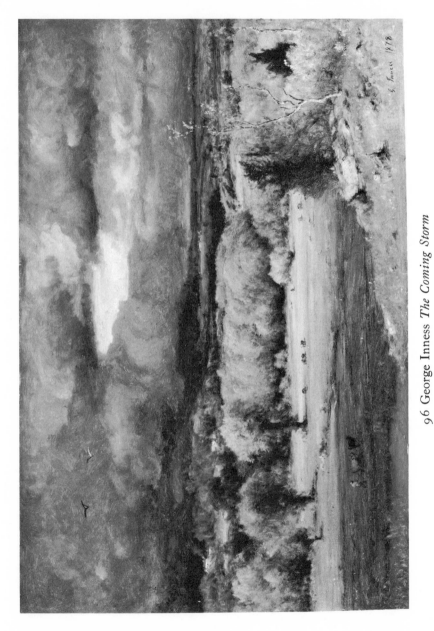

96 George Inness *The Coming Storm*

Oil on canvas; 1878; 26 × 39; Albright Art Gallery, Buffalo, New York.

and quaint composition reminiscent of Corot has been mysteriously imbued with an American wildness. And *The Coming Storm* is pure American observation: the old approach caught up into new wonders. Seen from a height, a meadow landscape stretches far back under rolling dove-gray clouds. Sunlight still striking in the middle distance brings to lush green fields and autumn-colored trees an eye-twinkling brightness that seems inexplicable when we step close enough to see, isolated from their surroundings, the pigments Inness actually used. Although the treatment is broad throughout, and the orderly progression of values is broken for more directly coloristic ends, the picture is as realistic as anything Durand or Kensett ever painted. It even has the ecstatic objectivity of the Hudson River School.

Around Inness, the American art world seathed. Back from Europe in increasing force, the new generation was aiming their hammer blows at the National Academy. However, they were primarily figure painters. No able landscapist was fully identified with their movement, and so they adopted Inness. They elected him to their Society of American Artists, and their critics promulgated the doctrine (still gospel in many circles) that the quality in his work was entirely the product of French inspiration, and that his development had been a mounting reaction against everything the Hudson River School stood for.

Adhering to Native School conceptions, Inness in fact disapproved of much that the New Movement stood for: their avoidance of native subject matter; their pride in foreign training (he insisted he was self-taught); the estheticism that filled their studios with *objets de vertu* (his was a bare workroom); their conspicuous painterly tricks, which he attacked as showing that "the artist was not one with his subject "(he wished his viewers to feel they were actually in God's outdoors); their self-congratulatory dependence on a cultural elite (he wished to communicate with even "the commonest mind"). In so far as Inness had any artistic allegiance it was to the National Academy, where his body was to lie in state.

However, the atmosphere of revolt encouraged him to slacken greatly the reins with which his conscious mind had directed his nervous impulses. He no longer studied from nature, believing that he had its forms, like an alphabet, at his fingertips. Nor did he try to depict any specific place. Although he sometimes found it hard to start on a bare canvas, as soon as a shape or color appeared, it inspired others. His *Under the Greenwood Tree* began, so his son tells us, with an oak in the middle of the canvas. He added for balance and human interest a nearer tree and the figure of a boy. Then

the strong light on the oak's trunk needed to be repeated on the other tree and on a white cloud he put in the upper right-hand corner. But the three lights in a row looked awkward: a line of radiance in the right foreground took the form of a path. Now the boy was outside the pattern: Inness put a dark sheep between him and the oak. This made too violent a contrast with the light on the oak, so he inserted a broad glow between sheep and tree. Some raw spots appeared, which he filled with more sheep. Since the entire composition lacked depth, he immersed the background in dark shadow. Later he touched up and varnished.

Such was his process at its most controlled. Often Inness would improvise in a compulsive frenzy, spraying paint over himself and the studio, pulling out his shirttail to serve as a paint rag, crying, "We don't know just what it's going to be but it's coming!" He would start with a marine, change the water to grass, put in a white spot and be hypnotized into a snow scene. At such times, he was incapable of stopping. He buried picture under picture until his inspiration ran out or he collapsed with exhaustion. He lost many compositions, often ones he had already sold, by setting his free association going, as he tried to touch up a detail. Sometimes, directly after having made a disastrous change, he would with complete sincerity accuse a bystander of having painted on his picture. But the release of actual creation was always happy; while at work, he never doubted that each new stroke was an expression of God-inspired genius.

Inness now came more into keeping with Barbizon practice by usually painting on small canvases restricted views.* The clear if broadly painted detail on which he had once insisted was most typically obscured by a haze that was often golden with dawn, sunset, moonrise. It was this style over which the New Movement raved and which catapulted Inness into stupendous prosperity and fame. Had not the then famous French artist Benjamin Constant given him the imprimatur of Gallic praise by stating that no better landscapist had ever painted?

The rich industrialist Thomas B. Clarke took from Inness's wayward hands the management of his business affairs: marketed, invested, propitiated the collecting "Philistines" (Inness took over the word from the younger painters) whom he insulted. When in the mood not to pile compo-

*The conception, so often employed in attacks on the Hudson River School, that it is by definition unartistic to paint a landscape large is Barbizon-inspired. It is in keeping with the neoclassical theory, which enjoyed so long an afterglow in France, that history painting, as the only high style, was alone worthy of large presentation. Corot normally painted his historical pictures big, his landscapes small. No such inhibitions bothered Constable and Turner, who, if anything, painted larger landscapes than did the Hudson River painters.

sitions on top of each other but to improvise on successive canvases, Inness could complete a dozen pictures a day. Everything sold, earning him what was then a fortune: twenty thousand dollars a year.

Always uneven in quality; Inness's work had become more so. Although he now expressed specifics with subtle suggestions, he was unwilling to abandon them altogether. He would find his facts getting too weak and try to strengthen them here and there, with the result that they became too obtrusive, and then he would have to tone them down again. After a picture had moved several times between the sharp and general, freshness vanished and the binding hues seemed less golden air than a swamp in which fragments of trees and cows uneasily wallowed. "Cavil not," the artist insisted, "at incomplete and imperfectly rendered forms, at blemishes, or scratches, or unexplained spots. . . . Behind all is the man and his vision, freely given and expressed. If we cannot see it, the fault lies with ourselves." And, indeed, his failures were bought as readily as his successes and almost as enthusiastically praised.

Inness was now selling less to the household market of the Hudson River School than to specialized collectors whose interest, like that of the younger painters, was not in glorification of reality but escape from it. They agreed with Hunt that, when an image was clear, "anybody sees all there is to it in a minute." A Corot, Hunt continued, was beautiful "because it is not what is called a finished picture. There is room for imagination in it." And, however confusedly, even an inferior Inness did speak for and to the imagination.

At its best, Inness's late style is truly evocative. In *Indian Summer* the composition pivots chromatically around the red plume of a middle-distance tree. Behind the foreground, which is an almost smooth olive-green, a patch of white with some dark around it coalesces from the viewing position into a seated girl. A dim shape suggests another person, and under a line of trees on the right there is some kind of shed. Autumn reeds form a pale orange horizontal strip; water is a line of blue under a golden headland with another tree and then a light blue sky with golden clouds. This is true twilight, full of space and air, the real and the imaginative fused into a single image or, as Inness himself put it, "the visible upon the invisible."

In some of his later pictures — for instance, *Overlooking the Hudson at Milton* — Inness included among passages more solidly painted limited areas of broken and altogether bright color that might have been French Impressionistic work. However, when French Impressionism began making its mark on American taste, Inness was outraged that his art should be consid-

ered "so lacking in necessary detail that from a legitimate landscape painter I have come to be classed as a follower of that new fad." He regarded Monet's virtual elimination of shadow and consequent weakening of three-dimensional form as "a pancake of color" unrelated to nature. The young man was either a humbug or needed an optician!

> Long before I heard of Impressionism [so Inness continued], I settled to my mind the underlying law of what may properly be called an impression of nature.... Whatever is painted truly according to any idea of unity will, as it is perfectly done, possess both the subjective sentiment — the poetry of nature — and the objective fact to give the commonest mind a feeling of satisfaction and through that satisfaction elevate to a higher idea.... In the art of communicating impressions lies the power of generalizing without losing that logical connection of parts to the whole which satisfies the mind. The elements of this are solidity of objects, and transparency of shadows in a breathable atmosphere through which we are conscious of spaces and distances.

Thus Inness defined what modern critics have called Native American Impressionism. Developing simultaneously with the French, the movement made use of similar sources — Constable, Turner, Delacroix, the Barbizon School — but it was an independent growth, grounded also on the Hudson River School naturalism that appealed so strongly to the basic American taste for the tangible in art.

For Native American Impressionism, Inness was a brilliant propagandist, since he was at his most effective a brilliant painter. The manner he pioneered continued for more than a generation in its own right, and also influenced painters like J. Alden Weir (1852–1919) and John H. Twachtman (1853–1902), who finally, in the late 1880s, developed an American version of the French Impressionist manner. However, in this volume we cannot carry the story of Native American Impressionism beyond three artists all born in 1836: Alexander H. Wyant, Homer Martin, and Winslow Homer. They marked, with Inness, its high tide.

Born in backwoods Ohio, Wyant graduated himself from harness making to landscape painting, and soon fell under the influence of Inness's pre-Civil War style. However, Inness's rapture before nature conflicted with his indwelling sense that nature was menacing. In the 1860s, no American landscape art expressed such pessimism, and thus it was a revelation to Wyant when, after he had come east, he happened at an exhibition on a

97 George Inness *Indian Summer*

Oil on canvas; 1894; 30 × 41½; John Astor, Miami Beach, Florida; photograph, Knoedler Galleries, New York.

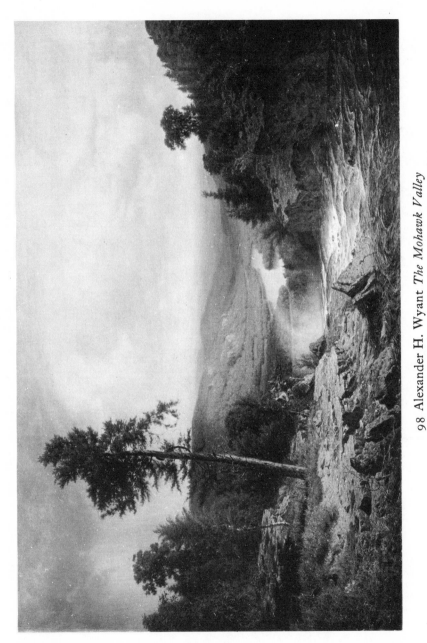

98 Alexander H. Wyant *The Mohawk Valley*

Oil on canvas; 1866; 34¾ × 53¾; Metropolitan Museum, New York, gift of Mrs. George E. Schanck in memory of Arthur Hoppock Hearn, 1913.

canvas by Gude, who painted the landscape near Europe's North Sea as alien to man. Wyant posted off to Germany to study with this Norwegian Düsseldorf master.

The Mohawk Valley, which Wyant painted shortly after his return home, is an amalgam of Gude's style with the Hudson River manner, both in its pure form and as modified by Inness. Like Gude, Wyant placed his greatest value contrasts in the middle distance, which became, as it were, a fulcrum on which foreground was balanced against background. Also from Gude, the American imbibed a tendency to seek broadness not (as Inness did) by synthesis but by leaving out some details and overemphasizing others, often the stern and harsh. The stronger drawing that makes even the stylized ripples in the water as firm as rock forms gives an impression of clutter greater than in the more detailed but more delicate Hudson River manner. From that manner, Wyant borrowed his point of view: a high spot from which he looked down a deep vista. However, instead of closing off his picture with mountains, he filled half his canvas with sky. The air is painted with a luminosity reminiscent of Inness (and of Constable, whose work Wyant had studied during a stop-off in London). In itself handsome, and indeed the best part of the picture, the sky is nonetheless too tender to top effectively the uncompromising hardness of Wyant's earth. However, such powerful if ungainly pictures shared in the general prosperity and acclaim of the Hudson River School.

The break came after Wyant had overtaxed himself on an expedition to add the Far West to his repertory. In 1873, he suffered a stroke that paralyzed his right hand. The transition to painting with his left was made arduous by continuing ill health, but was greatly facilitated by Inness's later work and the Barbizon pictures that were now flooding into America. Wyant turned from extensive vistas — which, indeed, he no longer possessed the endurance to paint — to intimate views, often of graceful saplings in second-growth thickets. He implied the foreground detail of the Hudson River School with roughness of paint surface, and used throughout his compositions impasto more than outline or specific color to imply form. Everything was mist-immersed or twilight-dimmed. Like Inness's late manner both vague and naturalistic, Wyant's Native Impressionistic work was much less brightly colored. It was melancholy and lassitudinous. Showing at its most typical the fall of night from overcast skies, Wyant's art was a gentle sigh, expressing the relief mixed with sadness that the day's end brings to an invalid whose day has been full of pain.

[267]

Although this "sentiment" would have been considered morbid by the Hudson River School, it was so satisfactory to new times that the slowly dying man was besieged with praise and orders. His art points to the more powerful crepuscular landscapes of Ralph Albert Blakelock (1847–1919), who spent his last eighteen years in an insane asylum, tragically unconscious that his works had become blue chips in the market. Not only vagueness but sickness had become watchwords of American art fashion.

Where Wyant was overpraised, Homer Martin was unappreciated. His paintings lacked "sentiment" as it was then defined, since he sought through his art not emotional release but rather self-control. Martin was temperamentally a classicist. That he could not help being entangled in the romantic attitudes of his place and time dictated his slow development. Unlike the neoclassicists, who were two generations out of date, he did not seek generalized experience in actual classical or Renaissance precedent. He had to work everything out for himself on his own terms. Yet he wished his personal expression not to be outbursts of moods but a summary of his deepest feelings. To find such inner equilibrium was for him a lifetime's quest. As a young man, he painted in a rage of frustration. Later he suffered long periods of sterility. "I do not know where the impulse comes from," he wrote, "or why it stays away. All I know is that when it comes, I can do nothing but paint, and when it goes, I can do nothing but dawdle."

Far from producing vague forms to incite the viewer's own emotions, Martin grappled the viewer to his own vision. His object, his wife tells us, was to find "that duplex image in which external nature fused with him, who was also part of nature." There were, she continued, "an austerity, a remoteness, a certain savagery in even the sunniest and most peaceful of them [his landscapes] which was also in him. . . . I told him he was Ishmael."

His wife's complaint that Martin was "so intensely masculine, so preeminently a man's man that he must necessarily have escaped through the comprehension of any woman" further explains why, in these new times, his pictures were excluded from rich drawing rooms. So was his person by his hideous appearance — he suffered from chronic eczema — his inordinate thirst for beer, his caustic and often ribald wit.

The son of a carpenter, Martin was raised in Albany, New York. When he was sixteen (1852), he set out as a professional painter under the influence of the local landscape leaders, James and William Hart. Perhaps it was his temperamental classicism that made him so much more dependent than most American beginners on exterior sources. In any case, for ten long years,

99 Alexander H. Wyant *The Pool*

Oil on canvas; 17¼ × 14½; Toledo Museum of Art, Toledo, Ohio.

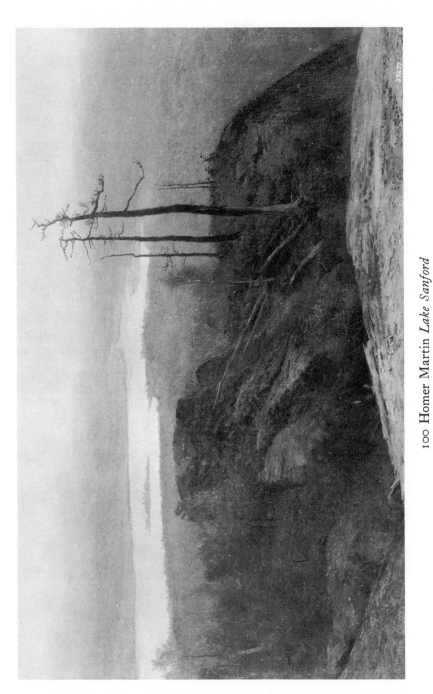

100 Homer Martin *Lake Sanford*

Oil on canvas; 1870; 24½ × 20½; Century Association, New York; photograph, Frick Art Reference

he thrashed around in the Harts' uninspired, overelaborated, decorative version of Hudson River realism, tearing some strands but never really breaking away from a manner that could not suit him. Since his eyesight distorted all perpendiculars, he could not hope to achieve miniscule realism. And some temperamental urge made him reverse a basic Hudson River practice: in the presence of nature he sketched compositions, adding detail and color, as best he could from unaided memory, in his studio. No wonder his efforts to apply the Harts' style ended in angry travesty: niggling, inaccurate detail, brassy naturalistic color.

Only after he moved to New York City in 1862 and became highly familiar with Kensett's work did Martin begin to find himself. He adopted Kensett's method of composing a picture as a balance of a few large forms, each of which contained within itself much carefully evolved small detail. He learned to pay exquisite attention to the edges where shapes meet each other or are silhouetted against the sky.

Martin was also clearly attracted by Kensett's serenity. However, what was for the older painters the unimpeded outflow of a placid temperament could only come to the junior as the result of anguished struggle. He approached closest to Kensettian optimism in slight canvases of meadow scenery where, with an almost playful touch, he gave rein to an elegance of form and a lyricism of color that he was not to synthesize into his major work until the end of his career. At his most powerful he was Ishmael, depicting, in the wilder reaches of the Catskills, mountains ravaged by the elements, nature at her least human, her most austere.

A half century after Cole had painted the untamed wilderness in hymns to God's unedited beneficence, landscape art, which had lingered in civilized valleys, returned to the heights. But now that the younger painters felt themselves outcasts from a society absorbed in material gain, the mood was not praise but stoicism. Before he was driven back, broken, to melancholy lowlands, Wyant had seen in bruising rocks and angry streams challenges to man's fortitude. Martin's reaction was more profound. He sought strength to face destiny through unity with the elemental earth, scarred and strong, yet one with the quicksilver beauty of the limitless sky.

His chief work of this period, *Lake Sanford*, features the mighty heave of a barren ledge from which protrude the nervous forms of a few short, thin, withered spruces. A stretch of forest beyond and somewhat below gives way to a bleak lake and then more forest that vanishes into dense clouds which efface the skyline. Foreground color is a resonant saturation of dark tones.

[269]

Further back, light blues shading into whites and grays strike a contrasting note of cold, pure virginal lyricism. The whole is powerful but inhibited. Martin's forms, being more ponderous than Kensett's, more kinesthetic, are bothered by Kensettian detail. And an enamel-like surface brings smoothness where roughness ought to have been.

In the early 1870s, Martin learned from Corot's pictures how to fill in his large elements with details not drawn out but suggested by color. He now alternated with the heavily-featured mountain scenery, which had been his favorite subject matter, pictures of almost featureless sand dunes on the shores of the Great Lakes. In color he became increasingly original, repudiating the pearly hues of both Kensett and Corot for bright pigments often strangely out of key with the somber mood his compositions implied. It was at this point that his art, formerly salable to the Hudson River School market, lost contact with all facets of American taste. Martin, however, did not blame the public for not welcoming what he sought to achieve. "If I could do it," he said, "they could see it fast enough."

Martin was forty when, in 1876, he first went abroad. Spending nine months in London, he became intimate with Whistler, examined closely paintings by Constable and the Old Masters. On his return to artistic chaos in New York, he became a charter member of the Society of American Artists. He had long been an associate member of the National Academy. However, he frequented neither.

As Martin absorbed what he had seen in England, his output dwindled. When he returned to creativity in the 1880s, his style showed no violent swing, merely a deepening. His touch continued to get looser, his details less insistent. But he did not abandon his grasp on firmness of image, and even if light became more and more the soul of his pictures, he indicated with skillful and varied manipulation the textures of earth. The most pregnant new direction was to let local color recede into generalized tone.

It was 1882 when Martin finally visited France. For four years, he lived in Normandy: Villerville and Honfleur. The Native American Impressionist was confronted with the French variety, by now well known in France. He looked at the pictures and at the Normandy countryside, but he painted hardly at all. It was only after his return to the United States that what he had seen slowly found expression in his art.

This very delay emphasizes the basic difference between Martin and the orthodox French Impressionists. His contemplative art was completely alien to instantaneous reactions. Always, even behind his most restricted

images, even behind the Normandy scenes he now painted, there was a philosophic sense of nature's largeness: space, atmosphere, hue that carried the mind far beyond the compass of the eye.

Although Martin's ends were inimical to broken color that sacrificed solidity to brightness, he made use of French Impressionist example in achieving on a lower gamut than theirs atmospheric brilliance through broken tones. Generalizing at last all local hues, he laid paint on heavily, often with a palette knife, and then kneaded the layers together into flat surfaces of compressed and blended hues. This method precluded sharp forms, but Martin still eschewed vagueness. Through mass and color, he indicated shape, texture, exact position in the picture space. Although he adhered to the logic of nature, repainting *The Harp of the Winds* when he realized that the middle-distance trees were unrealistically tall, he broke so far from Hudson River conceptions that he allowed the eye to recognize that his compositions were artfully contrived. However spacious, however deeply the result of reflection, each view carried, as nature does not, a monolithic visual impression.

Martin's sojourn in Normandy, where he was blessedly ignorant of the language, had been his happiest time: he even got on with his wife. Furthermore, in those anciently cultivated fields he found human accents — decaying manor houses, churches ravaged by the elements — that chimed with his elegiac mood. Such scenes, glowing with a dark poetry, now burst from his memory and imagination along with American views.

In 1890, Martin's health broke, and his eyesight vanished almost completely: one optic nerve died, and the other eye clouded with a cataract. But the artist exclaimed, "I have learned to paint at last. If I were completely blind now and knew where the colors were on my palette, I could express myself." Amazingly, this boast proved true. Martin's transcendent masterpiece, *The Harp of the Winds* (1895), was painted when he could hardly see.

This picture, so powerfully rendered on an almost unseen canvas by a dying hand, is a triumph of the human spirit. All his life, Martin had painted nature to learn to govern himself, and now, in the last great flash of his mind before he died, he showed the world no longer as menacing but as a beautiful and happy place. The scene is identified as on the Seine, but its true habitat is the human mind. The sky is a glorious radiance that glows again, only slightly dimmed, in land-bound water. The earth is a deeply extending, sculptured panorama, solid and also buoyant with the creativity

that pushes high into the multicolored ether thin poplars that respond with sinewy elegance to the music of the spheres.

All the more because it was painted according to the techniques of a new generation and showed an American's memory of France, this triumph of Native American Impressionism revealed the continuing vitality of Hudson River School conceptions. For it was a panoramic view seen from a high place and implying vastness. Even if solidity and depth were more subtly handled, they were, according to the Hudson River ideal, firmly there. And Martin had finally succeeded in merging the objectivism of his predecessors with the subjectivism of his own temperament and time into a single image which restates the ecstasy in the presence of nature, the sense of the goodness and beauty of the world, that was the old American landscape mood.

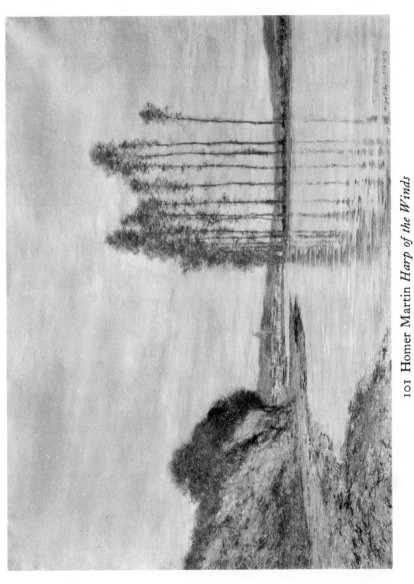

101 Homer Martin *Harp of the Winds*

Oil on canvas; 1895; 28¾ × 40¾; Metropolitan Museum, New York, gift of several gentlemen, 1897.

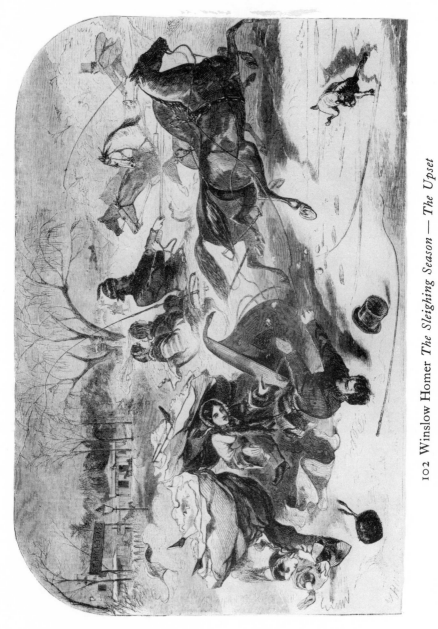

102 Winslow Homer *The Sleighing Season — The Upset*
Woodcut on paper; 1860; 9¼ × 14; New York Public Library, New York.

$$\left\{ \begin{array}{c} 19 \end{array} \right\}$$

WINSLOW HOMER

AS American Colonial painting ended with its climax, the majestic
portraiture of John Singleton Copley, so the Native School was
carried to its greatest heights by a final master, Winslow Homer
(1836–1910).* Copley and Homer were both faced in mid-career by the wave
of European influence that was to characterize the succeeding era of our art.
Having in the Colonial manner built on a native base only because he lacked
opportunity to acquire international sophistication, Copley switched styles;
moving to London, he became a leader of the Anglo-American School. But
Homer stemmed from a tradition that went its own way not because of
necessity but from choice.

Although Homer made two trips abroad, although at home fashion moved
away from his practice, he adhered doggedly to older American attitudes.
Yet that he was not deflected does not mean that he was untouched. It was
surely no coincidence that this transcendent American master was an exact
contemporary of France's transcendent masters, the Impressionists. Cer-
tainly Homer was helped to the heights by subtle assimilation.

He was born at Boston into a long line of Yankees modestly but substan-
tially concerned with overseas trade: his father imported hardware. His
mother was a semiserious amateur watercolorist of flowers. When he was
about six, the boy was taken to nearby Cambridge, where the glorious world

*Although Homer is usually bracketed with Thomas Eakins (1844–1916) and Albert Pinkham Ryder (1847–1917)
the two younger men were more closely linked to later developments. Eakins was, it is true, an inheritor of the
Native School concern with the realistic, the ordinary, and the local, yet like the other members of the generation
of 1870, to which he belonged, he went abroad after the Civil War not as a practicing professional but as a beginner,
and he brought home from Paris techniques that remained throughout his career the basis of his practice. Ryder's
style was largely *sui generis*, but in painting inner visions, not objective reality, he broke utterly with the approach
of Homer and the Native School.

of the outdoors came upon him as a passion. By the time he was eleven, he was drawing his companions at play with some of the realism and emphasis on mass that characterized his later work.

The hold of these early pleasures on his imagination was reinforced by his resentment when, at the age of nineteen, he was apprenticed in Boston to the extremely successful lithographer John H. Bufford. In his old age, he "remarked with some pathos in his voice that while other boys [sic!] were enjoying boyish play, he had his nose to the grindstone from eight in the morning until six in the evening." He rose early enough to start each day with an hour's fishing. He worked standing, insisting that otherwise he would get round-shouldered, and so successfully resisted the artistic possibilities of the lithographic crayon that it was never for him an important medium. However, he became Bufford's expert at putting pretty girls on the covers of popular songs.

Before he was released from his indenture on his twenty-first birthday, Homer had resolved that never again would he call any man his master: he would support himself as a free lance. His avowed objective was genre painting. But he was only willing to go about it his own way — "if a man wants to be an artist," he explained, "he should never look at pictures" — and he did not yet see his way. He had prepared for his freedom by learning the most up-to-date graphic craft: how to draw for wood-block cutters.

Wherever population, transportation, prosperity, and literacy had risen, there appeared a demand for mass-circulation weekly newspapers. To illustrate these, all established methods of reproduction were either too expensive, too slow, or not capable of large enough press runs. In Europe, publishers had made new applications of an old wood-block technique in which the areas that would print were not incised as in an etching but cut around so that the block would function beside type in the same manner.

European-trained cutters had emigrated to America, but in 1851, as the *American Art-Union Bulletin* commented, all American illustrated newspapers had failed for lack of "designers" who could draw effectively for the process. Every year saw an improvement, and in 1857 the activity recruited its greatest illustrator and its greatest publication: Homer and *Harper's Weekly*. The two soon came together, and in 1859 Homer moved to New York City, where the Harper office was.

Like his Hudson River School predecessors, and with equally important results on his mature style, Homer used a reproductive process as a technical school, but the lessons of the wood block were different from those taught

by engraving. The medium, which depended for gray on a rough cross-hatching, was incapable of expressing distance through a subtle gradation of values. Color could not come to the rescue, since none was used. Although a panoramic view could be given depth by perspective and the spacing of big forms, in genre scenes, where the emphasis had to be on foreground action, backgrounds could only be kept in position by blurred handling and shrinkage of size. Thus, far objects or vistas could play no significant role: the compositions had to be in essence shallow.

The wood-block medium was too coarse to delineate natural objects with Hudson River detail or to bring to faces much expression or personality. Really illusionistic light effects were almost unobtainable, since shadows came in only a few intensities. That gradations of gray could not be made to melt imperceptibly into each other impeded efforts to indicate the round: figures were most effective when treated as bold black and white designs much dependent on outline.

The medium called for simplification of reality. This usually embarrassed the designers, and (being often Englishmen) they tried, by adapting the elaborate genre compositions of English painters like Frith, to hide stylization with force of numbers. At first Homer joined with his colleagues in stretching across his foregrounds friezes several layers deep of persons all reacting to the central situations in varieties of poses and gestures. Through these crowds he tossed lights and darks like confetti to create unfocused pictures busy with multitudinous bursts of energy. But as he worked his way into the medium, he realized that if its strong lines and unsubtle shadows were used with simplicity, they could have a tremendous striking power. He began moving his crowds back to serve as anonymous choruses supporting a few principals who summarized the situation. Take three pictures of dances: in 1859, the page is all aswirl with gyrating revelers; in 1863, three couples are spaced across the foreground; in 1867, a single pair forms a unified and magnificent design. In this final group, Homer hid his protagonists' faces as irrelevant to the larger effect he could achieve through pose and costume, and he handled his lights and darks powerfully in big areas for strong contrast and emotional effect.

The aspect of the medium that pointed furthest from traditional European practice was the fact that when large spaces were left between objects in the main picture area, the eye was not carried through them, as in a less basically shallow art, to distances. If not to be destructive, emptiness had to play as important a role in design and effect as the objects which bounded it. Homer

[275]

usually filled in all gaps but occasionally — as in his *Football at Harvard* — made brilliant use of tension between the presence and absence of tangible form.

In many particulars, Homer's practice came to resemble another wood-block art, that of the Japanese, which was at that very moment exerting its impact on such revolutionizers of European painting as Manet and the expatriate Whistler. During the late 1850s, sailors had brought to Boston volumes of Hokusai and others which had excited La Farge and Hunt. Homer was friendly with La Farge, and in all probability he saw Oriental prints in New York as well, since, once opened by Commodore Perry, trade with Japan was brisk. Some of the pictures Homer drew or painted before he first visited Europe show what seems to be direct Japanese influence. But that influence did no more than encourage and refine tendencies which grew naturally from his day-to-day activities as a wood-block craftsman.

The love of pictures cultivated in the United States by the Native School is in no way better demonstrated than by the fact that Homer was the star illustrator of the nation's most successful weekly newspaper without once (until the Civil War intervened) drawing anything newsworthy. For his subject matter, he went back to the beginnings of the Native School and ahead to new conceptions, but, immune to sentimentality, he jumped over the intermediate genre years. He eschewed Brown's newsboys, seeing the city streets in the old manner with a countryman's eye as a place where pedestrians were subject to comic pratfalls: if you walked under an awning, it was sure to inundate you with snow. To country life, he reacted with the old exuberant optimism. Like Mount, he depicted children's pranks and the merrymaking of adults with happy inner participation. His forms often showed a wild exuberance that reminds us of Quidor: a beach picnic is so instinct with swinging line and bouncing shape that a man holding up a lobster seems to be dancing the tarantella, while a sleeper lying on his back is about to be propelled into the air.

The older genre painters had adhered to the homely and the masculine. When the intermediate workmen had brought in society and the ladies, the result had been stiff or sticky with sentiment. But Homer applied his naïve joy in youthful merrymaking without discrimination to both sexes and all classes. He acclimated high life to the American scene by taking it out of doors, where top hats remained miraculously fixed to the heads of men playing ball, and girls roamed the fields as freely in ribbons and flounces as if they wore farm clothes.

[276]

Homer was, so time was to demonstrate, at heart as dedicated a realist as the Native School ever grew. However, he was also a passionate craftsman who sought out the best uses for a medium, and a young man whose blood had a lyrical flow. He applied to designs that resembled but did not mirror nature high spirits, sharp and sprightly forms, harmonies of balance, and great decorative gifts. Thus, he became in his twenties the greatest and — be it said to the credit of American taste — one of the most popular of our woodblock illustrators.

With what vigor he could dream a world where youth and beauty are exempted from harm is revealed by *The Sleighing Season — The Upset*. This was a subject which Blythe had pursued for its macabre humor. Homer's version contrasts real horror with a pretty girl tossed lightly into the air away from the accident by the overturning sleigh. Her hands outstretched in a gesture less of self-protection than grace, she sails with her legs thrown so high that her little feet, with a daring display of ankles, emerge enticingly from a crisp sea of petticoats. Her face reveals only coquettish pleasure in how gracefully she is soaring, and, indeed, she need have no fear; such a vision will never be stretched bloody on the ground. The composition encourages this unreal reality, for it is fundamentally an abstract balancing of tensions, values, and shapes.

Homer was to paint beauties mooning by the seashore or dreaming over flowers. However, this similarity of subject matter with the rising drawing-room school dedicated to expressing female sensibility did not mean that he had abandoned the basically masculine orientation of the older genre artists. Always he saw the ladies from the outside with male appreciation of the Victorian daintiness of girls who did not in the twentieth-century manner parboil their flesh in shorts or exhibit their complexes in woman-to-man talk. Even if today they seem prim, his pictures of girls with wet bathing suits clinging voluminously to their contours represented then the very maximum permissible amount of public revelation. To at least one newspaper writer they seemed the final proof that fathers should not let their daughters go swimming. Homer laughed at such strictures and, in a letter to an uneasy patron, made fun of the conception that a good woman could with moral effect show more of her person than a bad woman could. "I can vouch," he wrote concerning some girls he had painted on a beach, "for their moral character, for they are looking at anything you wish to have them look at."

However, Homer seems to have had an instinctive fear of tarnishing his

vision of womanhood by too close contact. He did not feel it necessary to draw from the nude, and like Mount, Kensett, and so many more of his older colleagues, he never entangled himself in the intimacy of marriage. He saw girls with the authentic glow and the lack of psychological depth that characterizes love at first sight.

Nor for the American were the bald revelations of Manet's *Dejeuner Sur l'Herbe!* Although the comparison may seem strange to those familiar with Homer's later austerities, as a young man he had moods that resembled Watteau's or Fragonard's. Even if his fashionably dressed cuties do not wander with lovers in umbrageous eighteenth-century gardens but play croquet in the clear air of shore resorts, Homer drew on wood blocks and was soon to paint many an American *fête champêtre.*

However, there was no European precedent for applying the same attitude to farm girls. Homer's rural charmers were not urban ladies in unfancy dress,* nor were they quaintly folksy. To the dramatis personae of the old rural genre painters Homer added the lyrical American milkmaid. Carrying pails or leading cows, she is altogether lovely, one with the dew of the morning.

After the outbreak of the Civil War, Homer made several trips to the Front for *Harper's Weekly.* He found none of the exhilaration in man's inhumanity to man that he was later to feel in man's battles with nature. His drawing *The Walking Wounded* expressed horror with a spare misery of line that presaged the World War I protests of the Expressionist George Grosz. For this direction he was to have no use in peacetime, but he was to apply to his epics of the sea the preference he now developed for building towards rather than showing the greatest violence of action. Thus he would envision a sharpshooter taking aim but keep the human target outside the picture. He was happiest and most prolific when he applied to war the old genre attitude, when he showed high jinks in camp.

Homer's few illustrations of actual fighting are given ferocity by the Quidorlike energy of his shapes and lines, but are emotionally shallow: they are far from his best work. Yet they are the best depictions ever made of Civil War battles. Americans had forgotton, since Trumbull created his powerful representations of carnage in the Revolution, how to paint cruelty and blood. And although France's long procession of Na-

*In a significant reversal, when Homer briefly (1878) experimented with metaphoric costumes, he did not accouter city ladies as milkmaids but dressed country girls as eighteenth-century shepherdesses. Dwelling lovingly on the contrast between the artificiality of the Old World frills and firm athletic bodies, gently direct faces, he created some of the most enticing of all his female visions.

103 Winslow Homer *The Walking Wounded*

Pen and brown ink on paper; 1861–1862; 4¾ × 7½; Cooper Union, New York City.

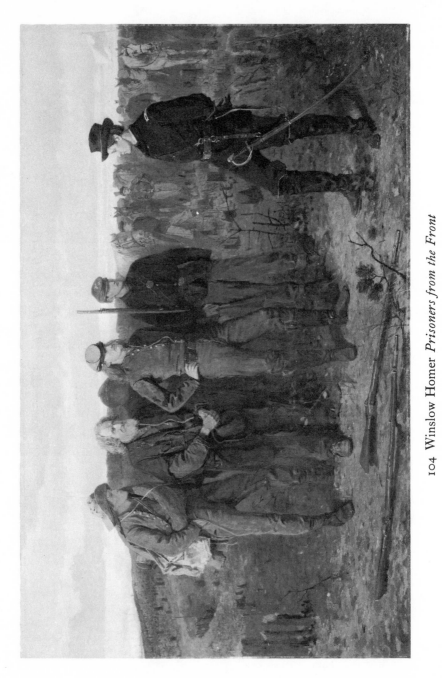

104 Winslow Homer *Prisoners from the Front*

Oil on canvas; 1866; 24 × 38; Metropolitan Museum, New York, gift of Mrs. Frank B. Porter, 1922.

poleonic War paintings was just reaching a climax in the work of Meissonier, no important effort was made here to revive, in response to the new opportunity, the now moribund mode of historical painting.

It was during the Civil War, when he was twenty-five, that Homer made his long-delayed start with oils. He got an obscure artist to show him how to set a palette and handle brushes; then he journeyed to that academy of the Hudson River School: nature's own woods and fields. He laid his pigments on in the directest and least complicated manner — opaque color, no effective use of underpaint, no contrasts between thick in lights and thin in shadows, no transparent glazes — a technique he found so satisfactory that he adhered to it, in opposition to sophisticated practice, for the rest of his career.

Decoration that departed from nature's own arrangements not being demanded by the oil medium, Homer dedicated it from the first to naturalism, but he carried over aspects of his woodblock technique. Silhouetting his protagonists against background light, he kept costume details in shadow, thus applying his basic adherence to large forms. Faces were also shadowed. He relied, as in his illustrations, on the whole figure for characterization; he continued to enlarge the individual into the type. This enabled him to give a saving universality to popular subject matter that his fellow genre painters made unbearably sentimental: he could paint almost impersonally two soldiers listening in wistful poses to a distant band playing "Home, Sweet Home."

Homer had still only partially combed clutter from his wood blocks; his early paintings often featured a foreground frieze of persons. At first his figures, however effective in silhouette, seemed paper-thin, but he soon gave them enough solidity to keep its lack from being a blemish. Until he discovered the softening effects of atmosphere, his surfaces had a brassy hardness. However, he quickly transmuted the wood block's semiabstract patterning of black and white into a naturalistic rendition of light and shade, which he applied with largeness, if as yet without smooth gradations through halftones. The color sense that was to become one of his greatest glories came slowly to the artist so long immersed in monotone. He began by filling shapes with somewhat discordant local hues. Then he tried to achieve a more general effect by toning his palette down to the verge of drabness.

In an occasional painting, Homer combined the flatness of the old medium with the depth of the new to make what was then a very original use of

empty space as a dominant element in design. Thus, *Defiance* shows a man daring sharpshooters to pick him off as he prances on a breastwork that lifts him to the exact center of the canvas, his lonely figure tiny against a bright sky. The effect lies in the contrast between this molecule of brittle humanity and the vastness it defies.

Struggling for naturalism, Homer lost in his oils the grace of his best wood-block designs; he wielded the heavier medium with a ponderous verisimilitude that would have made close-ups of actual fighting unbearable. This aspect of his reportage, as well as his grisly depictions of the wounded, he did not translate onto canvas. However, be brought to behind-the-lines genre a masculine vitality — none of the angel-faced drummer boys that Hunt, Eastman Johnson, and the others concocted — which made even the delicate souls who edited the Pre-Raphaelite journal *New Path* state that Homer stood almost alone among artists in telling the truth about the war. He was elected a full member of the National Academy when he had been painting only four years.

Just after the final Southern surrender, Homer dressed a jointed dummy alternately in Union or Confederate uniforms and painted from it in bright sunlight on a balcony outside his New York City studio. The result was *Prisoners from the Front*, which contrasted a dapper Union officer with three battle-soiled Southern prisoners: two bewildered, one exhibiting all the sad heroics of the lost cause. It is indicative of the attitude of the Northern artists and their public that this painting, which did not take sides but emphasized (as a critic wrote) "brotherly feeling," was the most praised and popular painting to come out of the Civil War. It is also significant that, although in this, his greatest success so far, Homer had made for him unusual use of facial expression, he returned at once to his more generalized treatment of mankind.

Prisoners and one of Homer's camp scenes were selected for exhibition at the Paris Universal Exposition of 1867. Homer went along. In the old Hudson River manner, he showed, during his ten months' stay in France, what a friend called a "difficulty . . . in taking impressions of foreign art [that] is almost ludicrous." Having no conscious interest in Old Masters, at the Louvre he did not copy pictures but drew the pretty girl copyists.

Although the *Gazette des Beaux-Arts* ascribed to Homer "firm but precise painting in the style of Gérôme but with less dryness in the execution," canvases by Gérôme and his fellow academics did not appeal to the American open-air naturalist. The yet much criticized Barbizon School worked in so

different a temperamental key that it does not seem to have interested him. The Japanese woodcuts shown at the Exposition were not new to him and could only have encouraged his existing practice. More relevant to his ambitions was a show staged by Manet and Courbet. Since Manet had not yet entered his plein-air stage (the Impressionists' first group exhibition lay seven years in the future), it was Courbet who disturbed the American. *A French Farm,* painted by Homer near Paris, was a hesitant picture containing Courbetlike overtones. But the hesitancy and the visible overtones soon passed.

Although known as "the father of French naturalism," Courbet was less naturalistic than Homer and the Hudson River School, for in both color and composition he transmuted nature into what was obviously a picture conceived in the mind and executed by the hand of man.* To have followed Courbet or, indeed, any of the examples he had seen in Paris would have encouraged Homer further to incorporate into his oil technique his woodblock direction of imposing on nature conscious design. Instead, when he had returned to the United States after ten months in France, he was soon badgering the wood-block cutters into trying to reproduce images that would, like his oils, seem unedited slices of life. He had not been deflected at all from the traditional attitudes of American naturalism. Nor was the specific influence of any foreign artist discernible in the work he now produced. Yet certainly memories emerged when needed from his unconscious mind.

Homer, who had seen more of the fighting than most painters, came out of the Civil War with a passionate desire to return to nature. This was the typical reaction not of genre but of landscape artists. However, he continued, in the illustrators' manner, to combine the two modes. "A quiet little fellow," as a friend wrote, who nevertheless "liked to be in the thick of things," he was by preference an observer of his fellow men even as he was by species an observer of clouds and trees. Without any of Cole's literary symbolism, he saw man and nature at a single glance, and in seemingly impersonal images he found what was for him the essence of personal expression. He could not, as an examination of all the known letters he wrote in his lifetime shows, communicate emotion except in terms of his art, which he liked to consider less part of himself than of the outside world.

*Courbet was surprisingly uninfluential on American painting, probably because his work was not naturalistic enough to suit the traditional American vision, while those painters who, like Inness, wished to bring subjective poetry into the Hudson River style, found in Barbizon more fruitful examples.

"The above," he explained after praising one of his own works, "would seem that W. Homer had a great opinion of himself, but it is *the picture* that I am talking about."

Homer never painted his wartime memories, and, far from responding to the progressive urbanization of American life, he abandoned (although he still spent his winters in New York City) all depictions of city scenes. He continued his concern with children and pretty girls. He showed vacationists on mountain and seashore, and deepened his view of farm life by adding to festive occasions the activities of every day. A brief foray to the South in 1875 encouraged some handsome renditions of Negro life — he admired the Negroes' color sense as expressed in their varicolored garments — but this subject matter was for him exotic and soon laid aside. Having discovered the excitements of hunting trips to the north woods, he initiated in 1876 the vein of purely masculine adventure that would become for him ever more meaningful. To no part of this range did he apply panoramic views, preferring the shallow designs, which silhouetted foreground action against backgrounds summarily indicated, that grew out of his wood-block practice. His mood remained during these years a deep-seated joy in the realities of American country experience.

Seeking always deeper naturalism, Homer paralleled the development of French Impressionism by making increasingly purposeful use of the way bright sunlight dazzles away from the eyes their ability to register sharply. This assisted him to keep forms large, to soften outlines, to make light itself a background that, while keeping the picture space shallow, implied depth, and to bring to his compositions atmospheric unity.* But, like the other Native American Impressionists, he did not abandon, with the French, the dark part of the palette, nor was he willing to submerge, with Inness and Wyant, local color into an over-all emotional color scheme. He labored to make every inch of his picture true to natural appearances. With a boldness that can be considered naïve, he sometimes, as in his *Long Branch* (1859), achieved great brilliance by silhouetting against darks brighter colors than any French painter would have dared use at that time.† He could do this because he did not, in the sophisticated manner, seek unity through tone, but relied on values to bring his hues into satisfying relationships. As a

*Concerning that bible of the French Impressionists, Chevreul's book on the physiology of color, Homer said, "It is my Bible."

†Homer was careful, when he mixed his colors, to avoid crushing the minute granulations, and he preserved the original sparkle by laying them on with a light, deft touch. He did not muddle over passages that displeased him, but took them out with the palette knife and started anew.

result, his pictures are not decorative in the usual sense. They do not dress up a wall but seem a window cut through it.

In *The Country School* a utilitarian room is shown in all its homeliness, yet the cracked walls and scarred benches are given visual interest by tiny variations in brushstroke and hue. With technical virtuosity the more marvelous because completely concealed, sunlight is made to flood the air. We can hear — although of course they are not painted in — the drowsy droning of flies half asleep against the windowpanes. From outside those windows, nature beckons its votaries caught in a long, wearisome routine. Although no prettier than most, the young teacher's form conveys the pathos and mystery of womanhood held in its springtime to a conventional round. Her charges are unidealized little brats, their angular anatomy protruding from their tattered clothes, but after the closing bell rings, they will become Dionysian, miraculously one with the springing flowers and the high-blowing clouds. The vision is happy, for the restraint is transient: nature will soon reclaim its own.

Homer has caught an eternal moment, an uncontrived vision that epitomizes a profound aspect of the human lot. Yet most sophisticated viewers find his subject matter so obtrusive that they cannot get beyond it to esthetic appreciation. This is partly because, even to Americans, American scenes seem oddities in art, more conspicuously "subjects" than, say, a boating party on the Seine. But there is a deeper explanation too. "When I select a thing carefully," Homer said, "I paint it exactly as it appears." Of course, it did not appear to him as it would to an ordinary man, yet in the Native School manner he did not superimpose his emotions on the factual image but merged the two. Thus, if Homer's reaction to his subject is strongly at variance with the viewer's, it set up such confusions as in 1875 Henry James expressed:

> Before Mr. Homer's little barefoot urchins and little girls in calico sunbonnets, straddling beneath a cloudless sky upon the national rail fence, the whole effort of the critic is instinctively to contract himself, to double himself up, as it were, so that he can creep into the problem. . . . [Homer] is almost barbarously simple and to our eye he is horribly ugly, but there is nonetheless something one likes about him. What is it? For ourselves, it is not his subjects. We frankly confess that we detest his subjects — his barren plank fences, . . . his flat-breasted maidens suggestive of a dish of rural doughnuts and pie. . . . He has chosen the least pictorial features of the least pictorial range of scenery and civilization; he has resolutely treated them as if they *were* pictorial, as if they were every inch as good as Capri or Tangiers, and to reward his audacity he has incontestably succeeded.

Homer, so James continued, "naturally sees everything at one with its envelope of light and air." If he only had "a good many more secrets and mysteries and coquetries," he might, despite his lack of "fancy," be an almost distinguished painter."

Less perceptive proponents of the new taste that was sweeping in from Europe could see no virtues at all in Homer's genre scenes. Thus the muralist Kenyon Cox (1856–1919) wrote that Homer's "failure" proved tragic fact that the United States could never have a Millet of her own, since it was "one more proof that the American farmer is unpaintable. His costume and tools are too sophisticated to suggest the real simplicity and dignity of his occupation."

Although Homer could usually sell oils at moderate prices to members of the middle class who were still faithful to the old American taste, he needed to eke out his income with illustration. In the early 1870s, he increasingly drew on wood blocks with wash in an effort, valiantly seconded by the *Harper's* cutters, to reproduce naturalistic light and shade. The results, because of their resemblances to his paintings, are better known than his earlier designs, but less effective as woodcuts. He was no longer thinking in the medium. However, even as he was becoming alienated from it, the craft that had long been his teacher showed him the direction that enabled him in 1875 to say farewell to woodcuts forever. From drawing with wash on blocks to drawing with multicolored watercolor on paper was a short step, and as the watercolor medium grew on him,* he found he could work in it quickly to produce pictures that he could sell cheaply and in quantity.

Although freer English watercolors had been available for his study in New York, Homer began in the illustrators' manner of coloring within drawn outlines. But it did not take him long to recognize the medium's ability to record with effective fluency instantaneous impressions received in the open air. Watercolor became for him not only an end in itself but what sketching in oil had been for the more meticulous Hudson River School: a method of finding and recording natural effects to be later incorporated in completer pictures.

His watercolor experiments encouraged him in his oils further to reduce form to expressive essentials and to record from nature highly unconventional hues. Even his admirers were puzzled. As were the Impressionists

*Although Homer had from the beginning of his career made an occasional watercolor drawing, he did not work seriously in the medium until 1873.

[284]

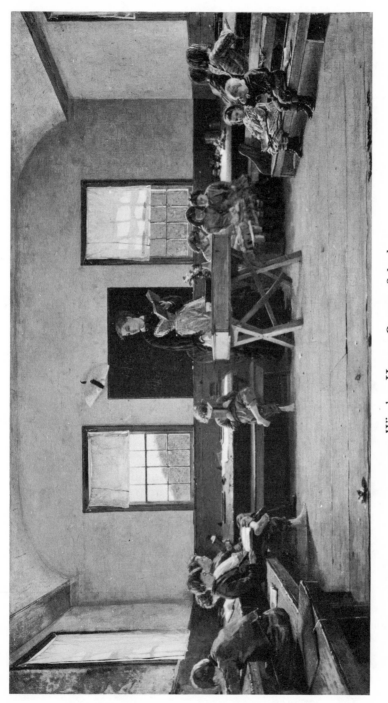

105 Winslow Homer *Country School*

Oil on canvas; 1871; 21 × 38; City Art Museum of St. Louis.

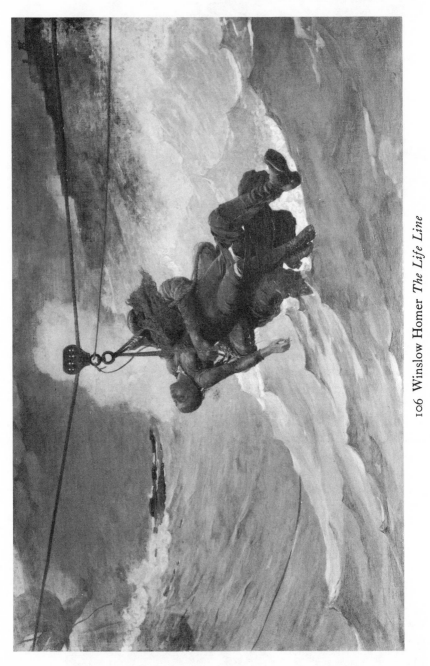

106 Winslow Homer *The Life Line*

Oil on canvas; 1884; 29 × 45; George W. Elkins Collection, Philadelphia Museum of Art.

and Whistler, he was accused of trying to pawn off sketches as finished pictures. And critics who saw nature through art considered his colors a travesty on nature. He was, indeed, daring and achieving effects for which one might search the art galleries of Europe in vain. Take, for instance, his *Camp Fire*, which showed sparks as scarlet threads against darkness. He painted this night scene altogether from nature, lighting a new fire when he wanted to make revisions.

Homer preserved the lyricism of youth much longer than most artists, but when he advanced into his forties, it ceased fully to satisfy him. And as his simple sensuous pleasure in countryside experience receded, he found himself at odds with the world. No longer himself sure of his future directions, he became enraged at the tendency of critics, impressed despite themselves, to write that if he would only do this or that, he could be great. "For fifteen years," he burst out, "the press has called me 'a promising young artist,' and I am tired of it." He became loath to send anything to the Academy lest his pictures be hung in a corridor, and more than ever unwilling to look at other painters' work for fear he would somehow be lured to desert himself.

Homer had once been among America's most popular artists; now he was pleasing neither the old taste nor the new. He could not, like the members of the New Movement, dismiss as undiscriminating everyone who did not admire him. His dream of the ideal showplace was a store window around which crowds surged at Christmastide. He mourned that "the average man" lacked "the comprehension of art" to stay with him, but when members of what public he still had left came to call, he found receiving them too disturbing. To confuse possible visitors, Homer hung on his studio door a sign reading "coal bin."

Homer tried to make his peace with a materialistic society by concluding that painting "was just like any other business." But from this there came an unfortunate corollary: businessmen were judged by the amount of money they made. That he earned, as he put it, less than a clerk in a department store became a complaint that remained with him, even after his family's real-estate operations had made him financially secure. But if patrons paid for his pictures the large sums he liked to demand, he was embarrassed.

When the crisis was at its worst, Homer vanished from his entire acquaintance for months at a time and almost completely abandoned painting in oil. In watercolor, however, he was able to preserve (even, as it turned out,

[285]

to old age) a lyricism largely untroubled by deepening thought. In this medium, he now labored to bring to undiluted naturalism more of the decorative sense, the formal organization he had naïvely exhibited in his wood-block art. Spending the summer of 1880 isolated on a tiny island with a family of a lighthouse keeper, he recorded the natural radiance that shimmered daily over Gloucester Harbor. The luminousness he achieved, even in shadow, brought him — so his biographer, Lloyd Goodrich, has pointed out — very close to French Impressionist practice, although in a somewhat darker key. As he was to explain, "Out of doors you have the sky overhead giving one light, then the reflected light from whatever reflects, then the direct light of the sun, so that, in the blending and suffusing of these several illuminations, there is no such thing as a line to be seen anywhere."

For several summers now, Homer had visited members of his family at Prouts Neck, a rocky promontory jutting into the ocean from the Maine coast. The untamed sea and the human beings who dangerously tore from it their livelihood appealed to the new needs of his darkening temperament. However, he could not break with the sunny gaiety that had occupied him so long until he left behind every place and every person he had ever known. In 1881, he took off for England, where for some eighteen months he occupied a cottage near Tynemouth on bleak cliffs overlooking the North Sea. Although he still painted pretty girls, they were now fishermen's wives and daughters formed by hard labor and the ocean's menace. That menace now came into his art — he depicted lifesaving parties battling their way to wrecked ships, and also the gray skies and fierce beauty of an ocean no longer a playground but an angry challenge to heroic humanity.

Hidden from passers by high walls, Homer wrestled alone in his Tynemouth garden with his heavier style, even for a time elaborating his watercolors as if they were oils. The results imply that in his great need he had visited London and studied the Pre-Raphaelites, Lord Leighton, and other English academics.* To achieve more weight, he gave fishergirls a bulbousness somewhat removed from exact observation; he sought more artful compositions by an artificial repetition of forms; he gave a new sway to storytelling and sentimentality. Although Homer was to discard every bit of this that he could not absorb into naturalism, the temporary twist in his style served, when the pictures were exhibited at home, as his passport to acceptance by the critics of the New Movement, who believed that he had

*That he sought solutions in England rather than France was a hangover from earlier American attitudes and may have been encouraged by a fear that he would be overinfluenced by models closer to his own manner.

at long last been convinced that there must be a separation between nature and art.

Soon after his return, Homer established his permanent residence at Prouts Neck. Although vacationists had once been a mainstay of his art and were now the basis of his real-estate prosperity, he kept them at a distance, by rudeness if necessary. He was happiest and most prolific when, "the last tenderfoot having been frozen out," he had a free choice between associating with the simple fisherfolk or with no one at all. He precluded the possibility of putting up visitors by filling one of the two rooms that he kept in commission during the winter with a large boat: "I have never yet had a bed in my house. I do my own work. No other man or woman within half a mile, and four miles from the railroad and P[ost] O[ffice]. This is the only life in which I am permitted to mind my own business. I suppose I am the only man in New England who can do it."

After accompanying the fishing fleet into the deep ocean off the Grand Banks, he painted those epics of man on nature's wildest element that call to mind that other Homer, who wrote the *Odyssey*. A fisherman rowing against huge waves in a small boat stares stoically at the mother ship to which he must return, but which is about to be lost in fog: like the sea itself, the oarsman's form is pure strength; the rowboat responds to the conflict between them with a sickish pitching. Or on a large ship in the great landmarkless sea, two oilskin-clad figures — one holding a sextant, the other a recording pad — seek their bearings; the sun has gone behind clouds but still streaks them and the ocean; all is routine and undramatic, yet the mystery of human destiny is there. Violent drama is summarized in *The Life Line:* pulled by one rope, dangling from another, two figures move across the picture space. The wreck they have left, the safety they seek are both outside our vision. We see only furious waves reaching towards dimly indicated cliffs, the male rescuer, and the unconscious woman he holds in his arms. He is impersonal, his face hidden by a blowing scarf. Her drenched black dress clings to a robust form built for labor; her boots are heavy, her stockings coarse; yet the curve of her body, her dangling arm, her wet face connote feminine gentleness that needs protection from a brutal world. Few other artists could have painted such a subject without the sentimentality which Homer cut beneath to achieve a universal image.*

*"If you want more sentiment put into this picture," Homer sarcastically wrote his dealer concerning another composition, "I can with one or two touches in five minutes give it a stomach ache that will suit any customer."

Although attractive primarily to males, this subject matter did not repel the new critics, as Homer's glorifications of ordinary American life had done. He was, indeed, combining the immediacy of genre painting with the greater universality which history painters sought: his dramas could have been enacted wherever ships and men braved the ocean. In the 1890s painters committed to other esthetic ideals came to admit that Homer was the greatest living American painter, and to this both the public and many advanced connoisseurs agreed. Museums acquired his work; gold medals lay among the fishing tackle in his Prouts Neck home.

Homer took special pleasure in a medal awarded his pictures (1900) in the capital of the New Movement, Paris. (He is said to have secreted it in his night clothes during his last illness.) However, he was as much bothered by the estheticism of his younger colleagues as they were to see him dressed, so Cecilia Beaux (1863–1942) put it, like a prosperous "diamond expert." Perhaps because, as he sought in nature the universal, he himself felt out of key with his times, Homer could not comprehend that he had won back, although on a higher level, to the national acceptance he had as a young man enjoyed. He continued to feel undervalued and, even in the presence of his admirers, apprehensive lest he be misjudged.*

From his first settlement at Prouts Neck, Homer had gone on extended vacations, in some summers to the Adirondacks, in some winters to the tropics, particularly the Bahamas and Nassau. He left his oil painting equipment behind with all the problems of the world (he did not have his mail forwarded). Now he was a watercolorist. Having found in his paintings an epic style suited to his maturity, he could with good conscience give full rein to the lighthearted sensuousness of a nature still in part amazingly boyish. Expressing a sheer physical delight in form, movement, color, he became certainly one of the great watercolorists, perhaps even the greatest watercolorist, in Western art.

Instead of imposing patterns on nature as he had in his early wood blocks, he now found patterns there. His *Leaping Trout* is basically an essay in pure color, yet he achieved his effect by making the fish — backs mottled red and yellow, whitish bellies — glow like jewels against darkness and, without any loss in naturalism, showing the water below as a black glisten

*On his way home from serving on a Carnegie Institute jury in 1897, Homer wrote the director, "Something has appeared in the newspaper the nature of which I do not know. If it is in any way discreditable to me, as I am led to suppose by certain remarks, *it is a great mistake....* I wish to assure you that I am a man of truth and honor and worthy to associate with gentlemen. Anything you wish explained (as there appears to be something), I will do with pleasure."

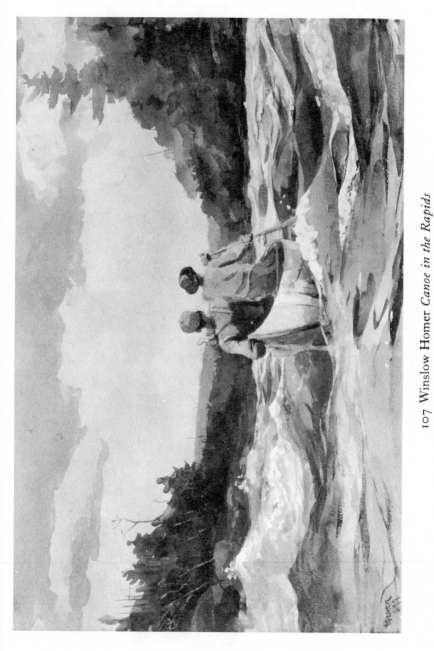

107 Winslow Homer *Canoe in the Rapids*

Watercolor on paper; 1897; 13½ × 20½; Fogg Art Museum, Cambridge, Massachusetts.

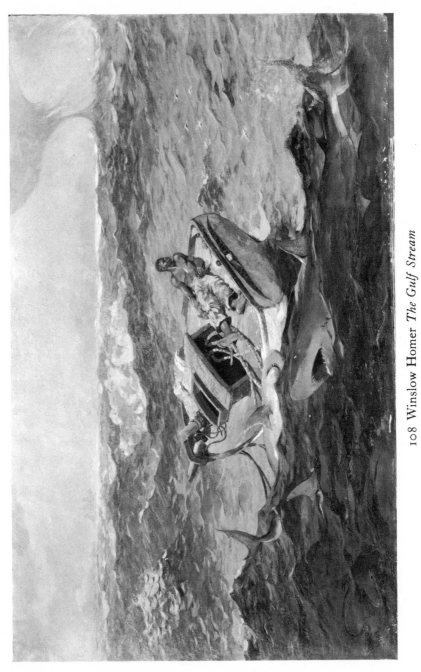

108 Winslow Homer *The Gulf Stream*

Oil on canvas; 1899; 28⅛ × 49⅛; Metropolitan Museum, New York, Wolfe Fund, 1906.

broken with bright bands. To express the essence of subject remained his intention, yet in his later watercolors he completely abandoned description and was willing to distort in favor of his major effect minor aspects of reality. To make the muscles feel the stresses involved in a canoe going through rapids he contrasted with the shape and movement of the waves the shape and movement of the boat and its inhabitants realized as a single form that proves, on irrelevantly close examination, to be slightly out of proportion.

Homer's watercolor style now placed much reliance on sweeping brush-strokes in which, to quote Isham, he preserved "the accidental felicities of a trained hand." He makes us accept as factual colors not previously perceived in nature. Thus his *Adirondack Guide* features dead branches of light blue, a deeper blue tree trunk, background woods in which loose bright masses contrast with darks, and water that is an abstraction of mingled tints. But his brightest drawings are of the brightest subject matter: the tropics. Here he ran the gamut from black to the highest possible hues. The resulting brilliance is a visual delight, but is achieved by different means from the brilliance of the Impressionists. "It is wonderful," Homer said, "how much depends on relations of black and white. . . . A black and white if properly balanced suggests color. . . . The question is truth of values."

An oil sketch Homer made at the World's Fair (Chicago, 1893) of a gondola advancing in front of a fountain seems to glow with color; we must look a second time to realize it is altogether in black and white. And this composition which might be of Venice reminds us again that Homer's nature included a vital elegance which, had he been born in another place and time, might have carried his art even in the direction of Tiepolo.

Homer's art continued to grow until he was almost seventy. Sometimes, as the Hudson River painters did with their oil sketches from nature, he translated onto canvas effects which he had originally recorded in his watercolors. At other times, he would try to catch directly in the slower medium the kind of evanescent natural phenomena to which his watercolor practice had acclimated him. He would get down as much as he could before the effect faded, and then wait — a year if need be — for it to reappear. He wrote concerning *West Point, Prouts Neck:* "The picture is painted *fifteen minutes* after sunset — not one minute before — as up to that minute the clouds over the sun would have their edges lighted. . . . You can see that it took many days of careful observation to get this, with a high sea and tide just right."

Except for such transitional, moralistic pictures as Cole's *Destruction of Empire*, the Native School had avoided the darker sides of life —pain and death — that had so fascinated European romantics. But when in 1899 he painted *The Gulf Stream*, Homer revived subject matter Copley had pioneered more than a century before in *Brook Watson and the Shark* (1778), and which Géricault had carried on in *The Raft of the Medusa* (1819). However, Homer brought to his picture of a colored man floating helplessly in a dismasted boat surrounded with sharks a new starkness which, although it might seem the opposite, was the ultimate extension of the optimism of the Native School. Copley and Géricault had both depicted maritime suffering at the moment of rescue. Homer's disdain for this approach is shown by his sarcastic comment when his painting frightened away purchasers: "You can tell these ladies that the unfortunate Negro, who is now so dazed and parboiled, will be rescued and returned to his friends and home, and ever after live happily."

There was dramatic gesturing in Copley's and Géricault's pictures. Homer's protagonist sprawls on his deck watching stoically the approach of a waterspout that will probably mean his end.* Man, the picture tells us, is strong enough to meet without flinching any fate. Homer's acceptance of reality was so deep that he found whatever was true was also beautiful.

By the time he created *Gulf Stream*, Homer was rarely painting inhabited canvases. More commonly he turned away from that newcomer, man, to paint the battle, as old as creation, between angry ocean and stubborn rock. When winds began to howl, he fixed his palette with rising excitement, and the height of the tumult found him at its very center, in a little glass-walled cabin placed where wave and land met. From so close a view, he achieved compositions which could seem to someone who had never seen the ocean abstract expressions of stresses in his own mind. His *Northeaster* opposes only a few generalized rock forms to the massively constructed onrush of the waves crowned with pelting spray that combines power and airy lightness. There is a new broadness and sweep in his application of oil paint, and his color too has been simplified, the hues still darker than his watercolors but aglow with iridescent light.

In this concentration of artistic language, the naturalism that had for sixty years characterized the Native American School is in no way sacrificed. Looking at great art, we feel we are seeing not the work of man but Nature herself as she was created by God in His eternal glory.

*There is similar laconic savagery in some of Homer's hunting scenes, which depict without repining a world where nature had placed in man and animals a need for meat and in meat half secured fear, pain, and despair. Here, as in many other ways, Homer anticipated Ernest Hemingway.

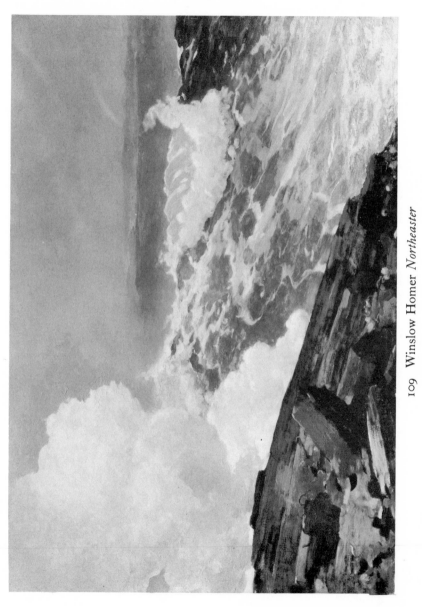

109 Winslow Homer *Northeaster*

Oil on canvas; 1895; 34⅜ × 50¼; Metropolitan Museum, New York, gift of George A. Hearn, 1910.

CONCLUSION

THE NATIVE SCHOOL

"WHEN I was in America," the British art critic Anna Brownell
Jameson wrote of a trip made in 1838, "I was struck by the
manner in which the imaginative talent of the people had
thrown itself forth in painting: the country seemed to me to swarm with
painters." Ruling that "the immense proportion" of the artists were "posi-
tively and outrageously bad," she explained that "there was too much
genius" to produce "mediocrity. They had started from a wrong point,
and in the union of self-conceit and ignorance with talent; and in the absence
of all good models and any guiding light, they had certainly put forth perpe-
trations not to be equaled in originality and perversity." What horrified
the cultivated bluestocking, a disciple of Ruskin who adored the windy
neoclassicism of the dying Munich Mural School, was that the Americans
in their "perversity" were not ashamed of but rather delighted with their
"originality."

Among American painters, Mrs. Jameson admired primarily the Italianate
Allston, although she reported and regretted his sterility. That sterility,
as duplicated in other artists who had tried to import the high style, encour-
aged in their juniors an exaggerated fear of European influence. Ideally, the
early Native School travelers should have — as Inness did in the 1860s —
assimilated greater riches. Yet it is vain to ask revolutionaries to be moder-
ate, and there is much evidence that for the first generation of the Native
School any true synthesis of the American and the foreign was not a psycho-
logical possibility. Not only did Cole practice two almost separate styles,
but so many painters felt it necessary, on their return from abroad, to rub off
much of what they had acquired on the hard surface of the Catskills.

The sharp break the painters envisioned between European and American

inspiration reflected not only broad historical forces but their specific esthetic situation. When the period opened, no foreign style could be adequately studied from actual examples in America. The impact of the Düsseldorf Gallery was partly because it was the first comprehensive and authentic showing in all our history of any European school. However, Düsseldorf had little to offer our painters that was not retrograde. As for the French works that began being imported at about the same time, they represented reaction in France. And in Bryan's and Jarves's collections of Old Masters the illusionistic works that had most relevance to existing taste were predominantly spurious.

The ocean was, for pre-Civil War painters, a divide that separated by weeks of very expensive travel American life from European models. This immensely complicated the always difficult problem of applying artistic riches developed in one place and time to the expression of another.

However, the lack of imported models was a less basic difficulty than the short time America had been inhabited by art-creating man. An Old World child was commonly surrounded from birth by man-made beauty, for not only had taste been exerted for centuries, but time is a brilliant repainter, bringing even what was once ugly into harmony with its surroundings. However, in the United States few tasteful objects had accumulated, and time had hardly begun to wield his amending brush. The esthetic sophistication that seemed inborn abroad had to be for Americans an acquisition.*

Seeking that sophistication, the older painters had destroyed themselves. The younger, assisted by a rise in nationalism throughout the Western world, resolved to make use of what assets they had at hand. There was American nature, which was truly beautiful and, according to some ideas of high romanticism, more elevating than the European because in its wildness it was closer to God. And there was American man, envisioned as neither a toady to aristocrats nor an aristocrat enslaved by artificial vices, but a natural exemplar of nature's inborn goodness. Towards bringing the two together the luxurious products of tradition were often ruled as irrelevant and debasing as a whore's paint would be on a virginal face.

Although only Catlin carried such reasoning to its logical extreme by repudiating all sophisticated influence, the favorite pedagogical device of the Native School was self-education in the presence of nature. Modern institu-

*This situation has not altered as much as we should like to think. Although more man-made beauty is now available in the United States, it must usually be purposefully visited, and often there is hardly any within an American child's range.

tionalization had given the term "self-taught" a crude sound and encouraged its application only to crude artists, yet the method can eventuate in great skills. Lincoln was self-taught, and he was no political Grandma Moses.

The fact that painters usually began their careers as craftsmen did more than ground oil styles on sign painter's, engravers', or wood-block techniques. Artisans imbibed a public and a pragmatic approach: art was for distribution, useless if left in the studio; skill was achieved in a series of stages, each brought to completion and offered for sale. Hunt, one of the few altogether school-trained painters, regretted his late start: "We could have a boy learn all that could be taught of painting — I mean the mechanical part — before he was twenty." Had he begun as a sign painter's apprentice, Hunt would have had to master a simple but solid technique when in his late teens.

The most basic foreign affinity of the Native School came to the painters imperceptibly from their own environments. It is impossible to determine today where in the culture the artists' inherited English lessons ended and American inventions began. How could they, caught up, as it were, in the flood, make distinctions? Even the vernacular traditions from which the painters emerged were as English as they were American.

Immigration and importation continued to flow in from the old homeland. During the entire hegemony of the Native School, the upper echelons of American painting included only one Frenchman, Gignoux (Bodmer was but a visitor); only two or three Germans, Leutze, Bierstadt, and perhaps Wimar; and not a single artist from any other Continental nation. However, the immigrants from England were numerous — they included the very founder of the School — while another sizable group, including that leader of the second generation Kensett, grew up in the United States with British parents. Identity of language flooded the land with English publications, many carrying pictures. America's most elaborate art magazine, the *Art Journal* (started in 1875), was the New York edition of a London periodical. If a native painter argued against a critic, it was likely to be Ruskin — or Mrs. Jameson. Our intellectuals and our ladies looked for behavioral and cultural inspiration to America's former homeland. They often required that ideas from other nations be transshipped in London.

When Native School pictures were shown abroad, they were most sympathetically received in England. On the other hand, American artists, even if they admired Wilkie, Constable, and Turner, had little use for more contemporary English painting and rarely centered their studies in the

British Isles.* They created a gap in the long line of important American artistic expatriates in England that had extended from West through Leslie, and was to pick up again with Whistler. The Native School was, like the civilization it expressed, an offshoot of English traditions that was going its own way.

In turning its back on a sophistication that the United States did not naturally possess, the Native School was in keeping with the international trend towards romantic realism. Local landscape and to a lesser degree genre were to take over European painting, after a long struggle, in the second half of the nineteenth century. If the Native School jumped into this tide somewhat late, during the trough which followed the collapse of the first major wave and which preceded the second that was eventually to overflow France and triumph, once romantic realism got started here, it conquered with unprecedented rapidity. Thus was reemphasized a general principle in American culture. Those artistic forms that have appealed particularly to European upper classes have always had hard sailing here, because we have never had such classes. We have had, of course, groups who *pretended* to be the equivalent of European's hereditary temporal or cultural aristoc- racies, but pretense produces neither strong art nor the prestige that enables an elite to impose its taste on commoners. As Henry James put it, "A bourgeoisie without an aristocracy to worry it is of course a very different thing from a bourgeoisie struggling *in* that shade." The high style died hard in Europe, but crumbled in the United States as soon as challenged.

When an American "elite" had been trying to "uplift" the taste of the masses, orators before such select groups as the old American Academy had felt it necessary to attack a popular belief that the fine arts were, as a hang- over from aristocracy, dangerous to a democratic nation. But once painting, instead of fighting the tastes of the people, served them, the United States displayed a love and hunger which utterly disproves the statement, later revived by new generations of uplifters, that American society had always been too materialistic to be deeply concerned with art.

In changing from a luxury for a few to a friend of the many, American painting espoused the most serious beliefs of the people: optimism, the identification of God with Nature, a love of childhood, a wholesomeness of attitude, and a purity of intention that made much European painting of the

*That England lacked the conveniences offered by Düsseldorf, Paris, and to a lesser extent Rome and Florence (it was hard to get into galleries to copy and into the life classes), served to discourage casual art students, but would not have turned ambitious Americans away had they really desired to be educated in the English manner.

time seem — as Americans wrote — frivolous and lascivious, calculated to inspire dilettantism and the darker passions. Even our exoticism struck a wholesome note. While French painters were seeking raw sensation among the ancient civilizations across the Mediterranean, Catlin was finding among the Stone Age mores of our Western Indians lessons in nobility for the civilized. And Church's South American views served curiosity rather than escapism: they were an invitation to the zest of the hiker, to the tap of the geologist's hammer.

That the Native School insisted on verisimilitude chimed with international conceptions: even Delacroix's extremest visions were painted as if they were real. But the United States carried realism further and mingled it with democratic thinking: painters should not desert the ordinary for mansions to which the keys were either culture or genius. They should show what the common man could see with his physical eyes in a way that would not seduce but rather heighten his vision. This esthetic protected its devotees from the literary fallacy, but blocked all doors to romantic idealism. Once the transition which Cole and Quidor inhabited had passed, the closest approach to fantasy within the Native School was those pictures by the Beards in which animals were made to play, as realistically as possible, the roles of men. And outside the Native School esthetic, creativity did not flourish. Although Page and Rimmer had their flashes, not a single historical painter enjoyed a fertile career. Hunt, who tried to people the American world with half-imaginary, half-European types, was driven by despair to suicide.

That in pursuing separately those two main branches of romantic realism, landscape and genre, the Native School was more successful with the former again reflected the international situation. Nineteenth century romantic realism achieved everywhere its most complete expression in landscape. When the second generation of genre painters, having lost their way in a United States that was no longer the rural paradise they wished to paint, went abroad in a frank search for inspiration, they could find little that they could use. Except for the political satire of cartoonists like Daumier, which went against the determined predilections of the United States, nothing truly exciting happened in European genre between Wilkie, whose example had helped set the Native School in motion, and Millet, the inapplicability of whose example to the New World Hunt tragically demonstrated. So the American genre painters sat at the feet of Düsseldorf artists and modified Couture's formulas with results largely unfortunate.

Although American genre did not suffer with the European from aristo-

cratic condescensions to the common man, the American push towards optimism was at times equally damaging. And middle-class prudery impinged on every aspect of American figure painting. In addition to taboos concerning the nude, there persisted the old neoclassical disapproval of sensuous color. The tints with which Inness flooded his landscapes would, if applied with equal poetry to the body, have been considered shocking.

Nature could be approached in a wider variety of moods than man. She laid herself open — her violences, her privacies, her most physical aspects — to less inhibited inspection. And American optimism felt most secure in its adoration of the world God, not man, had made. While figure painting shied away from everything depressing, the solace found in nature was so great that landscape ecstasy was able to absorb — as in the work of Wyant and Martin — sickness, melancholy, and pain. It was by merging genre with landscape that Homer brought within the scope of the Native School's naturalism human savagery and even the death of man.

The landscape painting of the mid-century was so deep a national expression that today, three quarters of a century after the pictures were laughed out of court by a different sophistication, even the descendants of the laughers define a beautiful view in Hudson River School terms. However sophisticated a summer community on the eastern seaboard, it does not consider a Barbizon glade top premium real estate. Everyone covets locations that look out over valleys and water to mountains, or on a mingling of cliff and sea.

Not until there emerged in France a landscape school that paralleled in many ways the aims of the Hudson River School did there appear an effective non-English influence in American painting. Barbizon had perhaps no more — perhaps less — to offer the Americans than Constable, to whom the French painters were, indeed, much beholden. But for three major reasons the later influence proved more acceptable. The American landscapists were now so sure of themselves that they were not afraid of being bowled over. Secondly, Constable's views had seemed to the earlier American painters far removed from the soul of American scenery, but by the time Barbizon came along, the Hudson River School world and style had turned to domestic and pastoral landscape. And thirdly, where Constable could be studied only during a European trip, collectors brought many Barbizon canvases to America. Both Wyant and Martin were primarily influenced not in France but at home.

The purchasers of European art were able to have this fructifying effect

on American painting because there existed beside them purchasers of American art. The experiences of the next generation revealed what happens when emphasis shifts almost completely to imported pictures and tastes. The result was not increased assimilation of foreign styles, but rather for artists a choice between such worldly failure as Eakins suffered or imitation fashionably stretched across sterility. What does it profit a nation to erect a great marble museum full of paintings, however great, by the distant and the dead, if in so doing it reduces most of its own artistic quarter to desert?

When the Barbizon influence streamed in, the native landscape tradition was strong and well supported. It picked up like quicksilver the French gold without losing its contact with the American world and the Hudson River School's own deep-rooted version of plein-air naturalism.

To say that American naturalism reflected the materialism fostered by the conquest of new environments is undoubtedly true, but requires qualification. Materialism can be many things. It can be the pleasure of a glutton in his food, of the vulgar in conspicuous waste. These were alien to the aspect of American development that the Native School at its best expressed. Materialism can be joy in an object because of what you can do with it: the Native School admired tools for their usefulness towards pragmatic ends. A good axman works in the woodshed, not the parlor, and shows skill by leaving stumps altogether smooth. The Native School worked not in tricked-up studios but functional rooms, and they used technique to hide technique.

In his *Painting and Sculpture in Europe, 1780–1880*, Fritz Novotny tells us that the great struggle of nineteenth-century European art was to achieve a synthesis of naturalism with idealism. Americans saw less of a problem. At peace with the world and convinced that it existed for them to use, they needed to draw no sharp line between themselves and the world. Furthermore, they were used to expressing ideas through things. National greatness was canals and then railroads; love of one's fellow men was founding new centers for prosperity; poetry could be an improved plow; philosophy was appreciating the wonders of the physical universe; religion was establishing unity with those wonders. America painted the physical as a manifestation of the holy.

It is not paradoxical that in the most democratic period of the most democratic of nations esthetic theory skimped purely personal expression. Individualism was so triumphant that it did not have to be asserted; aspiration urged the community of men. Only after the new millionaires had

[297]

shattered Jacksonian equality and scorned American creativity did self-expression seem to the artists different from expression for all.

Another characteristic of the Native School was energy: the energy of young men in a morning world. So youthfully minded, indeed, were the painters that they envisioned sensual pleasure in an athlete's terms. Their symbols of bodily joy were not a perfumed boudoir and its inhabitant, but a mountain to be climbed, an icy lake to dive in. No modern school of painters has been less concerned with love, with courtship, with marriage. And their subtlety — they could be very subtle — was not that of sensibility. It was the exquisite timing, attention, control that makes an athlete great.

That the members of the Native School were, with the single exception of Lily Martin Spencer, men and that at their most typical they painted for masculine consumption were among the considerations that divided the painting from the literature of the time. Many ladies were successful authors, and, at least by the mid-century, imaginative writing was primarily consumed by women. In novels or extended verse, love-interest was almost always present, even if it had to be poured over the main purpose like sauce.

With the new academic interest in the study of American civilization as a whole, it has become the fashion to find parallels between the various arts, and since literature has been the aspect of our culture most studied, it has been assumed that writing called the tunes to which all the others danced. Thus, a distinguished curator has stated concerning Emerson's celebrated speech, "The American Scholar": "No one heeded this cultural declaration of independence more than the painters." Actually it was not till 1837, when the Native School was already in full freshet, that Emerson argued that American's dependence on other lands "draws to a close." And, as we have seen, the New England cultural renaissance was inimical to creativity in painting.

The Native School shared with Emerson, Whitman and many another author an optimistic belief in the uplifting influence of unspoiled nature, a skimping of the problem of evil, a conviction that what was true was right and also beautiful. Yet, within the broad framework dictated by place and time, painting and literature were less remarkable for their similarities than for their divergencies. The greater feminine influence on writing was only a secondary explanation. The primary reasons were, in addition to the inherent requirements of the two media, differences in the availability of European materials, and differences in social status.

Since the first settlement of British America, English books had sailed

across the ocean to be widely distributed or even reprinted here. In Colonial times, when portraiture flowered in semi-isolation up to the major achievements of Copley, imports satisfied literary readers and, except for religious and political essays, frightened local literary creativity. Not till almost the moment of the Native School did an important American imaginative literature emerge, and it was then dominated by an attitude which persisted through much of the period here discussed. As Cooper stated it, the United States possessed different opinions, but in taste and form English and American writing were based on the same models.

At its more original, pre-Civil War literature did some borrowing from the vernacular — Emerson gave permanence to the lecture, and Poe deepened short magazine fiction — but in their use of language, leading writers avoided American usage. Although their medium, having become through generations of familiarity with British publications the national educated manner, was not borrowed in the same sense as the high painting style was, their traditional vocabulary, sentence structure, and metaphor did remove the writers a full step from the realities of all but the most cultivated American life. That Whitman, despite his other freedoms, never broke with this mold was one reason why, although he set himself up as the democratic everyman, he failed to communicate with ordinary Americans the way the Native School did.

Among writers, it was popular humorists who first — during the 1840s in newspapers and the 1850s in books — sought American idiom. Their subject matter — the Negro, the Yankee, and the backwoodsman — paralleled Mount's and Bingham's, even if their humor was more exaggerated, closer to that which faded out of important painting with Quidor. They never rose, as the painters did, above vernacular expression. Not till Mark Twain appeared was the American vernacular raised in writing to an artistic mode. It was Mark Twain's *The Innocents Abroad*, Van Wyck Brooks tells us, which "first cut the umbilical cord that bound Colonial America to the mother country." That was in 1869, after the Native School had been flourishing for some forty years.

The convention of piracy enabled publishers to print British works for free which, in turn, eviscerated the prices American writers could command. Most literary men lived on inherited incomes or made money from other professions. Longfellow is said to have become, during the 1850s, the first to make poetry more than an avocation. However, even he, despite his immense popularity, had difficulty getting as much as twenty-five dollars

[299]

for a poem. "There is," he complained, "not wealth and munificence in this country to afford sufficient encouragement and patronage to mere literary men." Prosperous professional painters then abounded.

Because painting required working with your hands to create for sale physical objects, it had traditionally been regarded, here as in Europe, as an occupation unsuited to a gentleman's son. That in mid-century America it offered — as socially correct literature did not — self-support to men of low economic background did not help its prestige with the polite. As Hunt's biographer, Helen M. Knowlton, put it, "The profession of artist would not have been chosen by any educated American of that period."

Although some sons of the well-to-do — conspicuously Church and Gifford — became painters, the tone in the studios was set by men who had been farm boys, clerks, apprentices. Few top painters reached high school, and almost none were graduated from college. However, the writers were predominantly college-educated, which meant, in those days before scholarships, that their families had means. Others, like Melville, came from financially depressed gentry. Whittier and Whitman were exceptional among authors in stemming from the less exalted classes, from which painters were commonly recruited. The painters were birthright members of the Jacksonian revolution, while the writers were as a group identified with the *ancien régime*.

Better off than their fathers, the painters were pleased with the environment in which they and men like them had risen. However, the writers, whose hereditary position was being undermined by the Jacksonian revolution, felt a nostalgia for the past that made the Colonial period and the American Revolution (themes the painters left to Leutze and the illustrators) favorite literary themes. The old Puritan obsession with evil that haunted Poe and Hawthorne had no place in the painters' sunny world. Among the major figures in the Native School, only the partial precursor Cole would have found any relevance in Hawthorne's statement, "No author, without a trial, can conceive the difficulty of writing a romance about a country where there is no shadow, no antiquity, no mystery, no picturesque and gloomy wrong, not anything but commonplace prosperity, in broad and simple daylight, as is happily the case of my dear native land."

The painters felt no urge to move away from the delightful actualities of contemporary living into those imaginary worlds where many of the writers were most successfully at home. When Melville wrote artistic reportage about the tropics, he was close to Church's South American paintings, but

when he scoured a half-imaginary ocean for a symbolic whale, he pointed among painters to Ryder, who lived in later times.

The mid-century authors were usually as eager to communicate with the democratic man as were the painters — they avoided obtuse styles and unexplained learned allusions — but the literary objective was less to give expression to the nonélite, more to improve them. Poe called for an "artistocracy of blood" to establish taste; Whitman preached at his neighbors to violate their favorite shibboleths; and Emerson phrased condescension in his masterly manner when he said, "Art has not yet come to its maturity if it do not . . . make the poor and uncultivated feel that it addresses them with a voice of lofty cheer."

Sometimes the voice spoke philosophy and ethics; sometimes it sought to acclimate to the United States those Old World glories that were the principal subject matter of formal American education. Poe dreamed of going "home" to ancient times, and Longfellow tried to clothe America in European fancy dress. Trollope wrote that the author of "Hiawatha" and "Paul Revere's Ride" was "the last I would have guessed to be an American."

Although sporadic efforts — like the early manner Maria Catherine Sedgwick soon abandoned — were made to see the common man both frankly and with affection, literary writers usually considered their unrefined contemporaries either vulgar or quaint. Some, like Cooper, excoriated with what they hoped was an improving lash the mob that had taken the reins of government from their betters. Cooper preferred (as did Catlin, who was among the best-born of the painters) "the Noble Savage." In genre poems like Longfellow's "The Village Blacksmith" and Lowell's "The Courtin'" the Boston Brahmins hit as the literary critic Robert Spiller and his associates wrote, "precisely the right tone of gentlemanly condescension to the lower classes." This was the Düsseldorf approach, and that of American genre only when belief and inspiration failed.

Even as the writers entered the artisan's workshop and the farmer's kitchen as visitors, their experience had not brought them truly intimate communion with nature. Only Whittier was raised on a farm. While painters rambled over mountain and valley, authors delivered lectures or sat at their desks reading books. It was for Thoreau an exotic adventure to live in a cabin in a thicket alongside a pond. And typically, Thoreau was not studying nature for her beauty but rather to develop philosophical conceptions. While authors thought themselves into natural phenomena, painters held nature against their hearts and believed that such unintellectual

communion was the springboard to a higher life. Although most nature poetry was didactic — Whittier was significantly a partial exception — didacticism was utterly absent from the fully evolved Hudson River School. Closer, indeed, to the landscapists were the descriptions of natural settings in novels which, because they were merely pieces in a larger design, could be left temporarily free of exterior introduction of meaning. Landscape, that queen of painting, tended in writing to be a handmaiden to philosophy or storytelling.

The authors belonged to the same social groups as the connoisseurs against whose conceptions the Native School had rebelled. It is thus not surprising that painting and literature most resembled each other before the rebellion had solidified. Quidor followed Irving into a mythological American past, and Cole's romantic idealist pictures were an anthology of literary directions: he moralized; he longed to import Old World mellowness; he mourned with Irving and Bryant over the brevity of existence; he shared with Poe the image of man's destiny as a frail boat on the flowing waters of time. Cole and Catlin were both accomplished writers, and Durand wrote extremely well. After that, the painters ceased to find effective expression in words. The situation had developed of which Henry James complained when he stated that American painters were more averse to criticism by literary men than were those of any other nation, which seemed to James ridiculous, when French painters were happy to execute literary subjects and consult with their "literary *confrères.*"

During the middle half of the nineteenth century, roughly from the 1830s through the 1870s, painting was more indigenous in manner than literature and much more concerned with the contemporary, the local, and the day-by-day aspects of existence in the United States. However, at the time of the Civil War a reversing current became perceptible.

Authors had done much, while painters stood inert or disapproving, to promote the war. The actual explosion drove the genre painters away from reality, but drew novelists towards realism. The martyrdom of Lincoln, so celebrated in verse, was not depicted by any important painter.

As a reduction in piracy and an increase in audience enabled American writers to support themselves with the pen, imported tastes and canvases began to undermine the economic position of American painters. And for the first time in our history the artists had the opportunity authors had always had of examining in their homeland first-rate imported examples. Among painters, the prestige of European attitudes and techniques soared as it

weakened in writing. Young artists felt as revolutionary in turning away from ordinary American experience as the writers felt in turning to it. Winslow Homer and Mark Twain were born within three months of each other. The painter was the final figure in a fine arts tradition wedded to American vernacular roots. Mark Twain initiated a literary tradition rising from the same source.

The development of American sculpture was altogether different from that of the Native Painting School. In so far as they did not practice portraiture, the sculptors were mesmerized by the unique position their art enjoyed in the revelation of the human body, usually female, through classic draperies or even "classically" in the complete nude. This obsessive subject matter carried them altogether away from American life to ancient heroines or victims, or to female embodiments of virtues (never vices!). Add that the conception involved the use of cold white marble, that such marble was easiest to come by in Italy, and that Italy possessed expert craftsmen-carvers who could help materialize and then duplicate an artist's conceptions in the desired stone — and you had compelling reasons why the vast majority of American sculptors should make their careers abroad. The few who stayed home, like Erastus Dow Palmer of Albany, New York, showed their taste (and skirted taboos) by doing what the expatriates did. The exception was John Rogers, who mass-produced Mountian genre in painted plaster groups that enjoyed as much popularity then as they suffer from execration now. Actually, Rogers's original bronzes are not altogether without quality, although even more than any aspect of mid-century painting they set modern teeth on edge.

In architecture the three major stylistic directions of the time — romantic realism, neoclassicism, and romantic idealism — were deployed differently than in painting. Although realism was dictated for floor plans by the necessities of function, professional architects made every effort to hide the pragmatic and local approach in which the Native School reveled. Interior embellishment, exterior decoration and shape were correctly neoclassical (Greek Revival) or obeyed romantic idealism (Gothic, Romanesque, Moorish, Egyptian, and other exotic forms as they had arrived via England). Neo-classicism was given a democratic twist when respectable greengrocers were housed in shrunken temples to Venus freely rendered in wood. The romantic idealists sought originality through eclectic mixtures and distortions of old transatlantic styles, achieving sometimes a wild charm for which no parallels can be found on any important canvases after Cole's. In the 1860s, an

architectural student, George P. Post, noted with annoyance that the Native School painters did not regard architecture as an art. Yet when they themselves built, the painters came no closer to American reality: Church, with the assistance of Calvert Vaux, designed his home overlooking the Hudson as Victorian-Moorish; Cropsey tried to bring "beauty" to New York City's elevated railways by making the stations gimcracky Queen Anne kiosks; and the painter members did not object when the architects in the National Academy cast its new building (1865) in the Venetian Gothic taste popularized by Ruskin.

The vernacular was limited to purely utilitarian buildings like factories, warehouses, and routine housing, often executed in the cheap method of balloon construction that had been invented in 1833 but was not accepted by correct architects for half a century. To such haphazard erections there was added an occasional purposeful style like the octagon house promulgated (1849) on a theory of utility by the phrenologist Orson Fowler. The results were almost always hideous because, as that pioneer charter of the American vernacular John A. Kouwenhoven wrote, "freedom . . . was bought at the cost of losing all contact with the human tradition of western European art."

A native school in American architecture awaited a wedding of the vernacular and fine arts traditions that was not to take place until the last decades of the nineteenth century. Its high priest, Louis H. Sullivan, explained in words that might have been written by Durand, "With me, architecture is not an art but a religion, and that religion but a part of the greater religion of democracy."

Music in which, as in no other art, creativity is divided between composer and performer, between professional and amateur, followed its own laws. On the fine arts level, performance of imported repertoire usually by foreign-trained men supplied (as it does today) a sense of local achievement that felt almost no need for local composition. On the other hand, tens of thousands of practicing amateurs made music the richest of all the vernacular arts. Between the two groups were professional entertainers.

The tremendous amateur activity brought prosperity to American publishers and arrangers, but not to composers, since even more than in literature unpaid foreign competition overwhelmed. The efforts of the well-educated were, indeed, to drive out of the singing books as unprogressive all indigenous tunes to make room for European material edited to suit local needs. There are some exceptions, like the Creole-inspired compositions of Louis M. Gottschalk, but as a general rule it was only when music moved away from the cultivated, the centers, and the most up-to-date books that the vernac-

ular began to operate. On that level, originality was tremendously enhanced by a unique phenomenon: the presence of the Negroes, a group populous yet culturally semiautonomous whose background was not European, whose art form was music, and who kept tunes going independently of texts in the true folk art manner. Their influence was so great that when popular music was not composed for religious camp meetings or feminine parlor performance, it was written by white men to be performed in blackface.

All this created a great surging on the vernacular level, while on the fine arts level music was being neatly organized according to the German taste, the importation of which is considered by correct historians the most important development of the mid-century. There was hardly any such merging of the vernacular and the fine arts traditions as predominated in painting — but out of the seething there arose the brief, tragic career of Stephen Foster. No more than a tunesmith but within his limitations great, Foster gave musical expression to the United States of the Native School. Yet the only means of performance within his grasp were the minstrel shows, which forced him to write, despite ignorance of the South, pretended Negro melodies. That his best work was regarded as "trash" by the gentlemanly class, into which he had been born, intimidated him into refusing to sign his name to "Home, Sweet Home"; he wasted much time trying to compose genteelly. Had he been able to make his living from creation as the painters did, and had his indigenous work been with theirs admired, Foster might not have died in mid-career of alcoholism; he might well have applied his genius much more richly.

During the mid-century, when our society was at its most equalitarian, painting much more consistently than any other fine art spoke for the people. In those years, when politically and economically the United States was resolutely going its own way, painting more than any other art went hers. The Native School alone raised American vernacular expression into a deep vehicle for feeling. One in background and point of view with the ordinary man, depicting lovingly what viewers also loved, the artists appealed directly to self-educated eyes, and moved, with images often sophisticated, unsophisticated hearts. They gave the most profound esthetic expression to that major aspect of the development of the United States, Jacksonian democracy.

However, it was not the object of the painters to be historians or reporters: they yearned to be great artists. To what extent did they succeed? On the all-important matter of quality, the reader must have reached conclusions. It only remains for the writer to state his own.

It seems incontrovertible that the Native School has been grievously

[305]

undervalued. The principal stumbling block to appreciation has been the School's determination to make emotion seem inherent in the subject rather than the contribution of the artist. For eyes acclimated only to European styles, this seems by definition "unartistic."* But once we give the painters the considerate attention that we automatically accord to imports from accepted schools, we realize that the Native School, far from being an aberration to blush at or laugh at, is an aspect of American culture of which we may well be proud.

Among the American arts of the mid-century, literature has been considered the leader, and with this verdict I will not quarrel, although I believe the gap is much smaller than has been supposed, and I foresee that it will be further narrowed when the Native School has received such exploration in depth and cooperative appreciation as the authors have long enjoyed. As for the other American arts — sculpture, architecture, and music — it seems clear that in the mid-century they did not reach heights comparable with the painters'.

To rank the Native School in relation to world developments in painting is a slippery task but must be essayed. Obviously, the American movement did not constitute one of history's greatest esthetic outbursts. If, however, we compare it to other groups within its own period, it looms impressively. France, which led painting at the time, was, of course, conspicuously ahead of the United States. But when we look away from France, we may cast our eyes where we will in mid-century Europe without finding any schools to which the Native School cannot be compared to its advantage.

Internationally, the mid-century was a literary period. In Scandinavia, Germany, England, Italy, and Austria, painting was in the doldrums, often, as was the case with Biedermeier and the Pre-Raphaelites, dragged along by the writers. However, the Native School was an original, vital, and in its own way valid expression of the painters' art. And it produced in Winslow Homer one truly major artist, equivalent, so I believe, in creative force to his French Impressionist colleagues.

That subsequent generations buried rather than refined the native tradition was a misfortune not only for the painters but for the entire society of the United States. As that local achievement was hooted first from favor and then from remembrance, belief in American artistic creativity faded too. Painting became to its devotees a fascinating stranger, who, after having

*It is not a coincidence that the exceptions within the total School to this typical approach—Inness, Wyant, Martin—alone survived the critical blight.

been lured by money to our continent, cast about her spells woven in richer places and times. A knowledge of art came from books, from museums, from university courses, from trips abroad. The result was an increase in information and a broadening of taste, but certainly much was lost. As the tragic isolation of Eakins shows, locally inspired achievement, even if it made use of European skills, was banned from the mainstream of American acceptance. And a charm went out of our national life.

In Edith Wharton's *The Age of Innocence* the hero, despite the *Study of Sheep* by Verboeckhoven that he owned, could find no better escape from the narrowness of New York society than an abortive love affair with his wife's cousin, who had been given cachet by having lived abroad. How much healthier it would have been had he shared with artists in earlier studios the excitements of creating the Native School!

During a visit to the United States in the early twentieth century, Arnold Bennett heard in drawing rooms filled with "proofs of trained taste, . . . and usually from the lips of an elegantly Europeanized American woman with a sad, agreeable smile, 'There is no art in the United States. . . . I feel like an exile.' . . . They associate art," Bennett continues, "with Florentine frames, matinee hats, distant museums, and clever talk full of allusions to the dead." How much better off our refined compatriots would be if, instead of beating butterfly wings in a self-imposed perpetual winter, they could see and nurture the flowers in their own back yards! Would our museums be so relatively unfrequented, would our land be so riddled with advertising posters and neon signs and hideous shopping centers had we not been taught to despise the esthetic possibilities of our own land?

There are portents that today, almost a century after the Native School was seriously challenged, a belief in her own artistic creativity is returning to the United States. May this volume, by recalling the successes and failures of America's most long-lived and glorious school of indigenous painting, contribute to the cultivation of that talent and beauty which can emerge wherever men work courageously, feel sincerely, and dare to dance before the universal gods in the light of their own stars.

ACKNOWLEDGMENTS

AMONG institutions, my special gratitude is due to the New York Public Library, which has made available to me, during a considerable part of my labors on this book, the superb facilities of their Frederick Lewis Allen Memorial Room. I am also particularly indebted to the Frick Art Reference Library, the New-York Historical Society, and the New York Society Library.

Among individuals, I received the greatest assistance from Lloyd Goodrich who, with great generosity twice placed his personal notes at my disposal: once on David Gilmor Blythe and, still more valuably, on Winslow Homer. I am also grateful to John I. H. Baur, Gilbert Cam, Bartlett Cowdrey, Marshall Davidson, William Davidson, Alfred Frankenstein, Albert T. E. Gardner, William Gerdts, Mr. and Mrs. Gerald Gignoux and Miss Adèle Gignoux, Francis S. Gruber, Robert B. Hale, Julius Held, Norman Hirschl, Hannah Johnson Howell, David C. Huntington, Mr. and Mrs. Louis C. Jones, Mr. and Mrs. Henry Livingston, Allan Nevins, Barbara Novack, Sadayoshu Omoto, Heinz Peters, Edgar P. Richardson, Victor Spark, Mildred Steinbach, Oscar Von Hagen, Richard Wonder, Rudolph Wunderlich, and Mrs. A. C. Wyer.

My wife, Beatrice Hudson Flexner, has contributed valuable suggestions at every stage of my efforts. Violet Serwin and Maxine Yeater have expertly typed the manuscript.

SELECTED BIBLIOGRAPHIES

IN preparing these selected bibliographies, I have attempted to combine usefulness and conciseness. Had I listed every publication from which during more than three years of labor I gleaned a bit of information, the result would have been almost a book in itself. Nor has it in most cases been possible to make one citation stand for many, since on almost all the artists and movements discussed, no book summarizing scattered sources has been published.

I have found it necessary to omit references to all recent catalogues of collections except a very few — conspicuously the *Karolik Collection* — which are in themselves scholarly summaries. Otherwise, I have made the effort to include all books directly relevant. Among periodical references, I have given the preference to those contemporaneous with the painters. This has seemed doubly justified because modern periodicals are indexed in the *Art Index* and similar works, while recent articles are cited under the names of the painters in Groce and Wallace's *The New-York Historical Society Dictionary of Artists in America.*

Because of the extent of the material involved, a single alphabetical bibliography would be almost unusable. On the other hand, a linking of source references with every statement in the text would create impractical bulk. Thus, I have prepared a bibliography of "General Sources," and have followed it with specific bibliographies broken by chapter into subheadings.

In no case is more of a title quoted than is necessary for clarity. Even such "short titles" are given only once, either in the bibliography of "General Sources" or in conjunction with that part of the text to which the reference is most relevant. Elsewhere, an abbreviated reference is followed by a symbol in parentheses that indicates where the fuller title may be found. The letter "G" — as in "Isham, *History* (G)" — refers the reader to the general list.

A Roman numeral in parentheses — as in "Whittredge, *Autobiography* (XIV)" — refers to the bibliographies grouped under chapters — in this case, Chapter 14.

General references are cited again in relation to specific topics only when they constitute important sources. Thus the account of a painter in the *Dictionary of American Biography* is only singled out when it adds to the record rather than summarizing it. The author assumes that the reader will take such obvious steps as looking in Cowdrey's compendium catalogue of the National Academy to see whether a painter has exhibited in that institution.

GENERAL SOURCES

Art Index, I–XII (1929–1962).

Baltimore Museum of Art, *250 Years of Painting in Maryland*, Baltimore (1945).

Barker, Virgil, *American Painting*, New York (1950).

Baur, John I. H., "American Luminism," *Perspectives*, No. 9 (1954), 90–98.

——, "Unknown American Painters of the Nineteenth Century," *College Art Journal*, VI (1947), 277–282.

Benjamin, S. G. W., *Art in America*, New York (1880).

——, *Our American Artists*, 1st Ser., Boston (1886); 2nd Ser., Boston (1881).

Bizardel, Yvon, *American Painters in Paris*, New York (1960).

Bolton, Theodore, *Early American Painters in Miniature*, New York (1921).

Born, Wolfgang, *American Landscape Painting*, New Haven, Conn. (1948).

——, *Still Life Painting in America*, New York (1947).

Brooks, Van Wyck, *The Dream of Arcadia*, New York (1958).

Burroughs, Alan, *Limners and Likenesses*, Cambridge, Mass. (1936).

Butts, Porter, *Art in Wisconsin*, Madison, Wis. (1936).

Caffin, Charles H., *American Masters of Painting*, New York (1913).

Chew, Paul A. (ed.), *250 Years of Art in Pennsylvania*, Greensburg, Pa. (1959).

Clark, Edna, *Ohio Art and Artists*, Richmond, Va. (1932).

Clark, Eliot, *History of the National Academy of Design, 1825–1953*, New York (1954).

Clement, Clara Erskine, and Hutton, Laurence, *Artists of the Nineteenth Century, . . . Containing 2,050 Biographical Sketches*, 2 vols., Boston (1879).

Cook, Clarence, "American Art," *Art and Artists of Our Time*, III (*c.* 1888), 145–299.

Cowdrey, Bartlett (comp.), *National Academy of*

Design Exhibition Record, 2 vols., New York (1943). A compendium catalogue.

——, *American Academy of Fine Arts and American Art Union*, 2 vols., New York (1953). Vol. I contains, with other matter, an invaluable account of the Art-Union by Charles E. Baker. Vol. II is a compendium catalogue of both the Academy and Art-Union.

Cummings, Thomas S., *Historic Annals of the National Academy of Design*, Philadelphia (1865).

Davidson, Marshall, *Life in America*, 2 vols., Boston (1951).

De Voto, Bernard, *Across the Wide Missouri*, Boston (1947).

Dickson, Harold E., *A Working Bibliography of Art in Pennsylvania*, Harrisburg, Pa. (1948).

Dictionary of American Biography, ed. by Allen Johnson and Dumas Malone, 20 vols., New York (1928–1936).

Dreppard, Carl W., *American Pioneer Arts and Artists*, Springfield, Mass. (1942).

Dunlap, William, *Diary*, ed. by Dorothy C. Barck, 3 vols., New York (1930).

——, *History of the Rise and Progress of the Arts of Design in the United States*, 2 vols., New York (1834); Dover Reprint (1969).

Eliot, Alexander, *Three Hundred Years of American Painting*, New York (1957).

Eyland, Seth (pseud. for David Edwin Cronin), *The Evolution of a Life*, New York (1884).

Fairman, Charles E., *Art and Artists of the Capitol of the United States of America*, Washington (1927).

Fielding, Mantle, *American Engravers upon Copper and Steel: . . . a supplement to Stauffer's American Engravers*, Philadelphia (1917).

——, *Dictionary of American Painters, Sculptors, and Engravers*, Philadelphia (1926).

[313]

Flexner, James Thomas, *America's Old Masters*, New York (1939); Dover Reprint (1967).
————, *American Painting: First Flowers of Our Wilderness*, Boston (1947); Dover (1969).
————, *American Painting: The Light of Distant Skies*, New York (1954); Dover Reprint (1969).
————, *The Pocket History of American Painting*, New York and Boston (1950).
Ford, Alice, *Pictorial Folk Art*, New York (1949).
Frankenstein, Alfred, *After the Hunt*, Berkeley and Los Angeles (1953).
French, Henry W., *Arts and Artists in Connecticut*, Boston (1879).

Greenough, Horatio, *The Travels, Observations, and Experiences of a Yankee Stonecutter*, New York (1852).
Groce, George C., and Wallace, David H., *The New-York Historical Society's Dictionary of Artists in America, 1564–1860*, New Haven, Conn. (1957).

Hamilton, Sinclair, *Early American Book Illustrators and Wood Engravers, 1670–1870*, Princeton, N. J. (1950).
Hartmann, Sadakichi, *A History of American Art*, 2 vols., Boston (1911).
Hone, Philip, *Diary*, ed. by Bayard Tuckerman, 2 vols., New York (1889); ed. by Allan Nevins, 2 vols., New York (1927).
Howe, Winifred E., *A History of the Metropolitan Museum of Art*, 2 vols., New York (1913).

Isham, Samuel, *The History of American Painting*, New York (1936).

James, Henry, "On Some Pictures Lately Exhibited," *Galaxy*, XX (1875), 90–97.
Jones, Agnes Halsey, *Rediscovered Painters of Upstate New York*, Utica, N. Y. (1958).

Karolik, M. and M., Collection of American Paintings; Foreword by John I. H. Baur, Cambridge, Mass. (1949).
Kouwenhoven, John A., *Adventures of America, 1857–1900; A Pictorial Record from Harper's Weekly*, New York (1938).
————, *Made in America*, New York (1948).

Lanman, Charles, *Letters from a Landscape Painter*, Boston (1845).

Larkin, Oliver W., *Art and Life in America*, New York (1949).
Lipman, Jean, *American Primitive Painting*, New York (1942).
Lipman, Jean, and Winchester, Alice, *Primitive Painters in America*, New York (1950).

Mather, Frank Jewett, *Estimates in Art, Series II*, New York (1931).
————, "The Hudson River School," *Magazine of Art*, XXVII (1934), 297–306.
Maurice, Arthur B., and Cooper, Frederic T., *The History of the Nineteenth Century in Caricature*, New York (1904).
McCracken, Harold, *Portrait of the Old West*, New York (1952).
Metropolitan Museum of Art, *Life in America*, New York (1939).
Murrell, William, *A History of American Graphic Humor*, 2 vols., New York (1933, 1938).

Neal, John, *Observations on American Art*, selected by Harold E. Dickson, State College, Pa. (1943).
Nevins, Allan, and Weitenkampf, Frank, *A Century of Political Cartoons . . ., 1800–1900*, New York (1944).
Novack, Barbara, *Cole and Durand: Criticism and Patronage (A Study of American Taste in Landscape, 1825–1865)*, doctoral dissertation, Radcliffe College (1947).

Pach, Walter, *The Art Museum in America*, New York (1948).
Peat, Wilbur D., *Pioneer Painters in Indiana*, Indianapolis, Ind. (1954).
Peters, Harry T., *America on Stone*, Garden City, N. Y. (1935).
————, *Currier and Ives, Print Makers to the American People*, 2 vols., Garden City, N. Y. (1929, 1931); 1-vol. condensation (1942).

Richardson, Edgar P., *American Romantic Painting*, New York (1944).
————, *Painting in America*, New York (1956).
————, *The Way of Western Art*, Cambridge, Mass. (1939).
Rutledge, Anna Wells, *Artists in the Life of Charleston*, Philadelphia (1949).
————, *Cumulative Record of Exhibition Catalogues, The Pennsylvania Academy of the Fine*

Arts, 1807–1870; The Society of Artists, 1800–1814; The Artists Fund Society, 1835–1845, Philadelphia (1955).

Saarinen, Aline, The Proud Possessors, New York (1958).

Saint-Gaudens, Homer, The American Artist and His Times, New York (1941).

St. Louis Art Museum, Mississippi Panorama, ed. by Perry Rathbone, St. Louis (1949).

———, Westward the Way: . . . The Louisiana Territory as Seen by Artists and Writers of the 19th Century, ed. by Perry Rathbone, St. Louis (1954).

Sartain, John, The Reminiscences of a Very Old Man, New York (1899).

Sears, Clara Endicott, Highlights Among the Hudson River Artists, Boston (1947).

———, Some American Primitives, Boston (1941).

Sheldon, G. W., American Painters, New York (1879).

Slatkin, Charles E. and Shoolman, Regina, Treasury of American Drawings, New York (1947).

Smith, Francis H., The Fortunes of Oliver Horn, New York (1902).

Soby, James T., and Miller, Dorothy C., Romantic Painting in America, catalogue of an exhibition at the Museum of Modern Art, New York (1943).

Spiller, Robert E., and others, Literary History of the United States, 4 vols., New York (1948).

Stauffer, David McN., American Engravers on Copper and Steel, New York (1907).

Stokes, I. N. Phelps, and Haskell, Daniel C., American Historical Prints, New York (1933).

Swan, Mabel M., The Athenaeum Gallery, Boston (1940).

Sweet, Frederick A., The Hudson River School, catalogue of an exhibition at the Art Institute of Chicago and the Whitney Museum of American Art (1945).

United States National Capital Sesquicentennial Commission, American Processional, 1492–1900, Washington (1950).

Vail, R. W. G., Knickerbocker Birthday: A Sesquicentennial History of the New-York Historical Society, 1804–1954, New York (1954).

Van Nostrand, Jean, and Coulter, Edith, California Pictorial, . . . 1786–1859, Berkeley and Los Angeles (1948).

Walker, John, and James, McGill, Great American Painting from Smibert to Bellows, New York (1943).

Weitenkampf, Frank, American Graphic Art, New York (1944).

Whitney Museum of American Art, American Genre, Introduction by Lloyd Goodrich, New York, (1935).

———, A Century of American Landscape Painting, Introduction by Lloyd Goodrich, New York (1938).

FOREWORD

RELATIVE PROSPERITY OF PAINTING: Baker, *Art-Union* (VI), 216; *New York Times* (7/31/61).

STATEMENTS ON ART: Cowdrey and Williams, *Mount* (II), 11; Cummings, *Annals* (G), 237, 342; Isham, *History* (G), 210-211; Mount, William Sidney, "Undated notation," ms. at New-York Historical Society.

CHAPTER 1

OPENING OF ERIE CANAL: Colden, Cadwallader D., *Memoir . . . at the Celebration of the Completion of the New York Canals*, New York (1825).

COLE DISCOVERED: Cole, Thomas, to William Dunlap (9/?/1834), ms. at New-York Historical Society; Dunlap, *History* (G), II, 359-360; *New York Evening Post* (11/22/1825); Noble, *Course* (see THOMAS COLE below), 57-58.

JOHN TRUMBULL AND WILLIAM DUNLAP: See bibliographies in Flexner, *Light* (G).

THOMAS COLE: Cole Papers: photostats, typescripts, microfilm, and photographs of correspondence, notations, writings, sketches, etc., from the New York State Library, Albany, N.Y., and other sources, compiled by E. Parker Lesley (1938–1948), at New-York Historical Society; Cole, "Emma Moreton, a West Indian Tale," *Saturday Evening Post*, IV (6/14/1825), 1-2; Cole, "Essay on American Scenery," *American Monthly Magazine*, new ser., I (1836), 1-12; Cole, "The Late Mr. Ver Bryck," in Cummings, *Annals* (G), 182-184; Cole, "Lecture on American Landscape Delivered before the Catskill Lyceum," *Northern Light*, I (1841), 25-26; Cole, "A Letter to Critics on the Art of Painting," *Knickerbocker Magazine*, XVI (1840), 230-233; Cole, "Sicilian Scenery and Antiquities," *Knickerbocker Magazine*, XXIII (1844), 103-113, 236-244; American Art-Union, *Exhibition of Paintings by the Late Thomas*

Cole, New York (1848); Bryant, William Cullen, *A Funeral Oration Occasioned by the Death of Thomas Cole*, New York (1848); Buffet, "Mount" (II), 37; Cummings, Abbott Lowell, "The Ohio State Capitol Competition," *Society of Architectural Historians Journal*, XII (1953), 15-18; Dunlap, *Diary* (G), III, 634, 760; Dunlap, *History* (G), II, 350-367; Hone, *Diary* (G), ed. Tuckerman, I, 74, 236; La Budde, Kenneth J., *The Mind of Thomas Cole*, photocopy of dissertation, University of Michigan (1954); Lanman, Charles, "Cole's Imaginative Paintings," *United States Magazine and Democratic Review*, XII (1843), 598-603; Lanman, "The Epic Paintings of Thomas Cole," *Southern Literary Messenger*, XV (1849), 351-356; Lesley, Everett Parker, "Some Clues to Thomas Cole," *Magazine of Art*, XLII (1949), 42-48; Lesley, "Thomas Cole and the Romantic Sensibility," *Art Quarterly*, V (1942), 42-48; *National Magazine*, IV (1854), 312-321; Noble, Louis L., *The Course of Empire . . . and other Pictures of Thomas Cole, N.A., with Selections of His Letters and Miscellaneous Writings*, New York (1853)*; O'Donnell, Thomas E., "The Greek Revival Capitol at Columbus, Ohio," *Architectural Forum*, XLII (1925), 5-8; Richardson, Edgar P., "The Romantic Genius of Thomas Cole," *Art News*, LV (Dec. 1956), 42ff.; Tunnard, Christopher, "Reflections on the Course of Empire and Other Architectural Fantasies of Thomas Cole," *Architectural Review*, CIV (1948), 291-294; Wadsworth Atheneum, *Thomas Cole*, Introduction by Esther I. Seaver, Hartford, Conn. (1948).

THOMAS DOUGHTY: Cole Papers (see THOMAS COLE *above*): Robert Gilmor to Cole (12/13/-1826 and 12/5/1827); Doughty, Howard N.,

*The scholar must be warned that Noble edited the documents he quoted. Thus, he omitted the negative criticism in Cole's comments on Allston's death, leaving only the one brief positive statement. Changes were made to make Cole seem, as a young man, the pious churchgoer he was to become in his last years.

"The Life and Works of Thomas Doughty," ms. deposited with notes used in its preparation at the New-York Historical Society; Doughty, Howard N., "Thomas Doughty," *Appalachia*, No. 103 (1947), 307-309; Doughty, J[ohn], and Doughty, T[homas], *Cabinet of Natural History and American Rural Sports*, I-III (1830-1833); Dunlap, *Diary* (G), II, 485, 501; Dunlap, *History* (G), II, 380-381; Lanman, *Letters* (G), 247; Lewis, E. Anna, "Thomas Doughty," *Graham's Magazine*, LXV (1854), 483-484; Neal, *Observations* (G), 34, 41-42; *Philadelphia Directories* (1814, 1816-1818, 1820); Sweet, *Hudson* (G), 35-41.

WILLIAM AND THOMAS BIRCH: See bibliographies in Flexner, *Light* (G).

INTERNATIONAL ARTISTIC BACKGROUND: Arts Council of Great Britain, *The Romantic Movement*, London (1959); Bate, Walter J., *From Classic to Romantic*, New York (1946); Boase, T. S. R., *English Art, 1800-1870*, Oxford (1959); Brion, Marcel, *Kunst der Romantik*, München and Zurich (1960); Clark, Kenneth, *Landscape Painting*, New York (1950); Flexner, *First Flowers* (G); Flexner, *Light* (G); Gilpin, William, *Three Essays on Picturesque Scenery, on Picturesque Travel, and on Sketching Landscape*, London (1808); Hauser, Arnold, *The Social History of Art*, III and IV, New York (1958); Kingender, Francis D., *Art and the Industrial Revolution*, London (1947); Manwaring, Elizabeth W., *Italian Landscape in Eighteenth Century England*, New York (1925); Muther, Richard, *History of Modern Painting*, 3 vols., New York (1896); Novotny, Fritz, *Painting and Sculpture in Europe, 1780-1880*, Baltimore (1960); Oldenbourg, Rudolph, *Die Munchner Malerei im neunzehnten Jahrhundert*, I, München (1922); Reynolds, Graham, *Painters of the Victorian Scene*, London (1953); Reynolds, Sir Joshua, *Discourses*; Richardson, *Way* (G); Winckelmann, Johann Joachim, *The History of Ancient Art*, 2 vols., Boston (1856).

CHAPTER 2

GEORGE W. FLAGG: *Dictionary of American Biography* (G); Dunlap, *History* (G), II, 448-450; Durand Papers (IV): Flagg's correspondence with Luman Reed; Flagg, Ernest, *Genea-*

logical Notes on the Founding of New England, Hartford (1926), 102-105; French, *Connecticut* (G), 91-92; Tuckerman, *Book* (G), 404-408.

COLE ON PORTRAITURE: Cummings, *Annals* (G), 183.

JOHN QUIDOR: Baur, John I. H., *John Quidor*, Brooklyn, N.Y. (1942); Cosmopolitan Art Association, *Catalogue of American and Foreign Paintings*, New York (1860); Costello, Augustine E., *Our Firemen*, New York (1887), 167-168; Cummings, *Annals* (G), 76-81, 202; Dunlap, *History* (G), III, 87; Eyland, *Evolution* (G), 30; Lebell, Robert, "Quidor and Poe," *VVV* (1943), 55-57; Smith, Irving Jerome, "All Dressed Up like a Fire Engine," *Art in America*, XLIV (1956) 54-57, 69-70; Thorpe, T. B., "New York Artists Fifty Years Ago," *Appleton's Journal*, VII (1872), 574.

ALBERTUS D. O. BROWERE: Howell, Warren R., "Pictorial California," *Antiques*, LXV (1954), 62-65; Jones, *Rediscovered* (G), 26-27; Sweet, *Hudson* (G), 81.

WILLIAM SIDNEY MOUNT: Mount Papers at the New-York Historical Society and the Suffolk Museum, Stony Brook, N.Y.; Buffet, Edward Payson, "William Sidney Mount," articles clipped from *Port Jefferson Times* (1923-1924) and mounted in a scrapbook at New York Public Library; Cowdrey, Bartlett, and Williams, Hermann W., Jr., *William Sidney Mount*, New York (1944); Dunlap, *History* (G), II, 408, 451-452; Flexner, James T., "Painter to the People," *American Heritage*, XI (Aug. 1960), 11-23, 91-92; Jones, William A., "A Sketch of the Life and Character of William S. Mount," *American Whig Review*, XIV (1851), 122-127; Lane, James W., "William Sidney Mount," *Art Quarterly*, IV (1941), 134-143; Lanman, Charles, *Haphazard Personalities*, Boston (1886), 168-180; Lanman, *Letters* (G), 243-248; Suffolk Museum, *The Mount Brothers*, Stony Brook, N.Y. (1947); Wegelin, Oscar, *Micah Hawkins and the Sawmill*, New York (1917).

CHAPTER 3

THOMAS COLE: See bibliography for Chapter 1.

JOHN MARTIN: Martin: *The Paradise Lost of*

Milton, with Illustrations Designed and Engraved by John Martin, London (1827); Balston, Thomas, *John Martin*, London (1947).

CHAPTER 4

ALVAN FISHER: Doughty, *"Life"* (I), 70; Flexner, *Light* (G), 183-184, bibliography, 260.

ASHER B. DURAND: Durand Papers at the New York Public Library, and Correspondence with Cole and Sketches at the New-York Historical Society; Durand, "Letters on Landscape Painting," *Crayon*, I (1855), 1-2, 34-35, 66-67, 97-98, 145-146, 209-211, 273-275, 354-355 and II (1855) 16-17; *American Art-Union Bulletin* (1851), 32; Blanchard, Julian, "The Durand Engraving Companies," *Essay Proof Journal* (Apr. and July 1950, Jan. 1951); Born, *Landscape* (G) 24; Dunlap, *History* (G), III, 60-65; Durand, John, *The Life and Times of Asher B. Durand*, New York (1884); Grolier Club, *Catalogue of the Engraved Works of Asher B. Durand*, Introduction by Charles Henry Hart, New York (1895); Huntington, Daniel, *Memorial Address for Asher B. Durand*, New York (1887); Lewis, E. Anna, "Asher B. Durand," *Graham's Magazine*, XLV (1854), 318-322; Ortgies & Co., *Executor's Sale* (of Durand's Effects), New York (1887); Sweet, Frederick A., "Asher B. Durand, "*Art Quarterly*, VIII (1945), 141-160; Tuckerman, *Book* (G), 187-196.

GIFT BOOKS: Buffet, *Mount* (II), 30; Doughty, *"Life"* (I), 30; Durand, J., *Durand* (see ASHER B. DURAND above), 58-61, 90; Lovejoy, David S., "American Painting in Early Nineteenth Century Gift Books," *American Quarterly*, VII (1955), 345-361; Weitenkampf, Frank, "The Keepsake in Nineteenth Century Art," *Boston Public Library Quarterly*, IV (1952), 139-148.

CHAPTER 5

PAINTERS OF INDIANS IN GENERAL: De Voto, *Missouri* (G); McCracken, *Portrait* (G); St. Louis Art Museum, *Mississippi* (G); St. Louis Art Museum, *Westward* (G).

BEFORE CATLIN: Ewers, John C., "Charles Bird King, "*Annual Report, Smithsonian Institution,* Washington (1953), 463-473; Lewis, J. O., *The Aboriginal Portfolio*, Philadelphia (1835); McDermott, John F., "Peter Rindisbacher," *Art Quarterly*, XII (1943), 129-45; McDermott, "Samuel Seymour," *Annual Report, Smithsonian Institution* (1950), 497-509; Nute, Grace L., "Peter Rindisbacher," *Minnesota History*, XIV (1933), 283-287; Nute, "Rindisbacher's Minnesota Watercolors," *Minnesota History*, XX (1939), 54-57; Smith, Alice E., "Peter Rindisbacher," *Minnesota History*, XX (1939), 173-175.

GEORGE CATLIN: Catlin, *Catalogue[s] of Catlin's Indian Gallery*, New York and elsewhere (first published, 1837); Catlin's "Handbills and Illustrations Descriptive of the Visit of George Catlin to England and France," mounted and bound, New York Public Library, (1844-1845); Catlin, *Letters and Notes*, London (1841); Catlin, *North American Indian Portfolio: Hunting Scenes and Amusements*, London (1844); Catlin, *North and South American Indians, Catalogue Descriptive of Catlin's Indian Cartoons*, New York (1871); Catlin, *Opinions of the English and American Press on Catlin's North American Indian Museum*, London (c. 1841); Catlin, *Souvenir of the North American Indians*, London (1850); Catlin, *Views of Niagara, Drawn on Stone and Colored from Nature*, n. p. (c. 1831); Baudelaire, Charles, *Curiosités Esthétiques*, Paris (1889), 123-124; Cummings, *Annals* (G), 80, 84; Donaldson, Thomas, *The George Catlin Indian Gallery in the United States National Museum, Smithsonian Institution*, Washington (1887); Dunlap, *History* (G), II, 378; Haberly, Loyd, *Pursuit of the Horizon: A Life of George Catlin*, New York (1948); McCracken, Harold, *George Catlin*, New York (1959); Ross, Marvin C. (ed.), *George Catlin, Episodes from "Life Among the Indians" and "Last Rambles,"* Norman, Okla. (1959).

KARL BODMER: Bodmer Sketchbooks, owned anonymously; Draper, Benjamin P., "American Indians Barbizon Style: The Collaborative Paintings of Millet and Bodmer," *Antiques*, XLIV (1943), 108-110; Smithsonian Institution, *Karl Bodmer*, Washington (1954); Maximilian, Prince of Weid-Neuweid, *Travels in the Interior of North America, 1832-1834*, 3 vols. Washington in facsimile, Cleveland (1906);

Weitenkampf, Frank, "A Swiss Artist Among the Indians," *Bulletin of the New York Public Library*, LII (1948), 554-556.

ALFRED JACOB MILLER: Miller, Original Sketchbooks, owned anonymously; *Descriptive Catalogue of Watercolor Drawings by Alfred Jacob Miller in the Public Archives of Canada*, Ottawa (1951); Hunter, Wilbur H., *The Paintings of Alfred Jacob Miller*, Baltimore (1930); Ross, Marvin C., "A List of Portraits and Paintings from Alfred Jacob Miller's Account Book," *Maryland Historical Magazine*, XLVIII (1953), 27-36; Ross (ed.), *Artists' Letters to Alfred Jacob Miller*, Baltimore (1951); Ross (ed.), *The West of Alfred Jacob Miller*, Norman, Okla. (1951).

SETH EASTMAN: Eastman, *Sketchbook, 1848-1849*, Austin, Texas (1961); Eastman, Mary and Seth, *The American Aboriginal Portfolio*, Philadelphia, (1853); Bushnell, David I., "Seth Eastman," *Smithsonian Miscellaneous Collections*, LXXXVII, No. 3 (Apr. 1932); McDermott, John F., *Seth Eastman*, Norman, Okla. (1961); Schoolcraft, Henry R., *Information Respecting the History, Condition, and Prospects of the Indian Tribes of the United States*, 6 vols., Philadelphia (1851-1857).

CHARLES DEAS: Baur, *Unknown* (G), 280-281; *Broadway Journal*, I (1845), 254; *Karolik* (G), 214-215; Lanman, Charles, *A Summer in the Wilderness*, New York (1847), 15-17; McDermott, John F., "Charles Deas," *Art Quarterly*, XIII (1950), 293-311; Tuckerman, *Book* (G), 424-429.

NEW ATTITUDE TOWARD INDIANS: Whittredge, *Autobiography* (XIV), 51.

CHARLES WIMAR: City Art Museum, St. Louis, *Charles Wimar*, Introduction by Perry Rathbone, St. Louis (1946); Hodges, William R., *Karl Wimar*, Galveston (1908); Hodges, "Charles Ferdinand Wimar," *American Art and Art Collections*, II (1889), 281-288; Western Academy of Art, *First Annual Exhibition*, St. Louis (1860).

JULES ÉMILE SAINTIN: Michelez, Charles, *Tableaux Commandé ou Acquis par l'Administration des Beaux Arts, Salons de 1864 et 1865*, Paris (1864, 1865).

JOHN MIX STANLEY: Stanley, "Portraits of North American Indians," *Smithsonian Miscellaneous Collections*, II (1862); Bushnell, David I, "John Mix Stanley," *Annual Report, Smithsonian Institution, 1924*, Washington (1925) 507-512; Kinietz, W. Vernon, *John Mix Stanley*, Ann Arbor (1942); Taft, Robert, *Artists and Illustrators of the Old West, 1850-1900*, New York (1953), 1-21.

CHAPTER 6

LUMAN REED: Reed, correspondence with and about, in Cole Papers (I), Mount Papers (II), and Durand Papers (IV); Durand, J., *Durand* (IV), 100-126; Cummings, *Annals* (G), 140-142; Lossing, Benson J., *History of New York*, II, New York (1884), 88, 614-617; New-York Historical Society, "The New York Gallery of Fine Arts and Reed Collection," *Catalogue of the Gallery of Art*, New York (1915), 1-12; Scoville, Joseph A., *Old Merchants of New York* (1870), I, 92, III, 47-50, 106; Thorpe, T. B., "New York Artists Fifty Years Ago," *Appleton's Journal*, VII (1872), 574.

OLD PAFF: Paff, Michael, "Advertisement," *National Advocate* (7/10/1818); Durand, J., *Durand* (IV) 66; Howe, *Metropolitan* (G), 79; Tuckerman, *Book* (G), 20.

NATIONAL ACADEMY: Clark, Eliot, *History* (G); Cowdrey, *National Academy* (G); Cummings, *Annals* (G); Flexner, *Light* (G), 230ff.

ARTIST LIFE: Buffet, *Mount* (II), 47; *Cosmopolitan Art Journal*, IV (1859-1860), 82; Cummings, *Annals* (G), *passim*; Durand, J., *Durand*, (IV) *passim*; Smith, *Horn* (G); Whittredge, Worthington, "The American Art Union," *Magazine of History*, VII (1908), 66-67; Whittredge, *Autobiography* (XIV), 59-60.

MERCHANT AMATEURS: Cummings, *Annals* (G), *passim*; Dunlap, *History* (G), II, 457-465; Durand Papers (IV): J. Sturges to Durand (6/23/1857); Durand, "Letters" (IV), I, 98; Durand, John, *Prehistoric Notes of the Century Club*, New York (1882); Isham, *History* (G), 210-211.

NEW YORK GALLERY OF FINE ARTS: Cole Papers (I): Theodore Allen to Cole (10/17/1844);

Cummings, *Annals* (G), 178-179, 189; Durand Papers (IV): Allen to Durand (3/2/1844), and Francis Edmonds to Durand (9/16/1844); Durand, J., *Durand* (IV), 126-130; Howe, *Metropolitan* (G), 62-67; New York Gallery of Fine Arts, *Catalogue of Exhibition[s]*, New York (first published, 1844); New-York Historical Society, *Catalogue* (*see* LUMAN REED *above*); Noble, *Course* (I), 358.

AMERICAN ART-UNION: American Art-Union, Papers at New-York Historical Society, also *Bulletin* (1848-1852), *Catalogue[s]* (1839-1852), and *Transactions* (1839-1849); Baker, Charles E., "The American Art-Union," in Cowdrey, *National Academy* (G), 95-240; Bloch, E. Maurice, "The American Art-Union's Downfall," *New-York Historical Society Bulletin*, XXXVII (1953), 331-359; Cowdrey, *American Academy* (G); Cummings, *Annals* (G), 147ff.; Durand, J., *Durand* (IV), 168-172, 179-180; Mount Papers (II): Mount to George P. Morris (12/3/1848).

FREE GALLERY DESCRIBED: *American Whig Review*, IV (1847), 3; Bryant, *Cole* (I), 15; *Knickerbocker Magazine*, XXXII (1848), 442-447; *Literary World*, III (1848), 852-853.

NONLITERARY CULTURE: Curti, Merle, *The Growth of American Thought*, New York (1943), 268-269; Isham, *History* (G), 251; James, *Some Pictures* (G), 96; Spiller, *Literary History* (G), II, 513, 525.

DUNLAP CRITIC FOR MIRROR: Cole Papers (I): A. B. Durand to Cole (12/25/1837); Durand, J., *Durand* (IV), 63.

CHAPTER 7

DÜSSELDORF GALLERY: *American Art-Union Bulletin* (1849), No. 2, p. 16, No. 3, pp. 8-17; *Cosmopolitan Art Journal*, I (1856-1857), 135, 154-155, 161, 165, II (1857-1858), 43, 53-57; Cowdrey, *American Academy* (G), I, 142-143, 168; Cummings, *Annals* (G), 210, 312-313; *Descriptive Catalogue of the Paintings on Exhibition at the Institute of Fine Arts, ... Comprising the Celebrated Pictures of the Well-Known Düsseldorf Gallery ... and the Unique Jarves Collection of Old Masters*, New York (1860); Düsseldorf Gallery, *Catalogue[s] of a*

Private Collection of Paintings and Original Drawings by Artists of the Düsseldorf Academy of Fine Arts (title appears variously), New York (1849–1859); *Gems from the Düsseldorf Gallery, Photographed from the Original Pictures by A. A. Turner*, New York (1863); Whittredge, *Autobiography* (XIV), 23-24.

DÜSSELDORF SCHOOL: Eberlein, Kurt Karl von, "Die Düsseldorfer Malerschule und Immermann's Musterbühne," *Westdeutches Jahrbuch für Kunstgeschichte*, IX (1936), 228-238; Flagg, Jared B., *The Life and Letters of Washington Allston*, New York (1892), 311-312, 316; *Hundert Jahre Künstlerverein Malkasten, Düsseldorf 1848–1948*, n.p. (n.d.); J. W. E. (John Whetten Ehninger?) "The School of Art at Düsseldorf," *American Art-Union Bulletin* (1850), 5-7; Muther, *History* (I), I, 255-267; II, 300-312; Peters, Heinz, *Meisterwerke der Düsseldorfer Galerie*, Honnef/Rhein (1955); Schaarschmidt, Friedrich von, *Zur Geschichte der Düsseldorfer Kunst, insbesondere im XIX Jahrhundert*, Düsseldorf (1902).

GOUPIL: American Art-Union, *To the Friends of Art in the United States* [New York (1849)]; *American Art-Union Bulletin* (1849), No. 8, pp. 11, 13; Cowdrey, *American Academy* (G), I, 143-146, 166-167; Cummings, *Annals* (G), 217-218, 221; Goupil & Co., *Catalogue and Price List of Artists' Materials*, New York (1857); *International Art Journal*, I (1849); International Art-Union, *Prospectus of the ... and Catalogue of Works of Art*, New York (1849).

ACADEMY PETITIONS FOR IMPORT DUTY: Cummings, *Annals* (G), 254; *Galaxy*, III (1867), 345.

COSMOPOLITAN ART ASSOCIATION: Cosmopolitan Art Association, *Catalogue of American and Foreign Paintings Now on Exhibition*, New York (1860), and *Illustrated Catalogue[s]*, New York (1854–1856), and *Transactions ... for the Year*, New York (1855–1856); *Cosmopolitan Art Journal*, I-IV (1856–1860).

FRENCH TASTE: Cummings, *Annals* (G), 266-267; Durand J., *Durand* (IV), 192-195; King, Edward S., and Ross, Marvin C., *Catalogue of the American Works of Art, Walters Art Gallery*, Baltimore (1956); *Sartain's Magazine*, IV (1849), 77; Strahan, Edward (pseud. for Shinn, Earl), *Art Treasures of America*, Philadelphia (c. 1878), 53, 87-88.

ENGLISH TASTE AND RUSKIN: *American Art-Union Bulletin* (1849), No. 6, pp. 11-21; *Crayon* I-VII (1855–1861); Cummings, *Annals* (G), 266-267; Durand, J., *Durand* (IV), 192-195; Isham, *History* (G), 243-244; *Nation*, I (1865), 273; *The New Path, Published by the Society for the Advancement of Truth in Art*, I-II (1863–1865); Sheldon, *American* (G), 9; Steegmuller, *Jarves*, (*see* JARVES COLLECTION *below*), 231-232; Tuckerman, *Book* (G) 524.

JAMES HAMILTON: Baur, John I. H. "A Romantic Impressionist: James Hamilton," *Brooklyn Museum Bulletin*, XII (Spring 1951), 1-9; Clement and Hutton, *Dictionary* (G), I, 327; Kane, Elisha Kent, *Arctic Explorations*, 2 vols., Philadelphia (1856); Tuckerman, *Book* (G), 565-566.

WILLIAM J. STILLMAN: Stillman, *The Autobiography of a Journalist*, 2 vols., Boston and New York (1901); *Dictionary of American Biography* (G); Jones, *Rediscovered* (G), 70-71; *William J. Stillman* (Union College Worthies, XII), Schenectady, N.Y. (n. d.).

TASTE FOR OLD MASTERS: Cowdrey, *American Academy* (G), 164; *Crayon*, I (1855), 100; *Knickerbocker Magazine*, XXXII (1848), 447; *New York Evening Post* (6/25/1840), 2.

BRYAN COLLECTION: Information from New-York Historical Society and Julius Held; *American Art Review*, II, Pt. 1 (1882), 226; Brooks, *Arcadia* (G), 241; Bryan Gallery, *Catalogue of the Bryan Gallery of Christian Art from the Earliest Masters to the Present Time*, New York (1852); Eyland, *Evolution* (G), 38-45; New-York Historical Society, "The Bryan Collection," *Catalogue of the Gallery of Art* (1915), 54-99; Saarinen, *Possessors* (G), xxi; Tuckerman, Henry T., *Proceedings of the New-York Historical Society on the Announcement of the Death of Thomas J. Bryan*, New York (1870); Vail, *Knickerbocker* (G), 126-128, 135, 152, 168, 266, 406; Wharton, Edith, *False Dawn;* White, Richard Grant, *Companion to the Bryan Gallery of Christian Art*, New York (1853).

JARVES COLLECTION: Boas, George, "The Critical Practice of James Jackson Jarves," *Gazette des Beaux Arts*, 6th Ser., XXIII (1943), 295-397; *Catalogue of the Jarves Collection . . .*

Deposited in the . . . *Yale School of Fine Arts, to be Sold at Auction*, Boston (1871); *Descriptive Catalogue* (1860), (*see* DÜSSELDORF GALLERY *above*); Jarves, James Jackson, *Art Hints*, New York (1855); Jarves, *The Art Idea*, New York (1864), new edition with Introduction by Benjamin Roland, Jr., Cambridge, Mass. (1960), page references are to the old edition; Jarves, *Art Studies*, New York (1861); Jarves, *Art Thoughts*, New York (1869); Steegmuller, Francis, *The Two Lives of James Jackson Jarves*, New Haven, Conn. (1951); Yale University, *A Descriptive Catalogue of the Pictures in the Jarves Collection . . . by Oswald Siren*, New Haven, Conn. (1916).

PLEASING THE LADIES: *Cosmopolitan Art Journal*, IV (1860), 34; Cummings, *Annals* (G), 230, 262, 268; Whittredge, *Autobiography* (XIV), 49.

SANITARY FAIR: *Catalogue of the Art Exhibition at the Metropolitan Fair*, New York (1864); *Recollections of the Art Exhibition, Metropolitan Fair, . . . Photographed and published by M. B. Brady*, New York (1864).

CONTINUING BOOM FOR ART: Cummings, *Annals* (G), 282, 309, 320, 338; Durand, J., *Durand* (IV), 90; Isham, *History* (G), 98, 210-211; *Magazine of Art*, V (1882), 266; Whittredge, *Autobiography* (XIV), 43, 62.

CHAPTER 8

FRANCIS W. EDMONDS: *American Art-Union Bulletin*, II (1849), No. 1, pp. 14-15; Cummings, *Annals* (G), 317-320; *Dictionary of American Biography* (G); Hone, *Diary*, ed. by Tuckerman (G), I, 353-354; Lanman, *Letters* (G), 239-241; Tuckerman, *Book*, (G), 411-414.

JAMES G. CLONNEY: Jones, *Rediscovered* (G), 32-33; *Karolik* (G), 166-185.

RICHARD C. WOODVILLE: Information from Francis S. Gruber; *American Art-Union Bulletin* (1850), 7 (1851), 12, 98; Champney, *Memories* (XIV), 88; Cowdrey, Bartlett, "Richard Caton Woodville," *American Collector*, XIII (Apr. 1944), 6-7, 14, 20; *International Art-Union Journal*, I (1849), 51; King and Ross, *Walters* (VII), 13; Pleasants, John Hall, Notes on deposit at Frick Art

Reference Library; Tuckerman, *Book* (G), 408-411; Woodville, Richard Caton, Jr., *Random Recollections*, London (1914); William Woodville to William C. Pennington (6/13/1879), ms. in New York Public Library.

WILLIAM T. RANNEY: *American Art Review*, II, Pt. 2 (1881), 4; *Crayon*, V (1858), 26; Cummings, *Annals* (G), 265-266; *Dictionary of American Biography* (G); *Karolik* (G), 462-464; McDermott, *Bingham* (*see* GEORGE C. BINGHAM *below*), 190; Tuckerman, *Book* (G), 431-432.

GEORGE CALEB BINGHAM: Bingham, "Letters to James S. Rollins," *Missouri Historical Review*, XXXII (1937-1938), 3-34, 164-202, 340-377, 484-522, XXXIII (1938-1939), 45-78, 203-229, 349-384, 499-526; Christ-Janer, Albert, *George Caleb Bingham*, New York (1940); "George Caleb Bingham Sesquicentennial Exhibition," *Nelson Gallery and Atkins Museum Bulletin*, III (1961), No. 3; McDermott, John F., *George Caleb Bingham*, Norman, Okla. (1959); Museum of Modern Art, *George Caleb Bingham*, New York (1935); Richardson, Edgar P., "The Checker Players by George Caleb Bingham," *Art Quarterly*, XV (1952), 252-256; Rollins, C. B., "Some Recollections of George Caleb Bingham," *Missouri Historical Review*, XX (1926), 463-484; Rusk, Fern H., *George Caleb Bingham*, Jefferson City, Mo. (1917); Taggart, Ross E., "Canvassing for a Vote and Some Unpublished Portraits by Bingham," *Art Quarterly*, XVIII (1955), 231-237.

CHAPTER 9

FREDERICK E. CHURCH: Information from Victor Von Hagen and David Huntington; Church, Drawings and Sketches at Cooper Union, and at his own mansion at Hudson, N.Y.; Church, Diary extracts transcribed by Von Hagen; *Art Journal*, London, XXVII (1865), 265-267, 688; *Cosmopolitan Art Journal*, I (1856-1857), 155, II (1857-1858), 38-39; III (1858-1859), 35, 49, 87, 133, 178-179, 182; *Crayon*, I (1855), 203; Gardner, Albert Ten Eyck, "Scientific Source of the Full-Length Landscape," *Metropolitan Museum Bulletin*, IV (1945), 59-65; James, *Some Pictures* (G), 96; Jarves, *Art Idea*

(VII), 232-234; *London Morning Post* (7/21/-1865); Metropolitan Museum of Art, *Paintings by Frederick E. Church*, New York (1900); *Monthly Illustrator*, IV (1895), 324; *New York Herald* (4/4/1909); New York Public Library, Collection of newspaper clippings relative to Church's work; Noble, Louis L., *After Icebergs*, New York (1861); Noble, *The Heart of the Andes*, New York (1859); Sheldon, *Painters* (G), 10-14; Stillman, *Autobiography* (VII), 114-115; Tuckerman, *Book* (G), 370-386; Whittredge, *Autobiography* (XIV), 21, 28-29; Winthrop, Theodore, *A Companion to the Heart of the Andes*, New York (1859).

JOHN F. KENSETT: Kensett, "Journal", 2 vols. (6/1/1840-5/31/1841), ms. at Frick Art Reference Library; Century Association, *Proceedings at a Meeting in Memory of John F. Kensett*, New York (1872); Champney, *Memories* (XIV), *passim*; Cowdrey, Bartlett, "The Return of John F. Kensett," *Portfolio*, IV (1945), 122-126; Isham, *History* (G), 239-240; Johnson, Ellen H., "Kensett Revisited," *Art Quarterly*, XX (1957), 71-92; Mather, *Hudson* (G), 305-306; Tuckerman, *Book* (G), 510-514; Whittredge, *Autobiography* (XIV), 60.

CHAPTER 10

ART INSTRUCTION: Cummings, *Annals* (G), *passim*; Dunlap, *History* (G), II, 429; Smith, *Horn* (G), 234-242.

THE NUDE: *American Art-Union Bulletin* (1851), 49; *Art Journal*, N. Y., new ser., V (1879), 374; Cummings, *Annals* (G), 251; Eyland, *Evolution* (G), 58-59.

ATHENAEUM CONTEST: Swan, *Athenaeum* (G), 93-94.

ROBERT W. WEIR: Dunlap, *History* (G), II, 381-396; Greenough, *Travels* (G), 40-44; *Harper's Weekly*, XXXIII (1889), 419; Jones, *Rediscovered* (G), 76-77; *New York Tribune* (5/2/1889); Weir, Irene, *Robert W. Weir*, New York (1947).

HISTORY FOR THE CAPITOL: Fairman, *Capitol* (G), 114-127.

HENRY P. GRAY: *Dictionary of American Biography* (G); Daly, Charles P., *In Memory of*

Henry Peters Gray, New York (1878); Tuckerman, *Book* (G), 442-445.

DANIEL HUNTINGTON: Benjamin, S. G. W., "Daniel Huntington," *American Art and Art Collections*, I (1889), 18-36; Benjamin, "Daniel Huntington," *American Art Review*, II (1881), Pt. 1, pp. 223-228, Pt. 2, pp. 1-6; *Catalogue of Paintings by Daniel Huntington, N. A., Exhibited at the Art-Union Building*, New York (1850); *Dictionary of American Biography* (G); G.W.P., "Mr. Huntington and the Art-Union," *American Art-Union Bulletin* (1850), 4-5; *Graham's Magazine*, XLV (1854), 143-144; Lanman, *Letters* (G), 237-239; Tuckerman, *Book* (G), 321-332.

WILLIAM PAGE: Page; "The Art of the Use of Color in Imitation in Painting," *Broadway Journal*, I (1845), 86-88, 114-115, 131-133, 150-151, 166-167, 201-202; Page, "The Measure of a Man," *Scribner's Monthly*, XVII (1879), 894-898; Page, *Some Descriptions of a Few Pictures Painted by William Page*, New York (1867); Page, "A Study of Shakespeare's Portraits," *Scribner's Monthly*, X (1875), 558-574; Page (?), *Venus Guiding Aeneas and the Trojans to the Latin Shore*, n.p. (*c.* 1860); Carter, Susan Nichols, "The President of the National Academy, William Page," *Appleton's Journal*, VI (1871), 617-620; *Cosmopolitan Art Journal*, III (1858-1859), 180; *Harper's Weekly*, XV (1871), 427; Jarves, *Art Idea* (G), 216; Page, Sarah, letters home from Florence and Rome (1850-1852), mss. in collection of Miss Lois Cole, New York City; Paradise, Scott H., "William Page," *Phillips Bulletin*, XXVIII (1933), 12-22; Richardson, George P., "Two Portraits by William Page," *Art Quarterly*, I (1938), 91-103; *Sartain's Magazine*, IV (1849), 76; Taylor, Joshua C., *William Page*, Chicago (1957); Townley, D. O'C., "Living American Artists: William Page," *Scribner's Monthly*, III (1872), 599ff.; Tuckerman, *Book* (G), 295-299.

BOSTON: *Broadway Journal*, I (1845), 290; Brooks, *Arcadia* (G), 56-57; *Cosmopolitan Art Journal*, IV (1859-1860), 82; Durand Papers (IV): Doughty to Durand (6/5/1833) and Fisher to Durand (4/13/1834); Emerson, Ralph Waldo, "Art," *Essays, First Series*; Metzger, Charles R., *Emerson and Greenough: Tran-* *scendental Pioneers of an American Esthetic*, Berkeley and Los Angeles (1954); Perkins, Charles C., *Art Education in America*, Boston (1870); Pierce, H. Winthrop, *Early Days of the Copley Society*, Boston (1903); Spiller, *Literary History* (G), II, 377; Swan, *Athenaeum* (G), *passim.*

FRANCIS ALEXANDER: Alexander, Correspondence with Cole in Cole papers (I); Alexander, Constance G., *Francesca Alexander*, Cambridge, Mass. (1927); Brooks, *Arcadia* (G), 80, 181; Dunlap *History* (G), II, 423-433; Pierce, Catherine W., "Francis Alexander," *Old Time New England*, XLIV (Oct.-Dec. 1953), 29-46.

GEORGE LORING BROWN: Benjamin, *Our American Artists* (G), 1st. Ser., 163-178; *Karolik* (G), 145-153, Tuckerman, *Book* (G), 346-354.

AMERICANS IN ITALY: *American Art-Union Bulletin* (1849), No. 1, p. 21, No. 5, p. 27, (1851), p. 61; Brooks *Arcadia* (G), *passim;* Cole Papers (I): J. Mason to Cole (1/12/1838); Detroit Institute of Arts, *Travellers in Arcadia, American Artists in Italy, 1830–1875*, Detroit (1951); Durand Papers (IV): J. C. Hooker to Durand (9/24/1847); Taylor, *Page* (*see* WILLIAM PAGE above), 103ff.; Tuckerman, *Book* (G), 447; Weir, *Weir* (*see* ROBERT W. WEIR above), 27.

EMANUEL LEUTZE: Baur, *Johnson* (XII), 10-13; Boetticher, Friedrich von, *Malerwerke des neunzehnten Jahrhunderts*, Leipzig (1948); Brewster, Anne, "Emanuel Leutze," *Lippincott's Magazine*, II (1868), 533-538; *Hundert Jahre ...Malkasten* (VII), *passim;* Hutton, Ann Hawkes, *Portrait of Patriotism*, Philadelphia and New York (1959); *Jahrbuch der Staatlichen Kunstakademie Düsseldorf, 1948–1950*, Düsseldorf (n. d.), 131-133; *Sartain's Magazine* IV (1849), 414; Schaarschmidt, *Düsseldorfer* (VII), 102, 117-119, 184, 186; Towne, Henry R., *The Fate of a Famous Picture*, n.p. (1904); Tuckerman, *Book* (G), 333-345; Whittredge, *Autobiography* (XIV), 22-23.

COMMENTS ON DÜSSELDORF: Champney, *Memories* (XIV), 87; J.W.E., *School* (VII); Whittredge, *Autobiography* (XIV), 21-28, 30-31.

WILLIAM RIMMER: Rimmer, *Art Anatomy*, Bos-

ton (1877); Rimmer, *Elements of Design*, Boston (1864); Bartlett, Truman H., *Art Life of William Rimmer*, Boston (1882); Champney, *Memories* (XIV), 10; Whitney Museum of American Art, *William Rimmer*, ed. by Lincoln Kirstein, New York (1946).

CHAPTER 11

HENRY INMAN: Bolton, Theodore, "Henry Inman," *Art Quarterly*, III (1940), 353-374, 401-417; Bryant, *Cole* (I), 17-18; *Catalogue of Works by the Late Henry Inman with a Biographical Sketch*, New York (1846); Dickson, Harold E., *John Wesley Jarvis*, New York (1949); Dunlap, *History* (G), II, 348-350; Dunn, Esther C., "Inman's Portrait of Wordsworth," *Scribner's Magazine*, LXVII (1920), 251-256. "Henry Inman," *American Art-Union Bulletin* (1850), 69-73; Tuckerman, *Book* (G), 233-246.

CHARLES LORING ELLIOTT: Bolton, Theodore, "Charles Loring Elliott," *Art Quarterly*, V (1942), 59-96; Buffet, *Mount* (II), 41; Clark, L. Gaylord, "Charles Loring Elliott," *Lippincott's Magazine*, II (1868), 652-657; Jarves, *Art Idea* (VII), 230, 255; Lester, C. E., "Charles Loring Elliott," *Harper's New Monthly Magazine*, XXXVIII (1868), 42-50; Park, Lawrence, *Gilbert Stuart*, New York (1926), I, 385-386, III, 227; *Post Standard Pictorial*, Syracuse, N. Y. (12/26/1954), 8; Thorpe, T. B., "Personal Reminiscences of Charles Loring Elliott," *New York Evening Post* (9/30 and 10/1/1868); Tuckerman, *Book* (G), 300-305.

PHOTOGRAPHY: Barker, *American* (G), 391; Cole Papers (I): Isaiah Townsend to Cole (2/26/-1844) and Cole, "Thoughts," (4/28/1839); *Crayon*, I (1855), 107; Morse, Edward L., *Samuel F. B. Morse*, Boston and New York (1914), II, 143; Taft, Robert, *Photography and the American Scene*, New York (1938).

GEORGE P. A. HEALY: *Reminiscences of a Portrait Painter*, Chicago (1894); Bigot, Mrs. Charles, *Life of George P. A. Healy Followed by a Selection of his Letters*, n.p. (n.d.); De Mare, Marie, *G. P. A. Healy*, New York (1954); Jarves, *Art Idea* (VII), 255; Virginia Museum of Fine Arts, *Healy's Sitters*, Richmond (1950).

THOMAS COUTURE: *Crayon* I (1855), 281; Healy,

G. P. A., "Thomas Couture," *Reminiscences* (*see* GEORGE P. A. HEALY *above*), 77-106; Isham, *History* (G), 281; Jarves, *Art Idea* (VII), 217-218; Sheldon, *Painters* (G), 71.

HUNTINGTON AND GRAY: See bibliographies for Chapter 10.

FEMALE PORTRAITURE: *American Art-Union Bulletin* (1849), No. 5, p. 7.

JEREMIAH P. HARDY: Hardy, "Account Book" (6/12/1827–10/11/1856), photostat at Frick Art Reference Library; *Bangor Daily News* (7/20/1934); Eckstrom, Fannie Hardy, "Jeremiah Pierson Hardy," *Old Time New England*, XXX (1939), 30, 41-66; Hardy, Charlotte W., "List of Paintings by J. P. Hardy," typescript at Frick Art Reference Library; *Karolik* (G), 282-288.

THOMAS HICKS: *Dictionary of American Biography* (G); *The Historic First Portrait of Abraham Lincoln . . . by Thomas Hicks*, Parke-Bernet Galleries, New York (11/23/1940) Sheldon, *Painters* (G), 35-39; Tuckerman, *Book* (G), 465-466.

EASTMAN JOHNSON: See bibliographies for Chapter 12.

CHAPTER 12

DAVID G. BLYTHE: Information from Lloyd Goodrich; Abraham, Evelyn, "David Gilmour Blythe," *Antiques*, XXVII (1935), 180-183; Hadden, James, *A History of Uniontown, Pennsylvania*, Uniontown, Pa., (1913), 589-608; Hadden, "Sketch of David G. Blythe," *News Standard*, Uniontown, Pa. (Apr.–May 1896); Miller, Dorothy, *Life and Work of David Gilmour Blythe*, Pittsburgh (1950); O'Connor John, Jr., "David Gilmour Blythe," *Western Pennsylvania Historical Magazine*, XXVII (1944), 29-36; O'Connor, "David Gilmour Blythe," *Panorama*, I (1946), 38-45; *Pittsburgh Evening Chronicle* (5/10/1865); Whitney Museum of American Art, *Paintings by David G. Blythe and Drawings by Joseph Boggs Beale*, Introduction by Lloyd Goodrich, New York (1936).

GENRE DECLINES: Barker, *American* (G), 547; Jarves, *Art Idea* (VII), 220; Pattee, Fred L., *The Feminine Fifties*, New York (1940), 52.

LILY M. SPENCER: Beach, Arthur G., *A Pioneer College: The Story of Marietta*, Chicago (1935), 47, 236; *Catalogue of Miss Martin's Paintings* [Marietta, Ohio], (1841); Cole Papers (I): W. A. Adams to Cole (8/6/1842) and B. M. McConney to Cole (6/20/1847); *Cosmopolitan Art Journal*, I (1856–1857), 27, 49-50, 165, II (1857–1858), frontis., 151, 209, III (1858–1859), 190, 234; Cowdrey, Bartlett, "Lily Martin Spencer," *American Collector*, XIII (Aug. 1944), 6-7, 14, 19; *Marietta Intelligencer*, (8/25, 8/26, and 9/12/1841); *Marietta Register*, Marietta (5/24/1902); *Marietta Times* (5/24/1944); Reiter, Edith S., "Lily Martin Spencer," *Museum Echoes*, XXVII (1954), 35-38; Schumer, Ann Byrd, "Aspects of Lily Martin Spencer's Career in Newark, N.J.," *Proceedings of New Jersey Historical Society*, LXXVII (1959), 244-255; Sweet, Frederick A., *Lily Martin Spencer*, typescript at New York Public Library.

SEYMOUR J. GUY: *Art Journal*, New York, new ser. I (1875), 276-278; *American Art and Art Collectors*, II (1889) 589-590; *Dictionary of American Biography* (G); Isham, *History* (G), 343-344; Sheldon, *Painters* (G), 66-70.

JOHN G. BROWN: Benjamin, S. G. W., "A Painter of the Streets," *Magazine of Art*, V (1882), 265-267; *Dictionary of American Biography* (G); New York Evening Journal (2/8/1913); *New York Herald* (2/9/1913); *New York Times* (2/9/1913); Sheldon, *Painters* (G), 141-144.

JAMES HENRY BEARD: Beard, Dan, *Hardly a Man Is Now Alive*, New York (1939); Cole Papers (I): W. A. Adams to Cole (8/6/1842); *Dictionary of American Biography* (G); Sheldon, *Painters* (G), 113-117; Smith, S. Winfred, "James Henry Beard," *Museum Echoes*, XXVII (Apr. 1954), 27-30; Tuckerman, *Book* (G), 436-437.

WILLIAM BEARD: Beard, *Humor in Animals*, New York (1885); *Art Journal*, New York, new ser., IV (1878), 321-324; Baur, John I. H., "The Beard Movement," *Magazine of Art*, XLIII (1950), 16-17; Benjamin, S. G. W., *Art* (G), 86; Benjamin, "An American Humorist in Paint," *Magazine of Art*, V (1882), 14-19; Benjamin, *Artists* (G), 1st Ser., 6-21; *New Path*, I (1863), 134, II (1864), 5; Sellstedt, Lars G., *Art in Buffalo*, Buffalo, N.Y. (1910), 104-111; Sheldon, *Painters* (G), 56-60; Tuckerman, *Book* (G), 498-501.

JOHN W. EHNINGER: *American Art-Union Bulletin*. (1849), No. 1, p. 21; *Cosmopolitan Art Journal*, III (1858–1859), 3; *Dictionary of American Biography* (G); J.W.E. *School* (VII); Tuckerman, *Book* (G), 461-464.

EDWIN WHITE: *New York Herald* (6/9/1877); Tuckerman, *Book* (G), 438-440.

EASTMAN JOHNSON: American Art Gallery, *Catalogue* (3/17-20/1914); Baur, John I. H., *An American Genre Painter: Eastman Johnson*, Brooklyn, N.Y. (1940); Benjamin, S. G. W., "A Representative American: Eastman Johnson," *Magazine of Art*, V (1882), 485-490; Crosby, Everett U., *Eastman Johnson at Nantucket*, Nantucket, Mass. (1944); Hartmann, Carl Sadakichi, "Eastman Johnson," *International Studio*, XXXIV (1908), 106-111; Heilbron, Bertha L., "A Pioneer Artist on Lake Superior," *Minnesota History*, XXI (1940), 149-157; Isham, *History* (G), 341-343, 351-352; Keck, Sheldon, "A Use of Infra-Red Photography," *Technical Studies*, IX (1940–1941), 145-152; *New Path*, I (1864), 135; Selby, Mark, "An American Painter: Eastman Johnson," *Putnam's Monthly*, II (1907), 533-542; Sheldon, *Painters* (G), 166-169; Tuckerman, *Book* (G), 466-471; Walton, William, "Eastman Johnson," *Scribner's Magazine*, XL (1906), 263-274.

CHAPTER 13

TOURING PICTURES: *American Art-Union Bulletin* (1849), No. 6, p. 27; Minnigerode, Meade, *The Fabulous Forties*, New York (1924), 31, 141-143, 155, 218, 274; Pattee, *Fifties* (XII) 147, 152, 286-288.

PANORAMAS: Arrington, J. Earl, "Leon D. Pomarede's Original Panorama of the Mississippi River," *Missouri Historical Society Bulletin*, IX (1953) 261-273; Bachman, C. L., "The Story of Stockwell's Panorama," *Minnesota History*, XXXIII (1953), 284-290; Born, *Landscape* (G), 12; Butts, *Wisconsin* (G), 51-65; Champney, *Memories* (XIV), 88; Heilbron,

Bertha L., *Making a Motion Picture in 1848:* *Henry Lewis' Journal*, St. Paul, Minn. (1936); McDermott, John F., *The Lost Panoramas of the Mississippi*, Chicago (1958); St. Louis, *Wimar* V, 10; St. Louis, *Westward* (G), *passim*.

PRINTS: See relevant titles in the General Bibliography; *American Art Review*, II, Pt. 2 (1881), 4; Cummings, *Annals* (G), 242; *The Illuminated Bible . . . Embellished with 1,600 Historical Engravings by J. A. Adams, more than 1,400 of which are from Original Designs by J. G. Chapman*, New York (1843–1846); Richardson, *History* (G), 255-257.

COLE'S *Voyage* REVIVED: Abbott, Rev. Gorham D., *Cole's Voyage of Life*, N. Y (1860); Baker, *Art-Union* IV, *passim*; Cole Papers I, relevant correspondence; Cummings, *Annals* (G), 176-177.

CURRIER AND IVES: Crouse, Russel, *Mr. Currier and Mr. Ives*, Garden City, N. Y (1930); Peters, *Currier* (G); Simkin, Colin (ed.), *Currier and Ives' America*, New York (1952).

GEORGE HENRY DURRIE: Durrie, "Journal, 1845–1846," ms. at New-York Historical Society; Durrie, Mary C., "George Henry Durrie," *Antiques*, XXIV (1933), 13-15; Peters, Harry T., "George Henry Durrie," *Panorama*, I (1945), 27-29; Wadsworth Atheneum, *George Henry Durrie*, Introduction by Bartlett Cowdrey, Hartford, Conn. (1947).

"FOLK ART": See relevant titles in general bibliography; *American Art-Union Bulletin* (1849), No. 3, pp. 16-17; *Catalogue of Paintings by Daniel Huntington* (X), 5-6; Cummings, *Annals* (G), 194; Flexner, *Light* (G), 196-199, 208-214, 220-226; *Harper's New Monthly Magazine*, XXXVIII (1868), 44; Little, Nina Fletcher, *American Decorative Wall Painting, 1700–1850*, Sturbridge, Mass. (1952).

RUFUS PORTER: Lipman, Jean, "Rufus Porter," in Lipman and Winchester, *Primitive* (G), 57-66; Lipman, "Rufus Porter," *Art in America*, XXXVIII (1950), 135-200.

THOMAS CHAMBERS: Jones, *Rediscovered* (G), 30-31; Little, Nina Fletcher, "Earliest Signed Picture by Thomas Chambers," *Antiques*, LIII (1948), 285; Little, "Thomas Chambers," in Lipman and Winchester, *Primitive* (G),

106-112; Little, "Thomas Chambers, Man or Myth," *Antiques*, LIII (1948), 194-196.

ERASTUS SALISBURY FIELD: Field, *Descriptive Catalogue of the Historical Monument of the American Republic*, Amherst, Mass. (1876); Dods, Agnes M., "A Checklist of . . . Field," *Art in America*, XXXII (1944), 32-40; Robinson, Frederick B., "Erastus Salisbury Field," in Lipman and Winchester, *Primitive* (G), 72-79; Robinson, "Erastus Salisbury Field," *Art in America*, XXX (1942), 244-253.

CHARLES CODMAN: *Karolik* (G), 186-188; Neal, *Observations* (G), 90-91, 96.

CHAPTER 14

HUDSON RIVER SCHOOL IN GENERAL: Baur, *Luminism* (G), 93; Cole Papers (I): Sketch of my Tour to the White Mountains (1828); James, Henry, *William Wetmore Story and His Friends*, Boston (1904) I, 298; Jarves, *Art Idea* (VII), 231; Tuckerman, *Book* (G), 18, 374; Whittredge, "Autobiography," (*see* WORTHINGTON WHITTREDGE *below*), 33-34, 42, 54.

BENJAMIN CHAMPNEY: Information from Mrs. A. C. Wyer, Champney's daughter; Champney, *Sixty Years' Memories of Art and Artists*, Woburn, Mass. (1900); *Dictionary of American Biography* (G).

WORTHINGTON WHITTREDGE: Information from Sadayoshi Omoto; Whittredge, "Autobiography," ed. by John I. H. Baur, *Brooklyn Museum Journal*, I (1942), 5-68; *Art Journal*, New York, new ser., II (1876), 149; Isham, *History* (G) 245; Mather, *Hudson* (G), 304; Western Art Union, *Record*, Cincinnati, I (1849), No. 1; Western Art Union, *Transactions*, Cincinnati, Ohio (1847-1848).

BARBIZON SCHOOL: Clark, *Landscape* (I), 83; Isham, *History* (G), 369; Sheldon, *American* (G), 51; Whittredge, "Autobiography," (*see* WORTHINGTON WHITTREDGE, *above*), 21.

WILLIAM AND JAMES M. HART: *Cosmopolitan Art Journal*, II (1857–1858), 30-31, 183-184, 209, III (1858–1859), 88; *Dictionary of American Biography* (G); Sheldon, *Painters* (G), 46-51, 84-88; Tuckerman, *Book* (G), 546-551.

JOHN W. CASILEAR: *Art Journal*, new ser., II (1876), 16-17; Champney, *Memories (see* BENJAMIN CHAMPNEY *above)*, 143; *Dictionary of American Biography* (G); Durand Papers (IV); Sheldon, *Painters* (G), 154-156; Tuckerman, *Book* (G), 521-522.

TRASH LITERATURE: Jarves, *Art Idea* (VII), 231.

JASPAR F. CROPSEY: *Art Journal*, New York, new ser., V (1879), 77-78; *Dictionary of American Biography* (G); Forman, William H., "Jaspar Francis Cropsey," *Manhattan Magazine*, III (1884), 372-382; Tuckerman, *Book* (G), 532-540.

MARTIN J. HEADE: Baur, *Luminism* (G); Jarves, *Art Idea* (VII), 236; *Karolik* (G), xxv, xliii, 301-349; McIntyre, Robert G., *Martin Johnson Heade*, New York (1948); Soby and Miller, *Romantic* (G), 70, 136; Tuckerman, *Book* (G), 542-543.

LUMINISM: Baur, *Luminism* (G).

JAMES A. SUYDAM: Baur, John I. H., "A Tonal Realist, James Suydam," *Art Quarterly*, XII (1950), 221-227; Tuckerman, *Book* (G), 540-542.

FITZ HUGH LANE: Baur, *Luminism* (G), 92; Brooks, Alfred M., "Fitz Hugh Lane's Drawings," *Essex Institute Historical Collections*, LXXXI (1945), 83-86; Champney, *Memories, (see* BENJAMIN CHAMPNEY *above)*, 10, 99; *Karolik* (G), xli, xlix, 396-415; McCormick, Gene F., "Fitz Hugh Lane," *Art Quarterly*, XV (1952), 291-306; Peters, *Stone* (G), 261.

SANFORD R. GIFFORD: *Art Journal*, New York, II, (1876), 203-204; Benjamin, *Artists* (G), 1st Ser., 75-87; Century Association, *Gifford Memorial Meeting*, New York (1880); Jarves, *Art Idea* (VII), 236; Metropolitan Museum, *Catalogue of ... Sanford R. Gifford, with a Biographical and Critical Essay by John F. Weir*, New York (1881); Sheldon, *Painters* (G), 14-20; Tuckerman, *Book* (G), 524-527; Whittredge, "Autobiography" *(see* WORTHINGTON WHITTREDGE *above)*, 56-60.

CHAPTER 15

STILL LIFE IN GENERAL: Born, *Still Life* (G); Cummings, *Annals* (G), 309; Frankenstein, *Hunt* (G); McCausland, Elizabeth, "American Still Life Painting in the Collection of Paul Magriel," *Antiques*, LXVII (1955), 324-326; Newark Museum, *Nature's Bounty and Man's Delight*, Introduction by William Gerdts, Newark, N. J. (1958).

GEORGE H. HALL: Born, *Still Life* (G), 26; Clement and Hutton, *Artists* (G), I, 135; *Dictionary of American Biography* (G); Tuckerman, *Book* (G), 482-483.

MOUNTS: See bibliographies for Chapter 2; Buffet, *Mount* (II), 39.

PEALES: Baur, John I. H., "The Peales and the Development of American Still Life," *Art Quarterly*, III (1940), 81-92; Born, Wolfgang, "The Female Peales, Their Art and Its Tradition," *American Collector*, XV (Aug. 1946), 12-14; Born, *Still Life* (G), 11-16; Flexner, *Light* (G), 113-114, 264; Frankenstein, *Hunt* (G), *passim*.

SAVERIN ROESEN: Born, *Still Life* (G), 25-26; Frankenstein, *Hunt* (G), 32-33.

JOHN F. FRANCIS: Born, *Still Life* (G), 23-24; Frankenstein, *Hunt* (G), 32, 135-137; Frankenstein, Alfred, "J. F. Francis," *Antiques*, LIX (1951), 374-377, 390, 393; *Karolik* (G), 262-264; Richardson, *Romantic* (G), 33, Figs. 121-122.

TROMPE L'OEIL: Inness, *Inness* (XVIII), 124; Novack, *Cole* (G), 82-83.

CHAPTER 16

ALBERT BIERSTADT: *Art Journal*, London, new ser., XIV (1875), 348; Born, *Landscape* (G), 103-104; Byers, William N., "Bierstadt's Visit to Colorado," *Magazine of Western History*, XI (1890), 237-240; Clement and Hutton, *Artists* (G), I, 62; Hardy, Rush G., "A Mountain Traveller," *Appalachia*, (1950) 63-70; Jarves, *Art Idea* (VII) 234-235, 254; *Karolik* (G), 74-110; McCracken, *Portrait* (G), 137-142; *New Path*, I (1863), 160-161; St. Louis, *Westward* (G), *passim*; Spieler, Gerhard G., "A Noted Artist in Early Colorado: The Story of Albert Bierstadt," *American-German Review*, XI

(June 1945), 13-17; Taylor, Mrs. H. J., *Yosemite Indians and Other Sketches*, San Francisco (1936), 80; Tuckerman, *Book* (G), 387-397; Whittredge, "Autobiography" (XIV), 26-28, 32.

THOMAS HILL: Benjamin, *Artists* (G), 2nd Ser., 22-26; Champney, *Memories* (XIV), 145-146; Clement and Hutton, *Artists* (G), I, 356-357; *Dictionary American Biography* (G); Richardson, *History* (G), 231; Taylor, *Yosemite* (*see* ALBERT BIERSTADT above), 79.

THOMAS MORAN: *Art Journal*, New York, new ser., IV (1879), 41-42; Barker, *History* (G), 588; Frÿxell, Fritiof M., *Thomas Moran*, East Hampton, N. Y. (1958); Jackson, W. H., "Famous American Mountain Paintings — with Moran in the Yellowstone," *Appalachia* (1936), 149-158; Langford, N. P., "The Wonders of the Yellowstone," illus. by Moran, *Scribner's Monthly*, II (1871), 1-17, 113; *Magazine of Art*, London, V (1882), 89-93; *New York Tribune* (5/3/1872); Ortgies & Co., *Catalogue of Paintings in Oil & Watercolor by Thomas Moran . . . to be sold*, New York (1886); Teeter, Henry D., "The Mountain of the Holy Cross," *Magazine of Western History*, XI (1889), 3-8.

CHAPTER 17

WILLIAM M. HUNT: Hunt, *Talks on Art*, comp. by Helen M. Knowlton, Boston, 1st Ser. (1877), 2nd Ser. (1883); Angell, Henry C., *Records of William M. Hunt*, Boston (1881); *Art Journal*, New York, new ser., IV (1878), 116-117, new ser., V (1879) 346-349; Danes, Gibson, "William Morris Hunt and His Circle," *Magazine of Art*, XLIII (1950), 144-150; Goodrich, Lloyd, "William Morris Hunt," *Arts*, V (1924), 279-283; *Harper's New Monthly Magazine*, LXI (1880), 161-166; Knowlton, Helen M., *Art-Life of William Morris Hunt*, Boston (1899); Shannon, Martha A., *Boston Days of William Morris Hunt*, Boston (1923); Vinton, Frederic P., "William Morris Hunt," *American Art and Art Collections*, I (1889), 93-109.

CHAPTER 18

GEORGE INNESS: Inness, *Fifty Paintings by . . .*, Introduction by Elliott Daingerfield, New York (1913); Inness, "Mr. Inness on Art Matters," *Art Journal*, New York, new ser., V (1879), 374-377; Inness, *A Letter from George Inness to Ridgely Hitchcock*, New York (1928); *Catalogue of a Special Exhibition of Oil Painting, Works of George Inness*, American Art Galleries, New York (1884); Daingerfield, Elliott, *George Inness*, New York (1911); Goodrich, Lloyd, "George Inness and American Landscape Painting," *Arts*, VII (1925), 106-110; Inness, George, Jr., *Life, Art, and Letters of George Inness*, New York (1917); Isham, Samuel, "American Landscape Painters, George Inness, Homer Martin, A. H. Wyant, etc.," *Mentor* (8/11/1913); *International Art-Union Bulletin*, I (1849), 53; Jarves, *Art Idea* (VII), 238-240; Mather, *Estimates* (G), 39-69; McCausland, Elizabeth, *George Inness*, New York (1946); Sheldon, *Painters* (G), 29-35; Trumble, Alfred, *George Inness*, New York (1895); Tuckerman, *Book* (G), 527-532; Van Dyke, John, *American Painting and Its Tradition*, New York (1919), 19-42.

RÉGIS GIGNOUX: Information from Mr. and Mrs. Gerard Gignoux and Miss Adèle Gignoux; Clement and Hutton, *Artists* (G), I, 296; Tuckerman, *Book* (G), 507-510.

HUNT ON VAGUENESS: Angell, *Hunt* (XVII), 2.

ALEXANDER H. WYANT: Wyant, *Sixty Paintings by . . .*, ed. by Eliot Clark, New York (1920); *Art Journal*, New York, new ser., II (1876), 353-355; Clark, Eliot, *Alexander Wyant*, New York (1916); Brewster, Eugene V., "Wyant, the Nature Painter," *Arts and Decoration*, X (1919), 197-200, 234; Gage, Eleanor R., "Alexander H. Wyant," *Arts and Decoration*, II (1912), 349-351; Isham, "Landscape" (*see* GEORGE INNESS above); Van Dyke, *Painting* (*see* GEORGE INNESS above), 43-64.

HOMER D. MARTIN: Martin, *Fifty-eight Paintings by . . .*, ed. by Dana H. Carroll, New York (1913); Isham, *History* (G), 262-265; Isham, "Landscape," (*see* GEORGE INNESS above); Martin, Eliza G., *Homer Martin, a Reminiscence*, New York (1904); Mather, *Estimates* (G), 121-151; Mather, Frank Jewett, *Homer Martin*, New York (1912); Van Dyck, *Painting* (*see* GEORGE INNESS above), 65-88; Whitney, *Landscape* (G), 16-17.

CHAPTER 19

WINSLOW HOMER: Homer Papers: transcripts of all known letters written by Homer, compiled by Lloyd Goodrich, who, with great generosity, made the archive available to me; Aldrich, Thomas B., *Our Young Folks*, Boston, II (1886), 393-398; *American Art-Union Bulletin* (1851), 79; Cox, Kenyon, *Winslow Homer*, New York (1914); Downes, William H., *The Life and Work of Winslow Homer*, Boston (1911); Gardner, Albert T. E., *Winslow Homer*, New York (1961); Goodrich, Lloyd, *Winslow Homer*, New York (1939); Goodrich, Lloyd, *Winslow Homer*, New York (1944); Isham, *History* (G), *passim;* James, *Some Pictures* (G), 90-94; National Gallery of Art, *Winslow Homer, a Retrospective Exhibition*, text by Albert T. E. Gardner, Washington, D. C. (1959); Sheldon, G. W., *Hours with Art and Artists*, New York (1882), 136-141; Smith College Museum of Art, *Winslow Homer, Illustrator*, prepared by Bartlett Cowdrey, Northampton, Mass. (1951); Van Dyck, *Painting (see* GEORGE INNESS *above)*, 89-114.

CONCLUSION

QUOTATIONS ON PAINTING: Hunt, *Talks* (XVII), II, 34; James, *Some Pictures* (G), 88-89; Jameson, Anna Brownell, *Studies, Stories and Memories*, Boston (1859), 330; Knowlton, *Art-Life* (XVII), 5; Novotny, *Painting* (I), 1-6.

PROBLEMS OF STUDENTS IN ENGLAND: *American Art Review*, II, Pt. 1 (1882), 227; Dunlap, *History* (G), III, 196.

QUOTATIONS ON LITERATURE: Brooks, *Arcadia* (G), 156; Spiller, *Literary History* (G), II, 238, 331, 436, 591, 629; Sweet, *Hudson* (G), 10; Kouwenhoven, *Made* (G), 138.

QUOTATIONS ON ARCHITECTURE: Kouwenhoven, *Made* (G), 84-85, 95.

QUOTATIONS ON LIFE: Kouwenhoven, *Made* (G) 210, 212.

INDEX

ABBOTT, GORHAM D., 208
ACHENBACH, ANDREAS, 101, 106, 168
ACHENBACH, OSWALD, 106
ADAMS, JOHN QUINCY, 127, 158
ADIRONDACKS, THE, 288
Aegean Sea, 143
AFRICA, 75, 166
ALBANY, N. Y., 154, 179, 254, 256, 268, 303
ALEXANDER, FRANCIS, 156, 160n; bibliography, 324
ALGER, HORATIO, 195
ALLEN, FREDERICK LEWIS, MEMORIAL ROOM, 309
ALLSTON, WASHINGTON, 12, 14, 19, 23, 42, 46, 107, 155-157, 159, 160, 163, 172, 174, 217, 291, 317n; *Belshazzar's Feast*, 14, 46, 159; *Dead Man Revived by Touching the Bones of the Prophet Elijah*, 23, 217
ALPS, THE, 44, 224, 243
AMATEUR ART, 100, 217-219, 228, 236-237
AMAZON RIVER, 138
AMERICAN ACADEMY OF THE FINE ARTS, 88-89, 95, 98, 154, 294
AMERICAN ART-UNION, xi, 94-100, 103, 108-109, 115, 120, 123, 127, 131, 154, 164, 197, 208, 259; *Art-Union Bulletin*, 96, 107, 131, 184, 215, 274; bibliography, 321. *See also* Apollo Association; Apollo Gallery
AMERICAN FUR COMPANY, 70
ANDES, THE, 135-136, 139-140
ANDOVER ACADEMY, 154
ANIMAL PAINTING, 197-199
ANTIQUE, THE, 10, 42, 55, 71, 95, 149-150, 153, 171
ANTWERP, 257
APOLLO ASSOCIATION, 94. *See also* American Art-Union
APOLLO BELVEDERE, 71n, 150

APOLLO GALLERY, 94. *See also* American Art-Union
APPALACHIAN RANGE, 241
ARABIA, 76-77, 173, 253
ARCHITECTURE, AMERICAN, 47, 143, 176, 249, 251, 303-304, 306; bibliography, 330
Arizona Highways, 245n
ART INSTRUCTION, 64, 85, 88, 99, 149-150, 154-155, 170-172, 215, 217-218, 236, 251-252, 292-293; bibliography, 325
Art Journal, 151, 256, 293
ARTISAN PAINTERS, 179, 214-219, 228, 236, 249, 251
ARTISTS' STUDIO BUILDING, 120
ART-UNION METHOD, 94. *See also* American Art-Union; International Art-Union, *etc.*
ASSYRIAN RELIEFS, 115
ASTOR, MRS., 249
ATLANTIC CITY, N. J., 112
Atlantic Souvenir, 53-54
AUCTIONS, 89, 110, 116, 119-120
AUDUBON, JOHN JAMES, 68, 73, 228
AUSTRIA, 105, 245, 306

BAHAMAS, 288
BALTIMORE, 44, 76, 78, 111, 123-124, 166
BANCROFT, GEORGE, xi-xii
BANK OF THE UNITED STATES, 54
BANKNOTE ENGRAVING, 54, 144
BANNERS, 127, 189, 217
BANVARD, JOHN, 207
BARBIZON, xiv, 60, 79, 119, 136-137, 199, 223-224, 232, 246, 260-262, 267, 296-297; bibliography, 327
BARKER, VIRGIL, 247
BAUDELAIRE, CHARLES, 79
BAUR, JOHN I. H., 25n, 229, 230-231, 309
BAVARIA, 142, 245

BAYLESS, WILLIAM H., 47
BEARD, JAMES HENRY, 196-199, 295; *North Carolina Immigrants*, 197; *Out All Night*, 198; *The Long Bill*, 197; *The Widow*, 197; bibliography, 326
BEARD, WILLIAM HOLBROOK, 196, 198-199, 295; *Jealous Rabbit*, 198; *Watchers*, 199; bibliography, 326
BEAUX, CECILIA, 288
BELGIUM, 57-58, 103, 119, 223, 245
BELLOWS, GEORGE, 137n
BENNETT, ARNOLD, 307
BENNETT, JAMES GORDON, 99
BERKSHIRES, THE, 241
BERLIN, 103-104,141,
BIBLE, 12-13, 26-27, 40, 41, 53, 152, 209, 216, 218
BIEDERMEIER, 104-105, 163, 306,
BIERSTADT, ALBERT, 106, 119, 136, 140, 163, 206, 208, 225; *Guerilla Scene*, 244; *The Rocky Mountains*, 119, 243, 244; *Yosemite Valley*, 119; bibliography 328-329
BINGHAM, GEORGE CALEB, 98, 101, 125-128, 152, 162n, 191, 197, 206n, 208, 210, 242, 299; *Canvassing for a Vote*, 130; *County Election*, 128, 129, 206n; *Emigration of Daniel Boone*, 131, 132; *Fur Traders Descending the Missouri*, 130-131; *The Jolly Flatboatmen*, 127, 153, 210, 212; *Landscape with Cattle*, 131; *Order No. 11*, 133; *The Palm Leaf Shade*, 133; *Mrs. John Sappington*, 126; *Mrs. Schackleford*, 126; *The Storm*, 131; *Stump Speaking*, 129; bibliography, 323
BIRCH, THOMAS, 9, 15-16, 17, 318
BIRCH, WILLIAM, 16, 318
Blackwood's Magazine, 112
BLAKE, WILLIAM, 81, 172
BLAKELOCK, RALPH ALBERT, 268
BLYTHE, DAVID GILMOUR, 118n, 174, 187-191, 208, 309; *Lafayette*, 188; *Libby Prison*, 189-190; *Pittsburgh Horse Market*, 189, 190; bibliography, 325
BODMER, KARL, 66, 74-76, 77, 83, 293; *Bison Dance of the Mandan Indians*, 75, 76; bibliography, 319-320
BOKER, JOHN G., 104
BOLTON-LE-MOORS, 5
BONBON, ACHILLES, 259
BONHEUR, ROSA, 101, 260
BONNAT, LÉON, J. F., 110
BORN, WOLFGANG, 45n, 64n, 237

BOSTON, 4, 14, 75, 93-94, 98, 109, 152, 155-160, 163, 170-172, 181, 185, 200, 205, 218n, 221, 231, 251-256, 273-274, 276; bibliography, 324
BOSTON ATHENAEUM, 116, 152, 156, 161; bibliography, 323
Boston Daily Advertiser, 161
Boston Evening Transcript, 156, 262
BOTANY, 75, 237.
BRADY, MATHEW B., 179-181
BRAZIL, 228
BREMEN, 168
BRETON, JULES, 110
BROOKS, VAN WYCK, 299
BROWERE, ALBERTUS D. O., 25; bibliography, 318
BROWERE, JOHN I. H., 22, 25
BROWN, FORD MADDOX, 113n
BROWN, GEORGE LORING, 113n, 161n; bibliography, 324
BROWN, JOHN G., 195-196, 210, 276; bibliography, 326
BROWNING, ELIZABETH BARRETT, 160
BROWNING, ROBERT, 160
BRUFF, GOLDSBOROUGH, 240
BRYAN GALLERY OF CHRISTIAN ART, 115, 119
BRYAN, THOMAS JEFFERSON, 115-116, 118-119, 292; bibliography 322
BRYANT, WILLIAM CULLEN, ix, 16, 18, 40, 43, 59, 96, 175, 302
BUFFALO, N. Y., 198
BUFFALO BILL, 80
BUFFORD, JOHN H., 274
BUNYAN, JOHN, 48, 153
BURNE-JONES, EDWARD, 113n
BYRON, GEORGE GORDON, LORD, 34-35, 76

CABANEL, ALEXANDRE, 110
CAFÉ GRECO, 135
CALIFORNIA, 242
CAM, GILBERT, 309
CAMBRIDGE, MASS., 273
CANADA, 233
CARICATURES, 21
CAREY, EDWARD L., 53, 163
CARNEGIE INSTITUTE, 288n
CARTOGRAPHY, 240
CASILEAR, JOHN W., 56, 57, 144, 226-227; bibliography, 328
CASSATT, MARY, 257
CASTS. See Antique, the
CATLIN, GEORGE, 66, 68-72, 73-76, 79-86,

146, 174, 215, 292, 295, 301-302; *Governor George Clinton*, 69; *Mandan Medicine Man: Ma-To-He-Ha*, 76; *Niagara Falls*, 69; bibliography, 319
CATLINITE, 70
CATSKILLS, THE, 17-18, 34, 44-45, 50, 56, 59, 90-91, 130, 136, 147, 221, 225, 242, 260, 269, 291
CENTRAL AMERICA, 229
CENTURY ASSOCIATION, 91n, 121
CHAMBERS, THOMAS, 216; bibliography, 327
CHAMPNEY, BENJAMIN, 164, 170, 208, 221, 231, 246; bibliography, 327
CHAPMAN, JOHN GADSBY, 153, 209, 216
CHEVREUL, M. E., 31, 282n
CHICAGO, 109, 182, 289
CHURCH, FREDERICK E., 101n, 114, 119, 135-145, 148, 206, 208, 222, 239, 243-245, 258-259, 295, 300-301, 304; *Aegean Sea*, 143; *Apotheosis to Thomas Cole*, 136; *Cotopaxi*, 140; *The Deluge*, 136; *Heart of the Andes*, 119, 135, 139-141; *Niagra*, 139, 243; *Parthenon*, 143; *The Plague of Darkness*, 136; *Valley of Santa Isabel*, 136; bibliography, 323
CINCINNATI, OHIO, 70, 97, 193, 223, 239
CIONE, NERDO DA, 118; *Madonna*, 118
CIVIL WAR, 32, 110-111, 119-120, 132-133 141, 179, 189-190, 193, 199, 201, 203, 220 256, 258, 260-261, 276, 278-281, 302
CLARKE, THOMAS B., 264
CLAY, HENRY, 127
CLEMENS, SAMUEL. *See* Mark Twain
CLEVELAND MUSEUM OF ART, 190
CLINTON, DE WITT, 3
CLINTON, GEORGE, 69
CLONNEY, JAMES GOODWYN, 122; *What a Catch*, 122; bibliography, 322
CODMAN, CHARLES, 217; bibliography, 327
COLE, THOMAS, 19, 52-53, 59, 72, 88, 91, 174, 212, 281; career, xiii, 5-9, 14-18, 34-51, 56-57, 59, 60-63, 89-90, 92, 106, 178-179, 290, 295, 300, 302-303, 317n; influence, 50-51, 56-58, 61-63, 102, 136-139, 142, 208-209, 216, 218, 224-225, 232, 259; *Architect's Dream*, 47; *Course of Empire*, 43-45, 47-48, 51, 92; *Cross of the World*, 50; *A Dream of Arcadia*, 49; *Expulsion from Eden*, 40; *Last of the Mohicans*, 37, 39; *Moses on the Mount*, 40; *Mountain Landscape with Waterfall*, 50; *Ox-Bow*, 38, 46; *Tree Trunks*, 8; *The Voyage of Life*, 48;

50, 66, 96, 139, 167, 208, 209, 218; bibliography, 317-318, 327
COLLECTING. *See* Patronage, *and also* Europe *and entries for specific countries*
COLLEGIATE INSTITUTE FOR YOUNG LADIES, 208
COLOGNE, 238
COLORADO, 145
COLOSSEUM, 160
COLUMBIA, MO., 126
COLUMBIA COUNTY, N. Y. 87
COLUMBUS, CHRISTOPHER, 164, 254
CONNECTICUT, 37, 69, 125, 144, 154, 212-214, 249
CONSTABLE, JOHN, xiv, 12-13, 15, 41, 57-58, 111, 144, 265n, 266, 267, 270, 293, 296
CONSTANT, BENJAMIN, 264
COOPER, JAMES FENIMORE, 17, 39, 51, 67, 299, 301
COOPER, PETER, 115
COOPER UNION, 142, 171, 115
COPENHAGEN ACADEMY, 12
COPIES, 9n, 88, 101, 159
COPLEY, JOHN SINGLETON, 4, 11, 156, 181, 184, 273, 290; *Brook Watson and the Shark*, 290
CORNELIUS, PETER, 166
COROT, JEAN BAPTISTE CAMILLE, xiv, 137, 145, 223, 254, 263, 265, 270
CORPSES, PORTRAITS OF, 212-213
CORREGGIO, 89, 157
COSMOPOLITAN ART ASSOCIATION, 108-109; bibliography, 321
COURBET, GUSTAVE, 254, 281
COUTURE, THOMAS, 183-184, 199, 201, 250-251, 295; *Romans in the Decadence of the Empire*, 183; bibliography, 325
COWDREY, BARTLETT, 309
COX, KENYON, 284
CRAYON, THE, 61
CROCKETT, DAVEY, 25
CROPSEY, JASPER FRANCIS, 227, 304; bibliography, 328
CRUIKSHANK, GEORGE, 21
CRYSTAL PALACE EXHIBITION, LONDON, 92, 180
CUMMINGS, E. L., 218-219; *The Magic Lake*, 218-219
CUMMINGS, THOMAS S., 98, 100, 120, 149, 235
CURRIER, NATHANIEL, 209
CURRIER AND IVES, 27, 194, 197-198, 209-212, 219; *Bound Down the River*, 210;

Central Park Winter: The Skating Pond,
210; *Darktown Comics,* 197-198, 211; *Home
to Thanksgiving,* 212; *The Mississippi in
Time of Peace,* 212; bibliography, 327
CURTIS, GEORGE W., 146

DAGUERRE, L. J. M., 178, 181
DAGUERREOTYPE, 178-181
DARLEY, FELIX O. C., 86, 209
DAUBIGNY, CHARLES F., 223, 254
DAUMIER, HONORÉ, 190, 295
DAVIDSON, MARSHALL, 309
DAVIDSON, WILLIAM, 309
DEALERS, 87, 90, 103, 108-111, 119-120,
138-139, 141
DEAS, CHARLES, 84; *The Death Struggle,* 84;
bibliography, 320
DECAMPS, ALEXANDRE G., 76-77; *Arabs in
Cairo,* 76
DELACROIX, EUGÈNE, 13, 41, 75, 77, 81, 254,
260, 266, 295
DELAROCHE, PAUL, 109, 165, 167, 178, 183,
206, 258; *Lady Jane Grey,* 165; *Napoleon
Crossing the Alps,* 109, 167
DELAWARE RIVER, 168-169
DENMARK, 12
DERBY, HENRY W., 108, 116
DES COMBES, 6-7
DETROIT, 85
DE VOTO, BERNARD, 75
DICKENS, CHARLES, 205
DICKESON, M. W., 207
DISTAFF VERNACULAR, 100. *See also* Feminine
influence
DORIA, CLARA, 253
DOUGHTY, THOMAS, 9, 15, 17, 36, 52-53, 156,
210; *View from Stacey Hill,* 17; bibliog-
raphy, 317-318
DUNLAP, WILLIAM, 5, 69, 102; bibliography,
317, 321
DUPRÉ, JULES, 254
DURAND, ASHER B., 18, 45, 46, 49, 71-72,
92-93, 100, 114, 136, 156, 174, 226; career,
xi, 20, 52-65, 89, 91-92, 99, 146-147, 175,
177, 179, 226, 261; influence, 61-65, 134,
137-138, 144-145, 225, 259, 261, 263, 302,
304; *Ariadne,* 55-56; *John W. Casilear,* 56;
Declaration of Independence, 53; *In the
Woods,* 61; *Kindred Spirits,* 59; *James
Madison,* 55; *Monument Mountain,* 59;
Morning and Evening of Life, 57; bibliog-
raphy, 318

DURAND, CYRUS, 54
DURRIE, GEORGE HENRY, 212-214, 236; *Home
to Thanksgiving,* 212; *The Sleighing Party,*
212; bibliography, 327
DÜSSELDORF, 85, 103-108, 118n, 119, 123,
124, 132-133, 141, 163-169, 183, 191-192,
199, 224, 235, 242-245, 249-250, 257, 267,
292, 294n, 295, 301; bibliography, 321,
324
DÜSSELDORF GALLERY, NEW YORK, 103-108,
116, 163; bibliography, 321
DUTCH ART, xiv, 8, 103, 106, 123, 201, 237,
258-259, 262

EAKINS, THOMAS, 273, 297, 307
EAST LIVERPOOL, OHIO, 187
EASTMAN, SETH, 80n, 83; *Lacrosse Playing
among the Sioux Indians,* 84; bibliography,
320
ECUADOR, 139, 140
EDMONDS, FRANCIS WILLIAM, 122; bibliog-
raphy, 322
EGAN, JOHN J., 207
EGYPT, 48, 142, 303
EHNINGER, JOHN W., 164, 200; bibliography,
326
ELIZABETH I OF ENGLAND, 165
ELLIOTT, CHARLES LORING, 25, 118n, 120,
177-178, 180-181, 185, 259; *James Feni-
more Cooper,* 181; *Thomas B. Thorpe,* 177;
bibliography, 325
EMERSON, RALPH WALDO, 71, 101, 114, 155-
156, 165, 205, 301
ENGLAND, American artists in, 4-6, 11-15,
34, 41-42, 45n, 57, 68, 79-80, 111-112,
143-145, 164, 169-170, 181, 206, 215, 223,
228, 246, 267, 273, 286-287; American
comments on English art, 41-42; American
collecting of English art, 101-102, 120;
English comments on American art, 112-
113, 141-142, 207-208, 229, 245-246, 291,
299, 303; influence on American art, 21,
29, 36, 39-40, 41-43, 45-46, 54, 57-58, 101,
110-116, 119-121, 175, 181, 192-197, 210-
211, 218-219, 232-233, 242, 246-248, 267,
270, 275, 284-285, 293-296, bibliography,
322. *See also individual artists and schools*
ENGRAVING. *See* Prints
ERIE CANAL, 3-4, 87, 89, 93; bibliography,
317
ETHNOLOGY, 71
EUROPE, American attitude towards, ix,

xii-xiv, 28, 42-43, 47, 88, 92, 95-96, 140-141, 143-144, 177-178, 191, 199-200, 221-222, 224-225, 241, 256-257, 273, 291-297, 305-306; American collecting of European art in general, xi, xii, 107-108, 119-120, 296-297, 307. *See also various nations, schools, and artists*
EXPERIMENTAL ART, 155, 162-163
EXPRESSIONISM, 23, 278

FEMININE INFLUENCE, 90-91, 100, 107, 120-121, 152, 171, 184-185, 192-197, 208-209, 216-219, 236-237, 250-252, 253-254, 255, 268, 277-278, 298; bibliography, 322, 325
FIELD, ERASTUS SALISBURY, 216-217; *Garden of Eden*, 217; *Historical Monument of the American Republic*, 217; bibliography, 327
FIELDING, HENRY, 20
FIGURE PAINTING, 149-152, 175, 183, 256. *See also* Genre, Indians, Historical painting, Portraiture, *etc.*
FIRE ENGINE PANELS, 22, 217
FISHER, ALVAN, 29, 52, 156
FLAGG, GEORGE W., 19, 89, 92; *The Murder of Princes in the Tower*, 19; *The Savoyard Boy*, 19; bibliography, 318
FLEXNER, BEATRICE HUDSON, 309
FLORENCE, 10, 141, 160, 164, 294n, 307
FLOWERS. *See* Still Life
FOLK, as subject matter, 19-20
FOLK ART, 74n, 126-127, 179, 214-219, 238. *See also* Amateur art, Artisan painters, Vernacular mode, *etc.*
FONTAINBLEAU, 249. *See also* Barbizon
FORT GIBSON, OKLA., 70
FORT SNELLING, MINN., 70, 83
FORT UNION, S. DAK., 70
FOSTER, STEPHEN, 305
FOWLER, ORSON, 304
FRA ANGELICO, 44n, 201
FRAGONARD, JEAN HONORÉ, 278
FRANCE, American artists in, 14-15, 42-43, 55, 57, 76, 78-79, 123, 131-132, 142, 143-145, 153, 164-165, 181-184, 200-202, 206, 223-224, 235, 241, 249-250, 260, 262, 269-271, 280-281; American comments on French art, 42-43, 57, 151, 224-225, 232-233, 245-246, 260, 265; American collecting of French art, 54, 101-103, 108-111, 114-115, 119-120, 296-297; French comments on American art, 27-28, 79-80, 123, 141-142, 151, 185-186, 246, 265; Influence on

American art, xiii-xiv, 66, 74-77, 82-83, 85, 165, 173, 181, 183-186, 199-200, 201-202, 206-207, 237, 249-263, 265-266, 269-271, 273, 281, 286-287, 292-297, 302; bibliography, 321. *See also individual artists and schools*
FRANCIS, JOHN F., 239; bibliography, 328
FRANKENSTEIN, ALFRED, 309
FRANKLIN, MO., 125
FRENCH AND INDIAN WAR, 66
FRÈRE, ÉDOUARD, 201
FRICK ART REFERENCE LIBRARY, 309
FRIEDRICH, CASPAR DAVID, 12-13
FRITH, W. P., 211, 275
FRONTIER, PAINTINGS OF, 66-86
FRUIT. *See* Still life
FYT, JAN, 92; *The Huntsman's Tent*, 92

GARDNER, ALBERT T. E., 309
GAVARNI, PAUL, 190
Gazette des Beaux Arts, 79, 280
GENRE, 9-10, 11-13, 15-16, 19-32, 38, 55-56, 84, 96, 104-105, 122-134, 158-159, 165, 174, 176, 187-204, 206n, 210-211, 221, 231, 243-244, 252-253, 255, 275-281, 293-297, 301, 325
GEOLOGY, 243-244
GERDTS, WILLIAM, 309
GÉRICAULT, JEAN, 290; *The Raft of the Medusa*, 290
GERMANY, American artists in, 84-85, 123, 163-169, 224-225, 232, 235, 241-243, 249-250; American collecting of German art, 102-108, 110-111, 119-120; influence on American art, 20, 43-44, 59, 84-86, 94, 101-111, 119-120, 124, 127-128, 132-134, 153, 163-169, 172, 191-192, 199-201, 202, 210-211, 224-225, 237-238, 242-245, 250, 257, 267, 292, 304-306. *See also* Düsseldorf *and individual artists and other schools*
GÉRÔME, JEAN LÉON, 111, 166, 280; *Dual After the Masquerade*, 111, 166
GETTYSBURG, 185, 189, 206
GIBBON, EDWARD, 160
GIBSON, JOHN, 135
GIFFORD, SANFORD R., 225, 232, 262, 300; *Kauterskill Falls*, 232-233; bibliography, 328
GIFT BOOKS, 53-54; bibliography, 319
GIGNOUX, ADÈLE, 309
GIGNOUX, MR. AND MRS. GERALD, 309
GIGNOUX, RÉGIS, 258-259, 293; *Niagara in*

Winter, 259; bibliography, 329
GILMOR, ROBERT, JR., 34, 36-38, 44, 123
GILPIN, WILLIAM, 36
GLOUCESTER, MASS., 231, 286
Godey's Lady's Book, 53, 102, 112, 166
GOLD RUSH, 85, 242-243
GOODRICH, LLOYD, 286, 309
GOTHIC ART, 47, 57, 193, 249, 303
GOTTSCHALK, LOUIS M., 304
GOUPIL AND CO., 103, 109-111, 120, 131, 168, 193, 206, 210; bibliography, 321
GRANT, ULYSSES S., 184
GREECE, 10, 53, 81, 142-143, 152, 233, 241
GREEK REVIVAL STYLE, 47, 303
GREEN MOUNTAINS, 147
GREY, HENRY PETERS, 95, 153-154, 159, 163, 175, 185; *Wages of War,* 95, 153; bibliography, 323-324
GREY, LADY JANE, 165
GROS, BARON, 181
GRUBER, FRANCIS S., 309
GUDE, HANS FRIEDRICH, 105-106
GUY, SEYMOUR JOSEPH, 194, 210

HACKENSACK, N.J., 258
HAGUE, THE, 201
HALE, ROBERT B., 309
HALL, GEORGE HENRY, 235; bibliography, 328
HAMILTON, JAMES, 111; *Atlantic City Scene,* 112; *Foundering,* 112; *Last Days of Pompeii,* 112; bibliography, 322
HANDEL, GEORGE F., 205
HARDING, CHESTER, 156
HARDY, JEREMIAH P., 185; *Mary Ann Hardy,* 185; bibliography, 325
Harper's Illuminated Bible, 209
Harper's Magazine, 162
Harper's Weekly, 259, 274, 278
HARRISON, WILLIAM HENRY, 127
HART, JAMES MCDOUGAL, 226-227, 268; bibliography, 327
HART, WILLIAM, 226-227, 268; bibliography, 327
HARTFORD, CONN., 136
HARVARD UNIVERSITY, 100, 249
HASENCLEVER, JOHANN PETER, 104, 242
·HAWKINS, MICAH, 25
HAWTHORNE, NATHANIEL, 152, 156, 169, 218, 226, 300
HEADE, MARTIN JOHNSON, 228-230, 235; *Rocks in New England,* 228; *Storm over*

Narragansett Bay, 229; bibliography, 328
HEALY, GEORGE P. A., 181-184; *Lewis Cass,* 181; *Pacemakers,* 184; *Louis Phillippe,* 181; bibliography, 325
HELD, JULIUS, 118n, 309
HEMINGWAY, ERNEST, 290
HICKS, EDWARD, 185, 228n; *Peaceable Kingdoms,* 185
HICKS, THOMAS, .185; *Dr. Francis Upton Johnson,* 185; *General George C. Meade,* 185; bibliography, 325
HILL, THOMAS, 246; bibliography, 329
HIRSCHL, NORMAN, 309
HISTORICAL LANDSCAPES, 39-40, 43-51, 57-58, 106-107, 136, 142, 208-209, 232, 281
HISTORICAL PAINTING, 7-16, 19-20, 42-43, 53, 55-56, 76, 95-96, 99-102, 104-105, 107-108, 149-173, 206-211, 217-219, 228n, 250, 254-255, 278-279, 303. See also Historical landscapes, Neoclassicism
HOBBEMA, 258
HOBOKEN, N. J., 56
HOGARTH, WILLIAM, 21
HOLLAND, 79, 99-100, 130, 201. *See also* Dutch art
HOLY LAND, 142
HOMER, WINSLOW, xii, 118n, 161n, 203-204, 232, 273-275, 296, 302, 306, 309; *Adirondack Guide,* 289; *Camp Fire,* 285; *Country School,* 283; *Defiance,* 280; *Gulf Stream,* 290; *Home Sweet Home,* 279; *Leaping Trout,* 288, *The Life Line,* 287; *Long Branch,* 282; *Northeaster,* 290; *Prisoners from the Front,* 280; *The Sleighing Season— the Upset,* 277; *The Walking Wounded,* 278; *West Point, Prouts Neck,* 289; bibliography 330
HONE, PHILIP, 42
HOOD, THOMAS, 161
HOWELL, HANNAH JOHNSON, 309
HÜBNER, KARL, 105, 133
HUDSON, N. Y., 232
HUDSON RIVER SCHOOL, xiv, 3, 5, 17-18, 32, 36-37, 52, 58-59, 83, 106, 113, 117, 131, 138, 147, 151, 154-155, 175, 179, 191, 194, 199, 213, 216, 220-226, 226-228, 230-231, 233, 235, 241-246, 256-258, 260-261, 265, 266-269, 272, 274-275, 279, 280, 284, 289, 296-297, 302; bibliography, 327-328. *See also* Landscape painting *and individual artists*
HUMBOLDT, BARON ALEXANDER VON, 138

HUNT, HOLMAN, 113n
HUNT, RICHARD MORRIS, 249, 251
HUNT, WILLIAM MORRIS, 171, 249-257, 265, 280, 293, 295, 300; *Bather*, 253; *Charles Sumner*, 252; *The Discoverer*, 254; *Flight of Night*, 254; *Ida Mason*, 252; *Judge Lemuel Shaw*, 252; *The Prodigal Son*, 250; bibliography, 329
HUNTINGTON, DANIEL, 46, 95, 153-154, 163, 175, 185, 208, 215; *Mercy's Dream*, 153, 185; *St. Mary and the other Holy Women at the Sepulchre*, 95; bibliography, 324
HUNTINGTON, DAVID C., 309

ICEBERGS, 141, 241
ILLUSTRATION, 112, 152-153, 169, 206, 209-211, 217, 246-247. *See also* Prints
IMMERMANN, KARL LEBERECHT, 104
IMMIGRATION, 191, 195
IMPRESSIONISM, 30-31, 251; American, xiv, 203, 258-271, 273-275; French, 180, 265-266, 270-271, 273, 281-282, 306
INDIANA, 75
INDIANS, 22, 66-86, 145, 152, 201, 243-244, 295; bibliography, 319-320
INDUSTRIALISM, 5-6, 34, 186, 188, 190-191, 194, 256
INGHAM, CHARLES C., 193
INGRES, JEAN A. D., 183
INMAN, HENRY, 26, 175-176, 178; *Mrs. James Donaldson*, 176; bibliography, 325
INNESS, GEORGE, 203, 281n, 282; career, 117, 239, 258-266, 291, 296; influence, 232, 233-234, 246-248, 266-267, 306n; *Barbarini Pines*, 202; *The Coming Storm*, 263; *Delaware Water Gap*, 262; *Evening at Medfield*, 262; *Indian Summer*, 265; *Overlooking the Hudson at Medfield*, 265; *Under the Greenwood Tree*, 263; bibliography, 329
INSTITUTE OF FINE ARTS, 108, 116
INTERNATIONAL ART-UNION, 103, 109, 259; bibliography, 321
IRELAND, 111-112, 176, 181, 187, 207
IROQUOIS, 67
IRVING, WASHINGTON, 16-17, 20-25, 302
ISHAM, SAMUEL, xi
ISLE OF SHOALS, 256
ITALY, American artists in, 19, 42-45, 50, 58, 115-118, 141-143, 144-145, 151-154, 156-157, 164-166, 182, 184, 200, 206, 224-225, 233-234, 241, 262, 294n; American comments on, 42-43, 44, 49, 163, 179;

influence on American art, 4, 9-10, 14-15, 58-59, 153, 160, 302; bibliography, 324. *See also* Neoclassicism, Old Masters, Virgilian mode, *individual artists and schools*

JACKSON, ANDREW, 54
JACKSONIAN DEMOCRACY, 51, 187, 194, 226, 298, 300, 305
JAMAICA, 142
JAMES, HENRY, 101, 119, 136, 222, 251, 283-284, 294, 302
JAMES, WILLIAM, 251
JAMESON, ANNA BROWNELL, 291, 293
JAPANESE ART, 254, 276, 281
JARDIN DES PLANTES, 237
JARVES, JAMES JACKSON, career, 114-119, 292; quoted, 101, 136, 140, 183, 191, 199, 220, 227, 229, 232, 245; bibliography, 322
JARVIS, JOHN WESLEY, 21, 175
JEFFERSON, THOMAS, 4, 13-14, 22, 25, 132
JEFFERSONVILLE, PA., 239
JOHNSON, EASTMAN, 99-100, 168, 186, 200-204, 280; *Family of Alfredrick Smith Hatch*, 186; *Maple Sugar Camp—Turning Off*, 203; *Old Kentucky Home*, 201-202; *Savoyard Boy*, 201; bibliography, 326
JOHNSON, DR. FRANCIS UPTON, 185
JONES, MR. AND MRS. LOUIS C., 309

KAFKA, FRANZ, 189
KANE, ELISHA KENT, 112
KANSAS, 133
KANSAS-NEBRASKA ACT, 132
KAROLIK, M. AND M., COLLECTION, 311
KEITH, WILLIAM, 246
KEMBLE, FANNY, 205
KENSETT, JOHN F., 57, 113, 143-148, 225-228, 230-231, 233, 259, 263, 269-270, 278, 293; *Storm over Lake George*, 146; *View of West Point*, 146; bibliography, 323
KING, CHARLES BIRD, 67, 80, 240; *Vanity of an Artist's Dream*, 240; bibliography, 319
Knickerbocker Magazine, 97
KNOWLTON, HELEN M., 300
KOCH, JOSEPH ANTON, 43
KOUWENHOVEN, JOHN A., 304
KRIMMEL, JOHN LEWIS, 128, *Election Day at the State House*, 128; *Fourth of July in Centre Square*, 128

LABRADOR, 141
LA FARGE, JOHN, 251, 254, 256, 276

LAKE ERIE, 197

LANDSCAPE PAINTING, xii-xiv, 5, 8-9, 10-12, 14-18, 29-32, 34-52, 56-65, 69, 72, 74, 75, 78, 88, 90, 95-96, 104-107, 111-112, 114-115, 119-120, 130-131, 135-148, 151, 158-159, 161n, 171-172, 174, 176, 178-179, 191, 206-207, 215-216, 220-234, 253, 256-257, 281, 293-297, 301-302

LANDSEER, EDWIN, 101, 197, 208; *The Challenge*, 208

LANE, FITZ HUGH, 230-231; bibliography, 328

LANMAN, CHARLES, 50

LAWRENCE, THOMAS, 175, 181, 184

LAWRIE, ALEXANDER, 195; *New York Interior*, 195

LEBANON, 142

LEFEBVRE, CHARLES, 110

LEIGHTON, LORD FREDERICK, 286

LE MOYNE, JACQUES, 67

LESLIE, CHARLES R., 12, 165, 294

LESSING, KARL FRIEDRICH, 104-105, 106; *The Martyrdom of John Huss*, 105

Letters on Landscape Painting, by Asher B. Durand, 58-59, 61-65, 100

LEUTZE, EMANUEL, 85, 95, 119, 131, 163-169, 206, 293; *The Attainder of Strafford*, 95; *An Indian Contemplating the Setting Sun*, 163; *Washington Crossing the Delaware*, 119, 131, 165, 167, 168, 169; *Westward the Course of Empire Takes its Way*, 169; bibliography, 324

LEWIS, HENRY, 207

LEWIS, JAMES OTTO, 67; bibliography, 319

LEWIS AND CLARK EXPEDITION, 68

LIBERIA, 200

LINCOLN, ABRAHAM, 184, 189

LISBON, PORTUGAL, 141

LITCHFIELD, CONN., 69

Literary World, 97, 162

LITERATURE, American, xii, 16-17, 44, 54, 71, 100-101, 155, 226, 298-303, 306, 330 (bibliography); influence on art, 11-12, 16-17, 19-25, 28, 37, 39-40, 44, 45n, 48, 72, 83, 100-102, 138, 155, 281; bibliography, 321

LITHOGRAPHY, 209. *See also* Prints

LIVINGSTON, MR. AND MRS. HENRY, 309

LONDON, 79-80, 141, 180-181, 206, 228, 245, 267, 270, 273

London Art Journal, 160, 229

LONG, S. H., 68

LONGFELLOW, HENRY WADSWORTH, 83, 169, 200, 207n, 299-301

LORRAIN, CLAUDE, 10, 17, 43, 58, 140, 160n, 259, 262

LOTTERIES, 94, 99, 108

LOUIS XVIII OF FRANCE, 169-170

LOUIS-PHILIPPE OF FRANCE, 181, 182

LOUISIANA, 109, 242

LOUISVILLE, KY., 70

LOUVRE, 132, 144, 280

LOWELL, JAMES RUSSELL, 155, 159, 160, 200

LUMINISM, 230; bibliography, 328

MADISON, JAMES, 55

MADRAZO, DON FREDERIC, 110

MADRID, 141

MAGDALENA RIVER, 139

MAINE, 200, 203, 215, 217, 286-289

Malkasten, Der, 167

MANDANS, 75-76

MANET, EDOUARD, 183, 276, 278, 281

MARIETTA, OHIO, 193

MARTIN, ANGELIQUE. *See* Spencer, Lily Martin

MARTIN, HOMER, 258, 268-271, 296, 306n; *Harp of the Winds*, 271; *Lake Sanford*, 269; bibliography, 329

MARTIN, JOHN, 39-40, 45, 209, 216; *Belshazzar's Feast*, 39; *Expulsion from Eden*, 40; bibliography, 318-319

MARYLAND, 111, 123

MASON, IDA, 252

MASSACHUSETTS, 15, 164, 216, 231, 242, 246, 260; *See* Boston

MATHEMATICS, 162

MATHER, FRANK JEWETT, 258

MAURER, LOUIS, 211

MAXIMILIAN, PRINCE OF WIED-NEUWIED, 75

MCENTREE, JERVIS, 224, 227

MCKIM, MEADE, AND WHITE, 249

MEADE, GEN. GEORGE G., 185

MEDIEVAL ART, 49, 71, 106, 113n, 218

MEDITERRANEAN ART, 241, 295

MEEKER, JOSEPH RUSLING, 242

MEISSONIER, J. L. E., 279

MELVILLE, HERMAN, 100, 147, 300

MENDELSSOHN, FELIX, 205

MERIAN, MARIA SIBYLLA, 237

METROPOLITAN MUSEUM, xi, 97, 121, 139, 147

METTERNICH SYSTEM, 12-19

MICHELANGELO, 87, 166, 172

MILLAIS, JOHN E., 113n
MILLER, ALFRED JACOB, 66, 76-78, 83, 175; *Christ's Charge to Peter*, 78; *Running Fight —Sioux and Crows*, 77; bibliography, 320
MILLET, JEAN FRANÇOIS, 79, 190, 249-254, 284, 295; *Sower*, 250
MILTON, JOHN, 45n
MINIATURES, 179
MINNESOTA, 70, 201
MINSTREL SHOWS, 197
MISSISSIPPI RIVER, 85, 207-208
MISSISSIPPI VALLEY, 66, 68, 242n
MISSOURI, 126-133; *See also* St. Louis
Missouri Intelligence, 126
MISSOURI RIVER, 70, 74-75, 126, 127
MOHAWKS, 71
MONET, CLAUDE, 266
MOORISH ART, 47-48, 303-304
MORAN, THOMAS, 246-247; *Chasm of the Colorado*, 247; *Grand Canyon of the Yellowstone*, 247; bibliography, 329
MORSE, SAMUEL F. B., 14-15, 88, 149, 153, 154, 174, 178-179, 181, 185
MOSES, MARY ANNA ROBERTSON, GRANDMA, 293
MOUNT, HENRY SMITH, 26, 236
MOUNT, SHEPARD ALONZO, 26, 177n, 236
MOUNT, WILLIAM SIDNEY, 53, 59, 105, 124, 147, 196, 276, 278; career, xi-xii, 25-33, 56, 89, 92, 99, 125, 128, 131, 175, 191, 202, 213n, 236, 299, 303; influence, 25-26, 63, 122, 128, 191; *The Banjo Player*, 31; *Christ Raising the Daughter of Jairus*, 26; *Eel Spearing at Setauket*, 32, 211; *The Power of Music*, 28; *The Rustic Dance*, 26; bibliography, 318
MOUNT DESERT ISLAND, 241
MOUNT MORAN, 247
MUNICH, 166, 203, 256, 291
MUNKÁCSY, MIHALY, 110
MURALS, 215, 217, 254
MUSEUM OF FINE ARTS, BOSTON, 253
MUSIC, AMERICAN, 26-27, 47, 170, 274, 304-306

NAÏVE ART, 69, 215-219. *See also* Amateur art, Folk art, *etc.*
NAPLES, 141
NAPOLEONIC WARS, 13, 19, 76, 169, 278-279
NASSAU, 288
Nation, 113
NATIONAL ACADEMY, 61, 88-89, 92-93, 95, 98-100, 103, 120-121, 154-156, 162, 185, 214, 232, 235, 257, 260, 263, 270, 280, 304; art school, 84, 88, 99, 149, 154-155; exhibitions, 26, 69, 88-89, 92-94, 98, 100, 120, 136, 159, 177, 212, 236, 250; bibliography, 320-321
NATIONAL PARK SYSTEM, 247
NATIVE SCHOOL, in general, xi-xv, 51, 61, 89, 100-102, 155, 214, 236, 251, 256-257, 273, 283, 290-307
NATURAL HISTORY, 68
NAZARENES, 44, 104, 113n, 119, 153, 167n
NEGROES, 27, 28, 31, 195, 198, 202, 290, 299, 305
NEOCLASSICISM, 9-15, 30, 35-37, 54, 59, 62-63, 66, 71, 88, 95, 100, 149, 153, 165-166, 171, 178, 214, 217, 265n, 268, 269, 303
NEVINS, ALLAN, 309
NEW BEDFORD, MASS., 242
NEW ENGLAND ART-UNION, 98
New England Magazine, 29
NEW HAMPSHIRE, 218, 221, 235
NEW HARMONY, IND., 75
NEW HAVEN, CONN., 212-214, 249
NEW JERSEY, 52, 98, 241, 258, 260
NEW JERSEY ART-UNION, 98
NEW ORLEANS, LA., 109
New Path, 113, 198, 280
NEW YORK CITY, xi, 3-5, 18, 21, 44, 47, 56, 69, 87-107, 115, 119, 122, 125, 126-129, 131, 136, 147, 152, 154-156, 159, 162, 164, 171, 175, 182, 185, 193, 197, 198, 201, 205-206, 211, 213, 229, 231, 242n, 249-251, 253, 257-258, 260, 269, 274, 280, 282
NEW YORK GALLERY OF FINE ARTS, 93, 115; bibliography, 320-321
NEW-YORK HISTORICAL SOCIETY, 115, 118n, 224
New York Mirror, 34, 102
NEW YORK PUBLIC LIBRARY, 309
NEW YORK SOCIETY LIBRARY, 309
NEW YORK STATE, 44-45, 85, 87, 156, 176, 232, 241, 254-255, 268, 303. *See also* New York City
New York Times, xi, 199
New York Tribune, 117, 179, 220, 247
NEWPORT, R. I., 147, 249, 251
NIAGARA FALLS, 40-41, 69, 139, 227
NOBLE, LOUIS L., 139, 141, 317n
"NOBLE SAVAGE," THE, 66, 301
NORMANDY, 271
NORTH CAROLINA, 197

NORTH CONWAY, N. H., 221, 230
NORTON, CHARLES ELIOT, 116
NORWAY, 105, 267
NOVA SCOTIA, 169
NOVACK, BARBARA, 309
NOVOTNY, FRITZ, 63n, 297
NUDE, 42, 54-55, 77, 85n, 107, 109, 150-152, 154, 159, 161, 170, 253, 296, 303; bibliography, 323

OCTAGON HOUSES, 304
OHIO, 6, 153, 164, 187, 198, 223, 224-225. See also Cincinnati
OHIO STATE CAPITOL, 47
OKLAHOMA, 70
OLANA, home of Frederick Church, 143
OLD MASTERS, 8-10, 29, 34, 36, 38, 50, 58, 84, 87-88, 92, 95, 96, 113, 119, 153, 156, 157, 224, 270, 280, 292; collected in America, 87-89, 92, 96, 101, 114-119; bibliography, 322
OMOTO, SADAYOSHU, 309
OREGON TRAIL, 76
ORINOCO RIVER, 138
OSWEGO, N. Y., 87
OVERBECK, JOHANN FRIEDRICH, 153

PACKARD, LEWIS R., 117
PAFF, MICHAEL, 87, 89, 96; bibliography, 320
PAGE, WILLIAM, 118n, 155-163, 175, 180, 261, 295; John Quincy Adams, 158; The Anger of Achilles, 154; Cupid and Psyche, 159; Head of Christ, 162; Shakespeare, 162; Venuses, 161-163, The Young Merchants, 159, bibliography, 324
PAINESVILLE, OHIO, 196
PALMER, ERASTUS DOW, 303
PALMER, FRANCES BOND, 194, 211, 218; The Mississippi in Time of Peace, 212
PANORAMAS, 85, 93, 188, 207; bibliography, 326-327
PANTHEISM, 35, 58, 100, 112, 137, 220, 261, 294
PARIS, 42, 76, 85n, 115, 123, 124, 132, 141, 165, 181-182, 199-201, 235, 250, 257, 260, 262, 273n, 280, 288, 294n
PARIS UNIVERSAL EXPOSITION, 220, 281
PARSONS, CHARLES, 211
PASSAIC, N. J., 258
PATRONAGE OF AMERICAN ART, xi, 27, 88-102, 110, 120-121, 257, 264-265, 267, 270, 300; bibliography, 317, 320

PEALE, ANNA CLAYPOOLE, 237-239
PEALE, CHARLES WILLSON, 70, 237
PEALE, JAMES, 237-239
PEALE, MARGARETTA ANGELICA, 237-239
PEALE, MARIA, 237-239
PEALE, MARY JANE, 237-239
PEALE, RAPHAELLE, 237-239
PEALE, REMBRANDT, 115n
PEALE, SARAH MIRIAM, 237-239
PEALE, Still Life, bibliography 328
PEALE'S MUSEUM, 69-70
PENNSYLVANIA, 8, 12, 17, 68, 93, 105, 187, 228, 237, 239, 241. See also Philadelphia
PENNSYLVANIA ACADEMY OF THE FINE ARTS, 8, 12, 17, 93
PENNSYLVANIA HOSPITAL, 105
PERKINS, CHARLES C., 155
PERRY, OLIVER HAZARD, 276
PERSIA, 143, 254
PETERS, HARRY T., 211n
PHILADELPHIA, 6-7, 8, 12, 16-17, 68-69, 80, 93, 112, 115, 122, 126, 128, 129, 131, 167, 206, 246
PHILADELPHIA ART-UNION, 98
PHOENIXVILLE, PA., 239
PHOTOGRAPHY, 85, 178-184, 185, 243; bibliography, 325
PITTSBURGH, PA., 8, 187-191
PLATTE RIVER, 76
PLYMOUTH, N. H., 218
POE, EDGAR ALLAN, 188, 189, 299-300, 302
POLK, JAMES, 127
POMAREDE, LEON, 207
PORTER, RUFUS, 215-216; bibliography, 391
PORTER, W. D., 184
PORTRAITURE, xii, 6-7, 9-11, 19, 21, 41, 53, 55-57, 67, 76, 120, 126-127, 132, 133, 154, 156, 167n, 170, 174-186, 195, 198, 212, 216-217, 237, 239, 252. See also Indians
PORTUGAL, 251
POST, GEORGE P., 304
POUSSIN, NICHOLAS, 259
POWELL, WILLIAM H., 153
POWERS, HIRAM, 97, 151, 160; The Greek Slave, 97, 151
PRE-RAPHAELITES, 44n, 113, 119, 141, 198, 229, 280, 286, 306
PRIMITIVES, AMERICAN. See Amateur art, Artisan painters, Vernacular mode, etc.
PRINCETON UNIVERSITY, 100
PRINTS, xii, 15, 53-56, 59, 67, 75-76, 79, 84-86, 94, 96, 120, 125, 127, 144, 168, 185,

193-194, 196, 197, 206, 208-212, 218, 221, 231, 274-281; bibliography, 327
PROUTS NECK, MAINE, 286-289
PROVINCIAL PAINTERS, 185, 214
PRUSSIA, 103-104, 168, 245
PUERTO RICO, 229
Purismo, 153

QUIDOR, JOHN, 67, 106, 276, 278; career, 21-25, 118n, 175, 176, 191, 295, 299, 302; influence, 24-25, 30, 102; *Ichabod Crane Pursued by the Headless Horseman*, 21; *The Money-Diggers*, 23; *Peter Stuyvesant's Journey Up the Hudson River*, 24; bibliography, 318

RANNEY, WILLIAM T., 125, 191; *Trapper's Last Shot*, 125; bibliography, 323
RAPHAEL, 10, 42, 44n, 118, 157
REED, LUMAN, 45-46, 56, 87-93, 98; bibliography, 320
REEVE, TAPPAN, 68
RELIGIOUS INFLUENCE, xii, 25, 27, 35-36, 48, 50, 61-62, 139, 261. *See also* Pantheism
REMBRANDT, 29, 115, 175, 201, 203
REMINGTON, FREDERIC, 86
REVOLUTION, AMERICAN, 4, 11, 13, 19, 66-68, 89, 278, 300
REVOLUTION, FRENCH, 12, 169
REVOLUTION OF 1830, 42
REVOLUTION OF 1848, 167
REYNOLDS, SIR JOSHUA, 201
RHINE RIVER, 208n, 232
RHODE ISLAND, 41n, 241
RIMMER, WILLIAM, 169-173, 228n, 231, 295; *Despair*, 170; *Evening: The Fall of Day*, 172; *Falling Gladiator*, 170-171; *Flight and Pursuit*, 173; *In the Arena*, 172; bibliography, 324-325
RINDISBACHER, PETER, 68; bibliography, 319
ROBERTSON, ALEXANDER, 4
ROCKY MOUNTAIN SCHOOL, 242-248
ROCKY MOUNTAINS, 68, 76, 140, 225, 242-248
ROESEN, SAVERIN, 238; bibliography, 328
ROGERS, JOHN, 303
ROMANESQUE ART, 303
ROMANIA, 182, 184
ROMANTIC IDEALISM, 10-13, 24-25, 71, 77, 100, 102, 111, 117, 217, 302-303
ROMANTIC REALISM, 10-16, 25-26, 72, 100, 117, 294, 303
ROME, 10, 43, 50, 58, 135, 141-142, 152-153,

164, 166, 182, 184, 200, 206, 262, 294n
ROSA, SALVATOR, 34, 113
ROSSETTI, DANTE GABRIEL, 113n
ROSSITER, THOMAS PRITCHARD, 57, 144, 206, 226
ROTHERMEL, PETER F., 206
ROTTMAN, KARL, 59
ROUSSEAU, JEAN JACQUES, 35
ROUSSEAU, THÉODORE, 119, 223, 259
ROWLANDSON, THOMAS, 21
ROYAL ACADEMY, 41, 161
RUBENS, PETER PAUL, 8, 57
RUSKIN, JOHN, 59, 101, 112-114, 116, 142, 201, 218n, 239, 291, 293, 304; bibliography, 322
RUSSELL, BENJAMIN, 208
RUSSIA, 103, 245
RUYSDAEL, 8
RYDER, ALBERT PINKHAM, 273n

SACO RIVER, 221
ST. CLAIRSVILLE, OHIO, 6-7
ST. LOUIS, MO., 67-68, 70, 84-85, 101, 125, 126, 130, 207, 242n
ST. PAUL, MINN., 70
SAINTIN, JULES ÉMILE, 85n; *Femme de Colon Enlevée par les Indiens Peaux Rouges*, 85n; bibliography, 320
SALON, FRENCH, 42, 161
SANDWICH GLASS, 116
SANDWICH ISLANDS, 116
SANITARY FAIR, Boston, 119n; New York, 119; bibliography 322
SARGENT, JOHN SINGER, 181
Sartain's Magazine, 167
SASSOON, SIEGFRIED, 189
SCANDINAVIA, 103-104, 306
SCENE PAINTING, 179, 205, 208, 245
SCHADOW, FRIEDRICH WILHELM, 104, 164
SCHEFFER, ARY, 42, 109
SCHIRMER, JOHANN WILHELM, 106
SCHOOLCRAFT, HENRY R., 84
SCHOOLS, ART. *See* Art instruction
SCHOUS, H. L., 45n
SCIENCE, influence on art, 68, 75, 76, 138, 141, 162, 237, 243
Scientific American, 215
SCOTLAND, 76, 122, 187
SCOTT, SIR WALTER, 4, 20, 152
SCULPTURE, American, 151, 170-171, 188, 249, 301, 306; Greek and Roman, *see* Antique, the

SEDGWICK, MARIA CATHERINE, 301
SENTIMENTALITY, 192-210, 212, 288
SERWIN, VIOLET, 309
SETAUKET, N. Y., 25
SÈVRES, 237
SEYMOUR, SAMUEL, 68
SHAKESPEARE, 12, 20, 104-105, 162, 205
SHAW, LEMUEL, 252
SHERMAN, WILLIAM TECUMSEH, 184
SICILY, 142
SIGN PAINTING, xii, 26-31, 85, 159, 236, 293
SILKWORMS, 170
SKETCH CLUBS, 91, 121
SMITH, JOHN RAWSON, 207
SMITHSONIAN INSTITUTION, WASHINGTON, D. C., 80n
SNOW SCENES, 212-213
SOCIETY FOR THE ADVANCEMENT OF TRUTH IN ART, 113
SOCIETY OF AMERICAN ARTISTS, 257, 263, 270
SOHN, CARL FERDINAND, 107, 123; *Diana and her Nymphs Surprised at the Bath*, 107
SOUTH AMERICA, 82, 228, 241, 295, 300
SOUTH DAKOTA, 70
SPAENDONCK, VON, BROTHERS, 237
SPANISH CONQUEST OF AMERICA, 206
SPARK, VICTOR, 309
SPENCER, LILY MARTIN, 193, 298; *Celebrating the Victory at Vicksburg*, 193; *Shake Hands*, 193; bibliography, 326
SPINGLER INSTITUTE, 208
SPIRITUALISM, 27-29
SPORTING ART, 86, 125
SPRINGFIELD, OHIO, 223
STANFORD, LELAND, 246
STANLEY, JOHN MIX, 80n, 85; *Osage Scalp Dance*, 86; bibliography, 320
STEARNS, JUNIUS BRUTUS, 206, 209n
STEINBACH, MILDRED, 309
STERNE, LAURENCE, 20
STEUBENVILLE, OHIO, 6
STEVENS, ALFRED, 110
STEVENS AND WILLIAMS, 141
STEWART, WILLIAM DRUMMOND, 76
STILL LIFE, 213, 229, 235-240, 257; bibliography, 328
STILLMAN, WILLIAM JAMES, 114; bibliography, 322
STOCK CERTIFICATES, 54
STOCK, JOSEPH, 179
STOCKWELL, SAMUEL B., 207
STONY BROOK, N. Y. 25-26

STORY, WILLIAM WETMORE, 160, 222
STRANGE, JOHN, 100
STUART, GILBERT, 4, 41n, 77n, 126, 156, 157, 160n, 167n, 168, 174-175, 177, 180, 216; *Athenaeum Washington*, 168; *Dr. William Hartigan*, 176-177
STURGES, JONATHAN, 91
STUYVESANT, PETER, 23-24
SULLIVAN, LOUIS H., 304
SULLY, THOMAS, 17, 107, 174-175, 177, 178, 193
SUMNER, CHARLES, 252
SURREALISM, 227
SUYDAM, JAMES, AUGUSTUS, 230; *Study near North Conway*, 230; bibliography, 328
SWEDENBORGIANISM, 160, 162n, 261
SWEENY, PETER B., 161
SWITZERLAND, 68, 75, 142, 241
SYRIA, 142, 233

TAIT, ARTHUR FITZWILLIAM, 86, 210-211; *Catching a Trout: We have You Now, Sir*, 211
TENIERS, DAVID, THE YOUNGER, *Interior of a Public House*, 190
TETON RANGE, 247
TEXAS, 125
THAXTER, CELIA, 256
THEATER, 205; influence on painting, 20, 55-56, 104-105, 199-200
THOREAU, HENRY DAVID, 70-71, 301
THORPE, THOMAS B., 177
THORVALDSEN, ALBERT B., 50
TITIAN, 55, 89, 92, 116, 154-157, 159, 162, 175
Token, 53
TOPOGRAPHICAL MODE, 16, 17, 57, 215-216. *See also* Vernacular mode
TOURING PICTURES, 205-206, 208-209; bibliography, 326. *See also* Panoramas
TRANSCENDENTALISM, 155, 160, 163
TREE PORTRAITURE, 60
TRENTON, N. J., 98
TRINITY CHURCH, BOSTON, 254
TROLLOPE, ANTHONY, 301
Trompe l'oeil, 31, 239-240; bibliography, 328
TROYON, CONSTANT, 254
TRUMBULL, JOHN, 4-5, 11, 13, 18, 53, 278; *Declaration of Independence*, 53; bibliography, 317
TUCKERMAN, HENRY T., 60, 101, 116, 141, 169, 199, 203, 245, 259

TULSA, OKLA., 70
TURKEY, 142-143, 233, 241
TURNER, JOSEPH M. W., 12, 13, 15, 41, 59, 77, 111-112, 137, 142, 232, 265n, 266, 293
TWACHTMAN, JOHN H., 266
TWAIN, MARK, 147, 299, 303
TWEED, W. M. (BOSS), 161
TWIBILL, LAVINIA, 155
TYNEMOUTH, 286

Uncle Tom's Cabin, 201
UNION LEAGUE CLUB, 121
UNIONTOWN, PA., 187
UNITED STATES CAPITOL, 153, 169; bibliography, 323
UNITED STATES CONGRESS, 80, 153
UNIVERSITY OF MARYLAND, 123
UTICA, N. Y., 176

VACATIONS, 147-148, 191
VAN DER NEER, AART, 259
VAN DYKE, ANTHONY, 175
VAN WINKLE, RIP, Quidor paintings of, 22-23
VANDERBILT, MRS. WILLIAM KISSAM, 249
VANDERLYN, JOHN, 14, 45, 55, 93, 174, 207; *Ariadne*, 55; *Marius Amid the Ruins of Carthage*, 14, 45; Versailles, 207
VAUX, CALVERT, 143, 304
VELÁSQUEZ, DIEGO, 183
VENICE, 10, 153, 304
VENUS, 161-162; de Medici, 150; de Milo, 150
VERMONT, 249
VERNACULAR MODE, xi, 15-16, 20-21, 29, 66, 79, 84, 88, 122, 213-219, 293, 304-305
VICTORIA, Queen of England, 170
VIENNA, 141
VIRGILIAN MODE, 10, 13, 14-15, 17, 43, 46, 47-49, 52, 57, 250
VIRGINIA, 94, 125, 136, 215
VOLLON, ANTOINE, 110
VOLTERRA, 43
VON HAGEN, OSCAR, 309

WACKENRODER, WILHELM HEINRICH, 44n
WADSWORTH, DANIEL, 37
WAGNER, RICHARD, 137
WALDMÜLLER, FERDINAND, 105, 110; *Children Leaving School*, 110
WALTERS, HENRY, 110n
WALTERS, WILLIAM T., 110

WAR OF 1812, xii, 13
WARD, SAMUEL, 48
WASHINGTON, D. C., 67, 84, 94, 127, 200, 240
WASHINGTON, GEORGE, 132, 209n
WATERCOLOR PAINTING, 77-79, 284-289
WATTEAU, JEAN ANTOINE, 278
WEBSTER, DANIEL, 80
WEEMS, PARSON, 165
WEIR, J. ALDEN, 266
WEIR, JOHN F., 234, 245
WEIR, ROBERT W., 152-153, 160; bibliography, 323
WEST, BENJAMIN, 4, 11, 67, 77n, 102, 105, 115n, 164, 209, 294; *Christ Healing the Sick*, 105
WEST POINT, N. Y., 83-84
WESTERN ART-UNION, 97
WESTMINSTER ABBEY, 4
WHARTON, EDITH, 307
WHISTLER, J. A. M., 73, 256-257, 270, 276
WHITE, EDWIN, 200; *Thoughts of Liberia*, 200; bibliography, 326
WHITE, JOHN, 67
WHITE MOUNTAINS, 147, 221, 241-243
WHITMAN, WALT, 147, 298-299, 301
WHITTIER, JOHN GREENLEAF, 200, 300-302
WHITTREDGE, WORTHINGTON, career, 168, 221-226; quoted, 85, 90, 121, 135-136, 164; *Crossing the River Platte*, 225; *The Crow's Nest*, 223; *The Foot of the Matterhorn*, 224; bibliography, 327
WILD WEST SHOW, 80
WILKIE, DAVID, 12-13, 20, 28-29, 111, 192, 208, 293; *Blind Man's Buff*, 28; *Harvest Festival*, 208
WILLIS, N. P., 192
WIMAR, CHARLES, 85, 163, 207, 293; bibliography, 320
WINCKELMANN, JOHANN JOACHIM, 9, 30
WINDOW SHADES, 213
WINTHROP, THEODORE, 139, 141
WISCONSIN, 150
WOLFE, JOHN, 110
WONDER, RICHARD, 309
WOODCARVING, 187
WOODCUTS, 209-210, 274-276, 279. *See also* Prints
WOODVILLE, RICHARD CATON, 118n, 123-124, 191; *The Cavalier's Return or Baby's First Step*, 123; *Old '76 and Young '48*, 124; *The Sailor's Wedding*, 123; bibliography, 322-323

WOMEN. *See* Feminine influence
WORLD'S FAIR (1893), 289
WORTH, THOMAS, 211; *Darktown Comics*, 211
WUNDERLICH, RUDOLPH, 309
WÜRTEMBURG, 163
WYANT, ALEXANDER H., 258, 266-269, 282, 296, 306n; *The Mohawk Valley*, 267; bibliography, 329

WYER, MRS. A. C., 309
WYOMING VALLEY, PA., 68

Yale Daily News, 119
YALE UNIVERSITY, 100, 117, 212
YEATER, MAXINE, 309
YELLOWSTONE NATIONAL PARK, 247

ZANESVILLE, OHIO, 7

A CATALOGUE OF SELECTED DOVER BOOKS
IN ALL FIELDS OF INTEREST

A CATALOGUE OF SELECTED DOVER
BOOKS IN ALL FIELDS OF INTEREST

CONDITIONED REFLEXES, Ivan P. Pavlov. Full translation of most complete statement of Pavlov's work; cerebral damage, conditioned reflex, experiments with dogs, sleep, similar topics of great importance. 430pp. 5⅜ x 8½. 60614-7 Pa. $4.50

NOTES ON NURSING: WHAT IT IS, AND WHAT IT IS NOT, Florence Nightingale. Outspoken writings by founder of modern nursing. When first published (1860) it played an important role in much needed revolution in nursing. Still stimulating. 140pp. 5⅜ x 8½. 22340-X Pa. $2.50

HARTER'S PICTURE ARCHIVE FOR COLLAGE AND ILLUSTRA-TION, Jim Harter. Over 300 authentic, rare 19th-century engravings selected by noted collagist for artists, designers, decoupeurs, etc. Machines, people, animals, etc., printed one side of page. 25 scene plates for backgrounds. 6 collages by Harter, Satty, Singer, Evans. Introduction. 192pp. 8⅞ x 11¾. 23659-5 Pa. $4.50

MANUAL OF TRADITIONAL WOOD CARVING, edited by Paul N. Hasluck. Possibly the best book in English on the craft of wood carving. Practical instructions, along with 1,146 working drawings and photographic illustrations. Formerly titled *Cassell's Wood Carving*. 576pp. 6½ x 9¼.
23489-4 Pa. $7.95

THE PRINCIPLES AND PRACTICE OF HAND OR SIMPLE TURN-ING, John Jacob Holtzapffel. Full coverage of basic lathe techniques—history and development, special apparatus, softwood turning, hardwood turning, metal turning. Many projects—billiard ball, works formed within a sphere, egg cups, ash trays, vases, jardiniers, others—included. 1881 edition. 800 illustrations. 592pp. 6⅛ x 9¼. 23365-0 Clothbd. $15.00

THE JOY OF HANDWEAVING, Osma Tod. Only book you need for hand weaving. Fundamentals, threads, weaves, plus numerous projects for small board-loom, two-harness, tapestry, laid-in, four-harness weaving and more. Over 160 illustrations. 2nd revised edition. 352pp. 6½ x 9¼.
23458-4 Pa. $5.00

THE BOOK OF WOOD CARVING, Charles Marshall Sayers. Still finest book for beginning student in wood sculpture. Noted teacher, craftsman discusses fundamentals, technique; gives 34 designs, over 34 projects for panels, bookends, mirrors, etc. "Absolutely first-rate"—E. J. Tangerman. 33 photos. 118pp. 7¾ x 10⅝. 23654-4 Pa. $3.00

AMERICAN ANTIQUE FURNITURE, Edgar G. Miller, Jr. The basic coverage of all American furniture before 1840: chapters per item chronologically cover all types of furniture, with more than 2100 photos. Total of 1106pp. 7⅞ x 10¾. 21599-7, 21600-4 Pa., Two-vol. set $17.90

ILLUSTRATED GUIDE TO SHAKER FURNITURE, Robert Meader. Director, Shaker Museum, Old Chatham, presents up-to-date coverage of all furniture and appurtenances, with much on local styles not available elsewhere. 235 photos. 146pp. 9 x 12. 22819-3 Pa. $5.00

ORIENTAL RUGS, ANTIQUE AND MODERN, Walter A. Hawley. Persia, Turkey, Caucasus, Central Asia, China, other traditions. Best general survey of all aspects: styles and periods, manufacture, uses, symbols and their interpretation, and identification. 96 illustrations, 11 in color. 320pp. 6⅛ x 9¼. 22366-3 Pa. $6.00

CHINESE POTTERY AND PORCELAIN, R. L. Hobson. Detailed descriptions and analyses by former Keeper of the Department of Oriental Antiquities and Ethnography at the British Museum. Covers hundreds of pieces from primitive times to 1915. Still the standard text for most periods. 136 plates, 40 in full color. Total of 750pp. 5⅝ x 8½.
23253-0 Pa. $10.00

THE WARES OF THE MING DYNASTY, R. L. Hobson. Foremost scholar examines and illustrates many varieties of Ming (1368-1644). Famous blue and white, polychrome, lesser-known styles and shapes. 117 illustrations, 9 full color, of outstanding pieces. Total of 263pp. 6⅛ x 9¼. (Available in U.S. only) 23652-8 Pa. $6.00

ACKERMANN'S COSTUME PLATES, Rudolph Ackermann. Selection of 96 plates from the *Repository of Arts*, best published source of costume for English fashion during the early 19th century. 12 plates also in color. Captions, glossary and introduction by editor Stella Blum. Total of 120pp. 8⅜ x 11¼. 23690-0 Pa. $4.50

Prices subject to change without notice.